CLARENDON STUDIES IN THE HISTORY OF ART

General Editor: Dennis Farr

High Romanesque Sculpture
in the Duchy of Aquitaine
c.1090–1140

ANAT TCHERIKOVER

CLARENDON PRESS · OXFORD
1997

Oxford University Press, Great Clarendon Street, Oxford OX2 6DP

Oxford New York

Athens Auckland Bangkok Bogota Bombay Buenos Aires
Calcutta Cape Town Dar es Salaam Delhi Florence Hong Kong Istanbul
Karachi Kuala Lumpur Madras Madrid Melbourne Mexico City
Nairobi Paris Singapore Taipei Tokyo Toronto Warsaw

and associated companies in
Berlin Ibadan

Oxford is a trade mark of Oxford University Press

Published in the United States
by Oxford University Press Inc., New York

British Library Cataloguing in Publication Data
Data available

Library of Congress Catologing in Publication Data
Tcherikover, Anat.
High Romanesque Sculpture in the Duchy of Aquitaine, c.1090–1140 / Anat Tcherikover.
(Clarendon studies in the history of art)
Includes bibliographical references.
1. Sculpture, French—France—Aquitaine. 2. Sculpture, Romanesque—France—Aquitaine.
3. Civilization, Medieval—12th century. I. Title. II. Series.
NB549.A6T36 1997 96-45141 r96
ISBN 0-19-817410-1

1 3 5 7 9 10 8 6 4 2

Typeset by Best-set Typesetter Ltd., Hong Kong
Printed in Great Britain
on acid-free paper by
Butler & Tanner Ltd.,
Frome and London

ACKNOWLEDGEMENTS

Special thanks are due to Professor George Zarnecki, who first introduced me to the subject of Romanesque Aquitaine. His insistence on overview as well as attention to detail has directed my work ever since. Professor Zarnecki also made available to me the material collected by the late Miss Jane Chubb, whose photographs in particular were a great help to me at the early stage of my research.

Over the years, many have contributed valuable comments and constructive criticism, in particular Professor Peter Kidson, Dr Lindy Grant, Dr Esther Levinger, Professor Aryeh Grabois, Professor Michael Goodich, and Mr Barrie Singleton. The staff of the Conway Library, at the Courtauld Institute, extended to me every possible help with the photographs. Travel and study grants came from the Central Research Fund of London University and the Israeli Ministry of Immigrant Absorption, while many friends in France generously offered hospitality and advice.

The publication of this book has been assisted by the Rector and the Faculty of Humanities, University of Haifa.

A. T.

CONTENTS

LIST OF PLATES

LIST OF FIGURES

LIST OF MAPS

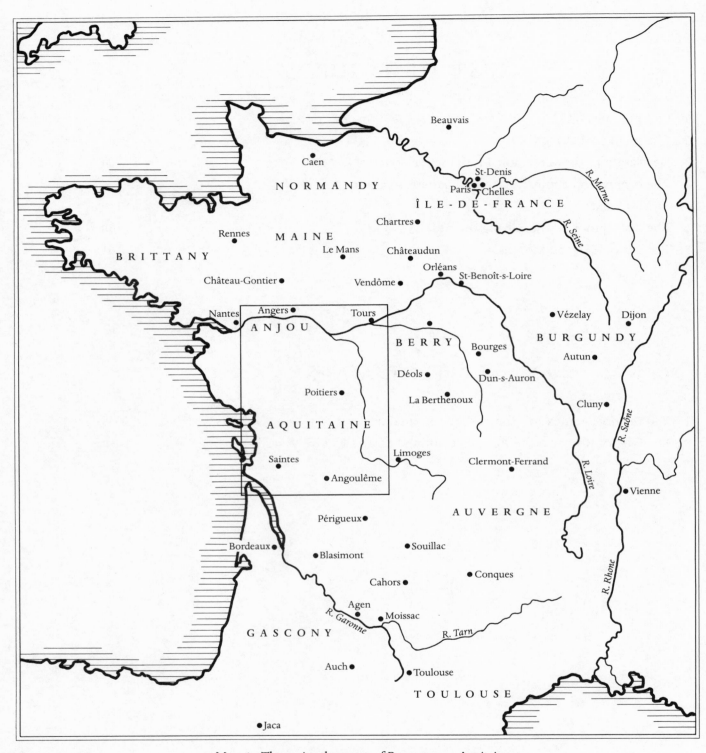

MAP 1. The regional context of Romanesque Aquitaine

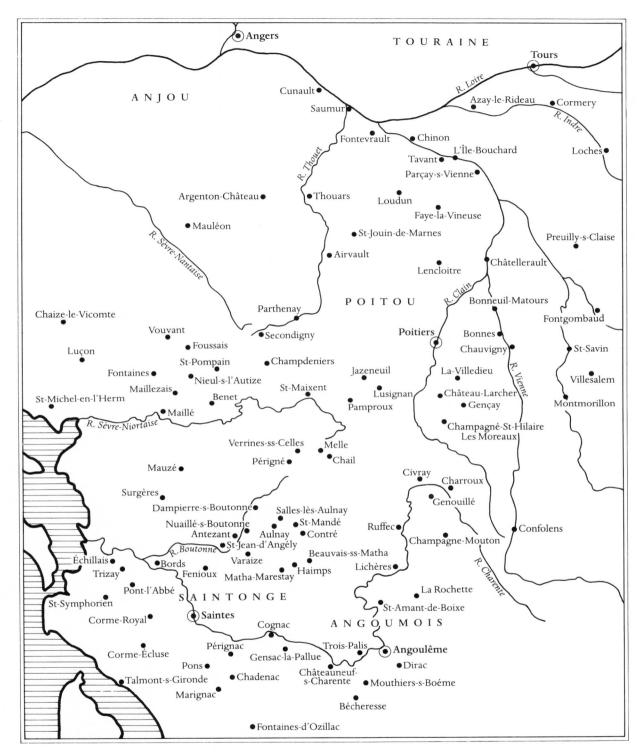

MAP 2. The core of Romanesque Aquitaine and the adjacent Loire Valley

INTRODUCTION

This book traces the history of church sculpture in the Aquitaine region of western France during the High Romanesque period, around the early twelfth century. It suggests that the remarkable diversity of Aquitainian sculpture in that period was the result of chronological overlap between the last flowering of a declining mode and completely new beginnings. On the one hand, the well-tried techniques of the architectural sculptor, inherited from the Early Romanesque of the eleventh century, were exploited for increasingly intricate decorative features, but they also proved regressive. On the other hand, monumental figure sculpture was being revived independently on numerous church façades, accompanied by new departures in every respect, including circumstances of patronage, stylistic preferences, and iconography. The two modes coexisted for a while, occasionally fused but generally distinct, until the old architectural mode reached a dead end while the new one grew into proto-Gothic.

The course of this transition emerges in this book from an assessment of the chronology of the monuments, a problematic issue which has long troubled all studies of Romanesque sculpture, in Aquitaine as elsewhere. Uncertainties concerning dates originally arose from the paucity of documents, and they have been aggravated by the chronological implications of some general theories on the nature of Romanesque, formulated in the early decades of this century. There was a tendency to assess dates on the grounds of supposed developments rather than the reverse, which has left a stubborn impression on subsequent dating systems and undermined the factual foundations of the whole subject. The full range of these theories exceeds the scope of this book, but the main ones and their consequences for Aquitaine may nevertheless be briefly outlined as follows.

One theory originated in the regional approach to the study of Romanesque, and involved the grading of various regional schools in a supposed order of priority. Scholarly preoccupation with a few select schools, in particular in Burgundy and the Languedoc, created the impression that these schools set the standard of Romanesque sculpture while others followed their example at some later date. Dissenting voices suggested other centres of influence, variously in the Loire Valley, Spain, or northern Italy, but Aquitaine has generally been regarded as a curious and provincial follower of the supposedly mainstream Romanesque of other regions, especially those to its south. The region as a whole has consequently acquired a persistent label of tardiness despite much evidence to the contrary on some key individual monuments.[1]

[1] The problems concerning interregional relationships go back to the theory of regional schools. The origins and the early history of this theory are discussed by Francastel (1942), with some conclusions for Aquitaine (pp. 141–2). The ensuing 'late datings' for the Aquitainian

Such contradictions convinced scholars of the necessity for a non-regional overview of Romanesque history. The most influential theory of this kind was that advanced by Henri Focillon, in which he claimed to detect a widely applicable pattern of stylistic evolution.[2] This theory has repeatedly met with scholarly disquiet,[3] but has never been thoroughly reassessed. As will be shown, it is weak at precisely the crucial point of a supposed development from the architectural sculpture of the eleventh century to the monumental figure sculpture of the twelfth, and therefore provides no true corrective to the dating system. Focillon has also been rightly criticized for his purely stylistic approach and apparent disregard for iconography, yet the critics offer no alternative dating system.[4] While the study of iconography has clarified the meaning of many individual monuments, all attempts to tie the iconography to a wider cultural context remain precariously balanced on a hypothetical chronological edifice.[5]

My point of departure was the dissenting views of René Crozet,[6] Arthur Kingsley Porter,[7] and more recent scholars of like mind,[8] who advocated total reappraisal of the twelfth-century monuments of Aquitaine. Such a reappraisal could not rely on any suppositions concerning developments, all of which have become hopelessly entangled in uncertain and often controversial hypotheses. I therefore concentrated on three kinds of evidence: documents, where they exist; the relative chronology which arises from the analysis of building phases; and formal analogies between dated and undated works. The result, as presented in this book, is a revised chronology of the twelfth-century material, which is shown to be generally earlier than previously believed. Significantly, the chronology of the eleventh-century monuments in some of the relevant regions has also emerged in recent French scholarship as correspondingly earlier than once thought. For eleventh-century dates I have often relied on these new studies, chiefly those by Marie-Thérèse Camus and Éliane Vergnolle.[9] The revised chronology also reveals systematic lines of descent and directions of influence, which I have arranged in diagrams. These are placed at the head of each relevant chapter and may be consulted in parallel to the text.

Once established, the chronology for both the eleventh and the twelfth centuries is seen to match several historical processes. The origins of the Romanesque school of Aquitaine thus correspond to the rise of the duchy of Aquitaine as a major feudal principality. As shown by the historian Jane Martindale, the policies of the duchy were at first directed towards the north and later towards the south,[10] and it is noteworthy that a similar shift of regional orientation may be detected in the history of the Aquitainian Romanesque. For this reason I have deviated from common practice and avoided an introductory definition of the regional scope of the school of

monuments appear, amongst others, in Deschamps 1930: 71–5; Aubert 1956; Rupprecht 1975: 88–97; Jacoub 1981, and, concerning some of the corresponding material in Anjou, Mallet 1984.

[2] Focillon 1931; id. 1969 edn. (first published in 1938). A penetrating analysis of Focillon's theories was offered by Francastel 1942: 194–200.

[3] Hearn 1981: 14–15. See also n. 4.

[4] Schapiro 1977b edn. (first published in 1932). This article strongly criticizes the views of Focillon's follower Baltrusaïtis (1931).

[5] Examples concerning Aquitaine include: Mâle 1978 edn. (first published in 1922): 440–3. Another scholar juggled his own convincing conclusions to match the current but flawed system of dating; see below, Chapter 3 n. 39. A relatively recent study largely avoids the issue of dates, but at some point nevertheless links the iconography of the Aquitainian façades to the ideological context of the Second Crusade: Seidel 1981: 72–3.

[6] A selection from Crozet's work is listed here in the Select Bibliography. Crozet did not deal directly with systems of chronology, but generally trusted documentary evidence rather than the theories of development current at his time.

[7] Porter 1923: 303–42. Penetrating and pioneering as it is, Porter's discussion of Aquitaine abounds with inaccuracies and should be treated with caution.

[8] e.g. Werner 1979.

[9] Camus 1992; Vergnolle 1985.

[10] See Chapter 2 n. 2.

Aquitaine. The discussion of the various workshops will show that those active in the duke's own county of Poitou fluctuated between old connections with the Loire Valley to the north and new exchanges with Saintonge, Angoumois, and the regions further south. It was only after a long series of these new exchanges that the school crystallized into the essentially southern one that it is normally understood to have been. By that time it had also become highly prolific, because the process coincided with demographic expansion and ecclesiastical reform which led to invigorated patronage, resulting in a significant increase in the building and decoration of churches. All in all, the school was one of the most innovative up to about 1140, at which time it began to decline, together with the duchy that created it.

When considered in chronological order, the school of Aquitaine is also seen to have responded repeatedly to the fast pace of new ideas characteristic of the ecclesiastical circles of the time throughout the West. Perhaps the best examples for this are the themes chosen for the monumental programmes of figure sculpture, which appeared on church façades from about 1100. The earliest emphasized the role of the Church as the only possible mediator between God and the terrestrial world, and their image of the Church was conceived in terms of papal propaganda in the wake of the ecclesiastical reform. Contrary to what might be expected, images concerning the moral issues of the punishment of sinners and the reward of the righteous were at that time reserved for marginal sculpture, such as on choir capitals, and did not come into the monumental façade programmes. The moralizing themes of virtues, vices, and parables alluding to the judgement of souls were introduced to façade iconography only from about 1130, in response to new ecclesiastical preoccupations typical of that period.

The revised chronology also discloses a certain pattern of artistic experimentation and innovation. It will not surprise most contemporary scholars that this pattern has nothing to do with the linear evolution and tendentious development envisaged in the past. All such notions of 'evolution' and 'development' are here generally avoided, although the processes which emerge may perhaps be regarded as evolutionary in the narrower sense of repeated selection. It thus seems that every new idea, stylistic or iconographical, was at first the subject of many different experiments, but only a few gave rise to lasting practices. At Melle, for instance, an early twelfth-century preoccupation with figure programmes took different forms on corbels, archivolt voussoirs, capitals, and relief slabs, but only the last had any continuous success. The other forms remained marginal and exerted no influence on mainstream figure programmes. A generation later, the ambitious iconographical programme of Angoulême Cathedral failed to establish a significant following, while another, at Argenton-Château, eventually became the norm. At any given moment, the school of Aquitaine reveals a multitude of parallel trends, but only a few of these had any effect on subsequent artistic currents.

Also the relationship outlined above between architectural sculpture and monumental figure sculpture was one of parallelism. Originally of ornamental character, architectural sculpture on capitals and other select members of the structure was a major vehicle for Early Romanesque experiments in figure sculpture during the eleventh century. Following Focillon, scholars have become accustomed to the notion of continuity between these experiments and the High Romanesque monumental complexes of the twelfth century; but the new chronology reveals that the figural experiments of the architectural sculptor came to a dead end. They were never

translated into monumental imagery. With the independent rise of monumental figure sculpture, architectural sculpture largely reverted to its old decorative function and in fact reached unprecedented heights of complex ornamentation. Even the architectural medium of the portal, often claimed as the chief vehicle for the growth of figure sculpture, actually remained predominantly ornamental until a very late stage in the history of monumental imagery. At that stage, new combinations of architecture and figure sculpture arose from a new process, which may be called proto-Gothic, and was unrelated to the old traditions of architectural sculpture. Aquitaine apparently represents the normal course of portal history, though significant exceptions existed in some other regions.

This presentation of the school of Aquitaine has been subjected to some deliberate restrictions. The quantity of the material is such that a lucid discussion demanded a selective approach, omitting many of the lesser or derivative works. Furthermore, the uncertain chronology of other Romanesque schools considerably limited the possibilities of examining the material in a wider context. The apparent influence of Burgundy and Italy, for instance, has therefore received no more than fleeting comment. Connections with closer regions nevertheless emerge in a new light, for the school of Aquitaine is seen to have mediated between the important centres of sculptural innovation in the Loire Valley and the somewhat later but equally important centres of the south, and may accordingly be linked to the acknowledged mainstream of French Romanesque sculpture.

1

THE COUNTY OF POITOU
*c.*1090–1120

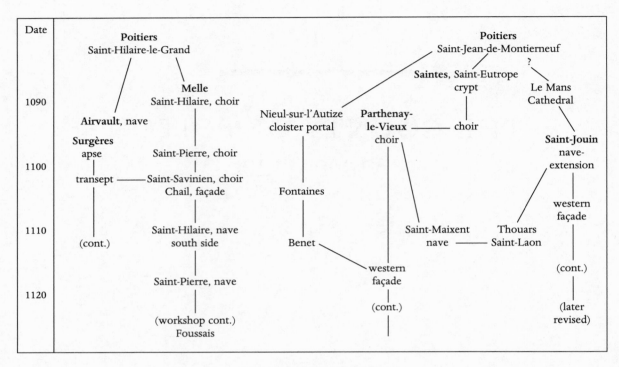

Fɪɢ. 1. Poitou *c.*1090–1120

A. THE HERITAGE OF THE ELEVENTH CENTURY

Church Patronage and the Gregorian Reform

Eleventh-century Poitou was a rising power. The local counts were gradually giving substance to their title of dukes of Aquitaine, acquiring wealth and prestige on such a scale that contemporaries described them in regal and imperial terms. In reality, ducal control of any area beyond Poitou relied on a rather unstable network of vassals and allies in the surrounding counties; yet one chronicler did not hesitate to compare Duke William the Great (*ob.* 1030) to Louis the Pious, Charlemagne, and the emperors of ancient times. He thus depicted the grand spirit of a ruling dynasty that was soon to boast greater political influence than the contemporary kings of France, a connection by marriage to the Salian emperors of Germany, and an independence which, despite some drawbacks, was to endure well into the twelfth century.[1]

Traditionally a matter of seigneurial responsibility, church building was a visible sign of this prominence. Like some other regions at that time, eleventh-century Poitou saw an unprecedentedly energetic spate of new constructions, apparently under the patronage of the dukes and their leading vassals.[2] Almost all the main churches in the ducal city of Poitiers were built or renovated between *c.*1020 and *c.*1090. After the cathedral (later replaced), there followed Saint-Hilaire-le-Grand, Notre-Dame-la-Grande, Sainte-Radegonde, Saint-Nicolas, Saint-Porchaire, Saint-Jean-de-Montierneuf, and others which are now lost, while parallel projects were undertaken in the countryside abbeys of Maillezais, Saint-Savin, Charroux, and more. As recently clarified in an important study,[3] the chain of ambitious projects was practically uninterrupted, which meant new opportunities for the builders and decorators. They found continuous employment, and acquired the experience that leads to expertise. As elsewhere, Poitou consequently came to possess a notable school of architectural sculptors, who produced carved capitals of increasingly complex workmanship for one building after another (e.g. Pls. 1–11).

However, all this impressive activity was only the preamble to a second wave of church building, which was to multiply the sculptor's opportunities and eventually transform his practices. Increasingly in evidence towards the end of the eleventh century and the beginning of the twelfth, the new wave involved a new form of patronage. Instead of the secular nobility, the ecclesiastical establishment itself now often assumed the responsibilities of church building. Here it is instructive to compare the wording of some documents relating to the construction of churches before and after this change. Recording the consecration of a renovated abbey, a chronicler of 1050 specified that Countess Agnes (countess of Anjou and regent of Aquitaine) and other noblemen 'caused it to be made'.[4] In a document of 1122, on the other hand, it is the bishop of Poitiers who is reported to have renovated a certain ruined priory, using for this

[1] Dunbabin 1985: 173–9; Historical studies of the duchy of Aquitaine include: Martindale 1965; Garaud 1964; Richard 1903.

[2] The 11th-cent. school of Poitou is presented most fully in Camus 1992, with a discussion of patronage on pp. 225–8.

[3] Camus 1992.

[4] The chronicle of Saint-Maixent for 1050: 'fuit consecratio facta monasterii Sancti Joannis Engeriaci, quam Agnes comitissa fecit facere et alii seniores' (Marchegay and Mabille 1869: 398).

purpose 'the worldly treasury of the [cathedral] church'. No lay noblemen are mentioned at all.[5]

These examples are far from accidental. They reflect a reorganization of the ecclesiastical property in the wake of the Gregorian reform movement, called after Pope Gregory VII (1073–85), though begun before him and consolidated by his successors. At the heart of the Reform was the independence of the Church from lay control. Churches were now transferred from lay to ecclesiastical hands, together with temporalities such as affiliated lands and revenues. With the active support of the duke, Aquitaine was one of the strongholds of the Reform from its beginnings, and consequently saw a veritable flood of such transfers which grew steadily during the relevant period in the second half of the eleventh century.[6] The abbey of Saint-Jean-d'Angély, for instance, received over two hundred and forty donation charters in that period, as opposed to thirty-one in the first half of the century and twenty-nine in the entire twelfth century.[7] Similar patterns recur elsewhere, and testify to the concentration of much wealth in independent ecclesiastical hands.

The new arrangements affected not only the fortunes of the recipient abbeys but also those of the acquired churches in the towns and villages. These were churches of secondary importance, many of which had originally belonged to the petty rural nobility, and thus fell outside the grand ducal patronage. Under the pre-Reform system, such churches stood little chance of good maintenance, let alone ambitious reconstruction, since their property was often divided among several different laymen. This is revealed by the complicated transactions aimed at extricating them from such multiple ownership; those concerning Saint-Hilaire at Melle can serve as an example. It was probably this church that was included in a donation made to the abbey of Saint-Jean-d'Angély by one Heirois, in a charter of c.1028, but other laymen still retained a right to it. In a charter of c.1080, the same church is said to have comprised part of the widow's dower of Aina Lupa, mother of Maingod, the lord of Melle. He gave it to the abbey with her consent. At about the same time, a deal concerning some property adjacent to the same church was concluded between the abbey, Aina's new husband, and her other son, Constantine, who was compensated for his share by the other parties.[8] Little by little, the church and its property were thus saved from competing lay interests and passed into the hands of a single ecclesiastical owner.

Shared ownership was the obstacle to be overcome before such churches could be reconstructed, but it was not quick to disappear. A multiplicity of lay donors could sometimes result in there being more than one ecclesiastical recipient, equally a situation that could no longer be tolerated. One or other of the new ecclesiastical owners had to prevail. The church of Saint-Jouin at Le Lude (in Maine), for instance, was shared by the Poitevin abbey of Saint-

[5] A papal confirmation of the bishop's donation of churches to the chapter of the cathedral, 1122, addresses the canons: 'et de Canavellis in castellania de Monte Oiranno destructo; eciam, per vestrum commune consilium, seculari cellerario ecclesie vestre prioratum constituit [i.e. the bishop]' (Robert 1891: 40). The rise of independent ecclesiastical patronage is also noted by Camus (1987: 10).

[6] For France in general, the effect of the Reform on ecclesiastical property is discussed in Lot and Fawtier 1962: 107 (contrast with the situation before the Reform, ibid. 62–7); also Fliche 1950: 262–3. For Poitou in particular, see Garaud 1960: esp. 373–4; Martindale 1965: 164–89. A detailed case-history is presented in Denécheau 1991. This article describes the progressive independence of one abbey during the 11th cent., and the consolidation of its wealth by the early 12th cent.

[7] The charters are published in Musset 1901.

[8] Musset 1901, charters nos. CCXLIV (pp. 297–9), CCXIX (pp. 275–6), CCXXVIII (pp. 284–5).

Jouin-de-Marnes and the Angevin abbey of Saint-Aubin, until the former yielded to the latter, in 1113.[9] Between 1096 and 1107, Saint-Laon at Thouars was the subject of a dispute between the incumbent canons and the monks of Saint-Florent-lès-Saumur; the canons eventually won.[10] Between 1100 and 1109, the priory of Villesalem was claimed by the abbeys of both Fontevrault and Fontgombaud. It fell to Fontevrault.[11] The matter was serious because not only were old churches at stake, but also the new opportunities arising from a demographic expansion that culminated in the same period. New villages were founded and old towns were enlarged, which meant that there were many more churches than before.[12] They all came into the possession of the abbeys, and later of the bishops and the cathedral chapters, together with dependent lands, privileges in the local markets, and other economic assets. Conditions were ripe for a new wave of church building, more intense than before.

The impact of the new property arrangements on building projects can be illustrated by the example of Saint-Pierre at Airvault. Originally a late tenth-century foundation by a viscountess of Thouars, this church was reformed with the consent of her descendant, Viscount Aimery IV (1055–93). A later episcopal confirmation charter (1095) gives an account of the main events from the time of the foundation up to the Reform. It relates how the founder enriched the church with various properties, and divided them individually among several canons. These led a secular lifestyle characteristic of the pre-Reform period, and bequeathed their shares to sons and daughters who had little interest in ecclesiastical aims. The church is thus seen to have reached a stage of multiple ownership. As the charter relates, it consequently came to the brink of ruin. The reformers' main task was therefore to reinstate everything in the common owner-ship of a chapter of Canons Regular under the leadership of an abbot.[13] The newly organized property must have created new possibilities for reconstruction, since another source reports a consecration of the church in 1100.[14] This is arguably the extant church on the site, which,

[9] Broussillon 1903, charters nos. DCCCXXI, DCCCXXIII–DCCCXXV, DCCCXXVIII, DCCCXXIX (pp. 300–6).

[10] Imbert 1875, charters III, IV, VIII, LVIII.

[11] The documents are discussed in Salet 1951; also Goudron de Labande 1868: 397–423.

[12] On the population expansion and the rural settlement of Poitou, see Sanfaçon 1967; also Beech 1964: esp. 20–34.

[13] The confirmation charter of 1095 (after *Gallia Christiana*: ii. 1386–7): 'quaedam comitissa Hildeardis nomine, Domina Thoarcensium . . . quondam aedificavit ecclesiam in honorem B. Petri Apostolorum principis, in loco qui vocatur Aurea Vallis; qua aedificata decenter, volens explere quod incoeperat, . . . multis et magnis ditavit bonis. Ut autem in eadem ecclesia ministerium posset honestius fieri, et digne tractarentur bona ecclesiae collata, consilio domini Gisleberti, bonae memoriae viri Pictavorum episcopi [975–1018], canonicos in ipsa constituit, . . . qui ob sui meritum laboris bona ejusdem loci in suis usibus obtinerent, et eorum unicuique divisionem praebendarum tradidit, et uni minus alteri amplius distribuit. Quibus ita compositis, canonicis ibidem abeuntibus, quia sine pastoris regimine locus extiterat, coepit eorum propago haereditate sanctuarium Domini Dei possidere, et bona Dei servitio debita usurpare, et filii et filiae a patribus, tanquam naturaliter sibi accidentia, ea obtinere. Haec tandem causa extitit per multa tempora illius ecclesiae et bonorum ejus desolatio, ut commoda sibi attributa amitteret, et Dei ministerium convenienter, uti deceret, illic non efficeretur. Causa itaque Dei in

tantam perniciem et dissipationem declinante, usque ad nostra ventum est tempora. Animadvertentes igitur tam lachrymabilem et damnosam hujus ecclesiae desolationem, et nisi subveniretur ei, eam intrinsecus et extrinsecus lapsum passuram, quia nostri est officii dispersa colligere, lapsa erigere, consilio et precibus domini Aimerici vice-comitis Thoarcensis [1055–93], temporalis illius terrae domini, et Arberti filii ejus condolentium loci ejusdem dissipationi, et canonicis qui illic commorabantur obnixe postulantibus, consideravimus quam maxime necessarium esse ut illic pastorem constitueremus, qui interiorum et exteriorum utilis provisor et procurator existeret. Canonici vero deinceps religiose et canonice sine proprio, secundum regulam Beati Augustini viverent, . . .'. The charter continues with additional specifications concerning the position of the abbot and the Rule, seeking (and receiving) the renewed agreement of the then viscount of Thouars, Aimery's son Arbert, and concludes with a list of dependent churches. The chronicle of Saint-Maixent mentions the arrival of the canons in 1064: 'Benedictio S. Petri Aureae Vallis fuit de crucifixo, tunc primum canonici coeperunt esse ibi' (Marchegay and Mabille 1869: 403). The canons in question were doubtless the Augustinian canons mentioned in the above-quoted charter, as opposed to the earlier secular canons, also mentioned in the same charter.

[14] The Chronicle of Saint-Maixent for 1100: 'Pridie Kal. Nov. fuit sacrata ecclesia S. Petri Aureae Vallis' (Marchegay and Mabille 1869: 419–20).

discounting some later alterations, is one of the more luxuriant monuments of late eleventh-century Poitou (Pl. 25).[15]

There was a similar link between reform, property arrangements, and ambitious reconstruction in the Benedictine priory of Saint-Eutrope at Saintes (Pl. 129). This church is reported to have been extracted by ducal initiative from lay hands (*de manu laicali*) in 1081. It was rebuilt soon afterwards under the auspices of newly installed Cluniac monks, and a consecration of altars followed in 1096.[16] Similarly, the document of 1122 cited above links the construction of another church to the conclusion of an ownership settlement, and it may well be asked if this was not the normal procedure. Having been secured in their own possessions or affiliated to some great abbey (or both), churches of all sorts now enjoyed new opportunities.[17]

This is not to say that laymen were no longer involved in the affairs of churches. There was, in fact, no clear separation between ecclesiastical and lay circles. The Church now possessed considerable temporal interests, so that bishops and abbots continued to feature in the entourage of the great feudal lords, to their mutual benefit. The layman provided protection, and his donations were often rewarded by burial and chantry services. If he retired to a monastery, he stood a good chance of reaching high position. Some of the abbeys, though duly reformed, continued to enjoy his patronage as in the previous period. The circumstances of any particular church project consequently depended on the local balance between the lay and the ecclesiastical powers, as will be shown.

Architectural Ornamentalism

It was the second wave of church building, especially from *c.*1100 onwards, that gave rise to the first important ensembles of monumental figure sculpture on church façades. This achievement appears all the more remarkable against the background of the eleventh-century traditions of stone sculpture, which had entailed very little of the figural. In the eleventh-century buildings, important figure programmes had generally been entrusted to the mural painter, while the sculptor was responsible for what may be called 'architectural fineries', that is, decorative elements of the structure proper. The eleventh-century concept of the stone sculptor as a mere architectural decorator was actually to prove persistent enough to compete against all new trends for quite a while. For this reason, some comments are in order here on the eleventh-century traditions of Poitou, which have already been investigated more fully by others.[18]

In Poitou as elsewhere, the main medium of the eleventh-century sculptor was the capital. It was usually ornamental, rarely figural, and exploited mostly for interior embellishment (e.g. Pls.

[15] Some aspects of the building's decoration are discussed below; see also n. 35. Later works in the building include the addition of a narthex, in the 12th cent., and eventually the vaulting of the nave in the Gothic style.

[16] On the transfer of the church in 1081, see Audiat 1875: 266–7. The evidence concerning the reconstruction, the consecration of 1096, and the translation of relics, is discussed in Crozet 1956b; also Terpak 1986: n. 10. The building history is analysed below, Chapter 2.A, and also in Tcherikover 1988.

[17] I evidently reject the theory, advocated in particular by Seidel (1981), that the reconstruction of churches in 12th-cent. Aquitaine depended on the patronage of the secular nobility. This theory involves a chronological distortion, because it relies on documented examples of lay patronage from the first half of the 11th cent. or earlier. These examples are indeed typical of their time, but irrelevant for the post-Reform situation of the 12th cent. For further details, see Tcherikover 1990b: 440–4 and n. 64.

[18] See the following three notes.

1, 2). Exterior sculpture was less common; in addition to some capitals, it appeared in the occasional stretch of corbels and metopes (Pl. 4), and, with a limited vocabulary of geometrical forms, also on the archivolts of some windows and portals (Pls. 67–74). The most promising vehicle of figure sculpture was the free slab-relief (Pl. 115), sometimes incorporated in the exterior masonry, but even this was often ornamental and remained generally modest. With few exceptions, such reliefs were inserted in the wall at random following no clear plan. There is some evidence for a growing interest in programmes of slab-reliefs on church façades, but few important churches possessed a suitable façade. Many of the church builders preferred arcaded entrance towers, which accommodated this sort of decoration less happily than the wide expanses of the simple wall. On the whole, no other form of stone sculpture could seriously compete with the capital.[19]

As is well known, eleventh-century capitals were often the vehicle for imaginative and masterly sculptural inventions; but, compared with what was to happen from *c.*1100 onwards, the pace of innovation was very slow. The evidence for this concerns not only the school of Poitou but also that of the adjacent Loire Valley, closely related to it and rightly acknowledged as the source of many of the innovations of the time. It was in the Loire Valley that new and unprecedentedly competent derivatives of the antique Corinthian capital appeared around 1030, in the tower of Saint-Benoît-sur-Loire,[20] followed in Poitou by additional variants in the tower of Saint-Hilaire-le-Grand at Poitiers, *c.*1030–40.[21] This style of capital undoubtedly broke new ground, yet it was now to be repeated with only subtle changes up to *c.*1070 and even later. For instance, a capital in the chevet of Notre-Dame-la-Grande at Poitiers (Pl. 1), apparently of *c.*1050–60,[22] faithfully reproduced the generation-old design of upright leaves surmounted by overhanging volutes. Scholars have identified numerous transmutations of this pattern, involving a replacement of the foliate elements by animals and even figures, but it is noteworthy that the new forms are rarely seen to have ousted the old ones. It seems that they were simply added to the sculptor's stock-in-trade, which eventually resulted in a cumulative formal vocabulary in which the old restrained the new.

The corpus of capitals in the Poitiers church of Saint-Hilaire-le-Grand can serve as an illustration for this kind of cumulative vocabulary. The building has a complicated history, beginning, as mentioned, around 1030–40, but the capitals in question belong to a subsequent reworking of the transept and the chevet, recently attributed to *c.*1060–80.[23] Besides the usual sprinkling of carved capitals on the interior (e.g. Pl. 2), many more are here positioned on the exterior, punctuating a string of corbels and metopes which runs under the cornice of the ambulatory and chapels (Pls. 3–6).

Among other patterns, this complex includes long-established variants of the Corinthianesque capital, some with foliage and others with animals and figures. On one of the interior capitals (Pl. 2), for example, pairs of rearing lions join heads at the upper corner to replace the volutes of the

[19] A useful synopsis of the various types of sculptural decoration in 11th-cent. Poitou can be found in Camus 1992: 80–1. On façades see also Camus 1991, and, on slab-reliefs, Camus 1982*a* and n. 94 of this chapter.

[20] Vergnolle 1985.

[21] The dates here adopted for the Poitevin examples of Corinthianesque capitals are after Camus 1992: 88–115 and 231–49.

[22] See n. 21 above.

[23] Camus 1992: 128–49 (on the nave and transept) and 150–78 (on the series of capitals with lumpy foliage, 'feuilles grasses', including those on the ambulatory and chapels of Saint-Hilaire-le-Grand). For the building history, see also Camus 1982*b*.

Corinthian model, a scheme used at least a decade earlier in the chevet of Notre-Dame-la-Grande at Poitiers, and some thirty years previously at Saint-Benoît-sur-Loire. At Saint-Hilaire-le-Grand, it remains highly conservative despite some changes of treatment.

A second type of capital is found on the north side of the ambulatory cornice. This type, too, is Corinthianesque, but of a different kind. It involves exceptionally prominent corner heads jutting out into space (Pl. 3), according to a formula current between *c.*1070 and *c.*1090 in the neighbouring region of Berry.[24] It should therefore be seen as one of the latest additions to the formal vocabulary of the complex.

The rest of the capitals along the ambulatory cornice are block shaped, and carved with lavish sprays of lumpy foliage growing from undulating ribbon-stems (Pl. 5). Peculiar to Poitou, this style is common in additional monuments of *c.*1060 onwards at Charroux (Pls. 7, 8), Saint-Savin, and elsewhere. The foliage often incorporates animal patterns similar to those in the conservative Corinthianesque style, testifying to an exchange of models, yet some of those at Saint-Hilaire-le-Grand are adapted in a new way (Pl. 6). Instead of the paired corner lions (cf. Pl. 2), a single animal is here depicted strolling across each corner of the block, its neck twisted backwards to reoccupy the place of the volute. This technique of adaptation is generally recognized as one of the period's main instruments for creating new patterns, but it may also be seen as one of the main spokes in the wheel of genuine innovation. The vicissitudes of the animal composition of Saint-Hilaire-le-Grand, here for convenience called 'the twisted-neck animal', can serve as an example of this.

Following Saint-Hilaire-le-Grand, the twisted-neck animal recurs in a number of additional monuments of *c.*1070–90. These include the nave of Saint-Savin (*c.*1070–5), the chevet of Saint-Jean-de-Montierneuf at Poitiers (between 1069 and 1086), and, north of the Loire, the aisles of Le Mans Cathedral (between 1085 and 1096).[25] A study of this sample (Pls. 9–11, 97) reveals a limited range of combinations. The twisted-neck lions of Saint-Savin are sunk in yet another version of the lumpy sprays of foliage (Pl. 9), while those at Le Mans are depicted against a lightly foliate background (Pl. 97). Montierneuf has twisted-neck dragons (Pl. 11) as well as another version of the lions (Pl. 10). These lions are positioned paw-to-paw and cleared of all additional decorations, which allows space for another variation: the animal's hindquarters are twisted upwards to counterbalance the twist of the neck. More examples could be cited, but this group gives a fair impression of the cautious changes of the time.

A somewhat different spirit governs the twisted-neck animals that can be found in the church of Saint-Pierre at Parthenay-le-Vieux. As will be proposed, this church belongs to the new wave

[24] On the Berry group, see Vergnolle 1972; ead. 1985: 258–74. The relationship between Saint-Hilaire-le-Grand and the Berry group still awaits research. The Berry church of La Berthenoux possesses a capital with animal heads, very similar to the one at Saint-Hilaire-le-Grand (Pl. 3), but, to my knowledge, it has never been illustrated (my own photograph is unprintable). This relationship involves a chronological problem, which may be summarized as follows. According to Vergnolle (1985: 19 and 201–57), the source of the Berry style is the choir of Saint-Benoît-sur-Loire, constructed in the main under Abbot William, 1067–80, but completed later (there was a translation of relics in 1107). Yet the date suggested by Camus for the relevant parts of

Saint-Hilaire-le-Grand, between *c.*1060 and *c.*1080 (see n. 23 above), entails a possibility that the style appeared first at Saint-Hilaire. If Camus is right, the relationship between the various members of this group may have been more complex than envisaged by Vergnolle.

[25] The date here given for Saint-Savin is that suggested by Camus (1992: 178). The chevet of Montierneuf is dated on documentary grounds (Camus 1992: 179–94, and Camus 1978). At Le Mans, the aisles and the western façade survive from the project of Bishop Hoel (1085–96), though much else was later altered; see Salet 1961; Cameron 1966; Mussat *et al.* 1981: 24–30.

of intensified construction characteristic of the turn of the century. It also reveals a new intensity of artistic invention, which nevertheless remains bound by restrictive traditions of design. On the capitals of the choir arch, a new sculptor is thus seen to have reproduced the twisted lions of Montierneuf (inscribed LEONNES, Pl. 12), now supplemented by a whole range of other twisted-neck creatures. There are mermaids (inscribed SERIENAE, Pl. 15), griffins (Pl. 14), and goat-headed monsters (inscribed CAPRICORNIVS, Pl. 13). It is possible that the choice of creatures reflects some symbolical intentions,[26] but the basic framework is still the architectonic and ornamental one of the twisted-neck corner animal.

Similar compositions now became highly popular in Poitou and the surrounding regions, not least owing to the efforts of the sculptor of Parthenay-le-Vieux. The lions, mermaids, and griffins on the choir capitals of Saint-Eutrope at Saintes, for instance, have long been attributed to this sculptor (Pls. 137, 138).[27] To these may be added the respond capitals at the west end of the nave at Saint-Maixent, which display the same lions (Pl. 16) and another version of the same mermaids (Pl. 17). The mermaids no longer have twisted necks, but betray the hand of the same sculptor by their sweeping outlines, plump physique, robust jaws, and thick locks of hair, as well as the criss-cross pattern on some of their fish-tails.[28]

This traditional and yet innovative sculptor was apparently active at the turn of the century, as suggested by the cumulative evidence from Saint-Eutrope, Parthenay-le-Vieux, and Saint-Maixent. Saint-Eutrope was reformed in 1081, rebuilt, and consecrated in 1096.[29] The earliest works, in the crypt, are of no relevance here. The capitals at issue are found in the choir above, and were probably produced nearer the consecration date. It was only a few years before, in 1092, that Saint-Pierre at Parthenay-le-Vieux passed from lay to ecclesiastical hands. The whole borough of Parthenay-le-Vieux was then recolonized,[30] which must have incurred much building activity, including the reconstruction of the church. Work at Saint-Maixent began at about the same time; according to the local chronicle, reconstruction of the monastery from its foundations got under way in 1093. Unfortunately, the church was greatly altered in later periods. Very little survives of the original east end, where the work presumably began, and the nave lost the original arcades. Perhaps our sculptor was engaged on this project from the start, but what actually survives of his work, at the west end, seems later. His capitals are here matched to a new type of composed pier, consisting of clustered half-shafts and quarter-shafts (Pl. 16), which is found neither at Saint-Eutrope nor at Parthenay-le-Vieux. Indeed, the project was probably completed only under Abbot Geoffrey, who entered office at Saint-Maixent in

[26] A similar choice of creatures can be noted in the central chapel of Santiago de Compostela, of the 1080s (see Durliat 1990: 210–12 and figs. 177, 181). I am not sure about the direction of influence (if any), because Montierneuf is earlier, but lost a great number of capitals. A moralizing symbolical interpretation has been offered for the similar creatures in the early 12th-cent. porch of Sant'Eufemia at Piacenza (Verzar-Bornstein 1988: 53 and figs. 45–9). Another symbolical interpretation of such fauna is suggested below (Chapter 2.B), concerning the transept portal of Aulnay.

[27] Cf. Crozet 1971b: 66 and 175.

[28] Twisted-neck animals, of various dates in the late 11th and 12th cent. can be found also at Saint-Jouin-de-Marnes, Surgères, Trizay, a loose capital in Poitiers museum, Salles-en-Toulon, Secondigny, Preuilly-sur-Claise, and many other places. There are some distinctive divergent series, including: in Poitou, the group of La-Villedieu-du-Clain, Château-Larcher, and Saint-Maurice-de-Gençay; in Touraine, the group of Tavant, Parçay-sur-Vienne, and Faye-la-Vineuse. There are many more in other regions of France and some in Italy. To the best of my knowledge, most of these are later. Their relationship to the Poitevin type still awaits research.

[29] See n. 16 of this chapter.

[30] This is clear from the charter of donation, issued by the lords of Parthenay in favour of the abbey of La Chaize-Dieu (Besly 1647: 396–7).

1107, and was eventually credited by the chronicler with important (though unspecified) build-ing works following a fire.[31] All this suggests that the sculptor in question was active from the 1090s to some date after 1107.

Although his work is repetitive and subject to old ornamental conventions of animal compo-sition, this sculptor should not be underestimated; he was employed on projects of the first rank. According to the twelfth-century book known as *The Pilgrim's Guide*, Saint-Eutrope was a major pilgrimage attraction and an impressive building,[32] as it still is, despite much destruction. The abbey of Saint-Maixent was exceptionally wealthy, being one of the main landholders in Poitou and on an equal footing with the leading members of the feudal nobility. What remains of its church testifies to a commensurately ambitious project. In view of this prominence, one form of stone sculpture is conspicuous by its absence from this sculptor's work, that is, figural imagery with a clear message. This sculptor was not an image-maker. He arose from the eleventh-century circle of architectural decorators and remained so throughout his career, whatever symbolical overtones might have coloured his choice of animal motifs.

Capital-Carvers, Painters, and Figural Imagery

Figural imagery was not something that a Poitevin capital-carver of the time would have embraced as a matter of course. With very few exceptions, his professional background drawn from eleventh-century Poitou and the Loire Valley allowed for no more than a fleeting aware-ness of the genre. Even the early and ambitious figural experiment on the tower capitals of Saint-Benoît-sur-Loire, around 1030, was seldom repeated until much later despite the immediate and immense influence of the ornamental capitals of the same building.[33] The related Corinthianesque series of Poitou, produced over a period of some thirty years (*c*.1040–70), thus preserves numerous ornamental pieces in the tower of Saint-Hilaire-le-Grand, the nave of Maillezais, the ambulatory complexes of Saint-Savin, Notre-Dame-la-Grande at Poitiers, and Sainte-Radegonde at Poitiers, but the entire corpus includes only five figural capitals.[34] A few more may be noted in other series of capitals, especially those produced during the second half of the century for the transept of Saint-Hilaire-le-Grand, the nave of Airvault, and some others, but none seriously tilts the balance of ornamental and figural elements.

[31] The documentation for Saint-Maixent comes from the local chronicle, and includes the following items: an entry of 1093: 'Eo anno Monasterium Beati Adjutoris Maxentii coeptum est a fundamento novum, adiuvante Domino et concedente in pulcriori opere et meliori' (Marchegay and Mabille 1869: 410); an entry of 1107: 'Ipso anno Goffredus abba ordinatur kalendis julii' (ibid. 423); an entry of 1134: 'Quinto Idus Januarii obiit Domnus Gaufredus bonae memoriae abbas monasterii sancti Maxentii. Hic in constructione monasterii sui, et in augmentatione sui gregis curiosus ac devotus mansit, ut rei eventu probatur, et opera declarant. Hic monasterium Sancti Maxentii, quod ei Dominus accommodaverat regendum post ultimum incendium quod evenit suo in tempore, foris ac desuper honorifice construxit' (ibid. 431). For a French translation of the last entry, see Verdon 1976: 456–7. Verdon interprets 'foris ac desuper' as a surrounding wall and a roof, but this seems too literal. More plausi-bly, Abbot Geoffrey completed the abbey (and not only the church) from all sides.

Concerning the early phases of the project, Camus argues (1992: 175) that the capitals with lumpy foliage, in the crypt, are of *c*.1060 and were reused or preserved in the building of 1093.

The sculptor of the twisted-neck creatures was apparently still present at Saint-Maixent when the west end underwent a change of plan, reflected in some disturbances around the respond-piers which carry his capitals. The shafts on the west faces of these piers were made redundant when the east wall of a narthex-tower was built up against them (and made to serve as the west wall of the nave). Yet that wall itself contains some capitals with swollen animals, very much in the style of that sculptor, in a blocked arch at ground level (Pl. 18).

[32] Vielliard 1978 edn.: 64–79. See also below, Chapter 2 n. 12.

[33] Examples of this influence can be found in Vergnolle 1985: 152–97; ead. 1983; Mallet 1984: 57–71 (on the church of Ronceray at An-gers).

[34] Camus 1992: 104–9.

Besides being rare, figural representation on capitals often escaped serious iconographical planning. This curious attitude can be illustrated by three different examples: the pair of figured capitals in the ambulatory arcade of Sainte-Radegonde at Poitiers (*c.*1060–70), a later pair in the ambulatory arcade of Airvault (consecrated in 1100),[35] and the ensemble of capitals in the four westernmost bays of the nave at Saint-Jouin-de-Marnes. This last complex constitutes an extension to an older nave, and the question of its date will be considered later.

One of the capitals of Sainte-Radegonde is carved with corner figures and rampant animals whose meaning remains obscure (Pl. 19).[36] The other is iconographically more promising; on one of its four faces it carries the theme of Adam and Eve, a consistent feature of choir iconography, which accordingly recurs on one of the ambulatory capitals at Airvault, in the choir of Saint-Benoît-sur-Loire, and elsewhere. The other sides of the same capital carry the story of Daniel in the Lions' Den, also common on capitals of the eleventh century, though it is here somewhat unusually depicted as a sequence of three scenes. First, there is an enthroned king; next, the angel ferrying Habakkuk and his provisions to Daniel's den (Pl. 20); and finally, the wicked being thrown to the lions. This sequence may be seen as a set cycle, since it recurs (with some differences of detail) in the Catalan *Roda Bible*, also of the eleventh century.[37] Adopted at Sainte-Radegonde in its fixed form of three scenes, the cycle fills three sides of the capital and leaves the fourth superfluous. Only the addition of Adam and Eve brings the total number of carved sides to the technically required four, and it may therefore be asked if this technicality is not the very reason for the combination of themes.

A set cycle is adapted also at Airvault, though in a different way. Here, one of the ambulatory capitals carries four of the Labours of the Months, beginning with March (pruning) and progressing through April (a man in foliage, Pl. 21) and May (a knight and horse) to June (mowing), only to leave off once all four sides of the block have been filled.[38] Here too, it is the technical requirement of the four-sided capital that dictates the adjustment of the cycle, this time by truncating it rather arbitrarily. On another capital of the same complex, the story of Adam and Eve is depicted as a separate cycle of four scenes.[39] It cannot be said with any certainty whether the two cycles were conceived by the sculptors as a single programme.

Where any real programme stands out at all, as at Saint-Jouin-de-Marnes, the guidelines emerge as formal rather than iconographical: similar motifs were made to face each other across the nave in pairs, at least in the most conspicuous positions (Pls. 90–5). On entering the nave by the central portal, the first two capitals to meet the eye are those on the western faces of the first pair of piers, which carry two different combinations of human-headed monsters and birds (e.g.

[35] The date here given for Sainte-Radegonde is after Camus 1992: 107–9 and 113–14. In a paper on Airvault (Tcherikover 1985*a*), I argue a date before 1100 for the Airvault capitals. The argument is based on the documentary evidence and on a series of stylistic comparisons to dated monuments of the late 11th cent. Yet it has been questioned; see Horste 1992: 146. The objection turns on a comparison I make between one of the Airvault capitals and the murals of Saint-Savin (*c.*1100), but that comparison is iconographical, and does not imply that Saint-Savin was the earliest to represent the relevant theme. Otherwise, no evidence has been advanced for any alternative dating. I therefore still believe in the argument presented in my article.

[36] According to one interpretation, this composition represents the Four Kingdoms in Daniel's prophecy (Skubiszewski 1985: 161). However, there are neither attributes nor parallels to substantiate the identification.

[37] Paris, Bibliothèque Nationale, MS Lat. 6, fo. 66ᵛ. The direct source of Sainte-Radegonde is unknown and need not have been Catalan, since selections from a Daniel cycle like that in the *Roda Bible* were known in 11th-cent. Normandy; see Alexander 1970: 194–5. The cycle was possibly known even in England (Lucas 1979).

[38] A fuller discussion and some illustrations can be found in Tcherikover 1985*a*.

[39] This capital is discussed in Stoddard 1981.

Pl. 99). On both vaulting capitals above this pair, there are foliage scrolls with corner masks (Pls. 90, 91). The capitals on the western faces of the next pair of piers are carved with two different compositions of lions (Pls. 92, 93). The most prominent motif on the vaulting capitals above, on both sides, is the atlantes at the corners (Pls. 94, 95). The atlantes also constitute the only figural element in this group of capitals. Whatever the meaning of the individual motifs (and they may well have been symbolically interpreted by some contemporary onlookers), they are still fitted into this system for no apparent purpose except to uphold the visual order across the nave.

It must be said at once that a completely different attitude to figural coherence is revealed in some other capitals of the late eleventh century, but these should be seen as an exception that proves the rule.[40] Most Poitevin sculptors of the time treated their figural themes singly rather than in programmes, and, as in the above examples, were seemingly indifferent to the iconographical cohesion, or even the completeness, of the subjects chosen. This attitude may seem strange, until it is realized that sculpture on capitals did not form the only decoration, indeed not even the main one, of the buildings in question. There were most probably painted decorations as well. In the Poitiers church of Saint-Hilaire-le-Grand, for instance, some of the capitals reveal traces of supplementary decoration in paint.[41] In addition, the walls of this church are covered by large figure murals,[42] which, even in their present state of decay, completely overshadow the meagre figural compositions carved on some of the capitals. In such surroundings, all carved capitals were probably seen at the time as little more than marginalia, and were accordingly enriched by any available theme including the occasional figural ones.

The surviving material at times testifies to some established sculptural traditions of figure design, yet certain figure styles occur just once in sculpture,[43] and are otherwise known only from painting. This suggests that some sculptors, rarely required to produce figural imagery, established no independent tradition but repeatedly imitated the painter. The figure style of the ambulatory capitals at Airvault is a case in point; it can be paralleled only in the approximately contemporary illustrations of a manuscript from Poitiers (Pl. 21, cf. Pl. 22).[44] This affinity extends to small details, such as the solid and somewhat stooping necks, the curved pleat above the near thigh, the lowered hemline at the back, and even some features of the background such as the twisted trees. Similarly, the atlantes on the nave capitals of Saint-Jouin-de-Marnes are closely paralleled in an eleventh-century manuscript from Angers (Pl. 23, cf. Pl. 24).[45] Although the details are much cruder, the carver reproduced quite faithfully the swollen belly, limp chest, stooping head with low-parting hair, and the oddly foreshortened palm of the hand with the same overlong fingers. There can be no certainty, however, that the sculptors were using manuscript models; with the loss of many mural paintings the influence of manuscript illumination may now seem more important than it really was. In fact, the illustrations in the Poitiers

[40] Cf. Vergnolle 1994: 182. Examples are discussed in part B of this chapter. Lyman detects a coherent programme of figured capitals in late 11th-cent. Toulouse, but also notes the rarity of such programmes at the time, and the eventual incoherent adaptation of the Toulouse programme elsewhere (Lyman 1971).

[41] Camus 1992: 82 and 221, figs. 22–6.

[42] Camus 1989.

[43] This is unlikely to be a simple matter of survival because the phenomenon is consistent up to *c.*1110, while later monuments reveal a completely different attitude despite the equal chance of survival.

[44] Poitiers, Bibliothèque Municipale, MS 250, the Life of St Radegund. On this manuscript, see most recently Carrasco 1990; Dodwell 1993: 219–20. In the Airvault ambulatory, not only the figural details but also some of the ornamental ones appear to have been borrowed from paintings; see Tcherikover 1985*a*.

[45] Rome, Vatican Library, MS Reg. Lat. 465, Lives of the Bishops of Angers, fo. 82. This manuscript is of uncertain date in the 11th cent. (Vezin 1974: 176 and 239–41).

manuscript are generally recognized as the work of the school of muralists active at Poitiers, Saint-Savin, Vendôme, and elsewhere,[46] and it is therefore possible that the painter was known to the sculptor chiefly as a muralist. Either way, it seems significant that consistent schools of figural work may be traced in painting more readily than in sculpture; figural work was the painter's field, occasionally invaded by the sculptor, but seldom to an extent that allowed continuous and independent experimentation.

Against this background, independent sculptural experimentation in figure design stands out as a rarity, and is therefore all the more noteworthy. One example concerns the decorations in the nave of the same church of Airvault, which combine an established tradition of architectural ornamentation with some new figural elements. The workshop responsible for these decorations was different from that of the ambulatory and not entirely typical of Poitou; some of the patterns on its capitals (other than those illustrated here) have been repeatedly traced by scholars to the Berry style of *c.*1070–90,[47] which had probably originated in the choir of Saint-Benoît-sur-Loire.[48] This style reveals a great interest in sculptural volume: the carvings on the capitals, whether foliage, animals, or figures, accordingly project boldly into space (Pls. 30–3). In the same vein, the workshop made an excursion into sculpture in the round, which was rare in both Poitou and Berry in the eleventh century. On a minor scale, this took the form of variously shaped base-spurs, and, on a larger scale, a set of statues representing standing saints (Pl. 26). The figure style is perhaps crude in comparison to contemporary paintings, but the interest in volume is the sculptor's own. Inserted in almost all the spandrels of the nave arcade (Pl. 25), these statues can no longer be regarded as marginalia. They amount to a prominent figural programme, the meaning of which still remains obscure.[49]

As noted, the church of Airvault may be assigned to the late eleventh century on documentary grounds. Statuary was highly unusual at the time, but this is not to say that exceptional enterprises were impossible. The statues of Airvault in fact reflect one of those rare traditions of figure design already established on capitals of the same period, and which may be illustrated by three examples: a capital from the same complex (Pl. 26); another, with the Sacrifice of Isaac, in the choir of Saint-Benoît-sur-Loire (Pls. 28, 29); and a third, with the Death of St Hilary, in the transept of Saint-Hilaire-le-Grand at Poitiers (Pl. 27). All these capitals present the same robust figurines in a doll's-house setting, complete with furniture in very high relief. The statues of Airvault (Pl. 26), carved in precisely the same style, are actually closest to the Saint-Benoît capital. A comparison reveals the same highly simplified and almost cubical shapes, with the same smooth surfaces, occasional fields of curved plate-folds framed by a raised edge (cf. Pl. 28), and even the same wedge-like noses, protruding eyes, and jug-handle ears. This comparison confirms the dating suggested above, because the relevant part of the choir at Saint-Benoît-sur-Loire was constructed under Abbot William, 1067–80, while the relevant parts of Saint-Hilaire-le-Grand are those recently attributed, on independent grounds, to *c.*1060–80.[50] Even if the

[46] Dodwell 1993: 235; on the Poitou-Loire school of painting, see also n. 107 of this chapter.

[47] Crozet 1935; Stoddard 1970; Tcherikover 1985*a*.

[48] See above, n. 24.

[49] Some scholars hold that the statues of Airvault were intended for the western façade, and were transferred to the interior when a narthex was added to the church (Grosset 1955: 43; Stoddard 1970: 19–

20). I am not sure that such a hypothesis is at all necessary, since these statues are unusual for their time in any location. Concerning the origins of this type of statue, there has been some speculation on possible southern sources (Porter 1923: i. 303). However, this is not supported by the chronology of the monuments.

[50] For both monuments, see above, n. 24.

sculptural ensemble in the nave of Airvault is the latest of this group, it may still be attributed to a period preceding the consecration of the church in 1100.

A first impression might suggest that the sculptor had finally crossed the barrier of monumental figure sculpture, and was treading a sure path towards the great figure programmes of the High Romanesque. This, however, was not so. The sculptors of Airvault were to remain popular as capital-carvers, but their statues failed completely to establish a following. The same is true of some figural slab-reliefs at Sainte-Radegonde and Saint-Hilaire-le-Grand, none of which can be seen to have exercised any direct influence on future practices. The eleventh-century experiments in grand figure design, even if quite daring, were undertaken in fits and starts which allowed no continuous growth. Conversely, High Romanesque meant regular production to consistent iconographical requirements, which was to open the way for continuous sculptural experimentation, and was still to come.

B. CROSS-CURRENTS

Workshop Diversity

Around 1100, a number of different workshops were active in the county of Poitou. Each produced its own fresh version of the earlier traditions, and the question arises whether any common tendency may be detected beyond this diversity.

A certain amount of common ground is to be expected because no workshop of the time was entirely distinct. The sculptors apparently formed groups for the purpose of collaborating on particular projects, and later separated and regrouped somewhere else. Every project therefore exposed each of them to new influences which he then brought to the next combination. The sculptor of the choir capitals of Parthenay-le-Vieux (Pls. 12–15), discussed in the previous section, can serve as an example of this practice: he is seen to have co-operated at Saintes with a local workshop which specialized in lace-like patterns of foliage (Pls. 137–42), unknown at Parthenay-le-Vieux. Later, at Saint-Maixent, his usual vocabulary of animals and monsters is found enriched by a hesitant version of the lace-like foliage (Pl. 17), perhaps under the influence of Saintes. The evidence concerning most other sculptors is less clear, because the major monuments which must have provided the best opportunity for collaboration have disappeared, but scores of rural derivatives nevertheless testify to the fusion of styles which had previously been separate, doubtless a result of such collaborations. This kind of evidence does not allow reconstruction of individual careers, but it can be used to define a series of schools, each turning on a limited number of such combinations, and apparently representing some loose workshop of flexible composition. It is in this sense that the term 'workshop' is used in the present study.

As an illustration of such workshop patterns the rural school of Melle is here examined in some detail, and, in a more cursory fashion, a separate school active in Bas-Poitou and Parthenay. This material is chronologically the most problematic and allows for no precise datings. All that can be shown is that the workshops in question originated in the late eleventh

century and were later exposed to the influence of some dated monuments of *c.*1100. For easy reference, the various relationships are also illustrated in Fig. 1.

As obscure as it must remain, the history of the schools in question nevertheless reveals a general artistic process behind the great variety of workshops. This process may be described as a growing fluctuation between two opposing systems of composing a sculpture programme: the traditional one based on architectural and ornamental considerations, and a hitherto unusual one, aimed at iconographical coherence of figured elements. Both systems became increasingly complex, which eventually forced the architectural sculptor to face an inevitable conflict between ornamental and figural aims.

The School of Melle

The area between the rivers of Sèvre-Niortaise and Boutonne gave rise to a distinctive school of sculpture, which apparently formed during the construction of several churches more or less contemporaneously. It is here proposed that the first projects in this group were the chevet and transept of Saint-Hilaire at Melle and some parts of the choir and transept of Notre-Dame at Surgères, both of which adapted some standard sculptural ornaments of the late eleventh century. However, during the work at Surgères the school was undergoing a series of changes characteristic of the period around 1100. The result of these changes can also be seen in the choir and transept of Saint-Pierre at Melle, the choir and transept of Saint-Savinien at Melle, and, in the surrounding countryside, the modest façade at Chail and the choir and transept at Verrines-sous-Celles. What immediately stands out is that this group is composed almost entirely of choir complexes. Each project was apparently undertaken with the aim of replacing some older church, and each began at the east end. At Saint-Savinien, the project never advanced any further, and the church still retains an older nave. Saint-Pierre, Saint-Hilaire, and Surgères eventually received new naves, some time after the completion of the east end. These naves represent a second phase of the Melle school and one which is particularly obscure, because all were later altered; of the original project, they preserve only some parts of the envelope walls. The nave of Verrines-sous-Celles is largely lost. There is an additional work of the same school at Foussais, some distance from the Melle area, but it seems later than the rest and is of little concern here.

This provincial school came into being under the auspices of the reformed Church. Such documentation as exists shows that the churches were extracted from the hands of the petty local nobility in the course of the eleventh century, and each passed into the possession of some great abbey. The main beneficiaries were the abbeys of Saint-Maixent to the north and Saint-Jean-d'Angély to the south, which not only took over churches but also established considerable landed domains all over the area. The church at Surgères fell to the Vendôme abbey of La Trinité. Nothing is known about Chail.[51]

[51] Saint-Hilaire and Saint-Savinien at Melle belonged to Saint-Jean-d'Angély, and Saint-Pierre to Saint-Maixent. On Melle and its churches, see Le Roux 1963; id. 1969–70; La Coste-Messelière 1957; Lefevre-Pontalis 1912. At Verrines-sous-Celles, Saint-Maixent held the church and was lord of the village; the relevant charters (between 1078 and 1123) can be found in Richard 1886: nos. cxxxviii (pp. 168–9), cxl (pp. 171–2), clxxiv (pp. 207–8), cclxxvii (p. 304). The Surgères church was given by the local lord to La Trinité at Vendôme some

The best-documented negotiations concern Saint-Hilaire at Melle. As already shown, the abbey of Saint-Jean-d'Angély acquired this church little by little, claiming a donation as early as *c.*1028, and later conducting a series of complicated transactions with several different relatives of the lord of Melle. Each of them held something of the church and its adjacent property, and it was only in the 1080s that the abbey managed to bring it all together.[52] The reconstruction of the church, which is not documented, arguably followed the ownership settlement, as in the documented examples of Airvault and Saint-Eutrope. The project began with an ambitious ambulatory chevet. There is a celebrated inscription above one of the ambulatory capitals, stating: 'Aimery requested me to be made' (FACERE ME AIMERICVS ROGAVIT).[53] This refers, in my view, to the whole structure, and commemorates Abbot Aimery who was in office at Saint-Jean-d'Angély at the time of the 1028 donation. By mentioning Aimery, the inscription implicitly claims that the abbey's plans for the church go back to that donation, even though they could not be carried out at that time. The reconstruction requested by Aimery had to await the final ownership settlement of the 1080s.

The capitals in the chevet of Saint-Hilaire at Melle are mostly foliate;[54] a few animals and one figured capital of obscure subject-matter are exceptions. These capitals were produced by a workshop with no local background. It drew on the experience of the older workshop of Saint-Hilaire-le-Grand at Poitiers (in existence by 1070–80).[55] This influence is reflected in the ornament of lumpy and clustered leaves, marked at junction points by hatchings and drill-holes, precisely as on the capitals under the ambulatory cornice of the Poitiers monument (Pls. 38, 39, cf. Pls. 5–6). Poitiers may also have been the source for a great number of Corinthianesque capitals (e.g. Pl. 40), previously common at Saint-Hilaire-le-Grand, Notre-Dame-la-Grande (Pl. 1), and other churches. These were now treated in a new way, because the Melle sculptors fused the two styles of Poitiers into one. The volutes of the Corinthianesque model accordingly gave way to deeply under-grooved corner leaves, as on some of the capitals with lumpy foliage (Pl. 40, cf. Pl. 38). In addition, Melle shows a predilection for strongly projecting elements which had sporadically occurred at Saint-Hilaire-le-Grand, but became common only with the nave of Airvault, consecrated in 1100 (Pls. 38, 39, cf. Pls. 30, 33).

It was the workshop of the Airvault nave that embarked on the project of Notre-Dame at Surgères, producing smaller versions of the Airvault capitals for the lower part of the apse (Pls. 34, 35, cf. Pls. 32, 33).[56] However, once the work reached the higher parts of the Surgères

time after 1062. There were some disputes with the bishop of Saintes concerning this donation, but these were resolved by 1098; see Métais 1893: 75–81. Surgères is situated some distance away from Melle but, according to La Coste-Messelière (1957: 294) and Debord (1984: 517), the early 12th–cent. lords of Surgères were a recently established branch of the Melle family. The connection between Surgères and the school of Melle indeed becomes evident especially from *c.*1100 onward.

[52] See Chapter 1.A, and n. 8 above.

[53] Favreau and Michaud 1977: 134–5. These authors discuss several possible identifications of Aimery, and prefer a late 11th-cent. lay donor of Saint-Jean-d'Angély. However, this donor cannot be specifically linked to Melle.

[54] Authentic capitals can be found only along the ambulatory wall and in the transept, because the chevet of Saint-Hilaire at Melle suffered a series of restorations. There was one in the 17th cent. (according to Lefevre-Pontalis 1912: 80), and another in the 19th cent. (Le Roux 1969–70: 125). The capitals in the ambulatory arcade are new or recut, and stand out sharply from the authentic ones.

[55] For the chevet of Saint-Hilaire-le-Grand, see n. 23 of this chapter.

[56] Observations on site also yield the following: the church of Surgères contains sculpture in several styles. The first, in the lower part of the apse, concerns us here. Others are found in the transept and the apse cornice, discussed below. Another, on the western façade, seems later and is of no relevance to the present discussion. The nave walls are cohesive with the transept on the north side only, while the

transept, the Airvault style lost its distinctive character; it was now combined with the style of Saint-Hilaire at Melle. One of the crossing capitals (Pl. 41), for instance, was carved with a net of ribbons filled with projecting chunks of foliage, apparently after Airvault (cf. Pl. 30), but the leaves now assumed the lumpy quality of the Melle foliage (cf. Pl. 39).

These combinations suggest that the projects of the nave of Airvault, the east end of Saint-Hilaire, and the east end of Surgères were all approximately contemporary, that is, after the Melle property settlement of the 1080s and before the consecration of Airvault in 1100. Between them, they established a vocabulary of foliage ornament which was to dominate the Melle school for some time. Examples include the foliage scrolls with lumpy leaves and drill-holes, which were repeated in the Melle church of Saint-Savinien (Pls. 51, 56) and at Verrines; the foliate nets of ribbons at Saint-Savinien (Pl. 49) and Saint-Pierre in Melle; and, almost throughout the group, the Corinthianesque capitals without volutes, some enriched by deeply under-grooved corners, and all treated in the new soft and lumpy manner of Melle (Pl. 45). It may be noted that another version of this style of foliage was to return to Airvault, in the narthex, which constitutes an addition to the church of 1100.[57]

Meanwhile, new elements appeared in the higher parts of the Surgères transept. The most notable are the plump and smooth twisted-neck lions, like those at Parthenay-le-Vieux, and perhaps the work of the same sculptor (Pl. 42, cf. Pl. 12). This is the sculptor who was traced above from the 1090s to the early twelfth century through the approximately dated monuments of Saint-Eutrope and Saint-Maixent (Pls. 137, 138, 16, 17). The higher parts of Surgères may therefore be placed around 1100. Saint-Pierre at Melle is seen to have followed suit with similar lions (Pl. 43), though the hand of a different sculptor is revealed by the emphasis on surface detail such as fur, and also by the grip of the ferocious claws on the astragal. The animal vocabulary is here enriched by new motifs, including bird-sirens (Pl. 44).

The history of the school now reaches the early twelfth century, and accordingly involves additional innovations of that period. One example concerns the rich display of animal motifs at Verrines-sous-Celles. There is a corbel with an archer-centaur (Pl. 48) and capitals with a variety of large creatures. Some feathered twisted-neck griffins repeat the ferocious style of the Saint-Pierre lions (Pl. 46, cf. Pl. 43); some plump and smooth quadrupeds resemble more closely those in the nave of nearby Saint-Maixent (Pl. 47, cf. Pl. 18). It may be remembered that Saint-Maixent preserves only a fraction of its original decoration, having lost the choir (begun 1093) and almost the entire nave arcade. Perhaps this was the source for both Saint-Pierre at Melle and Verrines-sous-Celles, since both these churches actually belonged to the abbey of Saint-Maixent.[58] Verrines, which is the richer in such animal decorations, probably postdates the completion of Saint-Maixent (after 1107),[59] and belongs well into the twelfth century.

south wall and the western façade, which share the same moulded plinth, are doubtless later. At the east end, some later changes partly obscure the original disposition. A crypt was at some point inserted into the apse, masking its lowermost part. The western crossing piers, excluding the higher parts with their capitals, were remade in a later period along with the nave piers. Some aspects of the church are described in Vicaire 1956.

[57] For a different interpretation of the relationship between Airvault and Melle, see Metz 1987: 59–81. On the narthex of Airvault, see most recently Camus 1991: n. 34.

[58] See n. 51 of this chapter.

[59] The date of Saint-Maixent is discussed above, in part A of this chapter, with the relevant documents in n. 31.

Back in the period around 1100, the school of Melle had also adopted a new range of figured capitals. The most prominent examples are found in the apsidal arch of Saint-Savinien at Melle, and represent Samson and the lion with another lion fighter (Pl. 50), and a scene of the Martyrdom of St Savinianus accompanied by explanatory inscriptions (Pl. 51). Another capital in the same complex carries a solemn figure identified by an inscription as Nicholas (Pl. 52), probably referring to the saint, although scholars have discerned in this figure some features of Christ himself.[60] It is possible that these capitals reflect the dissemination of new models from the Loire Valley southwards, since the 'Nicholas' repeats an image of Christ from the late eleventh-century transept of Saint-Benoît-sur-Loire (Pl. 53).[61] Similarly, the theme of St Michael slaying the dragon, which occurs on an earlier capital of Saint-Benoît-sur-Loire,[62] now appears to have passed southwards in new versions including one on a capital at Surgères (Pl. 54), another on a capital in the higher parts of Saint-Sernin at Toulouse, also of about 1100,[63] and a slab-relief on the façade of Chail (Pl. 55). There are also some completely new subjects including, on a capital of Verrines-sous-Celles, the story of Samson and Delilah.

The relative number of figural elements in each of these complexes is not significantly greater than in some earlier buildings, but they nevertheless seem to represent a new sculptural trend of some durability. The figure style of Saint-Savinien (Pl. 52) thus recurs at Chail (Pl. 55), and later on in an archivolt at Foussais (Pl. 298). All these examples present the same squat and weightless figurines with large heads and staring eyes, their bodies concealed by thin and congested draperies.

At some point, the school of Melle also acquired a taste for ambitiously figured corbels, alongside a more traditional selection of animal-corbels and head-corbels. Saint-Savinien preserves a much damaged but still impressive series, supporting the cornice above the portal of the south transept. These (Pl. 56) comprise a very fine bearded head (to recur at Foussais and elsewhere) and the fragments of several whole figures, including traces of a harp-player. Verrines, too, preserves some isolated figured corbels, but the summary project of the entire school is found under the apse cornice of Surgères (Pls. 57–9). This cornice was apparently added to the late eleventh-century apse during a vaulting campaign, and may therefore be assigned to the twelfth century like the rest of this group. Interspersed among capitals with feathered griffins after Verrines (Pl. 57, cf. Pl. 46), or a lion fighter after Saint-Savinien (Pl. 58, cf. Pl. 50), there is a whole range of figured corbels including dancers and musicians (Pl. 59). In the same frivolous spirit, the sculptor of Verrines carved a head lifted up to drink from a jug. Such sprinklings of profane figures were to recur in Poitevin ensembles of corbels throughout the twelfth century, sometimes providing a popular and parodic contrast to mainstream church iconography.[64] They also serve as a constant reminder of the originally casual and even disorderly character of figural representation in architectural sculpture. In the Melle school, how-

[60] Favreau and Michaud 1977: 137–9. These authors suggest that the inscription NICOLAVS refers to a sculptor or a donor. In my view, however, it refers to the saint, like the inscription on the opposite capital, which refers to the Martyrdom of St Savinianus without explicitly designating him as a saint: EST SAVINIANVS . QVEM SIC . NECAT AVRELIANVS (ibid.).

[61] On the relevant group of capitals at Saint-Benoît-sur-Loire, see Vergnolle 1985: 248–57.

[62] Vergnolle 1985: fig. 81.

[63] The relevant parts of Saint-Sernin in Toulouse are discussed in Durliat 1990: 115–16.

[64] As shown by Kenaan-Kedar 1986 and 1992; and, in a wider context of Romanesque corbel iconography, Kenaan-Kedar 1995: 9–76.

ever, a spirit of iconographical coherence emerged contemporaneously, as described in the next section of this chapter.

Figural Mini-Programmes

As noted, the sculpture inside the apse of Surgères is a product of the workshop of Airvault. That workshop was capable of producing a figural programme on a monumental scale, as in the nave of Airvault (Pls. 25, 26), but was here satisfied with a limited figure programme on the small scale of the capitals. For this purpose, it singled out the two interior capitals of the central window from the otherwise purely ornamental ensemble of sculpted pieces. Each of these two capitals carries a naked figurine of the sort that usually represents the soul of the dead. The one is accompanied by a pair of angels, while the other is tormented by a pair of ugly devils (Pls. 36, 37). Facing each other across the central window, and therefore on the main axis of the apse and behind the altar, these capitals constitute a modest but well-ordered reminder of the contrast between heaven and hell.[65]

It is the architectural setting that gives this programme its order, but also restricts it on two counts. First, the themes are embroiled in the predominantly ornamental context of the other capitals in the apse. Secondly, the dimensions of the capital impose a limit on size. It will eventually be shown that figure programmes depicted on capitals and other small architectural members, including corbels and archivolt voussoirs, persistently suffered from these limitations and consequently became distanced from the mainstream monumental programmes. For the sake of clear distinction, they are hereafter called 'mini-programmes'.

Doubtless intended as a pendant to apsidal paintings now lost, iconographical mini-programmes on capitals are fairly common in apses of the period around 1100. This tendency perhaps reflects the influence of such great ensembles of figured capitals as in the choir of Saint-Benoît-sur-Loire, and eventually Cluny, but no single model prevails. Each monument is unique. In the Melle church of Saint-Savinien, for instance, the programme is concentrated in the entrance arch of the apse, and is essentially hagiographic. On approaching the apse, the first themes to meet the eye are the story of St Savinianus on the northern capital and the St Nicholas on the southern (Pls. 51, 52). With hindsight, it may be observed that the programme of animal capitals at Parthenay-le-Vieux is also concentrated in the apsidal arch, which enhances the possibility already noted that it was conceived with some symbolic intention. The precise meaning of the programme is not of concern here, but rather the apparently deliberate choice of specific parts of the building for the display of some kind of iconographical programme.

The various monuments of the school of Melle reveal an interest in additional possibilities for depicting iconographical programmes. At Chail, there is a limited exterior programme of two

[65] The same themes recur on the well-known capitals of the Porte-des-Comtes of Saint-Sernin, Toulouse, apparently of the 1080s. An influence of Toulouse on Surgères is, however, doubtful. It may be noted that the Surgères figure style is that of the choir of Saint-Benoît-sur-Loire and the transept of Saint-Hilaire-le-Grand (Pl. 36, cf. Pl. 29), which had been related to the Airvault style from its beginnings, and probably predates the relevant parts of Saint-Sernin (see above, n. 24). It is possible that this is another case of dissemination from the Loire Valley and Poitou southwards, though none of the monuments in question can be dated precisely enough to allow hard and fast conclusions.

slab-reliefs, placed on the higher part of the façade, and representing respectively the above-mentioned St Michael (Pl. 55) and the scene of Christ investing St Peter with his key. These reliefs are the only figural element on the façade; the portal below remains purely ornamental, like most portals of that period, including the one in the south transept of Saint-Savinien (Pl. 72).

In the school of Melle, figural experimentation at some point extended to portals as well, but it was restricted to mini-programmes. The imagery was accordingly depicted on small architectural members, including archivolt voussoirs and corbels, all of which remained embroiled in the ornamental context characteristic of architectural sculpture. This is attested by the next stage in the history of the school, as represented by the naves of Saint-Hilaire and Saint-Pierre at Melle.

The nave of Saint-Hilaire must have been built after the completion of the late eleventh-century east end, since it meets the transept with straight masonry seams. It was apparently constructed in two separate building campaigns. Of the first, all that remains is the south wall; the north wall was apparently reconstructed during the second campaign, when the nave was also extended westwards by a double bay. The present discussion concerns the south wall excluding the additional bay. This wall is a complicated affair with an interior system of engaged triple shafts, and consequently numerous small capitals. These are carved with diminutive versions of the usual motifs of *c*.1100; there are griffins (Pl. 61), various quadrupeds with ferocious claws gripping the astragal (Pl. 60), and an additional enrichment by vivacious figurines (Pl. 62).[66] In the middle of the wall there is a portal. On the exterior it preserves some ornamental sculpture which escaped a rather thorough restoration (Pl. 63), but perhaps never amounted to very much. On the interior it incorporates a carved archivolt, in the same style as the capitals, but thematically more orderly. A row of figurines is placed on the main face (Pl. 64), while the ornamental animals and foliage are confined to the soffit (Pl. 65).[67]

The arrangement adopted at Saint-Hilaire for the archivolt sculpture is the one variously called 'radiating', 'radial', or 'voussoir-by-voussoir'. This system exploits the structure of the archivolt, which, like any other arch, is composed of roughly equal voussoirs. Melle presents one of several variants, by which each voussoir is treated as an individual metope with its own carved motif; hereafter 'metope-voussoir'. The soffit of the Melle archivolt accordingly carries a set of lions, birds, and segments of foliage scrolls, much like the set of real metopes on the eleventh-

[66] Some of the capitals along the south wall of Saint-Hilaire at Melle recall the few capitals that survive along the wall of the early 12th-cent. nave of Saint-Maixent. On the architectural design of the nave of Saint-Hilaire at Melle in relation to Saint-Maixent, the following observations may be offered: the south wall of the Melle nave was designed in accordance with a single-bay division, marked by triple wall-shafts, and which is unrelated to the double bay division of the nave piers (except where the portal spans two bays). The central shaft at every other division thus remains redundant. In the second building campaign, which involved an extra double bay at the west end and an apparent reconstruction of the entire north wall, this discrepancy was rectified. The new parts were accordingly designed with a systematic double bay division of alternate quadruple and double wall-shafts, approximately after the manner of the nave of Saint-Maixent (triple wall-shafts on dosserets, alternating with double shafts). The sequence of stylistic changes therefore seems as follows: (1) the south wall of Saint-Hilaire (single bays), (2) the nave of Saint-Maixent (double bays), (3) the north wall of Saint-Hilaire (double bays). The missing item, which was possibly the first in this sequence, is presumably the earlier part of Saint-Maixent (begun 1093), which no longer exists in its original form.

[67] The position of the archivolt on the interior is exceptional. There is some interior elaboration with colonnettes in an earlier portal of Melle, in the mid-11th-cent. western façade of Saint-Savinien, but I am aware of no other Aquitainian example of interior archivolt decoration like that of Saint-Hilaire. Perhaps the archivolt was intended for the exterior of the portal, now much restored. Some scholars hold that it was reused from an earlier project (Werner 1979: 83). However, this is unlikely, because the style of the archivolt is the same as that of the capitals in the same wall, indicating that all emanate from the same phase of the works.

century chevet of Saint-Hilaire-le-Grand at Poitiers, and possibly inspired by that very model (Pl. 65, cf. Pl. 4). The figurines on the main face are equally treated like individual metope motifs, composed on radial axes, and consequently radiating outwards (Pl. 64). Restricted as they are by the size and form of the voussoirs, these figurines amount to an iconographical mini-programme.[68] Christ is represented on the apex voussoir, followed by a retinue of saints on the remaining thirty voussoirs. Many of the figures repeat the standard type of saint holding a scroll or book, like the St Nicholas of Saint-Savinien, and a few are more specific: the first from the left is Moses with the Tables of the Law, the fourth is St Peter with his key, and the one to the right of Christ is a pope, bishop, or abbot with a pastoral staff.

In the Melle church of Saint-Pierre, the same sudden infusion of an iconographical mini-programme is seen on the corbels. The portal in the south wall of the nave is surmounted by a corbel-table (Pl. 66),[69] reminiscent of the one at Saint-Savinien (Pl. 56) but iconographically more coherent. Four of the corbels are carved with the symbols of the Evangelists accompanied by deteriorated inscriptions. Another, at the centre, is largely mutilated but apparently carried the Christ, for it is inscribed IESVS.[70] It was doubtless the conspicuous position above an entrance portal that induced this unusually systematic approach to the iconography of corbels. The portal itself is largely restored and therefore beyond any study, but it seems to have always been purely ornamental in accordance with the older traditions.

Taken together, the various members of the Melle school testify to a great diversity of figural mini-programmes around 1100 and the early twelfth century. Not only the themes but also the choice of architectural medium changed from one building to another, involving capitals at Saint-Savinien, metope-voussoirs at Saint-Hilaire, corbels at Saint-Pierre, and slabs at Chail.[71] No development can be traced from one system to another, but rather a common tendency governing different choices. Relying on their traditional proficiency as architectural decorators, the sculptors were harnessing different forms of architectural sculpture to a new purpose of religiously edifying programmes, a purpose that was to be achieved in the monumental figure programmes that followed. However, this is not to say that all these different schemes evolved towards monumental programmes. Diverse experimentation is perhaps a necessary stage in the history of every new tendency, but some schemes usually prove more successful than others. In the event, the new mini-programmes were to vie with ornamental trends of renewed vigour, and only figural slab-relief was to emerge from this competition unimpaired and even strengthened. All the other choices of the Melle school, including archivolt programmes voussoir-by-voussoir, were to relapse into ornamentalism and exert no influence on mainstream figure sculpture.

[68] The region preserves some figured Merovingian voussoirs in clay; see Costa 1964. Perhaps the Melle sculptor knew them. Yet they seem irrelevant for the iconographical programme of Melle, and merely represent the same idea of the figured metope-voussoir. Another portal with metope-voussoirs survives at Lusignan, on the north side of the nave. It carries a collection of creatures interspersed with some figures. Lusignan may well predate Melle, but I cannot prove this.

[69] Observations on site yield the following: the exterior walls of the nave of Saint-Pierre seem to have been constructed continuously with the original project of the east end, despite a masonry seam on the south side. The interior of the nave was later reworked, but this does not concern us here.

[70] The inscriptions are transcribed in Favreau and Michaud 1977: 135.

[71] A fifth type, involving a figurated lintel (gabled like some in Auvergne, and supporting a plain tympanum) had occurred in the 11th-cent. western façade of Saint-Savinien (see Le Roux 1963). This disposition, which predates the group discussed here, remained totally isolated in Poitou.

Parthenay-le-Vieux and the Ornamental Programme

The problem with voussoir programmes was the habitual practices of archivolt design established during the eleventh century, which were quite unrelated to iconography or indeed to anything which would usually be called sculpture. They involved rather a series of decorative tricks of the builder's yard. This background can be illustrated by a selection of window archivolts from several eleventh-century buildings, including the old part of the nave at Saint-Jouin-de-Marnes (perhaps of *c.*1050–60),[72] the choir of Saint-Eutrope at Saintes (dated between 1081 and 1096), and the nave of Airvault (consecration in 1100).[73] To these may be added a portal in the cloister of Nieul-sur-l'Autize which, though undated, is similar enough to the windows of Saint-Eutrope to be assigned to the same period in the 1080s or 1090s (Pl. 73, cf. Pl. 71).[74] The transept portal of Saint-Savinien at Melle, attributed above to the period around 1100, brings the group to the threshold of the twelfth century.

A glance at this group of archivolts (Pls. 68–73) reveals that a taste for decorative diversity was here satisfied by very simple means. Almost all involve playful variations on two basic builder's techniques, namely wall-facings of decorative masonry and ordinary mouldings of roll and cavity. Decorative masonry of axe-heads and other shapes is more usual on plain wall surfaces, as on the tower of Cormery (Pl. 67), but the same axe-heads recur on an archivolt of Saint-Jouin (Pl. 68). On the archivolts of Saint-Eutrope, pointed shapes of similar origins in decorative masonry are bordered by a roll moulding (Pl. 69). At Airvault, a pattern of discs is matched to roll mouldings which run across the soffit (Pl. 70). Another type of design, particularly common in this period of the late eleventh century, involves a roll moulding flanked by simple decorative motifs; the portal of Nieul-sur-l'Autize preserves a characteristic example, with an axe-head and a rudimentary foliate form respectively on either side of the roll on each voussoir (Pl. 73). Saint-Eutrope possesses another version of the same design, with star-like buttons and pine cones (Pl. 71), while additional variants can be found on some isolated voussoirs which survive from the destroyed western façade of Saint-Jean-de-Montierneuf at Poitiers (1086–96),[75] and, north of the Loire, on the western façade of Le Mans Cathedral (1085–96).[76] The portal of Saint-Savinien presents yet another pattern, with two voluminous rolls and an intermediary cavity filled with star-like buttons (Pl. 72).

What all such decorations have in common is that the basic unit of pattern is the individual voussoir. On any one archivolt all the voussoirs are identical; a single combination of motifs is rhythmically repeated on each voussoir along the entire arch. This is a sort of modular system, and in its dependence on the scheme of voussoirs it is itself a builder's technique. Yet there is no clear distinction between these architectonic schemes and the sculptural works so far discussed, because many of the archivolts are provided with carved hoods of the same workmanship as the capitals in the same buildings. At Saint-Savinien, for instance, the foliage on the portal hood is no

[72] On 11th-cent. Saint-Jouin, see Tcherikover 1987.

[73] See part A of this chapter.

[74] The abbey of Nieul-sur-l'Autize was founded in 1068. On its history, see Auzas 1956*a*; Dillange 1983: 142–7. Some parts of an 11th-cent. construction survive at the east end of the south aisle of the church. Much of the church and the monastic buildings were altered

in later periods. The portal in question is found on the south side of the cloister, and probably served the refectory. Everything around it was subject to much rebuilding, destruction, and restoration, which obliterated much evidence on its original context.

[75] Illustrated and dated in Camus 1991.

[76] See n. 25 of this chapter.

different from that on the impost of an interior capital (Pl. 72, cf. Pl. 51). This correspondence suggests that the same sculptors were responsible for all the carved embellishments, whether decorative capitals or modular archivolts. Architectural sculpture and architectonic stone-cutting were clearly related to each other, and should probably be seen as one and the same profession.[77]

Accustomed to the variety of capitals and metopes, some sculptors occasionally abandoned the repetitiveness of the strict modular system, and varied the design from one voussoir to the next. This method remained very rare during much of the eleventh century, but nevertheless existed. In a portal of that period at Chinon, each voussoir received a different element of architectural décor (billets, buttons, etc.), and one was even carved with the Hand of God (Pl. 74).[78] Such individualized voussoirs could easily be transformed into metope-voussoirs and even receive a figural mini-programme, like the early twelfth-century one noted above in the Melle church of Saint-Hilaire (Pl. 64). Alternatively, they could be exploited for new ornamental possibilities, as on the soffit of the same Melle archivolt (Pl. 65).

Metope-voussoirs and modular ones are the two systems of archivolt decoration that the twelfth century inherited from the eleventh. The relationship between them can be illustrated by the church façade at Benet, a short distance south-east of Nieul-sur-l'Autize. The relevant examples are from the lower part of this façade, which alone survives from the original design.[79] It presents two niches with carved archivolts enclosing some damaged figural reliefs, and also a portal, hidden behind a later porch, and reduced to mere vestiges including a single carved archivolt. This complex combines two types of archivolt. Those in the niches are of the modular type and in fact repeat the design of Nieul-sur-l'Autize, with the same roll moulding flanked by axe-heads and simplified leaves (Pl. 75, cf. Pl. 73). At the same time, the voussoirs of the portal archivolt are of the metope type; some carry foliage while others are carved with naked human busts sunk in roundels (Pl. 76). All these busts differ slightly, and give the impression of yet another mini-programme, the meaning of which remains unknown. There can be no doubt that the modular voussoirs of the niches and the metope-voussoirs in the portal belong to the same phase of the building, since both types possess decorative hoods of precisely the same workmanship, carved with star-like buttons. It is therefore quite clear that the two types of voussoir were at some point used side by side.

They also coalesced, as can be seen on an arch of unknown provenance preserved in Poitiers museum (Pl. 77). This arch carries a set of griffins which resemble the twisted animals on the metope-voussoirs of Melle (Pl. 65), but lack the variety of Melle. Instead, the same griffin recurs in mirror-image on alternate voussoirs, conforming to a kind of double-modular system. Since modularity was an architectural system, it is noteworthy that the griffins are treated like some of the old architectonic decorations, that is, embedded in a cavity and bordered by a corner roll. The same architectonic method governs a great variety of additional decorations; in the cloister of Saint-Aubin at Angers, for instance, modular human heads are similarly embedded in the

[77] Dodwell reaches similar conclusions by examining the uses of the word 'sculptor' in various texts of the 11th and 12th cents. (Dodwell 1987: esp. 49–52).

[78] The relevant portal at Chinon is hidden behind a later narthex; see below, Chapter 3, n. 5.

[79] The upper part of the Benet façade apparently took some time to complete, and was perhaps even subject to posterior alteration. It accordingly presents an entirely different style of sculpture.

cavity and bordered by a roll (Pl. 78). The last example leaves all the eleventh-century ones far behind, because the earliest date ever suggested for the relevant part of the Angers cloister is c.1115–25.[80]

This is also the date suggested here for the monument that sums up the various experiments on archivolts, namely, the western façade of Parthenay-le-Vieux (Pl. 215). As already noted, the construction of this church began in the 1090s with the east end. Further examination reveals that the lower part of the building is reasonably homogeneous all around the envelope walls, including the western façade. The work must therefore have advanced smoothly, and presumably reached the façade some time in the early twelfth century. Only the lower part of this façade has come down to us in its original form.[81] It presents a rich decorative scheme executed by new sculptors, different from the master of the choir capitals, and apparently connected with the circle of Nieul-sur-l'Autize and Benet.

The architectural design of the lower part of the Parthenay-le-Vieux façade comprises a portal and side niches (Pl. 215). The portal (Pl. 79) has a plain inner order surrounded by a roll moulding, and two outer orders of colonnettes, capitals, and decorative archivolts. This is exactly as at Nieul-sur-l'Autize (cf. Pl. 73). One of the niche capitals of Parthenay-le-Vieux even repeats a motif of the Nieul portal, consisting of an archer-centaur shooting a lion, and duplicated on two sides of the block (Pl. 87, cf. Pl. 86). The niches are stilted, as at Benet, and evidently for the same purpose of enclosing large slab-reliefs, though the reliefs themselves are different and were apparently executed later than the ornamental programme.[82] Otherwise these relationships support the dating suggested above: the cloister portal of Nieul-sur-l'Autize belongs to the late eleventh century, while the façades of Benet and Parthenay-le-Vieux take the style into the twelfth century, doubtless in that order. Benet (c.1110–15?) thus perpetuates some of the archaic elements of Nieul-sur-l'Autize, such as the axe-heads on the archivolts (Pl. 75, cf. Pl. 73), while Parthenay-le-Vieux (c.1115–25?) abandons this archaism in favour of more elaborate patterns (Pl. 83).

The archivolt decoration of Parthenay-le-Vieux is all modular, and the technique is generally that of roll and cavity. There is the veteran pattern of a central roll separating two rows of motifs, as at Nieul-sur-l'Autize and Benet, with the difference that the foliate motifs are now predominant (Pl. 83). The treatment of the leaves is much more daring than at Nieul-sur-l'Autize, with one row wrapped around the roll and another twisted at the arris, as if wrapped around an imaginary second roll. Most of the other motifs are embedded in single cavities as at Angers, and include double-modular griffins (Pl. 81), dogs, sirens (Pl. 80), and nude human busts sunk in some rounded containers (Pl. 82). These busts evoke those on the metope-voussoirs of Benet (Pl. 76), but the sculptor of Parthenay-le-Vieux repeated them in a modular fashion on all thirty-seven voussoirs of the arch. Rather than softening the old ornamental repetitiveness in favour of iconographical diversity, he thus forced the new figural motifs into the straitjacket of the old modular system. As with a word repeated too many times, whatever meaning they might have originally possessed was lost in ornamental rhythm.[83]

[80] Henry and Zarnecki 1957: 13–14 and pl. IV(3).

[81] The higher part of the façade was altered, together with the higher parts of the side walls and also the interior arcades, apparently in connection with a vaulting campaign. For details, see Tcherikover 1986.

[82] See Chapter 3.C.

[83] Nieul-sur-l'Autize, Benet, and Parthenay-le-Vieux amount to a loose school which lacks, however, a centre-piece and a model. Perhaps this was the important abbey of Maillezais, which is situated near Nieul-sur-l'Autize and Benet. That abbey was constructed during the

This ornamental diversion should not be seen as an isolated quirk, since capital-carving too was now ornamentalized much more than before. A capital at Benet is a case in point (Pl. 84), and there are more by the same sculptor on the façade of Fontaines, some distance to the north-west (Pl. 85). This sculptor produced mannered variations on the grand animals in the earlier style of the choir of Parthenay-le-Vieux, but his monsters and lions became disproportionately stretched, thoroughly twisted, and intertwined at the corner of the capital. It is doubtful that the old master of Parthenay-le-Vieux, who had taken pains to clarify the meaning of his animals with the help of inscriptions, would have approved of such distortions (cf. Pls. 13 and 12). Yet his heritage now met intensified ornamentalism even at Parthenay-le-Vieux itself. Like the sculptor of Benet and Fontaines, though in a different style, the new sculptors of the Parthenay façade tended towards mannered distortions on capitals. The duplicated centaur of Nieul-sur-l'Autize, for instance, here took on the appearance of Siamese twins split across the corner of the capital (Pl. 87, cf. Pl. 86). Other monsters, and some figurines, were also repeated and duplicated in various ways on one capital after another (Pls. 88, 89), to great decorative effect but falling little short of thematic chaos.

If the history of the Melle school in the early twelfth century suggests that a new figural serenity was about to oust the old ornamentalism of the eleventh century, then Parthenay-le-Vieux represents a reverse trend. The capitals and archivolts of that monument, which are arguably later than most of the figural mini-programmes of Melle, succumbed to intensified ornamentalism that worked against iconographical coherence. Considering the important iconographical programmes which were eventually to materialize in Poitevin archivolt sculpture, it is noteworthy that the wind was at first blowing in the opposite direction. Architectural sculpture still retained its traditional decorative role, and even grew in ornamental complexity, while the more important experiments in figure programmes took a completely different course.

C. THE POITOU–LOIRE IDIOM

The Façade of Saint-Jouin-de-Marnes

During the eleventh century, the regions of the Loire Valley, to the north of Poitou, gave rise to a distinctive type of decorated façade. Few examples survive intact, but the mutilated remains of the narthex façade of Saint-Mexme at Chinon (Pl. 205) give a general impression of the kind of decoration in question, essentially surface embellishment of variously shaped masonry and carved slabs.[84] This design was taken up on the western façade of the abbey church of Saint-Jouin-de-Marnes (Pl. 207), in northern Poitou, where it was combined with some new architectural features and enriched by an unprecedentedly extensive sculpture programme. The result was the first great façade of Aquitaine, or at least the earliest to have survived. Having been well

11th cent. and later received additional buildings, but now lies in ruins (see Crozet 1956c; Vergnolle 1985: 190; Camus 1992: 114). Amongst the sculptural fragments preserved on the site, there is a griffin-

voussoir like those of the Poitiers arch (Pl. 77), which was repeated also at Parthenay-le-Vieux (Pl. 81).

[84] See below, n. 94 of this chapter.

under way, as will be presently shown, in the early years of the twelfth century—contempor-aneously with some of the Melle monuments and before the façade of Parthenay-le-Vieux—the façade of Saint-Jouin-de-Marnes brings the prolific eleventh-century schools of Poitou and the Loire Valley to new beginnings.

Over an elevation of three portals, three windows, and a large gable, the Saint-Jouin façade carries two distinctive sculpture programmes. One consists of purely figural slab-reliefs and is concentrated mainly in the gable. The other is ornamental, and spreads over a great number of archivolts and capitals, in all the portals and windows, beside a profusion of capitals on a set of columnar buttresses. This ornamental programme yields to figural serenity only on one of the five archivolts in the central portal. Otherwise, it should be seen in the context of traditional architectural fineries and as largely separate from the figure programme on the slabs. The division between the figural and the ornamental elements was in some ways highly conserva-tive, but it also allowed the sculptors to elaborate freely on both types of sculpture. Saint-Jouin thus avoided the restrictions imposed on figural programmes at Melle, and at the same time gave unbridled licence to ornament; a dual purpose to be followed by most of the great Aquitainian façades of the twelfth century.

Unfortunately, this important complex has come down to us in a somewhat confused state, its original character obscured by the later addition of several proto-Gothic statues, discussed separately below.[85] A poor state of preservation gives everything a uniform tone, and a modern restoration further confused matters by replacing a few eroded pieces of both the original and the proto-Gothic sorts with modern fakes.[86] For the sake of clarity, all the additions are here marked in Pl. 208, and the photograph used for current reference is a pre-restoration one (Pl. 207).

Contrary to a widespread notion, the date of the façade of Saint-Jouin does not emerge from any written documents. Such documentation as exists concerns other parts of the church, each of which was constructed in a separate building campaign and is of no relevance to the façade. A word on the building history will clarify this point. The main body of the church, including the six easternmost bays of the nave, was in existence around the middle or the third quarter of the eleventh century.[87] Conversely, the four westernmost bays of the nave constitute a later extension, stylistically distinct from all other parts of the building, and even meeting the old part of the nave with a change of masonry. The façade forms an integral part of the nave-extension, and the workshop responsible for this project disappeared from Saint-Jouin after its completion. Nothing else in the building history therefore bears on the date of the nave-extension and its façade. A consecration date was recorded only for a completely separate extension, undertaken subsequently by a different workshop at the east end of the old church.[88] The much-quoted date of 1095, which it is very tempting to adopt for the beginning of work on the nave-extension, cannot be trusted at all. It comes from a rather fantastic interpretation of a vague chronicle entry.[89] In sum, there is no relevant documentary evidence, and what remain are stylistic considerations.

[85] Chapters 3.A and 5.C; see also Tcherikover 1985*b*.

[86] The restoration is discussed in Tcherikover 1982: 275–93.

[87] Tcherikover 1987. The archivolt here illustrated in Pl. 68 is found in the 11th-cent. part of the Saint-Jouin nave.

[88] See below, Chapter 4.B.

[89] The Chronicle of Saint-Maixent for 1095: 'coepit et Radulfus monachus Sancti Jovini suos et sua loca instruere' (Marchegay and Mabille 1869: 411), which I translate: 'Radulfus, a monk of Saint-Jouin, began to prepare his [people] and his monasteries'. In my view, this refers to the hermit Radulfus of La Fustaye, a monk of Saint-Jouin,

The capitals inside the nave-extension, carved with decorative arrangements of atlantes, animals, birds, monsters, and foliage (Pls. 90–5, 98, 99), combine two styles of the late eleventh century. One comes from the chevet of Saint-Jean-de-Montierneuf at Poitiers, the other from the aisles of Le Mans Cathedral (which survived a mid-twelfth-century reworking of the nave). It should perhaps be mentioned in passing that these two styles seem to have originally been related, but the precise nature of the relationship still awaits research. In any event, they recur fused together at Saint-Jouin-de-Marnes. For instance, the twisted-neck monsters on one of the Saint-Jouin capitals resemble those at Montierneuf (Pl. 99, cf. Pl. 11), but are spread more spaciously to allow for large intermediary motifs, as at Le Mans. Differences of treatment aside, Saint-Jouin also follows the Le Mans vocabulary of rearing quadrupeds (Pl. 95, cf. Pl. 96), or stunted lions creeping clumsily on their oversized paws (Pl. 92, cf. Pl. 97). The similarity sometimes extends to details such as the minimal elaboration with engraved lines and the gloomily drooping eyes. Some of the details testify to additional eleventh-century sources; the atlantes on two of the Saint-Jouin capitals have been compared above to a drawing in a manuscript of that period from Angers (Pl. 23, cf. Pl. 24).

In its relationship to the chevet of Montierneuf (1069–86) and the aisles of Le Mans Cathedral (1085–96), the workshop of the nave capitals of Saint-Jouin emerges as essentially belonging to the late eleventh century. Saint-Jouin is probably the latest in this group, around 1100, because the same workshop is seen to have continued its activity even later, producing very similar capitals with lions and foliage for the transept of Saint-Laon in the castle of nearby Thouars (Pl. 101, cf. Pls. 93, 91). It is unlikely that Saint-Laon predates the early twelfth century, for three reasons. First, it emerged from a lengthy and presumably paralysing ownership dispute only in 1107. Secondly, this settlement of ownership followed a fire, which devastated the castle of Thouars in 1104, and was probably followed by much rebuilding. Thirdly, the structure incorporates some new architectural features, unknown at Saint-Jouin, in particular clusters of half-shafts and quarter-shafts as in the early twelfth-century nave of Saint-Maixent (Pl. 101, cf. Pl. 16).[90] In short, the workshop seems to have been active about 1100–10, first at Saint-Jouin and later at Saint-Laon.

who is known from other sources to have founded monasteries north of the Loire around 1100. The history of the interpretation of this entry begins in the 19th cent. The historian Ledain (1883: 85–6) understood 'sua loca' to refer to the church of Saint-Jouin, and accordingly dubbed Radulfus a monk-architect in charge of the construction of his abbey church. This is the only source for the repeated claims that the construction of Saint-Jouin began in 1095. Subsequent scholarship accepted Ledain's interpretation without further questioning, and proceeded to establish a personal career for the supposed monk-architect. Some hypothesized that this was the same Radulfus who was to become abbot of Saint-Jouin some twenty years later (Piolin 1887). Others indeed identified him with the hermit Radulfus of La Fustaye, but assumed that he built Saint-Jouin and then turned to his new foundations (Berthelé 1886–7). What escaped these scholars is that a translation of 'sua loca' as 'his monasteries' indeed fits well the activities of Radulfus of La Fustaye as founder of monasteries, but leaves nothing in the text that could refer to the construction of the church of Saint-Jouin. A more recent scholar (Verdon 1976: 466) offered such a translation, but added that Radulfus was an architect and later abbot of Saint-Jouin, giving no reference except Piolin 1887; he was apparently unaware that the only source for this interpretation is the very chronicle entry which he translates differently.

[90] For the documents concerning Saint-Laon, see Imbert 1875: charters nos. III, IV, VIII, LVIII. The sources concerning the 1104 fire of Thouars castle are mentioned in Crozet 1942: no. 150. The church of Saint-Laon suffered many alterations in various periods, and only the south transept (with the capitals in question), as well as the much-restored tower above it, remain of the relevant project. According to Rhein (1910: 86–8), what is now the transept was originally the crossing. However, the evidence for this is inconclusive. Another problem concerns the restorations of the 19th cent., which were extensive. The main source on the restoration are the reports preserved in the Saint-Laon file of the Archives des Monuments Historiques, in Paris, which relate to the works carried out between 1864 and 1906 by the architects Segretain, Loué, and Deverin. The restoration documents do not allow an assessment of every capital, but nevertheless suggest that all the exterior details are completely new. However, the interior capitals are not mentioned in any restoration document, and are closer to the Romanesque work at Saint-Jouin than to the restoration work at Saint-Laon. The dry appearance of some of the Saint-Laon capitals can perhaps be attributed to a certain amount of recutting.

At Saint-Jouin, to the same workshop may also be attributed a few pieces on the façade, including a buttress capital with human busts (Pl. 102) whose heads are precisely like those of some of the interior monsters (Pl. 99), and whose draperies possess the limp quality of the interior atlantes (Pl. 94). Yet most of the exterior sculpture, on the façade as well as the side-wall windows, seems to be the work of a younger generation of the same workshop. When handling figural elements on capitals, the new sculptors (Pl. 103) betray their origins by using the same facial types as the old ones (cf. Pl. 102), but the figures are thrown into a new kind of agitated movement and their draperies possess a previously unknown quality of graphic precision. Some of the ornamental patterns by the new sculptors, though borrowed from the old sculptors, are treated in a new way; in particular, various combinations of elongated and somewhat fluttering folded leaves (Pl. 106, cf. Pl. 98), now arranged more rigorously and sometimes enriched by beading (Pl. 107). These folded leaves may indeed be seen as a hallmark of the Saint-Jouin workshop; though common in the northern parts of France, they were as yet practically unknown elsewhere in Aquitaine. Perhaps this motif, too, reached Saint-Jouin from Le Mans, where it had been abundantly used in manuscript illumination of the eleventh century (Pl. 114, cf. Pls. 98, 106).[91]

Animal patterns by the new sculptors reveal a change of balance: the old motif of the twisted-neck animal, going back to Montierneuf and Le Mans, has now largely given way to duplicated creatures joined by a single head (Pls. 104, 105), and the previously spacious compositions have consequently become more compact (Pl. 105, cf. Pl. 99). There is something of the spirit of the nave of Saint-Hilaire at Melle (Pl. 62) or the western façade of Parthenay-le-Vieux (Pls. 87–9) in these dense patterns and their delicate details, though each of these monuments is otherwise idiosyncratic. The animals of Saint-Jouin thus possess an uncommonly aggressive character, and decorative details include distinctive ornamental drilling.

The archivolts in the portals and windows are also the work of the new sculptors. There is one archivolt with repetitive heads, and others with additional modular patterns (Pls. 108, 109), according to the system noted above as normal for early twelfth-century Poitou. Yet the style of Saint-Jouin is otherwise highly unusual. Most of the voussoirs are rounded to form a continuous convex surface extending from the main face to the soffit, and many are also much longer than elsewhere in Poitou (Pls. 110–13, cf. Pls. 80–2).[92] The result is ample space on each voussoir which, in two of the façade windows, is exploited for an exceptionally rich display of motifs. Hardly any two voussoirs are alike (Pls. 110–12). Besides a variety of monsters, there are pairs of human-headed hybrids, rams rampant and a tree, a manikin in foliage, a foliate mask, intertwined long-necked birds, a centaur, a combat between two animals, and more. Some of the motifs seem to derive from painted sources; the winged quadruped with ruffled feathers and foliate tail (Pl. 113), for instance, may well have originated in an eleventh-century manuscript

[91] On folded leaves in the Romanesque sculpture of northern France, see Zarnecki 1955. In Poitou, the folded leaf appears in the initials of the 11th-cent. Poitiers manuscript of St Radegund (Poitiers, Bibliothèque Municipale, MS 250), probably under Norman influence. I am grateful to Professor. J. J. G. Alexander for his advice on this matter. Dodwell notes additional northern influences on the manuscript illumination of south-western France (Dodwell 1993: 219–21).

Two capitals with patterns of folded leaves, very similar to some at Saint-Jouin-de-Marnes, are preserved in the Musée du Berry at Bourges. Otherwise, I am not aware of any close parallels south of the Loire, except in later monuments discussed below, Chapter 5.

[92] This technique was apparently due to an Italian influence, as suggested below, Chapter 2.A.

from Le Mans (Pl. 114). Some are repeated in mirror-image on adjacent voussoirs (Pl. 113), but this meagre tribute to the double-modular system is somewhat lost in the general multiform procession of animal fantasies. The effect is quite different from the overwhelming repetitiveness imposed on such creatures on the Poitiers arch (Pl. 77), for instance. This diversity seems normal to the early twelfth century, the experimental period that gave rise to the metope-voussoirs of Benet and Melle in addition to the established modular system; the period of standardization was still to come.

The sculptors responsible for all this fauna on the window archivolts also introduced the figural programme to Saint-Jouin. Their style is revealed in the same graphic precision and much identical detail, including facial types and ornamental drilling (Pl. 121, cf. Pl. 110). This figural programme was so novel that its scope was apparently worked out only when the production of sculpture for the façade was already in full swing. Some of the ornamental pieces previously prepared were consequently rearranged. In the central portal (Pl. 108), for instance, the single figural archivolt seems to have ousted the modular head-voussoirs from the third order, which their total length would fit exactly. These head-voussoirs were relegated to the next order outwards, which necessitated a larger archivolt, and were therefore supplemented, on each side, by an additional voussoir of an entirely different sort. Since the structure of the portal is homogeneous, this change must have taken place in the course of construction.

The change of plan is also reflected in a group of ornamental slabs carved with grotesque heads and running animals, recognizably in the old style of the nave capitals (Pl. 100, cf. Pl. 99). These slabs were apparently rejected during the construction, and inserted arbitrarily around the north buttress of the façade together with an unfinished figural slab. At the same time, the new sculptors saw to it that the slab carvings on the façade proper were entirely figural. The transition from almost pure ornamentation to some sort of balance between the figural and the ornamental, which the other workshops of Poitou underwent much more slowly and hesitantly, was thus telescoped, at Saint-Jouin, into a single project.

Figural Slab-Reliefs

Viewed as a whole, the programme of carved slabs on the façade of Saint-Jouin-de-Marnes amounts to a conspicuous figural picture on a monumental scale. It comprises, in the gable, the Christ with trumpeting angels (Pl. 119), a retinue of smaller figures in the frieze below (Pls. 125, 126), and, lower down, various additional figures including a rider (Pl. 124), Samson and the lion (Pl. 123), single saints (e.g. Pl. 118), and an Annunciation (Pl. 121). The scope of this programme was undoubtedly determined by new iconographical requirements, which will be considered in another chapter,[93] but it may be noted here that the requirement for any kind of ambitious figure programme must have caught the sculptors largely unprepared. The contemporary iconographical mini-programmes, on capitals, corbels, and voussoirs, were trifling by comparison. The late eleventh-century statues in the nave of Airvault (Pl. 26), though undoubtedly monumental, were apparently considered unworthy of imitation and remained isolated. Ensembles of

[93] Chapter 3.B.

figural slabs had occasionally appeared on exterior walls throughout the eleventh century, both in Poitou and in the Loire Valley, but these were generally much more modest. The slabs in the transept gable of Saint-Hilaire-le-Grand, for instance, present a limited range of standing figures; those which come from the dismantled gable of Selles-sur-Cher, in neighbouring Touraine, comprise no more than sporadic figural themes intermingled with ornamental ones. Other slab programmes of Touraine constitute narrative friezes of no relevance to Saint-Jouin. With the possible exception of Chinon, which is too damaged to be judged (Pl. 205), nothing approaches the scope of the Saint-Jouin programme.[94]

Eleventh-century slab sculpture occasionally involved grand figure design, but traditions are difficult to assess because the surviving material is rather fragmentary. Two examples nevertheless testify to relatively ambitious experimentation towards the end of the eleventh century: one is a majestic Christ on the transept façade of Notre-Dame at Luçon (Pl. 116), the other a loose relief of a seated saint, preserved in Poitiers museum (Pl. 117). Both are carved in a similar style, characterized by confined gestures, strongly delineated limbs, and broad sheets of drapery. The similarity suggests the emergence of a consistent trend of figural slab-relief, and it is therefore worth exploring the rather elusive information on the origins of the two works.

Notre-Dame at Luçon was largely rebuilt in the late Middle Ages, and of the original Roman-esque structure only the north transept survives. Together with two winged animals, the slab with the Christ forms a tympanum in the transept portal. This is evidently due to rearrange-ment; the pieces are seen to have been trimmed to fit the tympanum space. As a result of this trimming the Christ lost a part of the nimbus, and one of the animals lost the tip of the wing. In some other form, however, these jumbled slabs may nevertheless have belonged to the original project, which is a documented one; it began in 1091.[95] Similarly, the Poitiers relief is totally divorced from its original context, but something may nevertheless be learned about its date. It comes from the destroyed church of Saint-Saturnin at Saint-Maixent, and, according to the Chronicle of Saint-Maixent, this church was reconstructed from its foundations in the late eleventh century and consecrated in 1099.[96] The evidence on each work separately is weak, but gains in strength because it leads to a similar date in the 1090s for both.

The sculptors of Saint-Jouin-de-Marnes were apparently acquainted with this late eleventh-century style of Luçon and the Poitiers relief, but were no longer satisfied with it. On the one hand, they repeated (e.g. Pl. 118) its calm simplicity, confined gestures, and shallow plate-draperies; and on garment borders they even reproduced the pattern of sunk lozenges from the mantle of the Luçon Christ and the neckband of the Poitiers saint. On the other, they introduced an additional and completely new range of lively figure-types, further enriched by intricate surface detail (e.g. Pl. 121).

[94] Recent publications on slab-reliefs in the Loire region include: Schmitt 1976; Vergnolle 1985: 107–13, 174–5, 181–4; Hubert 1988; Vergnolle 1992. For Poitou, see also Camus 1982a.

[95] On the church of Luçon, see Dillange 1983: 106–9. According to Crozet, there are two relevant documentary sources: the first specifies that the church was 'restored' in 1091, and the second refers to a consecration in 1121 (Crozet 1942: respectively nos. 119 and 167). I believe that the reliefs belonged to the early stages of the renovation project, nearer 1091; hence the similarity to the Poitiers relief (Pl. 117), which comes from a church that was consecrated in 1099 (see n. 96 below). The Poitiers relief is even of approximately the same size as the Christ relief of Luçon (90 cm.).

[96] Marchegay and Mabille 1869: 416–17. On the discovery of the relief and its association with that church, see Sandoz 1958: 22–5.

These new figure-types did not evolve from any precedents in sculpture, but seem to have been borrowed from the period's leading experts on monumental figure design, namely, the mural painters. Many details at Saint-Jouin can accordingly be paralleled in Poitevin murals of the same period, especially the vault paintings of Saint-Savin (*c*.1100).[97] It is instructive, for example, to compare the Saint-Jouin Virgin Annunciate (Pl. 121) with a woman in one of the Saint-Savin scenes (Pl. 122). The articulation of the lower body is the same, with an almond-shaped belly, a lightly bent leg with a thin fold curving under the knee, and a fan of straight folds over the other leg. Further similarities include the large head with somewhat plain features, and the expressively gesturing hands. The motif of triple drill-holes on the Virgin's garment is a sculpted version of the triple-dot ornament at Saint-Savin, for instance on a figure of Abel (Pl. 120). The same Abel may be compared to the trumpeting angel on the south side of the Saint-Jouin Christ (Pl. 119), which is the same slim and swaying figure with tubular torso and narrow, hunched shoulders. The little that survives undamaged of the rider relief in the Saint-Jouin ensemble, on top of the north buttress (Pl. 124), similarly finds its peer in a battle scene at Saint-Savin,[98] with the same conventions for the horse's neck and legs and also the same backward twist of the rider's torso.

All this suggests that the sculptors of Saint-Jouin still depended on painted models for their figures, like some of the capital-carvers before them (Pls. 21–4), and for the same reason that figures were still rare in contemporary sculpture. The reference to mural paintings also seems to underlie the choice of slab-relief as the main vehicle for figure sculpture, not only at Saint-Jouin but also at Benet and eventually Parthenay-le-Vieux. Slab carving was the only current form of sculpture which could be made large enough to exert a monumental effect comparable to that of the murals. Capitals, corbels, and archivolt-voussoirs were simply too small. Despite the experiments of Melle, most of the archivolts and capitals of Saint-Jouin, like those at Parthenay-le-Vieux, therefore reverted to marginalia and various fineries. In short, the first important figure carvings on a Poitevin façade did not grow out of traditional architectural sculpture such as on capitals and corbels. They were rather a translation in stone, on the exterior, of the monumental figure designs previously limited to interior mural painting.

Following some modest and sporadic experiments in the eleventh century, the period between 1100 and 1120 was beginning to see the first consistent trends of monumental figure programmes on church façades. This is true not only of France but also of northern Italy and Spain. The Burgundian school of Cluny, the Emilian school of Wiligelmus, and the southern school of Toulouse, León, and Santiago de Compostela, all embarked on new figural experimentation within that period. Each drew on a different range of models in antique sculpture, church fittings, paintings, and other works, but the central objective of displaying figure sculpture on façades remained the same. The evidence for the façade of Saint-Jouin suggests a project of the same period (though later retouched), and a faithful representative of that first trend of the High Romanesque. It may well be asked, however, if Saint-Jouin was important enough for such a feat, a question which requires a brief excursion into the abbey's history.

[97] A selective bibliography on the Poitou–Loire school of mural painting, and on the date of Saint-Savin, is given in n. 107 of this chapter.
[98] Illustrated in Demus 1970: Pl. 139.

The Circle of Thouars

The building history of Saint-Jouin-de-Marnes attests to a prosperous abbey which at some point fell into decline. During the eleventh century it was in a position to receive a new church,[99] and around 1100 embarked on the nave-extension with its exceptionally rich façade. There is also an extension at the other end of the building, involving a spacious chevet which was constructed by another workshop and consecrated in 1130.[100] The chevet is not as innovative or neat as the nave-extension. Between them, however, the two extensions made the church one of the largest and most ambitious in Poitou. After that, ambition failed. Much of the building remained in its eleventh-century simplicity, and was not even vaulted for another century or so. In the meanwhile, the additional proto-Gothic statues were inserted in the façade in a messy and clumsy fashion. By *c*.1200 the chevet proved to have been poorly built; it needed additional buttressing and eventually a replacement of vaults. All in all, the church turned out to be patch upon patch of additions and repairs, and it failed its early promise.

The earlier periods were accordingly the better ones, apparently on account of lay patronage. Very few donation charters survive, but the geographical distribution of the abbey's property suggests a close relationship with the neighbouring viscounts of Thouars and their vassals. By the twelfth century, the abbey had come to possess a considerable number of dependent churches, situated mainly in the area controlled by the Thouars (namely stretching westwards across the Thouet and the Sèvre-Nantaise rivers to the sea).[101] Judging by a charter of immunities issued by the count of Anjou in 1120, Saint-Jouin was as ardent as any reformed abbey against lay encroachment,[102] yet the connection with Thouars remained strongly in evidence. This connection had in fact been strengthening steadily since the end of the eleventh century, when Saint-Jouin was ruled by an abbot who came from Saint-Florent-lès-Saumur, another abbey under the patronage of Thouars.[103] The benefits of this patronage must indeed have been great, second only to ducal patronage, because the Thouars themselves were now at the height of their power and Viscount Aimery V even married into the ducal family.[104] The same Aimery must have held the abbey of Saint-Jouin in high favour, for it was here that he was eventually buried (1127).[105]

[99] Tcherikover 1987.

[100] Tcherikover 1989*b*, and below, Chapter 4.B.

[101] There are some donation charters by vassals of Thouars, subsigned by the viscounts, between the 9th and the 11th cents.; Grandmaison 1854: 1, 11, 12, 16, 17, 22. The possessions acquired by the abbey until the late 12th cent. are listed in a papal Bull of 1179; ibid. 38–43. On the location of castles dependent on Thouars, see Garaud 1964: 39–43.

[102] Grandmaison 1854: 27–30. This charter was issued in 1120 by the count of Anjou, and contains a confirmation of past rulings. It tells of two generations of lay encroachment on the abbey by his men, the lords of neighbouring Moncontour. Despite a reference to the monks temporarily leaving the place, this was not a case of lay takeover of the sort noted above concerning Airvault in the early 11th cent. The abbey of Saint-Jouin is described rather as long liberated, and in possession of lands and villages acquired from other noblemen. The lords of Moncontour are described as a relatively recent power, now attempting to usurp some of the land anew, and thereby enjoy the service of the men in some of the villages (masons, carpenters, and others). The charter seems to exaggerate in describing the abbey's woes, doubtless because the judge himself (the count of Anjou) was a party to the dispute, on the abbey's side, and Moncontour at some point refused to accept his ruling.

[103] The appointment of the Saint-Jouin abbot, probably Brictius, is mentioned in 'Historia Sancti Florentii Salmurensis' (Marchegay and Mabille 1869: 304). The relationship between Thouars, Saint-Florent, and Saint-Jouin is reflected in some other documents. For instance, in a charter of Saint-Laon at Thouars, issued in 1096, a monk of Saint-Jouin appears in the list of Saint-Florent witnesses (Imbert 1875: no. LVIII (pp. 53–4)). Abbot Brictius features second only to the abbot of Saint-Florent in the list of important dignitaries gathered in 1099 for the consecration of the Thouars foundation at Chaize-le-Vicomte, given as a priory to Saint-Florent (see 'Prioratus de Casa Vicecomitis, chronicon et cartularium', in Marchegay 1877*b*: 6). It was for this foundation that Aimery IV (ob. 1093) received an exceptional obituary in the 'Historia Sancti Florentii' (Marchegay and Mabille 1869: 303). So did Aimery V (see n. 104 below). Saint-Laon at Thouars was at some point claimed by Saint-Florent (see n. 10 of this chapter).

[104] On the marriage of Aimery V and Agnes, daughter of Duke William the Troubadour, see Martindale 1965: 146; and on the history of Agnes, also Vajay 1966.

[105] Aimery V was killed in 1127, as recorded in the 'Breve chronicon Sancti Florentii Salmurensis' (Marchegay and Mabille 1869: 191). The evidence on his burial is somewhat complicated. In 1139, Aimery VI was buried at Saint-Jouin. His successor, William, then issued a charter, opening with the words: 'Ego Guillelmus, Toarcensium

The abbey of Saint-Jouin is thus seen to have enjoyed especially good connections around 1100 and the early decades of the twelfth century. For its nave-extension and western façade, it then managed to secure the services of what seems to have been a leading workshop, and one that was equally connected to the circle of Thouars; as shown above, this workshop was also employed on the church of Saint-Laon at Thouars. Saint-Laon too was patronized by the viscount at that period and was in fact attached to Thouars castle.[106] The origins and the precise history of the workshop cannot be reconstructed with any certainty, largely because nothing survives of its work outside Saint-Jouin except for the few capitals at Saint-Laon, yet the impression created is one of a busy and ambitious circle around 1100 and the period immediately afterwards.

The circumstances of patronage therefore permit the conclusion reached above on grounds of style. Although very different from the other figural experiments of the early twelfth century, the project of Saint-Jouin-de-Marnes may nevertheless be attributed to the same period.

The Regional Duality of Poitou

One of the difficulties in assessing the importance of the Poitevin Romanesque monuments arises from an unclear regional definition. Saint-Jouin may seem unusually precocious in the context of Aquitaine, but perhaps this was not the true context of the Poitevin school at that time. Indeed, the material so far considered testifies rather to strong affinities between Poitou and all the lands around the Middle Loire Valley, from Berry and Orléanais to Touraine and Anjou, and even as far north as Maine. This regional relationship provides the necessary context for the relatively early dates offered above for the various Poitevin monuments, since it was in the Loire region that some of the most pioneering and influential centres of Early Romanesque arose. In artistic traditions, Poitou had been part of that region at least since the heyday of the Corinthianesque capital in the second and third quarters of the eleventh century; and the material already examined illustrates the continuity of this relationship subsequently. For instance, during the eleventh century there was a kinship between the archivolt techniques of Le Mans, Poitiers, Nieul-sur-l'Autize, and Saintes; this was followed, in the twelfth century, by a kinship between the archivolt forms of Angers and Parthenay-le-Vieux.

vicecomes, qui Aimerico Arberti filio successi . . . pro redemptione anime mee et pro anima patris mei, in abbatia Sancti Jovini sepulti, pro anima quoque predecessoris mei vicecomitis Aimerici, qui et ipse in eadem abbatia sepultus est . . .' (Grandmaison 1854: 34). From this it is clear that his father and his predecessor were two different persons, both buried at Saint-Jouin. His parents must have been Aimery V and Agnes, since his younger brother, Geoffrey, describes himself in a charter of 1151 as 'filius videlicet Aimerici, Willelmi quondam consulis Pictavorum ex sorore nepos' (ibid. 35–6). The duke in question is William the Toulousan, and his sister the said Agnes. It may be noted that Geoffrey is referring to past glory; at the time of his charter (1151) the duke of Aquitaine was King Louis VII. There is some contradictory information on the burial of Aimery V though it does not seem to carry much weight. It concerns a mention by a 19th-cent. Thouars historian of a donation made to Fontevrault by the same Geoffrey,

'dont le père et le frère avaient été inhumés dans l'église Ste Marie de Fontevrault' (Imbert 1865: 361). It is not clear what the source was for this information, since the author does not give a precise reference. I have not been able to find any document referring to such burials among the charters of Fontevrault in the *Archives des Maine et Loire* at Angers. The one charter signed by Geoffrey (101 H 55) makes no mention of them. It may be noted that any interest of the Thouars in Fontevrault must have been connected with Agnes, who, like other ladies of the ducal family, retired at that abbey. However, the death of Aimery V predates Agnes's retirement, and this makes the claims for his connection with Fontevrault even less likely.

[106] Saint-Laon 'in castro Toarcensi sita est'; as mentioned in a charter of 1096 (Imbert 1875: 53–4). Aimery V and his wife Agnes issued a joint charter in favour of Saint-Laon in 1117 (ibid. 11–12).

The height of this regional relationship is represented by the nave-extension and the façade of Saint-Jouin-de-Marnes; the stylistic parallels at Le Mans and Chinon speak for themselves. It may also be noted that the painters of Saint-Savin, who were so closely related to the Saint-Jouin sculptors, have indeed been traced by scholars to projects north of the Loire including La Trinité at Vendôme and the Angevin church of Château-Gontier.[107] All this accentuates the reality of a Poitou–Loire school of art, and it is even possible that Saint-Jouin is a chance survivor of a significant Poitou–Loire trend of sculpture of which all other traces have been lost. Was there anything of relevance at Marmoutiers, at Saint-Martin in Tours, at Saint-Florent-lès-Saumur? All these important abbeys of Touraine and Anjou preserve something to testify to ambitious eleventh-century undertakings, but are thin on subsequent projects, including documented ones.[108] The little relevant work that survives, at Chinon, is too badly damaged to allow any precise assessment of its relationship to Saint-Jouin. All the figural elements of that façade were simply hacked away, and only the ghost of one figure, light and vivid like those in the frieze of Saint-Jouin (Pl. 127, cf. Pl. 126), remains to testify to what was perhaps one of the more important sources of the style.

These artistic relationships reflect a common social ground, established during the eleventh century as a result of diverse political connections. The Poitevins had interests in Berry, for instance, while the Angevins continuously encroached on the Poitevin lands of the Loudunais, the Thouarsais, the Gâtine (Parthenay), and Saintonge. A parallel Angevin annexation of Touraine and an encroachment on Maine brought Vendôme and Le Mans into the same circle, and there were other such connections across the Loire.

This was the source for a regional duality that was to accompany the county of Poitou throughout the period discussed here. The Loire connections thus stood in diametrical opposition to the aspirations of the counts of Poitou as dukes of Aquitaine, which meant essentially southern interests. In the course of the tenth and eleventh centuries, the dukes accordingly pursued various political alliances in a vast southern territory, stretching down to the Pyrenees and from Auvergne to the Atlantic coast. Their success was variable but generally steady, especially after 1060, when Duke Guy-Geoffrey ejected the Angevins from Saintonge and also succeeded in annexing Gascony. As a result, Poitou was eventually to turn its back on the Loire and face southwards, albeit never completely.[109]

In the event, the south remained partly foreign to the Poitevins. Not only did the dukes govern Gascony as a separate duchy, but there were also great cultural differences. The author of the twelfth-century *Pilgrim's Guide*, who was probably a Poitevin, thus records speech differ-

[107] There are some general discussions of the Poitou–Loire school of mural paintings in the 11th and 12th cents., though most of these are somewhat outdated. They include Wettstein 1971 and 1978; Demus 1970: 419–23. See also Dodwell 1993: 233–6. Supplementary recent publications, on individual monuments, include Camus 1989; Taralon 1986; Toubert 1983 and 1987. The Saint-Savin paintings followed a series of building campaigns which ended around 1100; see Crozet and Crozet 1969 in conjunction with Riou 1972. The most recent scholarship attributes the paintings of Saint-Savin to about that time (Camus 1992: 178). For a similar dating of the closely related paintings at Vendôme, see Toubert 1983.

[108] At Saint-Florent, for instance, all that survives of the abbey church is the 11th-cent. crypt. However, the 'Historia Sancti Florentii Salmurensis' attributes considerable works in the nave to Abbot Matthew of Loudun (1128–55): 'Ipsa quoque de qua loquimur navis ecclesiae, arcuato opere ipsius tempore incoepta est et completa' (Marchegay and Mabille 1869: 307). Nothing is known of any intermediary works that would account for a loose capital, which carries confronted animals decorated with drilled bands, somewhat as at Saint-Jouin; it is illustrated in Mallet 1984: fig. 172. On building campaigns at Saint-Florent, see ibid. 44–50 and 161–7.

[109] This historical summary is based largely on Martindale 1965; also Dunbabin 1985: 58–63, 173–9. See also below, Chapter 2.A.

ences and strange customs in the lands south of Saintonge.[110] Anjou, on the other hand, always remained a familiar if troublesome neighbour, for although the Angevin encroachment on Poitou at some point weakened it was never fully repelled. The viscounts of Thouars, theoretically a Poitevin barrier against this encroachment, had dealings on both sides, and likewise the lords of Parthenay and Lusignan. At the ecclesiastical level, too, various northern connections were continuously cultivated. The great abbeys of the Angevin domains, and in particular Saint-Florent-lès-Saumur and La Trinité at Vendôme, possessed many dependencies in Poitou and Saintonge.[111] As already noted, Saint-Florent also enjoyed the patronage of the viscounts of Thouars, and in the late eleventh century had one of its monks appointed abbot of Saint-Jouin-de-Marnes.[112] The abbey of Fontevrault, founded about 1100 near the Loire and well inside the Angevin zone of influence, was to become a favourite retreat for the ladies of the Aquitainian ducal family.[113] The Poitevin schools of study at Saint-Hilaire-le-Grand (in the eleventh century) and Poitiers Cathedral (in the twelfth century) always looked northwards to Le Mans, Chartres, and even Paris.[114]

The duchy of Aquitaine can therefore be seen as a conjunction of two quite different worlds, the one northern and the other southern. The meeting of the two is the key to much that befell the local schools of sculpture during the twelfth century, as will be seen in the next chapter.

[110] Vielliard 1978 edn.: 16–21.

[111] On the Poitevin vassals and their dealings with Anjou, see Garaud 1964: 37; Chartrou 1928: 5. The charters concerning the possessions of the abbeys of Touraine can be found in Marchegay 1873 and 1877a, Métais 1893, and also Métais 1893–1904, nos. cvii (pp. 194–200), cxlvi (pp. 255–9), clxiv (pp. 284–90).

[112] See n. 103 above.

[113] See below, Chapter 4 n. 47.

[114] The schools of study are discussed in Descroix 1945, Garaud 1946, and Favreau 1960.

2

THE RISE OF THE SOUTH

*c.*1090–1120

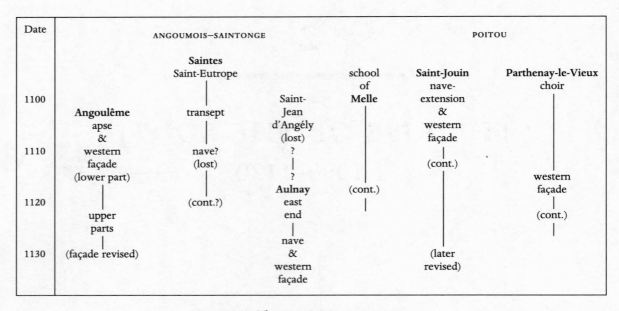

Date	ANGOUMOIS–SAINTONGE				POITOU	
		Saintes Saint-Eutrope			**Saint-Jouin** nave- extension	**Parthenay-le-Vieux** choir
1100				school of **Melle**		
	Angoulême apse &	transept	Saint- Jean d'Angély (lost)		& western façade	
1110	western façade (lower part)	nave? (lost)	? ?		(cont.)	western façade
1120	upper parts	(cont.?)	**Aulnay** east end	(cont.)		(cont.)
1130	(façade revised)		nave & western façade		(later revised)	

FIG. 2. The main projects, *c*.1100–20

A. THE SAINTONGEAIS IDIOM

The Shift of Regional Orientation

At the beginning of the twelfth century, the sculpture schools of western France were undergoing a slow but momentous transformation, which may be described as a shift of the main centres of influence from north to south. During the eleventh century, the schools of the Loire Valley and Poitou had apparently exercised considerable influence on the southern provinces of Aquitaine, but this influence slowly weakened as new southern idioms grew. From *c.*1090 onwards, the cities of Saintes and, later, Angoulême thus became important centres of sculpture in their own right, and soon provided models for all the surrounding lands. Their influence was eventually to blunt even the persistently distinctive character of the school of Poitou and establish an overall Aquitainian accent.

The sculpture schools of Saintes and Angoulême had much in common with the more renowned schools of Toulouse and Spain, but depended on them less than is sometimes supposed. All these southern schools of High Romanesque sculpture arguably grew in parallel, and through a similar process of increasingly powerful responses to initial influences from the north. This is manifest, for instance, in the vicissitudes of the Corinthianesque capital. Partly drawing on sources in the Loire region, it reappeared at Saintes, Toulouse, and León at about the same period of the late eleventh century: in the two-storey choir of Saint-Eutrope at Saintes between 1081 and 1096, in the chevet and transept of Saint-Sernin at Toulouse around 1080–1100, and in the Panthéon de los Reyes at León after 1072 and before 1101.[1] Other parallels among different centres of the south, during the early twelfth century, will be noted below. To be sure, models travelled in all directions, and Spain with Toulouse had ever more to offer, but so did Saintes, Angoulême, and other Aquitainian centres of sculptural activity. Together, all these centres represent an impressive rise of the southern Romanesque, which for a while was to overshadow the veteran centres of the Poitou–Loire milieu.

The Aquitainians were in a good position to give to the south as much as they received, because they were now governing an essentially southern principality. Saintonge had been under the direct government of the dukes since the ejection of the Angevins in 1062. Angoumois, though an independent county, was allied to them through numerous interests, especially in Saintonge. Duke Guy-Geoffrey (1058–86) achieved control of Gascony together with the key archbishopric of Bordeaux, and further strengthened his position in the south by marrying two of his daughters to Spanish princes. Since the government of Gascony was organized separately, the effect of these policies on the character of the duchy as a whole was

[1] Saint-Eutrope is discussed in the next section and, in more detail, in Blomme 1985; Tcherikover 1988. On the capitals of the relevant period at Toulouse, see Durliat 1990: 80–104. Some of the Toulousan capitals resemble earlier capitals in the tower of Saint-Benoît-sur-Loire, *c.*1030, but the relationship between the two projects still awaits detailed research. For the date and the sources of the Panthéon de los Reyes at León, see Williams 1973; also Durliat 1990: 183–96. It is only in the last two decades that modern research has established the anteriority of the 11th-cent. schools of the Loire Valley and Poitou over the similar schools of the south. See especially Vergnolle 1985 and Camus 1992, though a precursor may be seen in Grodecki 1958. Until then, most scholars had held that the predominant direction of influence was from south to north; e.g. Gaillard 1966, Sauvel 1938 and 1945. This view can no longer be accepted.

slow, but eventually crucial. Under Dukes William the Troubadour (1086–1126) and William the Toulousan (1126–37), the persistent inclinations towards Anjou and the north became a local Poitevin matter, while the grand ducal policies were increasingly directed towards the south. Ducal residences at Saintes and Bordeaux supplemented the one at Poitiers; expeditions to Spain, whether for pilgrimage or war, became a matter of course. An Aquitainian claim to Toulouse followed the 1094 marriage of William the Troubadour and Philippa, heiress to the county of Toulouse, and was temporarily successful between 1098 and 1119. All this meant that the south became increasingly Aquitainian and Aquitaine increasingly of the south.[2]

Saint-Eutrope at Saintes

The artistic affiliations of Saintes during the eleventh century may be illustrated by an example from the church of Notre-Dame, known as the Abbaye aux Dames. Originally constructed in the period of Angevin occupation (1032–62), this church later underwent several campaigns of renovation. Only the first of these is of concern at the moment. It involved a reinforcement of the crossing piers and may be assigned to the period following 1060, since the capitals of the reinforcement piers echo the normal Poitevin decorations of that time. For instance, there is a pattern of foliage scrolls looped at the bottom of the basket and curling at the upper corners, as at Charroux (Pl. 128, cf. Pl. 7), though small and flattened fan-leaves replace the lavish Poitevin foliage.[3] Similar influences from Poitou and the north were to set the tone of Saintongeais architectural sculpture for some time, and yet new ones were already on the horizon.

Constructed in two building campaigns involving two distinct workshops of sculptors, the priory church of Saint-Eutrope at Saintes ended up as a one-building illustration of the transition from Poitou–Loire influences to new and independent southern idioms. The transition can in fact be placed fairly accurately between *c*.1090 and *c*.1100, in accordance with the building history, which has already been presented elsewhere,[4] and may be briefly reiterated here.

As noted in the previous chapter, the priory of Saint-Eutrope was reformed in 1081, and then received a new church which was consecrated in 1096.[5] The structure that emerged in that building campaign was later incorporated as crypt and choir in a larger church, but originally it seems to have formed a building in itself (Pl. 129),[6] a kind of two-storey chapel, intended as a monumental shrine for the relics of St Eutropius. The flow of pilgrims must have justified this enterprise, since the relics are described in the *Pilgrim's Guide* as a major attraction of the southwest.[7] The building was accordingly constructed on a spacious plan, with aisles, ambulatory, and radiating chapels both in the crypt and on the upper level, and it survives in this form despite some later alterations. Discounting these, the structure looks cohesive enough to have advanced smoothly, with the crypt presumably completed in the 1080s and the upper storey in the 1090s.

[2] On the Aquitainian shift of regional orientation, see Martindale 1965: esp. 108–13 and 129–40; also Dunbabin 1985: 177–8. On Angoumois, Watson 1979; on the Aquitainian claim to Toulouse, Richard 1903: i. 404–24; on the relationship with the Spanish principalities, Boissonnade 1934–5.

[3] The renovation of the Abbaye aux Dames was to continue, see below, Chapter 4.C. [4] Tcherikover 1988.
[5] Chapter 1 n. 16.
[6] See below, and n. 11 of this chapter.
[7] Vielliard 1978 edn.: 64–79.

The sculptural decoration at both levels may largely be attributed to a single workshop, called hereafter 'the first workshop of Saint-Eutrope', while stylistic variation may be put down to changes introduced by the workshop in the course of the work.

The earliest version of the style of this workshop, represented by the decorative detail of the envelope walls and the crypt, reveals dependence on the traditions of the regions to the north. The window archivolts, up both storeys (Pls. 69, 71), are thus carved with simple modular patterns of the type noted above throughout Poitou and as far as Le Mans. The crypt contains grand Corinthianesque capitals with pronounced volutes, carved in a distinctive style, but nevertheless betraying similar northern associations. As in the crypt of La Couture at Le Mans, for instance, the traditional tiers of foliage are greatly simplified and the lower tier is sometimes replaced by a protruding foliate band (Pl. 130, cf. Pl. 131). As in the chevet of Saint-Jean-de-Montierneuf at Poitiers, the division into tiers is sometimes completely abandoned, allowing for a new division of the surface into medallion-like fields of feathery foliage (Pl. 132, cf. Pl. 133). Since the chevet of Montierneuf is dated on documentary grounds between 1069 and 1086,[8] the comparison to it supports the suggestion, also based on documentary evidence, that the crypt of Saint-Eutrope was constructed in the 1080s.

Yet the style of Saintes is not quite the same as at Le Mans and Poitiers. It is enriched by new details, apparently borrowed from the Roman remnants which abound at Saintes, a city of Roman origins. For instance, one capital in the crypt of Saint-Eutrope is carved with a pattern of upright acanthus leaves consisting of lightly jagged folioles, exactly like those on a Roman capital preserved in Saintes museum (Pl. 134, on the left, cf. Pl. 135). Another carries a classically inspired wreath sheathed by jagged acanthus and enclosing a small flower, seemingly based on Roman frieze fragments in the same museum (Pl. 134, on the right, cf. Pl. 136). These borrowings, of which more examples could be cited,[9] are of interest not only because of the evident reference to the antique, but also because the models are local. The workshop of Saint-Eutrope must have come across them while exploring the city, and consequently created a new and peculiarly Saintongeais version of the original Poitou–Loire style. This was the first in a series of changes that was to give the workshop an increasingly independent character despite a certain amount of recurrent influence from Poitou.

In the upper storey, the workshop apparently co-operated with a Poitevin sculptor, discussed in the previous chapter, who produced capitals with twisted-neck creatures like those at Parthenay-le-Vieux (Pls. 137, 138, cf. Pls. 14, 15). However, this new Poitevin element was now inundated by numerous capitals in an established local style of foliage ornament, in essence the style of the crypt with an added measure of harsh stylization (Pls. 137–41). The previously soft and versatile foliage now acquired the quality of flattened lacework, and all the classical motifs became dry and linear. The acanthus decorations were thus transformed into clusters of sharp digits, tightly packed and framed by striated ribbons (Pl. 141, cf. Pl. 134). Classically inspired wreaths became rigid spirals of serrated shapes (Pl. 139, cf. Pl. 134). The architectural arrangement of the sculpture also changed; straight-sided pilaster capitals (of a rather odd shape dictated

[8] See above, Chapter 1 n. 25. [9] An additional example can be found in Tcherikover 1988: fig. 17, cf. fig. 18.

by the complex elevation) were now incorporated between the rounded capitals of the half-columns, thus creating continuous capital-friezes. These changes suggest that the Saintes workshop finally outgrew its Poitou–Loire beginnings and succeeded in establishing itself independently. It was now even to exercise considerable influence of its own in Saintonge and further south.[10]

The consecration of 1096 must have seen the two-storey chapel more or less completed, since it involved the altars both in the crypt and on the upper level. At that point, however, there was a change of plan. The building was extended westwards by means of a two-storey transept and a mid-level nave, which were clearly an afterthought; where the transept joins the original structure there are straight masonry seams (clearest on the north side) and structural clashes (on the south side and the interior).[11] With the addition of the transept and nave, the original two-storey chapel became the crypt and choir of a great church. This was the 'great basilica . . . marvellously made', as described by the author of the *Pilgrim's Guide* some time around 1140.[12] Unfortunately, the nave was demolished in the nineteenth century and the rest bears signs of alterations in various periods, but parts of the transept survive in their original form, especially around the crossing.[13]

Further examination of the transept reveals that the change of plan must have followed close on the heels of the original project. It was thus the sculptors of the upper choir who now returned to ground level and participated in the works of the lower transept, contributing a capital-frieze in their usual style of lacy foliage (Pl. 142, cf. Pl. 141). The lower transept may therefore be assigned to *c.*1096 or soon after. The upper transept apparently followed without interruption, incorporating, in the crossing, bases identical to those in the upper choir but capitals in a different style.[14] This style shares with the old one the unusual arrangement of the capitals in continuous friezes, but otherwise involves a completely new range of ornamental and even figural themes. It undoubtedly represents a new workshop of sculptors, termed in the following chapters as 'the second workshop of Saint-Eutrope' (Pls. 143, 144, 146–9, 151). The activity of this workshop may well have extended beyond the transept; a loose figural capital in the same style is preserved in the municipal museum, and perhaps comes from the demolished nave (Pl. 152).

The second workshop of Saint-Eutrope was so inventive that any assessment of sources may

[10] Concerning the influence of this workshop on Saint-Caprais in Agen, see Terpak 1986. Its influence on 12th-cent. Saintonge is discussed below, Chapter 4.A.

[11] Observations on site yield the following: the masonry seam on the north side marks the western end of the original two-storey chapel. The stringcourse that runs above the crypt windows accordingly ends at that point with a properly carved corner, indicating that the building was not originally intended to extend further west and that the transept was added as an afterthought. Apart from this, the evidence on the north side is not quite clear, because the north transept was transformed into a tower in the late Middle Ages. However, the south transept still preserves much of its original character. It was evidently built after the completion of the choir and following a change of plan, since the transeptal chapel hides some parts of the original choir wall. On the interior, the upper choir meets the transept with a change in the thickness of shafts; the transition can be seen on the eastern face of the eastern crossing piers. It cannot be determined

how the transition was made at crypt level, since the corresponding piers of the crypt have not survived in their original form.

[12] 'super beati Eutropii corpus sanctissimum, ingens basilica sub ejus honore . . . a xpistianis miro opere fabricatur . . .' (Vielliard 1978 edn.: 76).

[13] On the various alterations, destructions, and restorations, see Blomme 1985.

[14] Other aspects of the building history are discussed in Blomme 1985. This author convincingly demonstrates that the vaults of the upper choir were not envisaged from the start. He attributes them to an independent building campaign. Perhaps this campaign corresponded to the construction of the upper transept, which I place around 1100 or slightly afterwards; see below. Blomme quotes a much later date, offered in previous literature, and based on comparisons to Aulnay. However, Aulnay is undated and, in my view, later than Saint-Eutrope; see below, part B of this chapter.

do it an injustice. An examination of the crossing capitals shows that even where precedents exist there is always some new twist. For instance, figural capitals flank the choir entrance, perhaps on the model of choir programmes at Melle and elsewhere, but they are set out against capital-friezes of unprecedentedly dense ornamentation (Pls. 143–4). The ornaments include ample foliage scrolls enriched by animal motifs, as earlier at Charroux or Saint-Savin (Pl. 147, on the left, cf. Pl. 9),[15] but scrolls and animals submit to strict stylization of a new kind. Other decorations consist of various creatures climbing on to each other (Pl. 147), as in some manuscript illuminations from Limoges,[16] but these creatures too are newly stylized; crouching figures, lions, and birds are placed one above the other and duplicated monotonously in rows, resembling a densely woven ornamental tapestry (Pl. 148). The handling of detail is linear and precise, as at Saint-Jouin-de-Marnes and other monuments of the eleventh and early twelfth centuries, but no Poitevin work of the time equals the clean-cut draughtsmanship of Saintes (Pl. 147).

This innovative style seems nevertheless highly eclectic and in fact brings together three disparate stylistic families. One is Italian, and will be discussed later, one is Poitevin, and one southern. The foliage décor, for instance, provides a clear illustration of the workshop's unique fusion of Poitevin and southern elements. On the one hand, there are some thick clusters of leaves after the eleventh-century Poitevin style of Charroux and Saint-Savin (Pl. 148, cf. Pls. 7 and 9). On the other, there are large palmettes of a distinctly southern form, with a button embedded in each foliole, as on the cloister capitals of Moissac (Pl. 145c, cf. Pl. 145d). A repeated southern motif is the splayed fan-shaped leaf, prolonged by a fluttering tendril (Pl. 143); this is a variant of the so-called 'Aquitainian leaf' which was common in manuscript illumination of the eleventh century at Agen, Moissac, and Limoges (Pl. 145a, cf. Pl. 145b).[17]

A transition from Poitevin to southern forms is manifest in some of the figural imagery, in particular the scene of Daniel in the Lions' Den, depicted on a capital of the south-eastern crossing pier (Pl. 149). It is instructive to compare this representation of Daniel with two others: in the ambulatory of Sainte-Radegonde at Poitiers and in the ambulatory of Saint-Sernin at Toulouse. The Poitevin example (Pl. 20), which is undoubtedly the earlier (1060–70),[18] shows concern for narrative detail and accordingly allows space not only for Daniel and the lions but also for the angel ferrying Habakkuk to the lions' den. Similar attention to the narrative can be detected at Saint-Benoît-sur-Loire,[19] and may be seen as typical of the Poitou–Loire milieu. The southern example, at Toulouse (1080s) (Pl. 150), is later than the Poitevin and attests to greater preoccupation with decorative conventions at the expense of some of the narrative: the angel and Habakkuk are omitted while the lions are multiplied in decorative tiers. The version of Saint-Eutrope is essentially Toulousan despite some variation in the arrangement of the lions, and it even repeats the same type of Daniel raising his hands in prayer. It may be noted that at Saint-Eutrope this scene is opposed to the scene of the Weighing of Souls, represented on the opposite crossing pier (Pl. 151), and that both recur on cloister capitals from La Daurade, also at

[15] On the influence of this Poitevin style, see Camus 1987: 552–3.
[16] Cf. Gaborit-Chopin 1969: fig. 28.
[17] Gaborit-Chopin 1969: 61–2.

[18] See above, Chapter 1.A.
[19] A capital in the north transept, illustrated in Vergnolle 1985: fig. 260.

Toulouse (*c*.1100).[20] This affinity strengthens the impression that Saintes and Toulouse shared some models.

The new relationship with Toulouse is also stylistic. The individual figures everywhere in the crossing of Saint-Eutrope follow the heavy style current in the 1080s in the ambulatory of Saint-Sernin (Pl. 149, cf. Pl. 150), now enriched by new drapery forms. These include clusters of double-line folds (Pl. 151) characteristic of several different southern sculptors of the 1090s, in particular Bernard Gelduinus who was active at Saint-Sernin about 1096,[21] and his followers in the cloisters of Moissac (shortly before 1100) and La Daurade.

It is noteworthy that the artistic connection between Saintes and Toulouse was established suddenly. There had been little indication of it before 1096, when the first workshop of Saint-Eutrope and Gelduinus of Toulouse were doing entirely different things. In 1098, however, Toulouse was controlled by the duke of Aquitaine. He was represented there by Duchess Philippa, who was a patron of Saint-Sernin.[22] Presumably, many Aquitainians were then present in Toulouse and its environs, and the projects of Saint-Sernin, La Daurade, and Moissac were taking shape before their very eyes. It took such a political and social presence for the latest innovations of the Toulousan milieu to burst on to the Saintes scene, where they were immediately absorbed into the powerful and apparently contemporary style of the second workshop of Saint-Eutrope.

Italianate Fashions and the Enhancement of Ornament

Saint-Eutrope combines the influence of Poitou and the south with the influence of northern Italy, which in fact played an important part in the history of the Aquitainian Romanesque in general and therefore requires particular attention.

Scholars have long suggested that much in Aquitainian Romanesque sculpture derives directly from the approximately contemporary monuments of Lombardy and Emilia.[23] The evidence for this is entirely stylistic and generally convincing, but difficulties arise regarding certain details. For instance, some of the stylistic analogies between the Aquitainian and the Italian monuments may reflect older or indirect influences which are not easy to identify. There is also a problem of precise dates; modern scholarship still struggles with the chronology of the Italian monuments, some of which may well have been constructed earlier than is commonly believed. A cautious interpretation of the evidence nevertheless reveals a chronological process: following sporadic connections during the eleventh century, the Italian influence on Aquitaine culminated around 1100. It was then absorbed into the local styles, and later subsided.

Some sort of connection with Italy apparently accompanied the unprecedented enrichment of the ornamental vocabulary on eleventh-century capitals. At Champdeniers, for instance, there are capitals with paired animal-protomes, as in Sant'Ambrogio in Milan.[24] The capitals with twisted-neck creatures, noted above as a consistent Poitevin motif from the second half of the

[20] Horste 1992: pls. 23, 49.
[21] Cf. Durliat 1990: fig. 62.
[22] Richard 1903: i. 404–24.

[23] De Francovich 1937–8: 61 ff.; also Porter 1923: 304, 309, and 315.
[24] See Zarnecki 1984.

eleventh century onwards, recur on a loose capital at Pavia (unfortunately of unknown provenance),[25] and also among the porch capitals of Sant'Eufemia at Piacenza.[26] A motif consisting of lions crossed head to tail is found in very similar form at Charroux (Pl. 8), the Poitiers church of Notre-Dame-la-Grande, Saint-Savin, and, in Italy, the apse of San Fedele at Como.[27] The widespread distribution of the motif of the mermaid is particularly well known; examples up to *c.*1100 include Santiago de Compostela, Parthenay-le-Vieux, the choir of Saint-Eutrope, and, in Italy, Rivolta d'Adda, the ambo of Sant'Ambrogio in Milan, and others. There is no reason to assume that the Italian examples always predate the French, but similar patterns evidently circulated in both lands, and not only in sculpture. The crossed lions recur, for instance, in the canon table of a late eleventh-century Bible from Limoges,[28] which suggests that the sculptors may have used portable models and were not necessarily aware of the precise architectural source of every motif.

It nevertheless seems that the Aquitainian sculptors became increasingly aware of Italian buildings, since from *c.*1090 onwards they adopted Italian methods for composing archivolts, capitals, and even bases. Neither the reasons for this seemingly intensified influence nor the means of its transmission are very clear.[29] No Italian hand has ever been identified anywhere in Poitou, Saintonge, or Angoumois; there was imitation rather than importation. Copying aids, such as sketches that may have been taken by travelling sculptors, belong to the domain of hypothesis. The interregional chronology too remains unclear, which is why an Italian influence may be assumed only where a decorative system normal to Italy appears in Aquitaine without any local precedents, and replaces the standard Aquitainian system.

One example concerns the façade archivolts of Saint-Jouin-de-Marnes. While the standard Poitevin system of the time involved archivolts of square section and narrow voussoirs (e.g. Pls. 64–5, 77–83), the north portal of Saint-Jouin incorporates in addition an archivolt of roll section and long voussoirs, embedded in the re-entrant angle of the square archivolt and the hood (Pl. 153).[30] This arrangement recalls the normal Lombard system; examples in existence by the time of Saint-Jouin include the late eleventh-century portals of Santa Margherita at Como (now in Como, Pinacoteca) and Sant'Abondio at Como.[31] The portal of Santa Margherita (Pl. 154) presents a typically Lombard roll archivolt, composed of very long voussoirs and covered by shallow foliage carvings which spread uninterrupted from one voussoir to the next. The roll archivolt of Saint-Jouin is essentially of this type, though the local Poitevin system intervenes in that the pattern is separate for each voussoir, as opposed to the continuous design of the Lombard model.

Similarly, the archivolts in the windows of the Saint-Jouin façade (Pls. 110–13), as well as some of those in the central portal (Pl. 108), present a strange hybrid of different systems. On the one hand, they are almost square in section and decorated voussoir-by-voussoir, in keeping with the

[25] Illustrated in Peroni 1975: no. 413.

[26] Illustrated in Verzar-Bornstein 1988: figs. 45–8.

[27] The Como example is illustrated in Zastrow 1978: fig. 120.

[28] Paris, Bibliothèque Nationale, MS Lat. 8, fo. 170ᵛ. On this manuscript, see Gaborit-Chopin 1969: 86–99.

[29] My impression is that the subject should be approached from the Italian rather than the French angle, and is perhaps connected with the leading role played by various centres of northern Italy in both the imperial and the papal policies of the 11th cent. This subject clearly exceeds the scope of this study.

[30] The south portal is similar but completely restored, apparently on the model of the north portal, which is original and only repaired.

[31] For the dating of the Como portals, see Zarnecki 1990.

Poitevin practice. On the other, the voussoirs are long and the decoration spreads from face to soffit as if wrapped around a roll, unlike anything else in contemporary Aquitaine. This peculiarity may well represent yet another adaptation of the roll archivolt, more imaginative and free than that in the north portal, but still under the influence of Lombardy. Indeed, some of the individual motifs equally echo a Lombard model; the docile quadruped which strolls along one of the window voussoirs, for instance, finds an almost exact parallel on a square archivolt in the Como portal of Santa Margherita, even to the similar branching of some foliage above its back (Pl. 155, cf. Pl. 154).

Moving on to Saint-Eutrope at Saintes, the Italian influence here concerns the capital-friezes in the upper choir and the crossing. Unprecedented in Aquitaine,[32] such friezes are normal to Lombard architecture from some point in the eleventh century onwards; some of the better known examples can be found in the atrium and nave of Sant'Ambrogio in Milan. The friezes in the choir of Saint-Eutrope, by the first workshop of that monument, in fact follow the Milan example quite closely; in both places (Pl. 156, cf. Pl. 141), the friezes are formed by pilaster capitals which bridge the gap between the rounded capitals of the half-columns, and the main patterns consist of lace-like spreads of foliage. Differences of detail can be put down to different local adaptations.

Although created by a second workshop, distinct from the first and employing a totally different range of motifs, the capital-friezes in the crossing of Saint-Eutrope (Pls. 143, 144) are equally Italianate. A comparison with the crossing capitals of San Michele at Pavia (Pl. 158) reveals the same basic scheme of a string of ornamental capitals punctuated by figural ones at the salient points, and even a similar predilection for rearing lions and twisted birds.[33] As at Pavia, the effect of continuous frieze is enhanced by the suppression of the Corinthianesque capital, previously so popular at Saintes and elsewhere (cf. Pls. 130, 139), but necessarily a self-contained ornamental unit unsuitable for continuous designs. Block capitals were therefore preferred in both places. At Pavia, they still preserve some debased volutes, but no longer at Saintes. In addition, the Saintes workshop manipulated the upper part of the blocks to create the impression of double imposts, a highly unusual feature, which makes sense only by comparison to the exceptionally tall imposts of Pavia and other Italian monuments. In San Savino at Piacenza (Pl. 157), to mention another example, the imposts carry two decorative strips of equal visual impact, the upper geometrical and the lower foliate. A similar arrangement recurs at Saintes (Pl. 144).

In anticipation of the diffusion of the Saintes style elsewhere in Aquitaine, some Lombard features may be noted at Aulnay-de-Saintonge and Angoulême. At Aulnay, the central window of the apse is flanked by elongated slab-carvings (Pl. 167), much like the apse windows of Sant'Abondio at Como. At Angoulême, two of the façade archivolts are carved with foliage scrolls, the one inhabited by twisted-neck lions and the other with birds, and both are strikingly similar to the inhabited scroll on an arch in the ambo of Sant'Ambrogio in Milan (Pls. 199, 200, cf. Pl. 204). It is not clear, however, whether these influences were direct or mediated by Saintes. Saint-Eutrope, which is the most Italianate of all the Aquitainian monuments so far considered,

[32] Except accidentally, where the shafts of clustered piers reach the same height, e.g. at Champdeniers. The effect is, however, quite different.

[33] The crossing of San Michele has been attributed to *c.*1100 (Wood 1978: 100–17 and 231). Yet it may well be earlier.

must have possessed additional decorations, lost with the demolition of the nave, and perhaps the source for both Aulnay and Angoulême.[34] Aulnay was certainly not the first place in the region to have received carved slabs at the sides of a window; an earlier though simpler example can be found in the eleventh-century Saintongeais church of Saint-Thomas-de-Conac.[35] At Aulnay, the genre was merely enriched by a new pattern, consisting of lively figurines with clinging garments clambering in stringy scrolls, and apparently deriving from a capital of Saint-Eutrope (Pl. 168, cf. Pl. 146).

Saint-Eutrope, like Saint-Jouin-de-Marnes, suggests that the Lombard influences were at their height around 1100, an impression strengthened by additional examples of that period. Sculpture on column-bases, for instance, appears in its most Italianate form in the nave of Airvault, consecrated in 1100. The carvings take the shape of enlarged spurs climbing up both rolls of the base, and include a human head, intertwined snakes, and other motifs, as in the church of San Pietro in Ciel d'Oro at Pavia (Pl. 159, cf. Pl. 160). No base decoration in the whole of Aquitaine is as diversified, or comes so close to the Italian type.[36] Later monuments present no more than sporadic variations, such as an isolated motif in the cavity of one of the bases in the transept of Aulnay. As noted above concerning the window slabs of Aulnay, the Italian influence on that monument was probably indirect, channelled through local styles and consequently mitigated.

Whether direct or mediated, the Italian influence was ultimately an enhancement of ornament. The sculptors of Aquitaine had been that way inclined since the eleventh century, but they met their match in their Lombard counterparts. There is little in the Romanesque world more ornamental than the Lombard style, with its interwoven foliage, animals, monsters, and, on the whole, a bewildering variety of strange motifs spreading on capitals, imposts, door-jambs, and archivolts, and completely overwhelming the occasional figural theme. The lesson was not lost on the sculptors of Aquitaine. Alongside the new Italianate patterns, they worked out new versions of their own ornamental traditions, such as the modular system of archivolt decoration described in the previous chapter. At Parthenay-le-Vieux, for instance, that system was injected with new motifs and became more decorative than ever before (Pls. 79–83).[37]

South of Poitou, all types of architectural ornamentation were now to become ever more flamboyant. As a result, none could be easily reconciled with the new experiments in figure sculpture, which are just as typical of the period. Compromise solutions were needed, and quite a few were to come. Some took after the Poitevin systems of Melle or Saint-Jouin-de-Marnes, but all were carried out with the greater flair characteristic of the young and dynamic milieu of the south. The chief examples come from the early twelfth-century projects at Angoulême and Aulnay, which apparently ran more or less in parallel (Fig. 2). Angoulême began first and was by far the more important and innovative. Yet attention must first be concentrated on Aulnay, because it represents the perfection of older forms rather than the initiation of new ones.

[34] On the lost parts of Saint-Eutrope, see Sauvel 1935 and 1936.

[35] Cabanot 1987: fig. 75, and a comparison to Como on pp. 76–7.

[36] On San Pietro in Ciel d'Oro, see Wood 1978: 49–99 and 230–1; also Chierici 1978: 44–5. The current dating of San Pietro, well into the 12th cent., is perhaps in need of reassessment. On Airvault, see above, Chapter 1.A; and also Tcherikover 1985*a*. The sculpted spurs in the

nave of Saint-Jouin-de-Marnes are modern copies of those at Airvault; see Tcherikover 1987: appendix, esp. 129.

[37] An alternative theory, suggesting that the ornamentalism of Aquitaine derives from Muslim sources, has never been demonstrated by any comparisons beyond a few isolated motifs; see especially Daras 1936; Seidel 1981: 74–80.

B. BETWEEN POITOU AND SAINTONGE

Aulnay-de-Saintonge

Belonging to the diocese of Poitiers but situated nearer Saintes, the village of Aulnay (known as Aulnay-de-Saintonge) preserves the gem of Aquitainian Romanesque, the church of Saint-Pierre-de-la-Tour. The building as such is quite modest. It comprises a one-bay choir with a simple apse, a transept with two chapels, and an aisled five-bay nave, all conforming to a consistent plan and executed with no significant breaks. At the same time, the display of well-preserved sculpture on all sides is exceptionally lavish and highly varied; one scholar in fact identifies three different workshops.[38] The first was engaged on the choir and transept (Pls. 161 ff.), where the construction undoubtedly began. When the work reached the higher part of the transept, the first workshop was replaced by a second (Pl. 257), which proceeded also to the nave (Pls. 262 ff.), and was joined by a third workshop for the project of the western façade (Pls. 350 ff.). Each workshop represents some major trend of the Aquitainian Romanesque, which makes the building a pivot of all scholarly debates on the chronology of the regional school. Following some of the latest opinions, it will be suggested here that the construction was undertaken around 1120, a date that matches both the history of the church and the origins of the first workshop.[39] The date of completion and the origins of the second and the third workshops will be dealt with separately later.

The church of Aulnay presents a riddle: for splendour and quality of workmanship it is one of the most ambitious in the region, yet there is nothing in the local circumstances to account for such ambition. The place was never of particular ecclesiastical importance, nor were there any special conditions of lay patronage. Aulnay was the seat of viscounts, but by the twelfth century they had long declined from their former importance.[40] Furthermore, the viscounts of Aulnay were never involved with the church in question. They never feature in any of the documents concerning it, not even as sub-signatories, which would normally be the case if they had any claim to overlordship. Their castle was served by another church, dedicated to St Justus,[41] while the church of Saint-Pierre which is discussed here seems to have served a borough of Aulnay. Its medieval surroundings included an old cemetery, some dependent houses, and another church, now lost.[42] The whole set-up was perhaps even more rural than at Melle, as it certainly is today.

This unimpressive background suggests some outside intervention which, to judge by the meagre documentation, had something to do with the reorganization of rural churches in the wake of the Gregorian Reform. The church of Saint-Pierre apparently passed from lay to ecclesiastical hands in accordance with the ideals of the Reform, and, following a probable phase

[38] Werner 1979.

[39] Werner enumerates the various dates offered for Aulnay, ranging from 1119–35 to 1160–1200. He suggests *c.*1120–40 for the whole project; see Werner 1979: 89–92.

[40] Martindale 1965: 211 and n. 93. On the former importance of the viscounts of Aulnay, during the 11th cent., see Garaud 1937: 445–6.

[41] This church, which is now lost, was given to Saint-Florent-lès-

Saumur between 1070 and 1086 by Cadalo 'vicecomes de castro quod dicitur Oenacus', and described as 'aecclesia beati martiris Justi quae in praedicto castro sita est'; Marchegay 1873, charter no. 85 (pp. 124–7).

[42] It is possible that the houses mentioned in a charter of Saint-Cyprien (see n. 43 below) belonged to the church of Saint-Pierre. On the adjacent church, dedicated to St Martin, see below, n. 45 of this chapter.

of multiple ownership, ended up in the possession of a powerful outside owner. The evidence for this is as follows.

An earlier church of the same appellation of Saint-Pierre-de-la-Tour had existed at Aulnay in the middle of the eleventh century, which is when it began to pass from lay to ecclesiastical hands. The little that can be gathered about the chain of owners begins with a local landed family by the name of Rabiola, who were castellans of nearby Dampierre-sur-Boutonne. They passed their rights in the Aulnay church to the Poitiers abbey of Saint-Cyprien. This donation was reason enough for Saint-Cyprien to include the Aulnay church twice in lists of possessions (*c.*1100 and 1119), although the rights in question were limited to a few isolated revenues, falling well short of full ownership.[43] Other contemporary owners are unknown, but the fact remains that Saint-Cyprien enjoyed only partial ownership. Indeed, the matter of ownership was decided by Bishop William Gilbert of Poitiers (1117–23) without any reference to Saint-Cyprien. In 1122, he obtained a papal confirmation for a donation made to the chapter of Canons Regular of Poitiers Cathedral, including the church of Saint-Pierre at Aulnay.[44] The date of the actual donation was presumably shortly before, perhaps around 1120, which is when the same bishop gave the adjacent church of St Martin (lost) to another beneficiary.[45] The intervention of the bishop is typical of the later stages of the Reform, in the early twelfth century, when the bishops began to outdo the monasteries in achieving direct control over various ecclesiastical properties.

Despite the partial donation to Saint-Cyprien, the church of Aulnay thus ended up in the possession of the chapter of Poitiers Cathedral around 1120. Comparisons to other examples of final settlement of ownership—noted above at Airvault, Saint-Eutrope in Saintes, and Saint-Hilaire in Melle[46]—suggest that this may well have been the occasion for the reconstruction. The rural church at Aulnay accordingly came to enjoy cathedral patronage, with all the appropriate splendour.

The First Workshop of Aulnay

Employed on the choir and transept, the sculptors of the first workshop of Aulnay produced virtuoso versions of almost every kind of architectural sculpture so far encountered in both

[43] Various rights, in several different churches, were given to Saint-Cyprien by Ramnulf Rabiola and his relatives around the middle of the 11th cent. These included 'in ecclesia Sancti Petri de Oenia, id est de Turre, duas partes sepulture et candelarum' (Redet 1874: charter no. 475 (pp. 291–2)). The charter further enumerates some houses and lands, but it is not entirely clear whether these belonged to the church of Aulnay or to other churches, mentioned in the same charter. Otherwise, the rights of Saint-Cyprien in the church of Aulnay amounted to no more than the specified portion from the revenues from burial and candles, that is, partial ownership only. The wording should be contrasted with that for full ownership, i.e. that which included the quintessential presbyterial fief, which the same charter accords the abbey of Saint-Cyprien in the church at Dampierre-sur-Boutonne: 'concesserunt . . . ecclesiam Sancti Petri apud castrum Dumpetra . . . cum omni fedo presbiterali et quicquid ecclesie pertinere videbatur . . .'. The donation at Aulnay was confirmed by Ramnulf's son, Hugh Rabiola, between 1087 and 1100 (Redet 1874:

no. 484, (p. 295)). For further information on the Rabiola up to 1105 (after which they are no longer mentioned in any documents), see Debord 1984: 460 and 521–3. For the lists of Saint-Cyprien possessions (of 1097–1100 and 1119 respectively), including references to the Aulnay church, see Redet 1874: no. 9 (pp. 11–14); no. 13 (pp. 17–19).

[44] Robert 1891: 40. The documentary evidence on Aulnay was put in order by Crozet (1945: 666–8). Crozet supposed, however, that the church passed wholly from the possession of Saint-Cyprien to the cathedral chapter, as opposed to the present interpretation, namely, that all that Saint-Cyprien ever owned of the church was the right for a few revenues; see n. 43 above.

[45] St Martin's at Aulnay was given to the monks of Saint-Florent-lès-Saumur, who administered the church of St Justus in the castle of Aulnay. It is described in the donation charter as 'aecclesiam Sancti Martini ejusdem villae, quae vicina est aecclesiae Sancti Petri de Turre' (Marchegay 1873: charter no. 95 (pp. 133–4)).

[46] See above, Chapter 1.

Poitou and Saintonge. The portal on the south face of the transept (Pls. 175, 176, 178–81) comprises no less than four orders of richly carved archivolts; capital-friezes crown the crossing piers (Pls. 161–4); single capitals proliferate on both the interior and the exterior (Pls. 166, 171–3); sculpted corbels hide under most of the cornices (Pls. 169, 170). Every one of the apse windows is set into a recess resting on a decorative string-course and incorporating archivolts with elaborate mouldings, supplemented, at the central window, by the decorative slabs already mentioned (Pls. 167, 168). There is even one sculpted base and a tiny jamb figure, on the innermost order of the portal. The only type of sculpture conspicuous by its absence is the monumental figure relief, which was to arrive at Aulnay only with the third workshop. This omission was not accidental; the first workshop of Aulnay showed little interest in monumental imagery even in its later projects.[47]

It was a workshop of miniaturists, specializing in what is here called 'architectural fineries' on capitals, voussoirs, and the like. It treated figural elements on an equal footing with the extraordinary variety of ornaments, and even the Elders of the Apocalypse, depicted on the second archivolt of the portal, cannot be seen to have been given any greater prominence (Pl. 178). There is a sprinkling of figured capitals representing, on the interior, Adam and Eve, Cain and Abel (Pl. 162), the story of Samson (Pl. 161), a knight with a dragon, men wrestling (Pl. 163), the tormented miser, and also, on the exterior, the Weighing of Souls. As if in disrespect, however, all were scattered among birds, lions, monstrous hybrids, masks, peopled scrolls, and other patterns (Pls. 164–6, 171–3).

The formal vocabulary of this sculptural complex suggests a workshop of Poitevin origins and new southern connections, like the second workshop of Saint-Eutrope at Saintes and in close correspondence with it. The workshop's attitude was even more eclectic than at Saintes. No decorative device was unacceptable, whether recently formed or long established, provided it served to enrich the endless march of figural and ornamental variations. The impression created is one of ever richer sets of models circulating between the different contemporary workshops of Poitou and Saintonge, with the workshop of Aulnay laying its hand on practically all of them.

From its Poitevin side, the workshop adopted something from almost every style of *c*.1090–1120. There are twisted-neck griffins like those in the choir of Parthenay-le-Vieux (Pl. 162, cf. Pl. 14) and net-capitals like those of the Melle school (Pl. 164, cf. Pl. 49). A procession of various creatures on the outer archivolt of the portal evokes the window archivolts of the façade of Saint-Jouin-de-Marnes; though handled differently, here are the same bearded human-headed hybrids (Pl. 180, cf. Pl. 110), the rearing ram (Pl. 179, cf. Pl. 110), the winged centaur, the combat between two creatures, and other comparable motifs. The capitals in the Aulnay portal reflect yet another Poitevin style: delicate patterns of monsters and figurines are duplicated across the corner of the block, in the spirit of the contemporary façade of Parthenay-le-Vieux (Pl. 173, cf. Pl. 89).

The transept portal of Aulnay may be counted among a group of Poitevin portals, also comprising the south portal of Saint-Hilaire at Melle (Pl. 63), the central portal in the façade of

[47] See below, Chapter 4.D.

Saint-Jouin-de-Marnes (Pl. 108), and the façade portal of Parthenay-le-Vieux (Pl. 79). Although the number of recessed orders and the style of carving vary, all these portals share some distinctive elements of design. For example, all possess colonnettes in each order of the embrasure except the innermost, which remains architecturally plain (this was later to change, contrast Notre-Dame-la-Grande at Poitiers and the Abbaye aux Dames at Saintes, Pls. 284 and 307).[48] In addition, the corner of some of the recessed orders is carved with small decorative motifs; a roll moulding marks the innermost jamb, or the innermost arch, or both; and the string of imposts acts as a unifying element across the embrasure. These features may be taken as characteristic of Poitou in the period 1100–20, to which each of these portals has been here assigned independently.

The group of Melle, together with its offshoots at Verrines-sous-Celles and Surgères, is geographically the nearest to Aulnay and was also the workshop's main source. Unlike the animals on the archivolts of Saint-Jouin-de-Marnes, those at Aulnay were fitted, rearing, on narrow voussoirs, as on the soffit of the portal archivolt of Saint-Hilaire at Melle (Pls. 179–81, cf. Pl. 65). Two of the archivolts in the Aulnay portal carry rows of dainty manikins, arranged singly on the narrow voussoirs (Pl. 178), as on the main face of the same Melle archivolt (cf. Pl. 64). The display of marginalia on the corbels includes a bearded head as at Saint-Savinien in Melle (Pl. 169, cf. Pl. 56), animals seen from the back as at Verrines-sous-Celles, and twisted acrobats like those of Surgères.[49] These influences are to be expected, since the career of the Aulnay workshop apparently passed through Melle itself. In the nave of Saint-Pierre at Melle, the style of this workshop is manifest in various sculpted string-courses and at least one capital, carved with animals and positioned in the west portal (Pl. 174, cf. Pl. 173).

Aulnay also shares with the Melle group a marked emphasis on scenes from the life of Samson. The capital-frieze of the north-western crossing pier carries not only the common theme of Samson and the Lion but also the scene of Delilah's betrayal (Pl. 161), as yet rare, but found on a capital of Verrines-sous-Celles.[50] At both Aulnay and Verrines, the sculptors even used very much the same system of narrative, conflating two different episodes from the story as told in the Book of Judges (16: 12–19). Samson thus appears once but Delilah twice, first binding him with new rope and then shearing his hair.[51] The Aulnay sculptor organized this scene more successfully than at Verrines, creating a sense of motion in space by allowing one figure to approach another across the corner of the block. This compositional device had already been used on the capital of St Savinianus in the Melle church of Saint-Savinien (Pl. 51), and further testifies to the debt of Aulnay to the school of Melle.

Against this essentially Poitevin background, the Aulnay workshop adopted many stylistic elements characteristic of the crossing capitals of Saint-Eutrope at Saintes.[52] These include the theme of the Weighing of Souls which appears on an exterior capital of the apse, the motif of a

[48] Cf. Werner 1979: 31.

[49] Illustrated in Werner 1979: figs. 56, 63, 70, 71.

[50] On the new 12th-cent. interest in the theme of Delilah's betrayal, see Krouse 1949: 54–62. On the propagation of the scene of Samson and the Lion (present at Saint-Savinien, Surgères, and Aulnay), see Stern 1970.

[51] The Aulnay capital of Delilah's betrayal is accompanied by a problematic inscription, on the impost: SAMSONEM VINCIT COM VNCS CRINE MO. For possible interpretations, see Favreau and Michaud 1977: 83.

[52] According to the argument presented above, the transept of Saint-Eutrope is earlier than Aulnay. Other scholars consider it to be contemporary or later; see Werner 1979: n. 190.

bird perched on a lion (Pls. 172 and 181, cf. Pl. 147), and the repetitive rows of crouching figures (Pl. 176, cf. Pl. 148). As mentioned, the slabs which flank the central window of the apse, though ultimately Italianate, reproduce a design of manikins clambering in scrolls after a capital of Saint-Eutrope (Pl. 168, cf. Pl. 146). In the treatment of individual figures, many of the drapery forms equally follow Saintes; Aulnay adopted, for instance, the typical Saintes convention of striated garments, clinging separately to each leg and resembling trousers (Pl. 163, cf. Pls. 151, 152). Other drapery forms derive from the related style of the Moissac cloister, including a reasonably faithful reproduction of the Moissac device of criss-cross bandages on and around the belly (Pl. 176, cf. Pl. 177).[53] The Moissac style may seem old-fashioned for a monument of c.1120, but the eclecticism of the Aulnay workshop allowed for such archaisms and even more blatant ones. On a slab of the central window (Pl. 168), for instance, one tendril of the foliage scroll suddenly breaks at an angle, which is a completely outdated and erratic citation from the angular scrolls which had been current around the middle of the eleventh century on capitals at Conques,[54] and elsewhere in the south.

Considering the wide range of the workshop's sources, details of treatment are surprisingly consistent throughout the complex. It is possible to distinguish a number of different hands, but these cannot be identified as specifically Poitevin, Saintongeais, or southern. All share an overall quality of linearity and graphic precision that evokes both Saint-Jouin-de-Marnes and Saint-Eutrope, with additional restlessness and almost obsessive attention to fine detail. All are inclined to mannered complications, including abrupt twists of limb or fold (e.g. Pl. 178), vigorous undercutting, and playful sprinklings of double-line folds, zigzag bands, and drilled studs. This consistent style suggests a workshop of some experience, which had already assimilated its main sources and arrived at Aulnay fully integrated. I would venture to place the beginnings of this workshop at nearby Saint-Jean-d'Angély, which was one of the most important abbeys of Saintonge but preserves nothing of its Romanesque buildings. The area around Saint-Jean-d'Angély indeed abounds in different versions of the Aulnay style in combination with some of the source styles, as if some central melting-pot of Poitou and Saintonge spouted different amalgams in all directions. Two of these combinations are considered here.

There is the little church in the village of Salles-lès-Aulnay, where the abbey of Saint-Jean-d'Angély was a landowner.[55] In the west portal, that church preserves some string-courses and capitals which are exactly in the style of Aulnay (Pl. 182), and, on the apse, an arched corbel-table also of the Aulnay type.[56] Given the geographical proximity of Aulnay and Salles-lès-Aulnay, it can be safely assumed that the same sculptor was engaged on both projects at very much the same time. Yet so was another sculptor, who remained more faithful to the heritage of Melle. On the interior capitals, this sculptor produced invigorated versions of the somewhat stiffly crouching animals typical of the capitals in the south wall of Saint-Hilaire at Melle (Pl. 183, cf. Pls. 60–2).

A combination of a different sort may be observed in the equally small church at Antezant, situated about half-way between Aulnay and Saint-Jean-d'Angély. What remains of that building

[53] I believe that Moissac and other monuments of the Languedoc exercised a very limited influence on Aulnay, though others consider this influence more important; see Werner 1979: 83–92.

[54] Illustrated in Durliat 1990: figs. 9–10.

[55] Musset 1901, charters nos. CCXLIV, of c.1028 (pp. 297–9); LXVII, of 1039 (pp. 94–6); LXVI, of c.1085 (pp. 93–4).

[56] Cf. Werner 1979: 110–11, and figs 333, 334, 337.

is the lower part of a modest western façade, which is a reduced version of the corresponding lower part of the façade at Parthenay-le-Vieux (Pl. 184, cf. Pl. 215). It dispenses with the buttresses between the portal and the side niches, but repeats the same stilted arches and the same roll moulding all around the portal (cf. Pl. 79). Antezant also reproduces some distinctive sculptural details of the Parthenay façade, including an archivolt with double-modular griffins precariously balanced on pairs of volutes (Pl. 185, cf. Pl. 81), another archivolt with modular foliage, and string-courses with rows of lions peeping out from behind large leaves (Pl. 186, cf. Pl. 88). At the same time, the sculpture of Antezant incorporates some elements characteristic of nearby Aulnay, such as the plump human-headed birds (Pl. 186, cf. Pl. 173).

It is impossible to tell if Antezant, Salles-lès-Aulnay, and Aulnay itself were, respectively, the first of their particular kind of stylistic combination. There are several gaps in the surviving material; besides the loss of Saint-Jean-d'Angély, the destroyed nave of Saint-Eutrope should also be remembered. All that can be said is that the area was the scene of a lively workshop active around 1120, which occasionally co-operated with other workshops of the same period. The distribution of the different versions over a limited area suggests that the workshop was based in that area, and that the Poitevin patrons of the Aulnay church came across it locally. In anticipation of the later work at Aulnay, it may be noted that the patrons looked elsewhere when it came to monumental imagery for the western façade. Yet for the first task of architectural ornamentation over the east end, the local workshop was as good as any, even if in some ways conservative.[57]

Imagery and Ornamentation in Conflict

The centre-piece of the first workshop's project at Aulnay is the portal in the façade of the south transept (Pl. 175). With its four orders of densely carved archivolts (Pl. 178), this portal is the most elaborate of those so far considered,[58] and also iconographically the richest. The period was that of new figural experimentation, whether in the form of mini-programmes—as defined in the previous chapter—on the capitals and voussoirs of nearby Melle (Pl. 64), or as various portal programmes in other regions of France. The Aulnay portal can be shown to reflect some of these new trends. However, iconographical order was as remote from the Aulnay sculptors as it was from any of the contemporary architectural decorators at Saintes, Parthenay-le-Vieux, and elsewhere in Aquitaine. It will be seen how strangely they treated an ambitious iconographical scheme that somehow infiltrated their range of models.

Of the four archivolts in the portal, the second and third are figural. On the soffit, each carries a row of atlantes, similar to the crouching figures on the capitals of Saint-Eutrope (Pl. 176, cf. Pl. 148), and apparently of mere ornamental value. On the main face, one of these archivolts carries the Elders of the Apocalypse; they are provided with their normal attributes of crowns, phials, and viols, but their number exceeds the usual twenty-four. The other figural archivolt carries a

[57] This workshop was to receive commissions even in the 1130s, when its style was by all accounts *passé*. See below, Chapter 4-D. On the western façade (third workshop), see Chapter 5.

[58] The western portal of Parthenay-le-Vieux possesses only two orders; the south portal of Saint-Hilaire at Melle possesses two on the exterior and another on the interior; the central portal in the façade of Saint-Jouin has five, but they are less prominent than those at Aulnay.

row of agitated manikins who face each other in pairs, and who have never been convincingly identified. Some hold phials similar to those of the Elders and may therefore have something to do with the same subject. These two figural archivolts are sandwiched between two archivolts with animal decorations, of which the upper is the most prominent element of the whole scheme, and deserves a more detailed account.

This archivolt is carved with a veritable menagerie of real and imaginary animals. Some of the creatures apparently come from popular writings on beasts, such as the *Bestiary*, the *Physiologus*, and the *Etymologies* of Isidore of Seville;[59] examples include the owl (Pl. 179),[60] the chimera (inscribed),[61] the siren (Pl. 178), and an archer-centaur (Pl. 179).[62] A combat between two creatures (Pl. 180) evokes the *Bestiary* story of Hydra and Crocodile,[63] while epic and fable provided a Cyclops (Pl. 181) and an ass with a lyre.[64] And as if such curiosities were not enough, there are also some sheer monstrous fantasies, including many semi-human hybrids (Pl. 180), besides the ornamental configurations of birds and lions after Saint-Eutrope (Pl. 181). Perhaps no other collection among all the Romanesque monuments so suits the famous words of the contemporary Bernard of Clairvaux, directed against the fantasies of sculpted fauna. Bernard admits the beauty of such carvings but questions their purpose, implying that their value is chiefly aesthetic.[65] Yet the same carvings may also carry an iconographical message, even if this is masked by what Bernard describes as a confounded delight in the fanciful and the wondrous.[66]

The iconographical message arises from the conjunction made at Aulnay between the animals and the Elders of the Apocalypse, depicted on the adjacent archivolt, for this conjunction is not accidental and can in fact be paralleled elsewhere. It was to recur in a set of pictured hangings, now unfortunately lost, which were made between 1128 and 1155 for the abbey church of Saint-Florent-lès-Saumur and described by a contemporary chronicler. This text gives information on the distribution of the pictures in the building, revealing a thematic hierarchy which at Aulnay is somewhat obscure. It specifies that the more important ones, made for the choir, carried the twenty-four Elders with their viols and phials as well as other subjects from the Apocalypse (unspecified), while others, made for the nave, carried lions, sagittarii, and 'other living creatures'.[67] Descending from the choir to the nave, these themes faithfully reflect the retinue of the revealed God as described in the Apocalypse, which descends from the twenty-four Elders and other celestial beings to 'every creature which is in heaven, and on the earth, and under the earth, and such as are in the sea, and all that are in them . . .' (Apoc. 5:13). Neither Saint-Florent nor the Aulnay portal makes any reference to the revealed God himself, probably because the

[59] Selected Bibliography on *Bestiaries* and related texts: James 1928, McCulloch 1960, Muratova 1981, Schuchard 1986, Hassig 1995.

[60] Cf. Oxford, Bodleian Library, MS Bodl. Laud Misc. 247, fo. 38ᵛ (in James 1928).

[61] This motif apparently derives from Isidore; see Favreau and Michaud 1977: 80.

[62] The centaur and siren are presented together in the *Bestiaries*; cf. Oxford, Bodleian Library, MS Bodl. Laud Misc. 247, fo. 147 (in James 1928); see also Hassig 1995: 106.

[63] Cf. McCulloch 1960: pl. V, 2b (from Cambridge, Corpus Christi College, MS 53, fo. 206). Another version can be found in London, British Library, MS Stowe 1067, fo. 2ᵛ.

[64] On the last theme, see Mâle 1978 edn.: 340.

[65] This interpretation of Bernard is according to Schapiro 1977c edn.

[66] Rudolph 1988.

[67] The Saint-Florent text runs as follows: 'Fecit etiam hic venerabilis pater [Abbot Matthew, 1128–55] dossalia duo egregia, quae praecipuis solemnitatibus extenduntur in choro; in quorum altero viginti quatuor seniores cum cytharis et phialis depinguntur, in reliquo Apocalipsis Johannis opere descripta est eleganti. Fecit insuper quosdam mirae pulchritudinis pannos, sagittariis et leonibus et caeteris quibusdam animantibus figuratos, qui in navi ecclesiae festis sollemnibus oppenduntur' (from 'Historia Sancti Florentii Salmurensis', in Marchegay and Mabille 1869: 306).

subject was represented in an apsidal painting, but both add the animals to the Elders. It is even possible that both followed the same models, since Saint-Florent possessed, at Aulnay, the lost church of St Martin, which was adjacent to the church discussed here.[68]

The important point about the animals in this context is that they come from all parts of the earth, whether near at hand or hidden and remote, and therefore represent the entire terrestrial world. However, the text of the Apocalypse presents a problem: it provides no specifications on individual creatures. The sculptors of Aulnay filled the gap with their own selection, including the imaginary animals which fit the theme precisely because the *Bestiary* allocates them to remote lands.[69] For similar reasons, they added a host of semi-human beings, who were believed to await salvation like the rest of mankind, though in some strange places.[70]

Émile Mâle noted the popularity of such zoomorphic 'images of the world', as he called them, in Romanesque Burgundy, culminating in the highly imaginative procession of strange humans and semi-humans in the tympanum of Vézelay.[71] Yet perhaps the idea was not as peculiarly Burgundian as he thought. In Aquitaine it seems to go back to the 1090s, when the capitals in the choir arch at Parthenay-le-Vieux were carved with various animals and monsters, some inscribed with their names (Pls. 12–15), and all serving as a pendant to the painting of Christ that probably existed in the apse. It is because of this affinity to the portal programme of Aulnay that, in the previous chapter, the Parthenay scheme has been described as an iconographical mini-programme rather than pure ornamentation. The same interpretation could perhaps be applied to the similar creatures in the choir of Saint-Eutrope at Saintes and to others of that sort.[72]

The portal programme of Aulnay, as well as some other quasi-ornamental ensembles of animals, can thus be seen to reflect some iconographical logic. Yet this logic was not quite as neat as it may seem. The notion of universal Revelation, attested by everything celestial and terrestrial, actually sanctioned any subject whatsoever; any collection of creatures would do. The sculptors consequently had a perfect excuse to indulge in all sorts of wondrous fantasies of the sort deplored by Bernard of Clairvaux. Furthermore, the Revelation of God as described in the Apocalypse was apparently understood by contemporaries as timeless and eternal, manifest in the entire history of the world from beginning to end,[73] which could equally sanction almost everything. This concept accordingly allowed for the entire range of biblical, mythological, hagiographical, or secular events from the past, present, and future. The Aulnay sculptors, as has been shown, chose a number of such events for some of their capitals, but any other choice would also illustrate the same concept. This is not what would usually be called an iconographical programme, that is, a purposeful selection and arrangement of subject-matter. If anything,

[68] See n. 45 of this chapter.

[69] As is well known, the *Bestiary* also attaches to the animals a symbolical and moralizing value, but in my view this is irrelevant to Aulnay.

[70] On the place of fauna in the medieval concept of universality, see Lecoq 1987; Wittkower 1942: 176–7; and, for the theological grounds from John Scotus Erigena (9th cent.) to Honorius Augustodunensis (early 12th cent.), Alverny 1953. Compare also Frugoni 1984; this

article gives a similar interpretation to the set of creatures on the metopes of Modena Cathedral.

[71] Mâle 1978 edn.: 324–32.

[72] For instance, in the axial chapel of Santiago de Compostela; Durliat 1990: figs. 177 and 181. There is an alternative interpretation of such ensembles of animals, in a moralizing sense. One example concerns the porch capitals of Sant'Eufemia at Piacenza; see Verzar-Bornstein 1988: 53.

[73] Klein 1990.

the notion of universal and timeless Revelation provides ideological grounds more for the rampant eclecticism characteristic of much of Romanesque work.

In fact, the Aulnay sculptors did not even try to order the sculpture programme along any over-rigorous iconographical lines. They simply fitted it into the current system of architectural ornamentation. A word of explanation on portal archivolts will clarify this point.

The portal is the most complicated piece of co-operation between sculptors and builders. The sculptor is allocated particular parts of the structure, such as the capitals or the archivolts, and has to find a solution for inflexible conditions. The shape of an archivolt, for instance, is necessarily dictated by the builder, who follows his own conventions and may impose them on the sculptor. One of these conventions is the radiating system of archivolt decoration described in the previous chapter, which sometimes occurs in a strictly modular fashion and sometimes more freely, but always voussoir-by-voussoir according to the traditions of architectural décor inherited from the eleventh century (Pls. 68–83). This restrictive framework generally favours ornamental programmes, as in the portal of Parthenay-le-Vieux and in fact most Aquitainian portals of the time, but it also governs the figural archivolts in the south portal of Saint-Hilaire in Melle (Pl. 64) and at Aulnay (Pl. 178). Whether ornamental or figural, the system involves a firm correspondence between sculpture and architecture on two counts: the number of motifs inevitably matches the number of voussoirs, and, like the voussoirs themselves, the size of the motifs is identical and their rhythm monotonous. The Aulnay workshop introduced a slight technical adjustment in that the springer voussoirs are almost double the usual size, but this was not allowed to spoil the rhythmical effect; each of the doubled voussoirs carries two motifs, in simulation of two ordinary voussoirs.

The result is an iconographically abnormal multiplication of figures in accordance with the number of voussoirs. The archivolt with the Elders of the Apocalypse consists of four double-voussoirs and twenty-three single ones, resulting in a total of thirty-one carved units. Since the units are the Elders themselves, their number rose to thirty-one instead of the canonical twenty-four. In the same spirit of architectonic décor, the figures on the adjacent archivolt seem to have been subjected to a loose double-modular system; like the double-modular griffins or mermaids of Parthenay-le-Vieux (Pl. 80), they face each other in pairs across pairs of voussoirs. It is little wonder, therefore, that the theme remains iconographically illegible.

Scholarly disquiet over the anomalous multiplication of figures at Aulnay has given rise to widely opposing theories. Some dismiss the phenomenon as pure formalism and an arbitrary outcome of the scheme of voussoirs, while others search for a symbolical explanation connected with the iconography of the Elders.[74] Thirty-one, however, is not only the number of Elders at Aulnay but also that of the entirely different figures depicted on the interior archivolt of the south portal of Saint-Hilaire at Melle (Pl. 64). This correspondence suggests that the number is neither arbitrary nor specifically connected with the choice of iconographical themes. The explanation for it is apparently to be sought in the builder's calculations, because the common denominator between the portals of Melle and Aulnay is architectural measurement: in both

[74] For the first view: Focillon 1969 edn.: i. 87–8. For the second: Werner 1979: 33; cf. Seidel on the 54 Elders of Saintes: 'this radial voussoir disposition may well have been selected for their display at Saintes to emphasize both their number and the tangibility of their ceremonial role' (Seidel 1981: 44–5).

places the door-opening measures about 160 cm, and the width of every additional recess (on the exterior) is about one and a half times its depth (Pl. 175, cf. Pl. 63).[75] The precise calculation of the archivolt voussoirs can no longer be reconstructed, not least because there are also some differences between the two portals, but it may nevertheless be noted that the correspondence at archivolt level involves figure numbers rather than voussoirs: the thirty-one figures are arranged at Melle on thirty-one voussoirs, but at Aulnay on twenty-seven (of which four are double the usual size). The inevitable conclusion is that the figure numbers are not merely an outcome of the architectural system but form an integral part of it. In other words, the arrangement of the sculpture programme of Aulnay was determined by a builder concerned with architectural order rather than iconography. The sculptors who executed this programme should accordingly be seen as architectural decorators, following the builder's design even at the expense of iconographical clarity.

It must be assumed that these sculptors were working in the knowledge that coherent figural imagery was to receive its due place somewhere else in the building, whether in mural paintings or some other sculptural ensemble. Indeed, mural paintings are known to have existed at Aulnay but were erased by a careless restorer.[76] A major figure programme was also to materialize in sculpture, on the western façade. Although this programme was executed about a decade later, the western façade may well have been designated for figure sculpture from the start, which allowed the sculptors of the east end to indulge in essentially decorative configurations. They were in this sense similar to their eleventh-century predecessors, who had experimented with figural imagery to a limited extent and always in an ornamental context, while the more important figure programmes were left to the specialist mural painter.

Aulnay demonstrates that no amount of figural infusion could seriously alter the essentially ornamental character of the traditional architectural fineries like voussoirs and capitals. The more complex the iconography, the greater was the conflict between content and form, resulting in iconographical absurdities such as the thirty-one Elders or the double-modular manikins of Aulnay. There was more of this to come, but the system of radiating iconographical programmes on sets of voussoirs had already collapsed. When archivolt sculpture was eventually harnessed to important iconography, this was due to new beginnings on completely different lines.[77]

There was only one way to reconcile major figure sculpture to the ever more flamboyant architectural ornamentation, and this was to separate the two as at Saint-Jouin-de-Marnes. This solution was already being worked out even more neatly, in its southern version, at Angoulême.

[75] Among the portals so far considered, these measurements are peculiar to Melle and Aulnay and must reflect a particular subregional tradition; the stylistic debt of Aulnay to Melle has been noted above. Contrast with Saint-Jouin-de-Marnes and Parthenay-le-Vieux, where the door-opening measures over 230 cm, and the width and depth of the recesses are approximately equal; hence the closely set capitals (Pl. 79), as opposed to the spaced-out capitals of Melle and Aulnay.

[76] The Aulnay murals were apparently erased by the infamous restorer Paul Abadie (the same who caused much damage at Angoulême and Périgueux). Referring to a letter by Abadie, Labande-Mailfert describes his work at Aulnay as follows: 'il a fait laver le badigeon blanc qui recouvrait les murs, au jet d'eau et à la brosse en chiendent, ce qui a fait jeter les hauts cris à un archéologue connu de Saintes, à cause "d'imperceptibles traces de peintures qu'à ma grande surprise la brosse n'a pas enlevées"' (Labande-Mailfert 1962: 215). Abadie's funds at Aulnay were fortunately very limited, and he caused little other damage.

[77] See below, Chapter 5.

C. THE SOUTHERN IDIOM OF ANGOULÊME

Bishop Gerard's Cathedral

The cathedral church of Angoulême was rebuilt under Bishop Gerard II (1102–36), and was arguably the most important ecclesiastical building project undertaken at the time south of the Loire. This is because Bishop Gerard was permanent legate to successive popes from 1107 onwards, and as such represented the papal authority in the archdioceses of Bordeaux, Auch, Tours, and Bourges. Permanent legates of that sort were created as an instrument of control by the Reform papacy of the late eleventh century, and, although their power was eventually to flag, it was still significant in Gerard's time. Angoulême therefore represents the temporary rise of an otherwise secondary provincial cathedral, owing to the special circumstances of the Reform period.[78]

The main source for the works of the cathedral is the twelfth-century *History of the Bishops and Counts of Angoulême*,[79] which makes two important points clear. First, those involved in the construction, presumably by funding and organization, were the bishop himself and one of the canons, Iterius Archambaud. No laymen are mentioned at all; the cathedral of the papal legate was a stronghold of Church independence. Secondly, the project undertaken under this patronage in the cathedral precincts was exceptionally ambitious. Besides a reconstruction of the cathedral 'from the first stone' (which perhaps should not be taken too literally), it also involved the bishop's palace, a new hall, and the collegiate buildings (all lost or greatly altered).[80] There apparently remained very little to do on the site after Gerard's death. His successor merely added another hall in the bishop's palace, and otherwise turned to building projects elsewhere.[81]

Gerard's career as a building patron must have begun almost as soon as he assumed office at Angoulême in 1102, and certainly not much later than his appointment as papal legate in 1107, since in 1114 he issued a charter in his new hall.[82] The cathedral too was undoubtedly completed in his lifetime, as the *History* attributes to him not only the building but also the various fittings, and then deplores his burial 'outside the church which he built'.[83] In addition, the dedication of the cathedral is mentioned in a document of 1128, a good eight years before Gerard's death.[84]

[78] On Gerard's career, see Claude 1953; and, in relation to Angoulême Cathedral, also Daras 1942. On papal legates, see Robinson 1990: 146–78, with reference to Gerard on pp. 156–8.

[79] 'Historia pontificum et comitum engolismensium' (Castaigne 1853: 11–61).

[80] 'Et vero Engolismensem [ecclesiam] a primo lapide aedificavit [Gerardus]; in qua reaedificatione supradictus Iterius Archambaudi in constructione parietum medietatem de proprio suo ministrabat. De proprio suo aedificavit [Iterius] dormitorium, refectorium, cellarium, presbyterium, januas ferreas; . . . Obiit [Iterius] in senectute sua, MCXXXV ab incarnatione Domini Anno [or in 1125, according to an epitaph, see Daras 1942: 109], et inter pontifices collatus . . . Gerardus itaque, Engolismensis episcopus, aulam pontificibus construxit, et ecclesiae quam, ut diximus, aedificavit, haec munera obtulit: contulit vero textus aureos et magnum textum cum lapidibus nimirum, thuribula deaurata et crucem de argento, duo candelabra argentea, unam capsulam argenteam, unum urceum argenteum, . . . duo altaria argentea . . . et centum volumina librorum . . . Aulam pontificibus et capellam et cameram Pictavi aedificavit, . . . migravit a saeculo,

MCXXXVI anno ab incarnatione Domini. Sedit in episcopatu annis triginta tribus, . . . proh dolor! extra ecclesiam quam aedificavit, sub vili latet lapide' (from 'Historia pontificum' in Castaigne 1853: 48–52). On the bishop's palace and its later alterations, see Dubourg-Noves 1973: cat. 8, pl. VIII.

[81] 'Historia pontificum' (Castaigne 1853: 52–3).

[82] See Crozet 1960. Another assessment of dates is presented in Daras 1942: 41–2. Daras placed the beginning of the project of the cathedral around 1110, following some financial arrangement between the bishop and the chapter. There is no specific information, however, that this arrangement concerned the works of the cathedral.

[83] See n. 80 above.

[84] The document in question does not deal directly with the cathedral. The relevant point is that it was issued by Gerard, in 1128, 'on the third day after the dedication of the church of Angoulême [tertio die post dedicationem Engolismensis ecclesiae]'; see Monsabert 1910: charter no. XXXVI (pp. 142–5). Following Crozet (1960: 49), I accept that this wording refers to the dedication ceremony of the new cathedral. The wording was at one time interpreted by another scholar

All this suggests that the main works of Angoulême Cathedral took place between 1102 and 1128.[85]

The cathedral church is large and imposing (Pl. 187),[86] comprising a spacious apse accompanied by radiating chapels (though without an ambulatory), towers over the transepts, a nave of three huge and aisleless bays vaulted by domes (Pl. 188), and a lofty western façade covered by figural and ornamental sculpture (Pls. 212, 219). This building has been somewhat disfigured by a nineteenth-century restoration, but much of the masonry and most of the sculpture is nevertheless authentic, and much else can be visualized with the help of pre-restoration drawings and photographs.[87] What emerges is an essentially southern building, following a type of domed church that can be traced back to late eleventh-century models at Périgueux and elsewhere.[88] There is a Roman grandeur about the wide spaces and the massive construction, alleviated by blind arches on both the interior and the exterior. Unlike some lesser buildings discussed above, Angoulême Cathedral was apparently constructed in one concentrated effort, and therefore turned out relatively homogeneous. The only exception concerns some older work incorporated in the fabric, on which more presently.

Like the architecture, the sculpture too is relatively homogeneous. Nearly all of it can be attributed to a single workshop, but one that continuously embarked on new stylistic and iconographical experimentation throughout the lengthy building campaign of some two decades or more. The result is several different versions of the style, each of which will be considered in its chronological turn. In general, however, it may be noted that the early version of the style is found in the lower parts of the building at both ends, that is, the apse and the lowest zone of the western façade. Conversely, the later versions are found towards the middle of the building and all the higher parts. This division, which implies that work on the cathedral began simultaneously at both ends, cannot be easily reconciled with the traditional scholarly view that the construction advanced from west to east.[89] Something must therefore be said about the evidence concerning the building history.

What seems to have determined the course of the works is the fact that the site was occupied by an older cathedral church. The east end of this church is partly known from excavations in the south transept.[90] A comparison between the old and the new layouts (Pl. 187) reveals that

as a reference to the anniversary of an older dedication (Serbat 1912*a*), but this interpretation involves an attempt to reject documentary evidence in favour of the stylistic dating system current at the time, and cannot be accepted.

[85] Porter (1923: 304–15) was among the few to have accepted the documented dates for Angoulême. He rejected the developmental theories which were current earlier this century, and which allowed some scholars to assign unreasonably late dates to much of the Angoulême sculpture. These theories survive in one form or another to the present day, compounded by additional theories on stylistic influences. For instance, some scholars assume that the sculpture of the Angoulême façade reflects a belated reaction to portal sculpture at Toulouse and Moissac; e.g. Dubourg-Noves 1974: esp. 110–11; Daras 1942: 152; Sauvel 1945: 183–90. It will be seen below that the relationship between Angoulême, Toulouse, and Moissac was entirely different, and agrees with the documented dates. Another unacceptable argument concerns a stylistic comparison between sculpture at Angoulême and the tympanum of Saint-Michel-d'Entraygues, supposedly of 1137; see Sauvel 1945: 198. The source on this date is,

however, a document of the 17th cent., and the stylistic relationship is not one that allows a close chronological association.

[86] The ground plan in Pl. 187 is based on two sources: a plan of 1851, illustrated in Dubourg-Noves 1973: pl. XII; a reconstruction plan of part of the old south transept, after Daras 1942: fig. 4.

[87] Dubourg-Noves 1973.

[88] The chronology of the domed churches of the south has still to be worked out. Meanwhile, the most useful account remains Vallery-Radot 1931*b*: 116–42. Current opinions (e.g. Durliat 1979: 306–9) depend largely on what seems a misinterpretation of the relationship between different phases in the nave of Angoulême.

[89] Especially Daras 1942: 41–66. This is implied also by Serbat 1912*b*, Vallery-Radot 1931*b*:128–9.

[90] The old cathedral of Angoulême was consecrated in 1014 (Crozet 1960: 49). On the excavations of the old transept, undertaken in the 19th cent., see Daras 1942: 32–3 and fig. 4. There were also excavations in the old crypt, where the evidence is not entirely clear because of a mixture between the old work and some 12th-cent. insertions; see ibid. 34 and Laurière 1870.

Gerard's east end was built virtually around the old one, exceeding it sideways and eastwards, but nevertheless maintaining the old position of the western wall of the transept. The conjunction of the transept and nave, and therefore the general alignment of the nave itself, must therefore correspond roughly to the old layout. At the west end, the nave indeed incorporates an older structure, serving as its westernmost bay. Previous interpretation of the course of construction centred on this bay, which therefore requires closer attention.

Though much altered by restorers, the westernmost bay of the nave is known from drawings and descriptions to have originally possessed a plain and heavy character, very different from the rest of Gerard's church, and comparable to the apparently earlier work at Saint-Étienne in Périgueux.[91] Previous scholarship assumed that Gerard's project began with this bay and, with a change of style, advanced eastwards to the next bay and the rest of the church.[92] However, as noted by a nineteenth-century observer (before all structural evidence was obliterated by the restorers), the break between this bay and the next was not only stylistic but also structural.[93] This means that it belonged to a separate phase of the building. I therefore believe that Gerard's builders found this bay already in position, at the west end of the old nave. I shall call it 'the old bay'. Its relationship to the rest of the old church is problematic, but is not of concern here.

Gerard's project apparently began beyond both ends of the entire complex of old structures, including the old bay, with the aim of postponing any demolitions as long as possible. At the east end, the new apse was constructed farther east of the old one. At the west end, a new façade was plaqued against the old bay. As the western façade was rising, the construction of the church walls also advanced, from east to west, replacing the old church when it reached it, and finally joining the old bay. This was the reason for the structural break, noted at the joining point by the pre-restoration observer, but eliminated by the restorers. The old bay was to be retained, partly because the other bays of the new nave were anyway built to a roughly similar plan, and partly because the lower zones of the new western façade were already leaning against it. From that stage onwards, the building rose at a similar pace all around, to the higher zones of the western façade, the domes (including a revaulting of the old bay?), and the transept towers. Hence the division of sculpture styles as outlined above, with the earliest style at both ends of the building, and the later ones in the middle and the higher parts.

The Beginnings of the Angoulême Workshop

This discussion is limited to the first version of the Angoulême style, as manifest in the apse and the lower part of the façade, whereas the later versions will be considered in the next chapter.

[91] Dubourg-Noves 1973: pls. XIV, XXII (Cat. 25); Michon 1844: 285. For analysis and comparisons see Vallery-Radot 1931b: 128–9; Daras 1942: 43–4. The comparisons given by Vallery-Radot are illuminating, but his dating of Saint-Étienne in Périgueux seems too late. On Daras, see also n. 93.

[92] Daras 1942: 41–66.

[93] Michon 1844: 279 and 285. It may be noted that Michon's testimony on the structural break was thoroughly twisted by Daras (1942: 60–1). Michon tells how the second bay of the nave (which definitely belongs with Gerard's work) met the old and plain bay with various structural irregularities, including some which concern the position of wall-shafts and carved capitals. Faced with the restored building, Daras ignored the fact that Michon was describing a particular point in the building, and used Michon's observations to argue that the capitals (and hence the rest of the sculpture) of the entire building were inserted belatedly. He thus juggled the evidence in order to reconcile a dated building to the stylistic dating system of his time, which dictated a date after Gerard's death for the sculpture of Angoulême Cathedral.

Within the chronological limits of the whole project, 1102–28, the apse is here assigned to the first decade of the century, and the lower part of the façade to a period overlapping to *c.*1115. The history of the Angoulême workshop in fact begins more or less where we left the second workshop of Saint-Eutrope at Saintes, which was active around 1100 or shortly afterwards, and carved the capital-friezes in the crossing of Saint-Eutrope (Fig. 2). The Angoulême workshop was not the same but its stylistic tendencies were similar, doubtless owing to some awareness of Saintes. This is to be expected, because the ecclesiastical authorities of Saintes and Angoulême had been closely related for at least a century.[94]

In the apse of Angoulême, the mass of the wall is alleviated by a stretch of arcading, comprising half-columns on dosserets. The rounded capitals of the half-columns and the straight-sided capitals of the dosserets form continuous capital-friezes carved with animals and foliage (Pls. 189–91), generally similar to those in the crossing of Saint-Eutrope (cf. Pls. 143, 144), though more modest and also stylistically heterogeneous. Each frieze centres on a rounded capital which is invariably Corinthianesque and purely vegetal, while the animals are confined to the lateral dosseret capitals. The single figural scene, a combatant angel (Pl. 191), is similarly positioned on one of the lateral capitals, having lost the central position given to figured capitals at Saint-Eutrope. As will be seen, this apparent disregard for the figured capital represents a new attitude, opposed to the earlier figural experimentation on capitals at Melle, Saintes, and elsewhere, but counterbalanced by the rise of monumental figure sculpture. A number of ornamental details similarly depart from the tradition of Saintes: the animals possess a more ferocious character and some are joined under a single head, a motif absent from Saint-Eutrope, and the treatment of the volumes is generally bolder with no trace of the old linear precision. The foliage decorations include splayed leaves spreading open like a fan, apparently a variation on the fan-leaf of Saintes (cf. Pl. 145*a*), but differently treated: the tip of the last foliole is now consistently worked into a kind of knob. This fan-leaf was to become a hallmark of the Angoulême style and its derivatives.

The western façade is much more elaborate. A system of blind arcading divides it into six horizontal zones, all carrying sculpture (Pl. 219), though only the lowest belongs to the phase of the work considered here. This zone incorporates a portal flanked by four blind arches, commonly called 'niches'. The portal offers little authentic work; it was altered twice and consequently lost all its original components except for one archivolt. Its tympanum is modern.[95] The niches, however, are largely original, including most parts of the sculpted tympana inside them. These tympana are carved with large figures (Pl. 196) and evidently constitute the main element of the sculpture programme. In addition, there are ornamental designs of animals and foliage, occasionally punctuated by small figural motifs, and spreading to the niche archivolts (Pls. 199, 200, 201), the portal archivolt (Pl. 194), and the capital-frieze across the entire complex (Pls. 192, 193, 195). The architectural setting dictates an elaborate version of the capital-frieze, comprising long stretches of ordinary friezes which serve as lintels for the niche tympana, but the style of carving is otherwise a richer version of that in the apse. The foliage thus consists largely of the

[94] Various connections are mentioned in the 'Historia pontificum' (Castaigne 1853: 26, 27–8, 29, 34, 49). See also Crozet 1960: 49 and 60; Watson 1979: 43–4 and 61–2.

[95] An 18th-cent. portal, together with the single Romanesque archivolt, is shown in Pl. 212. The 19th-cent. restorers rebuilt the portal completely, incorporating the original archivolt, see Pl. 219. These alterations are discussed in Dubourg-Noves 1973: cat. 130, pl. LXII.

same fan-leaves with terminal knobs, animals are treated in the same bold manner (Pl. 195, cf. Pl. 189), and rounded capitals on colonnettes are still Corinthianesque and purely vegetal (though most of these are nineteenth-century copies).[96]

The animals dominate the decorative scheme. On the archivolts, birds and lions clamber in the lavish foliage scrolls (Pls. 199, 200), and monsters struggle with humans (Pl. 194). On one of the capitals, convulsed monsters emerge from behind birds and their long necks loop around the birds' heads (Pl. 192). The whole possesses a restless and luxurious quality which compounds the old ornamentalism of Saintes and allows little scope for figural elements. Like the angel in the frieze of the apse (Pl. 191), a scene of Samson and the Lion is relegated to a secondary position, and in fact hides in the shade of a large capital with ornamental lions and foliage (Pl. 195). Even an extensive battle scene, depicted on one of the lintels (Pl. 193), is noticeable only at close range. In a general view it can barely be singled out from the ornaments (Pl. 219). These figural elements complement a wider iconographical programme, discussed in the next chapter, but they are nevertheless swamped by the rolling ornamentation and seem haphazardly strewn in the decorative scheme.

The more important figural imagery, on the niche tympana, is entirely different (Pls. 196, 197, 199, 200, 201). The figures are much larger, the composition is free from ornamental interpolations, and the iconography is rigorously ordered. In contrast to the diffuse imagery of the capital-friezes, all the monumental figures form a unified composition and a single scene: the twelve Apostles departing to preach the Gospel. Technically divided in groups of three Apostles between the four niche tympana, this scene unrolls sideways from the portal and covers the full width of the façade (Pl. 219). This arrangement of the monumental imagery across the portal may reflect the latest Italian innovations of the time—the narrative frieze of Wiligelmus across the façade of Modena Cathedral comes to mind—but the Angoulême composition is otherwise unprecedented in façade design.

Even the figure style is new to stone sculpture, though comparisons to paintings suggest that it is indigenous to the southern provinces of Aquitaine. Close stylistic parallels can thus be found in manuscript illuminations from Limoges. One of the Apostles (Pl. 197) may be compared to a prophet from a Limoges Bible of the early twelfth century (Pl. 198);[97] both figures present exactly the same rectilinear and somewhat rigid forms of body and garment, the same zigzag hems, pinched box-pleats, narrow and parallel folds on the chest, and the same swaddling stretch of drapery below the knee. The bundle of folds around the hand of the Limoges figure is a recurrent motif at Angoulême (e.g. Pl. 201). It recurs at about the same time in additional southern complexes of monumental figure sculpture, notably a spandrel figure in the Porte Miègeville of Saint-Sernin at Toulouse, and attests to the popularity of the Limoges style in diverse centres of the south.[98] However, this is not to say that the sculptors copied manuscripts. As earlier at Saint-Jouin-de-Marnes, mural paintings were probably more relevant for a sculptor in search of models for monumental imagery, but none of relevance survives.

The figural tympana of Angoulême form an independent programme, distinct from the ornamental programme. This division may recall the façade of Saint-Jouin-de-Marnes, con-

[96] Cf. an old photograph (Dubourg-Noves 1973: pl. XL).
[97] Paris, Bibliothèque Mazarine, MS Lat. I and II; see Gaborit-Chopin 1969: 127–40 and 176; also Zaluska 1979. [98] Durliat 1990: fig. 430.

structed less than a decade before, but a comparison reveals significant differences. Saint-Jouin looks back to the old Poitou-Loire tradition of independent figural slab-relief, and although its figure programme is unprecedentedly elaborate the slabs remain isolated on the open wall surface, physically apart from the ornamental programme of the capitals and archivolts (Pl. 207). At Angoulême, on the other hand, the figural and the ornamental programmes are correlated by means of the arcaded framework. This is true of the façade as a whole (Pl. 219) but especially the lower zone, where the figural tympana are tightly framed by the decorative archivolts and friezes. Such correlated schemes are a new element in façade design, and testify to the intense experimentation that now came to distinguish the young southern schools from the veteran and somewhat tired schools of the Poitou–Loire milieu.

The very arrangement of the monumental imagery in great tympana was at that time essentially new; precedents are few and far between, except perhaps in Burgundy. The figured tympana in the niches of Angoulême were in fact amongst the earliest in the south, where even portal tympana had previously been scarce. The southern revival of monumental figure sculpture at first centred largely on free slab-relief, just as in Poitou. At Saint-Sernin in Toulouse, for instance, the late eleventh-century double portal of the transept façade (the Porte des Comtes) had been constructed as a pair of open arches without tympana, allowing for figural slab-reliefs only in the spandrel zone. Even as late as 1110–17, when particularly ambitious figural reliefs were produced for Santiago de Compostela and San Isidoro at León, this was not in the context of tympana. In the Puerta de las Platerias at Santiago, as in the lateral portal of the nave at León, some reliefs were rearranged as tympana only as an afterthought. Undoubtedly prepared for some other location, they consequently ended up crudely trimmed and arbitrarily grouped.[99] Against this background, real tympanum sculpture on any significant scale stands out as an exception. It was sporadically introduced to the south during the early decades of the twelfth century; the best known of these innovative enterprises is the tympanum in the Porte Miègeville of Saint-Sernin at Toulouse, c.1110–15.[100] This is also the date suggested above, on grounds of building history, for the lower zone of the Angoulême façade with its four niche tympana.

It cannot be said whether the Porte Miègeville predates Angoulême or vice versa, but since neither work copies the other, this is perhaps immaterial. Conceived by two different workshops at about the same time, the two projects introduce to the south two independent versions of the great figural tympanum enclosed in an arch. The Angoulême version belongs with side-niches, leaving the portal, as was more usual at that time, for minor decorations (as noted above, the figural tympanum which now exists in the Angoulême portal is modern). In its concentration on the portal itself, Toulouse represents a deviation from common practice. It would be some time before Aquitaine accepted the portal as the centre of the figure composition on façades, and even then it was in a different form.[101]

The various centres of the south were largely independent of each other, whatever exchanges may have occurred from time to time. Angoulême never adopted, for instance, the highly

[99] On Santiago de Compostela and León, see most recently Durliat 1990: 326–40 and 376–85. At Santiago de Compostela, the rearrangement of the reliefs in tympana must have taken place before c.1140, when the tympana of the Puerta de las Platerias were described in the *Pilgrim's Guide*; see Vielliard 1978 edn.: 99–103.

[100] Most recently Durliat 1990: 398–410.
[101] See below, Chapter 5.A and 5.B.

romanizing figure style for which Jaca, León, Santiago de Compostela, and Toulouse are renowned. Yet it does possess some romanizing features of its own.

The Roman and the Romanesque: Some Open Questions

As shown by René Crozet, the Romanesque builders and sculptors of Aquitaine made considerable use of antique models, which were available at or near Poitiers, Angoulême, and Saintes.[102] In the regional context, little can be added to his observations except more examples of Romanesque derivation from the antique. It may indeed be asked what was the purpose of such imitations, but this question involves what is commonly known as the 'twelfth-century renaissance' throughout the West, and is therefore largely outside the scope of the present regional study.[103] Yet Angoulême illustrates an important additional question: how did the Romanesque sculptor identify the antique, and in what way did this affect his choice of models? This question arises from an analysis of archivolt forms and some types of capital.

The system used at Angoulême for archivolt decoration is different from those so far described in that the patterns break the restrictions of the individual voussoir and spread uninterrupted from one voussoir to the next. One band of pattern unrolls along the face of the archivolt and another on the soffit, separated from the first by a pronounced rim at the arris. There can be little doubt about the source of this design; Saintes museum preserves a Roman arch which may well have been its direct model. Even the chain of rosettes on its soffit is repeated, with understandable stylistic changes, on one of the archivolts of Angoulême (Pl. 202, cf. Pl. 201). In the same museum there is also a Roman slab with a decorative blind arch, carved with birds which strongly evoke those on another of the Angoulême archivolts (Pl. 203, cf. Pl. 199), but here the relationship between the Roman and the Romanesque is more problematic and apparently involves additional models of the recent past. As already noted, the birds of Angoulême are intertwined in foliage scrolls, much like the birds and lions on an arch in the ambo of Sant'Ambrogio in Milan (Pls. 199, 200, cf. Pl. 204), and are probably modelled on contemporary Lombard works of that sort.

A first impression might suggest that the sculptor of Angoulême combined disparate sources at random, but this is perhaps misleading. The combination testifies, I believe, to a particular concept of the antique, which had little to do with strict historical periodization. It apparently involved the identification of certain properties as antique, and meant that anything which possessed those properties, of whatever period, represented the antique just as much as the real Roman. Accordingly, the sculptor may have regarded the Lombard model as interchangeable with the real antique model which he knew from Saintes, because he considered sculpted arches an antique architectural feature. The modern observer may find this attitude peculiar, especially because of the completely non-Roman style of the Lombard model, but twelfth-century man is unlikely to have shared the modern perception of period styles and sensitivity to anachronisms. For him, it was not the style that mattered but the continuation of what he understood to be an

[102] Crozet 1954 and 1956a. [103] See most recently Benson and Constable 1982.

antique genre of sculpted arches. He was mistaken, since the Lombard type of archivolt probably emanated from early medieval rather than antique sources,[104] but the few Roman examples of Saintes legitimized his error. It is therefore possible that the purpose of all these imitations was to re-create an antique prototype, even if the sculptors knew full well that some of their models were in fact recent.

Another example concerns a peculiarity of the capital-friezes in the apse of Angoulême: they centre on foliate Corinthianesque capitals of a distinctly old-fashioned type for a monument which is squarely dated to the twelfth century (Pls. 189–91). One of these capitals is carved with flattened leaves enlivened by prominent folded tips (Pl. 191), as on a late eleventh-century capital in Saint-Sernin at Toulouse.[105] Another carries a pattern of undulating ribbons with side sprigs and palmettes which, but for the versatile modelling and tighter proportions, goes back to an eleventh-century capital in the Abbaye aux Dames at Saintes (Pl. 189, cf. Pl. 128). These outdated patterns do not seem to have arisen from simple conservatism, since there is nothing conservative about the adjacent dosseret capitals, which form an integral part of the same capital-friezes. These carry the animal decorations which were fashionable at the time at Saintes and elsewhere. Moreover, the fact that the purely foliate patterns recur systematically, on all the rounded capitals of the half-columns, indicates consistent thinking and a deliberate choice.

It is possible that this choice too arose from the desire to re-create a Roman mode, a desire that indiscriminately legitimized any old pattern as long as it was vegetal, as most ancient capitals were. This was the attitude already established in the crypt of Saint-Eutrope at Saintes, where the antique mode of the great foliate capital had been re-created out of a mixture of contemporary Corinthianesque models and real antique models (Pls. 130–6). At Angoulême, the straight-sided dosseret capitals did not succumb to this attitude simply because they were not real capitals; only rounded capitals on columns represented the venerable Roman tradition, and had to be clearly displayed as such.

This attitude towards the antique necessarily worked against the earlier Romanesque efforts to convert the capital into a vehicle of figural imagery. Whole series of capitals reverted to foliage, not so much for reasons of frivolous ornamentalism as for intentional classicism. At Angoulême, most of the capitals on the higher part of the façade are thus purely foliate (Pls. 251, 252). It is noteworthy that this renewed classicism coexisted with the non-classical ornamentalism of the time, and that both tendencies proved equally adverse to figural experimentation. The ornamentalism of Aulnay distorted the programme of figural voussoirs, and the classicism of Angoulême left no room for figural programmes on capitals. Both types of figure programme, defined above as mini-programmes, thus suffered a setback and were eventually to become an exception. On the other hand, monumental figure programmes were already gaining ground independently in another bid to re-create an antique mode. This is the subject now to be approached from a different angle, that of the history of the Aquitainian façade up to the great ensemble of figure sculpture on the higher parts of the Angoulême façade.

[104] On the sources of the late 11th-cent. archivolts at Como, which may be taken as representative of the Lombard style, see Zarnecki 1990: esp. 41–4.

[105] Illustrated in Durliat 1990: fig. 58.

3

CHURCH FAÇADES AND THE
MONUMENTAL FIGURE
PROGRAMME, UP TO 1128

A. THE ARCHITECTURAL FRAMEWORK

The Chronology of Façades

The western façade introduces the church to the outside world. Free from additional structures, which tend to accumulate along the other sides of the church, it advertises the church's main entrance and in fact the whole complex of church and dependent buildings. It does so by means of special architectural or sculptural features, more elaborate than elsewhere in the church, and often unique. Secondary entrances such as in transept façades are sometimes advertised in a similar way.

The design of façades is therefore a category in itself, and is indeed treated as such in numerous publications on Aquitaine.[1] These illustrate a great variety of architectural forms, ranging from plain walls with some modest decorations to diverse combinations of buttresses, blind arcades, portals, and windows, sometimes incorporating equally diverse sculpture programmes. However, in the absence of a precise chronology it is not easy to determine the origins, and therefore the purpose and meaning, of the different types of design. A chronology of all the varieties is still a remote prospect, but a certain sequence of changing fashions nevertheless emerges from the chronology of the monuments examined in the previous chapters.

It thus seems that the design of façades underwent a transformation between the end of the eleventh century and the completion of Angoulême Cathedral, dedicated in 1128. The main changes arose from a tension between the old Poitou–Loire traditions and the innovations of the south. In Poitou and the Loire region, the forms inherited from the eleventh century were very different from those usually associated with the Aquitainian façade. Blind arcading, for instance, was rare and modest, while significant sculpture programmes first occurred in non-arcaded designs, notably on the early twelfth-century façade of Saint-Jouin-de-Marnes. Within a decade, however, a different design began to emerge at Angoulême. It combined a wide range of sources from both Poitou and the south, resulting in a new and particularly complex fusion of blind arcading and sculpture. This design was never fully repeated, though its influence nevertheless extended to Poitou and transformed the character of the typical Poitevin façade. Other changes took place with the appearance of great portals, first in Poitou and subsequently elsewhere in Aquitaine, but with few exceptions this is a later phenomenon.

The Poitou–Loire Idiom and the Ascending Scheme

In Poitou and the Loire Valley, the eleventh-century church entrance was of two kinds: the tower and the simple wall façade. The tower was the more important and elaborate, present in

[1] The list is extensive and is here restricted to relatively recent items: Lyman 1977; Gardelles 1978; Seidel 1981; Orlowski 1991. All contain references to earlier literature. The central issue in most publications on the subject is the form, origins, and purpose of systems of blind arcading. In the main, Lyman's observations on this issue are taken up in the present study. Gardelles and Seidel offer symbolical interpretations, partly based on comparisons to the minor arts, which I find difficult to accept. Orlowski cites the narthex façade of Airvault as a Poitevin prototype of c.1100, but this façade is much later; see Camus 1991: n. 34.

most of the major projects.[2] Towers were sometimes constructed even against pre-existing wall façades, hiding them from view.[3] The wall façade consequently suffered a setback, and benefited little from the important eleventh-century innovations of the Poitou–Loire milieu in other fields of church building. Though sometimes richly decorated, it was architecturally very simple. It often consisted of little more than a plain blocking wall, taking the shape of the nave or transept behind it, and accordingly crowned by a gable to close the triangular roof-space. When the fashion for entrance towers finally declined, in the late eleventh century, this type of façade remained as the main model for the twelfth-century builder.

There were several types of wall façades, and their discussion requires special terminology. The common term 'tripartite' is here restricted to the façades of aisled naves, which match the broad proportions of such naves, and their division into three parts is created by the buttresses which correspond to the nave arcades. In the central part, the tripartite façade incorporates the main portal and a window above. In the lateral parts, there is usually a pair of additional windows or oculi, and sometimes also additional portals. Conversely, the façade of an aisleless structure is narrow, tall, and pierced by a single portal and a single window. It is similar to the central part of the tripartite façade, and may therefore be called 'single-part' regardless of various subdivisions.[4]

The tripartite façade was apparently quite common in eleventh-century Poitou and the Loire Valley, though destruction, alteration, or the addition of towers left no complete examples.[5] However, the essentials of this type of façade may be illustrated by a comparison between two relatively late examples: the western façade of Le Mans Cathedral, probably constructed under Bishop Hoel (1085–96),[6] and the western façade of Saint-Jouin-de-Marnes, attributed above to the early twelfth century.[7] At Le Mans (Pl. 206), the correlation between the central and the lateral parts is slightly spoilt by reinforcement buttresses, added around the middle of the twelfth century, but the basic tripartite design can still be discerned. Three portals and three windows are divided among the three parts, an arrangement repeated at Saint-Jouin. The side portals of Saint-Jouin were at some point altered, as shown in a pre-restoration photograph (Pl. 207), but eventually restored.[8] These two façades are in some ways very different and in others alike. They will here be examined from three points of view: the effect of the structural requirements on the tripartite layout, the decoration of the wall surface, and the blind arcading, which is central to the design of Le Mans but conspicuous by its absence at Saint-Jouin.

[2] Camus 1991: especially 248–53; also Camus 1992: 54–6 and 81.

[3] e.g. at Saint-Savin; see Labande-Mailfert 1971.

[4] A division by buttresses sometimes appears on single-part façades of aisleless churches as a result of the integration of a protruding portal. The protruding area is thus sandwiched between two buttresses; e.g. on the 11th-cent. western façade of Saint-Savinien at Melle. The tall proportions and the unified appearance of the single-part façade are nevertheless preserved.

[5] The late 11th-cent. tripartite façade at Champdeniers underwent some alterations but essentially survives (Pl. 210). The first façade of Saint-Mexme at Chinon, hidden behind a later narthex, is particularly interesting. Observations on site yield the following. The façade preserves a central portal (Pl. 74), which can be seen from the ground floor of the narthex. Above, a large but blocked window can be seen from the upper floor of the narthex. There is decorative masonry in the spandrels of the window and a figural relief in the centre of the gable. This relief is almost entirely covered by the vault of the narthex.

The lateral parts of the façade, originally facing the no longer extant aisles, are each provided with an oculus window, now blocked. This façade may well belong with the original building, founded between 980 and 1007. On that building, see Crozet 1948b: 342; Hubert 1988: 33.

[6] See above, Chapter 1 n. 25.

[7] Chapter 1.C. There are some later finishing touches, here irrelevant, and discussed in Chapter 4.B.

[8] In the pre-restoration photograph (Pl. 207), one of the lateral portals appears altered and the other blocked. Both were later restored, and serve as portals to this day. There has been a suggestion that they had originally been blind niches; see Labande-Mailfert 1962: 180. This, however, seems unlikely. The northern portal, which the restorers found blocked, actually preserves much of the original stonework, testifying to the correctness of the restoration. Moreover, all three portals are marked in a rough ground plan of 1724 (Poitiers, *Archives départementales de la Vienne*, KK 54).

The tripartite layout is changeable. It depends on the plan and elevation of the building behind the façade, including the type of roof behind the gable. The nave of Le Mans is essentially basilical: each of the three vessels is roofed separately, and a clerestory raises the central vessel and its roof high above the aisles. The central part of the façade, together with its gable, rises correspondingly high above the lateral parts. Saint-Jouin, on the other hand, is a hall church of the type normal to Poitou, that is, without clerestory. The omission of the clerestory allows for very tall aisles which come under the same roof as the central vessel. The lateral parts of the façade are correspondingly tall and, since the gable always corresponds to the roof, they come under the same gable as the central part. It is the structure of the hall church that dictates this unified design crowned by a wide gable. Similar designs in other regions sometimes act as a 'screen façade', disguising a basilical discrepancy of heights between the central vessel and the lateral ones,[9] but there is nothing of this at Saint-Jouin, where the façade fits perfectly the structure of the hall church behind it.[10] The Poitou–Loire façade of the period around 1100 thus emerges as structurally simple and logical, whatever complications were to disturb this logic later in the twelfth century.

The decorations of the Poitou–Loire façade stem directly from the traditions of the eleventh century. The architecturally uncomplicated façade of that period, whether tripartite or single-part, allowed for wide expanses of plain wall suitable for free arrangements of surface embellishments. Besides various ornate crosses in the gable,[11] the most common eleventh-century arrangement combined variously shaped decorative masonry and sets of slab-reliefs, sometimes disposed in rows to form friezes.[12] Touraine preserves some of the best examples of this combination; at Azay-le-Rideau, for instance, there are modest figural friezes as well as triangular fields of decorative masonry framed by slanting string-courses. The narthex façade of Saint-Mexme at Chinon (Pl. 205) is more elaborate (though unfortunately decayed and mutilated);[13] from the window zone upwards, it is covered by a number of friezes, placed one above the other, and intermingled with decorative masonry. The friezes are composed of numerous slabs, one of which preserves the faint traces of a figural representation (Pl. 127).

Le Mans and Saint-Jouin present two divergent adaptations of this type of mural decoration. At Le Mans (Pl. 206) there are extensive fields of decorative masonry, some enriched by corresponding sections of slanting string-courses, as at Azay-le-Rideau. The sculptural decoration is secondary; a single figure and two monsters are almost lost in the decorative masonry above the central portal. At Saint-Jouin (Pl. 207), there is much decorative masonry and even some slanting string-courses, towards the top of the gable, but the emphasis is otherwise on the figural slab-reliefs. Some are positioned singly to the sides of the central window.[14] Others form a continuous frieze, positioned at the base of the gable, and separated by a band of decorative masonry from the slabs of Christ and the angels above. A few additional slabs apparently existed

[9] e.g. at San Michele in Pavia.

[10] The only discrepancy is that the roof is much lower than the gable, but originally it was probably higher. It was remade during the first restoration works, undertaken by the architect Loué in 1878–81, and involving also the top of the aisle walls. This restoration was noted by Ledain (1883: 136 n. 1), and is also evident in an old photograph (Paris, Archives Photographiques, MH 2770).

[11] e.g. in Anjou, at Saint-Maur-de-Glanfeuil; in Poitou, at Saint-

Savin (traces only, hidden behind the later tower).

[12] On decorative masonry, see Lesueur 1966; on such masonry in combination with slab-reliefs, Hubert 1988: 30–4; on the early reliefs, Camus 1982a; Vergnolle 1992.

[13] This façade is not to be confused with the earlier façade of the same church, hidden behind the narthex; see n. 5 above.

[14] Those above the side windows belong to the later additions, as shown in part B of this chapter.

but disappeared with the modern restoration; the photograph reproduced here, which was taken before the restoration (Pl. 207), shows their decayed remains to the sides and above the Christ and angels. The original design therefore seems to have comprised several friezes of slabs one above the other, as at Chinon. It may be noted that the slab programmes were not as yet framed by blind wall-arcading as on some later façades (e.g. Pl. 284). Neither Chinon nor Saint-Jouin possesses any wall-arcading at all (except on the lateral faces of the Saint-Jouin portal, which are hidden from frontal view).

Blind arcading, which is the main element of design at Le Mans, appeared on Poitevin façades at about the same period of the late eleventh century or slightly earlier. One of the earliest examples, which therefore deserves particular attention, is found at Champdeniers. This church was probably constructed about 1070–90,[15] and has an aisled nave with the appropriate kind of tripartite façade divided by buttresses (Pl. 210). The lower zone of the central part of the façade is now hidden behind a late medieval porch, but was originally exposed to view (Pl. 211). It carries a triple arcade stretching from buttress to buttress and pierced in the middle by the portal, which is otherwise quite plain. In addition, there was apparently a corresponding arcade in the window zone above, of which only two colonnettes remain. The resulting arrangement of two-tier arcading can be easily visualized, since it recurs on the slightly later single-part façade of the transept at Luçon (Pl. 209).[16] The design of the central part of the Le Mans façade (Pl. 206), though more elaborate and differently proportioned, follows the same principle of two-tier triple arcading.

There has been much scholarly speculation about the origins and purpose of such arcading,[17] and perhaps the best way to assess the various possibilities is to pinpoint the common denominator for these early examples, at Champdeniers, Luçon, and Le Mans. Some possibilities are consequently eliminated. For instance, contrary to what might be expected the triple arcading could not have originated in the tripartite division of the façades of aisled churches, since in none of these examples does it overlap a tripartite division. On the tripartite façades of Champdeniers and Le Mans the triple arcading is in fact confined to the central part, an arrangement that makes it a single-part design. It can therefore be expected on single-part façades of aisleless structures, as at Luçon, and was indeed to recur on such façades later. Triple arcading came to overlap tripartite divisions only in the twelfth century, and this should be seen as an aberration, requiring special explanation.[18] Similarly, the exploitation of the arcading for framing a sculpture programme is essentially a later phenomenon; the early arcades of Champdeniers and Le Mans are blank. Eleventh-century arcading elsewhere sometimes incorporates a modest slab-relief,[19] but anything which seems more ambitious is in fact due to posterior rearrangement of pieces removed from other places, as already noted concerning Luçon (Pl. 116).[20]

Whether the façade is tripartite or single-part, sculpted or not, only one feature is common to all the early examples: the arcading centres on the main portal (or the only portal). Where the

[15] Camus 1992: 200–11.

[16] The reconstruction of the Luçon church started in 1091; see above, Chapter 1 n. 95. The capitals in the higher zone of the transept façade resemble some in the ambulatory wall of Airvault, which also predates 1100; see Chapter 1.A.

[17] See above, n. 1 of this chapter.

[18] Previous scholarship assumed the opposite, namely, that triple

arcading is normal to tripartite façades, and that its appearance on single-part façades requires special explanation; see most recently Seidel 1981: 17–18, with references to earlier literature.

[19] e.g. a single slab to the side of the nave entrance at Maillezais (inside the western block), and another on the much restored façade of Saint-Laurent at Parthenay.

[20] See Chapter 1.C.

arrangement survives intact, at Luçon and Le Mans, it is also clear that the upper zone of arcading is not merely supplementary to the portal zone; it is actually the more pronounced. The huge window in the centre of the upper arcade of Le Mans is particularly impressive, and tilts the balance of the composition upwards.

With its emphasis on the upper zone, the arcaded façade of the Poitou–Loire milieu joins a long line of entrance structures, all of which advertise an important doorway by means of the special features above it. Some of these designs have been traced by scholars to Roman imperial entrances, though the intervening centuries gave rise to a complex ramification of new variants. In southern France, for instance, there is an early eleventh-century type with high-placed rows of many small arches overlooking the portal area.[21] The eleventh-century entrance towers of the Poitou–Loire milieu fulfil the same function by means of arcaded storeys, rising high above the entrance storey. At Champdeniers, Luçon, and Le Mans, there is no tower but the arcaded storeys remain as applied decoration, still governing the church entrance and the area above it.

In summarizing the various types of Poitou–Loire façades, it is instructive to compare the overall schemes of decoration at Le Mans and Saint-Jouin-de-Marnes. They are seemingly very different: the blind arcades and the shaped masonry of Le Mans create a decorative effect by architectural means, while Saint-Jouin exploits primarily the sculptural element of the slabs and friezes. Yet both façades follow the same principle, by which the decoration expands from the centre upwards and sideways, accentuating the upper parts. In both places, the decorative features thus become more numerous and pronounced as the eye rises from the central portal and around the huge central window to the base of the gable. This may be called 'the ascending scheme'; it was to reach its culmination at Angoulême, albeit on a different type of structure (Pls. 212, 219). Whether architectural or sculptural, this scheme of mural decoration was apparently the normal way of advertising the church entrance in the period in question. Special elaborations of the portal itself were as yet quite rare though soon to become more common.

The Decorative Portal

Champdeniers illustrates the traditional eleventh-century portal of the Poitou–Loire milieu: shallow and barely decorated (Pl. 211). In the early twelfth century, a new emphasis on the portal was at first expressed in additional recessed orders of richly carved archivolts, perhaps under the influence of Lombardy already noted. The chronology of the Italian examples is not entirely clear, but there is no doubt that the Lombard tendency to multiply decorative orders started as early as the 1080s, for instance at Sant'Abondio and Santa Margherita in Como (Pl. 154),[22] and that the number of orders increased consistently up to twelfth-century Pavia (Pl. 308). In Aquitaine, on the other hand, there was no such consistent trend. Each of the early twelfth-

[21] Lyman (1977) pointed out the role of high-placed arcading in relation to the portal below, and gave as examples the southern 11th-cent. façades of Saint-André-de-Sorède and Arles-sur-Tech. He compared the arrangement to an entrance of Diocletian's palace at Split. For another version of the same disposition, in the Great Mosque at Cordoba, see Watson 1989: 12–13, with reference to the same Split prototype. An early medieval variant should perhaps be seen in the so-called Palace of Theodoric at Ravenna.

[22] The early Italian examples are discussed in Zarnecki 1990.

century workshops (e.g. Saint-Jouin, Melle, Parthenay-le-Vieux, Angoulême, the first workshop of Aulnay) (Pls. 108, 79, 175) produced a different version, each with a greater or lesser number of recessed orders, regardless of the chronology. This suggests that the fashion arrived in the region fully formed and was variously adapted by the local builders.[23] On western façades, such portals were still overshadowed by the opulence of the upper parts, as at Saint-Jouin-de-Marnes. Their sculpture remained predominantly ornamental, as at Parthenay-le-Vieux. The figural sculpture programme still had great difficulties in descending into any portal, at any location; the distorted programme in the transept portal of Aulnay is recalled.

In fact, the deeply recessed portal was adopted in the region so unexpectedly and was so out of context, that at first it even created a structural problem because of the extra wall thickness required to accommodate it. This can be seen at Saint-Jouin-de-Marnes, where a portal with five recessed orders projects well over a metre in front of the main wall surface, and is consequently badly correlated to the wall: its upper surface slopes awkwardly backwards towards the window, and its columnar buttresses end inconsequentially.[24] To judge by surviving examples, this particular arrangement did not impress the builders of Aquitaine; it was never repeated on any major façade.

The problem of accommodating a deep portal was eventually solved by a new application of blind arcading. The main examples date from 1125–30 onwards, and will therefore be examined later. In general, the principle of these later façades was simple: the depth of the portal dictated the thickness of the lower zone (Pl. 284) and sometimes the entire façade (Pl. 300), while the side spaces were alleviated by blind arches. There were some eleventh-century precedents for this method,[25] but most of the early systems of arcading nevertheless remained essentially decorative and unrelated to deep portals, as at Champdeniers, Luçon, Le Mans, and eventually Angoulême and its derivatives.

Angoulême and its Influence

From the early twelfth century onwards, there was hardly a limit to the new and imaginative combinations of portals, arcading, and mural programmes of sculpted slabs, though the slab sculpture was of real weight only in the more important projects. Otherwise, it was arcading and portal. On the single-part façades of the aisleless structures, the Luçon type (Pl. 209) consequently underwent some transformation. On the transept façade of Aulnay, for instance, the introduction of a very large portal left no room for the full range of triple arcading in the lower zone, but only in the window zone (Pl. 213). This was rather unusual; the more common twelfth-century variant of single-part façades, especially in the southern provinces of the duchy,

[23] Poitou possesses an early deep portal in the 11th-cent. façade of Saint-Savinien at Melle. I have left it out of the discussion because it is of an unusual type which failed to establish a school in the region.

[24] See the illustration in Labande-Mailfert 1962: fig. 71. The 19th-cent. restorer was surprised and rather unhappy with the design of the Saint-Jouin portal, and suggested various additions to help blend it into the rest of the façade design. These included a gable above the

portal and a pair of winged lions above the inconsequential buttresses, all of which were his own invention, and fortunately failed to materialize. He presented these suggested additions in two drawings, preserved in Paris, Archives des Monuments Historiques, file of Saint-Jouin-de-Marnes, nos. 12941 and 12946.

[25] e.g. the western façade of Saint-Savinien at Melle.

preserves the triple arcading in the portal zone, but substitutes the upper range for the above noted southern device of rows of many small arches (Pl. 214).[26]

The most unexpected transformation concerns the broad tripartite façades of aisled naves. The triple arcading, previously confined to the central part of the façade, was now made to spread across all three parts and, for the first time, came to correspond to the tripartite division by buttresses.[27] At Benet and Parthenay-le-Vieux, for instance, the portal remained isolated in the central part, while the two blind arches were relocated to the lateral parts, taking the place of lateral portals (Pl. 215). The tripartite façade consequently became similar to the single-part façades of aisleless churches, and, except for its broader proportions, was eventually to lose its distinctive character. On the celebrated façade of Notre-Dame-la-Grande at Poitiers, probably of *c*.1130,[28] the division by buttresses was even abandoned in favour of an uninterrupted single-part design, creating the false impression that the church is aisleless. This design consists of a magnified version of the triple arcade in the lower zone, and rows of small arches in the upper (Pl. 284). The arrangement of the lower zone comes to solve the structural problem of the deep portal noted above, yet this structural necessity can hardly account for the arrangement of the upper zone, or for the disposition of the sculpture programme, now fitted into the arcading.

The main reason for these transformations lies, in my view, in the influence exercised by the greatest façade ever built in Romanesque Aquitaine, and for an aisleless building at that, namely, the façade of Angoulême Cathedral.

For architectural sophistication and sculptural opulence, the façade of Angoulême Cathedral is in a class of its own. There is nothing in Romanesque Aquitaine quite like the complexity of several systems of arcading interlocked to form six distinct wall-zones, all of them carrying sculpture (Pls. 212, 219). The ambitious character of the project is undoubtedly due to the important patronage of the papal legate Gerard, and stands out all the more for the relatively early date. To reiterate in brief the chronology suggested in the previous chapter, the lowest zone of the façade was possibly under construction in the first decade of the twelfth century and certainly by 1110–15. This is when the basics of the design must have been laid out, although some details of the upper zones were perhaps determined as the work advanced, which took some time. The upper zones were thus built in parallel with the higher parts of the rest of the building all around, and were probably completed nearer to the dedication of 1128.

The general layout of the Angoulême façade is based on a set of giant blind arches, reaching from ground level up to the fifth zone, and repeated rhythmically across the whole space. This type of arcading is different from the one discussed above, and is not even special to façades. It arises rather from the system of construction. The entire nave of Angoulême, and also some parts of the transept, are built with such arches, like the eleventh-century choir of Saint-Eutrope at Saintes (Pl. 129) and others built afterwards. On side elevations such as at Saint-Eutrope, the giant arches serve to relieve the burden of the vault and roof, and are usually repeated singly bay by bay. However, the domed bays of Angoulême are exceptionally large and therefore call for

[26] Examples illustrated in Seidel 1981 include: fig. 2 (Plassac-Rouffiac), fig. 3 (Corme-Écluse), fig. 12 (Échillais).

[27] A similar correspondence had occurred earlier on the single-part façade of Saint-Savinien at Melle, but the niches here seem to be a purely technical outcome of the problem of accommodating a deep portal, and they are dissimilar to the 12th-cent. type discussed.

[28] See below, Chapter 4.B.

more arches. There are two on the side of each bay and five on the façade, which was evidently singled out for finer and more elaborate architectural detail. It is nevertheless noteworthy that even this more elaborate version was never understood by contemporaries as peculiar to entrance façades; Saint-Étienne at Périgueux, for instance, possesses a domed bay of the second half of the twelfth century, with four such arches on the side wall and five on the eastern wall.[29]

At Angoulême, the giant arches all around the nave reach more or less the same height. The more elaborate set of five, on the western façade, is surmounted by a substantial entablature which screens off the dome behind it.[30] The original arrangement at the top is unknown; a modest Renaissance superstructure existed until the nineteenth century,[31] and was then replaced by a tall modern superstructure, consisting of a gable between two towers, and spoiling the effect of the entablature. Pre-restoration photographs (Pl. 212) suggest that the original design involved a contrast between the vertical accent of the giant arches and the horizontal accent of the entablature, which is what gave it the often-noted character of a Roman triumphal arch. This was doubtless intentional, and in keeping with the romanizing character of the domed spaces and some of the decorative detail, as shown in the previous chapter.

This basic scheme is combined with two others, previously used separately and more modestly, namely, rows of decorative arcading and a mural sculpture programme. Both are governed by the five giant arches. At ground level there is a corresponding low order of five arches, amounting to the above-noted arrangement of portal and four niches, and enriched by carved archivolts, capital-friezes, and, in the niches, figured tympana as well. Higher up, the giant arches punctuate two rows of smaller arches of the southern type, this time framing an ensemble of figural slabs. Like the sculpture programme of Saint-Jouin-de-Marnes though on a grander scale, this decorative scheme of the higher zones expands from the centre upwards and sideways. The whole system reaches a climax with an abrupt take-off of the central giant arch, which is stilted on a pair of long colonnettes at the centre of an extra row of small arches, on the entablature. The treatment of the central arch thus deviates from the otherwise regular pace of the giant arches, doubtless for the sake of the extraordinary array of sculpted slabs which are placed inside it (Pl. 221). In this way, the ascending scheme reaches its ultimate expression in both architecture and sculpture.

Clearly, those who designed Angoulême Cathedral were bent on putting together the best of everything, whether architectural or sculptural, Poitevin or southern. Some of the features had perhaps been combined earlier, in some lost monuments such as the western façade of Saint-Eutrope at Saintes, but there is nothing to suggest that the full version predates Angoulême. As

[29] On the domed churches, see above, Chapter 2 n. 88. Because such arches exist on eastern and side walls as well as western façades, I tend to disagree with Lyman's interpretation of the Angoulême giant arches as another decorative device for emphasizing a portal. Yet the precedents he cites at Arles-sur-Tech and Cellefruin seem to fulfil this function, and the rest of his theory on façade arcading is very convincing. See Lyman 1977.

[30] The correspondence between the entablature and the domes can be seen in a longitudinal section by the restorer Abadie, illustrated in Dubourg-Noves 1973: pl. XVI. The pre-restoration photographs show that on the side walls, too, there was a stretch of masonry, at the same level as the entablature and hiding the domes. I am not sure, however, how much of this masonry was original, because it met the transept cornice in an irregular manner; see ibid., pls. XLV and XLVIII.

[31] See Dubourg-Noves 1973: Cat. 89, pl. XXV; Cat. 97, pl. XXXIII.

has already been shown, the tympana of the lowest zone were in fact among the first of their kind in the whole of the south-west.[32]

Even the first zone alone, with its full-width arrangement of niche-tympana, archivolts, and friezes, was the most ambitious sculpture scheme so far attempted in Aquitaine and one of the finest of its time anywhere in the Romanesque world. It must have created a stir in the circle of patrons and craftsmen as soon as it began to emerge. The façade of Benet, which was probably under construction at about the same time,[33] may well reflect an early rumour of the Angoulême niches before they were even completed. The builders of Benet, like the later ones at Parthenay-le-Vieux, produced their own version to the best of their ability, and introduced arches containing sculpture in the lateral parts of their otherwise ordinary tripartite façade (Pl. 215). They even stilted the arches in order to enlarge the space available for the sculpture, but paid no attention to the finer points of true tympanum composition. The preferred Poitevin form remained the ordinary slab-relief.

Later, when the façade of Angoulême was completed, the higher parts were also imitated. The high-placed rows of slab-reliefs under arcading were thus repeated at Notre-Dame-la-Grande in Poitiers, above the Poitevin scheme of triple arcading and recessed portal. There were more imitations of various details from the lower and the upper zones of Angoulême (e.g. Pl. 247), but none was ambitious enough to reproduce the full scheme.

Introduction to Façade Sculpture

In the first two decades of the twelfth century, as the façade of Saint-Jouin-de-Marnes was completed, Angoulême was rising, and Aulnay was about to emerge, façade sculpture underwent some significant changes. Even on the basic decorative level the demand for sculpture simply grew, because the increasing complexity of portals and systems of arcading meant ever more numerous capitals and archivolts. This was not just a matter of quantity but also of quality, for there is a new spirit of luxury in the dense tapestry of carvings on the multi-order portals of Saint-Jouin and Aulnay, and on the arcades of the lower zone at Angoulême. Figural sculpture too became more prominent; there is a great difference between the occasional relief or frieze of the eleventh century and the programme of monumental imagery on the façade of Saint-Jouin, soon to be outdone by the veritable billboard of reliefs and statues on the higher parts of the Angoulême façade.

Saint-Jouin and Angoulême represent respectively the early Poitou–Loire idiom and the new southern one. Between them they illustrate the vicissitudes of the great sculpted façade of Aquitaine in the early decades of the twelfth century. Both reveal some secondary tendencies to decorate the portal area, Saint-Jouin with the deeply recessed portal and Angoulême with the programme of side-niches in the lowest zone, but the main scheme nevertheless remains the

[32] See above, Chapter 2.C. The western façade of Saint-Eutrope could not have been entirely similar to that of Angoulême. It was flanked by two towers which must have created a very different effect; see Blomme 1985: 8–10 and figs. 1–3.

[33] As shown above, Chapter 1.B.

ascending one. This scheme, acting as an advertisement for the church entrance and everything behind it, is the one that incurred the first figure programmes on any significant scale, as opposed to the occasional mini-programmes which were swamped by ornament on capitals and archivolts.

B. THE FRONTISPIECE OF THE CHURCH TRIUMPHANT

A Note on Revisions and Restorations

The figure programmes of Saint-Jouin-de-Marnes and Angoulême have not come down to us in their original form. Besides erosion and mutilation, there were also some deliberate changes and additions. These are particularly disturbing because they distort the original iconography.

Some of these changes were introduced by modern restorers and can be easily identified. At Angoulême (Pl. 219), it is quite clear that the portal tympanum is a nineteenth-century invention, since nothing of that sort appears in any of the pre-restoration photographs (e.g. Pl. 212). The same is true of the equestrian statues of St George and St Martin, positioned in the second zone. It has often been claimed that these replace different riders, but there is much evidence to show that the original programme included no riders at all.[34] The only original element in that zone of the façade is an agitated figure, very similar to the tormented man in a hell scene in the fourth zone (Pl. 241, cf. Pl. 240), and doubtless the remnant of a similar hell scene.

At Saint-Jouin, the nineteenth-century additions include the two lower figures to the north of the central window and the Evangelist symbols in the outer spandrels of the side windows, all of which replace some unrecognizably eroded pieces that show in a pre-restoration photograph (Pl. 207). The Evangelist symbols are particularly strange: there are only two, the eagle of St John and the man of St Matthew, while the supposedly supplementary two, in the inner spandrels of the same windows, are in fact bull corbels. This leaves nothing for the lion of St Mark, and suggests that the restorers misinterpreted the original material.

A more serious problem concerns some indications that the programmes were revised still in the twelfth century. New themes were added, giving a new iconographical slant to the entire programme. These revisions testify to an important change of iconographical requirements during the Romanesque period, and should therefore be clearly identified.

At Saint-Jouin-de-Marnes (Pl. 208), the original reliefs include the central group in the gable, the frieze of little figures below, the two reliefs on top of the buttresses, and the three to the south of the central window (Pls. 118, 119, 121, 123, 124, 125, 126). Besides these, there is a whole group of added statues. It comprises everything between the side windows and the cornice, including a representation of Luxuria tormented by serpents (Pl. 390) and some unidentified figures; the elegant lady to the north of the central window (Pl. 392); and another lady, probably the Virgin Mary, at the centre of the frieze (Pl. 388). All these are statues in the round, unlike the flattened reliefs in the original style, and stylistically very close to a group of proto-Gothic statues

[34] See n. 67 of this chapter.

at Montmorillon, to the south-east of Poitiers. The Montmorillon group even includes very similar representations of Luxuria (Pl. 391), the elegant lady (Pl. 393), and the Virgin Mary.[35] Given this resemblance, the statues of Saint-Jouin also emerge as proto-Gothic.

These proto-Gothic statues are inserted rather clumsily amongst the original reliefs, causing various irregularities. To the sides of the Virgin Mary, for instance, the original decorative masonry is patched by means of two crude slabs carved with geometrical patterns.[36] The canopy above this statue is very carelessly positioned, its opening and its decoration facing downwards (Pl. 388), which is abnormal. In the area of the central window, the original material seems to have been disturbed and then rearranged together with the new. The middle relief on the north side of this window (itself completely eroded by the time of the modern restoration, and replaced by the restorers) accordingly rests on a misplaced impost of a capital, like those in the windows, and evidently out of position. The relief in the corresponding position on the south side (Pl. 118), which is original, rests on a piece of string-course of a different sort, and is topped by a canopy which must belong to the additions; it fails to enclose the head, which is how such canopies function for the statues of Montmorillon (Pl. 391) and one of the added statues at Saint-Jouin (Pl. 392). Perhaps the bull corbels in the inner spandrels of the side windows are statue-supports, belonging to the same group of added statues, but inserted in the façade separately. The modern restoration is not to blame for any of these muddles, since they all show in the pre-restoration photograph (Pl. 207). It may be concluded that a group of proto-Gothic statues with canopies and supports, probably intended for some other location, was at some point scattered on the façade and rearranged together with some of the original reliefs.

At Angoulême, the sculpture programme on the higher parts of the façade is stylistically heterogeneous, apparently as a result of revision in the course of the work. The original carvings include all those above the window, on the entablature, and, in the third and fourth zones, twelve figures positioned in groups of three on either side of the window, in two rows (Pls. 229, 230, 232–7). Though apparently produced by several sculptors, all are carved in the same rigid style, much inclined to drapery patterning. Besides these, there is a large group of statues in a different style, related to the first but revealing a new spirit of agitated movement. This group includes all the statues in the fifth zone (Pl. 238) as well as two hell scenes, placed at the extremities of the fourth zone. The hell scenes, each consisting of a figure tormented by a devil (Pls. 239, 240), are very different from everything else on the façade, and seem to have been carved separately. They are fitted under original arcades, but an additional figure in the same style has been noted above in the non-arcaded second zone (Pl. 241, cf. Pl. 240). The whole group seems to represent a last-minute addition at the close of the building campaign, allocated whatever space remained available regardless of the original arcaded framework.

The addition of the hell scenes gave the programme of Angoulême a strong moralizing tone, which it otherwise lacks. Similarly, it was only the revision that gave Saint-Jouin the equally moralizing theme of the punishment of Luxuria (Pl. 390). It will be argued below that moralizing façade programmes became current in Aquitaine only from about 1130, with the sudden intro-

[35] The statues of Montmorillon, which include some typically proto-Gothic column figures, are discussed below, Chapter 5.C.

[36] The section of the original frieze immediately to the south of the Virgin Mary seems rearranged (Pl. 208). It also includes some slabs with supplicating figures, doubtless an addition introduced with the large statue of the Virgin Mary.

duction of Virtues, Vices, and parables alluding to the judgement of souls.[37] The façade of Angoulême, in existence by 1128, may have caught up with this new moralizing tone at the end of the building campaign. The façade of Saint-Jouin, which had long been completed, underwent a revision.

Neither the moralizing elements nor any reference to the related theme of the Last Judgement existed in the monumental figure programmes of early twelfth-century Aquitaine in their original form. Capitals are a different matter, but there was no transition from the iconography of capitals to that of the monumental programmes. The juxtaposition of a blessed soul to a damned one on the apse capitals at Surgères (Pls. 36, 37), or the Weighing of Souls on a capital of Saint-Eutrope (Pl. 151) and another at Aulnay, remained foreign to the monumental figure ensembles of the Aquitainian façades of the time. The same is true of voussoir programmes; even the Elders of the Apocalypse, prominent on the voussoirs of Aulnay, were not included in the monumental programmes of Saint-Jouin, Angoulême, and the great majority of subsequent ones.

The Iconographical Framework

At both Saint-Jouin-de-Marnes and Angoulême, the main theme of the original figure programme is the Revelation of the glory of God. This is conceived not only in terms of the End of Days, but also as manifest in the terrestrial and temporal world. As noted, a similar reference to the terrestrial world is expressed at Aulnay in an almost indiscriminate collection of motifs, but Saint-Jouin and Angoulême are entirely different. The terrestrial themes are more carefully chosen, and the programme as a whole makes a well-defined statement: the mediator between the terrestrial world and the revealed God is the Church. In essence, this reference to the Church goes back to the Early Christian period, but it was now formulated in new terms. From Saint-Jouin-de-Marnes to Angoulême and some other examples, there is a growing accentuation of the Church as specifically the Church of Rome, in the spirit of the ecclesiastical reform characteristic of the period.[38] It is noteworthy that this message was adopted regardless of patronage. As seen in the previous chapters, Saint-Jouin had some claim to important lay patronage while Angoulême was an independent ecclesiastical project, yet both convey the same ecclesiastical message.

The various ingredients of the programme are well ordered in the exploitation of the ascending scheme of the façade design, with the Revelation of God at the top, the terrestrial elements at the bottom, and between them symbols of the Church. This framework is common to both façades though details vary, as described in the following sections.

[37] See below, Chapter 5.B.

[38] The effect of the Reform on the visual arts still awaits a comprehensive study. Several works deal with its effect on individual monuments, e.g. Verzar-Bornstein 1982; ead. 1988: esp. ch. 1; Gandolfo 1981; Toubert 1970 and 1983; Kitzinger 1972; Quintavalle 1984; Tosco 1992. My own comments on the subject (Tcherikover 1990*b*) are here repeated and expanded. In the same article, I also discuss alternative interpretations of some of the themes (see n. 49 of this chapter) but this has been left out of the present book. There is also a recent book on art in the service of the Reform papacy, Stroll 1991, but it is a historical rather than an art-historical study, and its conclusions on individual monuments should be treated with caution.

Revelation and the Terrestrial World

The theme of the Revelation of God has been thoroughly explored in the scholarly literature on the period, and a quick reminder of the relevant points will suffice for present purposes. Of the different possible sources, the one preferred at Saint-Jouin was Matthew's vision of the Second Coming:

And then shall appear the sign of the Son of man in heaven; and then shall all the tribes of the earth mourn, and they shall see the Son of man coming in the clouds of heaven with power and great glory. And he shall send his angels with a great sound of a trumpet, and they shall gather together his elect from the four winds, from one end of heaven to the other. (Matt. 24: 30–1)

This was depicted in the gable of Saint-Jouin (Pl. 207) with almost literal precision. The sign of the Cross is at the centre of the gable, with the Son of Man in front (Pl. 119). He is the God made visible, stretching out his wounded hands. Together with a retinue of two trumpeting angels, he soars above the Elect, male and female, who advance in procession from both ends of the gable, on the frieze (Pls. 125, 126). The Virgin Mary who is placed in the middle of the frieze should be ignored, since she belongs to the later additions. It may be noted that there are no damned souls to counterbalance the Elect, because the subject is not the Last Judgement but the heavenly summons. As clearly indicated in the above quotation, the important point about the Elect is that they congregate from far and wide, and the sculptor accordingly provided them with the walking staves characteristic of pilgrims. One even carries a pilgrim's pouch, and another has heaved his bundle over his shoulder (Pl. 125, extreme right). The whole composition amounts to what is arguably the most succinct and unadulterated representation of the Vision of Matthew on any Romanesque façade, which was perhaps a Poitou–Loire tradition going back to the late eleventh century. The hacked remains of a similar 'pilgrim' thus survive at Chinon (Pl. 127).[39]

At Angoulême (Pl. 219), the revealed God is represented inside the central arch, above the window (Pl. 221). Here too, he is accompanied by a gathering of lively figurines, though depicted differently. They are placed in roundels across the entablature (Pls. 224, 226), and draw on different sources, discussed below. The figures in the fifth zone form a second retinue, but may belong to the additions. Conceived later than Saint-Jouin, Angoulême abounds in further complications. The nearest thing to the sign of the Cross is the cross-shaped tree below Christ (Pls. 221, 222). It is flanked by adoring angels as in some Early Christian representations of the Cross as the Tree of Paradise.[40] There are also some pronounced quotations from additional scriptural descriptions of the God revealed, notably the Four Beasts of the Apocalyptic Vision. The Ascension, which is a divine apparition of the past but alludes to the Second Coming (Acts 1: 11), is represented by the two large angels who are normal to this scene (Pls. 221, 222), and

[39] The present analysis is indebted to the discussion of the Vision of Matthew in Christe 1969: 105–33. Christe linked Saint-Jouin to the early medieval type of the Vision of Matthew, before the elaborate versions of Autun and Conques. However, he was confronted by the unreasonably late dates ascribed to Saint-Jouin at the time he was writing, and therefore described it as an outdated example of the primitive type (ibid. 124–5). The present study places Saint-Jouin before both Autun and Conques, and therefore accords better with Christe's theory.

[40] Christe 1969: especially 85, 145–53, fig. 19, and pl. xxii, 1.

who indicate the celestial vision to the host of figures below. The mixture of the different themes suggests that the intention of the Angoulême composition was to represent God's timeless glory as it was revealed in the past and is to be revealed in the future. The idea is not greatly different from the timeless vision of God which is represented in the mosaics of Early Christian apses, albeit in a different form.[41]

At both Saint-Jouin and Angoulême, the other pole of the programme is the terrestrial world. At Saint-Jouin, this is expressed by a cycle of the Labours of the Months, depicted on one of the archivolts in the central portal. This archivolt unfortunately suffered much erosion. January (Janus), February (warming), and March (pruning) can still be identified on one side; October (filling wine casks), November (hog slaughter), and December (feasting) on the other side (Pl. 108 and Fig. 7). The middle was lost in the restoration, but the available space suggests that the cycle was originally complete.[42] There are two ways in which such a cycle indicates the terrestrial world. First, the Labours are the activities of mankind on earth. Secondly, the order of the months makes them into a time-cycle, like the cycle of Zodiac signs that often accompany them in other Romanesque monuments, and only the created world is governed by Time. The cycle should therefore be seen as temporal as well as terrestrial, and a fitting worldly contrast to the celestial vision depicted in the gable.[43] This was arguably the very reason for allocating the cycle to the portal, which is otherwise purely ornamental as was usual at that time, but its position at the bottom of the wall provides the desirable contrast to the theme of the gable.

The intermediary themes of the Saint-Jouin façade, above the portal and below the gable, present a combination of the celestial and the terrestrial. The Incarnation, which is God's descent into the world, is thus represented by the Annunciation relief to the side of the central window (Pl. 121).[44] The rest of the original reliefs in that area include two saints. One of these remains unidentified (Pl. 118), and the other is St Peter with his Key that loosens and binds in heaven as on earth (Matt. 16: 19). There were a few more figural reliefs, no longer recognizable.[45] In addition, the animals and monsters on the window archivolts (Pls. 110–12) are perhaps meant to allude to the Apocalyptic 'every creature', as in the south portal of Aulnay,[46] though they succumbed to the ornamental programme and their message became blurred.

At Angoulême, the essentially ornamental capital-frieze of the lower zone of the façade contains some scenes of hunt and battle (Pls. 193, 194), that is, distinctly terrestrial activities.[47] The frieze also contains a small image of Samson rending the lion (Pl. 195) which, according to one interpretation, may represent ecclesiastical authority over lay rulers.[48] Higher up, the areas

[41] In a paper on Angoulême, I accepted Christe's distinction between the Angoulême theme, which he sees as eschatological, and the timeless vision of God in the Early Christian apses (Tcherikover 1990b). I have obviously changed my mind. On the timeless concept of the Apocalyptic Vision, see Klein 1990; cf. Christe 1991: 261.

[42] The central part of this archivolt was replaced by seven uncarved restoration stones, as opposed to the original six voussoirs which show in a photograph taken during the restoration (Paris, Archives Photographiques, MH 44397) and which were too decayed to disclose any details. Together with the surviving six, they bring the number of voussoirs up to twelve, and presumably completed the cycle to the required twelve scenes.

[43] On the Zodiac and the Labours as time-cycles, see most recently Cohen 1990. On Time, timelessness, and eschatology, see also Carozzi and Taviani Carozzi 1982.

[44] The relationship between Marian scenes and eschatological ones is discussed in Christe 1969: 22–41.

[45] There were two decayed reliefs to the north of the central window (replaced by modern ones). Another still exists around the façade corner, on the south wall.

[46] See above, Chapter 2.B.

[47] The battle scene, depicted on one of the long friezes, is sometimes interpreted as a scene from the *Chanson de Roland*; see Lejeune and Stiennon 1966: 29–42. There is also another possibility, that it may represent a scene from the *Psychomachia* of Prudentius, see below, Chapter 5 n. 36. Neither interpretation is certain.

[48] This interpretation has been offered for the representation of the same theme in the portal of Nonantola, in Emilia (Tosco 1992).

to the sides of the window (zones 3 and 4, except for the added hell scenes) are occupied by the Virgin Mary and an array of Apostles or other saints, including St Peter with his Key (Pls. 229, 230, 236). Though essentially as at Saint-Jouin, this scheme of saints involves further complications, more on which follows later.

The programme of both façades thus ascends from the terrestrial to the celestial. In both places this was supplemented by symbols of a new kind, which therefore deserve closer scrutiny.

Church, Pope, and Gregorian Imagery

The remaining reliefs of the Saint-Jouin programme are placed on top of the inner buttresses, that is, they are the uppermost of all the 'earthly' figures and encroach on the 'celestial' gable. On the north side there is a rider, and on the south side Samson rends the lion (Pls. 124, 123). This scheme must have been considered an important element of façade programmes, since it was to recur with even greater prominence in the side niches of Parthenay-le-Vieux (Pls. 216, 217), in the side niches of the rural church of La Rochette (in Angoumois) (Pl. 218), and elsewhere. There are also a number of examples of the theme of the rider on its own or in combination with groups of saints; for example at Châteauneuf-sur-Charente (also in Angoumois) (Pl. 378). There has been much scholarly debate on the meaning of this theme; the suggestion here is that it alludes to the Church of Rome.

Underlying this interpretation is the well-known identification of the rider as Emperor Constantine the Great. Despite repeated controversy, some scholars have compiled a convincing corpus of evidence in favour of this identification, and have also suggested that the model for the Aquitainian riders was the antique equestrian statue of Marcus Aurelius at Rome, known in the Middle Ages as Constantine.[49] The identification of the model is important, because the Aquitainian riders can be shown to reflect the symbolical value attached to it at Rome. This equestrian statue was apparently seen at the time as a symbol of ecclesiastical authority in general and papal authority in particular, because it stood in front of the papal centre of government at the Lateran palace (whence it was removed only in the sixteenth century).[50] However, all notions of ecclesiastical authority were continuously undergoing change in this period of Reform, and the connotations of the Rome statue and its imitations accordingly changed nuance.

According to the original ideology of the Reform, as formulated by Pope Gregory VII (1073–85), Christian society was composed of laymen and clergymen, both of whom were subject to the authority of the Church in both the spiritual and the temporal sense. It was on these grounds that the Reform papacy clashed with the emperor and some others of the lay monarchs in what is known as the Investiture Contest, and also led the lay knights to the military expeditions of the

[49] The evidence for the Constantinian identification was presented most fully by Émile Mâle, 1978 edn.: 248–51. There is another theory, with which I disagree, which claims a connection between the theme of the rider and the influence of the local lay aristocracy; see Seidel 1976a, 1976b, and 1981; also Le Roux 1973–4; Labande-Mailfert 1965:

488–529; Eygun 1927. For a detailed assessment of this theory, see Tcherikover 1990b. Other publications on the theme of the rider include Crozet 1958 and 1971a.

[50] The following discussion of the Rome statue is largely based on Lachenal 1990.

Crusades. In support of its far-reaching claim, the papacy evoked the so-called Donation of Constantine, a document fabricated in the Carolingian period, purporting that Emperor Constantine acknowledged the pope's spiritual supremacy over all Christendom and also his temporal supremacy in the West.[51] Constantine therefore acquired a special significance in papal ideology. In fact, all who visited the papal palace of the Lateran could not possibly escape the Constantinian associations of the place. The Lateran palace itself is specified in the Donation document as Constantine's gift to the pope. The adjacent basilica and baptistery were reputedly built under Constantine's patronage, and remained connected with his name despite much rebuilding and redecoration in later periods. Believed to represent Constantine, and positioned in the square before the whole complex, the equestrian statue was the visible embodiment of all these associations.

A somewhat different symbolism emerged in the twelfth century, when the Donation of Constantine was gradually left out of papal propaganda. The papal claim to authority now relied on the status of the city of Rome itself, by virtue of its Constantinian and pre-Constantinian imperial past. This new ideology survived the Investiture Contest. The popes now adopted unprecedented imperial pomp as heads of the Church hierarchy,[52] tightened by decades of Reform, and centring on the ancient imperial city. The result was all the more significant for the equestrian statue, which is one of the most prominent examples of Roman imperial sculpture to have come down to the Middle Ages. Surrounded by other remnants of antique sculpture (the fragments of a colossus, the celebrated Lupa and Thornpicker), it remained a symbol of the authority of the city and the Church of Rome, this time by virtue of its antiquity.[53] And despite some attempts by learned clergymen, especially from c.1140 onwards, to dissociate it from the memory of Constantine, the connection was still known to the populace of Rome and also, apparently, in Aquitaine. The equestrian statue that once existed on the façade of the Abbaye aux Dames at Saintes is thus mentioned in a document of c.1146–51 as 'Constantine of Rome'.[54] Other such Aquitainian statues, at Aubeterre and the Poitiers church of Notre-Dame-la-Grande, were known as Constantine as late as the sixteenth century.[55] I suppose that the papal associations of these and other riders were still commonly known at that time, because in their anti-papal ardour the Huguenots now demolished them one by one. This is how the riders of Aubeterre, Notre-Dame-la-Grande, and others were lost, and are today known only from written accounts.[56]

The influence of the Rome statue abroad was at first doubtless transmitted by hearsay rather than direct acquaintance. The rider of Parthenay-le-Vieux (Pl. 216), for instance, possesses a bird and tramples a captive, both difficult to reconcile with any feature of the Rome statue as it stands now, but nevertheless mentioned in a twelfth-century description of it. The text in question is an account of the treasures of Rome composed in the 1140s, and known as *Mirabilia Urbis Romae*:

[51] Besides Lachenal 1990, see also, on the Gregorian notions of temporal and spiritual authority, Robinson 1973; on the Donation of Constantine and papal policies between the 8th cent. and the end of the 11th cent., Southern 1970: 91–102; Robinson 1990: 23–4 and 309; on related ideology and art in the 12th cent., Krautheimer 1980: 190–1.

[52] On the papal emulation of imperial administration and ceremony, see most recently Robinson 1990: 17–25.

[53] Lachenal 1990. The collection of antiques in front of the Lateran is also discussed in Krautheimer 1980: 192–7.

[54] See below, Chapter 4 n. 44. [55] Gellibert des Seguins 1862.

[56] On the Huguenot destructions, see Gabet 1990: 113–14.

They . . . made a horse of gilded brass without a saddle . . . The man himself rides thereon, stretching out his right hand . . . As a memorial on the horse's head is the owlet whose hooting won the squire his victory. The king [the rider's adversary in the story that precedes the description], who was of small stature . . . was also depicted, as a memorial, under the hoof of the horse.[57]

Apparently following some similar (though not identical) verbal account, and adding a saddle and a coronet, the sculptor of Parthenay-le-Vieux arranged the bird and the captive as he saw fit. He also juxtaposed the rider to Samson, as at Saint-Jouin-de-Marnes (Pl. 217, cf. Pl. 123). Now, by some twist of tradition of unknown origins, Samson too was associated with the Lateran antiques. He is mentioned in a description of the site by the late twelfth-century traveller Benjamin of Tudela, in conjunction with the equestrian statue and other works of art:

In front of St John in the Lateran, there is an image of Samson, and the ball in his hand is of stone. And also Absalom son of David [identification unknown], and also the king Constantine the Great who built Constantinople and after whom it is called Constantinople. His image is in bronze, and his horse is gilt.[58]

The Lateran 'Samson' actually had little to do with the figure presented astride a lion at Saint-Jouin-de-Marnes and Parthenay-le-Vieux. As is known from other sources, it was rather a fragmentary colossus, comprising a head and, separately, the hand with the 'ball'.[59] Hearsay, however, can substitute one type of Samson for another, and also do wonders for details. In the pair of reliefs on the façade of the Aquitainian church of La Rochette, different accounts of the Lateran antiques thus appear to have been hopelessly confused. Samson's lion tramples a captive, just like Constantine's horse, while the captive under the horse's hoof (Pl. 218) holds a ball in his hand in apparent allusion to the 'Samson' fragment at the Lateran. These confusions doubtless arose from travellers' accounts of varying accuracy. Some were presumably very brief and devoid of details, like Benjamin's, and forced the sculptors to invent the details. The sculptor of Saint-Jouin-de-Marnes, for instance, apparently had no notion of the real appearance of the Rome statue. He must have relied for detail on whatever sources were available to him, perhaps by sheer chance. The rider (Pl. 124) gallops over a dragon or serpent as on some coins of the early Byzantine emperors,[60] and also brandishes a sword.

The precise history of these images can no longer be reconstructed with any certainty, not least because oral accounts of Rome and its monuments doubtless preceded the written ones of the *Mirabilia* and Benjamin. Furthermore, in the process of transmission by hearsay, the images

[57] Nichols 1986: 19–21, translated from: 'et equum aereum pro memoria deauratum et sine sella, ipso desuper residente, extenta manu dextra qua ceperat regem; in capite equi memoriam cocovaiae, ad cantum cuius victoriam fecerat; ipsum quoque regem, qui parvae personae fuerat, retro ligatis manibus, sicuti eum ceperat, sub ungula equi memorialiter destinavit' (Valentini and Zucchetti 1946: iii. 32–3). This is also the very first text to dissociate the statue from Constantine in favour of some ancient (and unnamed) hero, while acknowledging that it was called Constantine by others. The above passage accordingly opens with: 'Lateranis est quidam caballus aereus qui dicitur Constantini, sed non ita est.' On the *Mirabilia* and its date, see Krautheimer 1980: 198–9.

[58] This is my translation of the Hebrew original as given in Adler 1907: 8. Adler translates the same passage differently. I give 'ball' for

the object in Samson's hand in accordance with the E-version mentioned by Adler in a footnote (ibid., n. 27). This tallies with what is known about the Lateran 'Samson' from other sources; see Krautheimer 1980: 193; and also n. 59 below.

[59] *Magister Gregorius de Mirabilibus Urbis Romae* (c.1200): 'beatus Silvester iussit ipsum templum [a temple of the Sun] destrui . . . Caput vero et manus praedicti ydoli ante palatium suum in Laterano in memoria fecit poni, quod modo palla sansonis falso vocatur a vulgo' (Valentini and Zucchetti 1946: iii. 196). The colossal head and hand, in bronze and without the ball (which was apparently made of stone, see the above quotation from Benjamin of Tudela), are preserved in the Capitoline Museum.

[60] Tcherikover 1990b: fig. 16.

seem not only to have changed shape but also iconographical nuance. They were continuously associated with new iconographical schemes, all of which nevertheless turn on the changing connotations of the Rome statue itself.

In the earliest imitations it was not so much the form of the rider that mattered but rather the association with the name of Constantine as the emperor who reputedly acknowledged ecclesiastical supremacy. Inscribed with his name, an equestrian Constantine was thus depicted in the mural paintings of the baptistery of Poitiers (*c.*1100?). He is here accompanied by other rulers (not inscribed), presumably other pious emperors.[61] On the façades of Saint-Jouin-de-Marnes and Parthenay-le-Vieux, this symbolism received a new slant with the addition of Samson. There is some evidence that the image of Samson rending the lion was seen in Aquitaine as a symbol of the clergy.[62] Samson and Constantine, as clergy and pious laity, therefore amount to an image of Christian society in Gregorian terms, in that both are subject to the authority of the Church. The scheme was new, but not the basic idea. An eleventh-century Exultet Roll, originating in the important Reform centre of Montecassino, in southern Italy, had utilized different motifs for representing the same notion of ideal Christian society. Here a group of laymen is opposed to a group of clergymen, and both come under the auspices of the Church, personified by a woman.[63] A female figure indeed occurs next to the Samson at Saint-Jouin and, later, next to the rider at Châteauneuf-sur-Charente, which suggests that the Aquitainian scheme represents the same idea albeit in a different form. The lay protector of Saint-Jouin-de-Marnes, namely the viscount of Thouars, would doubtless nod in approval, since he himself had just joined the crusade of 1101 in accordance with the same ecclesiastical notion of lay service to the Church.

All these early twelfth-century schemes therefore seem connected with the Gregorian notion of the relationship between the Church and the laity, which repeatedly occupied ecclesiastical circles until the temporary solution of the Investiture Contest with the Concordat of Worms in 1122.[64] Yet the theme survived the Investiture Contest, apparently because it was increasingly associated not only with the name of Constantine but also with the Lateran statue in its own right, as noted above concerning Parthenay-le-Vieux and other examples. With or without Samson, the equestrian image of 'Constantine of Rome' was now represented time and again on the Aquitainian façades as a symbol of the Lateran and the Church of Rome, standing for the authority of the terrestrial Church.

There were additional contemporary references to Rome and the Lateran. In the context of western France, the earliest belonged in the Poitou–Loire milieu. Recent research has thus shown that the murals executed around 1100 for the chapter house of La Trinité at Vendôme drew on other models in the Lateran, with different themes. This must have reminded the

[61] Favreau and Michaud 1974: 10–11.

[62] The theme of Samson and the lion recurs on a seal of the Larchevêque family of Parthenay, in allusion to an ancestor who was archbishop of Bordeaux, and accordingly accompanied by a crosier and mitre (Eygun 1938: no. 533). It therefore seems to allude to the clergy; see Tcherikover 1990b: 440. Compare also the recent interpretation of the same theme at Nonantola (Emilia) as 'an allegory of the submission of the kings of the Earth to the vicars of Christ, represented by the ecclesiastical authorities who promoted the

Gregorian Reform against the wishes of the feudal powers' (Tosco 1992).

[63] Rome, Vatican Library, MS Barb. Lat. 592; illustrated in Avery 1936: pl. CXLIX, 6; Cavallo 1994: 242. On the Gregorian notions underlying this illustration, see Toubert 1970.

[64] Constantine was to recur later in the similar context of the clash between Emperor Frederick Barbarossa and Pope Alexander III; see Lavagne 1991.

informed contemporary observer that the man responsible for the Vendôme project, Abbot Geoffrey (1093–1132), was an ardent supporter of the Reform papacy.[65] Similarly, the first riders belong in Poitou, which emerged above as closely related to the Loire milieu on many counts, stylistic and others. The earliest was perhaps the painted Constantine in the Poitiers baptistery, followed by the reliefs of Saint-Jouin, Parthenay-le-Vieux, and another, much mutilated, on the façade of Benet (see Fig. 1). The southern riders, such as at Châteauneuf-sur-Charente and the Abbaye aux Dames at Saintes, are later.[66] Contrary to some widespread notions, even the Angoulême façade does not seem to have possessed any monumental riders in its original form, and in fact not before the nineteenth century.[67] However, the associations with the Church of Rome were nevertheless to reach a certain peak with the appearance of other themes at Angoulême, under the patronage of the papal legate Gerard, and parallel to the growth of papal ideology concerning the centrality of the city of Rome.

The Triumph of the Reform

From bottom to top, the figure programme on the western façade of Angoulême Cathedral (Pl. 219) alludes to the universal mission of the terrestrial Church. This is the usual meaning of the theme of the twelve Apostles, which spreads across the entire lower zone, filling the four tympana (Pl. 196). As on the jambs of the slightly later portal of Vézelay, the Apostles depart, each his own way, to evangelize the world. On the upper zones the message is more complex. As shown above, the programme combines isolated motifs from the Apocalypse, the Ascension, and other themes, alluding to all of these as images of the Revelation of God. The apostolic mission is implied by the allusion to the Ascension; this follows from the last words of the ascending Christ, directed at the Apostles as a sort of testament:

But ye shall receive power, after that the Holy Ghost is come upon you; and ye shall be witnesses unto me both in Jerusalem, and in all Judaea, and in Samaria, and unto the uttermost part of the earth. (Acts 1: 8)

[65] Toubert 1983.

[66] See below, Chapter 5.A and 5.B.

[67] The argument is presented in Tcherikover 1995, and may be summarized as follows. In the second zone of the façade there are equestrian statues of St George and St Martin, which are completely modern. They were carved between 1862 and 1867, in the course of the restoration of the façade (Dubourg-Noves 1973: catalogue nos. 114 and 115, respectively pls. XLVIII and XLIX). The myth that they replace original riders arises entirely from the writings of Baron de Guilhermy and Abbé Michon, respectively of 1843 and 1844 (both quoted in Gabet 1990: 110–11), which refer to some supposed 'silhouettes' of hacked reliefs. Michon also provides an engraving which shows the faint ghost of riders (reproduced in Dubourg-Noves 1973: pl. XXXI, cat. 95). This recurs in a few later engravings (ibid., pls. XVII, XXXII, and XLIII). Otherwise, the entire documentation on the façade before its restoration, both before and after de Guilhermy and Michon, shows no riders at all. This documentation includes a lithography of 1828 and an engraving of 1831 (Dubourg-Noves 1973: respectively pls. LXXII, cat. 142; pl. XXV, cat. 89), all the pre-restoration photographs and also most of the engravings (ibid., pls. XXVI–XXVII, XXXIII, XXXIV, XXXVII, XL–XLII, XLV, XLVI; see also Pl. 212 of the present book). In view of this ample evidence, I suggest that de Guilhermy and Michon, who probably found some faint hacking marks, merely hypothesized the existence of riders. Michon's engraving illustrates his hypothesis rather than the physical remains, and the same hypothesis was taken up in the few subsequent engravings that show the supposed 'silhouettes'. Gabet (1990: 115) quotes another source, claiming that it refers to the supposed riders in the second zone. Yet as shown in my above-mentioned article, this text doubtless refers to the extant archivolt of the portal, with its dragons and little figures including two riders (Pl. 194), and has nothing to do with the monumental imagery of the second zone. Finally, there is the question of the only figure in this area of the façade which may be taken as original, since it appears in the old photographs (e.g. Pl. 212). This figure, provided with a 19th-cent. head, now oddly floats behind the 19th-cent. horse (Pl. 241), evidently unrelated to it. As suggested above, it seems originally to have formed part of a hell scene like those in the fourth zone (cf. Pl. 240); see also below, Chapter 5.B.

The differences between the two schemes of Angoulême, respectively in the lower and the upper zones, do not arise from any change of message but rather from the iconographical method. The lower zone, much like the gable of Saint-Jouin, presents a single subject with no further complications. This is the early method. Conversely, the later programme, in the upper zones, comprises several different subjects fused together. This is the system characteristic of the astonishingly creative period around 1115–30, when the great Burgundian portals and other monumental complexes were produced, each of them with an experimental and even unique fusion of otherwise distinct images.[68] In the portal of Vézelay, for instance, the apostolic mission is expressed by a unique combination of the revealed God, Pentecost, and extensive imagery of the terrestrial world.

At Angoulême, the imagery surrounding the revealed God is supplemented by an equally unusual combination of themes. For instance, the Cross from the Vision of Matthew is treated in a special way. Shaped like a tree and flanked by adoring angels (Pl. 222), it sprouts through a cornice and a row of figured medallions to invade the celestial zone of Christ and the Four Beasts (Pl. 221). It then sends forth foliage scrolls which undulate at the foot of Christ and flank the lower two Beasts (Pl. 223), while additional foliage scrolls appear above the figured medallions on the south side of the entablature (Pl. 224, cf. Pl. 219). The absence of such foliage on the opposite side is not necessarily as planned; problems seem to have arisen in assembling the carved slabs, some of which show signs of having been misplaced.[69] This muddle doubtless resulted from the experimental character of the work, but does not diminish the effect of an extensive foliate sprawl, overlapping some of the figure composition and seemingly of iconographical rather than ornamental value, since it issues from the Cross-Tree.

The significance of this foliate composition has been analysed elsewhere, and may be briefly reiterated here.[70] It emerges from a comparison to the apse mosaic of San Clemente at Rome, in which most of the space is taken by a rich spread of foliage scrolls issuing from the foot of the Cross (Pl. 225). At San Clemente, an inscription identifies the theme as a vine, enlivened by the Cross and symbolizing the Church.[71] The foliage in fact consists of the conventional acanthus, just as at Angoulême it consists of other conventional leaves, but the inscription at San Clemente leaves no doubt that the intention was this symbolic Vine. The artist of San Clemente expressed the symbolic association of the 'Vine' with the Church by interpolating many little figures, secular as well as ecclesiastical, and representing all walks of Christian society.[72] At Angoulême the continuity of the scrolls is disturbed on account of the technique, which involves separately carved slabs grouped together, and the social aspect of the composition is absent altogether. Yet all the figurines in the side medallions repeat the posture of one of the figurines of San Clemente, violently leaping sideways with a raised hand (Pl. 226, cf. Pl. 227).

This apparent relationship between Angoulême and San Clemente is not accidental, since the patrons responsible for both projects were undoubtedly acquainted; both were contemporary members of the papal entourage. San Clemente was rebuilt under its titular cardinal Anastasius

[68] Christe 1969: especially 17–18, 54, and 63.
[69] Cf. Dubourg-Noves 1982: 28.
[70] Tcherikover 1990b.

[71] The inscription reads 'ecclesiam Christi viti similabimus, isti quam lex arentem sed crus facit esse virentem' (Toubert 1970: n. 85).
[72] Toubert 1970: 140–5.

around 1120,[73] at precisely the time that Angoulême was being reconstructed under the patron-age of the papal legate Gerard. The key to the theme of the 'Vine'-Church is the atmosphere prevalent in the papal circle in that period, following a fresh outburst, in 1111–12, of the old Investiture Contest. Like his eleventh-century predecessor Gregory VII, Pope Paschal II (1099–1118) was again in conflict with the emperor, and the result was a recovery of the Gregorian ideology.[74] This ideology involved a concept of *renovatio*, aimed at reviving an ideal model of the early Church, now supplemented by the above-noted idealization of ancient Rome in its own right. The artists who were employed on church projects consequently resorted to ancient models, including the church mosaics of Early Christian Rome. The 'Vine'-Church of San Clemente is one of the most characteristic products of this *renovatio*, since its direct model was a fifth-century mosaic in the narthex of the Lateran baptistery.[75] Gerard could not have been unaware of this chain of events, especially since he had played a major role in the conflict of 1111–12, and was even sent as papal envoy to inform the emperor of the Lateran decisions in this matter.[76] His project at Angoulême accordingly seems to reflect the same artistic *renovatio* and similarly adopts the 'Vine'-Church, albeit in a different form and fused with the other themes of the façade.

Gerard may even have been conscious of the Lateran origins of the theme, because the composition of Angoulême, like that of San Clemente, reveals further references to the Lateran. The main additional model was seemingly the apse mosaic in the Lateran basilica, but this possibility should be approached with caution. The present mosaic is a nineteenth-century replica of a thirteenth-century mosaic, made by the mosaicist Torriti, and known through several graphic representations (e.g. Pl. 220). Since the thirteenth-century project was substantial and included some structural work,[77] the earlier aspect of the mosaic is uncertain. Yet most experts agree that the bust of Christ in the canopy of heaven, as well as the Cross below, reproduce the original fifth-century composition.[78] This was one of the main Early Christian representations of the Cross as the Tree of Paradise, in a form which is different from that at Angoulême but repeated at San Clemente. However, the semicircular and cloudy canopy of heaven is repeated more faithfully at Angoulême, with the same retinue of eight angels, ar-ranged somewhat differently and relegated to the surrounding arch (Pls. 221, 228). At the Lateran, the eight angels are supplemented by an oddly inverted Seraphim that perhaps did not exist in this form in the original work; it is indeed absent at Angoulême, which presents instead two descending angels in the middle of the canopy. It may be remembered that the surrounding arch with the angels is the one that departs from the regular architectural design and conforms more to the sculptural composition, perhaps in order to evoke the conch of an apse.

At both the Lateran and Angoulême, the theme is supplemented by rows of standing figures attesting the divine apparition. Some of those in the Lateran were certainly added by Torriti in

[73] Barclay Lloyd 1989: especially 60–5; Kane 1978: 99–113; Toubert 1970. All these scholars accept the association of the project with Cardinal Anastasius (*ob.* 1125). Stroll (1991: 118–31) dissociates the mosaic from the building project and attributes it to the period of the antipope Anacletus (1130–8), but the argument is beset with difficul-ties.

[74] On the crisis and its consequences, see Fliche 1950: 356–75; also Stroll 1991: 57–92.

[75] Toubert 1970: especially 123–4.

[76] Fliche 1950: 370.

[77] Krautheimer *et al.* 1977: 91.

[78] On the apse mosaic in the Lateran, see Oakeshott 1967: 70–3 and 311–13; Christe 1970 (which reverses some of the conclusions in Buddensieg 1959); Toubert 1970: 151. Pre-destruction documentation includes Valentini 1836: ii, pl. xxx (here reproduced as Pl. 220).

the thirteenth century, and in particular the small figures of Pope Nicholas IV (1288–92), St Anthony, and St Francis. Yet the larger figures, including the Virgin Mary and other saints, seem to have been reproduced or even preserved from an earlier composition (though not necessarily an Early Christian one).[79] An odd arrangement of draperies around the Virgin's arms, for instance, suggests that Torriti rearranged a pre-existing figure, remaking her right hand in order to place it on Nicholas's head. These large figures are positioned in two facing groups, three on each side, exactly like those in the fourth zone of the Angoulême façade (Pls. 229, 230). At both Angoulême and the Lateran, the first figure on the left is the Virgin. She is followed by St Peter; at Angoulême he was given his keys. Otherwise, there is no precise correspondence between individual figures. At Rome, the group on the right is headed by John the Baptist,[80] but the corresponding figure at Angoulême is young and beardless, evoking the normal type of John the Evangelist (who, in the Lateran, is the next figure in the same row). John and Mary are thus placed opposite each other as in Crucifixion groups, both raising their eyes to the Cross-Tree (Pl. 219). At San Clemente, the same idea is expressed more explicitly: a Crucifixion group was simply conflated with the Cross-Tree (Pl. 225). This triple relationship between the Lateran, San Clemente, and Angoulême tends to uphold the above suggestion that all these themes originated in the papal circle.

For Gerard's Angoulême, this relationship was significant for two reasons. First, the imitation of the Lateran can be seen as a statement that the provincial cathedral reflects the Church of Rome, which came out of a long period of Reform as the triumphant centre of Western Christendom.[81] Secondly, as noted above, both the basilica and the baptistery of the Lateran were traditionally associated with the patronage of Emperor Constantine the Great, an association which gave an Early Christian allure to the whole complex, regardless of actual dates. Like the rider Constantine, all models at the Lateran therefore signify the *renovatio* of ancient and Early Christian Rome, conceived as the foundation of papal power. Angoulême presents an unusually complex system of such references to Rome, which is probably why it remained isolated. The project was too ambitious and idiosyncratic to be intelligently imitated. The arrangement of the figures in the third and fourth zones, for instance, came to resemble the assembly of Apostles in Ascension schemes, and was accordingly simplified by subsequent French imitators. The well-known Ascension in the tympanum at Cahors thus seems to have derived from Angoulême,[82] but lost the original significance of the reference to Rome. It is rather the theme of the rider Constantine, typical of Poitou but absent from Angoulême, that retained this significance later.

All in all, the Gregorian Reform emerges as a major moving force in the history of the Aquitainian High Romanesque. As noted at the outset of this investigation, the late eleventh-century response to the property claims of the Church brought about a spate of church rebuild-

[79] The problem of possible revisions of the mosaic between the 5th and the mid-12th cents. has hardly been tackled in the literature, though both the palace and the basilica of the Lateran are known to have undergone repairs on several occasions in the early Middle Ages; see Lauer 1911: 101–19 and 137–40. Even the identity of some of the figures may have changed through revision; see n. 80 below.

[80] According to Buddensieg (1959: 194), the Lateran Baptist perhaps belongs with an alteration after 1144.

[81] There are similar references to Rome in the Romanesque art of northern Italy; see Verzar-Bornstein 1988: ch. 1, especially 14 and 37.

[82] The relationship between Angoulême and Cahors is discussed in Durliat 1979: 323–4. An older theory holds that Angoulême derives from Cahors (Mâle 1978 edn. (first published 1922): 398–9).

ing under independent ecclesiastical patronage. Appropriate Gregorian imagery followed suit. The Church in Aquitaine also seems to have clung to the Gregorian establishment for longer than elsewhere. The reforms of the New Monastic Orders, which, amongst other things, opposed the excessive centralization and quasi-imperial splendour of the Gregorian papacy, thus gained little ground in this region. The division between the old and the new reformers came to the fore in 1130, when two rival popes were simultaneously elected. In general, the old Gregorian guard that had served under Pope Paschal II (1099–1118) supported Anacletus II, whereas a new guard, more susceptible to the spirituality of the New Monastic Orders, sided with Innocent II. Innocent emerged victorious, but Aquitaine remained long with the conservative Anacletus. This was under the influence of Gerard of Angoulême and with the support of Duke William the Toulousan, and despite the revolt of the bishops of Poitiers, Saintes, Périgueux, and Limoges, who were consequently exiled. The duke at some point wavered, but not Gerard—not even when excommunicated by the widely supported Innocent II. Irregularly elected as archbishop of Bordeaux (1131), his choice was apparently shared by others in the region even after his death (1136) and until the death of Anacletus (1138), after which Innocent imposed his authority on Aquitaine with the help of a new legate.[83]

It may be noted in passing that the Church in Aquitaine thus allowed Gregorianism to overrun its course. Formerly a positive moving force, it now became the focal point of conservatism. This may have been one of the reasons for the eventual collapse, towards the middle of the twelfth century, of what has so far been seen as a thriving and highly innovative school of church art.

C. THE RISE OF THE FIGURE-CARVER

Statuary at Angoulême

The sculpture programme devised for the Angoulême façade was more ambitious than anything previously attempted in Aquitaine, and one of the first of that scope anywhere in the south-west. This programme required sculptors of sufficient talent to carry it out, and Gerard found some who were even capable of matching it with technical and stylistic innovations of their own. On the upper parts of the façade, they resorted to something very close to real statuary, alongside the established technique of bas-relief. Previously no more than sporadic, statuary now became a medium explored by a number of different sculptors gathered for this purpose at Angoulême, who were to exercise a lasting influence on others throughout the region. The stylistic influence of Angoulême was in fact greater than its iconographical influence, and it is in this sense that the project marks a fresh departure in the history of the Aquitainian Romanesque.

The extent of the innovation is perhaps best illustrated by a comparison between the figures

[83] On the schism of 1130, see Claude 1953: especially 145; Graboïs 1981: especially 605–7; Robinson 1990: 158; Stroll 1987 *passim*, with an account of Innocent's activity in Aquitaine in 1139 on pp. 134–5. Stroll doubts the division between new reformers and old Gregorians, and shows that it was not as clear-cut as once thought. Yet the fact remains that the support of the New Orders was an essential cause of Innocent's victory, whereas Anacletus saw himself as one of the Gregorian popes. For a summary of the problem, see Robinson 1990: 70–3.

in the tympana of the first zone and those on the south side of the third zone. The two groups seem very different, though both repeat the same figure types (Pl. 232, cf. Pl. 201; Pl. 233, cf. Pl. 200), with the same rectilinear limbs swathed in heavy draperies, closely clustered pleats, background mantles, flaring hemlines, odd stretches of folds below the knee, and the characteristic bundle of folds around the hands. A closer examination of details may reveal that the sculptors were different, but the similarities suggest the continued activity of the same workshop. However, what changed completely in the transition from the lower to the upper zone was the articulation of the forms in space. In the lower zone, all gestures had been worked out in a single plane, directed flatly sideways as in contemporary painting (Pl. 197, cf. Pl. 198), with inevitable distortions. One figure (Pl. 200), portrayed marching sideways and turning around in a kind of corkscrew motion, consequently ended up with a frontal chest, an awkward twist at the waist, and a sharply crossed-over thigh. In the third zone, however, a figure in a similar corkscrew motion was worked in three dimensions, allowing for a gentle twist of the body (Pl. 233). Other figures in the upper zones were similarly conceived as real statues, freely twisting and turning in space (Pls. 232–5). They even gained a more slender appearance, not owing to any real change of proportions but simply because limbs and draperies were no longer spread broadly sideways.

With the exception of the later additions noted at the beginning of this chapter, all the figures on the upper parts of the façade were apparently prepared at the same time and the work was divided among different sculptors. There are consequently several variants of the style of statues described above, but some of those which seem earlier are actually placed high up, regardless of the order of construction. The Christ, at the top, is thus closest in style to the earliest reliefs, in the first zone, and presents the same congested draperies which mask the form of the body (Pl. 231, cf. Pl. 196). As noted, the statues on the south side of the third zone were probably produced by another sculptor from the same workshop. Those on the north side of the same zone, as well as two of the six in the fourth zone, may be attributed to yet another sculptor. They are the most statuesque of all (Pls. 234, 235), conceived completely in the round, placed diagonally to the frontal plane, and relatively free of the old congested draperies.[84]

The most unusual of the various sculptors, and perhaps the least skilled in the craft of monumental statuary, is the one responsible for four figures in the fourth zone: the Virgin Mary, St Peter (Pl. 236), St John the Evangelist (Pl. 237), and another saint. These figures stand out from the rest by the emphasis on graphic detail such as double-line folds, and also by the curvatures of body and garment which give them a limp quality, as if on the verge of collapse. They consequently lack the statuesque quality of the other figures, and recall small-size relief on capitals. Indeed, an earlier version of the same figure style can be found on capitals, those by the second workshop of Saint-Eutrope at Saintes (Pl. 152). This is the workshop that exercised considerable influence on the ornamental work in the apse of Angoulême,[85] and it is possible that the sculptor in question originated in the same circle of Saintes.

The essential link between Saintes and the Angoulême façade was presumably the lost western façade of Saint-Eutrope. Details remain unknown, but pre-demolition descriptions

[84] For a more detailed analysis of hands, see Dubourg-Noves 1974. [85] Discussed above, Chapter 2.C.

make it clear that this façade carried an impressive ensemble of sculpture.[86] If the transept of Saint-Eutrope was constructed around 1100, as suggested in the previous chapter, then work on the nave and the western façade could well have run into the second decade and later, when the Angoulême project was well under way (Fig. 2). It may not be too far-fetched to postulate that work at Saint-Eutrope was now in the hands of a younger generation, originally trained in the style of the capitals of *c*.1100, and that a capital-carver of that generation also arrived at Angoulême and joined the local workshop. He now found himself engaged on the production of statues, and perhaps somewhat out of his depth. It is notable that some of the most important figures, including the Virgin Mary and St Peter, were nevertheless assigned to this conservative sculptor, which suggests that the long-established workshop of Saint-Eutrope was still highly regarded. This sculptor was in fact to be engaged on further projects of both the monumental and the minor sorts, as will be seen.[87]

Whether the sculptors had previously gained experience in monumental reliefs like those in the lower zone of Angoulême, or in capital-carving of the Saintes type, they were now evidently expected to produce statues. Yet none of the established carving practices specifically led to this. Earlier statues, such as in the late eleventh-century nave of Airvault (Pl. 26), are too different in appearance. The influence of other regions cannot be detected beyond the isolated detail, and most of the comparable examples are of about the same period and therefore entail the same question of origins. Nor did statuary evolve, in my view, directly from the earlier bas-relief by some sort of stylistic process, even if the same workshop practised both forms at different times. It is a misconception arising from the developmental theories current earlier this century that statuary is a more 'advanced' form of relief, which gradually gained in volume. In fact, bas-relief has always existed alongside statuary, and is not supposed to possess any comparable volume. Whether classical, Romanesque, or Renaissance, it always involves a certain amount of the period's conventions for two-dimensional representation. Statuary, on the other hand, is by definition worked out in real space, even when attached to a background or placed against a wall, which is an entirely different kind of artistic thinking. Hybrids of the two genres exist, even at Angoulême (Pls. 232, 233), but hybrids are precisely what they are; chronologically, they do not come between bas-relief and statuary as some sort of evolutionary middle stage. In short, if the sculptors of the Angoulême upper zones produced statues in preference to relief, this must have been simply because they chose to do so, perhaps at the instigation of their patron.

Admittedly, the technical proficiency of articulating a monumental image in space could not have come out of nothing. If previously outside the sculptor's range, it had to be learnt. And this is precisely what the Angoulême sculptors did, apparently by examining antique models. They produced, for instance, a lion in the round for a tower of the cathedral (now in the Cathedral Museum), which is practically a copy of an antique lion found locally (Pls. 242 and 243, cf. Pls. 244 and 245). The carving details are different, but the arrangement of the volumes, the angle of the head, and the raised hindquarters are all much the same.[88] Perhaps very little of Roman

[86] Sauvel 1936.

[87] Chapter 4.C.

[88] Cf. Daras 1942: 107–8. The antique lion is preserved in the Musée de la Société Archéologique et Historique de la Charente. Jacques Baudet, president of the Société, kindly advised me as follows: the lion in question was found in the 19th cent. during demolition of some medieval structures in Angoulême castle. There is no precise account of this finding (see the brief note by E. Castaigne in the *Bulletins et*

Angoulême or Roman Saintes was actually known in the Romanesque period, but a talented sculptor does not need a fresh stylistic model for every statue. A few copying exercises should suffice for learning the basics of articulation in space, and the rest is up to his own powers of innovation and invention. As noted, some of the Angoulême sculptors were better at it than others.

The example of the lion suggests that statuary appeared at Angoulême out of a wish to re-create the antique, in the spirit of *renovatio* characteristic of the Reform circles of the late eleventh and early twelfth centuries. In addition to the influence of this movement of renewal on the iconography of church imagery, its consequences for styles and techniques should not be underestimated. Scholars have long linked it, for instance, to the revival of the Roman and Early Christian art of mosaic in Italy in the late eleventh century, culminating, around 1120, with the mosaic of San Clemente.[89] The same impetus of renewal seemingly underlies the approximately contemporary rise of monumental figure carving in general and statuary in particular,[90] being of a kind rarely seen since ancient times, and one much admired by various writers of the Romanesque period.[91] The Angoulême sculptors produced statues for the same reason they preferred foliate Corinthianesque capitals (Pls. 251, 252) and adapted antique archivolt designs (Pl. 201, cf. Pl. 202), which was the same as the reason for the popularity of antique and Early Christian models in Gregorian iconography: all these features could pass as Roman even if details were worked out in accordance with more modern practices.

Such a romanizing attitude was not really new, but its intensity had fluctuated considerably since the re-creation of the Corinthian capital almost a century earlier. The eleventh-century sculptors, for instance the first workshop of Saint-Eutrope at Saintes (1080s), indiscriminately mixed vaguely romanizing contemporary models with real Roman models, and consequently blurred the antique qualities. This attitude was still evident in the lower zone of Angoulême,[92] but later changed, apparently because real Roman models gradually became better known and appreciated and the imperial past of the city of Rome aroused greater curiosity. The author of the *Mirabilia Urbis Romae* was now interested in the monuments of ancient Rome even more than in its churches, and the French intellectual Hildebert of Lavardin spoke of the ancient statues of the gods, honoured 'rather for the skill that shaped them than for their deity'.[93] Different sculptors doubtless found different merits in such models. For the Angoulême workshop it was the technique of carving in the round, but not much else. The contemporary style of Jaca, Santiago de Compostela, and Toulouse was classicizing in other ways, and that of northern Italy in yet others. All these are different aspects of the *renovatio* that had begun in the eleventh century and was intensified in the twelfth.

Sculptors attempted statuary from an early stage of this *renovatio*, in the eleventh century, but their efforts were at first sporadic. The late eleventh-century sculptors of Airvault thus produced a set of crude statues (Pl. 26), described above as an exceptional enterprise which remained isolated.[94] By the time Angoulême Cathedral was created, however, the artistic *renovatio* was

mémoires de la S.A.H.C. (1865), 112). Later excavations in the vicinity revealed the Gallo-Roman wall and other lions, all attesting to the existence of a Gallo-Roman city.

[89] Toubert 1970: 122; Kitzinger 1972: 95; id. 1982.

[90] Cf. Hearn 1981: 83–4 and 117–18.
[91] Bloch 1982.
[92] See above, Chapter 2.C.
[93] Krautheimer 1980: 199–202.
[94] Chapter 1.A.

already in full swing throughout the West, and monumental experimentation consequently fell on more fertile ground. The sculptors of Parthenay-le-Vieux, for instance, also attempted statuary now, and gave their Constantine a three-dimensional quality which had been absent from the earlier relief of the same subject at Saint-Jouin-de-Marnes (Pl. 216, cf. Pl. 124). Unlike the eleventh-century sculptors of Airvault, who could not have had much experience in the handling of statuary, the sculptors of Parthenay-le-Vieux now benefited from cumulative know-how. Their carving technique was consequently like that at Angoulême, with the figure positioned in three-quarter view and lightly pulled back at the shoulder (Pl. 249, cf. Pl. 248). I therefore believe that the Parthenay façade received the Constantine and the matching Samson no earlier than *c*.1120–5, after everything else was already in position, and contemporaneously with the emergence of the new style at Angoulême. From this point onwards, the intentional *renovatio* probably lost its edge and the handling of statuary became largely a stylistic matter. Statuary simply became one of the accepted ways of representing figural imagery, adapted by other sculptors of the region each in accordance with his inclinations and ability.

In short, it was overnight, as it were, with no preparatory process of evolution, that the art of statuary was accomplished at Angoulême and consequently elsewhere in Aquitaine. The pace of innovation was so fast that the earlier sculpture of Angoulême, in the lower zone of the façade, apparently had no time to exercise any significant influence except in combination with the statues of the upper zones. The most illuminating example of this combined influence is found in the abbey church of Saint-Amant-de-Boixe, some twenty kilometres north of Angoulême, and may be briefly presented as follows.

The transept façade of Saint-Amant-de-Boixe (the west wall of the north transept) carries two tiers of arches. In the lower, there is a portal with carved archivolts, and two niches with figured tympana framed by decorative archivolts and friezes. In the upper, there are three arches containing standing figures. Scholars have long observed that the lower zone is a copy of a part of the lower zone of the Angoulême façade.[95] The tympana are carved with similar groups of three Apostles, while the archivolts carry similar inhabited scrolls, incorporating the same twisted-neck animals and the same foliage ornament of fan-leaves (Pl. 247, cf. Pls. 199, 200). Yet the style of the figures, both those in the tympana (Pl. 247) and in the upper zone (Pl. 246), cannot be paralleled in the lower zone of Angoulême. Their slender physique and three-dimensional articulation suggest imitation, albeit poorly executed, of the style of statuary in the upper parts of Angoulême (cf. Pls. 232–5). The point is that this stylistic mixture apparently existed by 1125, which is when the relevant eastern parts of Saint-Amant-de-Boixe were advanced enough to allow a translation of relics. This means that at least some of the statues of Angoulême were in existence around 1120–5, that is, less than a decade after the reliefs of the lower zone and at least three years before the dedication of 1128. These dates have long been known to scholars,[96] but their relevance has sometimes been doubted,[97] simply because the style

[95] Serbat 1912*c*; Mâle 1978 edn.: 399; Dubourg-Noves 1977: 16–18. Serbat and Dubourg-Noves also give information on the dates cited below, but interpret them in different ways. It may be noted that some of the crossing capitals at Saint-Amant are very close to those in the church at Lanville, which was constructed, or at least begun, under the patronage of the same Bishop Gerard responsible for the

Angoulême project: 'Tempore cujus et beneficio et auxilio, ecclesia de . . . [altogether churches in three places] et de Aulavilla aedificari coeperunt' ('Historia Pontificum', in Castaigne 1853: 50–1).

[96] Cf. Porter 1923: 304–15.

[97] For Saint-Amant: Serbat 1912*c*, Dubourg-Noves 1977; cf., for Angoulême, Serbat 1912*a*, Daras 1942.

of Angoulême cannot be reconciled with the evolutionary suppositions current earlier this century. In the absence of such suppositions, all doubts concerning the documented dates of Saint-Amant and Angoulême disappear.[98]

Specialization

The chronology suggested above reveals a remarkable pace of innovation. Not all that long before, figural stone sculpture had been sporadic, swamped by ornamental carvings, and seemingly produced by capital-carvers as a sideline. Despite some precedents at Chinon and elsewhere, even the project of *c*.1100 at Saint-Jouin-de-Marnes was at first planned with a predominantly ornamental accent of the old kind, and received the figural programme only as an afterthought.[99] Yet from that point onwards figural experimentation became more consistent, in Aquitaine as elsewhere in the Romanesque world. The façade of Angoulême was planned, from the start, with the view of accommodating the figured tympana of the lower zone. By 1120–5, some of the sculptors of Angoulême were fully in command of new and unprecedentedly subtle forms of statuary. A quarter of a century, that is, less than a normal lifetime even in medieval terms, thus sufficed for establishing monumental figure design as a major sculptural proficiency.

The material examined in the previous chapters suggests, however, that the new interest in figure sculpture did not come at the expense of the old ornamental tendencies. At both Saint-Jouin-de-Marnes and Angoulême, a wealth of new decorative devices in fact intensified the ornamental character of capitals and archivolts. Within the brief period of 1100–25, the sculptors clearly faced increasingly complicated requirements on the ornamental level as well as the figural.

At first, the same sculptors seem to have executed both the figural and the ornamental programmes, handling slab-reliefs, capitals, and archivolts in very much the same carving style. A sculptor of Saint-Jouin-de-Marnes, for instance, gave the same distinctive facial features to the Virgin and angel of the Annunciation relief (Pl. 121), the distorted manikins on a capital at the same level of the façade (Pl. 103), and the semi-human monsters on a window archivolt (Pl. 110). At that time the sculptors were still essentially architectural decorators, and they simply added the figural work to their traditional preoccupation with capitals and archivolts. Similarly, a capital-carver from Saintes was apparently engaged on monumental imagery at Angoulême, as shown above (Pls. 236, 237, cf. Pl. 152).

Yet the Angoulême project involved a growing division of work. In the first zone of the façade, the figured tympana were apparently allocated to one set of sculptors, who specialized in purely figural work (Pl. 196). The decorative archivolts and friezes were produced by others, who mixed ornamental motifs with a few figural scenes in a softer style, different from that of

[98] A second date for Saint-Amant, concerning a solemn consecration in 1170, is irrelevant for the works in question. This is accepted also by Dubourg-Noves (see n. 97 above). The consecration seems to have followed a subsequent rebuilding of the nave, carried out in an entirely different style, and joined to the earlier eastern parts (which include the last bay of the nave) by a visible structural break.

[99] See above, Chapter 1.C.

the tympana (Pl. 195). As the work advanced to the higher parts of the building the division became sharper. The figural work now passed completely into the hands of the experts, while the sculptors responsible for the capitals and archivolts specialized in purely ornamental work. This can be seen in what survives of the original interior sculpture at that level, for example on the capitals in the substructure of the transept tower (Pl. 250); they carry tangles of foliage, animals, and decorative figurines, but no meaningful figural scenes. On the higher parts of the western façade, the earlier predilection for purely foliate Corinthianesque capitals is expressed in new and flamboyant foliate designs (Pls. 251, 252), but now even the archivolts in the rows of little arcading are entirely foliate (Pls. 229, 230). Some of the smaller capitals still carry a few animal motifs, but the figural elements have disappeared. There is no sign that the sculptors responsible for these architectural decorations were ever involved in any monumental imagery. Even the 'Vine'-Church, which is a foliate element but incorporated in the figure programme, is apparently the work of a different sculptor who preferred the flattened fan-leaf of the lower zone (Pls. 223, 224, cf. Pls. 192, 195) to the chunky foliage of the capitals and archivolts in the upper zones.

By the time of Angoulême, the upsurge of monumental imagery on church façades therefore seems to have entailed a new division of skills. Some sculptors specialized in the increasingly demanding elements of figure programmes, and concentrated on the appropriate techniques of slab-relief and statuary. The traditional architectural sculpture on capitals and archivolts was left to others, who specialized in ever more exuberant ornamentation. The middle course, that of the all-purpose architectural decorator who occasionally attempted edifying figural imagery, proved increasingly problematic. This has been noted above at contemporary Aulnay, where the decorators used the traditional architectural form of individualized archivolt voussoirs but injected it with important figural themes. The number of figures was matched to the number of single and double voussoirs, leading to iconographical absurdities such as thirty-one Elders of the Apocalypse. From now onwards, only the ornamentalists persisted in this system of voussoirs. Their occasional figural essays were arguably mere curiosities with no influence on mainstream figure sculpture; examples will be considered in the next chapter.

A notable exception to the new division concerns the angel-archivolt which surrounds the central figural theme at the top of the Angoulême façade (Pls. 221, 228). While all other archivolts in the higher zones of the façade were carved by the ornamentalists, this archivolt was produced by the figure-carvers, whose main concern was iconographical. The iconography required precisely eight angels, as in the Lateran, and the old system of individualized voussoirs was unacceptable because it caused numerical distortions of the sort at Aulnay. In fact, the figure-carvers of Angoulême did not use any of the conventional methods of archivolt composition,[100] though the continuous patterns of the lower zone (Pl. 199, etc.) may have suggested to them that voussoir-division could be ignored. Each of the angels was thus allocated one-eighth of the available space, which happened to be about four to five voussoirs, and was carved out of

[100] There was the system of the Labours archivolt at Saint-Jouin-de-Marnes, where the arch was divided into twelve large voussoirs to match the number of themes (it was only during the restoration that the arch received an extra plain voussoir, bringing the number up to thirteen; see n. 42 of this chapter). The Saint-Jouin system was highly unusual in western France, though a similar system was later used at Chartres and most other proto-Gothic monuments.

the entire set of voussoirs as if from a single block. Each was treated precisely like the statues below, and even provided with a similar patch of ground line. The only concession to the architectural medium was that the figures were positioned above each other along the curve of the arch. This system of archivolt composition, usually called 'longitudinal' or 'tangential', therefore seems to have arisen from removing the archivolt from the hands of the ornamentalist and placing it in those of the figure-carver.

Angoulême illustrates what was now to come, at least in the major projects: a largely separate history of architectural ornamentalists and figure-carvers despite some fruitful interchanges between them. It may well be asked whether the workshops active in other regions did not undergo a similar process of specialization around the same period, though perhaps at a different pace, because the division between figure-carving and ornamentation seems to have been well established by the time of the proto-Gothic and Gothic monuments. This subject exceeds, however, the limits of the present study.

4

THE ORNAMENTAL DRIFT
*c.*1120–30 AND ONWARDS

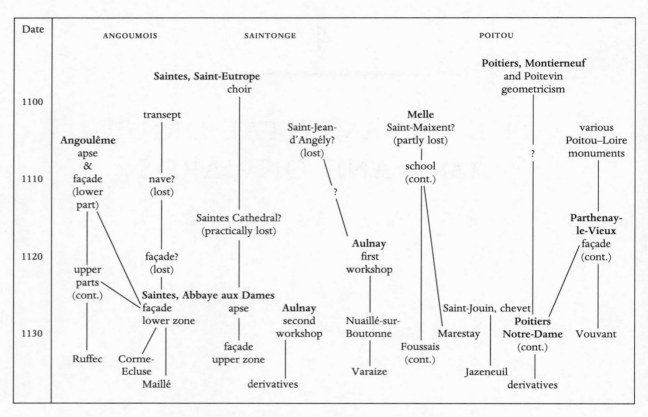

Date	ANGOUMOIS	SAINTONGE		POITOU
				Poitiers, Montierneuf and Poitevin geometricism
1100		**Saintes, Saint-Eutrope** choir		
		transept		**Melle**
	Angoulême apse &		Saint-Jean- d'Angély? (lost)	Saint-Maixent? (partly lost) various Poitou–Loire monuments
1110	façade (lower part)	nave? (lost)		school (cont.) ?
		Saintes Cathedral? (practically lost)	?	**Parthenay- le-Vieux** façade (cont.)
1120	upper parts (cont.)	façade? (lost)	**Aulnay** first workshop	
		Saintes, Abbaye aux Dames façade apse lower zone	**Aulnay** second	Saint-Jouin, chevet **Poitiers Notre-Dame** (cont.)
1130	Ruffec Corme- Ecluse	façade upper zone	workshop Nuaillé-sur- Boutonne Foussais (cont.)	Marestay Jazeneuil Vouvant
	Maillé	derivatives	Varaize	derivatives

FIG. 3. Derivation of the subregional ornamental styles of *c*.1130

A. THE ORNAMENTALIST

Architectural Decorations after Angoulême

When commissioned for a building project, the sculptors of *c*.1125 would be expected to possess proficiencies different from those of their predecessors of *c*.1100. At least some of them were no longer all-purpose carvers, as at Saint-Jouin-de-Marnes, but specialists, as at Angoulême. Some concentrated on monumental figure-carving while others were responsible for architectural ornamentation.

With hindsight, the figure-carver seems by far the more important. After all, he was soon to take over all the mainstream proto-Gothic façades and eventually the Gothic ones, and relegate the ornamentalist to a secondary position. Something of the sort was already happening at Angoulême, where the balance between the ornamental and the figural work changed during the work on the façade. Luxuriant decorations still dominated the lower zone, but were later reduced, on the upper zones, in proportion to the prominence of the figure sculpture (Pls. 229, 230, cf. Pls. 199–200).

However, this undoubtedly momentous change of balance does not seem to have been immediately appreciated elsewhere in Aquitaine. On the contrary, most of the Aquitainian churches of the time attest to a growing demand for ornamental work. The ornamentalists thus retained practically all capitals and, for a while, most archivolts, which were still the main carriers of sculpture in the majority of churches. Even where monumental imagery existed, it had to compete against an ornamental programme of capitals and archivolts in keeping with the lower rather than the upper part of the Angoulême façade. In fact, Angoulême appears to have been famous not only for its monumental imagery but also for the exuberant ornamentation on the capitals of the lower parts and the interior of its tower, which were widely imitated in the surrounding area and even as far as Fontevrault in the Loire Valley.[1] If the mainstream Romanesque style involved ever more imposing figure sculpture, this was counterbalanced, in Aquitaine, by an ornamental drift.

The demand for ornamental work fostered the continued activity of the veteran workshops of Saintes, Parthenay-le-Vieux, and others discussed in the previous chapters, which had always possessed decorative tendencies, and now gave rise to a new generation of expert ornamentalists. The present chapter will trace this new generation to ever richer projects, occasionally reflecting awareness of Angoulême but generally revealing an entirely different spirit. Some of these ornamentalists repeatedly injected the decorative patterns with various figural themes, but very few can be suspected of any serious interest in edifying figure pro-

[1] On Fontevrault see Crozet 1936*b*; Mallet 1984: 120–2. Ornamental derivatives of Angoulême in Angoumois include Mouthiers-sur-Boëme, Lanville, Champniers, Bécheresse, Nanteuil-en-Vallée, Fléac, La Couronne, Champmillon, and others. There are also many monuments in the related ornamental style of the Abbaye aux Dames at Saintes. The figure style of Angoulême recurs at Ruffec, and is also reflected at Gensac-la-Pallue, Trois-Palis, and on the archivolts at Genouillé and Champagne-Mouton. All other derivatives of the Angoulême figure style betray the additional influence of some later styles; examples include Fontaines-d'Ozillac, Pérignac, and Châteauneuf-sur-Charente; see Chapter 5.A.

grammes. Their occasional attempts to imitate the figure-carver were no more than eccentric exercises. More commonly, the ornamentalist used figural imagery as yet another pool of motifs, and forced it into the architectural and decorative framework. The resulting distortions are sometimes even greater than those noted above in the transept portal of Aulnay.

The work of the ornamentalist was presumably appreciated chiefly for its beauty, but it also seems to have carried a message. The luxuriant ornamentation of the east end of Aulnay, for instance, was just as representative of the triumphant Church as any message conveyed by orderly figure programmes, because the Church now regarded itself as a quasi-imperial power and was accordingly inclined to excessive splendour. This was one of the main characteristics of the twelfth-century version of Gregorianism, strongly criticized by the New Monastic Orders, but, in Aquitaine, stubbornly persistent well into the 1130s.[2] The Aquitainian ornamentalists of the same period accordingly explored new decorative possibilities, and some could even boast spectacular innovations in parallel to the figure-carver, albeit in their own chosen medium. Church ornamentalism was not to fade away gradually, but to make an unashamedly grand exit.

There were several distinct lines of ornamental experimentation, each emanating from a workshop of the previous generation and reaching some new juncture. In each line, the key monument at the juncture point can be assigned to c.1120–30, and its influence traced into the following decade and sometimes even later. The proposed chronological chart (Fig. 3) reveals an unprecedented concentration of projects in this period, which is not accidental. The reasons will be examined later, after the chronology of each line has been established separately. This is not a simple task, because the monuments which are most clearly dated are not necessarily the most important or influential. The chevet of Saint-Jouin-de-Marnes, for instance, is datable to the period in question on simple documentary grounds, but it was executed by a marginal workshop, very different from the older workshop of the western façade, and unsuitable as a focal point for the present discussion. A more important example concerns a workshop which originated at Saintes and matured at Aulnay, and which best illustrates the relationship between the ornamental drift and the mainstream project of Angoulême, completed in the 1120s.

The Two Trends of Saintes

As seen in the previous chapters, two different workshops appeared at Saintes within a short space of time. The first was engaged on the two-storey choir of Saint-Eutrope, 1081–96. It specialized largely in foliate capitals, highly diversified but increasingly subjected to standard stylization (Pls. 130, 132, 134, 139–42), and was important enough to exercise a certain amount of influence on other monuments of the south. A second workshop appeared around 1100, and produced the exuberant patterns of foliage scrolls with animals and figures on the transept capitals of Saint-Eutrope (Pls. 143 ff.). This exuberant style was even more successful; within two decades different versions of it were created by the important workshop of Angoulême as well as the first workshop of Aulnay. Unlike the older style, which grew increasingly

[2] See above, Chapter 3.B.

stern and regular, this style became increasingly dainty and playful. An essential aspect of Saintes and its zone of influence is that both styles continued in various forms well into the twelfth century, occasionally mixed together but generally preserving their independent characters.

New versions of both styles thus recur in a renovation project carried out in the church of the Abbaye aux Dames at Saintes (originally constructed before the middle of the eleventh century). The history of this project and its version of the exuberant style will be discussed separately later, while the vicissitudes of the stern foliate style are examined here. This style is found in the apse (Pls. 253, 254), which was now completely rebuilt, and also in some parts of the nave (Pls. 255, 256), which was remodelled.

The apse capitals are carved with simple patterns which follow the architectonic shape, stressing the symmetry of the block and accentuating the protruding upper corners. The predominant motif is the lace-like spread of flattened and jagged leaves grouped in large clusters (Pl. 253), as in the choir of Saint-Eutrope (cf. Pls. 140, 141), with some new details: the clusters are often stretched into chains bordered by thin ribbons, the body of the capital is sometimes shaped like a smooth basket with the foliage set into pockets (Pl. 254), and the volutes are replaced by additional foliage. It seems that a new workshop arose from the old one of Saint-Eutrope, introducing some changes, but otherwise continuing the same decorative traditions. This workshop assimilated additional foliage motifs as the renovation project advanced from the apse to the nave; alongside the capitals with chains of jagged folioles set in pockets, it now adopted a new type of splayed leaf with beaded veins (Pl. 255).

This seemingly unassuming style led to Aulnay, where it absorbed animal and figural elements but preserved its architectonic and purely decorative character.

The Second Workshop of Aulnay

Aulnay has been left above at an early stage of a total reconstruction, probably initiated when the church was acquired by the chapter of Poitiers Cathedral about 1120. A first workshop, commissioned in the vicinity, was then engaged on the choir and transept (Pls. 161 ff.).[3] The present discussion concerns a second workshop, which replaced the first before the completion of the transept. This new workshop produced the capitals, the window archivolt, and a series of corbels for the upper zone of the transept façade (Pls. 213, 257, 269), above the portal by the first workshop. It then proceeded to the capitals of the nave (Pls. 258–61, 265, 266, 268), and apparently also produced some foliage ornaments for the western façade (Pls. 263, 264). The sculpture in the nave is stylistically heterogeneous, probably owing to the co-operation of different hands. The most important collaboration can be noted at the west end, where a third workshop joined the project and provided figure sculpture for the façade (Pls. 350 ff.).[4]

The changing workshops of Aulnay doubtless reflect changing fashions, and yet they overlapped: the second workshop ran into the first in the transept, and the third into the second at

[3] See above, Chapter 2.C. [4] In the main, this workshop division is after Werner 1979.

the west end. It therefore seems that despite the changes all three workshops were active within a relatively short space of time. Indeed, the project must have been quick since the architectural design turned out essentially homogeneous. Clustered shafts, for instance, can be noted in all parts of the building and vary only in accordance with function: quadruple shafts for the nave piers, triple for the buttresses of both the apse and the nave, and up to seven-fold for corner buttresses and twelve-fold for the crossing piers. There is some variety in the decoration of base-cavities and the ordering of portal embrasures, but this does not impair the impression of a consistent architectural design carried out without delays or breaks.[5]

The approximate duration of such a neat project may be inferred from documented building campaigns elsewhere. The chevet and much of the nave of Saint-Jean-de-Montierneuf at Poitiers, for instance, were ready within seventeen years (1069–86) to receive a crossing tower.[6] Similarly, the two-storey choir of Saint-Eutrope at Saintes was completed within fifteen years at the most (1081–96).[7] At Angoulême, the entire cathedral was constructed in less than twenty-six years (after Gerard's appointment in 1102 and before the dedication of 1128).[8] The building campaign at Aulnay was probably shorter than any of these, for two reasons. First, the building is more modest. Secondly, the project must have involved an exceptionally large work-force; the employment of three workshops means that there were many sculptors, whatever the number of other workers.[9] Fifteen years for the entire project, with the possible exception of the crossing tower and some final embellishments, seems a generous estimate. If the first workshop was active around 1120, then this calculation gives an approximate date between 1120 and 1130 for the second workshop, and leaves enough time for the third.

The 1120s were when the Angoulême project was drawing to a conclusion, giving rise to ever more ambitious forms of figure sculpture. It will be suggested here that the contemporary second workshop of Aulnay was aware of some of these figural innovations, but nevertheless showed greater interest and skill in ornamental work. This is because it had apparently originated in a circle of unassuming capital-carvers, and was perhaps even a branch of the 'stern' workshop of the Abbaye aux Dames at Saintes.

Some of its capitals accordingly present additional versions of the lace-like foliage of the Abbaye aux Dames, with the same clusters and chains of jagged folioles bordered by thin ribbons, and the same foliate volutes (Pls. 258, 259, cf. Pl. 253). As in the Abbaye aux Dames, the beaded leaf was introduced to the workshop's vocabulary in mid-campaign—in fact, when the work reached the western part of the nave and the western façade—though it is possible that the Aulnay sculptors at that point split away from the Saintes workshop and collaborated with others. This is probably the explanation for the Aulnay combination of this motif with a new kind of folded leaf (Pl. 260), unknown at Saintes. Yet the old lace-foliage recurs even in these later parts of the nave, for example on a capital on the reverse of the western façade (Pl. 261). The jagged leaves on this capital are the same as before though some spring from looped stalks and

[5] Werner (1979: 23) postulated a change of plan around the westernmost bay of the nave, but there is no real structural evidence for this. No masonry break is to be seen at the relevant point, and the few irregularities noted by Werner (windows off axis, an inexplicable protrusion to some plinths) are not of the sort that usually arises from changes of plan or belated completion.

[6] Camus 1978 and 1991.
[7] Above, Chapter 2.A.
[8] Above, Chapter 2.C.
[9] The evidence of mason marks, which exist at Aulnay, is inconclusive; see Werner 1979: 4.

occasionally overlap in a new way. This spatial treatment reflects the latest innovations of the time, introduced shortly before 1128 on the grand foliate capitals in the higher parts of the Angoulême façade (Pl. 252).

Other innovations are reflected in a new range of animal motifs, apparently adopted in response to the contemporary exuberant styles. A few reiterate the version closest at hand, by the first workshop of Aulnay,[10] while others betray the spirit of Angoulême. In the transept window, for instance, there are capitals with ferocious corner heads and crouching quadrupeds (Pl. 257), recalling those on the apse capitals of Angoulême, though greatly simplified and newly rearranged (cf. Pl. 189). This influence is difficult to assess. On the one hand, Angoulême must have been famous enough to exercise direct influence on the workshop of Aulnay. On the other, its influence may well have been partly mediated by some lost works at Saintes, where the workshop originated. In the relevant period the bishop of Saintes was Peter of Confolens (1112–27), a former canon of Angoulême, and presumably intimately acquainted with the ambitious project then under way at Angoulême. Later sources attribute to him some works at Saintes Cathedral, but little of relevance survives.[11]

Having assimilated its various sources, the workshop acquired a new taste for big animal forms, imposing in weight rather than detail. It introduced to animal decorations on capitals what the roughly contemporary workshop of Angoulême introduced to figure sculpture, namely, three-dimensional presence. Unlike Angoulême, however, the nave capitals of Aulnay betray a purely architectonic technique for achieving this three-dimensional quality: each creature is tightly packed into half the main face of the capital, and is duplicated symmetrically at right angles across the corner as if viewed simultaneously from two sides (Pl. 265). Where the duplicated motif is a profile head, the result is remarkable: each half of the capital becomes a fully three-dimensional head (Pls. 259, 266). Some of the window capitals, which are necessarily smaller, are formed as single heads of the same kind, amounting to veritable sculpture in the round (Pl. 268).

The extent of innovation stands out all the more by comparison with earlier capitals with heads. An example in the choir of Saint-Benoît-sur-Loire (Pl. 267), for instance, illustrates one of the late eleventh-century variants, with grotesque human heads replacing the console and the upper corners of a Corinthianesque capital. As is usual on Corinthianesque capitals, the upper corners strongly project into space, and the corner heads consequently acquire a three-dimensional quality. However, their size is limited, since the lower half of the capital remains foliate. At Aulnay, both the first and the second workshops adopted this type of corner head and enlarged it to occupy the full height of the basket, dispensing with the foliage. The first workshop used it as applied decoration against a smooth background (Pl. 165), and somewhat lost the three-dimensional effect of the projecting corner. Conversely, the second workshop strengthened this effect by using the technique described above (Pl. 266), and further dispensed with all elements of background as if nothing was left of the capital except projecting corners. Architectural mass was in this way translated into sculptural volume. This tight correlation between the sculpture and the architecture is particularly accentuated on the smaller head capitals, in the

[10] See Werner 1979: fig. 307, cf. fig. 283.

[11] On Saintes Cathedral, see Blomme 1987: 14. Crozet gives the relevant information on Peter of Confolens, but attributes the surviving domed transept to a somewhat later period (Crozet 1956*d*).

windows, which possess monstrous features and seem to devour their supporting shafts (Pl. 268).

The sculptors of the second workshop of Aulnay were evidently masters of three-dimensional articulation by architectonic means; yet contrary to what might be expected, this did not help them with anything but capitals. When the same sculptors tried their hand at monumental imagery, on the archivolt of the transept window (Pl. 269), their methods proved inadequate. All they managed was in fact a rather poor imitation of the completely different methods used by the figure-carvers of Angoulême, who were active at about the same time. This relationship can be demonstrated by a comparison between the Aulnay archivolt and the angel-archivolt at the top of the Angoulême façade (Pl. 228).

The archivolt in the transept window of Aulnay carries four large personifications of the Virtues, positioned along the curve of the arch in accordance with the so-called longitudinal system, and trampling under foot the monsters of Vice. The subject is new to church sculpture in Aquitaine, but the compositional system repeats a peculiarity of the angel-archivolt of Angoulême: the lower part of each figure occupies the main face of the archivolt while its upper part is tilted diagonally inwards, head on, towards the arris and the soffit. This system of inwards tilting is highly unusual. It was doubtless invented by the figure-carvers of Angoulême specifically for the angel-archivolt, and was apparently never repeated except on the one archivolt at Aulnay.[12] In fact, even here it was not completely understood. The Aulnay sculptors had serious difficulties, for instance, with the spare spaces which resulted from the diagonal placement, and simply filled them with rosettes. Similarly, they tried to reproduce the statuesque quality of the Angoulême figures by using their usual architectonic method of correlating the two sides of the block, across the arris, but hesitantly masked the transition from side to side by the shields of the Virtues.

Considering the virtuoso achievement of the Aulnay workshop in the handling of sculptural volume on capitals, these hesitations are inexplicable unless the problem was the figural character of the work. Indeed, the examination of other archivolts by the same workshop, in other buildings, reveals that a requirement for monumental figure sculpture was not something that this workshop usually encountered. The portals at Contré and Saint-Mandé-sur-Bredoire as well as a side-niche at Civray, all of which may be attributed to the same workshop,[13] show that its archivolt decoration usually involved monsters, foliage, and geometrical patterns, interspersed with a few figurines, and arranged voussoir-by-voussoir in accordance with the old ornamental system. Viewed in this context, the figured archivolt in the transept window of Aulnay emerges as a curious exercise, off the workshop's beaten track of architectonic ornamentation, and apparently arising from a momentary fascination with the recent novelties of Angoulême.[14]

[12] All other longitudinal figures of Aquitaine, including those which were soon to be carved by the third workshop for the western façade of Aulnay, are either tangential to the arris or else tilted in the opposite direction. I discuss this system in Chapter 5.A.

[13] These attributions are according to Werner 1979. At Civray, there are also ambitiously carved figural archivolts of the longitudinal type, but these were produced by a different workshop, discussed below, Chapter 5.A and 5.B.

[14] The relationship between Aulnay and Angoulême is described differently by Werner (1979: 34–5). This scholar envisages a stylistic evolution of longitudinal archivolt figures, beginning with the Aulnay archivolt in question, continuing with the angel-archivolt of Angoulême, and finally leading to the archivolts on the western façade of Aulnay. There are two problems with this theory: first, whatever can be gathered about the dates of the two monuments, as presented above, suggests that the Angoulême archivolt is at the latest contemporary with the Aulnay transept window. Secondly, the archivolts on the western façade of Aulnay belong to an entirely different stylistic family; see Chapter 5.A.

The exercise was not repeated. Perhaps it was not even completed; hence the rough surfaces near the arris of this archivolt. Different sculptors, specializing in figure sculpture, were eventually commissioned to carve the figured archivolts of the western façade. Since the theme of the Virtues was then repeated (Pls. 353, 354), it may not be too far-fetched to postulate that the Virtues of the transept window were at first intended for the western façade, but were rejected and relegated to a secondary position with the appearance of the specialist figure-carvers on the site.

All this confirms what has already been suggested in the previous chapters, namely, that not every figural essay was necessarily a step towards monumental figure sculpture. Some were even degenerate imitations of mainstream imagery, carried out by ornamentalists who were not expected to innovate in this field. It was rather in its own chosen genre of architectural decorations that the second workshop of Aulnay revealed any outstanding ambition, and was also highly successful. Various decorations in the same style, some by the same sculptors and others by imitators, consequently recur in many other monuments, especially in Saintonge and southern Poitou. In addition to those already mentioned at Contré, Saint-Mandé, and Civray, examples have been noted by scholars at Les-Églises-d'Argenteuil, Sainte-Ouenne, Migron, Dampierre-sur-Boutonne, Saint-Étienne, Bords, and Villiers-sur-Chizé.[15] Others can be found at Nuaillé-sur-Boutonne,[16] Soudan, Beauvais-sous-Matha, Cozes, and Dirac. This list is neither comprehensive nor chronological; the precise history of the style still awaits detailed research. It nevertheless allows a glimpse at the scope of activity of the specialized ornamentalist, occasionally indulging in imitation of the figure-carver, but generally going his own way.

B. THE POITEVIN WORKSHOPS

The Chevet of Saint-Jouin-de-Marnes

The eleventh-century abbey church of Saint-Jouin-de-Marnes was partly renovated during the twelfth century. The renovation involved two separate projects of enlargement. As seen in the previous chapters, the first was undertaken around 1100 at the west end, and comprised a nave-extension with a new western façade. This project was executed by an ambitious and innovative workshop but was limited in scope; the rest of the church remained in its eleventh-century state. The workshop in fact disappeared from Saint-Jouin after the completion of the nave-extension and the façade.

Somewhat later, new builders appeared on the site. Working in a completely different style, they embarked on a separate project at the east end of the old church. This project comprised a new ambulatory chevet, replacing most of the old choir except one bay. Since this project concerned the choir, it may be associated with a reconsecration of the high altar and a translation of relics which took place in 1130. The account of the consecration ceremony specifies that the body of St Jovinus had previously been concealed in the same church and, having been removed

[15] All these from Werner 1979.
[16] The relevant works at Nuaillé-sur-Boutonne are the capitals at the east end. The western façade of that monument is a late work by the first workshop of Aulnay, discussed below, part D of this chapter.

from its 'tomb' (i.e. the crypt of the old church) and enclosed in a precious reliquary, it was now deposited on the high altar.[17] It may be assumed that the reason for the removal of the relics was the reconstruction of the east end, and that the occasion for their return was the completion of the new chevet, followed by the consecration of 1130. A charter of 1120 actually mentions masons and carpenters amongst various workers associated with the abbey, thus further testifying to building activity in the decade before the consecration.[18] The chevet of Saint-Jouin therefore emerges as a roughly dated monument of *c.*1120–30.[19]

The new chevet of Saint-Jouin (Pl. 270) is a spacious structure with an ambulatory and three radiating chapels. To judge by the style of corbels and capitals, the same building campaign also involved some final elaboration of the corner turrets at the top of the western façade, but otherwise left the rest of the church untouched. Saint-Jouin never recovered from this limited approach to renovation, and later underwent a series of *ad hoc* repairs and alterations. Those in the chevet included, around 1200, a thorough remodelling of the apse clerestory (altered again in modern times), the addition of some flying buttresses, and eventually a replacement of vaults. These works greatly altered the appearance of the higher parts of the structure. However, discounting some easily recognizable modern repairs, especially on the north side, almost everything below clerestory and vault level nevertheless belongs with the original project, including most of the decorative elements. These include carved capitals of wall-shafts, buttresses, and window colonnettes, as well as decorative dado arcading on both the interior and the exterior.[20]

As a reasonably dated monument, the chevet of Saint-Jouin deserves scholarly attention architecturally as well as sculpturally, as both aspects can illuminate some otherwise obscure chronological issues. One of these is the problem of conservatism. The building incorporates many features which separately seem antiquated and are indeed highly conservative, but they are combined in a new way creating a totally new effect. For instance, the exterior dado arcades contain two types of supports, which are divided in accordance with a scheme established well before 1100 at Saint-Savin: on the chapels, there are flat pilasters without capitals (Pl. 271), and, on the ambulatory wall, colonnettes with capitals (Pl. 277). This old scheme is enriched at Saint-

[17] The information on the consecration of 1130 comes from the introduction to a 17th-cent. copy of the charters of Saint-Jouin-de-Marnes, compiled by Roger de Gaignières (Paris, Bibliothèque Nationale, MS Lat. 5449, p. 5). It refers to the church as 'St John the Evangelist's' (the main dedicatory, together with St Jovinus and others; see Tcherikover 1987: 118). The relevant passage is as follows: 'Altare princeps ecclesiae S. Johannis Evangelistae anno 1130 denuo consecratum fuit ab episcopo cujus nomen reticetur, in honorem sanctorum Jovini, Martini atque Sebastiani . . . Inter haec sacra pignora praecipue celebratur integrum corpus S. Jovini, quod in ecclesia S. Johannis Evangelistae absconditum, dein anno 1130, tumulo extractum, in cupreo loculo argento auro lapidibusque pretiosis ornato inclusum, supra altare majus repositum fuit, una cum sacris B. Martini Vertavensis ossibus . . . ' (quoted in Ledain 1883: 90 n. 2). On the old choir and its probable crypt, made redundant with the construction of the new chevet, see Tcherikover 1987.

[18] 'immunes sint cementarii, immunes sint carpentarii, sint immunes falcatores [thatchers?], sint immunes et alia quelibet officia exercentes' (Grandmaison 1854: 30). On this charter, see above, Chapter 1 n. 102.

[19] This date is accepted by Labande-Mailfert (1962: 202), who notes that the chevet looks 'younger' than the nave-extension (she nevertheless attributes the nave-extension to about the same period, whereas in my view it is earlier; see above, Chapter 1.C). Other scholars, assuming that the church was constructed between 1095 and 1130, place the chevet around 1100 and the nave-extension later; see Oursel 1975: 239–45; Mallet 1984: 49. There are two problems with this dating. First, the date of 1095 arises from a documentary misinterpretation, and is in fact totally irrelevant for Saint-Jouin; see above, Chapter 1 n. 89. Secondly, these scholars seem to have assumed, without any documentary or structural justification, that the work advanced from east to west. However, the renovation of pre-existing churches, as at Saint-Jouin, did not always follow this rule. In fact, it often began with an ostentatious project at the west end and later continued with a separate project at the east end, as, for instance, at Saint-Benoît-sur-Loire and Saint-Denis. The course of the renovation of Saint-Jouin was apparently the same. For further details and references to older literature, see Tcherikover 1989*b*.

[20] The revision of *c.*1200 and the modern restoration are discussed in Tcherikover 1989*b*.

Jouin by additional decorative detail, in particular extensive nook-carving consisting of a large variety of decorative buttons. Previously used sporadically, at the bottom of some buttresses of the chevet of Fontevrault (1100–19) (Pl. 272),[21] these buttons are repeated at Saint-Jouin, as if compulsively, on every pilaster and every arch of the dado arcades of the chapels (Pls. 271, 273). The buttresses carry an additional type of nook-carving, and the dado arcades of the ambulatory wall enclose variously shaped masonry which further enriches the decorative scheme (Pl. 277). All these are traditional elements of architectural décor, current in the Poitou–Loire milieu for some time, but the combination is of unprecedented decorative intensity.

The documented date of the chevet of Saint-Jouin also allows a further check of the dates assigned above to other monuments, by tracing some distinctive architectural forms in the proposed chronological order. The form here chosen for this test is the clustered pier, used at Saint-Jouin in the hemicycle arcade of the ambulatory (Pl. 270).

A pier-form of four clustered shafts without any intermediate dosserets, sometimes called 'quatrefoil pier', had been introduced to Poitevin architecture in the later part of the eleventh century. It was then generally confined to nave arcades; examples can be seen at Champdeniers, the inner arcades of Saint-Hilaire-le-Grand at Poitiers, and the nave-extension of Saint-Savin. The same form was also used in the rotunda of Charroux, but ambulatory hemicycle arcades of that time retained the conventional plain columns.

In the early decades of the twelfth century, clustered piers became more prominent on two separate counts: usage and form. The usage of quatrefoil piers was extended to ambulatory arcades, while the form of piers in transeptal crossings and naves became more elaborate, consisting of multiple clusters of up to twelve shafts. According to the chronology proposed here, both innovations had matured by 1130. Examples of quatrefoil piers in ambulatories include the chevet of Saint-Jouin, 1120–30, and also the chevet of Saint-Aubin at Angers (lost, but known by a drawing), which was apparently completed in 1128.[22] Examples of multiple clusters can be found in the early twelfth-century work at Saint-Maixent and Saint-Laon in Thouars (Pls. 16, 101), and are particularly prominent at Aulnay, attributed above to 1120–30. Aulnay incorporates quatrefoil nave piers, buttresses composed of three, six, or seven shafts, and crossing piers of twelve shafts (Pl. 161). It has no ambulatory, which is why a direct comparison to the contemporary work at Saint-Jouin is impossible, but another monument fills the gap: in the church of Dun-sur-Auron, in neighbouring Berry, the ambulatory hemicycle consists of quatrefoil piers as at Saint-Jouin, whereas the crossing piers are composed of twelve shafts as at Aulnay.[23] Both forms evidently existed contemporaneously.

The sculptural styles of the second workshop of Aulnay and the chevet of Saint-Jouin may

[21] For the dating, see Crozet 1936b.

[22] For the chevet of Saint-Aubin, I accept the date suggested by Henry and Zarnecki (1957: 11–13). These authors associate the construction with a translation of relics in 1128. Yet it should be mentioned that another scholar associates the construction with another translation of relics, in 1151 (Mallet 1984: 148 and 153). The chevet of Saint-Aubin was followed by the even more complex example at Cunault, where the ambulatory piers consist of six shafts. The chevet of Cunault is undated; 1130–40 has been suggested by Salet (1964). This dating fits well the chronology suggested here.

[23] Illustrated in Tcherikover 1989b: fig. 15. The church of Dun-sur-

Auron is not dated. The structure betrays many Poitevin features; see Vallery-Radot 1931a. Some of the capitals resemble those in the chevet of Saint-Jouin. I therefore consider it as a monument of the same period, 1120–30. In Romanesque Aquitaine, there are no securely dated buildings to combine ambulatory piers of quatrefoil shape and nave piers of multiple shafts. This is probably due to an accident of survival: where there is an ambulatory, the nave and transepts belong to a separate building campaign (Saint-Jouin); where there is a nave, the choir is either lost (Saint-Maixent) or consists of a simple apse (Aulnay).

therefore be seen as contemporary. They are very different, but nevertheless share a few details. For instance, in the ambulatory of Saint-Jouin there is a head capital, poorly preserved and difficult to appreciate (Pl. 278), but close examination reveals that it is very similar to the head capitals in the nave windows of Aulnay (cf. Pl. 268), and presents the same biting jaws, pointed ears, and bulbous nose.

However, the chevet of Saint-Jouin is otherwise the antithesis of Aulnay: it is as conservative as Aulnay is innovative. Like the architectural design, the ornamental vocabulary largely perpetuates the long-established motifs of Poitou, mechanically elaborated in new ways. For instance a kind of waterleaf capital with smooth surfaces, long utilized by the Poitevin school,[24] recurs in the chevet of Saint-Jouin in a mannered version with broken and interpenetrating surfaces. This design is repeated with minor variations on all the capitals of the ambulatory arcade (Pl. 270). Other capitals, as well as imposts, are carved with plain spirals and billets (e.g. Pl. 279), perpetuating the old Poitevin predilection for geometricized embellishments. There are also some foliage designs, including one with large clustered leaves descending along the corner of the capital (Pl. 290); apparently a magnified quotation from the foliate net-capitals of the school of Melle and the first workshop of Aulnay (cf. Pls. 49, 164). Animal motifs are few and far between, and include some monsters (Pl. 280) and also the twisted-neck lions, current in Poitou at least since the choir of Parthenay-le-Vieux, in the 1090s. The new formal vocabulary of the third decade hardly made an impression on the sculptors of Saint-Jouin; besides the head capital mentioned above, the only new motif is a human hand, clad in a large sleeve, and gripping a vegetal scroll (Pl. 290).

All in all, the workshop of the chevet of Saint-Jouin emerges as a belated version of the eleventh-century architectural decorator, like him repeatedly rearranging a time-honoured vocabulary of ornaments. The result is a certain atmosphere of decadence, but also an intensified expertise. This is particularly clear in another project by the same workshop, at Jazeneuil, a short distance south-west of Poitiers. The workshop here constructed the apse of the church, decorating it with a more elaborate version of the dado arcades of the chapels of Saint-Jouin. Besides the nook-carvings (Pl. 274, cf. Pl. 273), the design was enriched by carved capitals, some of which are identical to the interior capitals of the Saint-Jouin chevet, but now expertly provided with undulating neckings to match the form of the chamfered pilasters (Pl. 276, cf. Pl. 275).[25] It was such little improvements of neckings and nooks that apparently interested the ornamentalist and could well have taken years to undergo any significant change, for which reason Jazeneuil remains undatable. All that can be said is that the date undoubtedly falls within the workshop's expected lifetime, that is, still before the middle of the century.[26]

[24] Examples can be found in the late 11th-cent. chevet of Saint-Jean-de-Montierneuf at Poitiers, in the transept of Parthenay-le-Vieux, and, around 1100, in the nave-extension of Saint-Jouin itself.

[25] For a more detailed comparison between Saint-Jouin and Jazeneuil, see Tcherikover 1989b: figs. 19–24.

[26] The choir of Jazeneuil, together with a similar choir at nearby Lusignan, was once regarded as work of the late 12th cent. The supposed evidence includes two items. The first concerns the inscriptions 'MCLXIIII' and 'MCLXLLIII' [sic] inside a niche at Jazeneuil (Lefevre-Pontalis 1903). The second concerns the fact that Lusignan castle was sacked in 1168 (Eygun 1951). The relevance of both pieces of information is, however, doubtful. Even if the Jazeneuil inscriptions refer to dates, the events which they commemorate remain unknown. At Lusignan, there is no evidence to show that the church required rebuilding after the sack of the castle. In fact, it is widely accepted that some parts of the north transept and the nave date from the 11th cent. (see Vergnolle 1985: 188). The argument for a late dating therefore proves void. The similarities to Saint-Jouin, which involve some architectural features in addition to the sculptural ones (see Tcherikover 1989b: 156–8), remain as the only indication of date.

The chevet of Saint-Jouin is not an important monument. It constitutes, however, a dated pivot for a whole group of churches. Starting from Jazeneuil and encircling Poitiers anticlockwise, similar (though not identical) formal vocabularies can be found at Lusignan, Château-Larcher, Champagné-Saint-Hilaire, Villesalem, Chauvigny, Bonnes, and many others. The relationship between some of these can be illustrated by the distribution of a type of small capital, carrying long-necked creatures paired symmetrically chest to chest and joining heads at the upper corner of the block (Pls. 280–3). At Saint-Jouin, a griffin with a long snake-tail and another creature are depicted in this way, their chests bulging and their heads unified and dominated by a very wide mouth (Pl. 281). At Champagné-Saint-Hilaire, there are quadrupeds with the same bulging chests and unified heads (Pl. 282), and also another version of the griffins, with the same snake-tail but different heads (Pl. 283). At Bonnes, the creatures are birds (Pl. 281), but distinctly similar to the griffins of Champagné-Saint-Hilaire. There are more examples, apparently produced by a variety of workshops, but their precise history still awaits research. It may nevertheless be noted that the somewhat crude character of this group cannot be dismissed as a rural phenomenon of secondary importance; the concentration of the different variants around Poitiers suggests some sort of exchange with the ducal city. Although far from exciting, the related material at Poitiers therefore merits particular attention.

Notre-Dame-la-Grande at Poitiers

The church of Notre-Dame-la-Grande at Poitiers was constructed in the eleventh century, and later received a nave-extension of two bays in a completely different style.[27] As in the first renovation project of Saint-Jouin-de-Marnes, this nave-extension was a project in itself, involving no other part of the building, and exploited for creating a new western façade.

The façade of Notre-Dame-la-Grande (Pl. 284) is a highly decorative screen of blind arcades and sculpture. It is divided by a pronounced corbel-table into two horizontal zones, the lower incorporating a deep portal flanked by two blind niches, and the upper carrying two rows of small arches punctuated by the window. As argued in the previous chapter, this arrangement of the upper zone reflects the influence of Angoulême (Pl. 219), which was completed and on view by 1128. Notre-Dame-la-Grande combines this influence with traditional Poitevin features after the older façade of Saint-Jouin-de-Marnes (Pl. 207), in particular the decorative masonry in the wide gable and the powerful corner buttresses with corner turrets.

The sculpture programme is extensive and tightly packed, at first sight chaotic but in fact involving a strict separation between ornamental and figural work. Sculpture on elements of construction, comprising all archivolts, capitals, small decorative tympana, corbels, metopes, and some exposed corners, is invariably ornamental (Pls. 285, 287–9). By contrast, the figure programme is carved on slabs, independent of the elements of construction. Some form a continuous frieze in the spandrels of the lower zone, and others are set inside the arcades of the upper zone and at the centre of the gable. Though large and ambitious, the figural elements are

[27] Crozet 1948a: 21, 108–9, 152; Labande-Mailfert 1962: 64–91; Oursel 1975: 188; Camus 1992: 28.

almost overwhelmed by the ostentatious ornamentation and are in some places physically at odds with the decorative elements. Some metopes in the corbel-table of the lower zone, for instance, seem to have been cut back to allow sufficient space for the frieze. This suggests that the figural programme was inserted late, after all the arches and cornices were already in position. It is therefore irrelevant to the present discussion.

The style of ornaments derives largely from Poitevin precedents of the late eleventh century and the first quarter of the twelfth century. It is recalled that the Poitevin style of that period involved archivolts with modular arrangements of decorative voussoirs, at first geometrical, and later enriched by animal and figural motifs on the façade of Parthenay-le-Vieux and elsewhere. Notre-Dame-la-Grande follows in the footsteps of Parthenay-le-Vieux, but preserves more of the original geometrical spirit. As at Parthenay-le-Vieux, the decorative motifs are disposed on the main faces of the voussoirs leaving the soffits blank, and comprise the same back-turned leaves (Pl. 285, cf. Pl. 83), seated dogs, and double-modular animals (Pl. 287, cf. Pl. 80). A row of peeping lions, typical of the imposts of Parthenay-le-Vieux, is repeated here on the hood of the south niche. In addition, there are some head voussoirs after the portal of Saint-Jouin-de-Marnes (Pl. 289, cf. Pl. 109), and also a certain amount of Angoulême fan-leaf. The execution is some-what rough and the forms highly stylized. Animals are bent into S-shapes and C-shapes (Pl. 287), repeated monotonously in the spirit of the geometrical décor of the eleventh century. Some of the archivolts indeed carry purely geometrical motifs (Pl. 285). The leaning towards geometrical stylizations probably arises from an old local tradition—the few geometrical voussoirs which survive from the destroyed eleventh-century façade of Saint-Jean-de-Montierneuf come to mind[28]—and it gives an archaic character to the entire complex.

This archaic quality may seem strange in a monument which otherwise betrays the influence of Angoulême, but the implied date of about 1130 can in fact be supported by a stylistic comparison to the chevet of Saint-Jouin-de-Marnes, consecrated in 1130. The comparable elements have been illustrated elsewhere,[29] and the most prominent may be briefly enumerated here. Like the chevet of Saint-Jouin, Notre-Dame-la-Grande possesses clustered shafts (in the portal and on the buttresses), geometrical motifs of spirals and billets (on the archivolts) (Pl. 285, cf. Pl. 279), a new version of the head capital (in the small arcades of the upper zone), and the new motif of a human hand gripping a foliage sprig (on a much damaged capital in the north niche). Both monuments also possess a number of comparable capitals, including those with large clustered leaves descending at the corners and climbing up the centre (Pl. 291, cf. Pl. 290). This motif is characteristic of Poitiers, where it recurs on a capital under the apse cornice of the little church of Saint-Germain (Pl. 292). The workshop of Poitiers was not the same as at Saint-Jouin, but the similarities nevertheless indicate a similar date.

Some of the other monuments mentioned above in the vicinity of Poitiers may also have been decorated by the workshop of Notre-Dame-la-Grande. The purely ornamental sculpture programme of Villesalem, for instance, has long been attributed to this workshop.[30] That church was founded shortly before 1109 (when Fontevrault won an ownership dispute over it). The

[28] For illustrations and dating see Camus 1991.
[29] For further details, see Tcherikover 1989*b*.
[30] Warmé-Janville 1979; cf. Tcherikover 1989*b*.

construction began with the east end, but the style of Notre-Dame-la-Grande is found in the later part of the work, on the nave walls (Pl. 286) and the western façade, presumably no earlier than *c.*1130.[31]

The whole group represents a run-of-the-mill production of architectural pieces which could well have continued in the same style for decades, for which reason there is little point in insisting on precise chronology.[32] Yet this conservatism is in itself illuminating, for it attests to the extreme withdrawal of the architectural ornamentalist into his own medium and away from the independent researches of the figure-carver. Of the whole group, only Notre-Dame-la-Grande possesses any monumental figure sculpture, undoubtedly executed by independent sculptors who were now free of regular architectural work.

Other Variants

The façade of Parthenay-le-Vieux was attributed above to the decade 1115–25. Its ornamental work was completed first, probably about 1120. As noted, the workshop responsible for these ornaments exercised some influence on Notre-Dame-la-Grande, but it also seems to have continued its activity separately. It thus reappeared at Vouvant, west of Parthenay, where it decorated the north transept, in particular the windows and the cornice of the transeptal chapel.[33] The style of Parthenay-le-Vieux is here immediately recognizable in the archivolt decoration of double-modular griffins balanced on little spirals (Pl. 293, cf. Pl. 81), or the imposts with knobbed foliage sheltering peeping lions (Pl. 293, cf. Pl. 88). Yet there is also a head capital and buttresses of clustered shafts, unknown at Parthenay-le-Vieux, and characteristic of the second workshop of Aulnay and the chevet of Saint-Jouin-de-Marnes, 1120–30. The same workshop probably also had something to do with the portal in the northern façade of the transept, which is, however, much restored. The little that can be trusted includes archivolt decorations of the kind which curves from face to soffit as if wrapped around the voussoirs (Pl. 294), like the animals on the much older façade of Saint-Jouin-de-Marnes (Pls. 110–12), but here they are figural and also deeply undercut in a new way. In sum, Vouvant represents yet another variation on the established Poitevin styles, incorporating some new elements.

Other workshops of the early twelfth century likewise continued their activity: for instance, the workshop which had been responsible for the south wall of Saint-Hilaire at Melle. The activity of that workshop has been noted above at Salles-lès-Aulnay, where it came into contact with the first workshop of Aulnay, *c.*1120.[34] Following that encounter, the Melle workshop apparently proceeded to Marestay, near Matha, a short distance south of the Aulnay area. Its ornamental vocabulary is here found enriched by motifs similar to those of the first workshop of

[31] On the church and its foundation, see Salet 1951; cf. Goudron de Labande 1868: 401–6.

[32] There are several opinions on the date of the façade of Notre-Dame-la-Grande and the related works at Villesalem and elsewhere. Some scholars assign the group to the middle or the second half of the 12th cent.; see Warmé-Janville 1979; Aubert 1946: 133. Others suggest earlier dates. For instance, Salet (1951) suggests a date around 1130–40 for the relevant part of Villesalem. Porter (1923: 320–1) dated the

figural sculpture in the celebrated frieze of Notre-Dame-la-Grande to *c.*1130; and the same conclusion was reached independently by a more recent scholar (Riou 1980). In my view, only the ornamental sculpture of Notre-Dame-la-Grande belongs to this period, whereas the figural work is later; see below, Chapter 5.C.

[33] The apse is in another style and the interior restored. The nave is entirely new, and adjoins the remnants of a much older structure.

[34] Chapter 2.B.

Aulnay (Pl. 295, cf. Pl. 166). The capitals display an impressive array of contorted figurines and odd creatures, including a staring manticore, bird sirens, ducks, and also pairs of seated griffins which are practically identical to some at Salles-lès-Aulnay (Pl. 296, cf. Pl. 183).[35] Such modernization as exists involves a heavier treatment of all shapes, and, in the window archivolts, some voussoirs with large and flattened heads, like those in the upper arcades of Notre-Dame-la-Grande (Pl. 297, cf. Pl. 289). Accordingly, Marestay may be assigned to the period around 1130.[36]

One of the new elements now adopted by several old workshops is the row of nook-motifs, generally more elaborate than the various buttons of the chevet of Saint-Jouin (Pl. 271). At Notre-Dame-la-Grande, there are birds and monsters (Pl. 288). The façade of Foussais (near Vouvant), attributed above to another branch of the Melle school (Pl. 298, cf. Pls. 52, 55),[37] also incorporates prominent nook-motifs shaped like crouching animals (Pl. 299). A little further south, at Maillezais, the church of Saint-Nicolas presents a portal in a style which owes much to the first workshop of Aulnay (Pl. 322, cf. Pl. 176), now enriched by very prominent nook decoration of fairly large figures standing on each other's shoulders (Pl. 323). At Maillezais, however, there intervenes a new influence which has little to do with the Poitevin traditions, and which leads back to Saintonge.

C. SAINTONGE AND ITS INFLUENCE

The Abbaye aux Dames at Saintes

Saintes was shown above to be the source of two parallel and distinct sculptural trends, both emanating from Saint-Eutrope. The first involved stern foliate capitals, carved with a limited range of lace-like compositions after the style of the late eleventh-century choir. The second originated in the exuberant combinations of foliage scrolls and vivacious creatures, carved in the early twelfth century by another workshop on the transept capitals. This exuberant style was quickly taken up by the otherwise different workshop of Angoulême and the first workshop of Aulnay, and its subsequent vicissitudes are the subject of the present discussion. The monument in which the two trends meet again is the Saintes church of the Abbaye aux Dames, and the relationship between them is reflected in the building history.

The Abbaye aux Dames was founded in the eleventh century by Count Geoffrey Martel of Anjou and the Countess Agnes, at that time regent of Aquitaine. The church was consecrated in 1047. As the building stands now, only the side walls of the nave, parts of the crossing, and parts of the transepts can be attributed to the time of the foundation. It is generally accepted that the nave was originally divided by arcades into central vessel and side aisles, and there were no

[35] Other examples, in a related style, exist at Haimps and Massac.

[36] Some documents are mentioned in Daras 1956. These suggest that the church of Marestay went through a period of multiple ownership and disputes, involving the chapter of Saintes Cathedral, the abbey of Saint-Jean-d'Angély, and the abbey of Saint-Maixent. Some sort of solution was reached during the episcopacy of Bishop Ramnulf of Saintes (1083–1107). The history of the project remains unknown,

since the church has not survived in its entirety. Presumably the construction began soon after the ownership settlement, as in some documented examples examined above, but the surviving parts seem to belong with the stylistic group that concerns us here, namely c.1120–30.

[37] Chapter 1.B.

vaults.[38] With the passage of time, this building underwent a series of modifications. The first concerned a reinforcement of the crossing piers with additional masonry, incorporating foliate capitals which may be attributed to the late eleventh century (Pl. 128).[39] This was a limited project, doubtless motivated by the wish to construct a crossing tower (though the tower itself seems later and also restored). A subsequent renovation, unrelated to the first, was much more extensive. The building received a new western façade (Pl. 300), the apse was completely reconstructed, the transepts were partly remodelled, and the interior of the nave was transformed into an aisleless and unified space. The alteration of the nave was particularly radical: massive piers were built against the old walls for the purpose of carrying domes (Pl. 301), as in the nave of Angoulême Cathedral, and probably under its influence.[40]

Two separate sculpture workshops participated in the main renovation project. Each followed one of the trends defined above, respectively the 'stern' and the 'exuberant'. The exuberant workshop decorated the lower part of the western façade (Pls. 303–7, 309–15), excluding, perhaps, the cornice, which is carved in another style (Pl. 316). At the other end of the building, the stern workshop was engaged on the new apse, producing capitals with lace-like foliage (Pls. 253, 254). This workshop reappeared in the nave, where it provided similar capitals for the piers which carry the domes (Pl. 255, cf. Pls. 253, 254), and, equipped with some new foliate patterns, it also executed the upper zone of the façade (Pl. 256). When this workshop reached the façade, it must have found the lower zone completed and ill suited for the new interior design of domes, since the necessary supporting piers now had to be added. The two at the west end consequently abut against the reverse of the façade with a different type of plinths and bases. Some structural elements on the interior of the façade were now made redundant, in particular a pair of twin shafts of unknown original purpose (Pl. 301).[41]

The course of the work may accordingly be reconstructed as follows. The two workshops started on two separate renovation campaigns, respectively at either end of the building. It is possible that the apse, by the stern workshop, began first. The project of the western façade was undertaken independently by the exuberant workshop, and was intended as a kind of face-lift for the old nave. The new façade was actually built some three metres to the west of the original west end of the nave,[42] presumably in order to delay as long as possible all interference with the old nave. The exuberant workshop completed the lower zone and then disappeared from the scene. The stern workshop had meanwhile completed the apse and now proceeded to the nave. Only at that point was the nave transformed into a domed structure. The higher parts of the façade were then completed by the same stern workshop. The process is not essentially different from the one noted above at Angoulême, where a reconstruction began within a short space of

[38] On the 11th-cent. foundation, see Grasilier 1871: p. i; and, on the 11th-cent. building, Crozet 1956e; Crozet 1971b: 41–3.

[39] See above, Chapter 2.A.

[40] The 12th-cent. remodelling was discussed by several scholars, notably Tonnellier 1970: 593; Crozet 1956e: 109–10; Crozet 1971b: 48. The vaults of the transept were constructed in a subsequent building campaign; they can be paralleled in the Early Gothic cathedral of Poitiers.

[41] I once thought (and wrote in my doctoral thesis) that these shafts were built when there was still an intention to retain an aisled nave,

but I am no longer sure about this. They reach a different height from the nave-facing shafts of the crossing piers, so the height of any arcade they might have received would have been oddly uneven. Although the building was originally divided by arcades (Crozet 1971b: 42–3), these might have disappeared by the period that concerns us here. Crozet, however, thought that new arcades were envisaged at that time, but the project was abandoned in favour of the unified and domed design (ibid. 48).

[42] The foundations of the original western façade are known from excavations (Crozet 1971b: 43).

time at both the east end and the west end (albeit by one workshop), and only later advanced to the middle and the higher parts.

This analysis of the order of construction throws new light on several disparate indications of date, which separately are weak but taken together corroborate each other. First, there is a celebrated inscription, found around the façade corner. It states that the monastery was built by one Berengarius, apparently a stone mason. Its wording contains a play on the name Petrus in connection with Berengarius's proficiency in working stone, *petra*, and arguably in honour of the bishop of Saintes and former canon of Angoulême, Peter of Confolens.[43] Bishop Peter was in office between 1112 and 1127. The apse of the Abbaye aux Dames may be assigned to the later part of this period, because its style of capitals recurs, as noted, in the nave of Aulnay, attributed on independent grounds to 1120–30. As suggested by the analysis of the Saintes building, the construction of its western façade was undertaken at about the same time. The next stage of the project turned on the decision to vault the nave by domes, after Angoulême, which was completed by 1128. That stage also involved the higher part of the façade, which must have been completed and on view by 1146–51; this is the date of a well-known charter referring to 'the Constantine of Rome who is found in the right-hand part of the church', undoubtedly the equestrian statue which is known to have existed on the upper north side of the façade.[44]

In sum, the dates which may be assigned to the Saintes project are 1120–30 for the apse; a similar date, perhaps nearer 1130, for the lower zone of the façade; and 1130–45 for the later works in the nave and the higher part of the façade.

The renovation as a whole followed a period in which the abbey's fortunes were on the rise. It was one of the few in Aquitaine to have been accorded the status of an independent abbey answerable directly to Rome and immune from all other intervention, in accordance with a deliberate policy of the Gregorian papacy from the late eleventh century onwards.[45] In addition, the abbey also increased in the favour of the Aquitainian ducal family. The abbess appears in the ducal entourage during the lifetime of Duchess Philippa (*ob.* 1117/18), while the later abbesses Sybille of Burgundy (*c.*1119–34) and Agnes of Barbezieux (*ob.* 1174) were themselves of the ducal family.[46] As earlier at Saint-Jouin-de-Marnes, the combination of ecclesiastical reform and lay patronage may seem self-contradictory, but it reflects one of those compromises characteristic of the more peaceful implementations of the Reform, and one beneficial to all sides. Church ideology, and hence church iconography, apart, social and economic interests were not ignored and aristocratic donations were fittingly rewarded by various services and positions. A certain amount of conspicuous building work is therefore to be expected. The situation at the Abbaye aux Dames was somewhat similar to that at Fontevrault, where an ambitious church was being

[43] For the inscription and the corroborating documents on Berengarius, see Favreau and Michaud 1977: 115–16; Tonnellier 1970.

[44] In the charter, one William David expresses a wish to be buried 'sub Constantino de Roma qui locus est ad dexteram partem ecclesie'. On this charter and its date, see Sauvel 1943. The relevance of the document depends on the identification of 'Constantine of Rome' with the equestrian statue that once existed on the façade, which scholars at some point doubted, but which now seems certain; see above, Chapter 3.B. Perhaps the rider was destroyed as early as the 16th cent. (Gabet 1990: 114), though traces of it were still noted in the 1840s (see Sauvel 1936: 182–6). These traces disappeared when win-

dows were pierced in the niches some time in the 19th cent. (Pl. 300). The architecture, though not the sculpture, was eventually restored; see Crozet 1956e: 106. The architectural articulation of the upper zone of the Saintes façade was closely imitated on the western façade of Saint-Amant-de-Boixe; cf. Mendell 1940: 49. This was constructed, with the rest of the nave of Saint-Amant, at some point after the completion of the first campaign, 1125, and before the solemn consecration in 1170; see above, Chapter 3 n. 98.

[45] Fliche 1950: 281.

[46] Richard 1903: i. 462–4, 495.

completed in the same period under similar circumstances of ducal connections.[47] In fact, like the renovated nave of the Abbaye aux Dames, that of Fontevrault was designed with domes after the model of Angoulême Cathedral;[48] evidently a popular design in this ducal circle.

The Exuberant Style

Executed by the exuberant workshop about 1120–30, the lower zone of the façade of the Abbaye aux Dames (Pl. 300) comprises a portal and two niches (pierced by windows in the nineteenth century and later restored). This design amounts to a triple arcade, later to be supplemented on the upper zone by a corresponding triple arrangement comprising a window and two niches (also pierced by windows and restored). The triple arcading stretches across the entire space and overlaps a tripartite division by buttresses,[49] according to a scheme current from the second decade of the twelfth century.[50] As already noted, overall arcading of this kind came into being partly under the influence of Angoulême and partly for technical reasons. It thus provided a neat solution to the problem of accommodating a deeply recessed portal, which in that period became increasingly common. Comprising four orders of colonnettes and archivolts, the portal of the Abbaye aux Dames was no longer annexed to an unsuitably thin wall, as earlier at Saint-Jouin-de-Marnes (Pl. 207); its depth now dictated the thickness of the entire lower zone (and eventually also the upper zone), while the side spaces were alleviated by the blind arches. The system is similar to that used at about the same time or slightly later in the lower zone of Notre-Dame-la-Grande in Poitiers (Pl. 284), though details vary and the upper zone is entirely different.

The decoration of the deep portal, which dominates the whole sculpture programme, apparently involved a conflict between two different systems. The first was the veteran Aquitainian system of predominantly ornamental portals, sometimes supplemented by a programme of monumental imagery on the higher parts of the wall. The second, current contemporaneously in Burgundy and elsewhere, centred on the portal itself as the main carrier of the figure sculpture. As will be seen, the sculptors of Saintes paid tribute to the second system and accordingly infused a figure programme into their portal decorations, but they forced it into the ornamental framework of the habitual Aquitainain system (Pl. 307). The more important figure programme, unfortunately lost except for one statue (top southern corner), was completed later by a different workshop on the higher part of the façade. The lower zone preserves some mutilated remains of sculpted slabs, positioned in the spandrel area of the portal and above the niches (Pl. 302), but it cannot be said whether these belonged to the original project.[51]

[47] Duchess Philippa retired at Fontevrault (Richard 1903: i. 473–4). She was followed by her daughter, Agnes of Thouars (Vajay 1966), and eventually by her granddaughter, Eleanor of Aquitaine.

[48] See most recently Mallet 1984: 120–2.

[49] The tripartite division may reflect an originally aisled articulation of the nave, before its transformation into a unified space vaulted by domes, but there is no direct evidence for this. See n. 41 of this chapter.

[50] See above, Chapter 3.A.

[51] These slabs may represent the remains of a frieze; see Sauvel 1936: 182–6. I doubt, however, that they belonged to the original design of the lower zone. The slabs are of different sizes, and spare spaces are filled with displaced decorative elements including some metopes (Pl. 302). This suggests rearrangement, as in the spandrel zone of the Puerta de las Platerías of Santiago de Compostela. Perhaps these pieces were originally intended for the upper zone, and were rearranged about 1130–45, when the upper zone was constructed by a different workshop (see above), and after a real spandrel frieze appeared on the façade of Argenton-Château (Pl. 342); see Chapter 5.A and 5.B. The location of the slabs also calls for a comparison with the celebrated spandrel frieze of Notre-Dame-la-Grande at Poitiers (Pl. 284), and this frieze is in my view even later; see below, Chapter 5.C.

The sculpture programme of the lower zone spreads on a series of archivolts and capital-friezes, both in the portal and in the side niches (Pl. 307). The exuberant style of these carvings recalls the capital-friezes in the crossing of Saint-Eutrope (Pl. 303, cf. Pl. 143), which were doubtless its ultimate source. However, the style of Saint-Eutrope was by now old and already superseded by new versions, notably those created by the workshop of Angoulême (lower zone of the façade) and the first workshop of Aulnay (choir and transepts). The version of the Abbaye aux Dames can be shown to combine them all.

The spirit of the Aulnay version, which is also the most dainty, permeates the complex throughout. As at Aulnay, there are crouching figures on the soffit of some voussoirs (Pl. 311, cf. Pl. 176), hoods with running animals, and capitals with light and hyperactive figurines, some engaging in violent struggle with animals and monsters (Pls. 303, 305, cf. Pls. 171, 172). The playfulness of Aulnay, so different from the earlier regularity of Saint-Eutrope, was now brought to the verge of chaos.

The figure style, especially on the archivolts, nevertheless follows directly from Saint-Eutrope, with the same odd curvatures and double-line patterning (Pl. 313, cf. Pls. 151, 152). Now turned soft and even limp, this is the version of the Saintes style also traced above from Saint-Eutrope to the Angoulême master of St Peter, who was engaged on the project of statuary in the upper zones of the Angoulême façade, *c.*1120–5 (Pl. 313, cf. Pls. 236, 237). The Saintes workshop can thus be seen to be at the threshold of monumental figure-carving, but at Saintes itself it did not cross over. The return influence from Angoulême was rather of the ornamental sort, and involved the characteristic fan-leaf (Pls. 303, 304, cf. Pls. 192, 195) and some other decorative conventions described below.

As shown in a previous chapter, one of the sources of all the exuberant styles was Lombard.[52] Saint-Eutrope emerged as the main junction of this influence, though the evidence is limited to the interior capital-friezes while the nature of the sculpture on the lost western façade is little known.[53] This gap is partly filled by the Abbaye aux Dames, which may well have imitated the lost work at Saint-Eutrope. The portal of the Abbaye aux Dames is in fact the most Italianate so far considered. Its dense ornamental embroidery, spreading uninterrupted on the capital-friezes and on the elaborate system of archivolts, doubtless goes back to Lombard works such as the portals of San Michele at Pavia (Pl. 307, cf. Pl. 308), though details vary. The ornamental character of the work is consequently intensified despite a generous infusion of figural themes.

The figural programme could not be easily reconciled with this ornamental exuberance. With few exceptions, most of the figural elements are small and practically inundated by the ornamental scheme, as in the old mini-programmes on capitals and voussoirs. In the portal (Pl. 307), the figures are disposed on four archivolts, alternating with thin intermediary archivolts of pure ornamentation. The innermost of the main archivolts is dedicated to the Hand of God accompanied by a retinue of angels. The next presents the Lamb of God with the Four Beasts of the Apocalypse, all somewhat deluged in foliage scrolls. After that, thematic clarity succumbs to the

[52] Chapter 2.A.

[53] Descriptions prior to the demolition of the nave of Saint-Eutrope (1831) refer to a façade programme comprising carved archivolts (no specifications), signs of the Zodiac, a rider, and four blind arcades enclosing reliefs (no specifications); see Sauvel 1936: 181. It is not certain that all these features belonged to the original building campaign; the façade could have been erected and decorated in several stages, as in the Abbaye aux Dames.

decorative distortions typical of radiating voussoirs, even more than in the transept portal of Aulnay.[54] Fifty-four Elders of the Apocalypse, over twice the canonical number, are thus repeated voussoir-by-voussoir on the outermost archivolt. They generally turn towards each other in pairs, in vague memory of double-modular voussoirs. Similarly, the scene of the Massacre of the Innocents is represented on the remaining archivolt in a triple-modular fashion, with a soldier, a child, and a woman repeated every three voussoirs along the entire arch (Pl. 309). It will be shown below that this scene was taken from a conventional iconographical cycle, used more sensibly elsewhere, yet it was here forced into the architectural and ornamental straitjacket of the modular system and its meaning was blurred.[55]

On the archivolt of the south niche, the twelve Apostles sit at the Last Supper, each on his own voussoir (e.g. Pl. 311, on the right), with Christ at the centre. This scene is central to Christian iconography in that it represents the institution of the Eucharist by Christ himself. However, since the scene requires only thirteen voussoirs, the rest are allocated to various devils and crouching figurines (Pl. 310). Although these may possess a symbolical meaning, they also serve as simple space-fillers and therefore impair the iconographical clarity.

In the north niche (Pls. 312, 313), the figures are disposed longitudinally and woven into foliage scrolls, much like the birds and lions on the archivolts of the lower zone of Angoulême. They even reproduce the posture of the Angoulême creatures—repeatedly bent backwards—as if they were another ornamental motif of the same kind (Pl. 313, cf. Pl. 200). It therefore takes some effort to discover that these figures nevertheless amount to a meaningful scene. Christ (at the top, identified by the cruciform nimbus) addresses a group of saints holding books, probably the Apostles. The sanctity of the scene did not prevent the sculptor from supplementing the design, at the bottom, with naked figures clambering in the scrolls, like the decorative figures on the hood of the opposite niche (Pl. 313, cf. Pl. 314).

There are evidently some new iconographical elements in this programme, but such distortions suggest that the Abbaye aux Dames is hardly the place to assess their importance. The sculptors seem to have been more interested in the manifold technical possibilities of organizing sculpture on archivolts. This means not only a choice between radiating and longitudinal compositions, but also a variety of ways for correlating the sculpture on the face of the archivolt with that on the soffit. The complex of the Abbaye aux Dames testifies to enthusiastic manipulations of all the previously known systems. Some of the radiating decorations involve one set of motifs on the main face and a separate set on the soffit, as at Aulnay (Pl. 311, on the left, cf. Pl. 176). Others are limited to a single set of motifs, curving from face to soffit as if wrapped around the archivolt, as at Saint-Jouin-de-Marnes (Pl. 309, cf. Pl. 110). The longitudinal scrolls, after Angoulême, are treated in both ways, sometimes confined to the main face (Pl. 313) and sometimes curved and wrapped over both sides (in the portal). In addition, there are hybrid systems: some carvings of the Aulnay type, that is, separate for face and soffit, interweave at the arris to resemble the curved compositions (Pl. 310); many of the curved figures, 'wrapped' over both sides, sharply bend their knees at the arris as if to re-create a separation between the face and the soffit (Pl. 311, on the right).

[54] The portal of Aulnay is discussed above, Chapter 2.B.

[55] According to one interpretation, the Massacre of the Innocents appears at Saintes as a symbolic reference to Martyrdom (Seidel 1981: 45–6). I prefer to see in it an extract from an Infancy cycle which appeared in the region with the rising popularity of Marian themes; see the discussion of Nuaillé-sur-Boutonne in part D of this chapter.

The correlation of face and soffit means that the archivolt is to be viewed simultaneously from both sides, like sculpture in space rather than bas-relief.[56] This spatial quality was doubtless considered important, since it was further intensified by extreme undercutting which throws the relief away from its architectural background. Some of the radiating figures (Pl. 311), for instance, are so deeply undercut that they seem to take over the bulk of the voussoirs. The naked figurines on one of the hoods (Pl. 314) are carved practically in the round, freely twisting and turning in space. On one archivolt with inhabited scrolls the deep undercutting creates an illusion of overlaid pierced work (Pl. 313). The Saintes workshop thus matched the three-dimensional experimentation of the figure-carvers of Angoulême with spatial essays of its own, albeit in a strictly architectural and ornamental context which perpetuates and even enhances all the old distortions.

The Experimenting Ornamentalist

The decorative conventions of the Abbaye aux Dames at Saintes proved a great success. They were imitated by a variety of hands throughout Saintonge and Angoumois; examples include the interior embellishments of Marignac, Étriac, and Conzac, the western façades of Châteauneuf-sur-Charente, Corme-Écluse, Avy, Saint-Symphorien, and others, besides distant derivatives in Bordelais to the south and Poitou to the north.[57] Some of these monuments are perhaps contemporary with the Abbaye aux Dames but others could well be later; *c*.1125–50 for the whole group is as good a guess as any. There is little point in aiming for more precise dates, because not only are there no documents but even chains of influence can barely be traced. As in the Abbaye aux Dames itself, the sculptors experimented concurrently with several stylistic systems, and the result was a different and original combination for almost every project.

All the different variants nevertheless share some qualities which may be taken as characteristic of the period, in particular the increasingly three-dimensional manipulation of archivolt sculpture in the manner of the Abbaye aux Dames. This can be illustrated by two different idioms, the one common to Saintonge and Angoumois and the other common to Saintonge and Poitou.

The first idiom can be traced from the façade of Châteauneuf-sur-Charente, a short distance from Angoulême, to the façade of Corme-Écluse, west of Saintes. The archivolt decoration in both places is essentially of the Angoulême type of inhabited foliage scrolls, disposed longitudinally on the main face of the archivolt. At Châteauneuf-sur-Charente (Pls. 317, 318), the designs are even bordered by a raised rim at the arris, as at Angoulême (cf. Pls. 199, 200), though the execution was doubtless by the workshop of the Abbaye aux Dames at Saintes. The innermost archivolt thus carries a somewhat muddled version of the Saintes archivolt with the Lamb of God and the Four Beasts, supplemented by an extra angel and an extra lion. The angel is very

[56] Cf. Werner 1979: 34. Werner envisaged an evolution from bas-relief separate for face and soffit, as at Aulnay, to the correlated scheme of Saintes. However, according to the chronology suggested here, each of the different methods for carving voussoirs had existed separately earlier, and they were merely combined at Saintes. For a detailed reappraisal of the evolutionary approach, see Tcherikover 1989a: 58–61.

[57] Some of the Poitevin examples are discussed below. The Bordelais group has recently been presented in *Congrès archéologique de France* (1987, appeared 1990).

similar to the convulsed figures in the north niche of the Saintes façade (Pl. 317, cf. Pl. 313). Another archivolt carries a lively combination of fan-leaves, lions, and dancing manikins, as on the capitals of Saintes (Pl. 318, cf. Pl. 304). This design is repeated at Corme-Écluse with some significant changes (Pl. 319). The restrictive rim at the arris is omitted, resulting in an effect of overlaid pierced work as at Saintes (cf. Pl. 313), with additional complications: the exposed edge of the pattern is exploited for a round view of the figurines, from the soffit as well as the main face (Pl. 320). The spatial experiments of Saintes were thus taken a step further in the direction of three-dimensional archivolt sculpture.

The second idiom is represented by a group of monuments distributed between the maritime side of Saintonge and the adjacent Marais Poitevin. These include, in what seems to me the correct chronological order, the portal of Saint-Symphorien, the portal of Saint-Nicolas at Maillezais, and another portal at nearby Maillé.

The origins of this group are essentially Poitevin. The sculptor who produced the middle archivolt in the portal of Saint-Symphorien (Pl. 321) chose double-modular animals as at Parthenay-le-Vieux (Pl. 80), wrapped them around roll archivolts as at Saint-Jouin-de-Marnes (Pl. 111), and then deeply undercut them. Yet the outer archivolt of the same portal is carved with figures which bend their knees at the arris, as in the Abbaye aux Dames at Saintes, no doubt in imitation of that monument (cf. Pl. 311). The deep undercutting likewise recalls Saintes but could have been independently devised; as, for instance, in the Poitevin church of Vouvant (Pl. 294).

The portal of Maillezais presents another combination of originally disparate models (Pl. 322).[58] On the main face of the archivolt there are double-modular creatures of the Poitevin type; the soffit is dedicated to crouching atlantes with trouser-like garments of the type of Aulnay; and the two sets of motifs interweave at the arris, as in the Abbaye aux Dames (cf. Pl. 310).

The prize for assimilating all the Poitevin and Saintongeais types of radiating voussoir compositions surely belongs to the portal of Maillé (Pl. 324).[59] On the innermost archivolt there are double-modular animals. On the adjacent archivolt, a lion is depicted on the main face of each voussoir, stooping over a human figure which emerges from the soffit (Pl. 327). The next archivolt carries a row of acrobats alternating with musicians, their legs folded on the soffit in the manner of the curved figures of Saintes. The outermost archivolt carries a row of figures holding foliate twigs (Pl. 325), evoking the Apostles who are flanked by such twigs on the voussoirs of the south niche at Saintes (cf. Pl. 311), but apparently stripped of their original meaning. Indeed, these figures are interwoven with soffit atlantes like those at Maillezais in a purely ornamental fashion (Pl. 326, cf. Pl. 322). It may be observed that the size of the soffit motifs corresponds to the depth of the carving on the main face, as in the overlaid pierced work of Corme-Écluse, and leaving the rest of the soffit blank. This is where all attempts to force the Aquitainian ornamentalist into some pattern of linear development reach a dead end. The sculptors of Maillé actually retreated from the Saintes tendency towards meaningful iconographical themes and fully carved soffits, and 'developed' only in what concerns the mastery of undercutting.

[58] The rest of the Maillezais façade is much restored, whereas the tower above and the nave are completely modern. There is some original work also at the east end. The restoration is discussed in Dillange 1983: 124.

[59] The lower part of the western façade, together with the portal, is the only surviving part of the Romanesque church. See Dillange 1983: 111.

Just how diverse was the sculptural experimentation of the time can be illustrated by an additional example of completely different lineage, on the façade at Ruffec, up the Charente river from Angoulême. The little that survives unaltered on this façade follows directly from Angoulême, and includes a portal and a set of statues.[60] The statues, positioned in the upper zone, may be attributed to the sculptor of the fifth zone of the Angoulême façade; his style is immediately recognizable in the arched postures of the figures and their feeble positioning on patches of ground-line (Pl. 328, cf. Pl. 238). It may be remembered that this sculptor executed some of the last pieces of the Angoulême façade, perhaps even after the completion of the original project (by 1128). The façade of Ruffec may therefore be assigned to the period around 1130 or possibly somewhat later. This provides some indication of the date of the portal, which forms an integral part of the façade but was executed by an independent ornamentalist. For the design of the portal archivolts (Pls. 330, 329), this ornamentalist borrowed from the lower zone of Angoulême the characteristic running patterns of birds and monsters embroiled in scrolls of fan-leaves, which he now threw into space by means of extreme undercutting, as at Maillé or Corme-Écluse. On the outermost archivolt he also buried a corner roll inside the sculpted design, thereby creating a spatial reversal of the traditional planes of relief. This trick of the buried roll can also be noted on the celebrated trumeau of Souillac, which may be seen as one of the high points of the ornamental trend of the south despite some figural interpolations, and is usually assigned to approximately the same period in the second quarter of the century.

Contrary to some firmly fixed notions on the Middle Ages in general and ornamental work in particular, perhaps these sculptors should be envisaged in terms of true artists, ever exploring new compositional possibilities even where the formal vocabulary was copied, and abandoning some of these compositions after a single experiment. At Maillezais, for instance, the Poitevin inclination towards prominent nook-motifs took on a special twist, with relatively large figures climbing up the embrasure (Pl. 323). Doubtless another figural curiosity by the experimenting ornamentalist, nook figures on that scale were never repeated in Aquitaine.

D. ARCHITECTURAL SCULPTURE AT THE CROSSROADS

The Emergence of an Aquitainian Regional School

The period from *c.*1120 onwards was shown above to be one of intense activity on numerous ecclesiastical building sites throughout the region. As a further check on the proposed chronology, it may be asked what were the reasons for this impulse, and whether any sign of intensified activity can be detected in the character of the works themselves.

Around 1120–30 several of the historical processes mentioned in the course of this investigation reached their peak. Demographic expansion and the corresponding movement of land recuperation were on the increase until about 1125 and brought new economic prosperity,

[60] At Ruffec, the coherence of the façade composition is somewhat obscured by later changes. Later stonework exists inside the portal and window, while the gable is partly ruined. The archivolt of the south niche and some corbels seem to have arisen from a restoration project.

attested to by the foundation of the trading town of La Rochelle in 1130.[61] Church ownership was no longer a problem; by *c.*1120, practically all churches had already been extracted from lay hands together with various dependent revenues. In addition, events affecting the Western Church in general created a new atmosphere; the Investiture Contest was temporarily resolved with the Concordat of Worms, 1122, and the Church saw itself as victorious. Perhaps the lay rulers were not quite subdued, but the wresting of so much wealth from lay hands was in itself a victory, now supplemented by tighter organization as a result of decades of reform in the ecclesiastical ranks. The triumph of the Church was further accentuated by the successes of the still young crusading movement, which depended strongly on papal propaganda, a sentiment of pilgrimage, and temporary religious vows. This movement added an appearance of political reality to the quasi-imperial attitude now adopted by the Church.[62]

From the point of view of the church builder and decorator, all this meant more work. More ecclesiastical projects of every size and rank were undertaken in the old towns and the new villages, supported by recently accumulated wealth and the striving for ostentation befitting a victor. The sheer quantity of these projects meant that a builder or sculptor could find employment within a limited geographical area for his entire career, which I believe to be the reason for the essentially subregional character of practically all the ornamental styles described above, whether in Poitou, Saintonge, or Angoumois. There was indeed a certain amount of interchange between the subregions, but a Saintongeais influence on Poitou (e.g. at Maillé) or a Poitevin intrusion in Berry (e.g. at Dun-sur-Auron) is now immediately recognizable as such. More work also meant an increasing number of workers, which seems to be the explanation for the barely traceable diversity noted above within the subregional schools. A growing number of sculptors created endless regional and subregional variations, never lacking an opportunity to try something new.

Another process to reach a decisive stage around 1120–30 was the Aquitainian shift of regional orientation from north to south. The south was up and coming, and its buildings increasingly served as models for imitation. The earlier direction of influences, from the Loire Valley southwards, was now largely reversed. If the Poitou–Loire milieu had produced the first figured façades of the turn of the century, as represented by Chinon and Saint-Jouin-de-Marnes, from 1120–30 onwards that milieu was on the receiving end. The façade of Notre-Dame-la-Grande at Poitiers (Pl. 284) accordingly combined the Poitou–Loire tradition with overall arcading containing statues after the model of Angoulême (Pl. 212). At about the same time the influence of Saintes permeated Bas-Poitou, as already discussed in the context of Maillezais and Maillé (Pls. 322–7). It may be added that even the Loire Valley was now subject to southern influences. The nave of Fontevrault, the cloister of Saint-Aubin at Angers, and other monuments, all present local variants of the ornamental idioms of Angoulême, Saintes, and their Poitevin derivatives.[63] Where figure sculpture was concerned, the Poitou–Loire milieu was still to recover its innovative spirit and influence in an impressive way, but, as will be seen in the next chapter, the innovations quickly succumbed to the aesthetic attitudes dictated by the south.

[61] Dunbabin 1985: 268; Gillingham 1984: 43.
[62] On the Reform, see above, Chapter 1.A; on the First Crusade, Riley-Smith 1986.

[63] Mallet 1984: 120–2 and 139–46; Connolly 1979.

The result of this series of influences was an overall Aquitainian accent, governing the different subregional variations, and even muffling some of the persistent differences between the Poitou–Loire idiom and the southern ones. It may be said that a school of Aquitaine came into being only now, centring on Saintonge, Angoumois, and Poitou, and in many ways distinct from other regional schools. At the same time, foreign influences became increasingly sparse. New Italian influences, for instance, can perhaps be detected here and there,[64] but none equals the wave of Italianisms characteristic of the previous generation. The influence of the Muslim world, though possibly to be expected in this period of crusades to the East and military expeditions to Arab Spain, remained negligibly sporadic.[65] The influence of the north was later to recover, but long remained limited. In short, the period following *c.*1120 was one of growing regionalism, certainly in Aquitaine, perhaps elsewhere too, though the extent of the phenomenon exceeds the scope of this study.

A synopsis of the various workshops already described reveals some of the identifying marks of the new Aquitainian accent. For instance, all these workshops tended towards ornamental over-elaboration. This is particularly clear in the decoration of portal archivolts, which combined previously distinct ornamental systems in increasingly complicated ways (Pls. 287, 307, 324). Nook-carvings were exploited for additional playful fineries. They were now enriched by animal motifs of the sort normally reserved for capitals, archivolts, and corbels; increasingly elaborate examples can be noted at Aulnay, Saintes, Poitiers, and Foussais, culminating in the figural nook-carvings of Maillezais (Pls. 288, 299, 323). In the same spirit of over-elaboration, some long-established ornamental devices were now put to new and unexpected uses. The decorative hood, which normally surrounds the outer order of a recessed arch (for instance, in the Aulnay portal) (Pl. 175), was multiplied at Saintes and appended separately to each of the four orders of the portal, creating an additional narrow archivolt (Pl. 307). Similarly, some corbels on the façade of Notre-Dame-la-Grande lost their function as cornice-supports, and were grouped around the window to form an additional archivolt.[66]

The same kind of mannered elaboration is seen in some of the architectural detail. Clustered shafts, for instance, appeared where they had never existed before, even in portal embrasures. Notre-Dame-la-Grande is one example, with triple shafts on both the innermost and the outermost orders of the portal (Pl. 284). An added shaft on the innermost order appears also in the portal of the Abbaye aux Dames (Pl. 307), as opposed to the straight inner order of practically all the portals of the previous generation, including those at Melle, Parthenay-le-Vieux, Saint-Jouin, and Aulnay (Pls. 63, 79, 175). Before long, portals were to be treated with a row of clustered shafts across the entire embrasure, to the exclusion of all straight recesses; the western portal of Aulnay is an example of this (Pl. 350).

One of the more pronounced characteristics of the period was the tendency towards sculptural articulation in the round, in preference to bas-relief. The figure-carvers and the ornamentalists alike shared this tendency, respectively from Angoulême and the Abbaye aux Dames onwards. There can be little doubt that both kinds of sculptors continued to pursue such

[64] For instance, in the iconography of the frieze of Notre-Dame-la-Grande; see Porter 1923: 320–8.

[65] On Islamic influences in French Romanesque, see Watson 1989.
[66] Cf. Henry and Zarnecki 1957: 10.

spatial experimentation in parallel. At Ruffec, for instance, the three-dimensional ornament on the portal archivolts and the statues in the upper zone must belong with one and the same project, because both are surrounded by foliate hoods of precisely the same workmanship (Pls. 328, 329), and one that arises, like the statues themselves, from the upper zones of Angoulême (cf. Pls. 229, 230, 236, 237).

The Theory of Architectural Sculpture

At some point all studies of French Romanesque sculpture need to come to grips with the only theory so far advanced on stylistic processes, that of Henri Focillon, which implies a gradual evolution from the architectural decorations of the eleventh century to the monumental figure sculpture of the twelfth. Focillon postulated that the figural traditions of the Early Middle Ages coalesced with the traditions of architectural stone-carving during the eleventh century, and that the ensuing architectural figure sculpture eventually evolved into monumental figure ensembles.[67] However, the material so far examined suggests rather a rupture between architectural decorations and figure sculpture. The traditional architectural sculpture on capitals, corbels, and archivolt-voussoirs was exploited for figural innovation only to a limited extent, and very quickly fell into the hands of sculptors who specialized in ornament. In consequence, by c.1120–30 architectural sculpture had become embroiled in themes and techniques peculiar to itself, having no bearing on mainstream figure sculpture. Monumental imagery had arisen independently, had drawn on other sources, had gained momentum as free slab-relief and statuary, and had increasingly become a matter for specialists. New combinations of architecture and figure sculpture were indeed to come, eventually leading to proto-Gothic, but this was an independent process unrelated to the old architectural sculpture of the eleventh century. A brief synopsis of the material so far considered will illustrate these points.

Regarding the attitudes towards iconographical programmes, much has already been said above on the decline of the architectural sculptor's mini-programmes, especially on radiating voussoirs. The themes chosen for such voussoir programmes simply failed to be transmitted to the monumental sculpture of the time. Even the important theme of the Elders of the Apocalypse, so popular on radiating voussoirs, remained extremely rare in the monumental programmes of Aquitaine.[68] In addition, the voussoir programmes themselves sank ever deeper into architectonic and ornamental distortions, notably at Aulnay and Saintes. Similarly, other early types of archivolt decoration, such as the inhabited scrolls of the lower zone of Angoulême,

[67] Focillon's wording is deliberately obscure, and others understood that the shape and the volume of the architectural ornaments were gradually transformed into figures, which eventually grew in size and came to stand in their own right; see especially Baltrušaïtis 1931. It is not clear whether Focillon himself originally saw the process as evolution in time; in his book of 1931 (esp. pp. 19–20) all phases of the process are said to have existed in parallel. However, in his later book of 1938 (Focillon 1969 edn.: 111) he claimed that his system 'will enable us to recognize, if not to solve, the historical problems posed by

the evolution of the sculpture of the Romanesque period'. This was the message conveyed to later scholars, e.g. Aubert 1946: 38; Werner 1979: 33–5; and, with some reservation, Vergnolle 1994: esp. 236, 282–3, and 338–42.

[68] The best-known monumental example, in the tympanum of Moissac, goes back to independent sources; see Mezoughi 1978. The theme of the Elders recurs on a proto-Gothic archivolt of Notre-Dame-de-la-Couldre in Parthenay, but this example, too, belongs to a separate lineage; see below, Chapter 5.C.

generally remained an ornamental genre. If injected with some figural subject-matter, as at Châteauneuf-sur-Charente and Saintes, this was somewhat confused and quickly reverted to the habitual ornamentation, as at Corme-Écluse.

The architectural sculptor had more to offer in technical matters, especially his methods for articulating the sculpture in space. As noted on capitals from Airvault (Pls. 30–3) to the second workshop of Aulnay (Pls. 266, 268), the essence of his method was to correlate the design on different sides of the block, and substitute sculptural elements for projecting corners and other such salient architectural parts. From *c.*1100 onwards, archivolt voussoirs were subjected to similar treatment, notably those of the roll type. 'Wrapped' in relief around both the face and the soffit, as at Saint-Jouin-de-Marnes (Pls. 110–12), such archivolt compositions necessarily infringe the restrictions of the single plane. It takes only the additional undercutting of Saintes to throw the relief into space (Pls. 310, 311). By the time of Saintes, however, three-dimensional statuary already existed, at Angoulême (Pls. 232–7). It owed its existence to the re-creation of an antique concept of statuary, sometimes drawing directly on antique models (Pls. 242, 243, cf. Pls. 244, 245), and in any case totally unrelated to any previous experimentation on capitals and archivolts.

Three-dimensional statuary was now to go from strength to strength, while the experiments of the architectural sculptor followed a completely different and in some ways regressive course. It was not the spatial possibilities of the Saintes archivolt compositions that appealed to the imitators at Corme-Écluse or Maillé (Pls. 319, 320, 324–7), but the decorative possibilities inherent in the shimmering surface of highlights and deep shades, the result of extreme undercutting, and as confusing to the eye as the excessive ornamentation itself. One outcome of such processes was a series of façades which combine monumental statuary with highly contrasting architectural ornamentation that seems to have come from an entirely different world, as at Ruffec and Notre-Dame-la-Grande.

As an innovator on anything but ornament, the traditional architectural sculptor thus seems to have reached the end of the line. It took a new beginning, at the hands of the new specialist figure-carver, for archivolt-carving to be given a new lease of life as a medium for mainstream figure sculpture. At Angoulême, the sculptors responsible for the monumental imagery of the façade accordingly took over one arch and carved it longitudinally with large figures in their usual style (Pl. 228), paying little attention to the conventional methods of archivolt composition. Such usurpations of select architectural pieces by the figure-carver were to become quite common in the second quarter of the century, especially in portals; the reasons for this phenomenon, which is essentially proto-Gothic, will be examined in the next chapter. In Aquitaine, different figure-carvers of various origins now began to take over an ever greater number of archivolts. The most influential were not, however, those of Angoulême, but a new group of sculptors, sometimes known as 'the third workshop of Aulnay' (Pls. 353–5). The traditional architectural sculptor remained alongside as ornamentalist, in great demand as such, and using for this purpose radiating voussoir compositions, face–soffit correlation, and other such old techniques. His occasional deviations from this ornamental fixation amount to no more than curiosities, like the one-off figural archivolt by the second workshop of Aulnay (Pl. 269), or the unusual nook-figures in the portal of Maillezais (Pl. 323).

The Later Career of the First Workshop of Aulnay

As may be expected, not all sculptors came to terms with the new tendency to specialize. Some attempted to meet the rising demand for sculpted figure programmes with the traditional tools of architectural decoration, just like the old all-purpose sculptors of Melle. Occasionally they were successful, but they found themselves competing unfavourably against the new specialists and eventually disappeared without heir.

The most outstanding example of this attitude can be seen in the first workshop of Aulnay. As argued in a previous chapter, this workshop arose from a mixed circle of Melle and Saintes, which was the circle that first cultivated and later ornamentalized the early twelfth-century genre of figural mini-programmes on capitals and voussoirs. Though highly proficient, this workshop was already old-fashioned when engaged on the east end and the transept portal of Aulnay, around 1120, and was eventually replaced by new workshops of specialists.[69] The replacement does not mean, however, that the old workshop ceased to exist there and then. It was still to be engaged on some further projects in the Aulnay area, notably at Nuaillé-sur-Boutonne and Varaize, where it made an effort to keep up with innovation.

Sainte-Marie at Nuaillé-sur-Boutonne is a small rural church, its modest western façade enlivened by a richly carved portal (Pl. 331). This has long been attributed to the first workshop of Aulnay on grounds of similarity to the portal in the Aulnay transept (Pl. 178).[70] Although restricted to two orders, as opposed to the four at Aulnay, it displays the same type of radiating figure voussoirs, a number of similar ornamental motifs, the same crisp and somewhat graphic carving style, and even a similar fluting on the colonnettes and parts of the door jambs. In the main, the figure style follows from that of the Aulnay Samson capital (Pl. 335, cf. Pl. 161), with an additional accentuation of zigzag hemlines.

Closer scrutiny reveals, however, the influence of later styles, attributed above to the period between 1120 and 1130. First, there is a clear indication that the second workshop of Aulnay was already active in the area, since some of the interior capitals of Nuaillé-sur-Boutonne are in its style (Pl. 332, cf. Pl. 259). Secondly, the innermost order of the portal carries half-columns as in the Abbaye aux Dames at Saintes, at variance with all earlier portals including the one at Aulnay. Thirdly, the portal hood is carved longitudinally with a series of figures (Pl. 333), which although iconographically new are arranged like the longitudinal figures on the niche hood of the Abbaye aux Dames. It is possible that this was the workshop's answer to the third workshop of Aulnay, which specialized in longitudinal figures on archivolts, and, as will be shown below, was already active in the area. The two workshops were in fact to cooperate at Varaize.

At Nuaillé-sur-Boutonne, the first workshop of Aulnay tried to meet the rising demand for figure programmes by reintroducing iconographical logic to the radiating voussoirs, and supplementing them with the longitudinal figures on the hood. The programme on the inner archivolt centres on an enthroned Christ, depicted on the apex voussoir as earlier in the south portal of Saint-Hilaire at Melle, and serving as a focal point for the otherwise repetitive row of saints

[69] See above, Chapter 2.B. [70] Most recently Werner 1979: 112–14. On the building as a whole, see also Dahl 1956.

depicted on the other voussoirs. The outer archivolt is dedicated to an Infancy cycle, with the figures still arranged radially but forming veritable scenes, including the Annunciation, the story of the Magi, and the Massacre of the Innocents (Pls. 333–5). Finally, the hood is dedicated to a set of angels, some holding censers. Unlike other voussoir programmes, none of these schemes is ornamentalized. The Infancy cycle seems somewhat muddled, but this can be shown to have arisen from iconographical rather than ornamental considerations.

The Infancy cycle is divided into three sections. These are separated by two foliate voussoirs, placed at the clock-positions eleven and half-past-twelve (Pl. 331). The middle section is dedicated to the Adoration of the Magi. Otherwise, the cycle occupies the two side sections, unrolls from the foliate voussoirs downwards, and fluctuates between the two sides. It thus opens, at the top of the right-hand section, with the Annunciation (two voussoirs), moves over to the opposite side for the Magi before Herod (five voussoirs) (Pl. 333), returns to the right-hand section for Joseph's Dream (two voussoirs) and the Magi's journey home (four voussoirs), and concludes with the Massacre of the Innocents, which is divided between the two sides at the bottom (four voussoirs on the left and two on the right).[71] This fluctuation between the two sides may seem strange, but it has a venerable precedent in the fifth-century mosaic on the triumphal arch of Santa Maria Maggiore at Rome. Here too, an Infancy cycle unrolls downwards on both sides, and the scenes concerning the Magi are divided between the two sides out of narrative order.

Considering the widespread imitation of Early Christian Rome, as noted above at Angoulême and elsewhere, this mosaic presents itself as the source of inspiration for the Nuaillé arrangement. Perhaps it was known to the sculptors only by hearsay, which is why the relationship does not extend to details. There are, in fact, further works in western France that attest to the fame of Santa Maria Maggiore. In another Magi cycle, painted on a double arch in the cloister of Saint-Aubin at Angers, a city is depicted on the springer section of the arch (Pl. 336) in apparent allusion to the representations of Jerusalem and Bethlehem in the Rome prototype.

Besides the Early Christian prestige, the allure of this prototype apparently lay in the dedication to Mary. The church of Nuaillé-sur-Boutonne is indeed dedicated to her. Another example leads back to the Abbaye aux Dames at Saintes, also dedicated to Mary, where an extract from an Infancy cycle is depicted on one of the portal archivolts. As mentioned, this extract is restricted to the Massacre of the Innocents, repeated on the row of voussoirs in a triple-modular fashion as if it were an ornament. The sculptors of Saintes were essentially ornamentalists, little concerned with iconographical coherence, but the comparison with Nuaillé-sur-Boutonne illustrates the kind of Infancy cycle available to them as a model.

At Nuaillé-sur-Boutonne and Angers, the crown of this cycle is the enthroned Virgin and

[71] There are twenty-seven voussoirs, here numbered clockwise, but described in sections. Right-hand section, from the foliate voussoir (no. 17) downwards: two voussoirs with the Annunciation: (18) angel; (19) Mary; two voussoirs with the Dream of Joseph: (20) Joseph, reclining in a bed which is distorted into an upright position because of the radial disposition of the motif; (21) angel; four voussoirs with the Return Journey of the Magi, combined with their dream: (22, 23, 24) Magi, with walking staves; (25) angel; two voussoirs supplementing the Massacre of the Innocents represented on the opposite side of the arch: (26) a man with a drawn sword; (27) another man, with a sheathed sword and a lance. Left-hand section, from the foliate voussoir (no. 10) downwards: five voussoirs with the Magi before Herod: (9) a guard with a drawn sword; (8) Herod; (7, 6, 5) Magi, with walking staves; four voussoirs with the Massacre of the Innocents: (4) Herod, enthroned; (3) a soldier in mail coat and drawn sword, turning his head towards Herod; (2) a man holding a staff (?); (1) a woman with a child. Middle section, between the foliate voussoirs: six voussoirs with the Adoration of the Magi: (11, 12, 13) Magi, the first carrying a pilgrim's pouch; (14, apex voussoir) the Virgin and Child; (15) Joseph, with a staff (or Simeon, see Werner 1979: 113); (16) a maid (or Anna, see ibid.).

Child. It was undoubtedly in order to emphasize this theme that, at Nuaillé, the scene of the Adoration of the Magi escaped the narrative order and was moved to the top section of the arch, with the Virgin and Child (somewhat damaged) solemnly positioned on the apex voussoir (Pl. 335). At Angers, the enthroned Virgin and Child are represented in sculpture above the painted cycle. Thuriferous angels accompany the Virgin in both works: at Angers they hold up her framing clipeus; at Nuaillé they are disposed longitudinally on the hood, and so converge above her head. Without entering the complex history of the theme, it may be noted that Nuaillé represents a new Marian accentuation which is unlikely to predate c.1130. At Angers, which is probably the later work, the new iconography actually comes very close to proto-Gothic art; it is not at all clear whether the Angers Virgin predates or postdates the very similar one in the southern tympanum of the western façade of Chartres.[72]

At Nuaillé-sur-Boutonne, there are also some badly eroded reliefs of humans and devils in combat, positioned in the portal spandrel and in a short section of frieze, and evoking hell scenes. These should be seen in the context of a new iconographical tendency towards moralizing themes, previously absent from the monumental sculpture of Aquitaine (except occasionally on capitals) but now becoming very common. At neighbouring Aulnay, the moralizing theme of the Combat of the Virtues and Vices was thus adopted by the contemporary second workshop, on the archivolt in the transept window. The third workshop of Aulnay repeated this theme on one of the archivolts in the west portal (Pls. 353, 354), and additional versions followed at Fenioux, Blasimont, and elsewhere.[73] The first workshop of Aulnay was now facing a flood of new themes and styles with which it could barely keep pace. This is manifest most clearly in a renovation project at Varaize, also in the Aulnay area.

The church of Varaize was apparently constructed towards the end of the eleventh century and later underwent substantial alteration. The first building, of which the transept survives, must have been more or less completed between 1095 and 1103, which is when the local lords donated some revenues towards the church's glass ('ad vitram ecclesiae'), presumably the windows.[74] At some later point the transeptal chapels and much of the apse were rebuilt. The present nave was constructed at the same time; it adjoins the older transept by straight masonry seams. This is where the first workshop of Aulnay appeared on the scene. It provided the new apse and chapels with a set of corbels (e.g. Pl. 337), and also participated in the works of a portal, positioned on the south side of the nave (Pl. 339). Unfortunately, the portal was much restored in modern times, and all the capitals and abaci but one are new. So are some of the voussoirs, especially in the inner two archivolts, but enough authentic ones survive to illustrate the original character of the work.

As at Nuaillé-sur-Boutonne, the sculpture of this second building campaign combines three stylistic elements: the style of the east end of Aulnay including radiating voussoir figures, the

[72] The relevant part of the Angers cloister is not to be confused with an earlier part, constructed and decorated in an entirely different style, and probably dating from 1115–25; see Henry and Zarnecki 1957: 13–14.

[73] The range of moralizing themes is discussed below in Chapter 5.B.

[74] Musset 1901, charter no. xcix (p. 127). A date before 1103 is indeed corroborated by a stylistic comparison: some capitals in the transept are reminiscent of the capitals at Champdeniers, which probably dates from c.1070–90; see Camus 1992: 200–11. At Varaize, the church and much other property came into the possession of Saint-Jean-d'Angély in the later part of the 11th cent. (Musset 1901, charters nos. xcvi–cviii (pp. 124–38)). This was presumably the background to the building activity.

influence of the Abbaye aux Dames, and a new style of longitudinal archivolt figures. The old style of Aulnay is manifest in the corbels of the apse and chapels, though some details are closer to the Nuaillé version. There is, for instance, a female figure which can be closely paralleled on one of the Nuaillé voussoirs (Pl. 337, cf. Pl. 335). On the outermost archivolt of the portal there is a radiating composition of seated figures carved in the same style, if somewhat more swollen and substantial (Pl. 341). The style of the Abbaye aux Dames is manifest in the cornice above the portal, carved with an inhabited scroll very similar to that on the hood of the north niche at Saintes (Pl. 338, cf. Pl. 315). The new style of longitudinal figures appears in the portal on the third archivolt inwards. This carries large and imposing personifications of the Virtues (Pl. 362), similar to those by the third workshop of Aulnay and related works at Fenioux and Blasimont (cf. Pl. 363). Though not quite the same, the angels on the hood also betray awareness of this new style (Pl. 340).

The portal of Varaize thus combines the old style of the first workshop of Aulnay with the new style of the third. The two styles are so different that observers may at first suspect two separate phases of work, but this is not supported by the structural evidence. Despite some trimming of the hood against the buttresses, the structure of the portal is reasonably homogeneous and belongs entirely with the project of the nave. The portal embrasure even courses into the nave wall. Moreover, the two styles are not entirely distinct; the angels on the hood share some features with the old style and others with the new. I shall not go into detail, because there is no way of establishing whether this was due to an old sculptor learning some new techniques, or a new sculptor borrowing from the old one, or perhaps some sort of overall supervision. All possibilities, however, indicate a somewhat awkward meeting between a fading generation and something completely new.

The old sculptor of the radiating voussoirs was still capable of the additional modest job. He reappeared on the site of another church, at Pamproux, where he provided the essentially ornamental portal with six figured voussoirs like those at Varaize, comprising two with the veteran radiating motif of the Elders of the Apocalypse.[75] This was just about the final flicker of the old all-purpose carver. Semi-ornamental ensembles of radiating figures recur here and there,[76] but the technique was largely abandoned by the new specialist figure-carvers and remained the domain of the contemporary ornamentalists of Vouvant, Maillezais, Notre-Dame-la-Grande at Poitiers, and the rest.

[75] The church of Pamproux was a priory of Saint-Maixent; see Richard 1886: p. xlix. Observations on site yield the following. The west end comprises a rather plain entrance block which was at some point carried higher as a tower, positioned off axis. The original part of the entrance block contains the portal in question. In contrast with the old type (Aulnay south portal, etc.), this portal contains no colonnettes but rather engaged half-columns, as in the innermost order of the Saintes portal. It incorporates two archivolts, carved mostly with foliate S-scrolls in radiating arrangement. Two voussoirs, in the inner archivolt, carry rampant animals. Six voussoirs, in the outer archivolt, are figural; from left to right: (9, 10) seated figures; (11) an Elder of the Apocalypse; (15, just off the apex) Christ; (16) a bearded man with a melon-cap (?); (17) an Elder of the Apocalypse (?).

[76] e.g. the portal of Foussais, by the old Melle workshop (Pl. 298, cf. Pl. 52). On the iconography of this portal, see Kenaan-Kedar 1986: 327–8, and also a comment below, Chapter 5.B. In Spain, radiating figures were to recur even as late as the Early Gothic Portico de la Gloria at Santiago de Compostela.

5

THE PROMISE AND FAILURE OF AQUITAINIAN PROTO-GOTHIC c.1130–40 AND ONWARDS

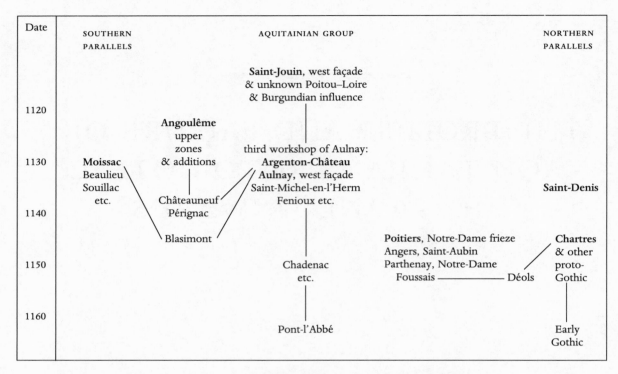

Date	SOUTHERN PARALLELS	AQUITAINIAN GROUP	NORTHERN PARALLELS	
		Saint-Jouin, west façade & unknown Poitou–Loire & Burgundian influence		
1120		**Angoulême** upper zones & additions		
1130	**Moissac** Beaulieu Souillac etc.	third workshop of Aulnay: **Argenton-Château Aulnay**, west façade Saint-Michel-en-l'Herm Fenioux etc.	**Saint-Denis**	
1140		Châteauneuf Pérignac		
		Blasimont		
1150		Chadenac etc.	**Poitiers**, Notre-Dame frieze Angers, Saint-Aubin Parthenay, Notre-Dame Foussais ——— Déols	**Chartres** & other proto-Gothic
1160		Pont-l'Abbé	Early Gothic	

FIG. 4. The origins and context of Aquitainian proto-Gothic

A. A NEW GENERATION OF POITEVIN FIGURE-CARVERS

The Third Workshop of Aulnay and the New Type of Portal

The ducal county of Poitou has so far emerged as a land of extremes. Having produced the first important figure sculptures of Romanesque Aquitaine, it also succumbed to the ornamental drift. For a while, only architectural ornamentation was practised widely enough to be established as a significant artistic trend. The demand for sculpted figure programmes remained infrequent, and therefore the early figural efforts of the sculptors of Airvault or Saint-Jouin-de-Marnes had little chance of immediate continuance. Even the influence of the figure-carvers of Angoulême was at first slow; serious opportunity was simply too scarce.

Yet this situation was quickly changing. The upsurge of building activity around 1130 meant new opportunities not only for the decorators but also for the figure-carvers, who were eventually engaged on façade programmes. They seem to have formed a new kind of specialist workshop, sometimes accompanied by its own ornamentalists, and concerned neither with interior capitals nor with any other aspect of construction except façades and portals. These sculptors were consequently free of the hindrances of lengthy building campaigns, could move quickly from one place to another, and eventually established a significant trend of high-quality figure programmes throughout the ornament-land of Poitou and adjacent Saintonge.

The western façades of Saint-Gilles at Argenton-Château and Saint-Pierre at Aulnay (Pls. 342, 350) were decorated by such a specialist workshop. At Aulnay, this workshop was the third on the site and distinct from the two workshops which had already decorated practically the whole church. At Argenton-Château, its programme of façade sculpture and a few matching architectural pieces must have been prepared separately from the rest of the building materials, since they are carved in a different stone.[1] Despite some losses, these two façades well illustrate the kind of design favoured by the new workshop. At Argenton-Château there is a large portal with carved archivolts, all of them purely figural and in fact carrying the bulk of the iconographical programme (Pls. 343–8). Supplementary slab-reliefs form a figural frieze in the portal spandrels (Pls. 349). Though decayed in parts, this programme apparently preserves its original character except for a certain amount of restoration work in the corbel-table above the frieze. At Aulnay, the design consists of a similar portal, flanked by two niches containing supplementary figural reliefs. The sculpture is exceptionally well preserved (Pls. 351, 353–5) though the sequence of portal and niches is disrupted by massive and unsightly buttresses of the late Middle Ages. For some unknown reason, the upper zone of the façade was completely reconstructed at the same time. Assorted decorative voussoirs, some belonging to a lobed arch and probably taken from the original upper zone, were badly assembled around the original archivolts of the side niches of the lower zone.[2] The programme of the damaged upper zone also included a monumental

[1] At Argenton-Château the relationship between the façade project and the rest of the church remains unknown, since much of the church was later rebuilt. The sculptors and builders apparently cooperated despite the change of material, since the complex of the façade is structurally coherent.

[2] There are various indications that the odd collection of voussoirs found in the outer archivolts of the niches was rearranged in that place only with the late medieval repair, when the buttresses were added. The spandrel area above the niches thus courses-in with these buttresses. The hood-stops of the portal were apparently added at the

equestrian statue, now lost, which stood in the niche above the portal. It is known from descriptions and a small fragment, preserved inside the church.[3]

These façade programmes testify to a new phenomenon: the repetition of set iconographical schemes. The experimental period that had given rise to the unique programmes of Saint-Jouin-de-Marnes and Angoulême was over, and regular demand for figure programmes was now met with something like mass production. The portal programmes of Argenton-Château and Aulnay are consequently very similar. Arranged on sets of archivolts respectively five and four orders deep (Pls. 342, 351), they centre on the Lamb of God and other images of Christ, and comprise the new or previously rare themes of the Combat of the Virtues and Vices, the parable of the Wise and Foolish Virgins, and full cycles of Zodiac signs alternating with the Labours of the Months. Differences are largely restricted to the accompanying programme of slabs. Those in the portal spandrels of Argenton-Château present the story of Lazarus and the Rich Man including some detailed (though badly preserved) hell scenes (Pl. 349). Those in the side-niches of Aulnay present Christ between two Apostles and Peter's Crucifixion (Pls. 358, 359), originally supplemented by the equestrian statue above the portal.

In the context of Aquitaine, the most important innovation of this scheme is the concentration of the main imagery in a great portal. This arrangement adds a new layer of sophistication to the growing iconographical complexities of the time, for it doubtless comes to emphasize the medieval concept of the church as 'the gate of heaven'. As shown in a recent study,[4] this symbolic concept originated in the liturgy of dedications and was expressed in numerous church inscriptions of the Middle Ages throughout the West. It reflects Jacob's words after his vision at Bethel: 'this is none other but the house of God, and . . . the gate of heaven' (Gen. 28: 17).[5] Perhaps such inscriptions at first referred to the whole church building,[6] but at some point 'the gate of heaven' came to be associated with the tangible portal of the church. The sculptors consequently sought to adjust the most sacred imagery to the architecture of the portal, which thus came to embody Christ's words: 'I am the door: by me if any man enter in, he shall be saved, and shall go in and out, and find pasture' (John 10: 9).

It is not entirely clear when and where these associations first took shape, but perhaps this is of no concern here because Aquitaine adopted the great figurated portal only after it had been well established elsewhere, notably in Burgundy. Earlier Aquitainian portals had been largely ornamental, and if injected with figural themes these were overwhelmed by ornamental conventions as in the south portal of Aulnay or on the façade of the Abbaye aux Dames in Saintes. The traditional Aquitainian place for important figure programmes was not in the portal but on the higher part of the façade in accordance with the ascending scheme, as at Saint-Jouin-de-Marnes and Angoulême. Only with the western façades of Argenton-Château and Aulnay

same time, and in a completely different style. There are original abaci underneath all the archivolts, but those under the rearranged voussoirs are badly joined to the rest and were probably reset in that position in the course of the repairs.

[3] On the lost rider, see Musset's entry in Robuchon 1890–5: ix (1894). 12–13.

[4] Favreau 1991.

[5] I have abbreviated the quotation from the Authorized Version to match the Vulgate: 'non est hic aliud nisi domus Dei, et porta caeli.'

[6] In the early 11th-cent. mural paintings which decorate the apse of San Vincenzo at Galliano, in Lombardy, the inscription HEC EST DOMVS DEI ET PORTA CAELI accompanies a picture of dedication, showing the donor, Aribert, presenting the church building, inscribed ECCLESIA. The expression 'porta caeli', the gate of heaven, thus seems to refer to the whole church. See *Milano* 1993: 285.

did Aquitaine first accept the portal as the decisive centre of the façade imagery, in a form different from the Burgundian and centring on the portal archivolts. The old ascending scheme was now replaced by a centralized scheme, leading inwards to the portal instead of upwards to the gable.

When this happened, the Aquitainian concept of façade changed radically. The new disposition of the imagery actually demanded that both the sculptor and the spectator reverse their viewing habits, for the straightforward hierarchy of the old ascending scheme was now turned upside down. While the old scheme had the elevated images of Christ placed at the top of the wall, the new centralized scheme had them relocated to the physically lowly position of the portal. It will be seen that even the portal archivolts should be read from the outermost inwards, that is, from top to bottom. The introduction of the great figurated portal at Argenton-Château, Aulnay, and subsequently elsewhere in Aquitaine therefore amounts to something of an artistic revolution.

Another result of the new concept of façade was a new division of work between the figure-carvers and their accompanying ornamentalists. As before, the ornamentalists were responsible for the capitals (Pls. 364, 365) and some of the archivolts, for instance in the Aulnay niches (Pl. 264), but the figure-carvers widened their scope. Besides the slab-reliefs and the equestrian statue, they also took over the portal archivolts (Pls. 342–8, 351, 353–5), which had previously been the domain of the ornamentalist. Significantly, these sculptors belonged to the generation of specialists who were capable of producing any type of figural relief and statue, as earlier at Angoulême, and they now applied these skills to the portal archivolts. The result was a new type of large and imposing architectural sculpture which may be called proto-Gothic, created by expert figure-carvers, and little related to the earlier experiments of the architectural decorator. As will be shown below, only one of the previously known systems for handling archivolts had any influence on the new figure-carvers, and this system was special because it had already been used in Burgundy in the context of other figurated portals.

In some places expanded and in others abbreviated, the new type of façade programme was now to gain enormous popularity in the region and all but supersede the earlier ascending scheme. However, the history of this trend is hard to establish, since none of the relevant monuments can be dated on simple documentary grounds. Some kind of relative chronology nevertheless arises from an examination of the material itself.

The monuments in question fall into two groups. The first may be associated with the activity and the early influence of the workshop of Argenton-Château and Aulnay. This group includes further portal complexes at Fenioux (Pls. 371, 372) and Varaize (Pl. 362), isolated slab-reliefs and statues at Melle, Pérignac (Pl. 375), and Châteauneuf-sur-Charente (Pl. 378), as well as a decayed archivolt in the conventual buildings of Saint-Michel-en-l'Herm (Pl. 356). All these may be assigned to 1130–40 together with some similar works by other workshops, notably the hell scenes which were now added to the original programme of the Angoulême façade (Pl. 239). The second group involves later adaptations of the first style, and may be placed between c.1140 and the third quarter of the century (Fig. 4). It comprises portal complexes and façades executed by a variety of workshops. The most important are found at Saint-Pompain (Pl. 361), Civray, Cognac, Blasimont (Pl. 363), Parthenay (Notre-Dame-de-la-Couldre) (Pl. 387), Angers (refectory

of Saint-Aubin), Chadenac (Pls. 394, 395), and Pont-l'Abbé-d'Arnoult (Pl. 396).[7] Georges Gaillard noted a close resemblance between some members of this group, and especially Chadenac, and the statues of bishops of Poitiers which come from the church of Les Moreaux, south of Poitiers, and are now preserved in Oberlin, Ohio. These statues cannot predate the fifth decade of the century, because they represent two identifiable bishops of Poitiers, inscribed with their names, the second of whom was in office in 1140–1/2.[8]

The origins and history of the first group are examined below; the second will eventually lead this investigation out of the Romanesque world.

Stylistic Variants between Poitou and the South

The new style was apparently formed in the Poitou–Loire milieu, perhaps in some lost major monument, though its earliest surviving examples are those at Argenton-Château and Aulnay. Although previous scholarship has claimed that this style came to Poitou from Saintonge and the south,[9] there is much evidence to the contrary, namely, that it passed from Poitou southwards to Saintonge and beyond. The dissemination of this style in the region in fact represents a second reversal of the direction of influences: if the eleventh-century direction, from north to south, had been reversed in the early twelfth century, then the predominance of the north was now reinstated. The rise of the south had indeed been spectacular, but apparently temporary, and it began to waver long before the triumph of the northern Gothic style.

The handling of the archivolt sculpture is perhaps the best indicator of the new workshop's break with the traditions of the southern provinces of Aquitaine. On the one hand, this workshop made little use of the system of small radiating figures (originally Poitevin but by now normal for Saintonge) and generally preferred large figures of the longitudinal type. On the other, it cannot be seen to have imitated any of the longitudinal systems which appeared in Angoumois and Saintonge around 1120–30. As seen in the previous chapter, there was the system of the angel-archivolt at Angoulême, with the longitudinal figures tilted inwards (Pl. 228); the related system of the second workshop of Aulnay with its architectonic correlation of the archivolt's face and soffit (Pl. 269); and the system of figured hoods at the Abbaye aux Dames in Saintes and at Nuaillé-sur-Boutonne (Pl. 333). The new workshop did not follow any of these. Its figures are not tilted inwards but rather upwards (Pls. 352, 359); they are not correlated across the face and soffit of the archivolt but are confined to the main face and leave a distinct soffit (Pls. 343, 353–5);[10] and they have nothing to do with hoods, which remain ornamental.[11]

[7] Some of the monuments in both groups, and in particular Aulnay, Argenton-Château, Melle, Fenioux, Varaize, Civray, Blasimont, and Chadenac, are discussed in Werner 1979.

[8] Gaillard 1972 edn. The statues are preserved in the Alan Memorial Art Museum, Oberlin College, Oberlin, Ohio. They were photographed in position, on the façade at Les Moreaux, by Arthur Kingsley Porter (Porter 1923: vii, pls. 1065–8). One of these statues is inscribed as Bishop William Adalelm (*ob.* 1140), the other as Grimoard (*ob.* 1141/2).

[9] Scholars have variously cited Toulouse, Moissac, and other monuments of the Languedoc as ultimate sources for the new style, and envisaged a slow expansion through Angoumois and Saintonge northwards. This view was strongly advocated by Mâle, 1978 edn.

(first published in 1922): 440–3. Likewise Crozet: 'Quant à la grande sculpture figurale, elle a eu, de la Saintonge et de l'Angoumois au Poitou, un vaste champ d'expansion; Saintonge et Angoumois ont insufflé, aux traditions poitevines, un regain de vie en leur transmettant, au surplus, des influences languedociennes' (Crozet 1948*a*: 273). The supposed influence of the south remained a recurring theme in the literature on individual Aquitainian monuments; see Sauvel 1938 and 1945; Werner 1979: 83–8. This view is reassessed below and, with further details, in Tcherikover 1990*a*: 79–80.

[10] There is a theory claiming that the new technique followed from that of the second workshop of Aulnay, which I do not find convincing. See my article of 1989*a*, esp. pp. 67–70.

[11] Figured hoods recur at Le Douhet, Blasimont, Varaize, and,

There was another system of archivolt composition which had so far been little used in Aquitaine. Arising from considerations of thematic clarity, this system involved correct positioning of the sculpted elements in relation to the spectator, that is, vertically. Some of the earliest figural compositions on archivolts, in Burgundy, were of this kind; with the loss of the Burgundian fountain-head of Cluny, the archivolt with the Elders of the Apocalypse at Anzy-le-Duc can serve as an example (Pl. 352). It shows a figural composition relatively free of architectonic considerations, though the vertical positioning necessarily results in longitudinal elements at the bottom of the archivolt, radiating ones at the top, and diagonal ones in the intermediary places. In Poitou, a debased version of the same system governs the archivolt with the Labours of the Months at Saint-Jouin-de-Marnes, resulting in a similar mixture of different types of voussoir. Of the three original voussoirs which survive on the right-hand side of this archivolt (Pl. 108), the lowest (December) is of the longitudinal type, whereas the third (October) is diagonal. A comparable mixture exists on the opposite side of the arch.[12]

These early twelfth-century examples of vertically placed figures seem to represent a substream of archivolt sculpture of some durability, later to recur in Poitou on the higher part of the façade of Benet and at Mauzé.[13] Aulnay and Argenton-Château represent a parallel trend with its own idiosyncratic version of the same system. In both places, most of the figures are too large to be positioned vertically or radially, but they are nevertheless tilted upwards, that is, as much as possible towards the vertical position (e.g. Pls. 348, 351, 354). There is no problem with the smaller figures of the Labours of the Months; on the Labours archivolt of Aulnay, the lower figures are longitudinal and the upper radiating, as a souvenir from the mixture characteristic of vertical positioning.[14] It is noteworthy that, despite the formation of different versions, the system remains consistent in some technical matters: the figures are always placed against a concave background that slants inwards, so that the soffit slightly recedes and sometimes even disappears. This can be seen in all the above examples, at Anzy-le-Duc, Saint-Jouin-de-Marnes, and Benet as well as the group of Argenton-Château and Aulnay.

The identity of the precise model for this system remains unknown, because the surviving material is deficient and the relationship to Burgundy still awaits research. It may nevertheless be noted that all the Aquitainian examples enumerated above come from monuments in Poitou. The examination of archivolt forms thus attests to a consistent Poitevin trend, involving, among others, the new workshop of Argenton-Château and Aulnay, and distinct from all other Aquitainian trends.

The figure style of the new workshop is equally Poitevin. It seems to derive from the style of Saint-Jouin-de-Marnes, while differences may be put down to the preferences of a new generation. The figure of Christ in the Aulnay niche, for instance, is a variation on the Christ in the gable of Saint-Jouin (Pl. 358, cf. Pl. 119). The treatment is lighter and more assured, but the figure otherwise possesses a similar calm quality and presents the same basic construction of the

north of the Loire, Châteaudun. However, this system had limited success, and most hoods in the monuments at issue here reverted to ornament.

[12] There are also some ornamental works with vertically positioned motifs, for instance, the animals at Angoulême (Pl. 199), but these seem unrelated to the figural type.

[13] Of the church of Mauzé and its portal, only a few mutilated remnants survive. At Benet, the archivolts in question are in the windows of the upper part of the façade. They are entirely different from those in the lower part, and undoubtedly belong with some later reconstruction. For a description of Benet, see Dillange 1983: 56–9.

[14] The same mixture recurs on some later archivolts with the Labours of the Months, at Cognac and Civray.

draperies, including a mantle meandering down from the left shoulder to be tucked into the high-placed belt, a decorative band around the neck and along the chest, and a broad drape across the knees (which is, however, reversed from left to right). Similarly, a number of archivolt figures, at both Argenton-Château and Aulnay, recall the Saint-Jouin Virgin Annunciate with its neatly delineated and tightly hugging draperies (Pls. 348 and 355, cf. Pl. 121), though they are treated differently. Most possess a new statuesque presence, and their firm limbs are covered by more orderly plate-folds enriched by V-folds. A lighter touch is achieved by the occasional attenuation of the ankles and feet (Pls. 346, 348, 358) as well as some freely falling chest-draperies (Pls. 347, 355, at the top).

The statuesque handling of the archivolt figures at Argenton-Château and Aulnay doubtless reflects the standards set by the statuary of Angoulême in the 1120s, but closer examination reveals a new method for organizing the sculpture in space. The concave background of the archivolt is exploited for offsetting the volume of the figures, and this concave space is occasionally accentuated by details of garment such as curved mantles, swinging from background to foreground, and creating a new sense of articulation in the round (Pl. 355). A similar exploitation of the concave background can in fact be noted in additional Poitevin works of the time, and not only on archivolts. There is, for instance, a slab-relief of an angel, preserved in the museum of Thouars and perhaps coming from one of the city's churches, which reveals a similar technique (Pl. 357). The style perpetuates the characteristic hugging draperies and ornate garment-borders of nearby Saint-Jouin-de-Marnes, with the difference that the figure is set against a concave background accentuated by the curve of the wings.

Taken together, the observations on the archivolts and the figure style suggest that the workshop's origins are in some way related to Saint-Jouin-de-Marnes and Thouars. This relationship is far from accidental, since all the monuments in question were associated at the time with a particular circle of patrons. Saint-Jouin-de-Marnes had long enjoyed the protection of the viscounts of Thouars;[15] Saint-Gilles at Argenton-Château was a dependency of Saint-Jouin, whereas the castellans of the place were vassals of the Thouars.[16] The workshop of Argenton-Château and Aulnay can also be traced to Saint-Michel-en-l'Herm, which was another abbey under the protection of Thouars. The poor remnants of the chapter house in that place include a single archivolt figure which, though badly eroded, still betrays the characteristic long, straight, and precariously poised legs, covered by thinly spaced V-folds, and standing out against the concave mantle characteristic of the new style (Pl. 356, cf. Pls. 348, 355).[17] All in all, the workshop

[15] See above, Chapter 1.C.

[16] On Argenton-Château, see Werner 1979: 128; also Robuchon 1890–5: viii (1894). 3 (entry by B. Ledain). Saint-Jouin possessed, at Argenton-Château, not only the church of Saint-Gilles discussed here, but also the castle chapel of Saint-Georges and, towards the end of the 12th cent., the cemetery chapel of Notre-Dame. Saint-Gilles and Saint-Georges are mentioned in a papal confirmation of the abbey's possessions in 1179 (Grandmaison 1854: 38–43, esp. 40). Notre-Dame is mentioned in a confirmation charter of 1199 (ibid. 44).

[17] The abbey of Saint-Michel-en-l'Herm was founded in the 10th cent. by the count of Poitou and given to the viscount of Thouars. Although the arrangement changed with the Gregorian Reform, the Thouars remained the abbey's protectors. They accordingly supported the abbey in its dispute with the lords of Parthenay in 1106–7,

concerning rival claims over some of the abbey's lands; see Imbert 1871: 66–7. Only towards the end of the 12th cent. did the Thouars lose their influence over the abbey to the lords of Mauléon. On the abbey and its history, see Eygun 1956a; Heliot 1967–8. These authors assigned the chapter house sculpture to the end of the 12th cent. or the beginning of the thirteenth, following a local tradition that attributes a reconstruction of the abbey to Savary de Mauléon (*ob.* 1233). A more recent scholar observed that some of the sculpture in the façade of the chapter house, which is the complex discussed here, shows signs of reuse, and should therefore be seen as earlier than the present structure (Dillange 1983: 191). The building indeed comprises, especially on the interior, some elements of construction which seem later, including base-forms which occur neither at Argenton-Château nor at Aulnay.

seems to have enjoyed Poitevin patronage of the highest rank including both the religious establishments in the circle of Thouars and the circle of Poitiers Cathedral. The above-mentioned statues of Les Moreaux, in a related style, thus represent bishops of Poitiers, and were apparently made under the patronage of the cathedral archdeacon.[18] Furthermore, the Aulnay church itself belonged to the cathedral chapter of Poitiers.[19] It had till then been decorated by the Saintongeais workshops close at hand, but this was no longer good enough when it came to the all-important figure programme of the western façade. The new Poitevin workshop was summoned instead.

All other works in this style may be seen as sporadic quotations from this Poitevin group. Saint-Pierre at Melle, for instance, has an isolated relief of Christ flanked by two figures, very similar to the one in the south niche of Aulnay. It is inserted above the portal and corbel-table of the early twelfth century.[20] Saint-Hilaire in the same town, the nave of which was now partly reconstructed, received a portal of the new type.[21] It is placed on the north side of the nave, surmounted by a large niche with an equestrian statue. This complex unfortunately offers a choice between badly eroded parts and restoration replacements, but it still reflects the original arrangement of the central part of the Aulnay façade, before the loss of the rider. Another such rider can be found in Angoumois, in the upper zone of the façade at Châteauneuf-sur-Charente. It repeats the drapery forms of the Aulnay style and may be attributed to the same Poitevin group (Pl. 378).

The dissemination of the style in Saintonge sometimes involved strained adaptations. At Fenioux (Pl. 366), for example, the same workshop was apparently commissioned to produce a portal programme for an unsuitably modest project of renovation, involving some remodelling of the interior and a small nave-extension with a new western façade.[22] The builders must have had serious difficulties with the portal, with some awkward results. Occupying the entire lower zone of the façade, this portal creates a protruding porch that partly hides a group of statues above. The enormous columnar buttresses project forward with the portal and are consequently barely correlated to the upper part of the façade. The sculpture on the portal archivolts (Pls. 371, 372) belongs to the ambitious line of Argenton-Château and Aulnay, though the style is some-what changed: some archaic features have been abandoned, while others can be paralleled only in later monuments. For instance, there is no trace of the old 'vertical' system; the figures now follow the curve of the arch as in the proto-Gothic monuments north of the Loire. The figures are lighter and more agile than those at Argenton-Château and Aulnay, even elegantly swaying, a feature to be further accentuated in later monuments of Saintonge, especially at Chadenac (Pl. 395).

Another stylistic variant, apparently contemporary with that of Fenioux but emanating directly from Argenton-Château and Aulnay, can be traced from Varaize, in the Aulnay area, to Blasimont in the south. In both places (Pls. 362, 363) the archivolt figures are exceptionally elongated: some occupy over six voussoirs as opposed to a range of two-and-a-half to five at

[18] Gaillard 1972 edn.

[19] See above, Chapter 2.B.

[20] Werner 1979: fig. 379. On the older work at Saint-Pierre at Melle, see above, Chapter 1.B. The interior arcades seem to have been rebuilt at the same time as the addition above the portal. Some of their

capitals have been identified by Werner as a late project of the first workshop of Aulnay (ibid. 114–15 and figs. 377, 378, 380–2).

[21] At Saint-Hilaire, the nave was extended westwards and the north wall rebuilt; see above, Chapter 1.B and n. 66.

[22] Eygun 1956b.

Argenton-Château and Aulnay. They are strikingly elegant and confidently composed. Their movement sometimes follows a sweeping diagonal, stretching uninterruptedly from the raised arm down to the crossed-over leg, a line echoed by the background mantle. Drapery forms are carefully matched, especially at Blasimont, where they create a concerted pattern of cascading curves. The result is a new kind of tense stylization which, in the context of south-western France, is immediately recognizable: it is the stylization characteristic of the Moissac porch, and especially the celebrated trumeau of that complex.

This may be called the southern variant of the new style. The date of its appearance at Moissac has been a matter of some debate, but there can be no doubt that at least some parts of the Moissac porch postdate the death of Abbot Roger, who is represented above the porch inscribed with his name and designated as 'blessed'. Roger died in 1131. Like the Poitevin variant of the style, Moissac too hints at a barely traceable mixture of Loire and Burgundian sources. These have long been detected in the iconography and style of its tympanum, though the subject otherwise awaits modern research.[23] In the meanwhile, all that can be said is that related high-quality workshops suddenly appeared all over the south-west, and did not necessarily arise from each other. Varaize seems to have derived directly from nearby Aulnay (Pl. 362, cf. Pl. 353), while Moissac was created by an independent and exceptionally ingenious workshop that must have belonged to a separate lineage. Blasimont, on the other hand, suggests awareness of both variants, and was probably the latest of all.

Another related style, whether earlier or later than Moissac it is not entirely clear, is represented by the hell scenes which were now added at the extremities of the fourth zone of the Angoulême façade. Previously absent from the monumental façade programmes of Aquitaine, hell scenes are a major feature of the Moissac programme and also appear at Argenton-Château (Pl. 349). Angoulême was updated in a similar way. On the north side (Pl. 239), there is a man of some social standing, enthroned and finely dressed. He wears the 'belt of strength', with the characteristic roundel at the back, which is known from other monuments of the period as an attribute of the mighty or the wicked.[24] He is being struck in the mouth by a demon who dances above the fiery pit. The corresponding figures on the south side of the façade are less imposing, partly because the demon was drastically recarved by the nineteenth-century restorers. As already mentioned, another similar scene probably existed in the second zone of the façade, of which one original figure survives, perhaps a woman (Pl. 241). Her head is from the nineteenth century, as is the adjacent rider, who was invented by the restorers and who transforms the meaning of the original scene.[25] Discounting these additions, the original figure emerges as exceptionally similar to the tormented man in the hell scene of the fourth zone (cf. Pl. 240), wearing like him a 'belt of strength', swaying on her seat, and throwing up her arms in dismay.

These scenes present a new version of the original style of Angoulême, perhaps created by a new generation of the same local workshop. The original style, for instance in the third zone (Pl. 232), was solemn, rigid, and inclined to stereotype drapery patterns. The figures in the fifth zone

[23] The Loire sources of Moissac were mainly iconographical. This has been demonstrated by Meyer Schapiro, who also convincingly disproved Mâle's theory of Spanish sources; see Schapiro 1977d edn. (first published in 1954). It is now generally acknowledged that the stylistic sources were Burgundian. For an assessment of the various

opinions on the origins and the date of the Moissac porch, see Mezoughi 1978; also Hearn 1981: 170 (n. 1).

[24] Zarnecki 1979 edn. (first published in 1963–4): 54–6.

[25] See above, Chapter 3, especially n. 67.

(Pl. 238) repeat some of the same drapery forms but introduce agitated motion. The style of the hell scenes resembles that of the fifth zone, now become even more agitated. Besides, little remains in these scenes of the old stereotype drapery patterns, garments are composed of billowing surfaces, and there are various fineries such as a beaded collar or intricately strapped shoes. The relationship to the architecture has also changed: the scenes in the fourth zone are organized across double arcades which act as a front screen (Pl. 239), much like the reliefs on the side walls of the Moissac complex.

Argenton-Château, Aulnay, the Angoulême additions, and Moissac all seem to represent different variants of the same stylistic trend, and quite possibly in that order. Precise dates are not available, but the Poitevin variant seems to have formed around 1130, that is, in parallel to the Moissac porch at the latest. True, this suggestion is in opposition to a traditional theory that gives priority to the south in general and Moissac in particular,[26] and therefore requires more thorough justification. This can be achieved by tracing various instances of cooperation between the new workshop of Argenton-Château and Aulnay and the older workshops of Aquitaine, and also by assessing the iconographical innovations of the group.

Encounters with the Older Workshops

As shown in the previous chapters, the entire project of Aulnay could hardly have exceeded fifteen years, including the sculpture by all three workshops. The first workshop began the project around 1120, and was by that time already old-fashioned and had probably been active for quite a while previously (at Saint-Jean-d'Angély?).[27] It was replaced by the second workshop some time between 1120 and 1130.[28] The third workshop, as discussed here, could not have been much later because it actually cooperated with both the others. Its cooperation with the first workshop has been noted above at Varaize, which is therefore unlikely to postdate 1130–5.[29] Its cooperation with the second workshop is attested to at Aulnay itself, on the western façade. The ornaments on the façade of Aulnay thus combine two styles. The capitals and imposts may be attributed to the ornamentalists who were also active at Argenton-Château and should therefore be seen as part of the third workshop. This style involves leaves with folded tips, previously unknown south of Saint-Jouin-de-Marnes, as well as vivid animals and scaly monsters, violently twisting and turning, with the occasional human or monster springing forward between them (Pls. 364, 365). Conversely, some of the foliage ornaments betray the style of the second workshop, reiterating a number of motifs from the nave capitals. These include spirals of jagged folioles (Pl. 263, cf. Pl. 261) and beaded fan-leaves (Pl. 264, cf. Pl. 260), though the style is now enriched by folded leaves, probably under the influence of the ornamentalists of the third workshop.

The second and third workshops of Aulnay can also be seen to have cooperated at Fenioux. As mentioned, the church of Fenioux underwent a renovation, involving a small nave-extension

[26] See n. 9 above. Cf. Sauvel 1938 and 1945; Werner 1979: 83–8. Other views in the same vein are discussed in Tcherikover 1990a: 79–80.

[27] Above, Chapter 2.B.

[28] Chapter 4.A.

[29] On the career of the first workshop up to Varaize, see above, Chapters 2.B and 4.D.

with a western façade. While the sculpture of the west portal is doubtless a product of the figure-carvers of the new workshop, the ornamentalists of the second workshop may be attributed with the interior capitals and an additional portal, positioned in the north wall (Pl. 366). The interior capitals thus include a head-capital which is practically identical to those in the nave windows of Aulnay (Pl. 367, cf. Pl. 268), while the capitals of the side portal are carved with lace-foliage and monsters, very similar to those produced by the same workshop for the transept window at Aulnay (Pl. 368, cf. Pl. 257). Another sculptor from this workshop was seemingly involved in the portal of the western façade; he produced some of the ornamental pieces, and left the figural pieces for the new workshop. This sculptor repeated a pattern of birds and crouching monsters from the Aulnay transept (Pl. 370, on the left, cf. Pl. 257, on the right), but otherwise favoured voluminous foliage in the spirit of the westernmost capitals in the nave of Aulnay, as well as the new folded leaf (Pl. 369, cf. Pls. 260, 263). In short, the relationship between the two workshops at Fenioux was the same as at Aulnay, yet it seems unlikely that the limited renovation project at Fenioux re-created the building history of Aulnay. More plausibly, the second workshop appeared at Aulnay between 1120 and 1130, was joined by the new workshop around 1130, and the two subsequently cooperated at Fenioux.

A different sort of workshop cooperation, resulting in an unusual fusion of different traditions of façade design, can be observed at Pérignac (Pl. 373), a short distance south-east of Saintes. This monument was greatly disfigured in later periods, and a few technical observations on its original appearance are therefore necessary. The massive corner buttresses belong to an Early Gothic reconstruction of the nave. The horizontal termination of the façade dates from the same time. It truncates the outline of a gable, which is still visible both on the front and the reverse of the wall, and belongs to the original design.[30] The gable carries the reliefs of Christ (Pl. 374) and three angels, the one on the right somewhat disturbed by the surrounding masonry, apparently as a result of resetting. To the sides of the window there is a run of arcades, enclosing some statues of the Virtues (Pl. 375). One tier down there is a second row of statues, which were apparently reset in an arcade during the Early Gothic reconstruction (Pls. 376, 377).[31] It is possible that the area immediately below was disturbed at the same time, and certainly by the fifteenth century, which is when the present modest portal was built. At the base of the wall there are some disused plinths that seem to have survived from the original portal. The distance between them indicates that the outer opening of that portal was 605 cm., while their depth, combined with that of the wall, indicates a portal depth of 247 cm. This is close enough to the 614 cm. and 248 cm. of the portal of Fenioux, and suggests that Pérignac originally possessed a similar portal.

Pérignac is thus seen to have combined a portal of the new type with a scheme of statues complete with a gable Christ, after the old ascending system of Angoulême (before 1128). A similar combination characterizes the figure style, for which reason I believe that all the statues of Pérignac date from about the same time, despite the resetting in the second zone. The gable Christ is a free copy of the one at Angoulême (Pl. 374, cf. Pl. 231), and even the Virtues (Pl. 375), which are a new subject, were conceived as statues in the spirit of Angoulême. All, however, betray the influence of the new style of Argenton-Château and Aulnay, with the same patterns

[30] Blomme 1987: 35–6.
[31] Some of the arch mouldings appear to have been crudely carved *in situ*. The capitals are crowned by a string of imposts of a sort unknown in Romanesque Aquitaine.

of plate draperies (cf. Pls. 371, 355). There is also a second version of this style, represented by the three statues at each end of the lower tier (Pl. 377), and involving additional influences which will be considered separately. A third style, represented by the rest of the statues in that tier (Pl. 376), is entirely different. It involves unstable postures, wide sheets of drapery clinging to the bulging shapes of the body, drapery patterns of concentric double-lines, and wavy hemlines which come down very low on the far side. All these features are unmistakable: this is the style of the Angoulême master of St Peter (Pls. 236, 237), now cleared of the archaic zigzag folds. It is even possible that these statues are the work of the master of St Peter himself, and thus testify to an overlap in the employment of the old and the new sculptors.

In sum, the new workshop appeared on the scene while the workshops of the third decade were still active. Its style was at first unrelated to any of them, but it eventually cooperated with at least three. This tends to support the suggestion that its earliest projects, at Argenton-Château and Aulnay, date from about 1130, while the combinations of Varaize, Fenioux, and Pérignac belong to the following decade.

B. THE MORALIZING PORTAL PROGRAMME

The Iconographical Framework

In some ways, the new portal programmes of Aquitaine may be seen as a rearrangement of the old ascending scheme of façade imagery. As earlier at Saint-Jouin-de-Marnes and Angoulême, the programme progresses from images of the terrestrial world and symbols of the Church to manifestations of God, with two important differences.

First, the whole programme is coloured by a new moralizing accent created by a variety of themes. Previously almost unknown in Aquitaine, these moralizing themes were now adopted by several different workshops and became exceptionally common. Other iconographical innovations, such as the Marian theme noted above at Nuaillé-sur-Boutonne, did not gain a comparable hold on Aquitaine except when the regional school was already in decline.

Secondly, the programme no longer ascends to the gable but unfolds from the outer fringes of the composition towards the centre of the portal. The portal archivolts should accordingly be read from the outermost inwards. As noted above, this centralized disposition of the imagery required a change of viewing habits. Some of the Aquitainians apparently found this difficult, since the old ascending scheme keeps surfacing here and there, variously combined with the new centralized scheme.

Moralizing Themes

In the earliest portals of the new type, at Argenton-Château and Aulnay, whole archivolts are dedicated to two moralizing themes: the parable of the Wise and Foolish Virgins and the Combat of the Virtues and Vices.

The first alludes to the judgement of souls. Having been always ready with their well-furnished lamps, the Wise Virgins are admitted to the Kingdom of Heaven, whereas the foolishly unprepared ones are left out (Matt. 25: 1–13). Christ is accordingly depicted at the top of the archivolt, pronouncing judgement on the two groups of virgins. At Aulnay, he is separated from the Foolish ones by a closed door, which is absent at Argenton-Château. Otherwise the scheme is practically the same in both places (Pls. 344, 348, 354, 355).

The second theme comprises female personifications of the Virtues, most of them armed, and trampling underfoot various monsters which represent the Vices. A series of inscriptions identifies them as Fides (faith) above Idolatria (idolatry), Paciencia (patience) above Ira (anger), and likewise four other pairs as listed in Fig. 5. This type of victorious Virtue is not entirely new to medieval art,[32] and yet the version adopted at Argenton-Château and Aulnay indicates a return to the original textual sources. Details of the Virtues' equipment, for instance, follow the metaphors offered by St Paul on the combat of the Christian soul against evil:

Above all, taking the shield of faith, wherewith ye shall be able to quench all the fiery darts of the wicked. And take the helmet of salvation, and the sword of the Spirit, which is the word of God. (Eph. 6: 16–17)

The shield, the helmet, and some sort of weapon, usually a spear but sometimes indeed a sword, are recurring features of the Virtues at both Argenton-Château and Aulnay (Pls. 346, 348, 353, 354). Exceptions are few: Fides and Humilitas at Argenton-Château, for instance, conquer with no weapons at all (Pl. 345, upper archivolt).

The other source for the theme of the Virtues has long been recognized as Prudentius's *Psychomachia*, a fifth-century poem that enjoyed tremendous popularity from the ninth century onwards. It describes a series of single combats between each Virtue and its opposing Vice. The sculpture reproduces none of the rich detail of the poem, but the pairs of Virtues and Vices, as identified by the inscriptions, evoke Prudentius's pairs with certain deviations. A comparison between the text and the inscriptions is here presented in Fig. 5a, which shows some changes of vocabulary, and also a reduction from seven pairs to six.[33] This reduction was done in two different ways. Argenton-Château omits the pair Sobrietas–Luxuria, whereas Aulnay conflates it with Castitas (Pudicitia)–Libido, resulting in the hybrid Castitas–Luxuria.

Despite the great similarity between the portals of Argenton-Château and Aulnay, the deviations from Prudentius reveal further important differences between them. To facilitate the comparison, the pairs of Virtues and Vices are numbered in the order of their appearance in the text of Prudentius in Fig. 5a, and the numerals used to indicate the position of each pair on the relevant archivolt of each portal in Fig. 5b. It is immediately clear that, with one exception, Argenton-Château faithfully reproduces the textual order, beginning at the bottom left with no. 2 and advancing clockwise. The exception concerns Fides (faith), no. 1, who is described in the above quotation from St Paul as 'above all', and was accordingly moved to the top of the arch. There was much more shifting about at Aulnay, for no apparent reason. In short, Argenton-Château followed the text more closely than Aulnay, and was therefore presumably closer to

[32] Katzenellenbogen 1939: 14–19.

[33] The inscriptions are published in Favreau and Michaud 1977: 126–7. Prudentius is here quoted after Katzenellenbogen 1939. For an English translation of the text, see Prudentius 1965 edn. For an analysis of the *Psychomachia* and its sources, see O'Reilly 1988: 1–38, with a reference to Argenton-Château on p. 49.

a. The pairs of Vitrues and Vices

no.	Prudentius	Argenton-Château	Aulnay
1	Fides–Veterum cultura deorum (faith–idolatry)	Fides–Idolatria	Fides–Idolatria
2	Pudicitia–Libido (modesty–voluptuousness)	Castitas–Libido	—
3	Patientia–Ira (patience–anger)	Paciencia–Ira	Paciencia–Ira
4	Mens humilis–Superbia (humility–pride)	Humilitas–Superbia	Humilitas–Superbia
5	Sobrietas–Luxuria (sobriety–sensuality)	—	Castitas–Luxuria
6	Operatio–Avaritia (mercy–avarice)	Largitas–Avaricia	Largitas–Avaricia
7	Concordia–Discordia (concord–discord)	Concordia–Discorda [*sic*]	Concordia–Discordia

b. The order of the pairs

Prudentius	Argenton-Château	Aulnay
1 2 3 4 5 6 7	4 1 / 3 6 / 2 7	4 6 / 2/5 1 / 3 7

FIG. 5. Psychomachia

whatever was the model for this kind of programme. In view of Argenton's location in the Thouarsais, this impression accords well with the above suggestion on the Poitou–Loire origins of the style.

The frieze in the portal spandrels of Argenton-Château (Pl. 342) presents yet another moralizing parable, that of Lazarus and the Rich Man (Luke 16: 19–31). Despite deep erosion, it is still possible to recognize, on the left, the feast of the Rich Man and, on the extreme right, the majestically seated figure of Abraham in Paradise (Pl. 349). Abraham carries not only the soul of Lazarus but a whole bunch of the souls of the righteous, depicted as little figures in his lap. Next to him, a sequence of three scenes represents the fate which awaits the Rich Man in hell. The first (from the left) shows the open jaws of the monster of hell, about to devour a host of little figures interspersed with some grimacing devils. The second comprises a pair of devils closing on a human figure, perhaps Luxuria, who is missing from the portal programme and was allocated instead to the frieze. The third scene is similar in composition to the second, but too decayed to be identified. All three scenes amount to a generalized image of hell of the sort that was to accompany the propagation of Lazarus friezes northwards and across the English Channel to Lincoln (*c*.1140),[34] and also southwards to Moissac. The contemporary hell scenes at

[34] Zarnecki 1988: 59–62.

Church	Wise and Foolish Virgins	*Psychomachia*	Hell scenes
Main group, in the descent of Argenton-Château and Aulnay			
Argenton-Château	west protal	west portal	portal spandrels, in context of the Lazarus story
Aulnay	west portal	transept window west portal	—
Fenioux	west portal	west portal	—
Melle, Saint-Hilaire	—	north portal	—
Civray	west portal	upper arcade	—
Blasimont	—	west portal	—
Saint-Pompain	—	west portal	—
Chadenac	west portal	west portal	—
Pont-l'Abbé	west portal	west portal	—
Secondary group, of mixed descent			
Nuaillé-sur-Boutonne	—	—	portal spandrel
Varaize	—	south portal	—
Angoulême	—	—	façade revision
Pérignac	—	statues in upper zone	—
Fontaines-d'Ozillac	—	west portal	—
Parthenay, Notre-Dame	—	west portal	—
Angers, Saint-Aubin	—	refectory portal	—
Corme-Royal	upper arcade	upper arcade	—
Saint-Symphorien	—	west window	—
Castelvieil	—	north portal	—
Bordeaux, Sainte-Croix	—	—	side arcades

FIG. 6. The distribution of moralizing themes

Angoulême, in the double arcades at the extremities of the fourth zone, also concern the punishment of the rich and mighty (Pl. 239). The narrative framework of the Lazarus story is here omitted, but the basic message remains similar.

Taken together, all these parables amount to a flood of moralizing themes. Their dissemination throughout the region is illustrated in Fig. 6, which also reveals a limited number of basic combinations. The portal of Argenton-Château is the only monument to possess the full range. From Aulnay onwards, other portals in the same style combine the *Psychomachia* with the Wise and Foolish Virgins, but abandon all reference to Lazarus or the hell scenes. Otherwise, various older styles were now updated, incorporating sporadic quotations from these moralizing themes and especially the *Psychomachia*. At Pérignac, the old ascending scheme was thus supplemented by statues of the Virtues (Pl. 375). At Fontaines-d'Ozillac (Pl. 360), a sculptor who would not give up the old ornamentalism of the lower zone of Angoulême nevertheless wove the Virtues into the foliate sprawl. Corme-Royal, Saint-Symphorien, Castelvieil, and Bordeaux perpetuate vari-

ous aspects of the style of the Abbaye aux Dames at Saintes, supplemented by some crude versions of the new themes. Even the first workshop of Aulnay, which survived, as seen in the previous chapter, alongside the new workshop, now produced a hell scene for the programme of Nuaillé-sur-Boutonne. Though very poorly preserved, this scene can still be identified on a slab in the portal spandrel.

The most important and perhaps surprising conclusion from this survey is that these moralizing themes became a normal feature of the Aquitainian façade only from *c.*1130 onwards. None of the old workshops had utilized them in its main monuments of the second and third decades. All received them only in the latest monuments of their career, such as at Pérignac and Nuaillé-sur-Boutonne, and doubtless under the influence of the new workshop of Argenton-Château and Aulnay. The Virtues in the transept window of Aulnay are the only precedent, but even these are unlikely to have significantly predated the new workshop. As suggested in the previous chapter, these Virtues could well have been intended for the western façade, rejected with the arrival of the new workshop, and consequently never completed.

A few other themes with a moralizing accent had occasionally occurred on Aquitainian façades earlier, but never on such a coherent and systematic level. In fact, the very identification of such themes before 1130 is highly problematic. The tormented figure on a capital under the cornice of Parthenay-le-Vieux is perhaps Luxuria,[35] but the ornamental character of all the other capitals weakens its significance. The battle scene on a frieze of the Angoulême façade (Pl. 193) evokes the *Psychomachia*,[36] but its traditional interpretation as a secular theme of knightly exploits is no less credible.[37] On a portal archivolt at Foussais, a 'radiating' celestial court is followed by a wild company of musicians, dancers, and acrobats who evoke Prudentius's train of Luxuria,[38] but the interpretation is uncertain, and an alternative one has also been offered in the literature on that church.[39] In all these examples, the uncertainties arise from the almost total absence of precise parallels, which demonstrates just how rare was any reference to moralizing themes before the time of the group discussed here. The interest in such themes evidently entered a new and far more serious phase from *c.*1130 onwards.

Contrary to a widespread notion going back to Émile Mâle, the reason for this sudden preoccupation with moralizing themes is unlikely to have been an interest in the Last Judgement,[40] because there was nothing sudden about this. Themes related to the Last Judgement had in fact occurred earlier on capitals, for instance, the Weighing of Souls at Saint-Eutrope (Pl. 151) and at Aulnay itself (apse exterior), but were not transferred to the portal programmes. Furthermore, none of these portal programmes amounts to an explicit Last Judgement like those of Autun or Conques, which invariably combine the image of Christ with the final separation of the Elect and the Damned. Even a representation of Christ of the Second Coming, above the Virtues of Pérignac (Pl. 374), does not incur such details. The same is true of Moissac, where the hell

[35] For this interpretation, see Seidel 1981: 66.

[36] This frieze (Pl. 193) can perhaps be read after Prudentius: after the battle between the Virtues and Vices (represented as a knightly battle on the left), Discordia treacherously strikes Concordia from behind (represented in the middle of the frieze), and is then destroyed by all the other Virtues at the city gate (on the right). Cf. Prudentius 1965 edn.: 102–4, verses 665–725.

[37] The secular interpretation remains generally plausible, although a more specific interpretation according to the *Chanson de Roland*, suggested in Lejeune and Stiennon (1966: 29–42), seems somewhat strenuous.

[38] Prudentius 1965 edn.: 91–5, verses 310–453.

[39] Kenaan-Kedar 1986: 327–8.

[40] Mâle 1978 edn. (first published in 1922): 442; cf. Werner 1979: 9.

scenes are juxtaposed to Paradise merely in the context of the Lazarus story, and adjoin a portal with the Apocalyptic Vision rather than the Last Judgement. The closely related portal at Beaulieu is carved with a very detailed representation of the Vision of Matthew, accompanied by all manner of motifs, except those usually associated specifically with the Last Judgement.[41] Perhaps the monsters on the lintels at Beaulieu or the capitals at Aulnay allude to the torments of hell, but the identification is very uncertain, and in any case has little to do with what is usually recognized as a Last Judgement. Something else must underlie the sudden popularity of moralizing themes.

Judgement of God and Judgement of the Church

The parable of the Wise and Foolish Virgins is related in the Gospel of Matthew as a sort of Last Judgement (25: 13), but even this did not induce any explicit reference to the subject in the portals of Aquitaine. Such indifference to a major theological theme may seem strange, until it is realized that the notion of the judgement of souls had changed considerably between the time of the Gospel and the twelfth century. The views of medieval theologians on the matter have been analysed in a recent study,[42] and may be briefly summarized.

Early Christian writings describe two forms of God's judgement on mankind: the particular and the universal. The universal is the Last Judgement, following the Second Coming, whereas the particular follows the death of each individual. This basic distinction is taken up by the early scholastic thinkers such as St Anselm (1033–1109), Abelard (1079–1142), and Hugh of St Victor (*ob.* 1142), and is given a twist in the direction of moral urgency by St Bernard (1090–1153), according to whom all individuals are subject continuously to the particular judgement even during their lifetime. Coming from the Cistercian Bernard, this notion of continuous judgement may be understood in the context of the preoccupation of the New Monastic Orders with penitence for the sins of individuals,[43] yet the issue is wider. It concerns the spiritual jurisdiction of the Church. This is clarified in the somewhat later writings of Richard of St Victor (*ob.* 1173), in which he combines all the previous notions of the judgement of souls and enumerates three types. The first, during life on earth, is pronounced by the Church. The second is met by each individual at death. The third is the Last Judgement, at the End of Days, which is the time for reward and punishment.

In the temporal world and during everybody's lifetime, the judgement on the soul is thus pronounced by the Church. The justification for this spiritual jurisdiction lies in the power of the Key, conferred by Christ himself on St Peter:

And I will give unto thee the keys of the kingdom of heaven, and whatsoever thou shalt bind on earth shall be bound in heaven, and whatsoever thou shalt loose on earth shall be loosed in heaven. (Matt. 16: 19)

[41] Cf. Christe 1969: 103–33. [42] Viola 1988. [43] On penitence and the New Orders, see Leyser 1984: especially 64.

The heir to Peter's authority is the pope, and hence all priests consecrated by him and his bishops down the ecclesiastical hierarchy. All of them possess the power to loosen and to bind, and, through their judgement, God himself makes a judgement, in heaven as on earth.

Since the strength of this theology depends on papal sanction of all ecclesiastical appointments, its formative period was that of growing papal power, in the wake of the Gregorian Reform, and especially in the early decades of the twelfth century. This was the theology behind the then new phenomenon of papal indulgences, like those increasingly offered to the crusaders. Still somewhat obscure during the First Crusade (1096), these had become normal by the time of the Second Crusade (1147). The intermediate formative period is that discussed here. During that period the same theology also gave rise to the practice of sacerdotal confession and absolution, which now assumed its familiar Roman Catholic form: an ordained priest is spiritually authorized to judge the penitent, absolve him of his sins, and thereby readmit him to the congregation and to the Eucharist, which is the Christ himself.[44]

It is precisely this parallelism between Church judgement on earth and God's judgement in heaven that governs the moralizing programmes of *c*.1130, and endows the portal symbolism of the 'gate of heaven' with an urgent moral message. Argenton-Château (Pls. 342–5) presents the neatest example. Accompanied by the signs of the Zodiac, the Labours of the Months retain the same meaning as earlier at Saint-Jouin-de-Marnes, and designate the terrestrial and temporal world.[45] They are depicted on the outermost archivolt that frames the entire scheme. Unrolling inwards from one archivolt to the next, the programme then passes to an image of Christ's kingdom on earth, which is the Church. This image consists of the twelve Apostles. They witness the Ascension (apex voussoirs) (Pl. 344, upper archivolt), on which occasion they were promised, as seen in the discussion of Angoulême, the power to witness to God 'unto the uttermost part of the earth' (Acts 1: 8). Poised solemnly with their books or scrolls, inscribed individually with their names, and led by St Peter with his Key, they are the authority behind the entire ordained ministry. The essence of this authority is then specified as spiritual jurisdiction, since the next scene inwards (Pl. 344, lower archivolt) is Christ pronouncing judgement on the Wise and Foolish Virgins. The former are admitted to him and the latter are excluded. As noted, this is tantamount to admission and exclusion by the terrestrial Church, which alone in this temporal world possesses the power to absolve a sinner and readmit him to the Eucharist, which is the Christ. The next theme is the *Psychomachia* (Pl. 345, upper archivolt), because only the victor over sin can be worthy of the Eucharist. In Prudentius's own words, the happy conclusion of the victory of the Virtues is thus:

> Hereafter Christ himself, who is the true high priest,
> Born of a Father mighty and unnamable,
> Supplying *bread from heaven* to the victors blest,
> Will enter the humble dwelling of the sinless heart
> And cheer it with a visit from the Trinity.[46]

[44] On papal indulgences and the Crusades, see Robinson 1990: 341–9. On 'Juristic theology', see Ullmann 1970 edn. (first published in 1955): 359–81. For a different interpretation of the Aquitainian imagery in connection with the Second Crusade, see Seidel 1981.

[45] See above, Chapter 3.B.

[46] Prudentius 1965 edn.: 81, verses 59–63 (author's emphasis). See also O'Reilly 1988: 26–32, on the Virtues constructing the Temple of Wisdom, which is conceived in terms of the Apocalyptic New Jerusa-

Accordingly, the final theme is the Lamb of God (Pl. 345, lower archivolt), which need not be here taken in its Apocalyptic sense but rather in the Eucharistic sense. Following the scripture 'Behold the Lamb of God who taketh away the sin of the world' (John 1: 29), it is thus the subject of the *Agnus Dei* prayer for mercy, ordinarily said before Communion. The precise wording was even inscribed, in the liturgical rather than the scriptural form ('qui tollit peccata' rather than 'ecce qui tollit peccatum'), on the lost façade of Saint-Martin at Pons, as attested to by an eighteenth-century observer.[47] At Pont-l'Abbé-d'Arnoult, which probably belongs quite late in the descent from Argenton-Château and Aulnay, the accompanying angels were even provided with various liturgical objects: a censer, a chalice, a candlestick.[48] Some of the angels at Argenton-Château and Aulnay also carried various objects, unfortunately no longer identifiable with any certainty (Pls. 346, 353).

Entering the church of Argenton-Château by the main door, the Christian thus enters the House of God and the Kingdom of Heaven through its only acknowledged form on earth, which is the Church, its liturgies, and its powers of spiritual judgement. Furthermore, by choosing the Lazarus story for the accompanying reliefs of the spandrel frieze, whoever devised this programme made it clear that the judgement of the Church was indeed tantamount to the future judgement. As recited in the Gospel of Luke (16: 19–31), the essence of the Lazarus story is that the protagonists undergo judgement after death, and receive reward and punishment as in the Last Judgement. This parallelism between the portal and the frieze doubtless arose from the novelty of the very distinction between the different types of judgement, namely, in life, after death, and at the End. Later, this parallelism was apparently taken for granted, since the frieze was never repeated in Aquitaine. Only the portal programme was to recur.

Curiously enough, the new iconography seems to have largely ousted the grand composition of the Revelation of God, previously prominent on the façades of Saint-Jouin-de-Marnes and Angoulême, and repeatedly accentuated in the portal programmes of Burgundy, Languedoc, and the Île-de-France. Perhaps the subject simply returned to interior apse paintings, like those preserved, for instance, in the church of Saint-Gilles at Montoire, north of the Loire. This would have given all parts of the church a symbolical meaning: the Christian would enter the building through a portal representing the authority of the terrestrial Church, progress through the various interior parts of the 'House of God', and eventually reach the grand celestial Revelation, at the east end. However, with the loss of all interior murals at Aulnay, Argenton-Château, Fenioux, and the rest, this interpretation remains purely hypothetical.

The portal programme of Aulnay is practically identical to that of Argenton-Château, with a few exceptions. These involve the already noted muddle in the order of the Virtues, an apparent miscalculation of the outermost archivolt that resulted in the displacement of the month of May,[49] the absence of any reference to Lazarus, and, more significantly, an omission of the

lem, the Church, and the Body of Christ. I am not sure, however, that the full range of this symbolism is relevant for Argenton-Château and Aulnay.

[47] Favreau and Michaud 1977: 99.

[48] Inscription around the Lamb: HIC DEUS EST MAGNUS QUEM SIGNAT MISTICUS AGNUS (ibid. 100).

[49] After the theme for February, the cycle was apparently damaged and at some point replaced by three blank voussoirs. The next extant theme is a man in foliage, which Werner (1979: 10) identifies as March, but it could also be April (see Fig. 7). Either way, May must have been missing or misplaced, because the next theme is June and the rest follows in correct order.

archivolt with the Apostles. The special interest of the Aulnay façade arises from the themes chosen to compensate for this last omission.

The imagery concerning the apostolic authority of the Church was relegated to the side-niches. On the south side (Pl. 358), Christ is seated between what are probably two Apostles (Peter and Paul?), a scene that essentially conveys the same message of witnessing to God as the Apostles on the archivolt of Argenton-Château.[50] Yet the scene of Peter's Crucifixion, depicted in the opposite niche (Pl. 359), reveals a hagiographical interest that surpasses such generalized apostolic references. Since the church is dedicated to Peter, this choice appears to have arisen from a growing preoccupation with patron saints, as on the approximately contemporary façades at Ferrara (St George) and Saint-Denis (St Denis),[51] and with celebrating the authority of the Church through the cult of its canonized saints. And looming above it all was the equestrian image of Constantine, now lost,[52] which had been the normal Poitevin symbol of the Church since Saint-Jouin-de-Marnes.[53] It stood in the niche that occupies the centre of the upper zone and dominated the portal, producing an effect still maintained by the restored rider of Saint-Hilaire at Melle, also positioned in a large niche above a portal. Something of the original appearance of these riders is probably reflected in the large and completely three-dimensional rider of Châteauneuf-sur-Charente (Pl. 378), which is positioned somewhat differently in an upper side-niche, but was attributed above to the stylistic descent of Aulnay (on the basis of drapery forms).

Divorced from the Samson that had accompanied it at Saint-Jouin-de-Marnes and Parthenay-le-Vieux (Pls. 123–4, 216–17), the Constantine of Aulnay, Melle, and others of the new trend was singled out as a prominent image in its own right. This prominence was doubtless due to the growing fame of the model, that is, the antique equestrian statue of Marcus Aurelius, then known as Constantine, which stood in the square before the pope's palace and church of the Lateran at Rome. Having followed some verbal descriptions of this statue at least since Parthenay-le-Vieux, imitators now seem to have also heard something of its formal qualities as a large and excellent example of antique sculpture in the round. To judge by the surviving example at Châteauneuf-sur-Charente (Pl. 378), they accordingly carved the new riders as large three-dimensional statues, daring spatial and technical intricacies otherwise unknown in contemporary Aquitaine. This was, I believe, a stylistic expression of a new ideology concerning the Lateran statue. As shown in a previous chapter, the associations of this statue with Constantine now became secondary, yet it remained a symbol of the papacy's claim to the imperial legacy of ancient Rome by virtue of its antiquity, expressed in its formal qualities. The Aquitainian sculptors emphasized this, and made the great riders announce their churches just as the antique statue in the round announced the palace and the church of the pope.

The Lateran statue had long been associated with the papacy in a very temporal and everyday sense also, because the square around it was used for the administration of papal justice and as a place of execution.[54] These judicial associations, too, apparently made their way to Aquitaine.

[50] On other identifications of the Aulnay scene, see Werner 1979: 11.

[51] The relevant part at Saint-Denis is the tympanum of the south portal, discussed in Crosby and Blum 1987: 209–12.

[52] See n. 3 of this chapter.

[53] Above, Chapter 3.B.

[54] Krautheimer 1980: 192; Lauer 1911: 143–4. The judicial and penal associations were apparently the reason for the imitation, in northern Italy, of other pieces of sculpture from the Lateran square; see Verzar-Bornstein 1988: especially 36–9.

At Poitiers, the fragment of another monumental rider (Pl. 379) thus survives among the ruins known as 'Les Trois Piliers', which are all that remains of a structure connected with some sort of lawcourt and a pillory.[55] The Aulnay combination of the rider Constantine with a portal of spiritual judgement, followed also at Melle, thus amounts to an all-embracing statement of the authority of the Church of Rome in both the temporal and the spiritual sense. It is little wonder, therefore, that in an outburst of Protestant zeal the Huguenots were eventually to destroy so many of these Aquitainian riders.[56]

The Dissemination of a Thematic Scheme

After Argenton-Château and Aulnay there were many different adaptations of the new imagery, especially in Saintonge and further south (Fig. 6), though the programme appears to have lost its initial coherence in proportion to the distance from Poitou. It sometimes incurred senseless muddles and was often reduced to mere quotations.

As noted in the previous chapter, Varaize combines the new style with the outdated one of the first workshop of Aulnay. The new elements are depicted on the two inner archivolts, and include the Lamb, the angels (largely restored but preserving some original pieces), and an abbreviated version of the *Psychomachia*. The outer archivolt reiterates the conventions of the older workshop; it carries an enthroned Christ flanked by a 'radiating' retinue of barely identifiable figures, including some of the Elders of the Apocalypse. There is a second retinue of angels, on the hood. This programme cannot be expected to possess much logic because of the hopeless mixture of old and new elements.

Fenioux (Pls. 371, 372) repeats the themes of Aulnay in a somewhat different order. The Labours of the Months and the Wise and Foolish Virgins, depicted on the two outer archivolts, are followed directly by the Lamb and angels, whereas the *Psychomachia* is moved to the fourth position, below the Lamb. The programme consequently loses some of its coherence, because the object held by the two central Virtues is a crown (much eroded) which should appear above the Lamb, as at Aulnay (Pl. 354), but here hovers above the purely foliate ornament of the innermost archivolt. Perhaps this confusion arose from an unsuccessful attempt to reverse the reading, redirecting it outwards and upwards from the *Psychomachia* to the Lamb in the ascending manner. Indeed, the portal programme is here combined with an ascending scheme; a large statue of Christ in Majesty, accompanied by a retinue of Saints, is accordingly placed above the portal (Pl. 366). Pérignac, which according to the reconstruction suggested above probably possessed a portal similar to that of Fenioux, takes this combination a step further. It thus possesses a gable Christ under the direct influence of Angoulême, and even the Virtues are incorporated in an ascending scheme of statues (Pls. 373–5).

Far south of the main group of Poitou and Saintonge, the portal of Blasimont is largely foliate though enriched by isolated quotations from the programme. These include the Lamb, the

[55] Eygun 1941. [56] On the Huguenot destructions, see Gabet 1990: 113–14.

angels, and the *Psychomachia* (Pl. 363), supplemented by some additional themes on the hood, which remain unidentified.

In the refectory portal of Saint-Aubin at Angers, also remote from the main group, but to the north, a double representation of Samson has ousted the Lamb from the innermost archivolt. The Lamb has ended up on the middle archivolt, flanked by angels and some prophets or Apostles (?). The Virtues, on the outer archivolt, hold the crown above it.

At Civray, the programme is exceptionally extensive though somewhat diffused. There is a hotchpotch of the usual themes and new ones, including what may perhaps be seen as a reintroduction of the grand Revelation of God. The Lamb is accordingly replaced by Christ in Majesty, flanked by thuriferous angels. The Wise and Foolish Virgins appear directly above it, whereas the *Psychomachia* is relegated to the window zone above. This is flanked, in the upper side-niches, by the rider Constantine and a programme of saints which can no longer be deciphered because of later interpolations.

At Pont-l'Abbé-d'Arnoult (Pl. 396), which is arguably the latest in this group, the notions underlying the original programme are spelt out with the help of new details. Instead of the Apostles of Argenton-Château, there are other saints of the Church, provided with various attributes and including two bishops. In the train of Aulnay, this hagiographical programme is expanded in the side-niches with scenes concerning St Peter. Back in the portal, the *Psychomachia* appears on the next archivolt inwards, followed as usual by the Lamb of God on the innermost archivolt. The liturgical significance of the Lamb is emphasized by the censer, chalice, and candlestick held by the accompanying angels. The Wise and Foolish Virgins are relegated to the outermost archivolt of the portal. It is doubtful whether this displacement is iconographically significant, since there were apparently some *ad hoc* adjustments in assembling the complex. As a result, something is missing at the apex of the two middle archivolts, where the heads and haloes of the central figures are trimmed to fit the space.

Notre-Dame-de-la-Couldre at Parthenay, the famous façade at Chadenac, and also Pont-l'Abbé, involve some further complications which take the original Poitevin scheme into a new Early Gothic world, and are not of concern here.[57]

C. THE WANING OF THE SOUTH

Aquitainian Proto-Gothic

Argenton-Château and Aulnay belong to a world of fresh and diversified experimentation that gave us, within a brief period of twenty years or so (*c.*1120–40), almost all the major Romanesque portals, including those of Autun and Vézelay in Burgundy, Moissac, Beaulieu, and Conques in the south, and Saint-Denis in the Île-de-France. It seems that this is when the great

[57] Detailed descriptions and further illustrations of Varaize, Fenioux, Blasimont, Civray, and Chadenac can be found in the respective catalogue entries in Werner 1979.

portal finally became commonplace in a variety of regional versions. Every one of these versions is in a way proto-Gothic. What I mean by this term is a new harmony between figure sculpture and architecture: the sculpture is tightly correlated to the architectural design without losing any of its thematic clarity and statuesque presence. This harmony, soon to be masterfully accomplished in the Portail Royal of Chartres and eventually in Gothic portals, was at first variously expressed by trumeau and jamb reliefs, column figures, and large archivolt figures. The Aquitainian choice was the archivolt figure; the old distortions of archivolt carving accordingly disappeared, and the shape of the arch became a loose framework for freely composed figure sculpture.

As I have attempted to demonstrate, this new harmony of sculpture and architecture was achieved only when the architectonic methods of the Early Romanesque sculptor were abandoned by those responsible for figure-carving. The new longitudinal arrangement of statuesque archivolt figures did not grow out of the earlier architectonic decorations, as some old theories hold, but were associated with architectural pieces by expert figure-carvers, already versed in the art of statuary and indifferent to the old methods of the architectural decorator. The embryonic form of 'vertical' archivolt figures thus appeared in the first Aquitainian monument with serious figure sculpture, at Saint-Jouin-de-Marnes. The first longitudinal figures were created by the sculptors responsible for the statues of Angoulême, and the genre was perfected by the figure-carvers of Aulnay and Argenton-Château, who were capable of producing large statues in the round like the lost rider of Aulnay and the extant rider of Châteauneuf-sur-Charente. Perhaps the column figures of the Île-de-France too were produced by such expert figure-carvers, and did not grow out of the rudimentary jamb decorations of earlier Romanesque sculpture. The reassociation of sculpture and architecture arose from new iconographical considerations such as the symbolism of the portal, and probably also from some new aesthetic attitudes, undocumented, but reflected in the works themselves.

It was apparently owing to such aesthetic considerations that the architectural framework was increasingly exploited in that period for tightening the visual coherence of the programme as a whole. At Angoulême this had been achieved by dividing the figure programme among the various blind arches, but the new system was much more sophisticated. The builder was now creating extra recesses inside the various arches specifically for the sake of the sculptor, who exploited them for a new arrangement of the sculpture in space. When the façade of Aulnay (Pl. 350), for instance, was still free of the repair buttresses which now disfigure it, the recess-shafts with their capitals and archivolts probably formed a unified design across the portal and niches,[58] as earlier in the Abbaye aux Dames (Pl. 300) and later at Chadenac (Pl. 394), imposing an overall rhythm of advancing and receding sculpted surfaces in a manner that heralds Chartres.

The iconography too was carefully thought out in relation to the architecture: images of the terrestrial Church centre on the moralizing parallelism of heaven and earth in the portal, which is 'the gate of heaven'. It may be noted that the approximately contemporary programme of Saint-Denis presents another solution to precisely the same parallelism. Allowing for a margin of error arising from the uncertain identification of the lost column figures, the following system

[58] Cf. a reconstruction drawing of the Aulnay façade in Werner 1979: fig. 2.

may be detected. The lower zone is designated as the temporal and terrestrial world, with the Labours of the Months and the signs of the Zodiac depicted on the jambs of the side portals. The original iconography of the tympana in these portals (restored) is not entirely clear, but at least one tympanum was dedicated to the patron saint, and hence to the Church, as in the north niche of Aulnay. The Wise and Foolish Virgins still belong to the worldly zone, and are accordingly depicted on the jambs of the central portal. Probably alluding to the judgement of the terrestrial Church, as in the Aquitainian archivolt programmes, they lead up to a complex image of the Revelation of God, depicted on the tympanum and archivolts above, and comprising elements of the Second Coming and the Last Judgement. This compromise between the new portal iconography and the old ascending scheme, leading upwards to a grand Revelation in the central tympanum, was arguably one of the reasons for the success of the northern version of the programme. In the event, this version had the greatest impact on future practices, and therefore came to deserve the title 'proto-Gothic' more rightly than others. Conversely, the Aquitainian version abandoned the grand Revelation and therefore remained defective.[59]

The Regional Duality of Poitou

The affinities between the new Poitevin style and the northern proto-Gothic are the crux of the chronological problem of the school of Aquitaine. In the matter of longitudinal archivolt figures, for instance, some scholars give priority to Aulnay or Argenton-Château and others to northern proto-Gothic, beginning with Saint-Denis.[60] The date suggested here for Argenton-Château is about contemporary with Saint-Denis. It seems to me that the question of priority turns on a few years and is of little account because neither monument copies the other; direct interchanges between Aquitaine and the north can be detected only later. The particular interest of the relationship between the new Poitevin style and northern proto-Gothic is entirely different; it lies in the possibility of common sources in the Poitou–Loire milieu of the earlier period, when that milieu was still important and influential. This issue exceeds the scope of this book, but may nevertheless be illustrated by two examples from the material examined above, the one iconographical and the other stylistic.

The iconographical example concerns cycles of the Labours of the Months. Fig. 7 illustrates the relationship among three groups of such cycles. The first is a Poitou–Loire group including a late eleventh-century capital at Airvault and the early twelfth-century portal archivolt of Saint-Jouin-de-Marnes, to which I have added an arch in the cloister of Saint-Aubin at Angers and also the displaced tympanum of Saint-Ursin at Bourges. The other two groups are later though contemporary with each other. The one includes the northern proto-Gothic cycles on the portal jambs of Saint-Denis and the archivolts of Chartres, and the other is the new Aquitainian group of Argenton-Château, Aulnay, Fenioux, and Civray, with the addition of Cognac. The table

[59] For details of the Saint-Denis programme, see Crosby and Blum 1987: 179–213.

[60] The priority of Aulnay or similar Aquitainian monuments is held by the following: Werner 1979: 89–92 and n. 130; Zarnecki 1971: 82;

Lapeyre 1960: 23 and 37. Others place Aulnay later than Saint-Denis: e.g. Aubert 1956; Jacoub 1981. Mâle assigned late dates to all the Aquitainian monuments with comparable archivolts, but denied the influence of northern proto-Gothic (Mâle 1978 edn.: 440–1).

shows that the northern proto-Gothic examples are closer to the early Poitou–Loire group than to their contemporary Aulnay group. Amongst the elements common to the Poitou–Loire and the northern groups, particularly striking are Janus for January, the sideways position of February, the walking knight for May, and the filling of wine-casks for September or October.[61] All these are altered in the Aulnay group, which also substitutes animals at the manger for the otherwise ubiquitous hog-slaughter in November.[62] In short, the northern proto-Gothic type might have arisen from the early Poitou–Loire type, but the Aulnay group represents an idiosyncratic regional diversion, distanced from the northern trend.[63]

The stylistic example concerns archivolt decoration of the type described above as curving from face to soffit as if wrapped around the bulk of the archivolt. This, it may be recalled, is the French version of the Lombard roll archivolt. Saint-Jouin-de-Marnes presents the earliest Aquitainian example (Pls. 110–12), with a mixture of rolls and other Italianate motifs. Beside Saint-Jouin and a few later examples in Poitou,[64] two other groups of monuments possess this kind of 'wrapped' archivolt decoration alongside other Italianate features. The one is the Saintes group of the third decade and onwards, as described above (Pls. 309, 311, 321). The other is found in the Île-de-France, and adheres more closely to the Italian models. For instance, the north portal of Saint-Étienne at Beauvais (c.1140 ?) possesses wrapped archivolts, of which one carries a procession of animals intertwined in scrolls (Pl. 380) as on the apse archivolts of Parma Cathedral.[65] One of the loose voussoirs which survive from the Romanesque portal of Chelles abbey, near Paris, is similarly wrapped in carving, consisting of an animal chewing the end of a foliage scroll (Pl. 381).[66] The same technique recurs on the outer archivolt of the central portal of Saint-Denis, where it was exploited for figural themes. This archivolt carries ten of the Elders of the Apocalypse, placed longitudinally and still intertwined in scrolls.[67]

The technique of wrapped archivolt decorations was thus adapted to important figural compositions at Saint-Denis. In Aquitaine, on the other hand, wrapped carvings became ever more ornamental in the Abbaye aux Dames, Maillé, and others of this group. The inevitable conclusion is the same as above, namely, that Aquitaine and the north represent divergent trends going back to similar sources. These sources were partly Italian and perhaps mediated by some early twelfth-century derivative of the Poitou–Loire milieu. The wrapped archivolt motif of an animal chewing a foliage scroll, for instance, occurs first at Saint-Jouin-de-Marnes (Pl. 111) and later in two divergent forms at Chelles in the north and Maillé in the south (respectively Pls. 381, 327). I do not suggest that the source was Saint-Jouin; the losses in the Loire region may be remembered. The intermediary lands between the Loire and Chartres in fact preserve yet another form of a proto-Gothic archivolt system, combining longitudinal animals and figures (on archivolts as well as hoods) with some distorted creatures which seem to have originated in a wrapped system, such as at Châteaudun, for instance (Pl. 382).

[61] Concerning the scenes for May and June, a comparison between Airvault and Saint-Denis is illustrated in Tcherikover 1985a: figs. 19–22.

[62] The animals at the manger may derive from Burgundian sources such as the celebrated Souvigny column.

[63] For an additional discussion, detailed descriptions, and some illustrations, see Webster 1938: 66–79.

[64] e.g. Vouvant and Saint-Médard in Thouars.

[65] Illustrated in Quintavalle 1974: fig. 164.

[66] Johnson 1995: no. 10. Johnson dates this piece, together with some other fragments, to the middle of the 12th cent., but to me it seems earlier.

[67] Illustrated in Crosby and Blum 1987: fig. 79.

Month	Early Poitou–Loire group				Northern proto-Gothic		Aulnay group				
	Airvault (capital)	Saint-Jouin (archivolt)	Angers, Saint-Aubin (arch)	Bourges Saint-Ursin (tympanum)	Saint-Denis (door jambs)	Chartres (archivolts)	Aulnay (archivolt)	Argenton-Château (archivolt)	Fenioux (archivolt)	Civray (archivolt)	Cognac (archivolt)
January	—	Janus between two doors	—	feasting	Janus between two doors	man at table (Janus ?)	seated man	seated man (damaged)	seated man	seated man	seated man
February	—	warming (sideways)	warming (sideways)	warming (sideways)	warming (two men, sideways)	warming (sideways)	warming (frontal)	warming (frontal?)	warming (frontal)	warming (frontal)	warming (frontal?)
March	pruning	pruning	pruning	pruning	pruning and digging	pruning	—	pruning	pruning	pruning	pruning
April	man in foliage	—	—	?	man in foliage	crowned man and tree	man in foliage	man in foliage	man in foliage	man in foliage	crowned man in foliage
May	walking knight and horse	—	—	?	walking knight and horse	walking knight and horse	—	rider (damaged)	rider	rider	rider? (damaged)
June	mowing	—	mowing	mowing	mowing	mowing	mowing	mowing	mowing	mowing	mowing
July	—	—	—	harvest (reaping)	harvest (reaping)	harvest (reaping)	harvest (reaping)	harvest (reaping)	harvest (reaping)	harvest (reaping)	harvest (reaping)
August	—	—	gathering fruit?	harvest (threshing)	harvest (threshing)	harvest	harvest (threshing)	harvest (threshing)	harvest (threshing)	harvest (threshing)	harvest (threshing)
September	—	—	treading grapes	picking grapes	filling casks	treading grapes	treading grapes (damaged)	treading grapes (damaged)	treading grapes	treading grapes	treading grapes
October	—	filling casks	filling casks	filling casks	beating acorns	beating acorns	beating acorns (damaged)	beating acorns (damaged)	beating acorns (damaged)	beating acorns	beating acorns
November	—	hog-slaughter	hog-slaughter	hog-slaughter	hog-slaughter	hog-slaughter	animals at the manger	animals at the manger	animals at the manger	animals at the manger	animals at the manger
December	—	man seated feasting?	?	feasting at table	feasting at table	feasting at table	feasting at table	feasting at table	feasting at table	feasting at table	feasting at table

FIG. 7. The Labours of the Months

These examples illustrate the persistence of the regional duality of Poitou, as noted at the outset of this investigation. From Airvault through Saint-Jouin-de-Marnes right down to the emergence of the new style at Argenton-Château and Aulnay, Poitou was never quite southern, or quite northern. It had something of both worlds, and probably gave to the north as much as it received. Yet the same examples also suggest that this balance was disturbed soon after the appearance of the new style. From Aulnay and the Abbaye aux Dames onwards, the Aquitainian styles became regionally idiosyncratic and exercised no influence on the course of northern proto-Gothic. In fact, the once prolific and inventive school of Aquitaine was already touched by decadence, and was eventually to be overshadowed by the new northern centres. The investigation of High Romanesque sculpture in the duchy should therefore end here. However, since the change was not instantaneous, there is room for some brief comments, by way of epilogue, on the monuments in the twilight period before the final decline.

Figural Conservatism and the Ornamental Swamp

Doubtless aware of the far-reaching innovations introduced to church sculpture north of the Loire from the fourth decade of the twelfth century onwards, the Aquitainian figure-sculptor nevertheless avoided straightforward imitation beyond isolated details. One example concerns the façade of Pérignac. Besides the influence of Angoulême and Aulnay, already noted (Pl. 374, cf. Pl. 231; Pl. 375, cf. Pls. 371, 355), the sculpture of this façade reveals the influence of a third style: the three statues at either end of the second zone combine the style of Aulnay with a previously unknown type of mildly clinging draperies marked by thin pleats (Pl. 377). The source for this new style was apparently northern; similar drapery forms can be seen in Montfaucon's engravings of the lost column figures of Saint-Denis.[68] It goes without saying that drapery forms were not the most important innovation of the northern proto-Gothic monuments, but the Aquitainian sculptor remained distinctly uninterested in anything else. In the main, Pérignac adheres to the ascending scheme of statues in the manner of Angoulême, enriched by the Virtues and other elements of the Aulnay style, as described above.

Elsewhere, too, a singular conservatism now seems to have gripped the previously pioneering school of Aquitaine. The Aquitainian sculptors of *c.*1140 and onwards relied on the local traditions of the early twelfth century, and produced endless variations of wall-mounted statues after Angoulême, archivolt figures after Argenton-Château and Aulnay, as well as new versions of the veteran frieze and niche relief. It will now be seen how a prolific group of Poitevin figure-carvers of that time variously used all these forms, and met the influence of northern proto-Gothic half-way and half-heartedly. These figure-carvers executed two kinds of projects: the enrichment of older façades at Poitiers, Foussais, Saint-Jouin-de-Marnes, and Maillezais, and the production of a new façade for Notre-Dame-de-la-Couldre at Parthenay. Some loose statues at Montmorillon may also be attributed to it.

On the façade of Notre-Dame-la-Grande in Poitiers (Pl. 284), the decoration of the portal and

[68] Illustrated in Crosby and Blum 1987: fig. 87.

niches represents the ornamental idiom of *c.*1130. The figure programme, which arguably was inserted later, is arranged on the higher parts of the façade as an outdated version of the ascending scheme of Angoulême, and includes rows of statues in the arcades of the upper zone and a Christ in the gable. In addition, the spandrels of the first zone are filled with a figural frieze, as at Argenton-Château,[69] though of a different and essentially Marian subject-matter. Since this frieze is very well known, a quick reminder of its content will suffice here. Following the Fall, the imagery unrolls through a series of Prophets who allude to the Incarnation, and continues with the Annunciation, Jesse with a rudimentary tree, David, the Visitation, the Nativity, and an unidentified scene of two fighting men.[70] All this is carved in two distinct styles. The Visitation is rigid and somewhat crude, but much of the rest is impressively statuesque (Pls. 385, 386), allowing for free and natural gestures, and in this sense outdoing Angoulême, Aulnay, and all other Aquitainian figural work up to 1130–40. It is possible that the style was touched by new influences from Burgundy or the south, but this still awaits research.

A second variant of the same style can be found in the niche sculpture of the façade of Foussais. In the southern niche there is Christ in the House of Simon and Christ's appearance to Mary Magdalene (Pl. 383). The northern niche contains the Deposition, which is signed by one Geraudus Audebertus of Saint-Jean-d'Angély.[71] However, the style is that of the frieze of Notre-Dame-la-Grande at Poitiers. The statuesque figures possess the same full faces with thick locks of hair terminating in curls, the same sturdy necks emerging from realistically carved collars, similar narrow plate-folds accentuated by double lines, and a similar sprinkling of beaded bands or edgings (Pl. 384, cf. Pls. 385, 386). There is some variety of drapery forms, but Foussais and the Poitiers frieze nevertheless seem to represent the activity of one and the same workshop.

The same workshop, though perhaps a different sculptor, may also have been responsible for the revision of the old façade of Saint-Jouin-de-Marnes (Pl. 208). As already shown, this façade at some point received an additional set of figures, clumsily inserted among the original ones. The new figures are statues in the round, designed to be seen from a side view as well as frontally, and completely different from the original flattened reliefs. They include, above the side windows, Luxuria tormented by serpents (Pl. 390) and some other figures (which remain unidentified), as well as the elegant lady to the north of the central window (Pl. 392). Together with some small reliefs of praying souls, a second female figure was inserted at the centre of the original frieze of the Elect (Pl. 388). It was perhaps intended to represent the Virgin Mary. All these statues are exceptionally bulky and firmly positioned on horizontal slabs, as at Foussais, and the Virgin even reproduces the Foussais style of tightly set plate-folds and flattened flaps of garment with beaded edging (Pl. 388, cf. Pl. 384). Another statue in the same style can be found in the north niche of the façade of Saint-Nicolas at Maillezais, a short distance south of Foussais. Despite deep erosion, it is still possible to recognize in this statue (Pl. 389) the general appearance of the elegant lady to the north of the Saint-Jouin window, enriched by the tossed head-dress of the Saint-Jouin Virgin (cf. respectively Pls. 392 and 388).

[69] The spandrel-frieze of Argenton-Château is in my view the earliest in the region. The purported spandrel-frieze of the Abbaye aux Dames at Saintes does not seem to belong to the original programme of the lower zone but to some later rearrangement; see above, Chapter 4 n. 51.

[70] Mâle 1978 edn. (first published in 1922): 146–51; Porter 1923: 320–28; Chailley 1966; Riou 1980. The last article also contains a more detailed bibliography.

[71] Geraudus Audebertus de Sancto Johanne Angeriaco me fecit (Crozet 1942: no. 142c). On the church, see Auzas 1956b.

There is evidence to show that all these figural pieces, at Notre-Dame-la-Grande, Foussais, Maillezais, and Saint-Jouin-de-Marnes, are belated additions to otherwise completed structures. First, nothing in this style appears on any of the structural elements of these façades. As seen in the previous chapter, the capitals and archivolts were in fact executed by several different workshops; there was a local workshop at Notre-Dame-la-Grande, a Melle workshop at Foussais, and there were others elsewhere. Secondly, all these façades betray technical irregularities of the kind which usually results from belated insertions. Those at Saint-Jouin-de-Marnes have already been noted.[72] At Foussais, the original imposts of the niches are crudely hacked, apparently because the reliefs could not be otherwise pushed in (Pl. 383). At Maillezais, the figure fits very tightly in the niche, and its halo is slightly trimmed. At Notre-Dame-la-Grande, some metopes are cut back in order to allow sufficient space for the frieze. Unless the workshop was singularly incompetent, the accumulation of so many irregularities suggests that the figural pieces were added after everything else was already in position. It seems that a workshop of figure-carvers was commissioned for the task of adding new sculpture to a series of façades, some much older and others in the course of completion, presumably in order to bring them up to new standards of figural richness. It is even possible that the workshop dispatched these pieces to the site (from Poitiers, from Saint-Jean-d'Angély?) and did not supervise the actual insertion, which was left to local workmen of varying ability.

This workshop was apparently active around the middle of the century, and at some point encountered the influence of northern proto-Gothic, characteristic of that period. The main examples of this encounter concern Montmorillon and Parthenay.

In the large octagon of the Maison-Dieu at Montmorillon, there are four elongated blocks resembling cloister piers, each carved with two or four figures. This ensemble is now set in a row inside a window, but perhaps comes from some other architectural complex which remains unknown.[73] Stylistically, the figures can be added to the group described above; some are very similar to the statues of Saint-Jouin-de-Marnes, even if cruder in execution. The first block (from the left) carries two representations of Luxuria, the one attacked by serpents as at Saint-Jouin (Pl. 391, cf. Pl. 390), and the other by toads. There is also a variation on the Saint-Jouin Virgin, on the side of the third block. The fourth block carries two elegant ladies who are practically identical to the one at Saint-Jouin (Pl. 393, cf. Pl. 392) but differently arranged: they are positioned back to back against a column. This arrangement must represent an Aquitainian response to the northern proto-Gothic invention of the column figure, albeit limited and hesitant.

The second example concerns the façade of Notre-Dame-de-la-Couldre at Parthenay, of which only the lower zone survives.[74] It contains a portal with longitudinally placed archivolt figures in the descent of Argenton-Château and Aulnay. The ornamental trimmings are actually identical to some at Blasimont, presented above as a late member of the same group of monuments. Otherwise, the complex deviates from the Aulnay style in several ways. First, Constantine and Samson (badly mutilated) are presented in the side-niches in accordance with

[72] Chapter 3.A. See also Tcherikover 1985b.

[73] The history of the site is presented in Grosset 1951.

[74] Notre-Dame-de-la-Couldre has come down to us in a fragmentary state. A part of the east end survives, with two corbels which allow no precise dating. At the west end, something remains of the side walls, adjoining the western façade, with a small portal on the south side.

a local tradition going back to Parthenay-le-Vieux, though the style is distinctly statuesque in the new manner.[75] Secondly, the style of the archivolt figures (Pl. 387) resembles the niche reliefs of Foussais, and involves some identical drapery forms and even similar canopies. Thirdly, the iconography of the Parthenay portal includes some completely new elements.[76] There is, for instance, a longitudinal version of the Elders of the Apocalypse, a theme absent from Aquitainian portals of the Aulnay type, but present at Saint-Denis and Chartres. Similarly, the archivolt with the Lamb of God carries two additional scenes, including an Annunciation with a distinct flavour of Chartres. The doll-like Virgin thus touches one of her sleeves with two fingers of the opposite hand,[77] exactly as in the south tympanum of the western façade of Chartres.

These works should doubtless be seen as provincial adaptations of northern proto-Gothic, a weighty subject that exceeds the scope of this book.[78] So neither the frieze of Notre-Dame-la-Grande nor other purportedly Romanesque works at Chadenac, Pont-l'Abbé-d'Arnoult, and elsewhere, will here be treated in any detail. All reflect something of the contemporary innovations of the north, though in a derivative manner that never gave rise to a significant local trend. In all other respects, these works represent a conservative sequel to the Aquitainian style of *c.*1130–40. Chadenac, for instance, presents an exceptionally ambitious and well-executed façade programme, which nevertheless amounts to no more than a mannered refinement of Aulnay and Fenioux with a limited number of additional themes (Pls. 394, 395).[79] The same is true of Pont-l'Abbé-d'Arnoult, which reiterates much of the programme of the Aulnay portal and niches. The portal iconography was expanded, the niche reliefs were carved more deeply, but the principle remained the same.

Even the old architectural ornamentalism was not to be abandoned. In some places, the ornaments were in fact made more exuberant than ever before, almost swamping the figure programme, and challenging the new proto-Gothic harmony of figure sculpture and architecture. At Pont-l'Abbé, for instance, an exceptionally rich ornamental programme spreads over the capital-friezes and the niche archivolts, dwarfing the figural reliefs in the niches (Pl. 397). This programme includes a chaotic tapestry of monsters and foliage and a prancing host of 'radiating'

[75] The workshop of Notre-Dame-de-la-Couldre must have been intimately acquainted with the older church at Parthenay-le-Vieux, since it apparently executed some new works in that church. Some of the capitals of Notre-Dame-de-la-Couldre, on the façade as well as in the side portal (see n. 74 above) are thus very similar to those used in a partial rebuilding of the nave of Parthenay-le-Vieux. This rebuilding involved the side windows and the higher zone of the façade, and was apparently connected with a project of vaulting; see Tcherikover 1986: esp. figs. 1–5.

[76] The order of the themes in the Parthenay portal, from the outer archivolt inwards, runs as follows: first archivolt: an abbreviated representation of the Elders of the Apocalypse, consisting of six Elders; second archivolt: six Virtues; third archivolt: a pair of angels with the Lamb of God, flanked by the Annunciation to the Virgin Mary and another scene, perhaps the Annunciation to Zacharias; innermost archivolt: an abbreviated Ascension, consisting of two angels carrying a clipeus with the figure of Christ, and flanked by two Apostles (or perhaps Enoch and Elijah). The complex rests on a largely figural capital-frieze, doubtless after the principle of Chartres, though somewhat confused and interspersed with ornamental elements. Some of the themes in this frieze, and hence its programme, still await identification.

[77] Illustrated in Seidel 1981: Pl. 39 (second archivolt).

[78] The proto-Gothic tympanum of Déols, now in Châteauroux museum, may well have been produced by the same Poitevin workshop. Some drapery forms in this work are practically interchangeable with Foussais. Current scholarship places the Déols portal variously between *c.*1150 and *c.*1180, namely, from about contemporary with the proto-Gothic façade of Chartres to almost a generation later. See Sauerländer 1972: 400–1; Lapeyre 1960: 81–3; Favière 1970: 200–1.

[79] The portal programme of Chadenac includes the standard Wise and Foolish Virgins as well as the Virtues. In addition, there is a completely new Marian and hagiographical accent. The innermost archivolt is carved with the Assumption of the Virgin Mary, modelled on Christ's Ascension, and invading an intermediary archivolt carved with the Virtues. On the next archivolt there are various saints provided with attributes: a star, an axe, a sword, a melon cap, and a staff. I shall not attempt precise identification, but note only that this sort of individualization had been practically unknown at Argenton-Château, Aulnay, or Fenioux, and evokes rather the individualized statues of saints produced north of the Loire from the Early Gothic period onwards. The same applies to the various saints on one of the portal archivolts at Pont l'Abbé-d'Arnoult.

archivolt figures, inherited from the Saintes style, and now undercut to the extent of being free-standing. In northern France such ornamental frivolities were rapidly going out of fashion or being relegated to less important positions, but the patrons and sculptors of Aquitaine were evidently content with the dual tradition of ornament and figure sculpture established during the first few decades of the century. It may be said that the very strength of the school of Aquitaine in that period now became its undoing, for it encouraged endless refinement of well-tried forms at the expense of innovation.

Changing Powers

Aquitainian Romanesque thus passed from dynamic and innovative beginnings to conservatism diluted by sporadic imitation of the new centres across the Loire. This rather radical change in the fortunes of the regional school, noted in monuments of *c.*1140 onwards, corresponded to the changing fortunes of the duchy itself.

The power of the duchy of Aquitaine had been at its height in the eleventh century, when Duke Guy-Geoffrey (*ob.* 1086) consolidated his government in the southern provinces and fended off the competing power of Anjou. He left William the Troubadour (*ob.* 1126) and William the Toulousan (*ob.* 1137) a principality of some standing, which reached a certain height of economic prosperity around 1130. Yet signs of political decline were already present. The ducal hold on the southern territories had been weakening since c.1120, and the renewed feudal strife was not to cease for decades. To make matters worse, William the Toulousan left no male heir, and his duchy was soon to become the troubled backyard of new powers, all of them northern. The marriage in 1137 of his daughter Eleanor to King Louis VII was presumably intended to strengthen the duchy, but the result was a new northern predominance followed by virtual neglect. In 1152, when Eleanor divorced Louis and married Henry Plantagenet of Anjou, the old Angevin claim to Saintonge and parts of Poitou materialized in straightforward annexation. The duchy now became part of the Plantagenet empire, the important centres of which were in Anjou, Normandy, and, two years later, England.[80]

For the Church in the duchy, this series of political events came at a crucial moment, following the turmoil caused by the dual papal election of 1130. The duchy was in the wrong camp, supporting Anacletus II, while the opposing party of Innocent II was led by the influential New Monastic Orders which increasingly enjoyed the protection of the rising French monarchy. Most of the Aquitainian bishops revolted and were exiled, while the archbishop of Bordeaux was now Gerard of Angoulême, excommunicated by the widely supported Innocent. After the death of Anacletus (1138), the victorious Innocent acted in the region through his new legate, who was no longer of the south but the bishop of Chartres.[81] Later, the Plantagenet dukes imposed on Aquitaine a new order after the model of Normandy, extending forceful protection to the Church and controlling its affairs more closely than before.[82]

It may seem that the policies of the duchy had come full circle. If the Aquitainians had turned

[80] Dunbabin 1985: 340–6; Gillingham 1984: 16–19. [81] Stroll 1987: 134–5. [82] Dunbabin 1985: 365–71.

southwards in the late eleventh century, they were now facing northwards again. Yet there is a fundamental difference between the two processes; the first took place under Aquitainian control, but not the second. Accordingly, the first resulted in a dynamic encounter of north and south on Aquitainian territory, while the second threatened the duchy with stale provincialism.

The period around 1130–40 can therefore be seen as one of changing powers. Though still enjoying the prestige of a great principality and the economic benefits of the early twelfth-century growth, the duchy of Aquitaine was already acquiring provincial characteristics under the shadow of a rising northern culture. Similarly, the Romanesque school of Aquitaine was still capable of producing its own proto-Gothic variant at Argenton-Château and Aulnay about 1130, but the later dissemination of this style in the region was touched by provincial conservatism and some northern influences. For all its excellent workmanship and ambitious programme, the façade of Chadenac accordingly represents the outdated flowering of a bygone era. Having played an important part in the forefront of the Romanesque revival, the Aquitainian sculptor was soon to submit to the renewed predominance of the north.

SELECT BIBLIOGRAPHY

ADLER, N. N. (1907), *The Itinerary of Benjamin of Tudela: Critical Text, Translation and Commentary* (New York).

ALEXANDER, J. J. G. (1970), *Norman Illumination at Mont St. Michel* (Oxford).

ALVERNY, M. T. D' (1953), 'Le Cosmos symbolique du XIIe siècle', *Archives d'histoire doctrinale et littéraire du Moyen Âge*, 28 (1953, appeared 1954): 31–81.

AUBERT, M. (1946), *La Sculpture française au Moyen Âge* (Paris).

——(1956), 'Église d'Aulnay', *Congrès archéologique de France*, 114 (La Rochelle): 316–27.

AUDIAT, L. (1875), *Saint-Eutrope et son prieuré*, Archives historiques de la Saintonge et de l'Aunis, 2 (Paris and Saintes).

AUZAS, P. M. (1956a), 'Nieul-sur-l'Autize', *Congrès archéologique de France*, 114 (La Rochelle): 67–73.

——(1956b), 'Foussais', *Congrès archéologique de France*, 114 (La Rochelle): 73–9.

AVERY, M. (1936), *The Exultet Rolls of South Italy* (Princeton).

BALTRUSAÏTIS, J. (1931), *La Stylistique ornementale dans la sculpture romane* (Paris).

BARCLAY LLOYD, J. (1989), *The Medieval Church and Canonry of S. Clemente in Rome*, San Clemente Miscellany, 3 (Rome).

BEECH, G. T. (1964), *A Rural Society in Medieval France: The Gâtine of Poitou in the Eleventh and Twelfth Centuries* (Baltimore).

BENSON, R. L., and CONSTABLE, G. (1982) (eds.), *Renaissance and Renewal in the Twelfth Century* (Cambridge, Mass.).

BERLAND, J. M. (1980), *Val de Loire roman* (La-Pierre-qui-vire).

BERTHELÉ, J. (1886–7), 'Recherches critiques sur trois architectes poitevins de la fin du XIe siècle', *Bulletin monumental*, 52: 560–75, and 53: 19–26, 113–28.

BESLY, J. (1647), *Histoire des comtes de Poictou et ducs de Guyenne* (Paris).

BLOCH, H. (1982), 'The New Fascination with Ancient Rome', in Benson and Constable (1982), 615–36.

BLOMME, Y. (1985), *L'Église Saint-Eutrope de Saintes* (Jonzac).

——(1987), *L'Architecture gothique en Saintonge et en Aunis* (Saint-Jean-d'Angély).

BOISSONNADE, P. (1934–5), 'Les Relations des ducs d'Aquitaine, comtes de Poitiers, avec les états chrétiens d'Aragon et de Navarre', *Bulletin de la société des antiquaires de l'Ouest*, 3rd ser. 10: 264–316.

BROUSSILLON, B. DE (1903), *Cartulaire de l'abbaye de Saint-Aubin d'Angers* (Paris).

BUDDENSIEG, T. (1959), 'Le Coffret en ivoire de Pola, Saint-Pierre et le Latran', *Cahiers archéologiques*, 10: 157–200.

CABANOT, J. (1987), *Les Débuts de la sculpture romane dans le sud-ouest de la France* (Paris).

CAMERON, J. (1966), 'Les Chapiteaux du XIe siècle de la cathédrale du Mans', *Bulletin monumental*, 124: 343–61.

CAMUS, M. T. (1978), 'Un chevet à déambulatoire et chapelles rayonnantes à Poitiers vers 1075: Saint-Jean-de-Montierneuf', *Cahiers de civilisation médiévale*, 21: 357–84.

——(1982a), 'Le Personnage sous arcade dans la sculpture sur dalle du Poitou roman—premières expériences', *Romanico padano—romanico europeo*, Convegno internazionale di studi, Modena–Parma, 1977 (Parma), 369–79.

CAMUS, M. T. (1982*b*), 'La Reconstruction de Saint-Hilaire-le-Grand de Poitiers à l'époque romane. La marche des travaux', *Cahiers de civilisation médiévale*, 25: 101–20 and 239–71.

——(1987), 'Les Débuts de la sculpture romane à Poitiers et dans sa région', Ph.D. thesis (University of Toulouse Le Mirail).

——(1989), 'A propos de trois découvertes récentes. Images de l'Apocalypse à Saint-Hilaire-le-Grand de Poitiers', *Cahiers de civilisation médiévale*, 32: 125–33.

——(1991), 'De la façade à tour(s) à la façade-écran dans les pays de l'Ouest. L'exemple de Saint-Jean-de-Montierneuf', *Cahiers de civilisation médiévale*, 34: 238–53.

——(1992), *Sculpture romane du Poitou; les grands chantiers du XIe siècle* (Paris).

CAROZZI, C., and TAVIANI CAROZZI, H. (1982), *La Fin des temps, terreurs et prophéties au Moyen Âge* (Paris).

CARRASCO, M. E. (1990), 'Spirituality in Context: The Romanesque Illustrated Life of St Radegund of Poitiers', *Art Bulletin*, 72: 414–35.

CASTAIGNE, E. (1853) (ed.), *Rerum Engolismensium scriptores*.

CAVALLO, G. (1994). *Exultet: Rotoli liturgici del medioevo meridionale* (Rome).

CHAGNOLLEAU, J. (1938), *Aulnay de Saintonge* (Grenoble).

CHAILLEY, J. (1966), 'Du drame liturgique aux prophètes de Notre-Dame-la-Grande', *Mélanges offerts à René Crozet* (Poitiers), ii. 835–42.

CHARTROU, J. (1928), *L'Anjou de 1109 à 1151* (Paris).

CHIERICI, S. (1978), *Lombardie romane* (La-Pierre-qui-vire).

CHRISTE, Y. (1969), *Les Grands Portails romans* (Geneva).

——(1970), 'A propos du décor absidal de Saint-Jean du Latran à Rome', *Cahiers archéologiques*, 20: 197–206.

——(1991), 'Aux origines du grand portail à figures: les précédents picturaux', *Cahiers de civilisation médiévale*, 34: 255–65.

CLAUDE, H. (1953), 'Un légat pontifical, adversaire de Saint-Bernard, Girard d'Angoulême', *Bulletin de la société historique et archéologique de Langres*, 12/156: 139–48.

COHEN, S. (1990), 'The Romanesque Zodiac: Its Symbolic Function on the Church Façade', *Arte medievale*, 2nd ser. 4: 43–51.

Congrès archéologique de France (1903) 70, Poitiers; (1910) 77, Angers et Saumur; (1912) 79, Angoulême; (1931) 94, Bourges; (1948) 106, Tours; (1951) 109, Poitiers; (1956) 114, La Rochelle; (1961) 119, Le Mans; (1964) 122, Angers; (1981, appeared 1986) 139, Blésois et Vendômois; (1984, appeared 1987) 142, Bas-Berry; (1987, appeared 1990) 145, Bordelais et Bazadais.

CONNOLLY, S. R. (1979), 'The Cloister Sculpture of Saint-Aubin at Angers', Ph.D. thesis (Harvard University).

COSTA, D. (1964), *Nantes, Musée Th. Dobrée, art mérovingien* (Paris).

CROSBY, S. McK., and BLUM, P. (1987), *The Royal Abbey of Saint-Denis* (New Haven and London).

CROZET, R. (1935), 'Chapiteaux berrichons en Poitou et en Touraine', *Bulletin monumental*, 94: 237–40.

——(1936*a*), 'Les Églises romanes à déambulatoire entre Loire et Gironde', *Bulletin monumental*, 95: 46–81.

——(1936*b*), 'L'Église abbatiale de Fontevrault, ses rapports avec les églises à coupoles d'Aquitaine', *Annales du Midi*, 48: 111–50.

——(1942), *Textes et documents relatifs à l'histoire des arts en Poitou*, Archives historiques du Poitou, 53 (Poitiers).

——(1945), 'Observations critiques sur les dates de construction des églises de Saint-Savin et d'Aulnay', *Bulletin de la société des antiquaires de l'Ouest*, 3rd ser. 13: 664–8.

——(1948*a*), *L'Art roman en Poitou* (Paris).

——(1948*b*), 'Chinon', *Congrès archéologique de France*, 106 (Tours): 342.

——(1954), 'Survivances antiques dans l'architecture romane du Poitou, de l'Angoumois et de la Saintonge', *Bulletin de la société nationale des antiquaires de France*, 9th ser. 3: 193–202.

——(1956*a*), 'Survivances antiques dans le décor roman du Poitou, de l'Angoumois et de la Saintonge', *Bulletin monumental*, 114: 7–33.

——(1956*b*), 'Saint-Eutrope de Saintes', *Congrès archéologique de France*, 114 (La Rochelle): 97–105.

——(1956*c*), 'Maillezais', *Congrès archéologique de France*, 114 (La Rochelle): 80–92.

——(1956*d*), 'Ancienne cathédrale Saint-Pierre de Saintes', *Congrès archéologique de France*, 114 (La Rochelle): 119–25.

——(1956*e*), 'L'Abbaye aux Dames de Saintes', *Congrès archéologique de France*, 114 (La Rochelle): 106–18.

——(1958), 'Nouvelles remarques sur les cavaliers sculptés ou peints dans les églises romanes', *Cahiers de civilisation médiévale*, 1: 27–36.

——(1960), 'Recherches sur les cathédrales et les évêques d'Angoulême et de Saintes depuis les origines jusqu'à la fin du XIIe siècle', *Mémoires de la société archéologique et historique de la Charente*, 45–60.

——(1961–2), 'Recherches sur la cathédrale et les évêques de Poitiers des origines au commencement du XIIIe siècle', *Bulletin de la société des antiquaires de l'Ouest*, 4th ser. 6: 361–74.

——(1971*a*), 'Le Thème du cavalier victorieux dans l'art roman de France et d'Espagne', *Principe de Viana*, 32: 125–43.

——(1971*b*), *L'Art roman en Saintonge* (Paris).

——and CROZET, J. (1969), 'Remarques sur la structure architecturale de l'abbatiale de Saint-Savin', *Bulletin monumental*, 127: 267–96.

DAHL, E. (1956), 'Nuaillé-sur-Boutonne', *Congrès archéologique de France*, 114 (La Rochelle): 297–303.

DARAS, C. (1936), 'L'Orientalisme dans l'art roman en Angoumois', *Bulletins et mémoires de la société archéologique et historique de la Charente*, 3–139.

——(1942), *La Cathédrale d'Angoulême, chef d'œuvre monumental de Girard II* (Angoulême).

——(1956), 'L'Église abbatiale Saint-Pierre de Marestay', *Congrès archéologique de France*, 114 (La Rochelle): 290–6.

——(1961), *Angoumois roman* (La-Pierre-qui-vire).

DEBORD, A. (1984), *La Société laïque dans les pays de la Charente* (Paris).

DEMUS, O. (1970), *Romanesque Mural Painting* (London) (trans. of *Romanische Wandmalerei* (Munich, 1968)).

DENÉCHEAU, J. H. (1991), 'Renaissance et privilèges d'une abbaye angevine au XIe siècle: étude sur quelques "faux" de Saint-Florent de Saumur', *Cahiers de civilisation médiévale*, 34: 23–35.

DESCHAMPS, P. (1930), *French Sculpture of the Eleventh and Twelfth Centuries* (Florence and Paris).

DESCROIX, J. (1945), 'Poitiers et les lettres latines dans l'Ouest au début du XIIe siècle', *Bulletin de la société des antiquaires de l'Ouest*, 3rd ser. 13: 645–63.

DILLANGE, M. (1983), *Églises et abbayes romanes en Vendée* (Marseille).

DODWELL, C. R. (1987), 'The Meaning of "Sculptor" in the Romanesque Period', *Romanesque and Gothic: Essays for George Zarnecki* (London), 49–61.

——(1993), *The Pictorial Arts of the West, 800–1200* (New Haven and London).

DUBOURG-NOVES, P. (1973), *Iconographie de la cathédrale d'Angoulême*, 2 vols (Angoulême).

——(1974), 'Les Sculpteurs de la cathédrale d'Angoulême', Ph.D. thesis (University of Poitiers).

——(1977), *Saint-Amant-de-Boixe* (La Rochefoucauld).

——(1978), *Jubilé de la cathédrale d'Angoulême*, Exhibition catalogue (Angoulême).

DUBOURG-NOVES, P. (1982), *La Cathédrale d'Angoulême* (Rennes).

DUNBABIN, J. (1985), *France in the Making, 843–1180* (Oxford).

DURLIAT, M. (1969), 'Les Origines de la sculpture romane à Toulouse et à Moissac', *Cahiers de civilisation médiévale*, 12: 349–64.

——(1977), 'L'Apparition du grand portail roman historié dans le midi de la France et le nord de l'Espagne', *Cahiers de Saint-Michel-de-Cuxa*, 8: 7–24.

——(1979), 'La Cathédrale Saint-Étienne de Cahors, architecture et sculpture', *Bulletin monumental*, 137: 286–340.

——(1990), *La Sculpture romane de la route de Saint-Jacques* (Cahors).

EYGUN, F. (1927), 'Un thème iconographique commun aux églises romanes de Parthenay et aux sceaux de ses seigneurs', *Bulletin archéologique du comité des travaux historiques et scientifiques*, 387–90.

——(1938), *Sigillographie du Poitou* (Poitiers).

——(1939–41), 'Les Trois Piliers de Poitiers', *Bulletin de la société des antiquaires de l'Ouest*, 3rd ser. 12: 742–60.

——(1951), 'Notre Dame de Lusignan', *Congrès archéologique de France*, 109 (Poitiers): 378–96.

——(1956a), 'Abbaye de Saint-Michel-en-l'Herm', *Congrès archéologique de France*, 114 (La Rochelle): 25–40.

——(1956b), 'L'Église paroissiale de Fenioux et la lanterne des morts', *Congrès archéologique de France*, 114 (La Rochelle): 304–15.

——(1970), *Saintonge romane* (La-Pierre-qui-vire).

FAVIÈRE, J. (1970), *Berry roman* (La-Pierre-qui-vire).

FAVREAU, R. (1960), 'Les Écoles et la culture à Saint-Hilaire-le-Grand de Poitiers des origines au début du XIIe siècle', *Cahiers de civilisation médiévale*, 3: 473–8.

——(1991), 'Le Thème épigraphique de la porte', *Cahiers de civilisation médiévale*, 34: 267–79.

——and CAMUS, M. T. (1989), *Charroux* (Poitiers).

——and MICHAUD, J. (1974), *Corpus des inscriptions de la France médiévale*, i/1. *Ville de Poitiers* (Poitiers).

————(1975), *Corpus des inscriptions de la France médiévale*, i/2. *Département de la Vienne* (Poitiers).

————(1977), *Corpus des inscriptions de la France médiévale*, i/3. *Charente, Charente-Maritime, Deux-Sèvres* (Poitiers).

FLICHE, A. (1950), *La Réforme grégorienne et la reconquête chrétienne (1057–1123)*, Histoire de l'Église, ed. A. Fliche and V. Martin, 8 (Paris).

FOCILLON, H. (1931), *L'Art des sculpteurs romans* (Paris).

——(1969 edn.), *The Art of the West*, i. *Romanesque Art* (London and New York) (trans. of *Art d'Occident* (Paris, 1938)).

FRANCASTEL, P. (1942), *L'Humanisme roman (critiques des théories sur l'art du XIe siècle en France)* (Paris).

FRANCOVICH, G. DE (1935), 'La corrente comasca nella scultura romanica europea (gli iniziî)', *Rivista del reale istituto d'archeologia e storia dell'arte*, 13: 267–305.

——(1937–8), 'La corrente comasca nella scultura romanica europea (la diffusione)', *Rivista del reale istituto d'archeologia e storia dell'arte*, 16: 47–129.

FRUGONI, C. (1984), 'Le metope, ipotesi di un loro significato', in *Lanfranco e Wiligelmo, il duomo di Modena* (Modena), 507–9.

GABET, P. (1990), 'Les Cavaliers de la cathédrale d'Angoulême', *Bulletins et mémoires de la société archéologique et historique de la Charente*, 110–28.

GABORIT-CHOPIN, D. (1969), *La Décoration des manuscrits à Saint-Martial de Limoges et en Limousin du IXe au XIIe siècles* (Paris and Geneva).

GAILLARD, G. (1972 edn.), 'Deux sculptures de l'abbaye des Moreaux à Oberlin (Ohio)', *Études d'art roman* (Paris), 389–94 (first published in *Gazette des beaux-arts*, 1 (1954), 81–90).

——(1966), 'Remarques sur les chapiteaux espagnols aux origines de la sculpture romane', *Mélanges offerts à René Crozet* (Poitiers), ii. 145–9.

Gallia Christiana (1870–99), ed. P. Piolin, 13 vols. (Paris).

GANDOLFO, F. (1981), 'I programmi decorativi nei protiri di Niccolo', *Nicholaus e l'arte del suo tempo*, Atti del seminario tenutosi a Ferrara dal 21 al 24 settembre 1981, ed. A. M. Romanini (Ferrara), 515–59.

GARAUD, M. (1937), 'Les Vicomtes de Poitou', *Revue historique de droit français et étranger*, 4th ser. 16: 426–49.

——(1946), 'Les Écoles et l'enseignement à Poitiers du IVe à la fin du XIIe siècle', *Bulletin de la société des antiquaires de l'Ouest*, 3rd ser. 14: 82–98.

——(1960), 'Observations sur les vicissitudes de la propriété ecclésiastique dans le diocèse de Poitiers du IXe au XIII siècle', *Bulletin de la société des antiquaires de l'Ouest*, 4th ser. 5: 357–77.

——(1964), *Les Châtelains de Poitou, et l'avènement du régime féodal, XIe et XIIe siècles* (Poitiers).

GARDELLES, J. (1978), 'Recherches sur les origines des façades à étages d'arcatures des églises médiévales', *Bulletin monumental*, 136: 113–33.

GELLIBERT DES SEGUINS, E. (1862), 'Aubeterre en 1562, enquête sur le passage des protestants en cette ville', *Bulletin de la société archéologique et historique de la Charente*, 3rd ser. 4: 343–86.

GILLINGHAM, J. (1984), *The Angevin Empire* (London).

GOUDRON DE LABANDE, J. (1868), 'Notice historique sur l'ancien prieuré de Villesalem', *Mémoires de la société des antiquaires de l'Ouest*, 1st ser. 33: 397–423.

GRABOÏS, A. (1981), 'Le Schisme de 1130 et la France', *Revue d'histoire ecclésiastique*, 76: 593–612.

GRANDMAISON, C. (1854), 'Chartularium Sancti Jovini', *Mémoires de la société de statistique du département de Deux-Sèvres*, 17, part 2.

GRASILIER, T. (1871), *Cartulaires inédits de la Saintonge*, ii. *Cartulaire de l'abbaye royale de Notre-Dame de Saintes* (Niort).

GRODECKI, L. (1958), 'La Sculpture du XIe siècle en France, état des questions', *L'Information d'histoire de l'art*, 3: 98–112.

GROSSET, C. (1951), 'La Maison-Dieu de Montmorillon', *Congrès archéologique de France*, 109 (Poitiers): 192–206.

——(1955), 'Étude sur les sculptures romanes d'Airvault', *Bulletin de la société des antiquaires de l'Ouest*, 4th ser. 3: 41–57.

HASSIG, D. (1995), *Medieval Bestiaries: Text, Image, Ideology* (Cambridge).

HEARN, M. F. (1981), *Romanesque Sculpture* (Oxford).

HELIOT, P. (1958), 'Observations sur les façades décorées d'arcatures aveugles dans les églises romanes', *Bulletin de la société des antiquaires de l'Ouest*, 4th ser. 4: 367–99.

——(1967–8), 'Notes archéologiques sur l'abbaye de Saint-Michel-en-l'Herm', *Bulletin de la société des antiquaires de l'Ouest*, 4th ser. 9: 639–49.

HENRY, F., and ZARNECKI, G. (1957), 'Romanesque Arches Decorated with Human and Animal Heads', *Journal of the British Archaeological Association*, 20: 1–34.

HORSTE, K. (1992), *Cloister Design and Monastic Reform in Toulouse* (Oxford).

HUBERT, J. (1988), 'L'Architecture et le décor des églises en France au temps de Robert le Pieux (996–1031)', *Cahiers archéologiques*, 36: 13–40.

IMBERT, H. (1865), 'Notice sur les vicomtes de Thouars', *Mémoires de la société des antiquaires de l'Ouest*, 1st ser. 29: 321–423.

IMBERT, H. (1871), *Histoire de Thouars* (Niort).

——(1875), 'Cartulaire de l'abbaye de Saint-Laon de Thouars', *Mémoires de la société de statistique, sciences, lettres et arts du département des Deux-Sèvres*, 2nd ser. 14.

JACOUB, D. (1981), Review of Werner (1979), in *Bulletin monumental*, 139: 113–16.

JAMES, M. R. (1928), *The Bestiary* (Oxford).

JOHNSON, D. V. (1995), 'Sculptures du XIIe siècle provenant de l'abbaye royale de Chelles', *Bulletin monumental*, 153: 23–46.

KANE, E. (1978), 'The Painted Decoration of the Church of S. Clemente', *San Clemente Miscellany*, ii. *Art and Archaeology* (Rome), 60–151.

KATZENELLENBOGEN, A. (1939), *Allegories of the Virtues and Vices in Medieval Art* (London).

KENAAN-KEDAR, N. (1986), 'Les Modillons de Saintonge et du Poitou comme manifestation de la culture laïque', *Cahiers de civilisation médiévale*, 29: 311–30.

——(1992), 'The Margins of Society in Marginal Romanesque Sculpture', *Gesta*, 31: 15–24.

——(1995), *Marginal Sculpture in Medieval France: Towards the Deciphering of an Enigmatic Pictorial Language* (Aldershot and Brookfield).

KITZINGER, E. (1972), 'The Gregorian Reform and the Visual Arts: A Problem of Method', *Transactions of the Royal Historical Society*, 5th ser. 22: 87–102.

——(1982), 'The Arts as Aspects of a Renaissance: Rome and Italy', in Benson and Constable (1982), 637–70.

KLEIN, P. K. (1990), 'Programmes eschatologiques, fonction et réception historiques des portails du XIIe s.: Moissac—Beaulieu—Saint-Denis', *Cahiers de civilisation médiévale*, 33: 317–49.

KRAUTHEIMER, R. (1980), *Rome: Profile of a City, 312–1308* (Princeton).

——, CORBETT, S., and FRAZER, A. K. (1977), *Corpus basilicarum christianarum romae* (Rome), v.

KROUSE, F. M. (1949), *Milton's Samson and the Christian Tradition* (Princeton).

LABANDE-MAILFERT, Y. (1962), *Poitou roman* (La-Pierre-qui-vire).

——(1965), 'L'Iconographie des laïcs dans la société religieuse aux XIe et XIIe siècles', *Miscellanea del centro di studi medioevali* (Milan), 3rd ser. 5 (1965, appeared 1968), 488–529.

——(1971), 'Nouvelles Données sur l'abbatiale de Saint-Savin', *Cahiers de civilisation médiévale*, 14: 39–68.

LACHENAL, L. DE (1990), 'Il gruppo equestre di Marco Aurelio e il Laterano', *Bollettino d'Arte*, 61: 1–52.

LA COSTE-MESSELIÈRE, R. DE (1957), 'Note pour servir à l'histoire de Melle', *Bulletin de la société des antiquaires de l'Ouest*, 4th ser. 4: 269–315.

LAPEYRE, A. (1960), *Des façades occidentales de Saint-Denis et de Chartres aux portails de Laon* (Paris).

LAUER, P. (1911), *Le Palais de Latran* (Paris).

LAURIÈRE, J. DE (1870), 'Note sur la découverte faite en 1868 d'une crypte en la cathédrale d'Angoulême', *Bulletin de la société archéologique et historique de la Charente*, 7: 155–61.

LAVAGNE, H. (1991), 'Le Triomphe de Constantin', *Cahiers archéologiques*, 39: 51–62.

LECOQ, D. (1987), 'La Mappemonde du *Liber Floridus*, ou la vision du monde de Lambert de Saint-Omer', *Imago mundi*, 39: 9–49.

LEDAIN, B. (1883), 'Notice historique et archéologique sur l'abbaye de Saint-Jouin-de-Marnes', *Mémoires de la société des antiquaires de l'Ouest*, 2nd ser. 6: 49–136.

LEFEVRE-PONTALIS, E. (1903), 'L'Église de Jazeneuil', *Congrès archéologique de France*, 70 (Poitiers): 322–9.

——(1912), 'Melle', *Congrès archéologique de France*, 79 (Angoulême): 79–95.

LEJEUNE, R., and STIENNON, J. (1966), *La Légende de Roland dans l'art du Moyen Âge* (Brussels).

Le Roux, H. (1963), ' Recherches sur l'église Saint-Savinien de Melle', *Bulletin de la société des antiquaires de l'Ouest*, 4th ser. 7: 251–303.

——(1969–70), 'Les Origines de Saint-Hilaire de Melle', *Bulletin de la société des antiquaires de l'Ouest*, 4th ser. 10: 119–38.

——(1973–4), 'Figures équestres et personnages du nom de Constantin aux XIe et XIIe siècles', *Bulletin de la société des antiquaires de l'Ouest*, 4th ser. 12: 379–94.

Lesueur, F. (1966), 'Appareils décoratifs supposés carolingiens', *Bulletin monumental*, 124: 167–85.

Leyser, H. (1984), *Hermits and the New Monasticism* (London).

Lot, F., and Fawtier, R. (1962), *Histoire des institutions françaises au Moyen Âge*, iii. *Institutions ecclésiastiques* (Paris).

Lucas, P. J. (1979), 'On the Blank Daniel-Cycle in MS Junius 11', *Journal of the Warburg and Courtauld Institutes*, 42: 207–13.

Lyman, T. W. (1971), 'The Sculpture Programme of the Porte des Comtes Master at St. Sernin in Toulouse', *Journal of the Warburg and Courtauld Institutes*, 34: 12–39.

——(1977), 'L'Intégration du portail dans la façade méridionale', *Cahiers de Saint-Michel-de-Cuxa*, 8: 55–68.

McCulloch, F. (1960), *Medieval Latin and French Bestiaries*, University of North Carolina Studies in the Romance Languages and Literatures, 33 (Chapel Hill, NC).

Mâle, E. (1978 edn.), *Religious Art in France, The Twelfth Century: A Study of the Origins of Medieval Iconography* (Princeton) (trans. of *L'Art religieux du XIIe siècle en France. Étude sur l'origine de l'iconographie du Moyen Age* (Paris, 1922)).

Mallet, J. (1984), *L'Art roman de l'ancien Anjou* (Paris).

Marchegay, P. (1873), *Chartes poitevines de Saint-Florent*, Archives historiques du Poitou, 2 (Poitiers).

——(1877a), *Chartes saintongeaises de l'abbaye de Saint-Florent près Saumur*, Archives historiques de la Saintonge et de l'Aunis, 4 (Paris and Saintes).

——(1877b), *Cartulaires du Bas-Poitou* (La Roches-Baritaud).

——and Mabille, E. (1869), *Chroniques des églises d'Anjou* (Paris).

Martindale, J. P. (1965), 'The Origins of the Duchy of Aquitaine and the Government of the Counts of Poitou (902–1137)', D.Phil. thesis (University of Oxford).

Mendell, E. L. (1940), *Romanesque Sculpture in Saintonge* (New Haven).

Métais, C. (1893), *Cartulaire saintongeais de l'abbaye de La Trinité de Vendôme*, Archives historiques de la Saintonge et de l'Aunis, 22 (Paris and Saintes).

——(1893–1904), *Cartulaire de La Trinité de Vendôme*, 5 vols. (Paris).

Metz, M. A. (1987), 'Saint-Hilaire de Melle and the Romanesque Sculpture and Architecture of Poitou', Ph.D. thesis (University of California at Berkeley).

Mezoughi, N. (1978), 'Le Tympan de Moissac: études d'iconographie', *Cahiers de Saint-Michel-de-Cuxa*, 9: 171–200.

Michon, J. H. (1844), *Statistique monumentale de la Charente* (Paris and Angoulême).

Milano e la Lombardia in età comunale, secoli XI–XIII (1993), exhibition catalogue (Milan).

Monsabert, D. P. de (1910), *Chartes et documents pour servir à l'histoire de l'abbaye de Charroux*, Archives historiques du Poitou, 39 (Poitiers).

Muratova, X. (1981), 'The Decorated Manuscripts of the Bestiary of Philippe de Thaon, and the Problem of the Illustrations of the Medieval Poetical Bestiary', *Third International Beast Epic, Fable and Fablieu Colloquium (Münster 1979)* (Cologne and Vienna), 217–46.

Mussat, A. (1963), *Le Style gothique de l'Ouest de la France* (Paris).

——et al. (1981), *La Cathédrale du Mans* (Paris).

MUSSET, G. (1901), *Cartulaire de l'abbaye royale de Saint-Jean-d'Angély*, Archives historiques de la Saintonge et de l'Aunis, 30 (Paris and Saintes).

NICHOLS, F. M. (1986) (ed. and trans.), *The Marvels of Rome*, 2nd edn. (New York).

OAKESHOTT, W. (1967), *The Mosaics of Rome* (London).

O'REILLY, J. (1988), *Studies in the Iconography of the Virtues and Vices in the Middle Ages*, Garland Series, Outstanding Theses in the Fine Arts from British Universities (New York and London) (originally Ph.D. thesis, University of Nottingham, 1972).

ORLOWSKI, T. H. (1991), 'La Façade romane dans l'Ouest de la France', *Cahiers de civilisation médiévale*, 34: 367–77.

OURSEL, R. (1975), *Haut-Poitou roman* (La-Pierre-qui-vire).

PERONI, A. (1975), *Pavia, musei civici del castello visconteo*, Musei d'Italia, Meraviglie d'Italia, 7 (Bologna).

PIOLIN, P. (1887), 'Le Moine Raoul, architecte de l'église de Saint-Jouin-de-Marnes, et le Bienheureux Raoul de la Fustaye', *Revue des questions historiques*, 42: 497–509.

PLAT, G. (1939) *L'Art de bâtir en France des Romains à l'an 1100* (Paris).

PORTER, A. K. (1923), *Romanesque Sculpture of the Pilgrimage Roads*, 10 vols. (Boston).

PRACHE, A. (1983), *Île-de-France romane* (La-Pierre-qui-vire).

PRUDENTIUS (1965 edn.), *The Poems of Prudentius*, trans. M. Clement Eagan, The Fathers of the Church, 52 (Washington).

QUINTAVALLE, A. C. (1974), *La cattedrale di Parma e il romanico europeo* (Parma).

——(1984), 'L'officina della Riforma: Wiligelmo et Lanfranco', in *Lanfranco e Wiligelmo, il duomo di Modena* (Modena), 765–834.

REDET, L. (1874), *Cartulaire de l'abbaye de Saint-Cyprien de Poitiers*, Archives historiques du Poitou, 3 (Poitiers).

RHEIN, A. (1910), 'Thouars', *Congrès archéologique de France*, 77 (Angers et Saumur): 1: 85–97.

RICHARD, A. (1886), *Chartes et documents pour servir à l'histoire de l'abbaye de Saint-Maixent*, Archives historiques du Poitou, 16 (Poitiers).

——(1903), *Histoire des comtes de Poitou* (Paris).

RILEY-SMITH, J. (1986), *The First Crusade* (Philadelphia).

——(1987), *The Crusades: A Short History* (London).

RIOU, Y. J. (1972), 'La Construction de l'abbatiale de Saint-Savin à propos de trois publications récentes', *Bulletin de la société des antiquaires de l'Ouest*, 4th ser. 11: 415–39.

——(1980), 'Réflexions sur la frise sculptée de Notre-Dame-la-Grande de Poitiers', *Bulletin de la société des antiquaires de l'Ouest*, 4th ser. 15: 497–514.

ROBERT, U. (1891), *Bullaire du pape Calixte II* (Paris).

ROBINSON, I. S. (1973), 'Gregory VII and Soldiers of Christ', *History*, 58: 169–92.

——(1990), *The Papacy, 1073–1198* (Cambridge).

ROBUCHON, J. (1890–5), *Paysages et monuments du Poitou* (Paris).

RUDOLPH, C. (1988), 'Bernard of Clairvaux's *Apologia* as a Description of Cluny, and the Controversy over Monastic Art', *Gesta*, 27: 125–32.

RUPPRECHT, B. (1975), *Romanische Skulptur in Frankreich* (Munich).

SALET, F. (1951), 'L'Église de Villesalem', *Congrès archéologique de France*, 109 (Poitiers): 224–44.

——(1961), 'La Cathédrale du Mans', *Congrès archéologique de France*, 119 (Le Mans): 18–58.

——(1964), 'Notre Dame de Cunault, les campagnes de construction', *Congrès archéologique de France*, 122 (Angers): 637–76.

SANDOZ, M. (1958), *Eléments datables d'art pré-roman et roman au Musée des Beaux-Arts de Poitiers* (Poitiers).

SANFAÇON, R. (1967), *Défrichements, peuplement et institutions seigneuriales en Haut-Poitou du Xe au XIIIe siècles*, Université Laval, Les Cahiers de l'institut d'histoire, 9 (Quebec).

SAUERLÄNDER, W. (1972), *Gothic Sculpture in France, 1140–1270* (New York) (trans. of *Gotische Skulptur in Frankreich 1140–1270* (Munich, 1970)).

SAUVEL, T. (1935), 'Un plan inédit de Saint-Eutrope de Saintes', *Revue de Saintonge et d'Aunis*, 45: 241–2.

——(1936), 'Quelques sculptures perdues', *Revue de Saintonge et d'Aunis*, 46: 179–89.

——(1938), 'De l'influence exercée par les ateliers languedociens sur la sculpture romane du Sud-Ouest', *Revue de Saintonge et d'Aunis*, 48: 180–90.

——(1943), 'Note sur la date de l'abbaye de Saintes', *Revue de Saintonge et d'Aunis*, 10–16.

——(1945), 'La Façade de Saint-Pierre d'Angoulême', *Bulletin monumental*, 103: 175–99.

SCHAPIRO, M. (1977a), *Romanesque Art* (London).

——(1977b edn.), 'On Geometrical Schematism in Romanesque Art', in Schapiro (1977a), 265–84 (first published as 'Ueber den Schematismus in der romanischen Kunst', *Kritische Berichte zur Kunstgeschichtlichen Literatur* (1932–3), 1–21).

——(1977c edn.), 'On the Aesthetic Attitude in Romanesque Art', in Schapiro (1977a), 1–27 (first published in *Art and Thought: Issued in Honor of Dr. Ananda K. Coomaraswamy on the Occasion of His 70th Birthday* (London, 1947): 130–50).

——(1977d edn.), 'Two Romanesque Drawings in Auxerre and Some Iconographic Problems', in Schapiro (1977a), 306–27 (first published in *Studies in Art and Literature for Belle Da Costa Greene* (Princeton, 1954), 331–49).

SCHMITT, M. L. (1976), 'The Carved Gable of Beaulieu-lès-Loches', *Gesta*, 15: 113–20.

——(1981), 'Traveling Carvers in the Romanesque: The Case History of St-Benoît-sur-Loire, Selles-sur-Cher, Méobecq', *Art Bulletin*, 63: 6–31.

SCHUCHARD, B. (1986), 'La Vérité d'un bestiaire', *Cahiers de Saint-Michel-de-Cuxa*, 17: 111–30.

SEIDEL, L. (1976a), 'Holy Warriors: The Romanesque Rider and the Fight Against Islam', in T. P Murphy (ed.), *The Holy War* (Columbus, Ohio), 33–54.

——(1976b), 'Constantine and Charlemagne', *Gesta*, 15: 237–9.

——(1981), *Songs of Glory: The Romanesque Façades of Aquitaine* (Chicago and London).

SERBAT, L. (1912a), 'Note sur une date de consécration de la cathédrale d'Angoulême', *Congrès archéologique de France*, 79 (Angoulême), 2: 211–17.

——(1912b), 'Angoulême', *Congrès archéologique de France*, 79 (Angoulême), 1: 3–36.

——(1912c), 'Saint-Amant-de-Boixe', *Congrès archéologique de France*, 79 (Angoulême), 2: 61–78.

SKUBISZEWSKI, P. (1985), 'Ecclesia, Christianitas, Regnum et Sacerdotium dans l'art des Xe–XIe siècles'. Idées et structures des images', *Cahiers de civilisation médiévale*, 28: 133–79.

SOUTHERN, R. W. (1970), *Western Society and the Church in the Middle Ages* (Harmondsworth).

STERN, H. (1970), 'Une mosaïque de pavement romane de Layrac (Lot-et Garonne)', *Cahiers archéologiques*, 20: 81–97.

STODDARD, B. W. (1970), 'The Sculpture from the Abbey of Saint-Pierre at Airvault (Deux-Sèvres),' Ph.D. thesis (New York University).

——(1981), 'A Romanesque Master Carver at Airvault (Deux Sèvres)', *Gesta*, 20: 67–72.

STROLL, M. (1987), *The Jewish Pope* (Leiden).

——(1991), *Symbols as Power: The Papacy Following the Investiture Contest* (Leiden).

TARALON, J. (1986), 'Les Peintures murales romanes de la salle capitulaire de l'ancienne abbaye de Vendôme', *Congrès Archéologique de France*, 139 (Blésois et Vendômois, 1981): 405–36.

TCHERIKOVER, A. (1982), 'Saint-Jouin-de-Marnes and the Development of Romanesque Sculpture in Poitou'. Ph.D. thesis (University of London).

——(1985a), 'Some Observations on Sculpture at Airvault', *Gesta*, 24: 91–103.

——(1985b), 'La Façade occidentale de l'église abbatiale de Saint-Jouin-de-Marnes', *Cahiers de civilisation médiévale*, 28: 361–83.

——(1986), 'La Sculpture architecturale à Parthenay-le-Vieux', *Bulletin de la société des antiquaires de l'Ouest*, 4th ser. 19: 503–16.

——(1987), 'The Church of Saint-Jouin-de-Marnes in the Eleventh Century', *Journal of the British Archaeological Association*, 140: 112–33.

——(1988), 'Anjou or Aquitaine?—The Case of Saint-Eutrope at Saintes', *Zeitschrift für Kunstgeschichte*, 51: 348–71.

——(1989a), 'Romanesque Sculpted Archivolts in Western France: Forms and Techniques', *Arte Medievale*, 2nd ser. 3: 49–75.

——(1989b), 'The Chevet of Saint-Jouin-de-Marnes', *Gesta*, 28: 147–64.

——(1990a), 'Aulnay-de-Saintonge and High Romanesque Figure Sculpture in Aquitaine', *Journal of the British Archaeological Association*, 143: 77–94.

——(1990b), 'Concerning Angoulême, Riders and the Art of the Gregorian Reform', *Art History*, 13: 425–57.

——(1995), 'Une invention du XIXe siècle: les prétendus cavaliers de la cathédrale d'Angoulême', *Cahiers de civilisation médiévale*, 38: 275–8.

TERPAK, F. (1986), 'The Role of the Saint-Eutrope Workshop in the Romanesque Campaign of Saint-Caprais at Agen', *Gesta*, 25: 185–96.

TONNELLIER, P. M. (1970), 'L'Architecte Beranger d'après son épitaphe à l'Abbaye aux Dames de Saintes', *Bulletin de la société des antiquaires de l'Ouest*, 4th ser. 10: 587–95.

TOSCO, C. (1992), 'Sansone vittorioso sul portale di Nonantola: ricerche sulle funzioni dell'iconografia medioevale', *Arte Cristiana*, 80/748: 3–8.

TOUBERT, H. (1970), 'Le Renouveau paléochrétien à Rome au début du XIIe s.', *Cahiers archéologiques*, 20: 99–154.

——(1983), 'Les Fresques de La Trinité de Vendôme, un témoignage dur l'art de la réforme grégorienne', *Cahiers de civilisation médiévale*, 26: 296–326.

——(1987), 'Peintures murales romanes. Les découvertes des dix dernières années', *Arte Medievale*, 2nd ser. 2: 127–60.

ULLMANN, W. (1970 edn.), *The Growth of Papal Government in the Middle Ages*, 3rd edn. (London) (first published in 1955).

——(1975), *Law and Politics in the Middle Ages* (New York).

VAJAY, S. DE (1966), 'Ramire II le moine, roi d'Aragon, et Agnès de Poitou dans l'histoire et dans la légende', *Mélanges offerts à René Crozet* (Poitiers), ii. 727–50.

VALENTINI, A. (1836), *La patriarchale basilica lateranensis* (Rome).

VALENTINI, R., and ZUCCHETTI, G. (1946), *Codice topografico della città di Roma* (Rome).

VALLERY-RADOT, J. (1931a), 'L'Église Saint-Étienne de Dun-sur-Auron', *Congrès archéologique de France*, 94 (Bourges): 462–79.

——(1931b), *Églises romanes, filiations et échanges d'influences* (Paris).

VERDON, J. (1976), 'La Chronique de Saint-Maixent et l'histoire du Poitou aux IXe–XIe siècles', *Bulletin de la société des antiquaires de l'Ouest*, 4th ser. 13: 437–72.

VERGNOLLE, E. (1972), 'Les Chapiteaux de la Berthenoux et le chantier de Saint-Benoît-sur-Loire au XIe siècle', *Gazette des Beaux-Arts*, 80: 249–59.

——(1978), 'Chronologie et méthode d'analyse: doctrines sur les débuts de la sculpture romane en France', *Cahiers de Saint-Michel-de-Cuxa*, 9: 141–62.

——(1982), 'Chapiteaux corinthisants de France et d'Italie (IXe–XIe siècles), *Romanico padano—romanico europeo*, Convegno internazionale di studi, Modena–Parma 1977 (Parma), 340–50.

——(1983), 'Saint-Arnoul-de-Crepy: un prieuré clunisien du Valois', *Bulletin Monumental*, 141: 233–72.

——(1985), *Saint-Benoît-sur-Loire et la sculpture du XIe siècle* (Paris).

——(1992), 'L'Art des frises dans la vallée de la Loire', in D. Kahn (ed.), *The Romanesque Frieze and Its Spectator* (London), 97–118.

——(1994), *L'Art roman en France: architecture—sculpture—peinture* (Paris).

VERZAR-BORNSTEIN, C. (1982), 'Matilda of Canossa, Papal Rome and the Earliest Italian Porch Portals', *Romanico padano—romanico europeo*, Convegno internazionale di studi, Modena–Parma, 1977 (Parma), 144–58.

——(1988), *Portals and Politics in the Early Italian City-State: The Sculpture of Nicholaus in Context* (Parma).

VEZIN, J. (1974), *Les Scriptoria d'Angers au XIe siècle* (Paris).

VICAIRE, P. (1956), 'Surgères', *Congrès archéologique de France*, 114 (La Rochelle): 272–82.

VIELLIARD, J. (1978 edn.), *Le Guide du pèlerin de Saint-Jacques de Compostelle*, 5th edn. (Macon) (first published in 1938).

VIOLA, C. (1988), 'Jugements de Dieu et jugement dernier, Saint Augustin et la scolastique naissante (fin XIe–milieu XIIe siècles)', in W. Verbeke, D. Verhelst, and A. Welkenhuysen (eds.), *The Use and Abuse of Eschatology in the Middle Ages* (Leuven), 242–98.

WALTER, C. (1970), 'Papal Political Imagery in the Medieval Lateran Palace', *Cahiers archéologiques*, 20: 155–76.

WARMÉ-JANVILLE, J. (1979), 'L'Église de Villesalem, l'harmonie de son décor et ses liens avec l'art roman de la région', *Bulletin de la société des antiquaires de l'Ouest*, 4th ser. 14: 279–96.

WATSON, K. (1989), *French Romanesque and Islam: Andalusian Elements in French Architectural Decoration, ca.1030–1180*, BAR International Series, 488, i (Oxford).

WATSON, R. (1979), 'The Counts of Angoulême from the 9th to the mid 13th Century', Ph.D. thesis (University of East Anglia).

WEBSTER, J. C. (1938), *The Labours of the Months in Antique and Medieval Art to the End of the Twelfth Century* (Princeton).

WERNER, F. (1979), *Aulnay de Saintonge und die romanische Skulptur im Westfrankreich* (Worms).

WETTSTEIN, J. (1971), *La Fresque romane* (Geneva).

——(1978), *La Fresque romane, II* (Geneva).

WILLIAMS, J. (1973), 'San Isidoro in León: Evidence for a New History', *Art Bulletin*, 55: 171–84.

WITTKOWER, R. (1942), 'Marvels of the East: A Study in the History of Monsters', *Journal of the Warburg and Courtauld Institutes*, 5: 159–97.

WOOD, M. L. (1978), 'Early Twelfth-Century Sculpture in Pavia', Ph.D. thesis (Johns Hopkins University).

ZALUSKA Y. (1979), 'La Bible limousine de la Bibliothèque Mazarine', *Le Limousin, études archéologiques*, Actes du 102e Congrès national des sociétés savantes (Paris), 69–98.

ZARNECKI, G. (1955), 'The Winchester Acanthus in Romanesque Sculpture', *Wallraf-Richartz Jahrbuch*, 17: 211–15.

ZARNECKI, G. (1971), *Romanesque Art* (London).

——(1979 edn.), 'A Romanesque Bronze Candlestick in Oslo and the Problem of the "Belts of Strength"', in *Studies in Romanesque Sculpture* (London), part VII (first published in *Arbok Kunstindustrimuseet i Oslo* (1963–4), 45–67).

——(1984), 'Animal Protomes in Medieval Art', *Scritti di storia dell'arte in onore di Roberto Salvini* (Florence), 13–17.

——(1988), *Romanesque Lincoln* (Lincoln).

——(1990), 'Como and the Book of Durrow', in E. Fernie and P. Crossley (eds.), *Medieval Architecture and Its Intellectual Context: Studies in Honour of Peter Kidson* (London and Ronceverte), 35–45.

ZASTROW, O. (1978), *Scultura carolingia e romanica nel comasco* (Como).

INDEX

PLATES

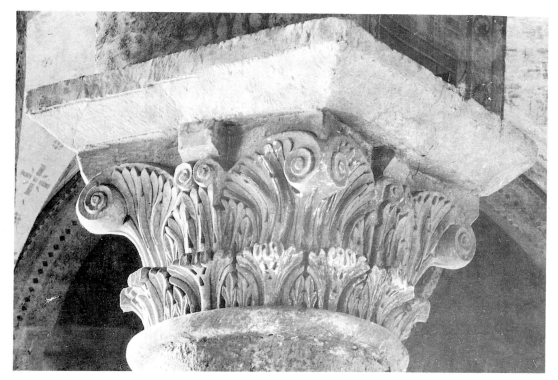

PL 1. Poitiers, Notre-Dame-la-Grande, capitals in the ambulatory arcade (photo: author, courtesy of the Conway Library, Courtauld Institute of Art)

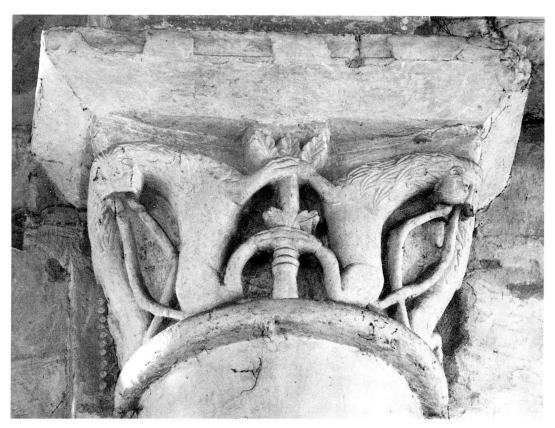

PL 2. Poitiers, Saint-Hilaire-le-Grand, crossing, capital on the north side (photo: author, courtesy of the Conway Library, Courtauld Institute of Art)

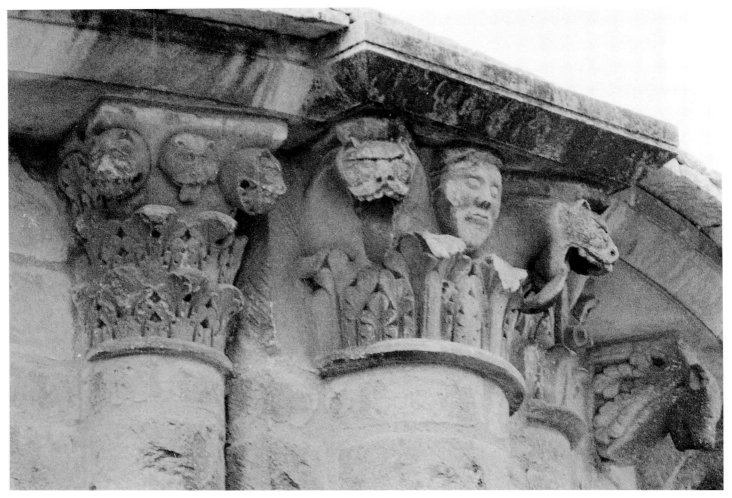

PL 3 . Poitiers, Saint-Hilaire-le-Grand, capitals under the cornice of the chevet (photo: author, courtesy of the Conway Library, Courtauld Institute of Art)

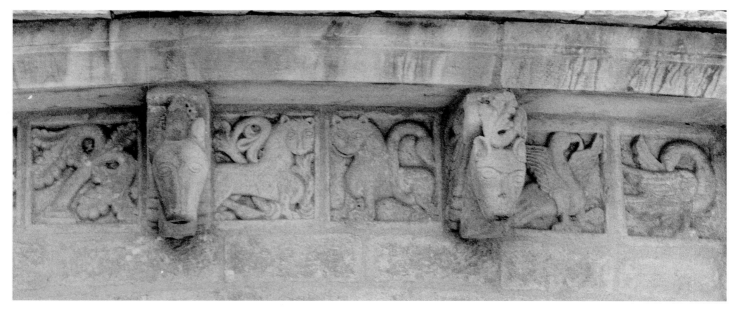

PL 4 . Poitiers, Saint-Hilaire-le-Grand, corbels and metopes under the cornice of the chevet (photo: author, courtesy of the Conway Library, Courtauld Institute of Art)

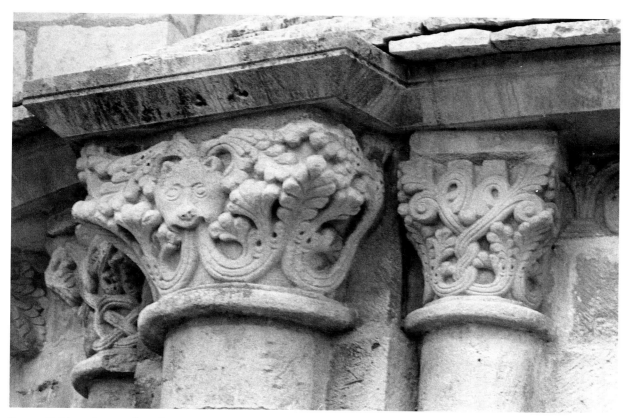

PL 5. Poitiers, Saint-Hilaire-le-Grand, capitals under the cornice of the chevet (photo: author, courtesy of the Conway Library, Courtauld Institute of Art)

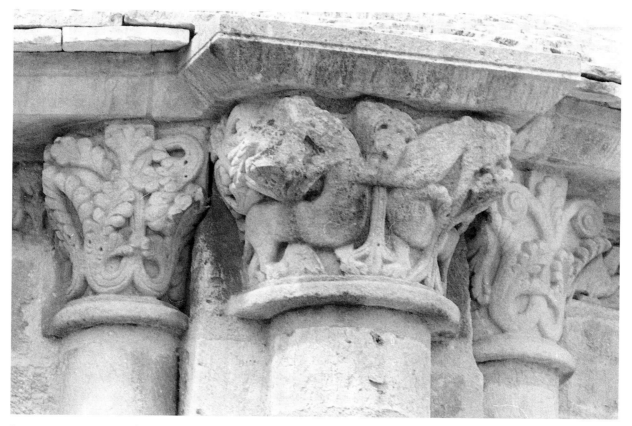

PL 6. Poitiers, Saint-Hilaire-le-Grand, capitals under the cornice of the chevet (photo: author, courtesy of the Conway Library, Courtauld Institute of Art)

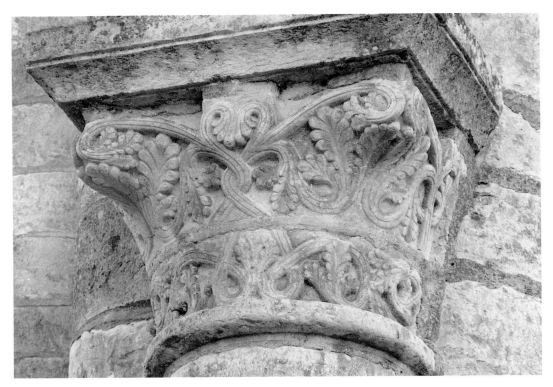

PL 7. Charroux, capital in the rotunda (photo: author)

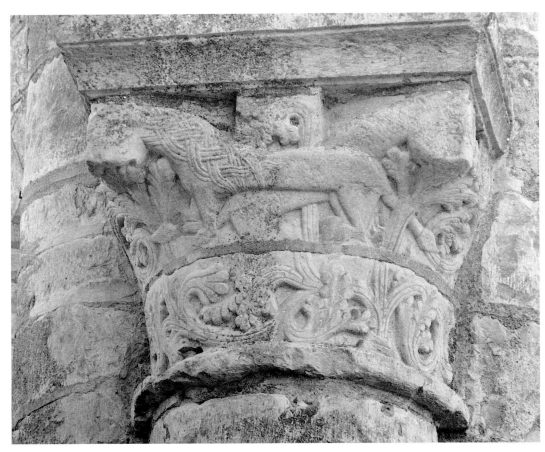

PL 8. Charroux, capital in the rotunda (photo: author)

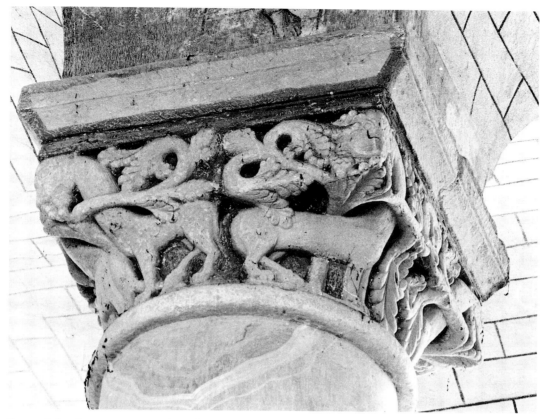

PL 9. Saint-Savin, nave, capital on the south side (photo: author, courtesy of the Conway Library, Courtauld Institute of Art)

PL 11. Poitiers, Saint-Jean-de-Montierneuf, capital in the interior dado arcade of the ambulatory (photo: author, courtesy of the Conway Library, Courtauld Institute of Art)

PL 10. Poitiers, Saint-Jean-de-Montierneuf, capital in the south transept (photo: author, courtesy of the Conway Library, Courtauld Institute of Art)

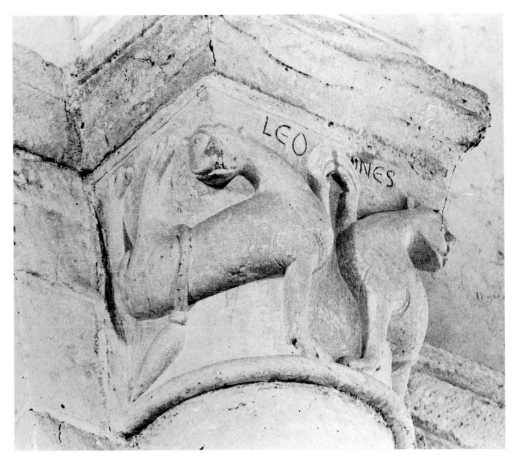

PL 12. Parthenay-le-Vieux, Saint-Pierre, crossing, north side, capital in the choir arch
(photo: author, courtesy of the Conway Library, Courtauld Institute of Art)

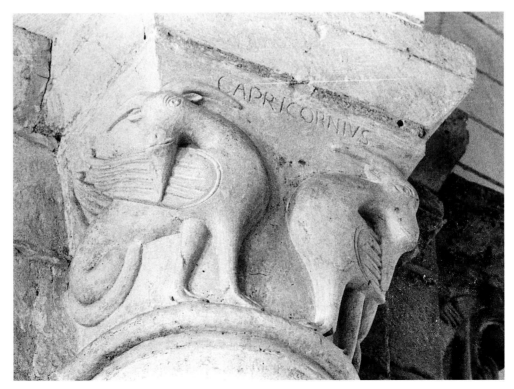

PL 13. Parthenay-le-Vieux, Saint-Pierre, crossing, south side, capital in the choir arch
(photo: author, courtesy of the Conway Library, Courtauld Institute of Art)

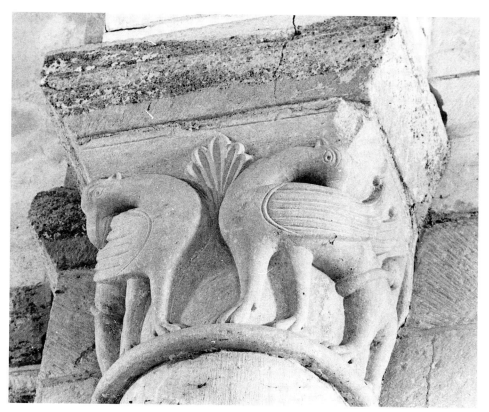

PL 14. Parthenay-le-Vieux, Saint-Pierre, crossing, capital on the north side (photo: author, courtesy of the Conway Library, Courtauld Institute of Art)

PL 15. Parthenay-le-Vieux, Saint-Pierre, crossing, capital on the south side (photo: author, courtesy of the Conway Library, Courtauld Institute of Art)

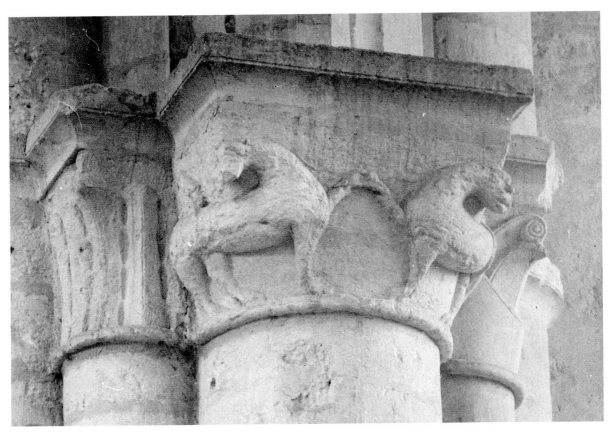

PL 16. Saint-Maixent, abbey church, west end of the nave, respond capital of the north arcade (photo: author, courtesy of the Conway Library, Courtauld Institute of Art)

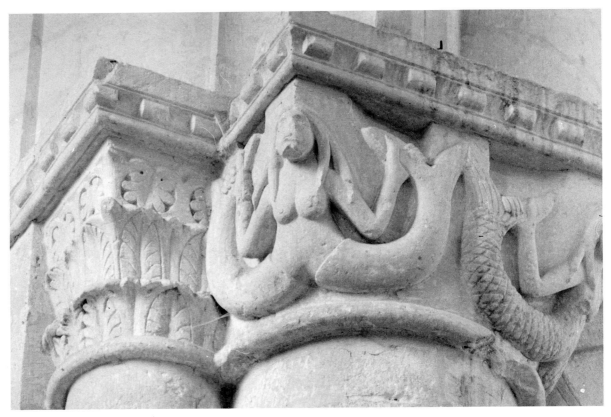

PL 17. Saint-Maixent, abbey church, west end of the nave, respond capital of the south arcade (photo: author, courtesy of the Conway Library, Courtauld Institute of Art)

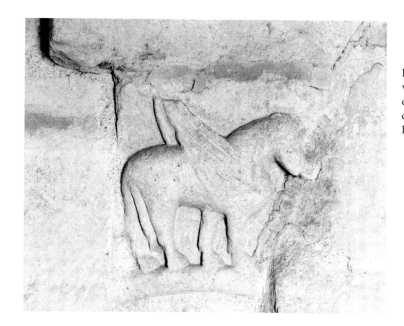

PL 18. Saint-Maixent, abbey church, west wall of the nave (inside the western tower), capital in a blocked arch (photo: author, courtesy of the Conway Library, Courtauld Institute of Art)

PL 19. Poitiers, Sainte-Radegonde, capital in the ambulatory arcade (photo: author, courtesy of the Conway Library, Courtauld Institute of Art)

PL 20. Poitiers, Sainte-Radegonde, capital in the ambulatory arcade: Daniel in the Lions' Den (photo: author, courtesy of the Conway Library, Courtauld Institute of Art)

PL 21. Airvault, Saint-Pierre, capital in the ambulatory arcade: the month of April (photo: author, courtesy of the Conway Library, Courtauld Institute of Art)

PL 22. Poitiers, Bibliothèque Municipale, MS 250, the Life of St Radegund, fol. 25v (photo: C. R. Dodwell and G. Zarnecki, courtesy of the Conway Library, Courtauld Institute of Art)

PL 23. Saint-Jouin-de-Marnes, nave, capital on the north side (photo: author)

PL 24. Rome, Vatican Library, MS Reg. Lat. 465, Lives of the bishops of Angers, fo. 82 (photo: Biblioteca Vaticana)

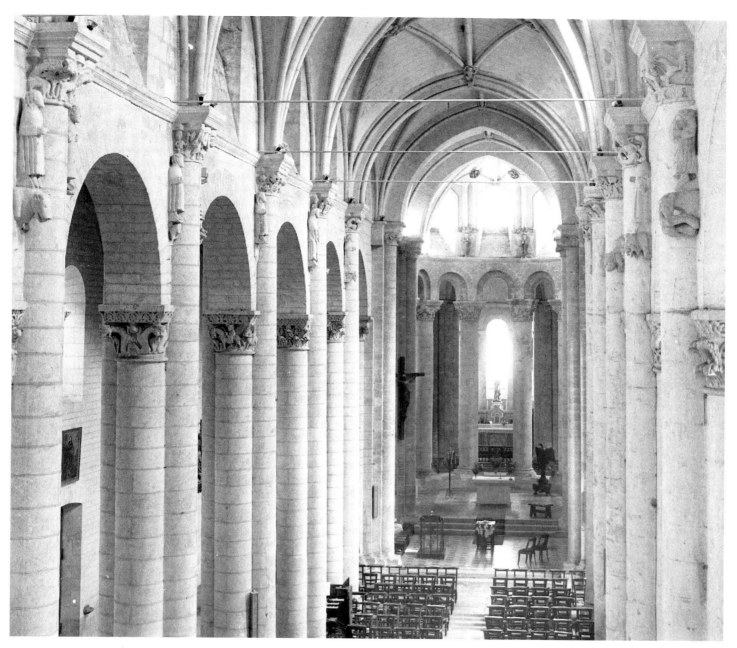

Pʟ 25. Airvault, Saint-Pierre, nave (photo: author)

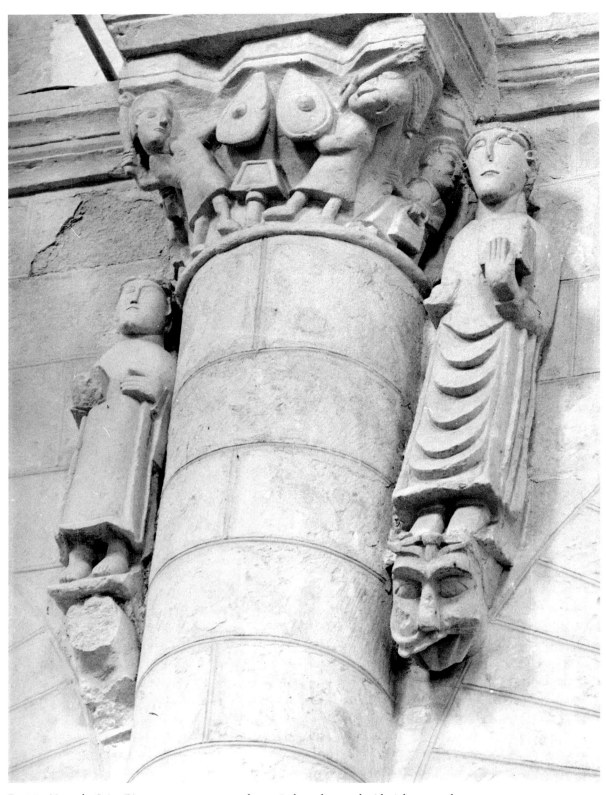

PL 26. Airvault, Saint-Pierre, nave, statues and a capital on the north side (photo: author, courtesy of the Conway Library, Courtauld Institute of Art)

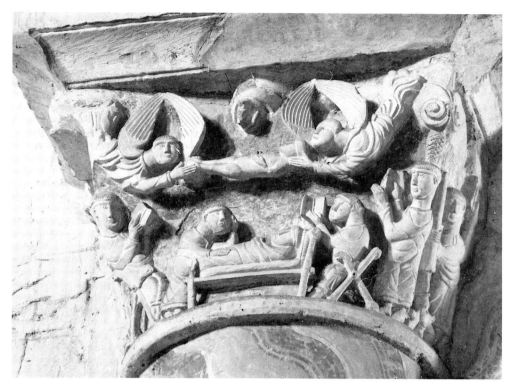

PL 27. Poitiers, Saint-Hilaire-le-Grand, capital in the north transept (photo: author, courtesy of the Conway Library, Courtauld Institute of Art)

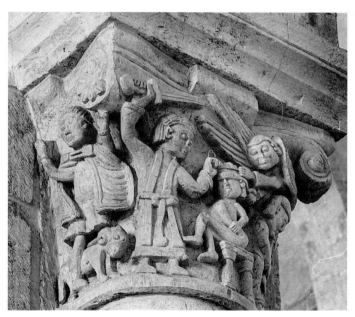

PL 28. Saint-Benoît-sur-Loire, capital in the choir: the Sacrifice of Isaac (photo: the Conway Library, Courtauld Institute of Art)

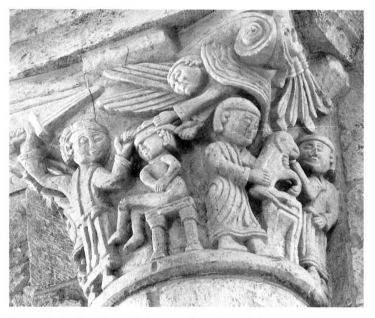

PL 29. Saint-Benoît-sur-Loire, another view of the capital in PL 28 (photo: the Conway Library, Courtauld Institute of Art)

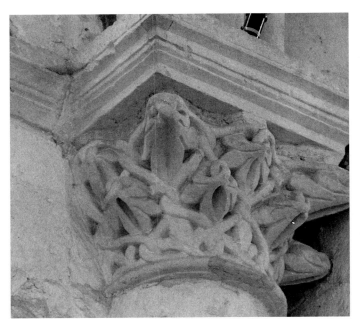

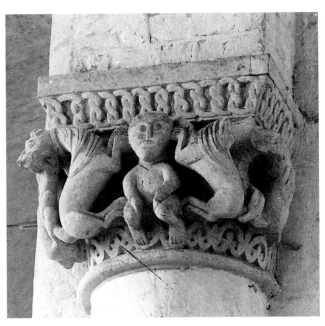

PL 30. Airvault, Saint-Pierre, nave, capital on the south side (photo: author, courtesy of the Conway Library, Courtauld Institute of Art)

PL 31. Airvault, Saint-Pierre, nave, capital in the south arcade (photo: author, courtesy of the Conway Library, Courtauld Institute of Art)

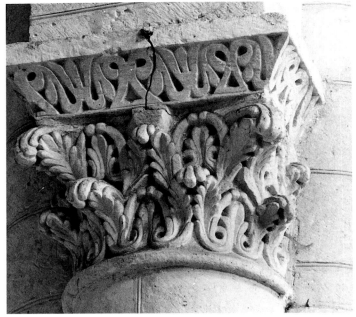

PL 32. Airvault, Saint-Pierre, nave, capital in the north arcade (photo: author, courtesy of the Conway Library, Courtauld Institute of Art)

PL 33. Airvault, Saint-Pierre, nave, capital in the north arcade (photo: author, courtesy of the Conway Library, Courtauld Institute of Art)

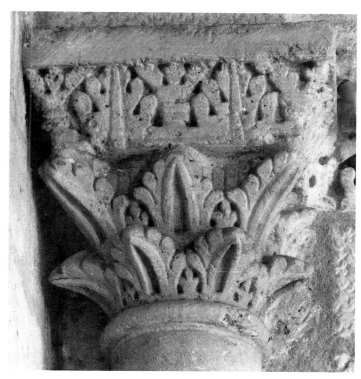

PL 34. Surgères, Notre-Dame, capital in the apse (photo: author, courtesy of the Conway Library, Courtauld Institute of Art)

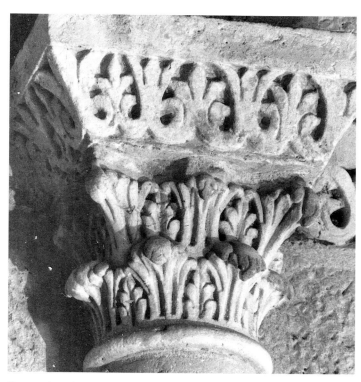

PL 35. Surgères, Notre-Dame, capital in the apse (photo: author, courtesy of the Conway Library, Courtauld Institute of Art)

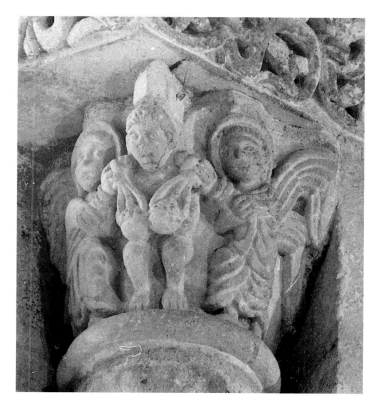

PL 36. Surgères, Notre-Dame, capital in the central window of the apse (photo: author, courtesy of the Conway Library, Courtauld Institute of Art)

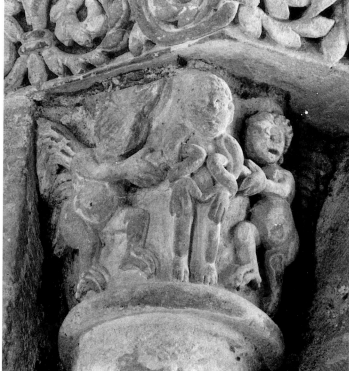

PL 37. Surgères, Notre-Dame, capital in the central window of the apse (photo: author, courtesy of the Conway Library, Courtauld Institute of Art)

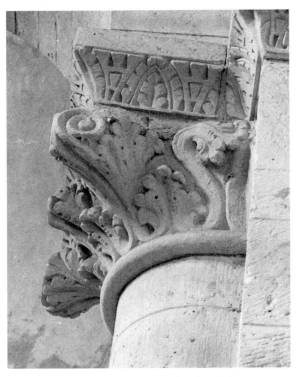

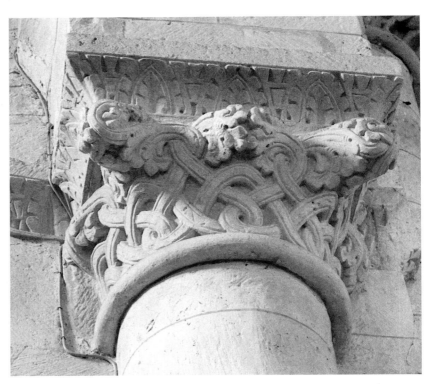

PL 38. Melle, Saint-Hilaire, north side of the crossing, capital on the aisle side (photo: author, courtesy of the Conway Library, Courtauld Institute of Art)

PL 39. Melle, Saint-Hilaire, capital on the north side of the crossing (photo: author, courtesy of the Conway Library, Courtauld Institute of Art)

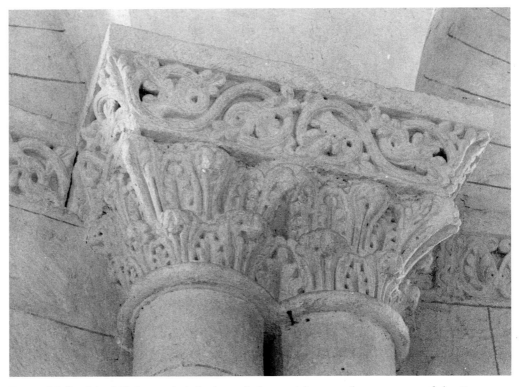

PL 40. Melle, Saint-Hilaire, capitals in the ambulatory (photo: author, courtesy of the Conway Library, Courtauld Institute of Art)

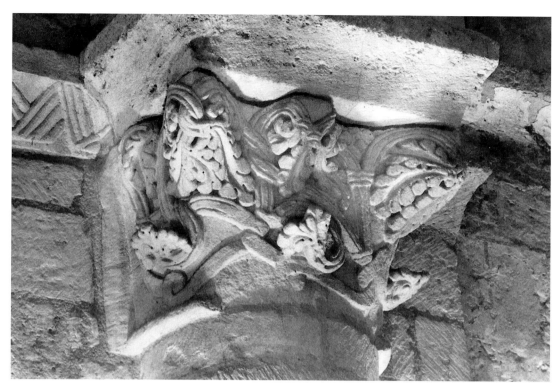

PL 41. Surgères, Notre-Dame, crossing, capital on the north side (photo: author)

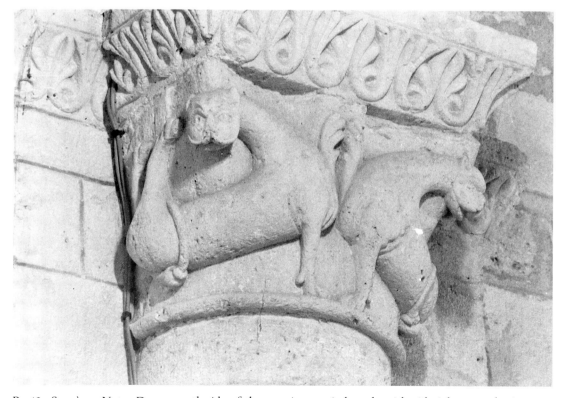

PL 42. Surgères, Notre-Dame, south side of the crossing, capital on the aisle side (photo: author)

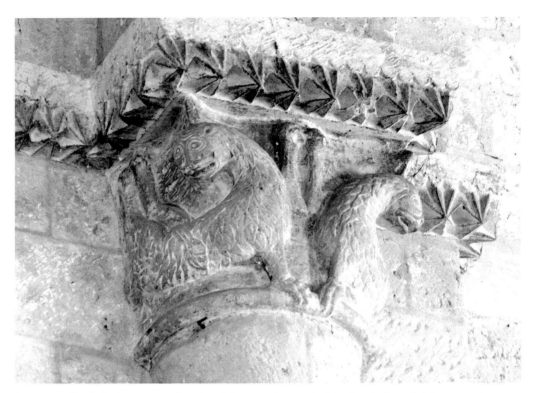

PL 43. Melle, Saint-Pierre, north side of the crossing, capital in the choir arch (photo: author, courtesy of the Conway Library, Courtauld Institute of Art)

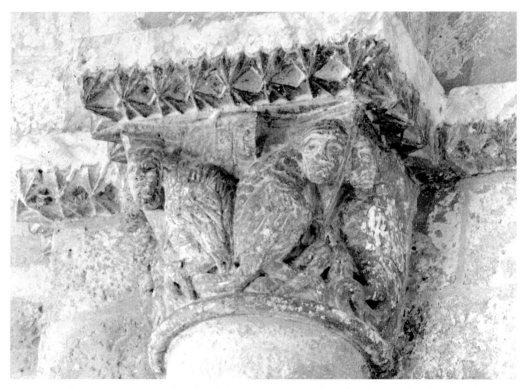

PL 44. Melle, Saint-Pierre, south side of the crossing, capital in the choir arch (photo: author, courtesy of the Conway Library, Courtauld Institute of Art)

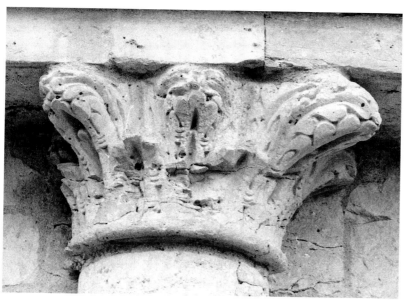

PL 45. Verrines-sous-Celles, capital of the south transept chapel (photo: author, courtesy of the Conway Library, Courtauld Institute of Art)

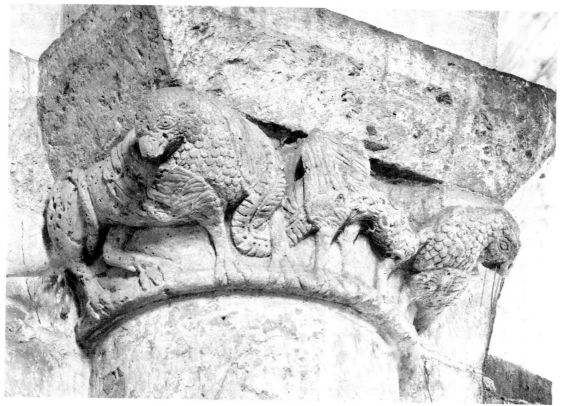

PL 46. Verrines-sous-Celles, crossing, capital on the north side (photo: author, courtesy of the Conway Library, Courtauld Institute of Art)

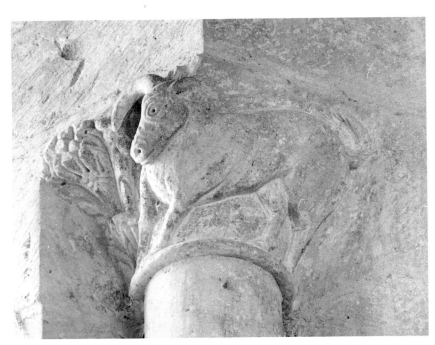

PL 47. Verrines-sous-Celles, choir, window capital (photo: author, courtesy of the Conway Library, Courtauld Institute of Art)

PL 48. Verrines-sous-Celles, corbels under the choir cornice (photo: author, courtesy of the Conway Library, Courtauld Institute of Art)

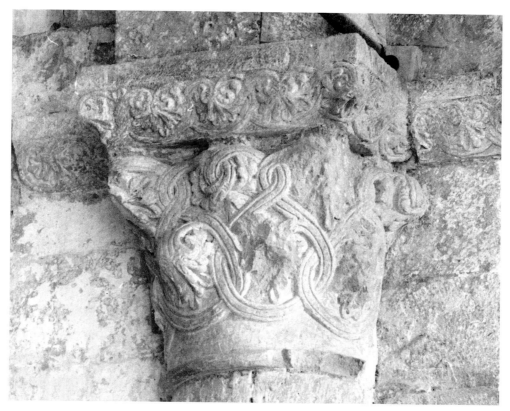

PL 49. Melle, Saint-Savinien, crossing, capital on the north side (photo: author, courtesy of the Conway Library, Courtauld Institute of Art)

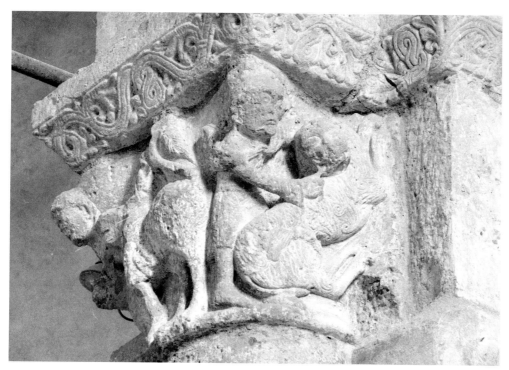

PL 50. Melle, Saint-Savinien, crossing, capital on the south side (photo: author, courtesy of the Conway Library, Courtauld Institute of Art)

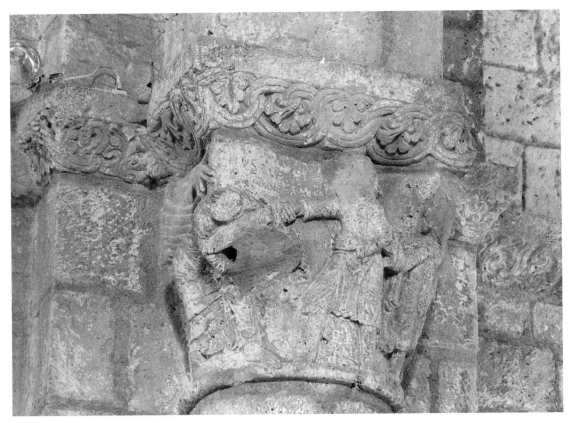

PL 51. Melle, Saint-Savinien, north side of the crossing, capital in the choir arch: the Martyrdom of St Savinianus (photo: author, courtesy of the Conway Library, Courtauld Institute of Art)

PL 52. Melle, Saint-Savinien, south side of the crossing, capital in the choir arch: St Nicholas (?) (photo: author, courtesy of the Conway Library, Courtauld Institute of Art)

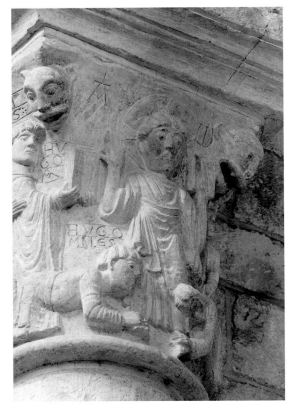

PL 53. Saint-Benoît-sur-Loire, capital in the north transept: Christ and donors (photo: James Austin)

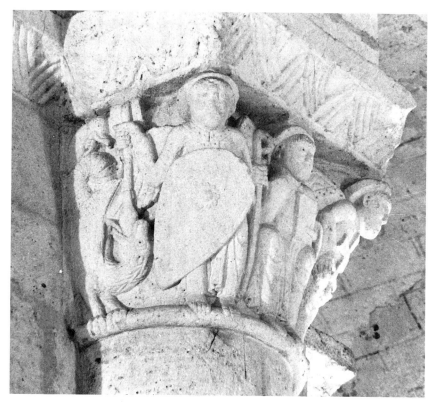

PL 54. Surgères, Notre-Dame, crossing capital on the north side: St Michael and other figures (photo: author)

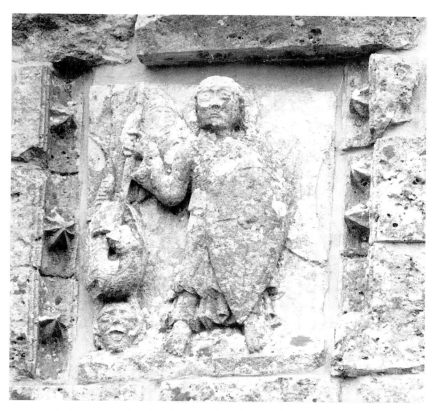

PL 55. Chail, western façade, slab-relief on the north side (photo: author, courtesy of the Conway Library, Courtauld Institute of Art)

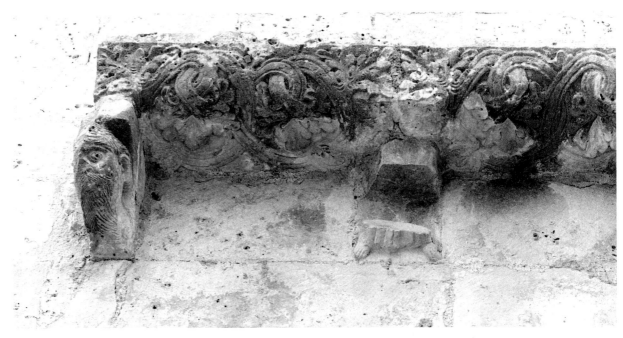

PL 56. Melle, Saint-Savinien, south transept façade, cornice above the portal (photo: author, courtesy of the Conway Library, Courtauld Institute of Art)

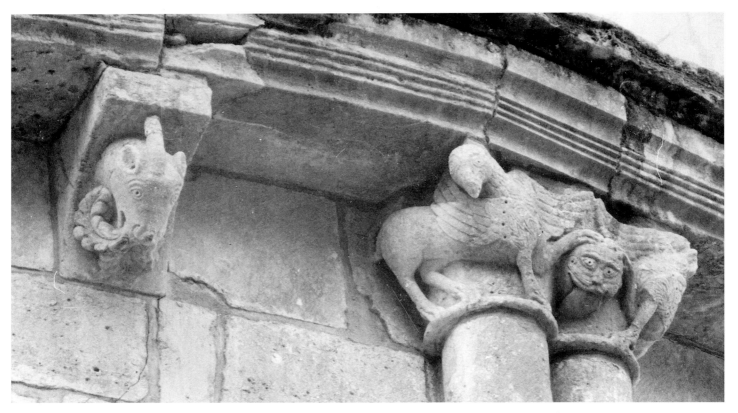

PL 57. Surgères, Notre-Dame, capital and corbel under the apse cornice (photo: author)

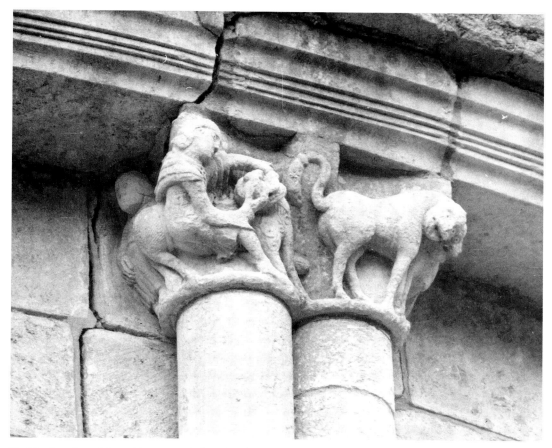

PL 58. Surgères, Notre-Dame, capital under the apse cornice: lion fighter (photo: author)

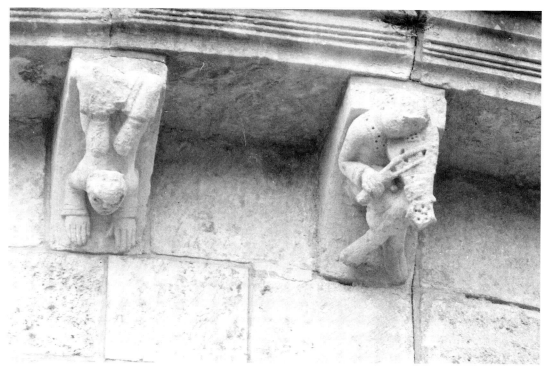

PL 59. Surgères, Notre-Dame, corbels under the apse cornice: musician and acrobat (photo: author)

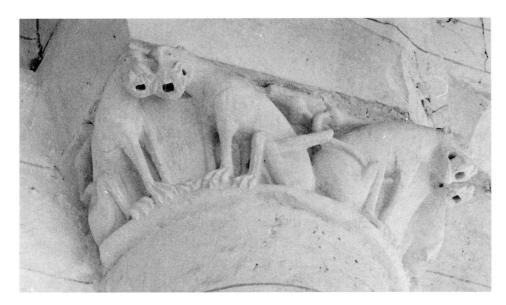

PL 60. Melle, Saint-Hilaire, nave, capital in the south wall (photo: author, courtesy of the Conway Library, Courtauld Institute of Art)

PL 61. Melle, Saint-Hilaire, nave, capital in the south wall (photo: author, courtesy of the Conway Library, Courtauld Institute of Art)

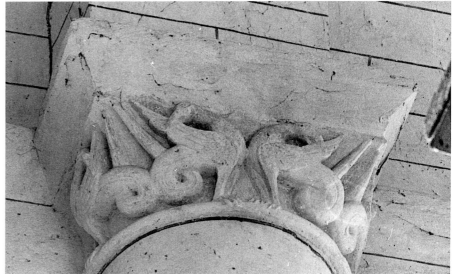

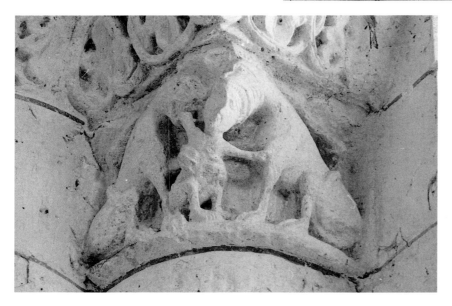

PL 62. Melle, Saint-Hilaire, nave, window capital in the south wall (photo: author, courtesy of the Conway Library, Courtauld Institute of Art)

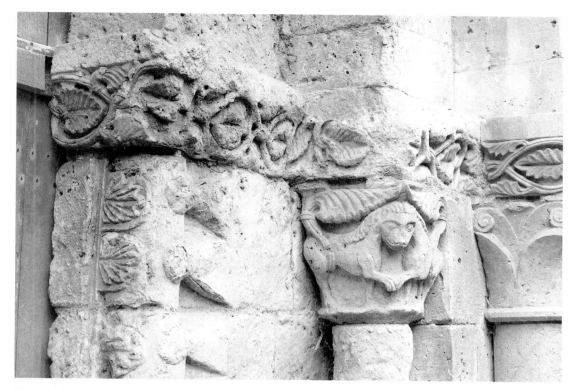

PL 63. Melle, Saint-Hilaire, nave, portal in the south wall, exterior details (photo: author, courtesy of the Conway Library, Courtauld Institute of Art)

PL 64. Melle, Saint-Hilaire, nave, portal in the south wall, interior archivolt: Apostles and other saints (photo: author, courtesy of the Conway Library, Courtauld Institute of Art)

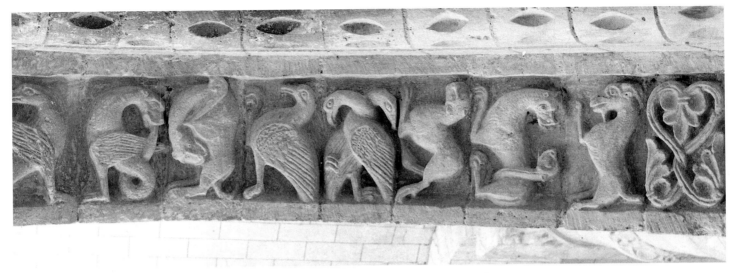

PL 65. Melle, Saint-Hilaire, nave, portal in the south wall, soffit of the archivolt in PL 64 (photo: author, courtesy of the Conway Library, Courtauld Institute of Art)

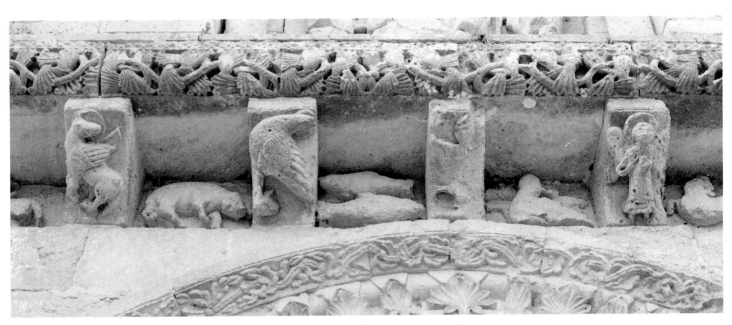

PL 66. Melle, Saint-Pierre, nave, cornice above the portal in the south wall (photo: author, courtesy of the Conway Library, Courtauld Institute of Art)

PL 67. Cormery, tower, decorative masonry (photo: author)

PL 68. Saint-Jouin-de-Marnes, eleventh-century part of the nave, window archivolt on the south side (photo: author, courtesy of the Conway Library, Courtauld Institute of Art)

PL 69. Saintes, Saint-Eutrope, crypt, window archivolt on the north side (photo: author)

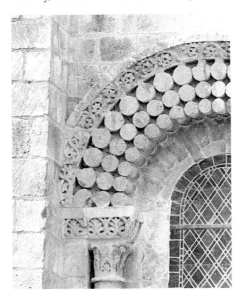

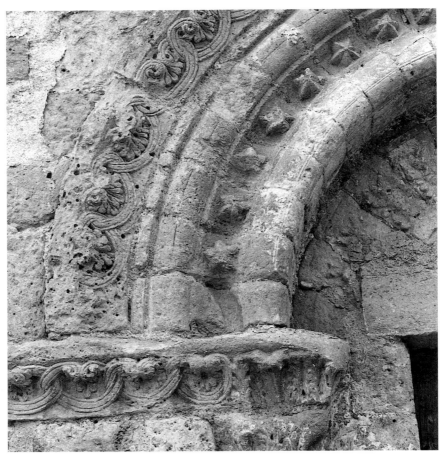

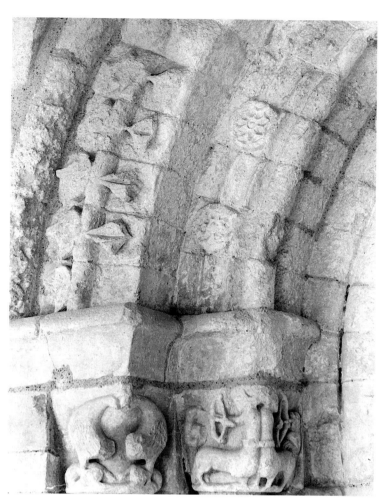

PL 73 (*left*). Nieul-sur-l'Autize, cloister portal (photo: author)

PL 74 (*below*). Chinon, Saint-Mexme, interior of the narthex, nave portal (photo: author)

PL 75. Benet, Sainte-Eulalie, western façade, south niche (photo: author)

PL 76. Benet, Sainte-Eulalie, western façade, voussoirs of the portal archivolt (photo: author)

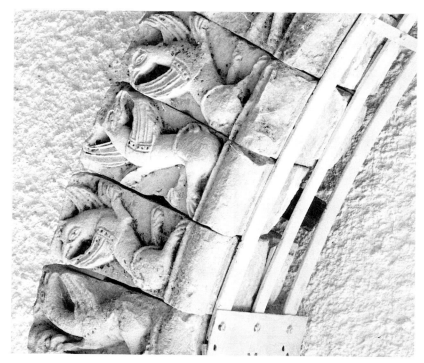

PL 77. Poitiers, Musée Municipal, arch (photo: author, courtesy of the
Conway Library, Courtauld Institute of Art)

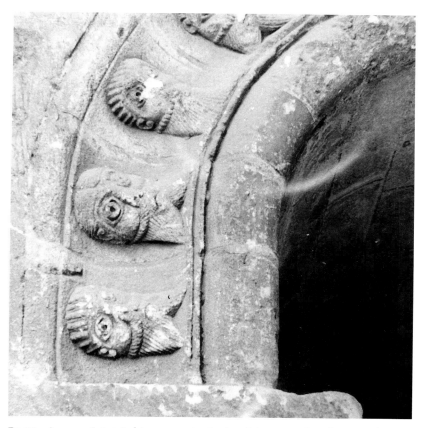

PL 78. Angers, Saint-Aubin, voussoirs in the cloister arcade (photo: author)

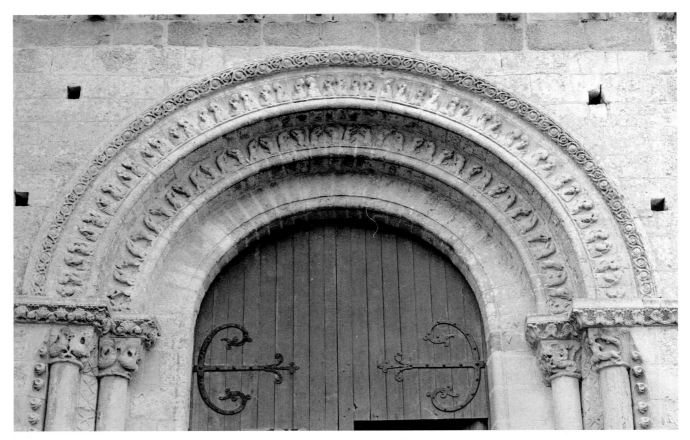

PL 79. Parthenay-le-Vieux, Saint-Pierre, western façade, portal (photo: author, courtesy of the Conway Library, Courtauld Institute of Art)

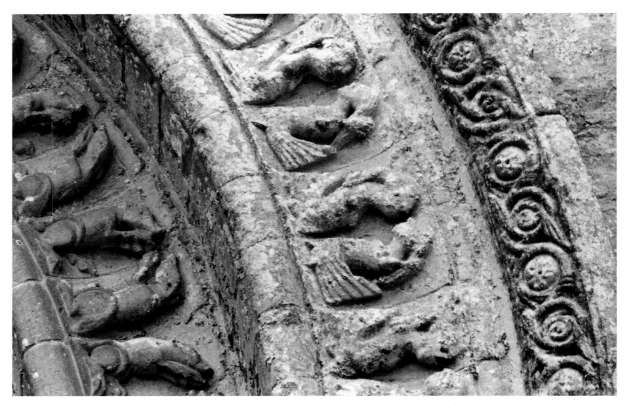

PL 80. Parthenay-le-Vieux, Saint-Pierre, western façade, portal archivolts (photo: author, courtesy of the Conway Library, Courtauld Institute of Art)

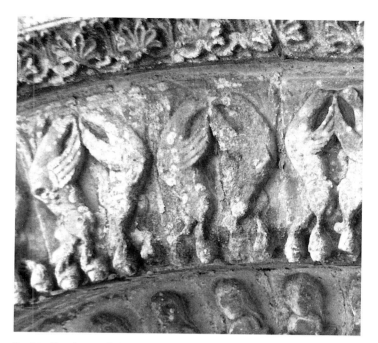

PL 81. Parthenay-le-Vieux, Saint-Pierre, western façade,
archivolt of the north niche (photo: author)

PL 82. Parthenay-le-Vieux, Saint-Pierre, western façade,
archivolt of the north niche (photo: author)

PL 83. Parthenay-le-Vieux, Saint-Pierre, western
façade, archivolts of the south niche (photo:
author, courtesy of the Conway Library,
Courtauld Institute of Art)

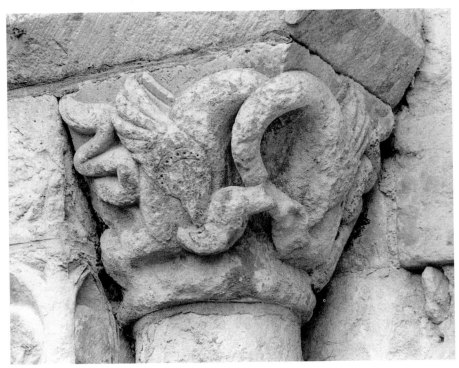

PL 84. Benet, Sainte-Eulalie, western façade, capital in the north niche (photo: author)

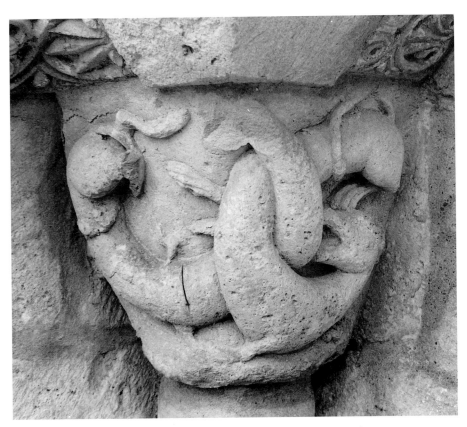

PL 85. Fontaines, Notre-Dame, western façade, capital (photo: author)

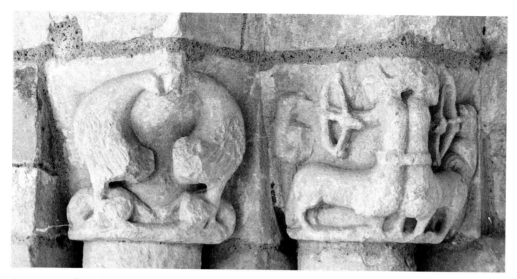

PL 86. Nieul-sur-l'Autize, capitals in the cloister portal (photo: author)

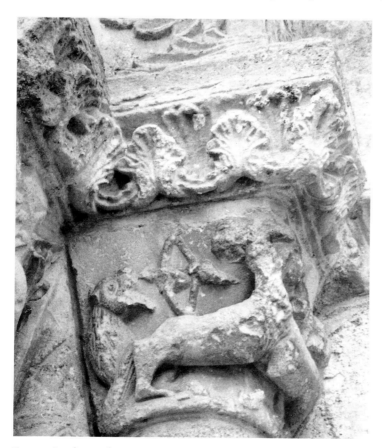

PL 87. Parthenay-le-Vieux, Saint-Pierre, western façade, capital in the south niche (photo: author, courtesy of the Conway Library, Courtauld Institute of Art)

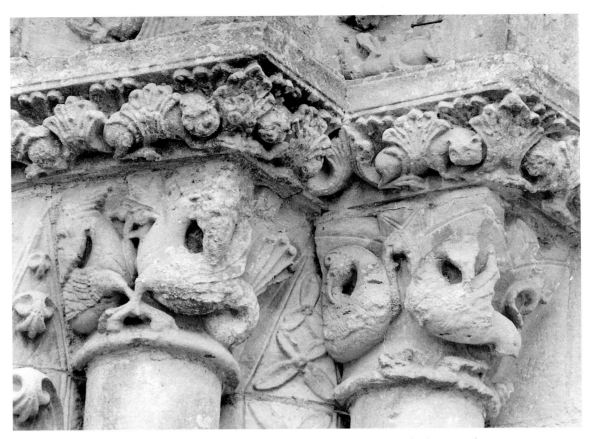

PL 88. Parthenay-le-Vieux, Saint-Pierre, western façade, capitals in the portal (photo: author, courtesy of the Conway Library, Courtauld Institute of Art)

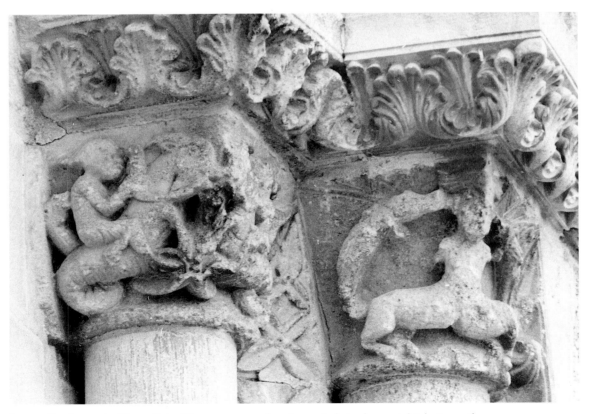

PL 89. Parthenay-le-Vieux, Saint-Pierre, western façade, capitals in the portal (photo: author, courtesy of the Conway Library, Courtauld Institute of Art)

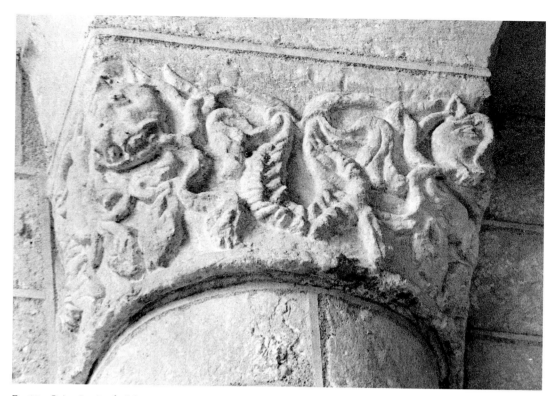

PL 90. Saint-Jouin-de-Marnes, nave-extension, north side, vaulting capital above pier 1 (photo: author)

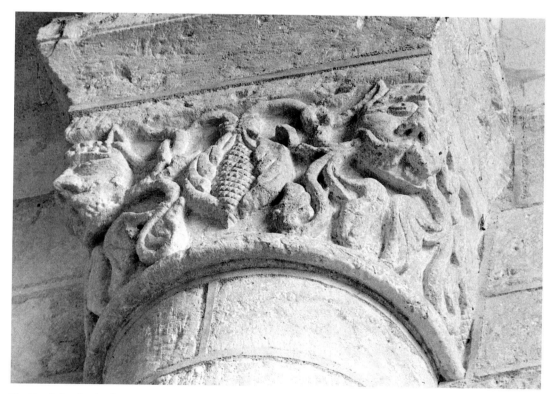

PL 91. Saint-Jouin-de-Marnes, nave-extension, south side, vaulting capital above pier 1 (photo: author)

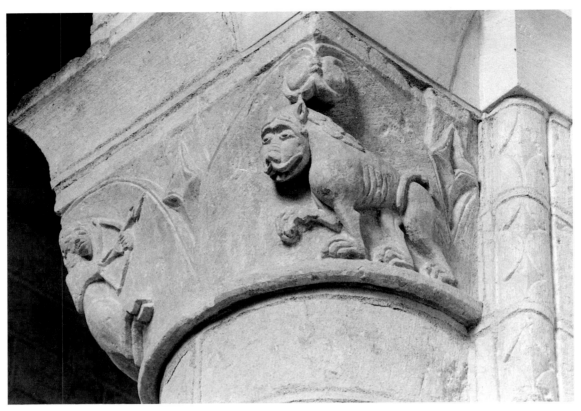

PL 92. Saint-Jouin-de-Marnes, nave-extension, north arcade, capital in pier 2 (photo: author)

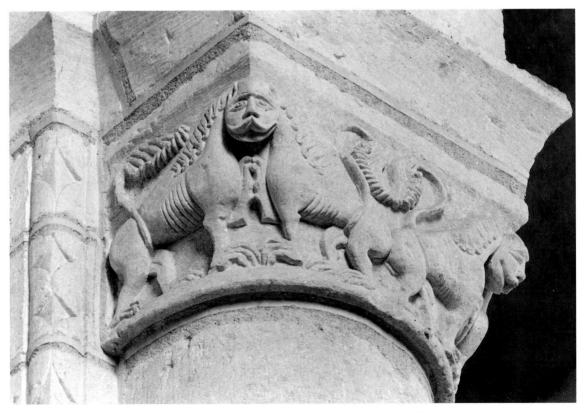

PL 93. Saint-Jouin-de-Marnes, nave-extension, south arcade, capital in pier 2 (photo: author)

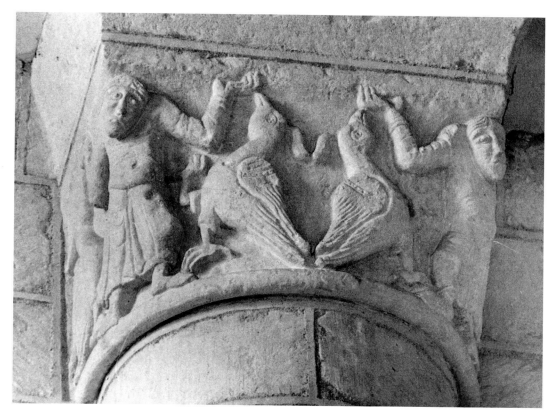

PL 94. Saint-Jouin-de-Marnes, nave-extension, north side, vaulting capital above pier 2 (photo: author)

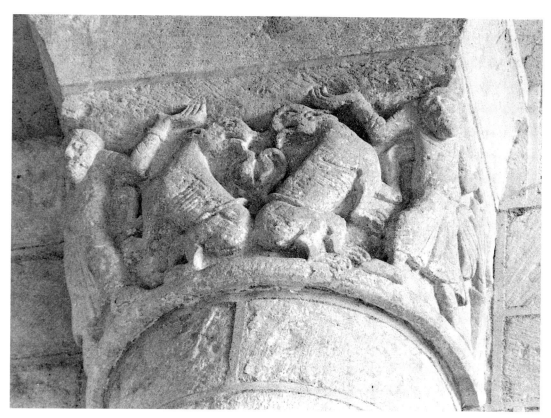

PL 95. Saint-Jouin-de-Marnes, nave-extension, south side, vaulting capital above pier 2 (photo: author)

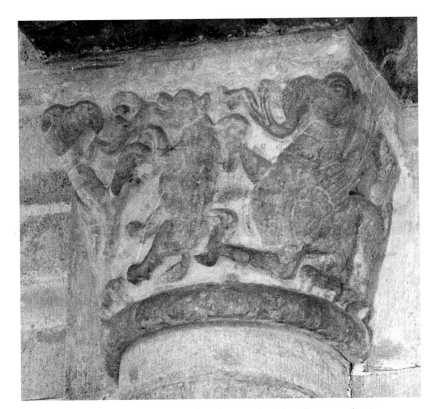

PL 96. Le Mans Cathedral, capital in the north aisle (photo: author)

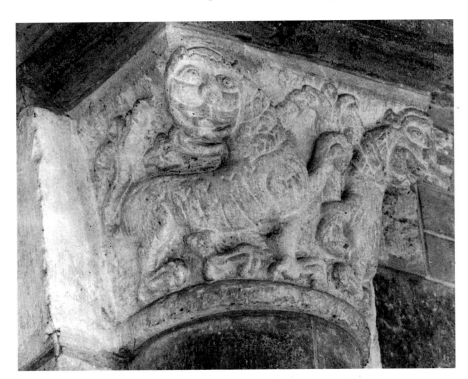

PL 97. Le Mans Cathedral, capital in the south aisle (photo: author)

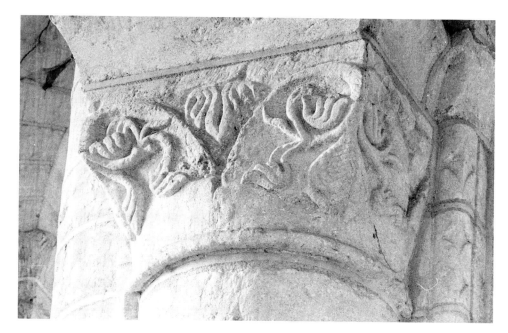

PL 98. Saint-Jouin-de-Marnes, nave-extension, south arcade, capital in pier 1 (photo: author)

PL 99. Saint-Jouin-de-Marnes, nave-extension, south arcade, capital in pier 1 (photo: author)

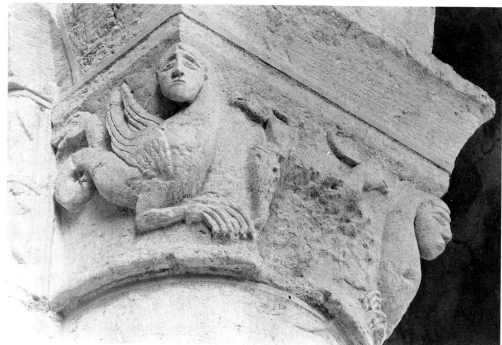

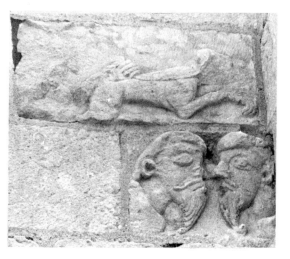

PL 100. Saint-Jouin-de-Marnes, western façade, frieze fragments at the north corner (photo: author)

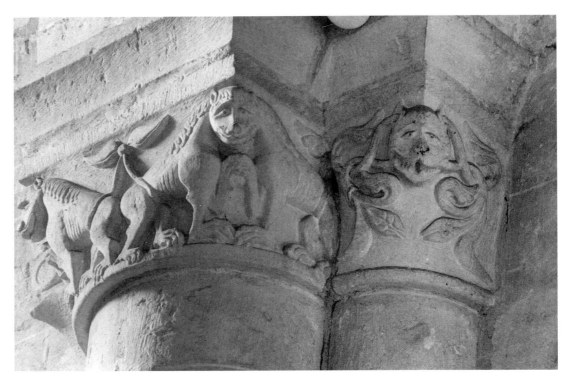

PL 101. Thouars, Saint-Laon, capital in the transept (photo: author)

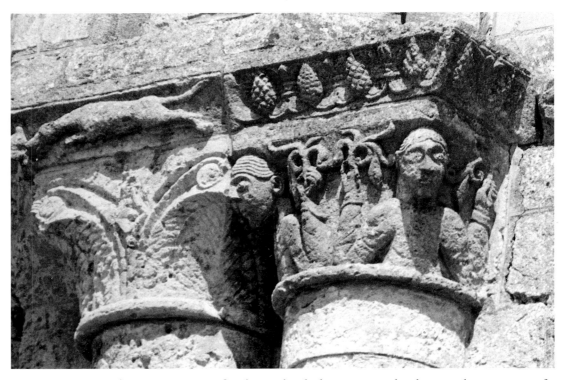

PL 102. Saint-Jouin-de-Marnes, western façade, north side, buttress capitals (photo: author, courtesy of the Conway Library, Courtauld Institute of Art)

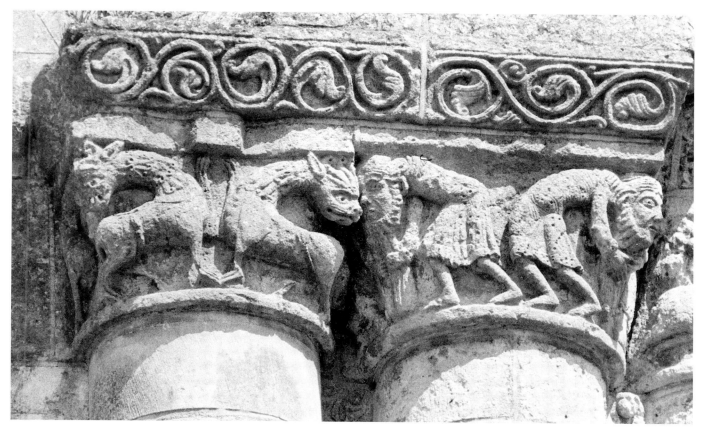

PL 103. Saint-Jouin-de-Marnes, western façade, south side, buttress capitals (photo: author, courtesy of the Conway Library, Courtauld Institute of Art)

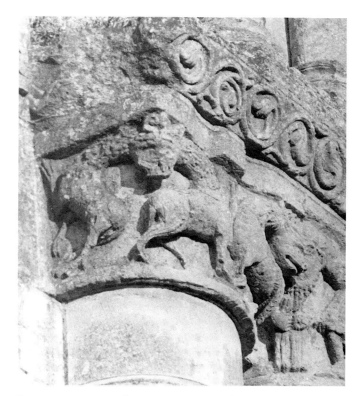

PL 104. Saint-Jouin-de-Marnes, western façade, south side, buttress capital (photo: author)

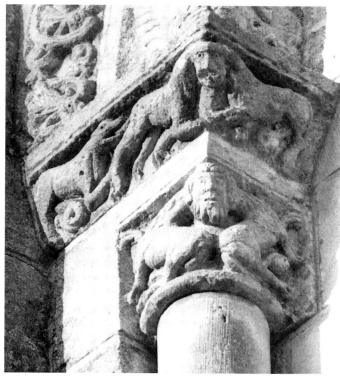

PL 105. Saint-Jouin-de-Marnes, western façade, capital in the south window (photo: author)

PL 106 (*right*). Saint-Jouin-de-Marnes, nave-extension, window capital on the south side (photo: author)

PL 107. Saint-Jouin-de-Marnes, nave-extension, window archivolt on the south side (photo: author)

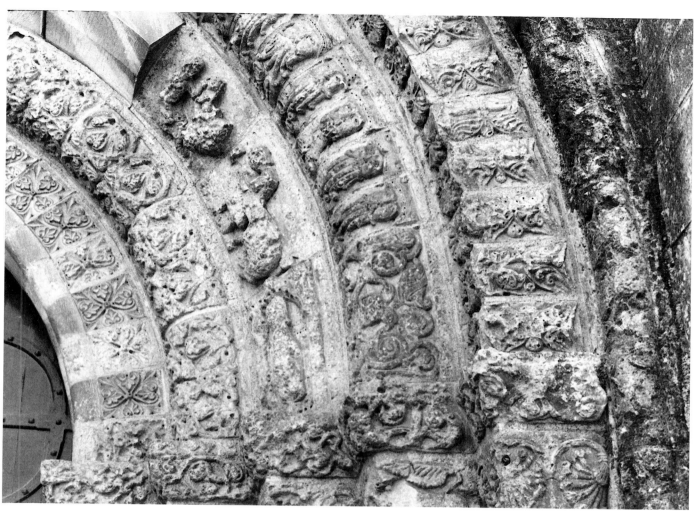

PL 108 (*above*). Saint-Jouin-de-Marnes, western façade, central portal, south side (photo: author, courtesy of the Conway Library, Courtauld Institute of Art)

PL 109 (*right*). Saint-Jouin-de-Marnes, western façade, voussoirs in the central portal (photo: author)

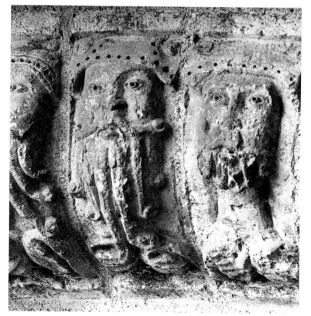

PL 110. Saint-Jouin-de-Marnes, western façade, voussoirs in the central window (photo: author)

PL 111 (*above*). Saint-Jouin-de-Marnes, western façade, voussoirs in the south window (photo: author)

PL 112 (*left*). Saint-Jouin-de-Marnes, western façade, voussoirs in the central window (photo: author)

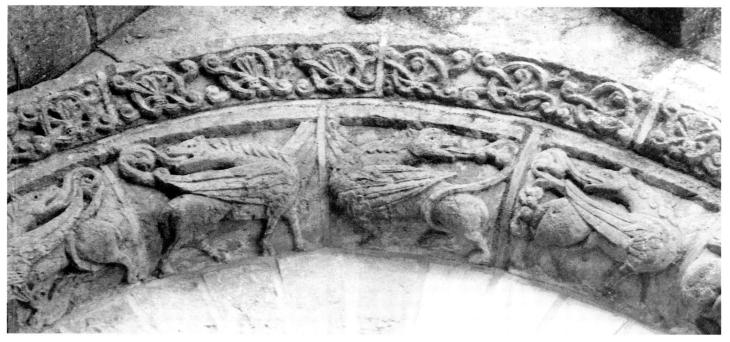

PL 113. Saint-Jouin-de-Marnes, western façade, voussoirs in the south window (photo: author)

PL 114. Le Mans, Bibliothèque Municipale, MS 261, fo. 91^V (photo: J. Alexander, courtesy of the Conway Library, Courtauld Institute of Art)

PL 115. Luçon, Notre-Dame (now the cathedral), north transept façade, slab-relief in niche (photo: author)

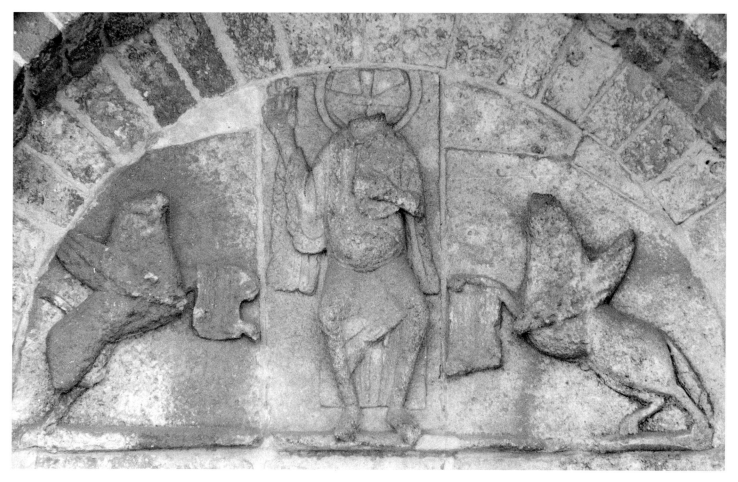

PL 116 (*above*). Luçon, Notre-Dame, north transept façade, slab-reliefs reused in tympanum: Christ and two animals (photo: author)

PL 117 (*right*). Poitiers, Musée Municipal, slab-relief from the church of Saint-Saturnin at Saint-Maixent (photo: author, courtesy of the Conway Library, Courtauld Institute of Art)

PL 118 (*far right*). Saint-Jouin-de-Marnes, western façade, slab-relief to the south of the central window: standing saint (photo: author, courtesy of the Conway Library, Courtauld Institute of Art)

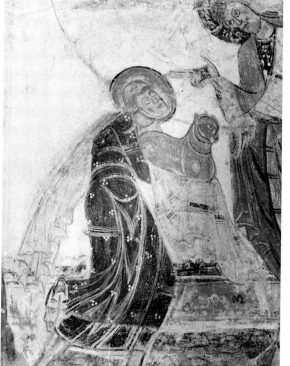

P L 119 (*above*). Saint-Jouin-de-Marnes, western façade, slab-reliefs at the centre of the gable: Christ and trumpeting angels (photo: James Austin)

P L 120 (*left*). Saint-Savin, vault painting in the nave: Abel (photo: author, courtesy of the Conway Library, Courtauld Institute of Art)

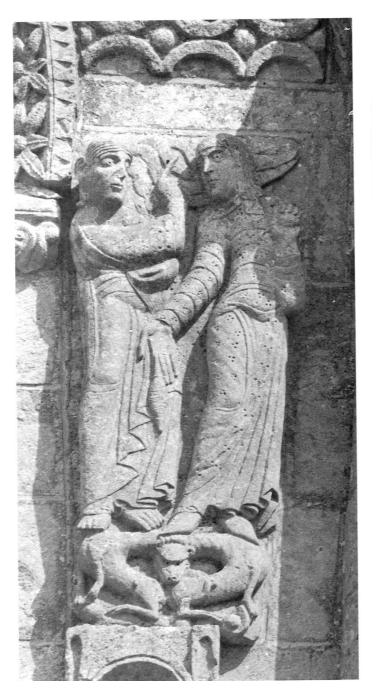

PL 121 (*left*). Saint-Jouin-de-Marnes, western façade, slab-relief to the south of the central window: the Annunciation (photo: James Austin)

PL 122 (*right*). Saint-Savin, vault painting in the nave: the Parting of Abraham and Lot (photo: author, courtesy of the Conway Library, Courtauld Institute of Art)

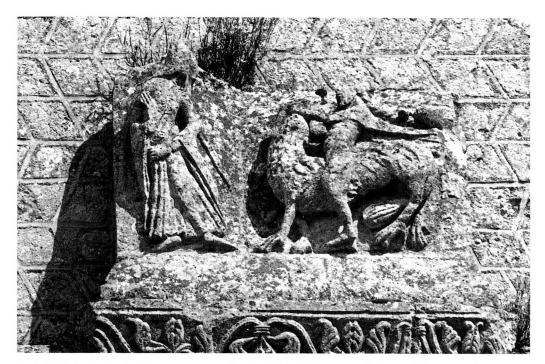

PL 123. Saint-Jouin-de-Marnes, western façade, slab-relief on top of the south buttress: Samson and a female figure (photo: James Austin)

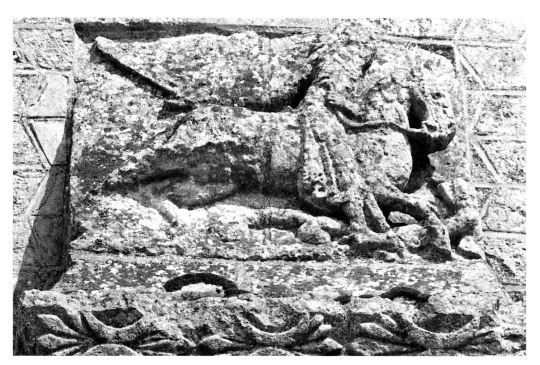

PL 124. Saint-Jouin-de-Marnes, western façade, slab-relief on top of the north buttress: the rider Constantine (photo: James Austin)

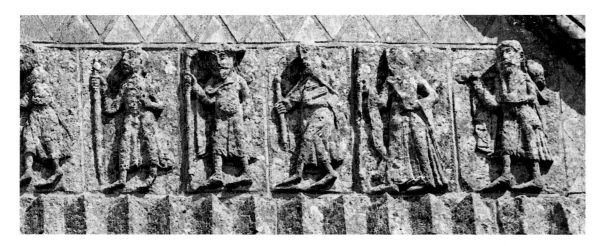

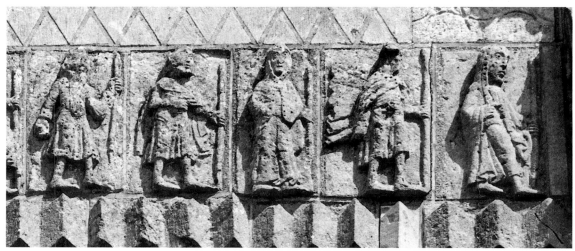

PL 125 (*above, top*). Saint-Jouin-de-Marnes, western façade, frieze at the base of the gable: the Elect (photo: James Austin)

PL 126 (*above*). Saint-Jouin-de-Marnes, western façade, frieze at the base of the gable: the Elect (photo: James Austin)

PL 127 (*right*). Chinon, Saint-Mexme, narthex façade, a mutilated slab-relief (photo: author)

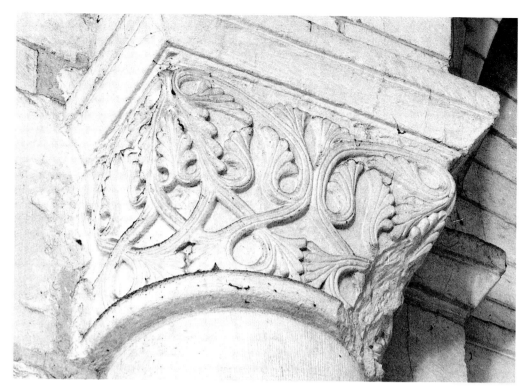

PL 128 (*left*). Saintes, Abbaye aux Dames, reinforcement work in the crossing, capital on the north side (photo: author)

PL 129 (*below*). Saintes, Saint-Eutrope, the two-storey choir, view of the north side (photo: the Conway Library, Courtauld Institute of Art)

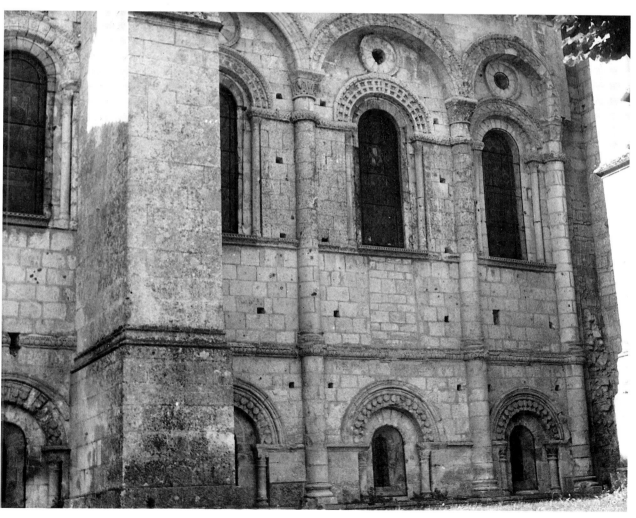

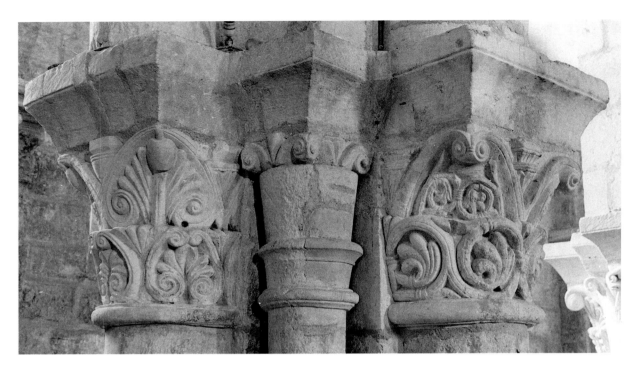

PL 130 (*above*). Saintes, Saint-Eutrope, capitals in the crypt (photo: author)

PL 131 (*right*). Le Mans, Notre-Dame-de-la-Couture, capital in the crypt (photo: author)

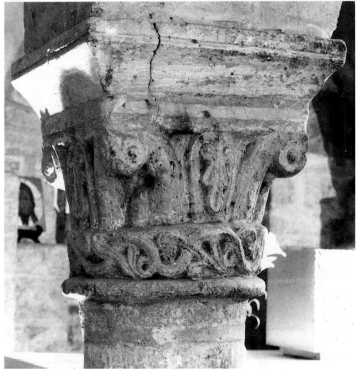

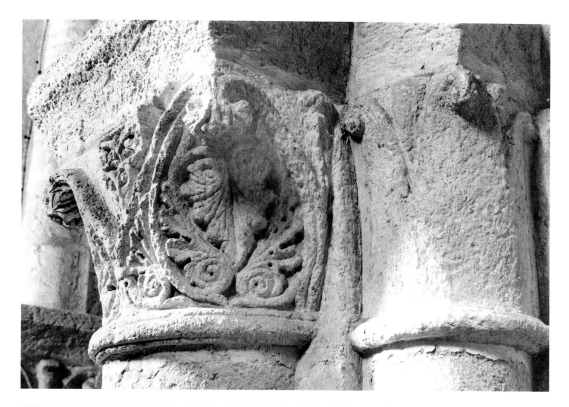

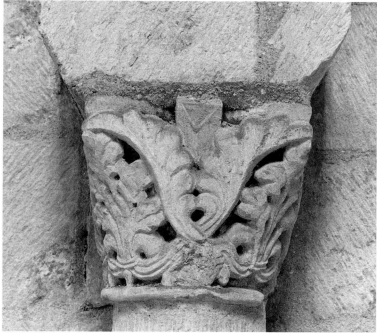

Pl 132. Saintes, Saint-Eutrope, capitals in the crypt (photo: author)

Pl 133. Poitiers, Saint-Jean-de-Montierneuf, capital in the interior dado arcade of the ambulatory (photo: author, courtesy of the Conway Library, Courtauld Institute of Art)

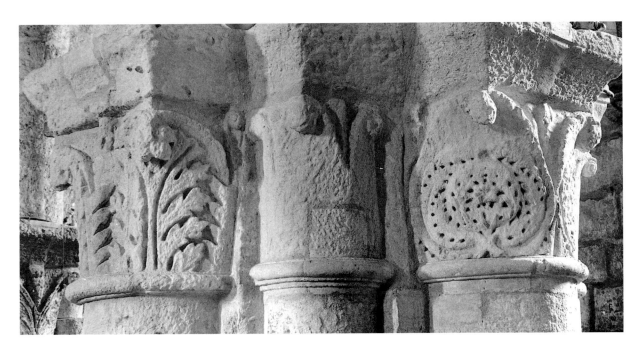

PL 134 (*above*). Saintes, Saint-Eutrope, capitals in the crypt (photo: author)

PL 135 (*left*). Saintes, Musée Municipal, Roman capital (photo: author)

PL 136 (*below*). Saintes, Musée Municipal, Roman frieze (photo: author)

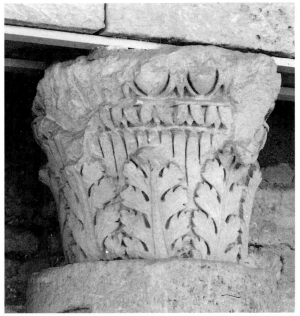

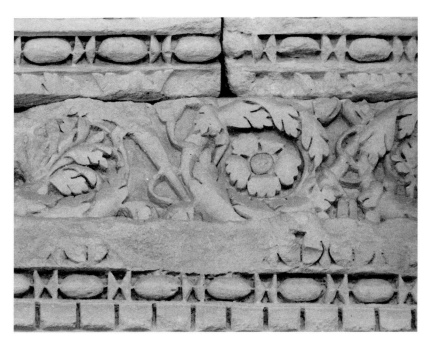

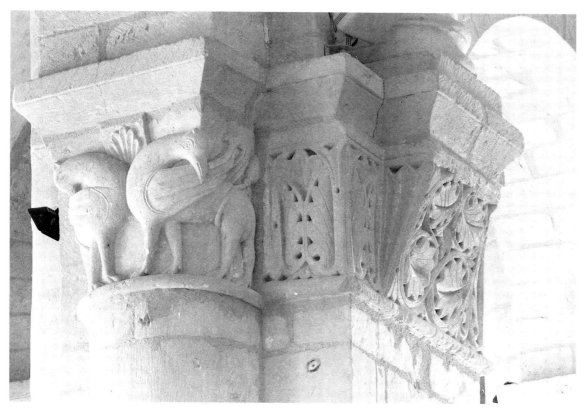

PL 137. Saintes, Saint-Eutrope, upper choir, capitals on the south side (photo: author)

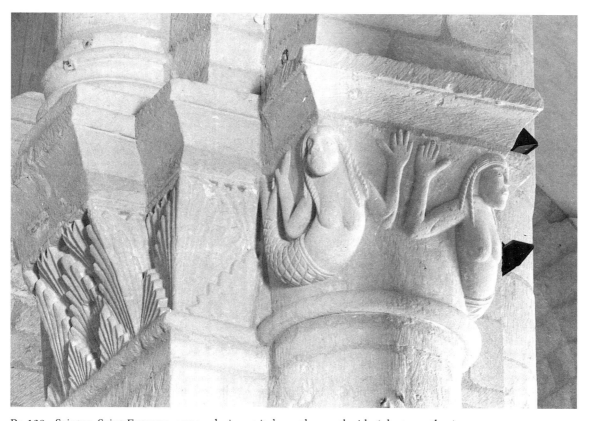

PL 138. Saintes, Saint-Eutrope, upper choir, capitals on the south side (photo: author)

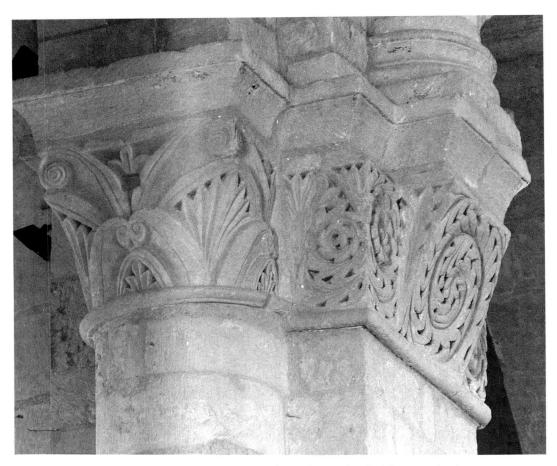

PL 139. Saintes, Saint-Eutrope, upper choir, capitals on the north side (photo: author)

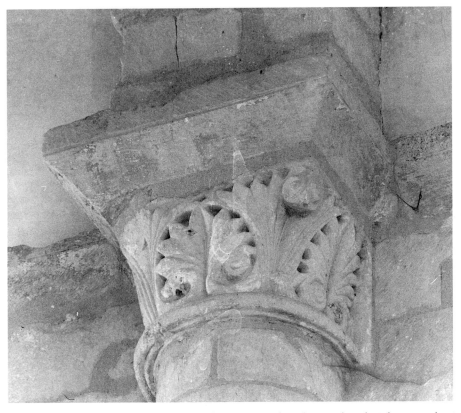

PL 140. Saintes, Saint-Eutrope, upper choir, a capital in the north aisle (photo: author)

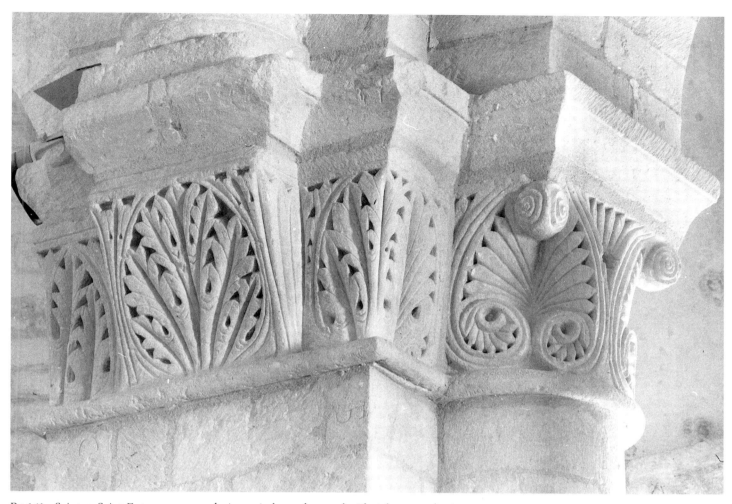

PL 141. Saintes, Saint-Eutrope, upper choir, capitals on the south side (photo: author)

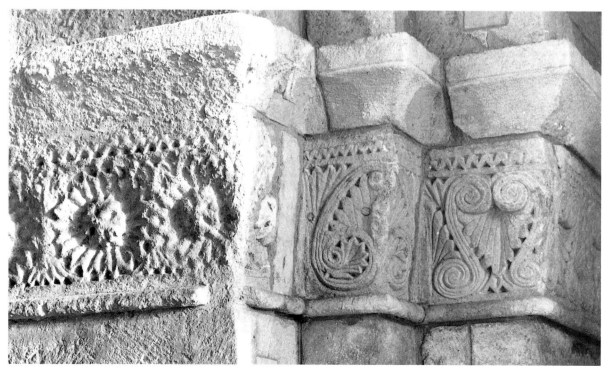

PL 142. Saintes, Saint-Eutrope, lower transept, capitals on the west side (photo: author)

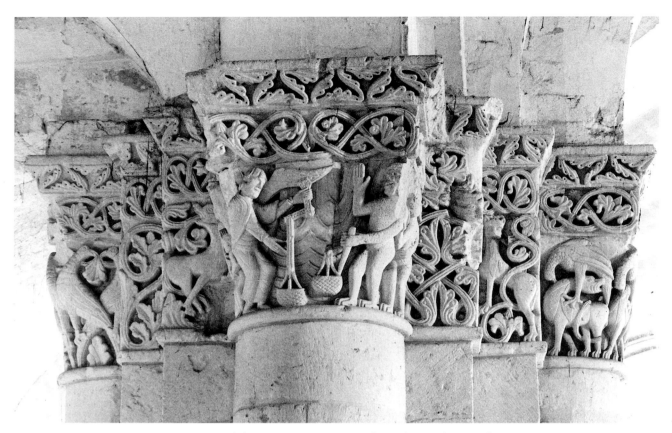

PL 143. Saintes, Saint-Eutrope, crossing of the upper transept, capitals on the north-east side
(photo: author)

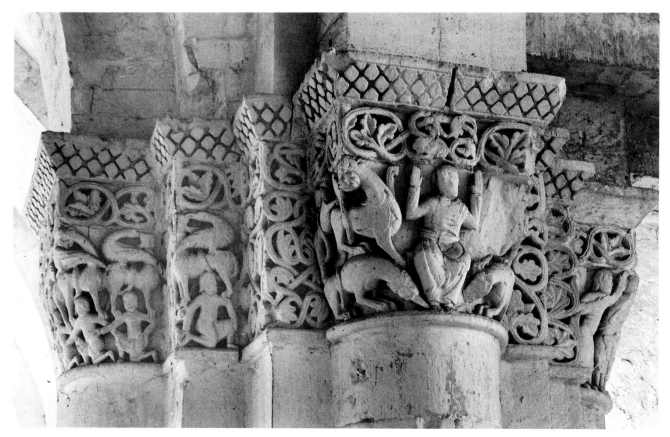

PL 144. Saintes, Saint-Eutrope, crossing of the upper transept, capitals on the south-east side
(photo: author)

PL 145. Foliage motifs:
a. Saintes, Saint-Eutrope, crossing capital (cf. PL 143)
b. Paris, Bibliothèque Mazarine, MS Lat. I, a Bible from Limoges, fo. 128$^{\mathrm{V}}$
c. Saintes, Saint-Eutrope, crossing capital (cf. PL 143)
d. Moissac, cloister impost

a

b

c

d

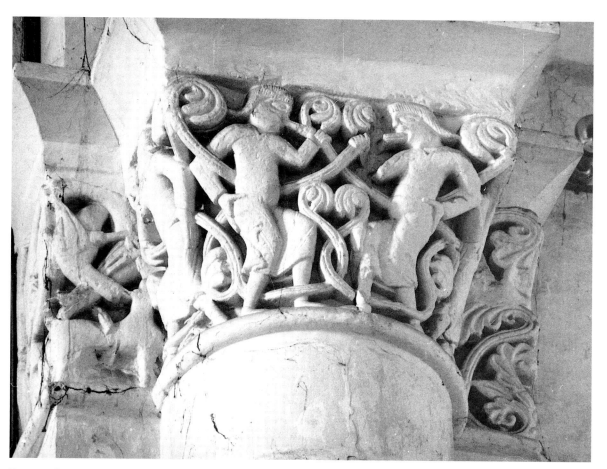

PL 146. Saintes, Saint-Eutrope, crossing of the upper transept, capitals on the south-west side (photo: author)

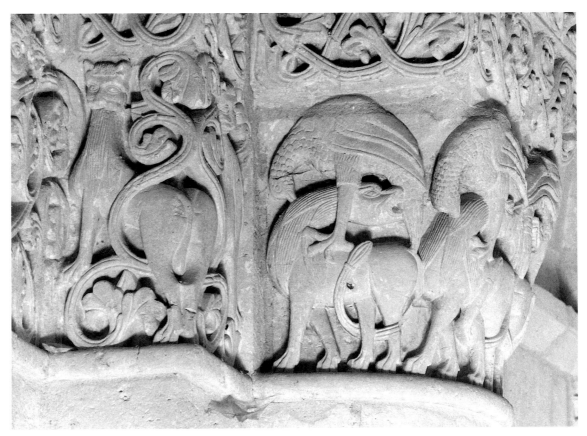

PL 147. Saintes, Saint-Eutrope, crossing capitals (detail from PL 143) (photo: author)

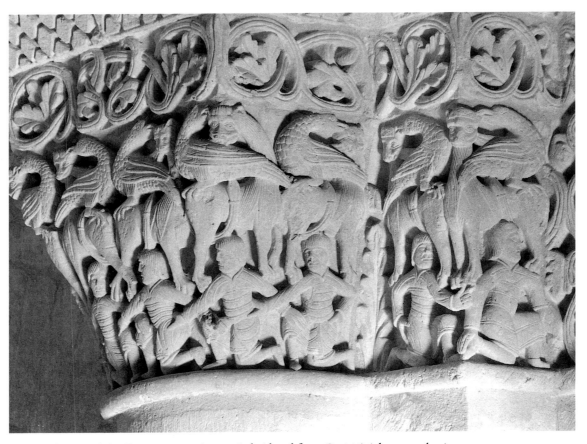

PL 148. Saintes, Saint-Eutrope, crossing capitals (detail from PL 144) (photo: author)

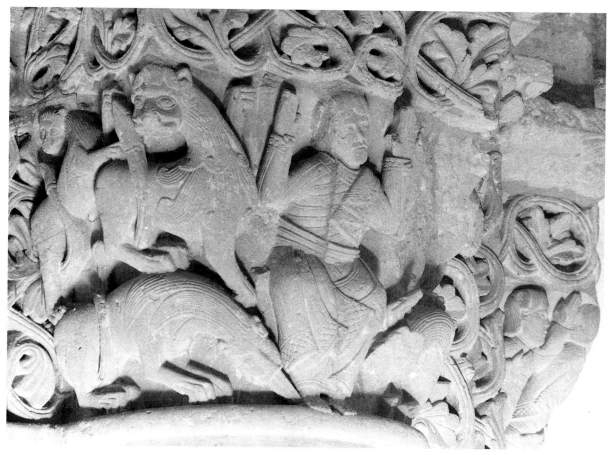

PL 149. Saintes, Saint-Eutrope, crossing capital (detail from PL 144): Daniel in the Lions' Den (photo: author)

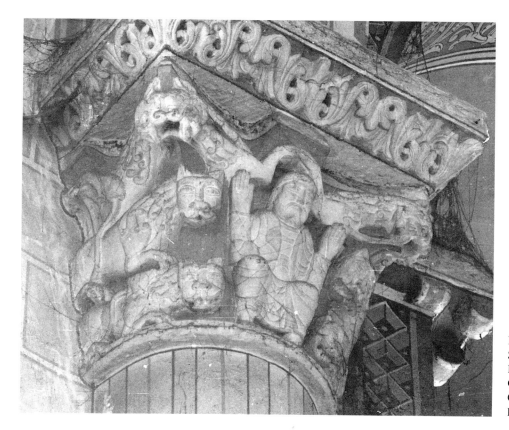

PL 150 (*left*). Toulouse, Saint-Sernin, capital in the ambulatory: Daniel in the Lions' Den (photo: G. Zarnecki, courtesy of the Conway Library, Courtauld Institute of Art)

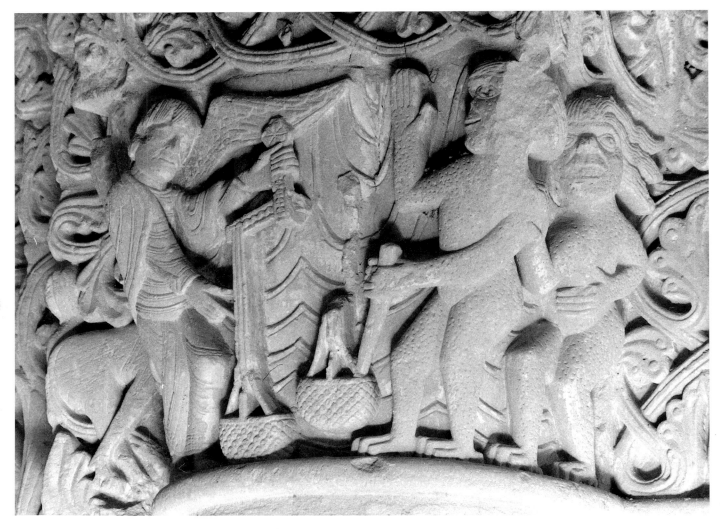

PL 151 (*above*). Saintes, Saint-Eutrope, crossing capital (detail from PL 143): the Weighing of Souls (photo: author)

PL 152 (*right*). Saintes, Musée Municipal, capital from Saint-Eutrope (?) (photo: author)

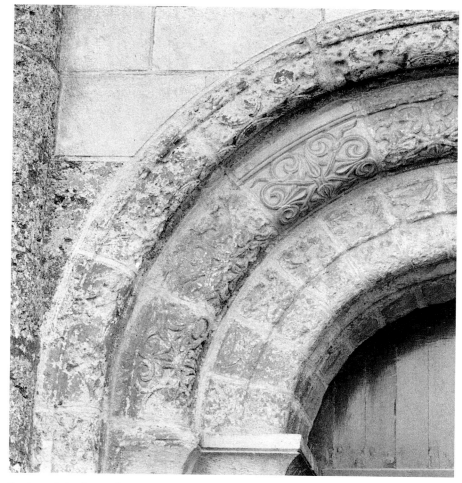

PL 153. Saint-Jouin-de-Marnes, western façade, north portal (photo: author, courtesy of the Conway Library, Courtauld Institute of Art)

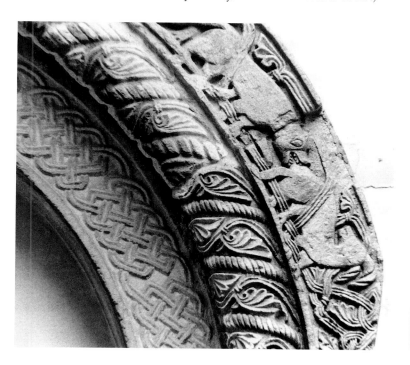

PL 154 (*left*). Como, Pinacoteca, portal from Santa Margherita, detail of archivolt (photo: author)

PL 155 (*below*). Saint-Jouin-de-Marnes, western façade, voussoir in the south window (photo: author)

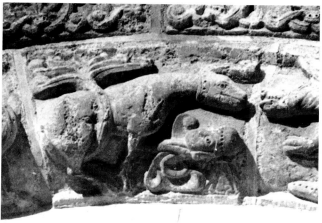

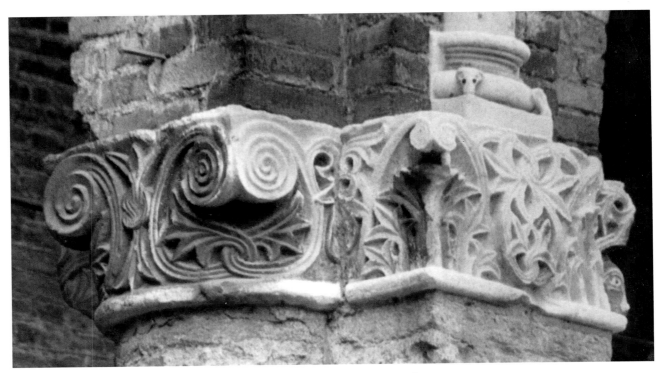

PL 156. Milan, Sant'Ambrogio, atrium, capitals on the south side (photo: author)

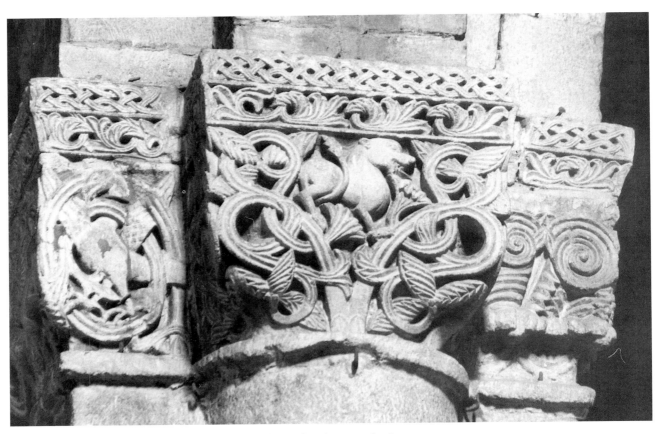

PL 157. Piacenza, San Savino, capitals in the north arcade (photo: author)

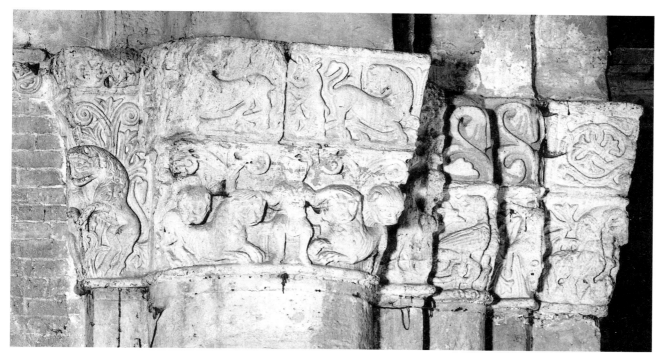

PL 158. Pavia, San Michele, crossing, capitals on the north side (photo: the Conway Library, Courtauld Institute of Art)

PL 159. Airvault, Saint-Pierre, nave, bases in the north arcade (photo: author, courtesy of the Conway Library, Courtauld Institute of Art)

PL 160. Pavia, San Pietro in Ciel d'Oro, nave, bases in the south arcade (photo: author)

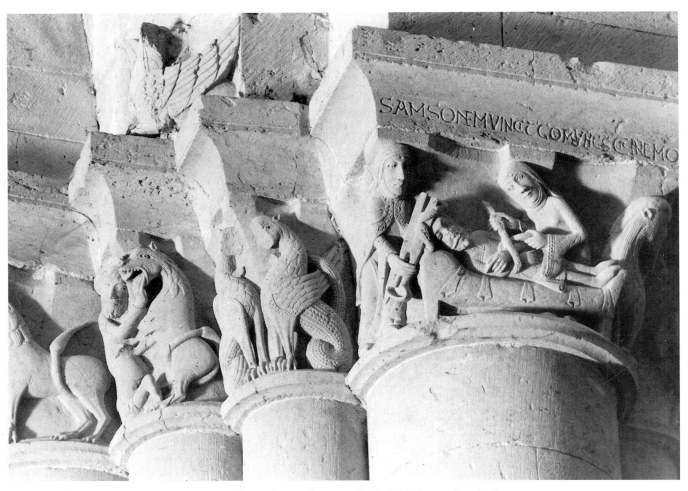

PL 161. Aulnay, Saint-Pierre, crossing, capitals on the north-west side: Delila's Betrayal and other themes (photo: author)

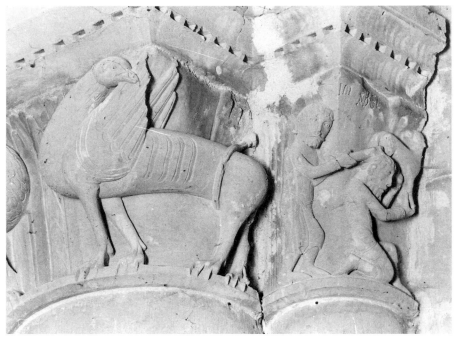

PL 162. Aulnay, Saint-Pierre, south-western crossing pier, capital on the aisle side (photo: author)

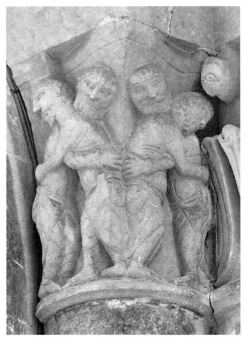

PL 163. Aulnay, Saint-Pierre, north-western crossing pier, capital on the transept side (photo: author)

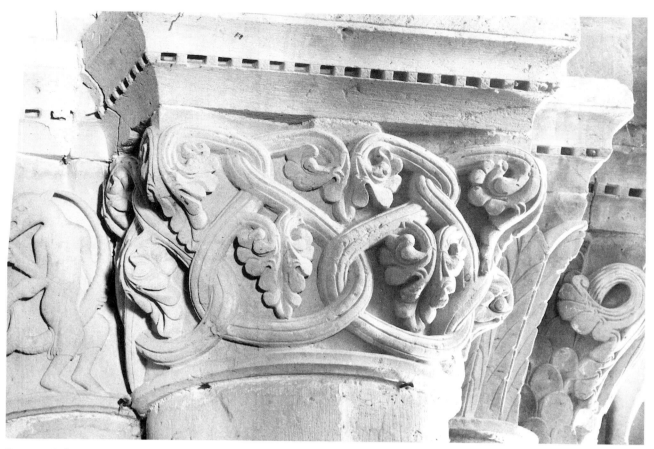

PL 164. Aulnay, Saint-Pierre, south-western crossing pier, capital on the nave side (photo: author)

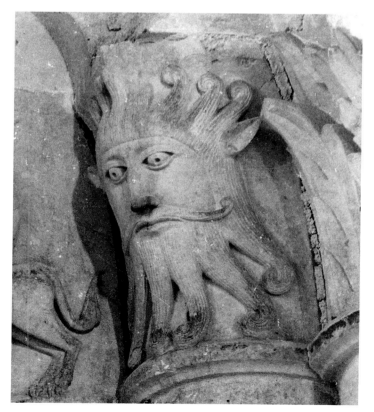

PL 165. Aulnay, Saint-Pierre, north-western crossing pier, capital on the aisle side (photo: author)

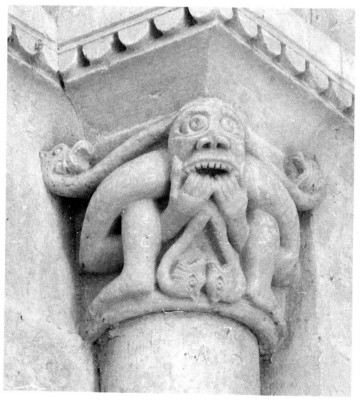

PL 166. Aulnay, Saint-Pierre, capital in the north transept (photo: author)

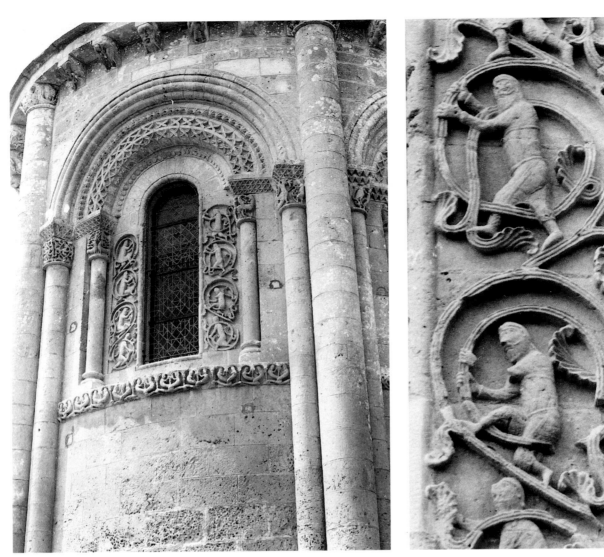

Aulnay, Saint-Pierre, apse: PL 167 (*left*). central window (photo: author); PL 168 (*right*). slab-relief at the central window (photo: author)

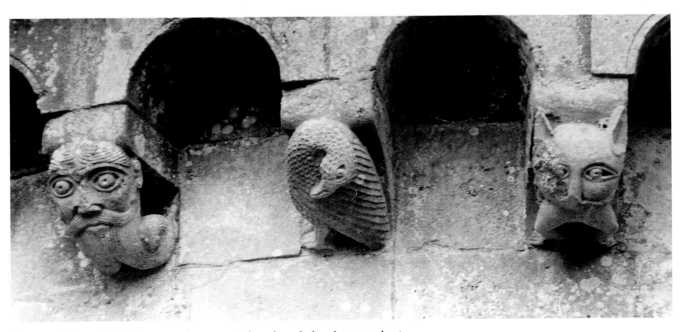

PL 169. Aulnay, Saint-Pierre, north transept chapel, corbels (photo: author)

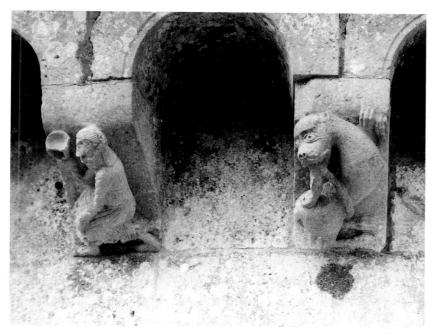

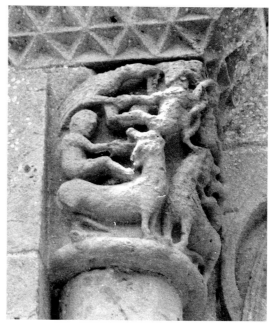

PL 170. Aulnay, Saint-Pierre, north transept chapel, corbels (photo: author)

PL 171. Aulnay, Saint-Pierre, apse, window capital (photo: author)

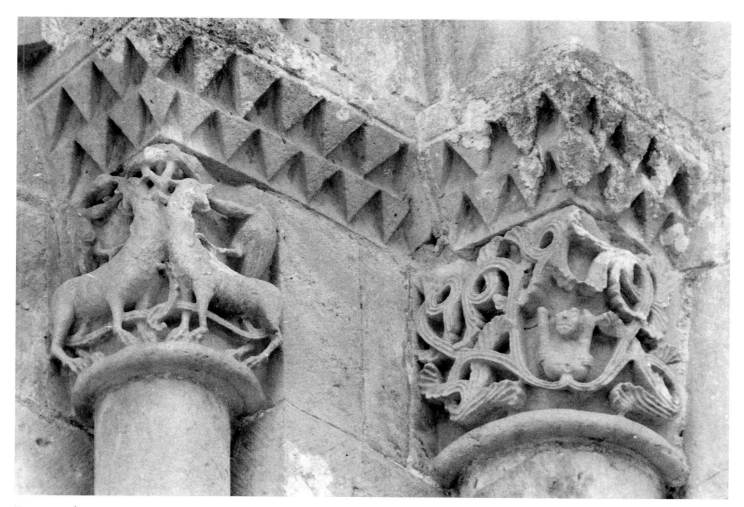

PL 172. Aulnay, Saint-Pierre, apse, window capitals (photo: author)

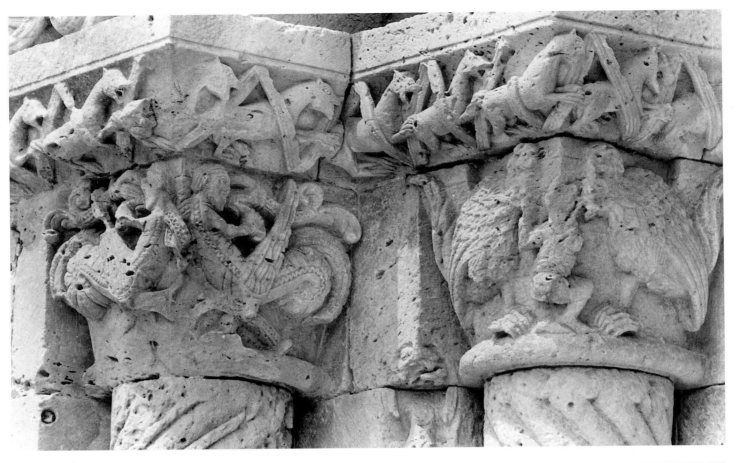

PL 173 (*above*). Aulnay, Saint-Pierre, south transept portal, capitals (photo: author)

PL 174 (*right*). Melle, Saint-Pierre, capital in the west portal (photo: G. Zarnecki, courtesy of the Conway Library, Courtauld Institute of Art)

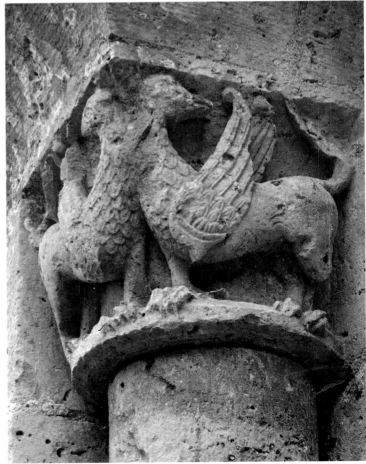

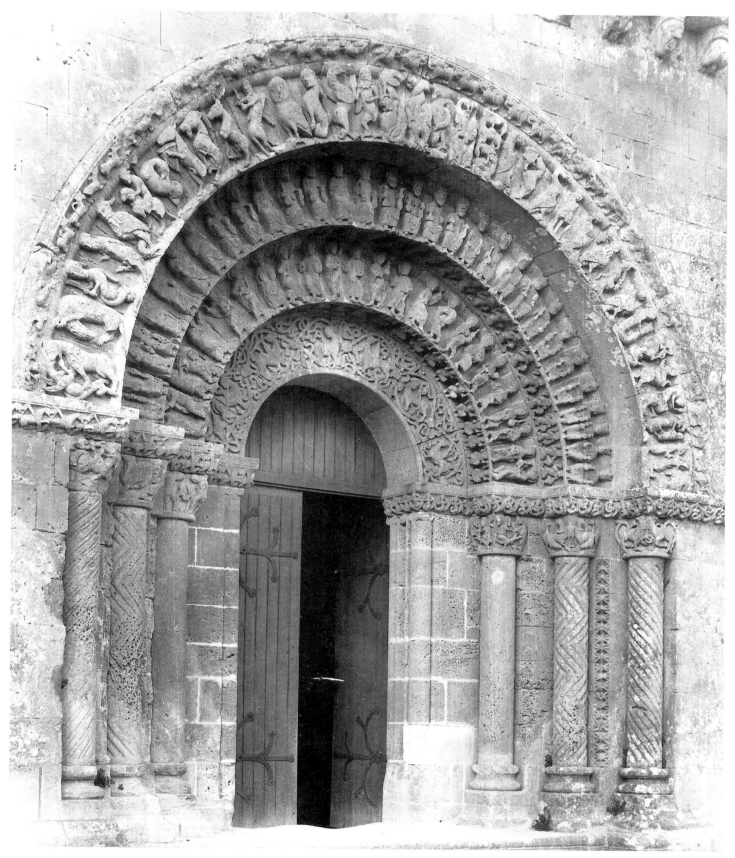

PL 175. Aulnay, Saint-Pierre, south transept portal (photo: author)

PL 176 (*left*). Aulnay, Saint-Pierre, south transept portal, soffit of an archivolt (photo: author)

PL 177 (*above*). Moissac, cloister capital, detail (photo: author)

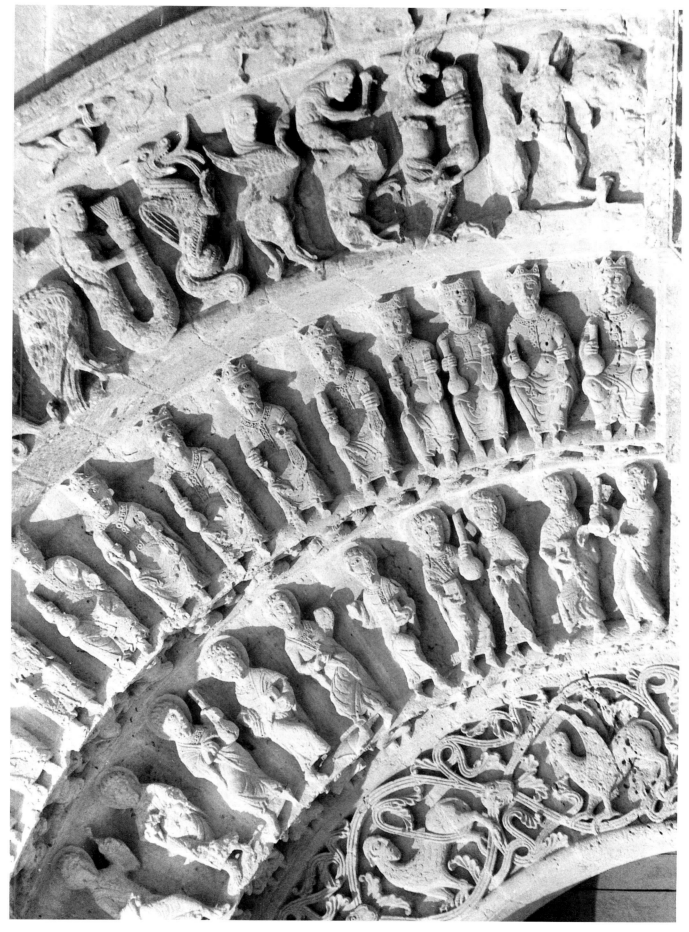

Pl. 178. Aulnay, Saint-Pierre, south transept portal, archivolts (photo: author)

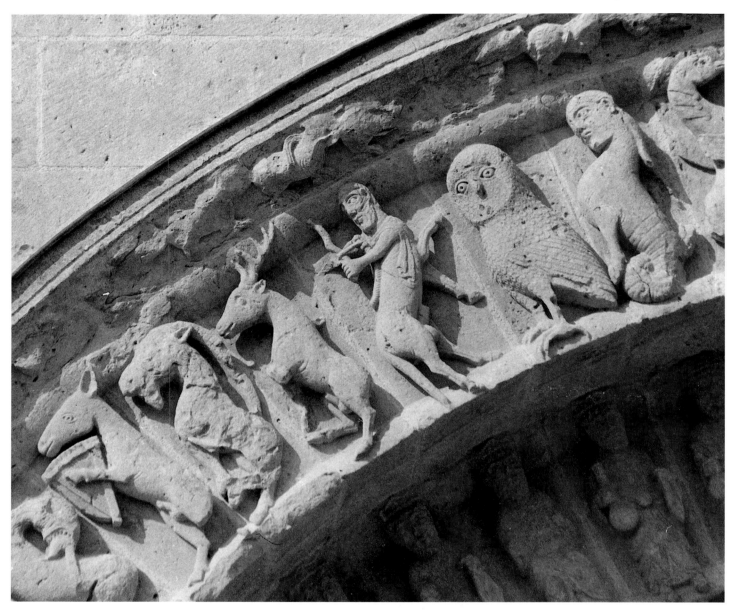

PL 179. Aulnay, Saint-Pierre, south transept portal, outer archivolt, detail (photo: author)

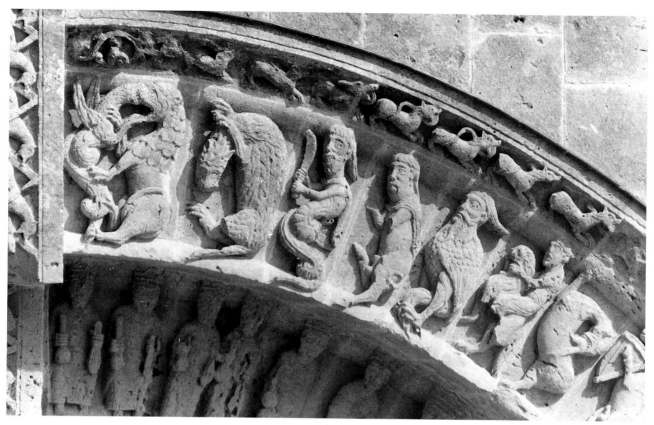

PL 180. Aulnay, Saint-Pierre, south transept portal, outer archivolt, detail (photo: author)

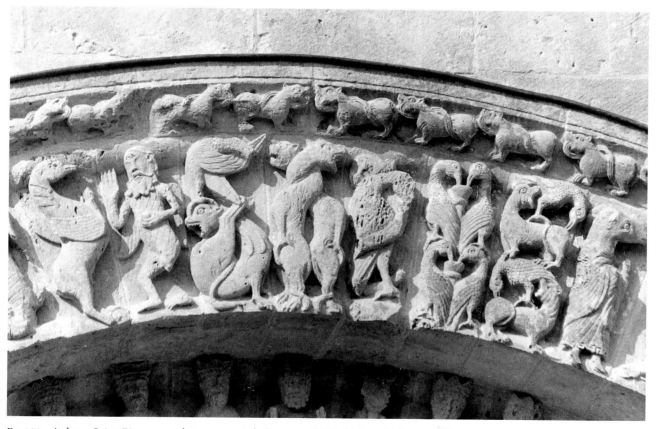

PL 181. Aulnay, Saint-Pierre, south transept portal, outer archivolt, detail (photo: author)

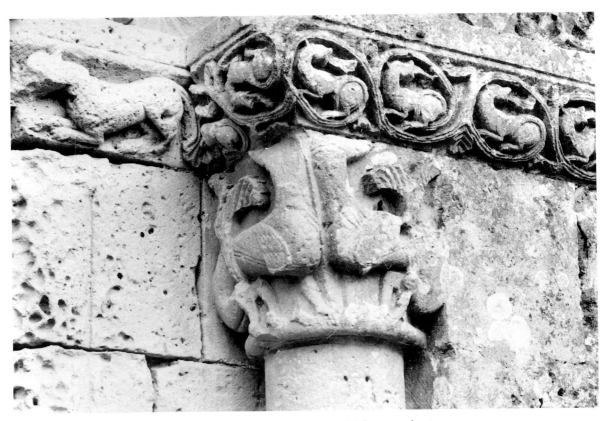

PL 182. Salles-lès-Aulnay, Notre-Dame, capital in the west portal (photo: author)

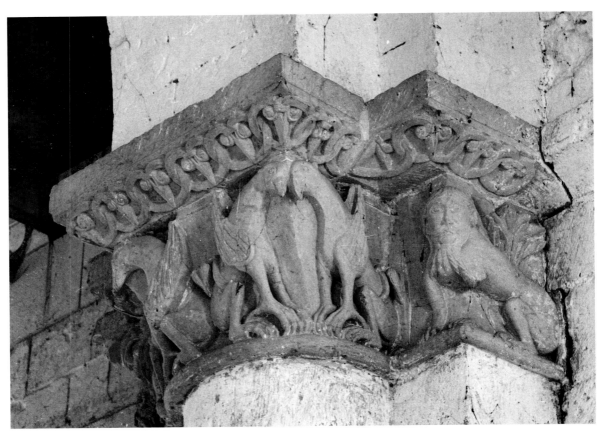

PL 183. Salles-lès-Aulnay, Notre-Dame, choir arch, capitals on the north side (photo: the Conway Library, Courtauld Institute of Art)

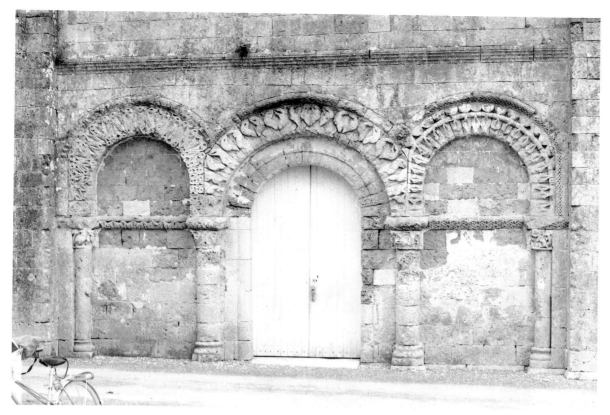

PL 184. Antezant, western façade (photo: author)

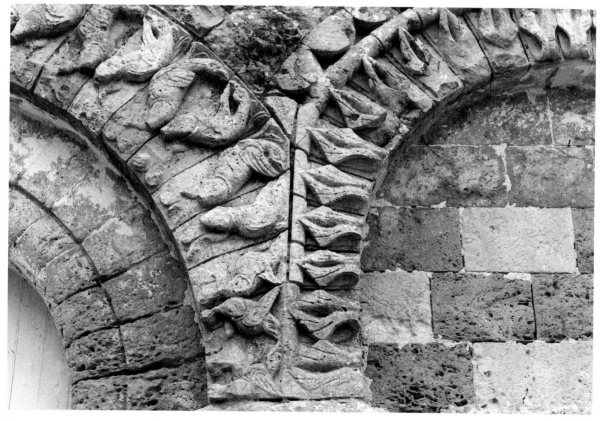

PL 185. Antezant, western façade, archivolts on the south side (photo: author)

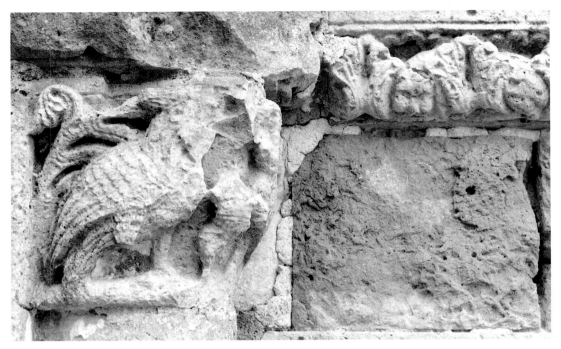

PL 186. Antezant, western façade, capital on the north side (photo: author)

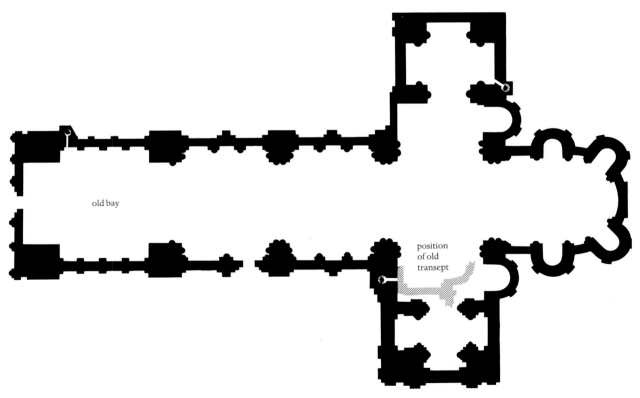

old bay

position
of old
transept

PL 187. Angoulême, Cathedral of Saint-Pierre, ground plan, combined with a reconstruction plan
of the old south transept (see Chapter 2 n. 86)

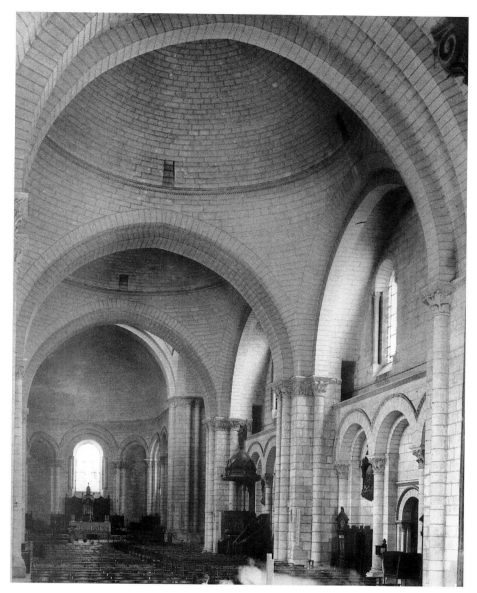

PL 188. Angoulême Cathedral, interior view, facing south-east (photo: B. Singleton)

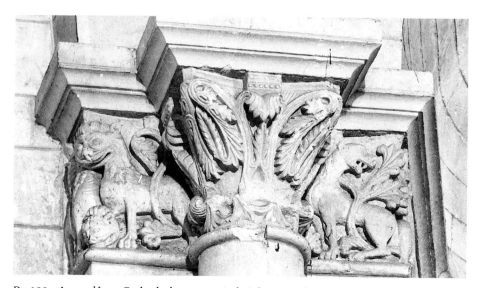

PL 189. Angoulême Cathedral, apse capitals (photo: author)

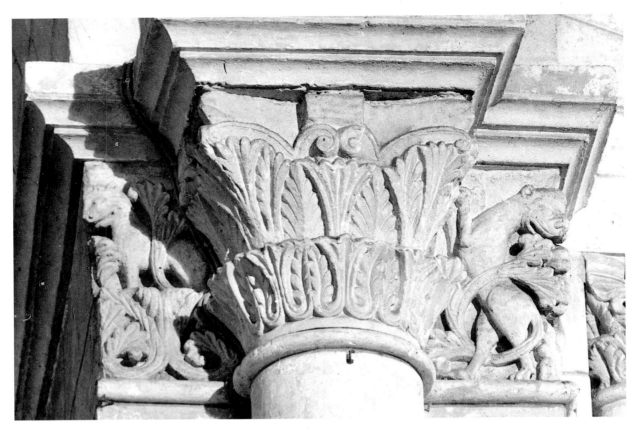

PL 190. Angoulême Cathedral, apse capitals (photo: author)

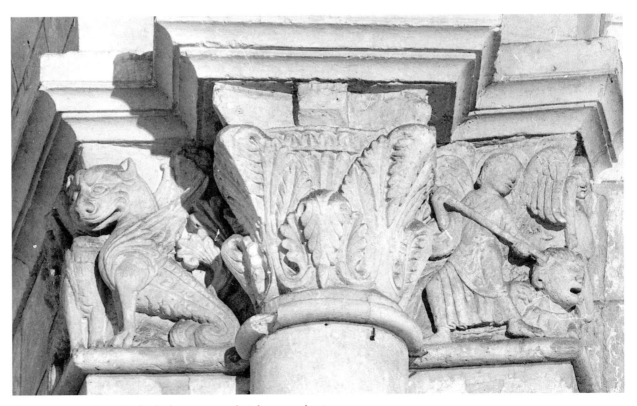

PL 191. Angoulême Cathedral, apse capitals (photo: author)

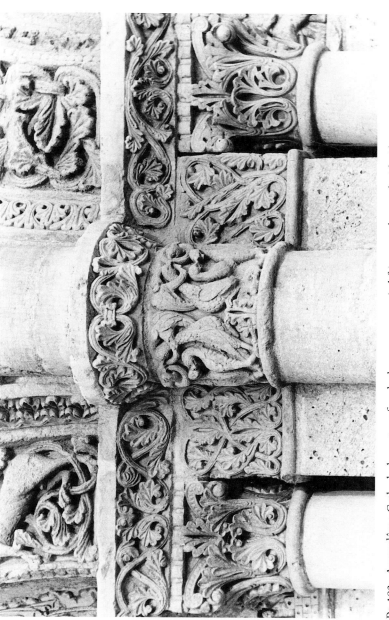

PL 192. Angoulême Cathedral, western façade, lower zone, capital-frieze on the south side (the two Corinthianesque capitals are restoration copies) (photo: author)

PL 193. Angoulême Cathedral, western façade, lower zone, frieze on the south side: chivalric themes or *Psychomachia* (photo: author)

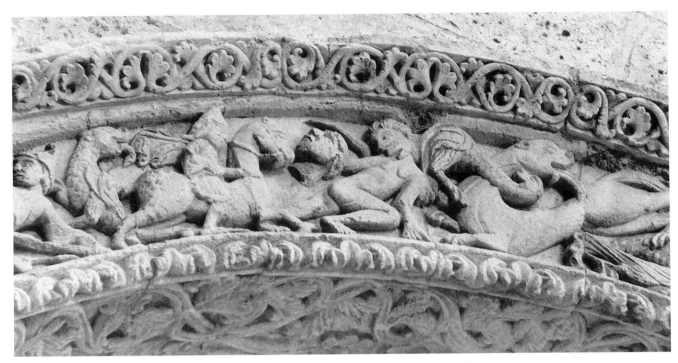

PL 194. Angoulême Cathedral, western façade, lower zone, portal archivolt (photo: author)

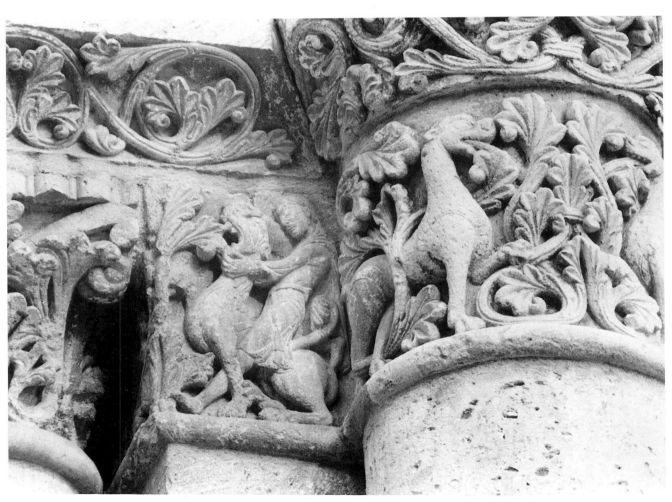

PL 195. Angoulême Cathedral, western façade, lower zone, capital-frieze on the north side: Samson (photo: author)

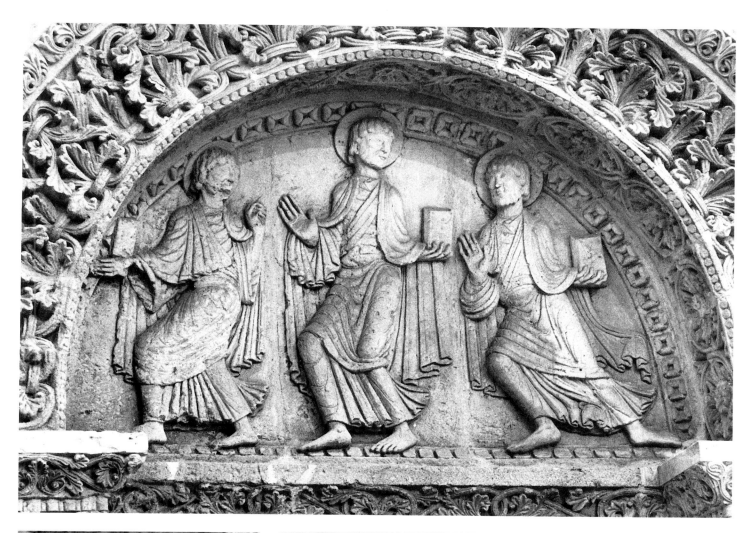

PL 196 (*above*). Angoulême Cathedral, western façade, lower zone, niche on the south side, tympanum: three Apostles (photo: author)

PL 197 (*far left*). Angoulême Cathedral, western façade, lower zone, niche on the north side, detail of tympanum: an Apostle (the head is probably restored) (photo: author)

PL 198 (*left*). Paris, Bibliothèque Mazarine, MS Lat. I, a Bible from Limoges, fo. 58ᵛ: the Prophet Jeremiah (photo: Jean-Loup Charmet)

PL 199. Angoulême Cathedral, western façade, lower zone, niche on the north side, detail of archivolt and tympanum (photo: author)

PL 200. Angoulême Cathedral, western façade, lower zone, niche on the south side, detail of archivolt and tympanum (photo: author)

PL 201. Angoulême Cathedral, western façade, lower zone, niche on the south side, detail of archivolt and tympanum (photo: author)

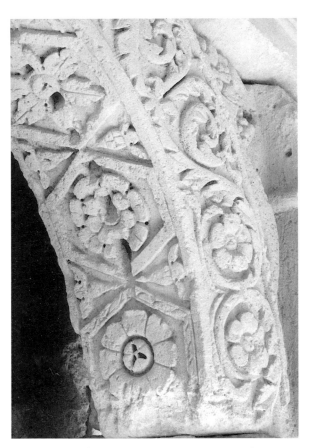

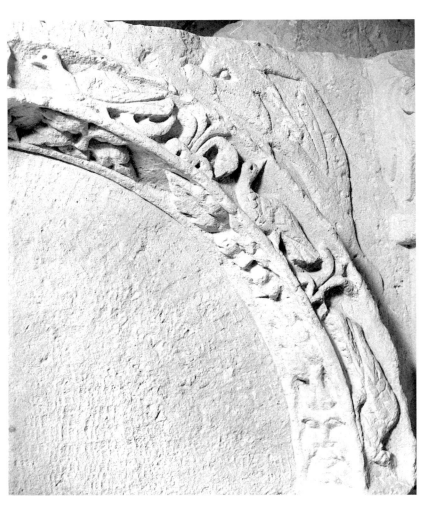

PL 202 and 203. Saintes, Musée Municipal, Roman arches (photo: author)

PL 204. Milan, Sant'Ambrogio, detail of ambo (photo: author)

PL 205 (*facing*). Chinon, Saint-Mexme, narthex façade (photo: author)

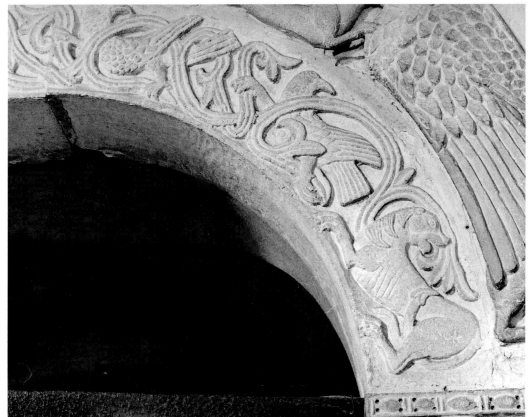

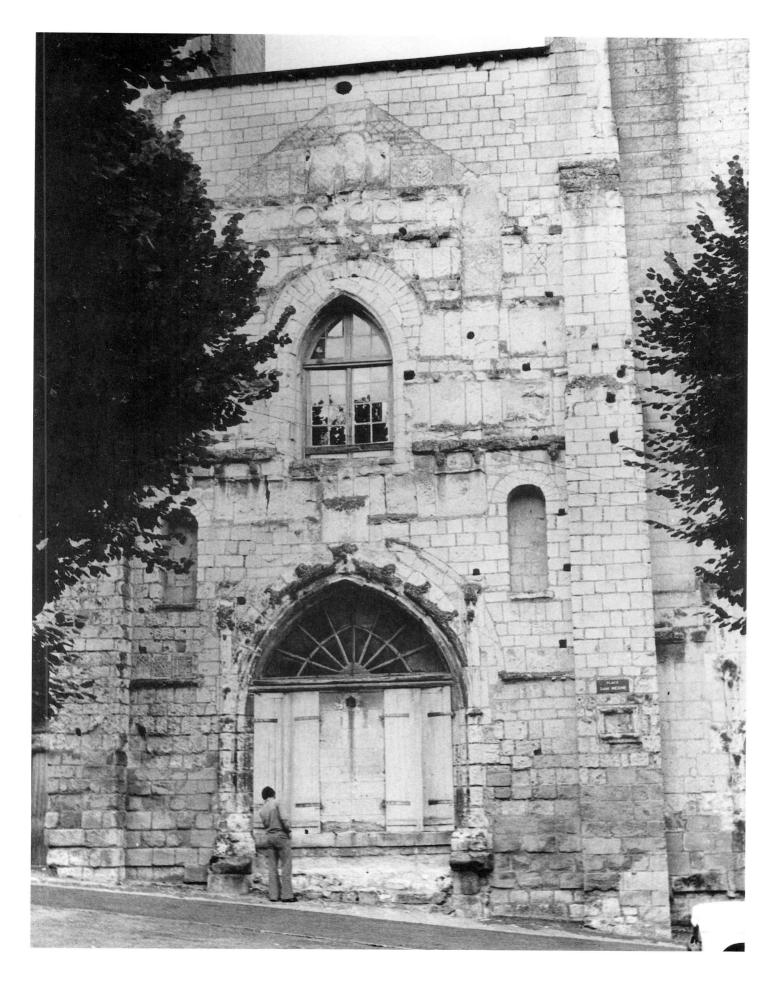

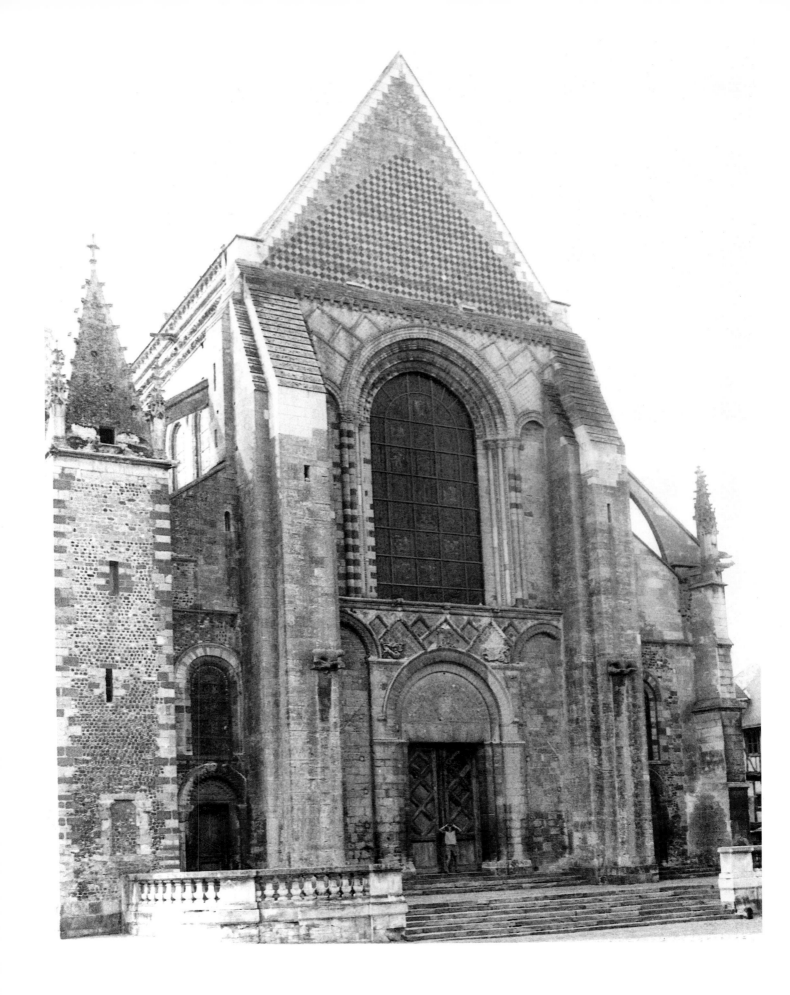

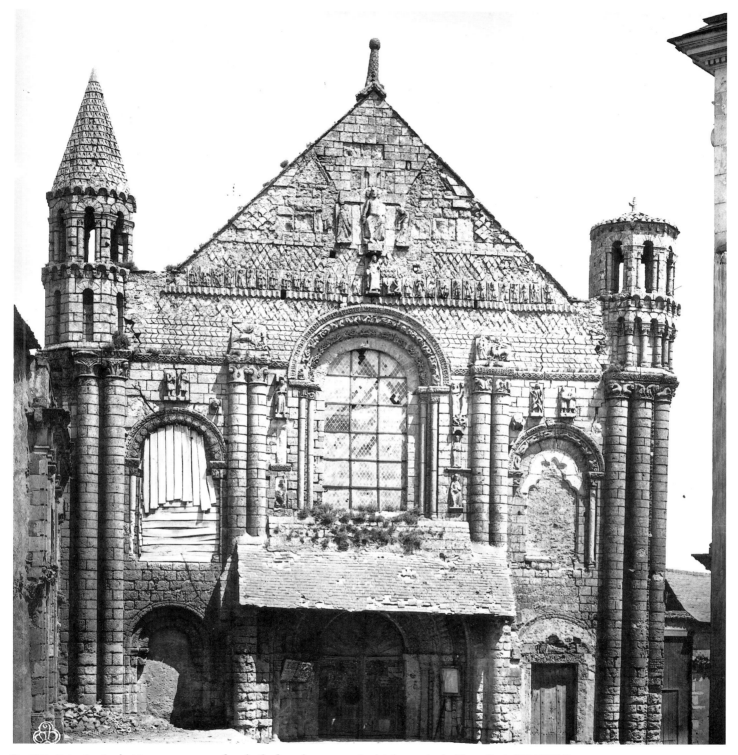

PL 207. Saint-Jouin-de-Marnes, western façade (before the restoration) (photo: Arch. Phot. Paris/SPADEM)

PL 206 (*facing*). Le Mans Cathedral, western façade (photo: author)

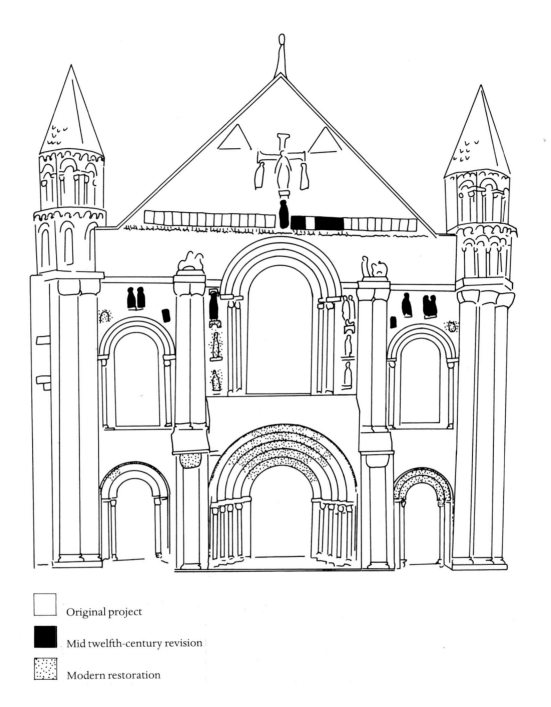

PL 208. Saint-Jouin-de-Marnes, the distribution of the sculpture on the western façade

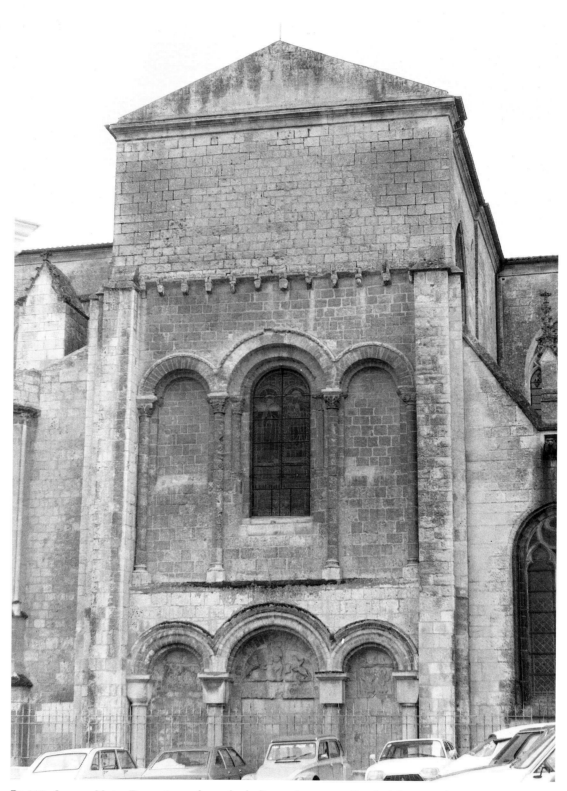

P L 209. Luçon, Notre-Dame (now the cathedral), north transept façade (photo: author)

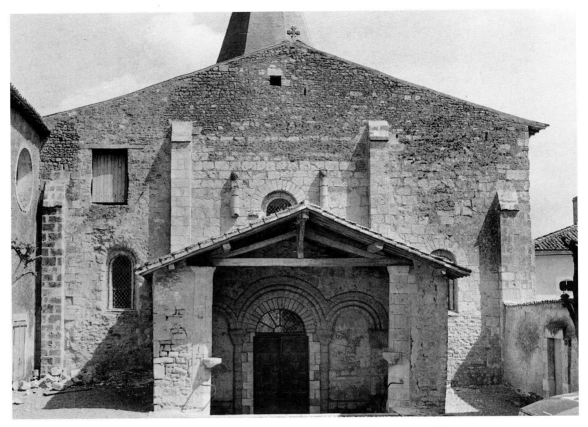

PL 210. Champdeniers, western façade (photo: author, courtesy of the Conway Library, Courtauld Institute of Art)

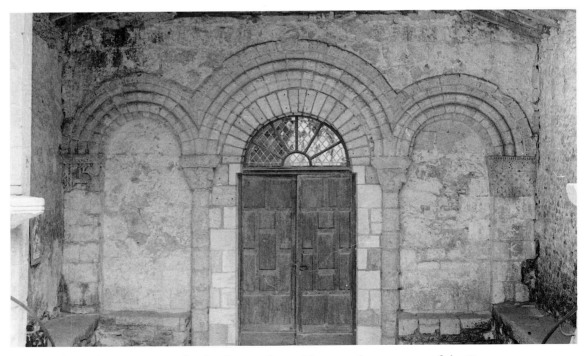

PL 211. Champdeniers, western façade, the portal area (photo: author, courtesy of the Conway Library, Courtauld Institute of Art)

PL 212 (*facing*). Angoulême Cathedral, western façade (before the restoration) (photo: Arch. Phot. Paris / SPADEM)

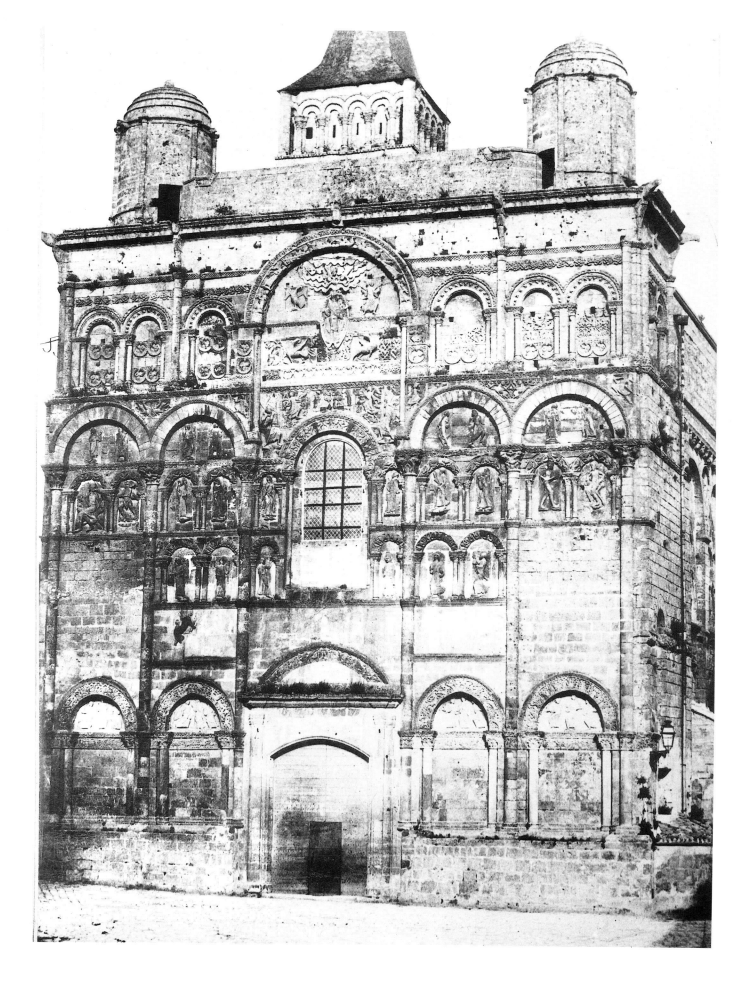

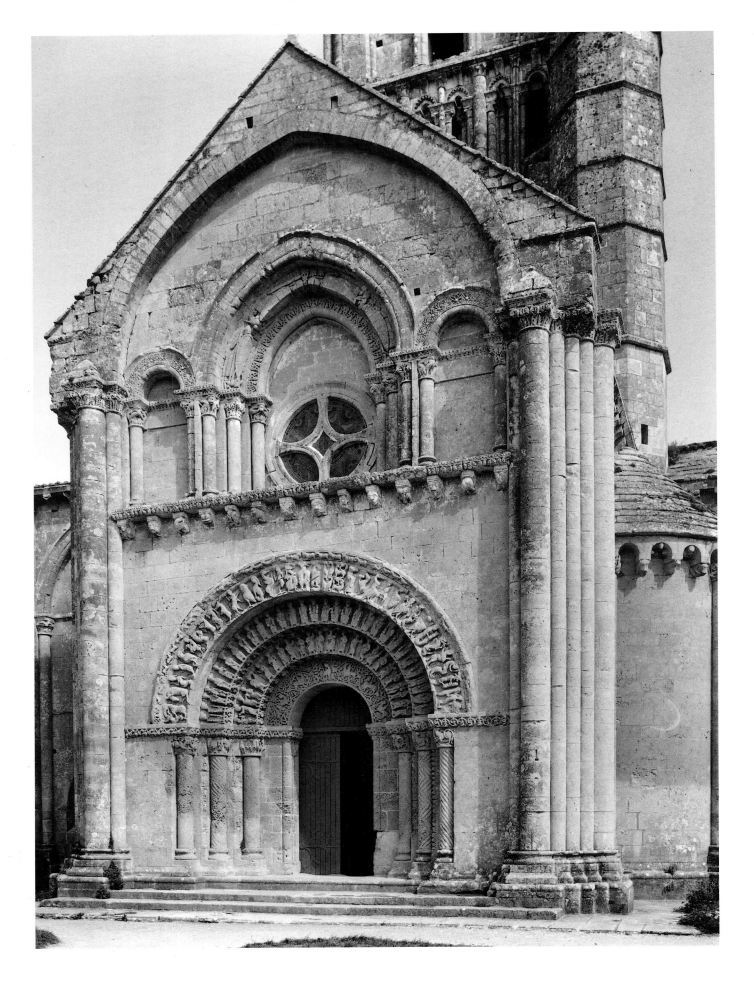

PL 213 (*facing*). Aulnay, Saint-Pierre, south transept façade (photo: James Austin)

PL 214 (*right*). Corme-Écluse, Notre-Dame, western façade (photo: author)

PL 215 (*below*). Parthenay-le-Vieux, Saint-Pierre, western façade (photo: author, courtesy of the Conway Library, Courtauld Institute of Art)

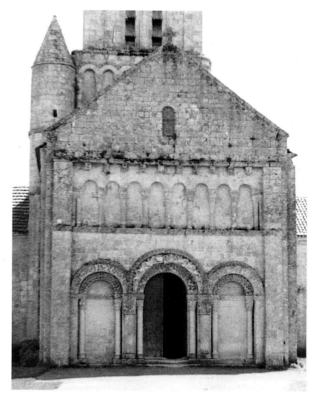

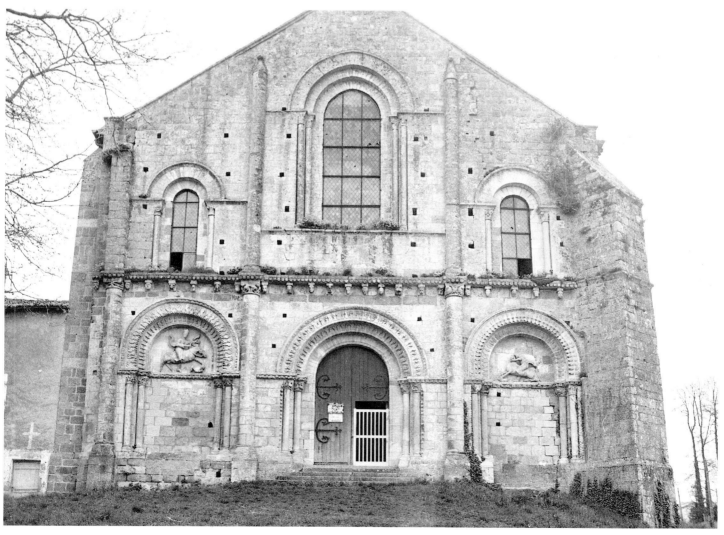

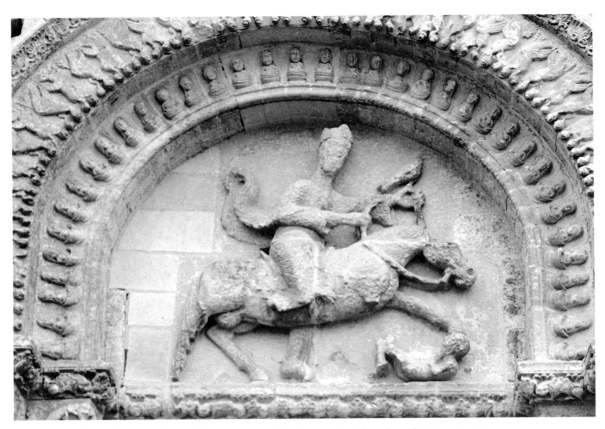

PL 216. Parthenay-le-Vieux, Saint-Pierre, western façade, north niche: the rider Constantine (photo: author, courtesy of the Conway Library, Courtauld Institute of Art)

PL 217. Parthenay-le-Vieux, Saint-Pierre, western façade, south niche: Samson (photo: author, courtesy of the Conway Library, Courtauld Institute of Art)

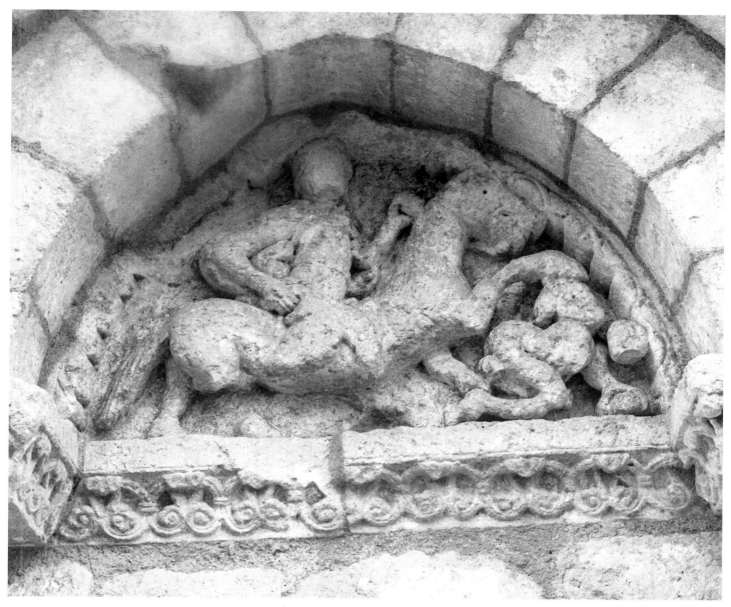

PL 218. La Rochette, western façade, north niche: the rider Constantine (photo: author)

Zone 6

Zone 5

Zone 4

Zone 3

Zone 2

Zone 1

PL 219. Angoulême Cathedral, western façade (photo: author)

P L 220. Drawing of the destroyed apse mosaic of the Lateran basilica at Rome (after Valentini 1836, by permission of the British Library)

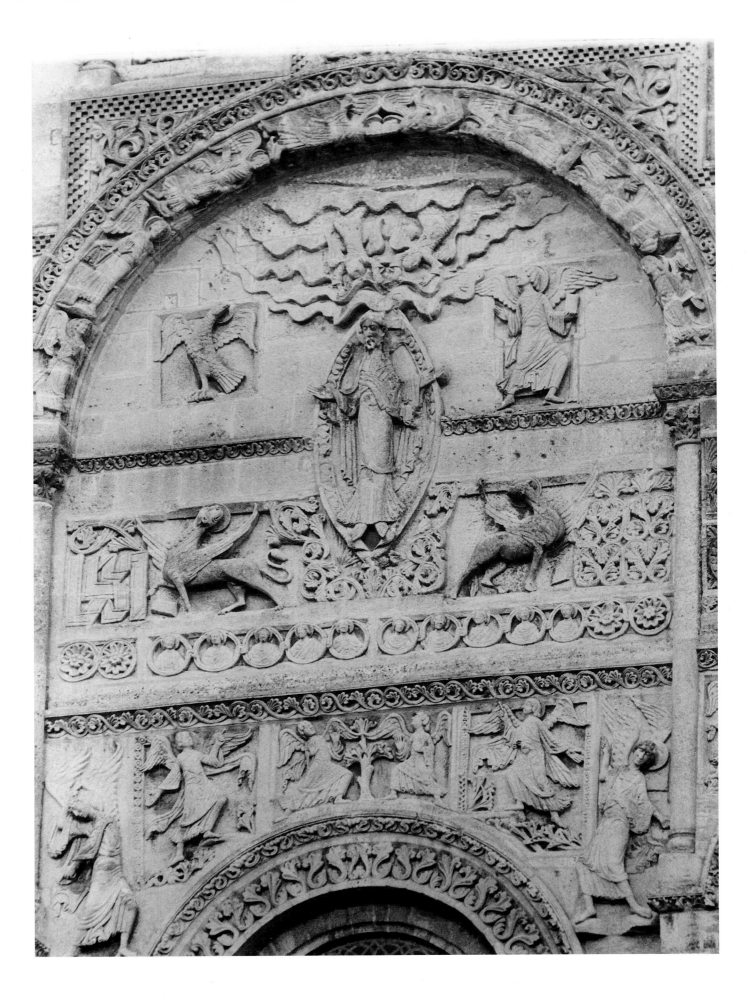

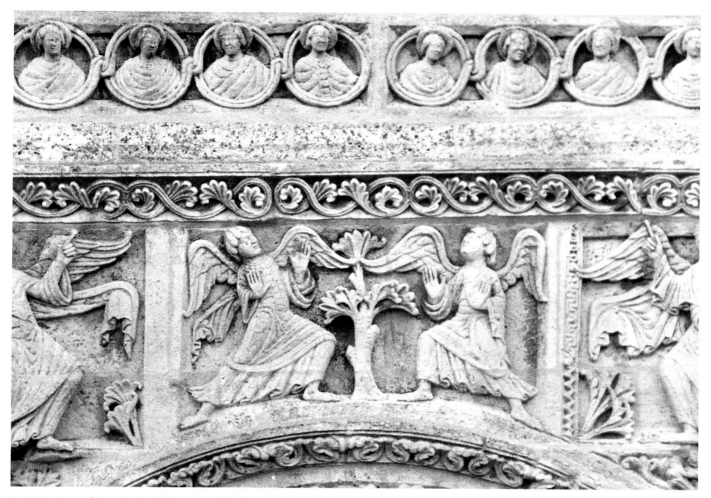

PL 222. Angoulême Cathedral, western façade, zone 5, central area: the Cross-Tree (photo: author)

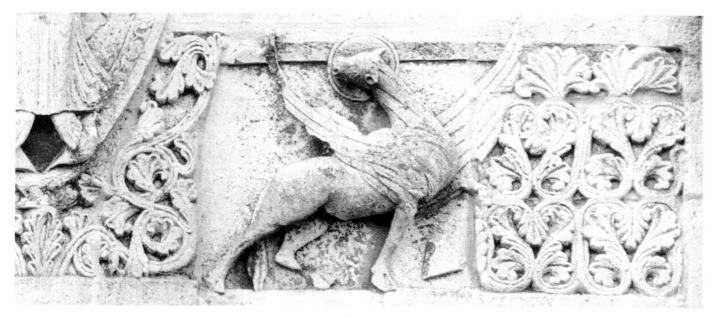

PL 223. Angoulême Cathedral, western façade, zone 6, central area: 'Vine' and a Beast of the Apocalypse (photo: author)

PL 221 (*facing*). Angoulême Cathedral, western façade, the central arch at zones 5 and 6 (photo: author)

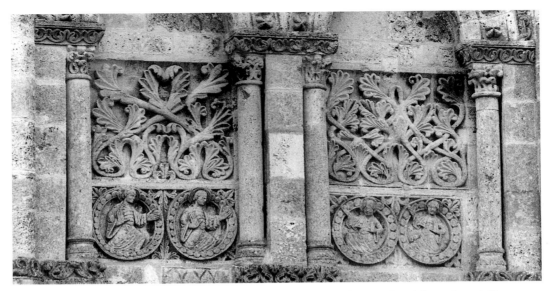

PL 224. Angoulême Cathedral, western façade, zone 6, south side: 'Vine' and figured medallions (photo: author)

PL 225. Rome, San Clemente, apse mosaic: 'Vine' with additional motifs (photo: Istituto centrale per il catalogo e la documentazione)

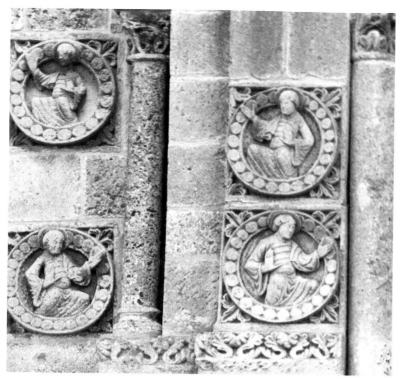

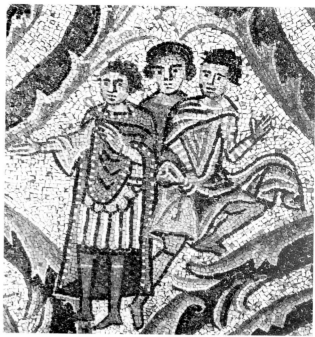

PL 226. Angoulême Cathedral, western façade, zone 6, south side: figured medallions (photo: author)

PL 227. Rome, San Clemente, apse mosaic, detail of PL 225 (photo: Istituto centrale per il catalogo e la documentazione)

PL 228. Angoulême Cathedral, western façade, zone 6, an archivolt with angels (photo: author)

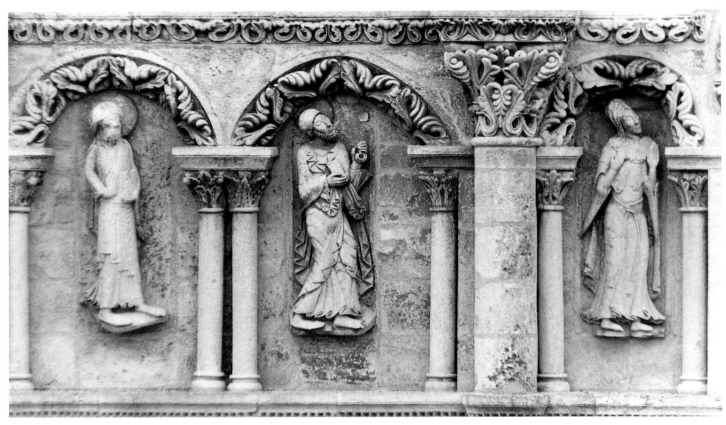

PL 229. Angoulême Cathedral, western façade, zone 4, north side: the Virgin Mary, St Peter, and another Apostle (photo: author)

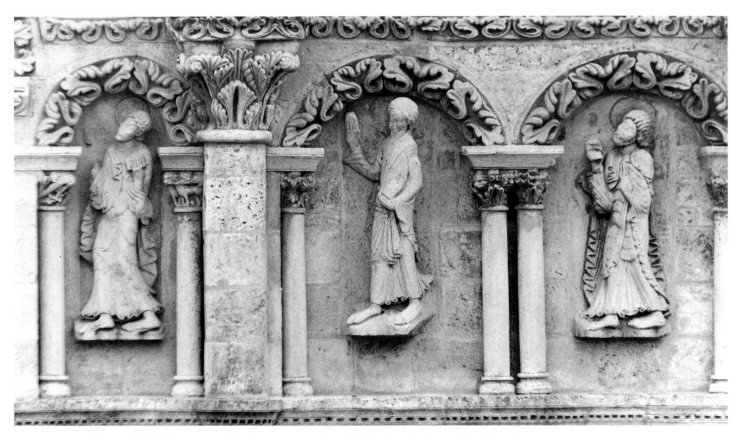

PL 230. Angoulême Cathedral, western façade, zone 4, south side: St John the Evangelist (?) and two other Apostles (photo: author)

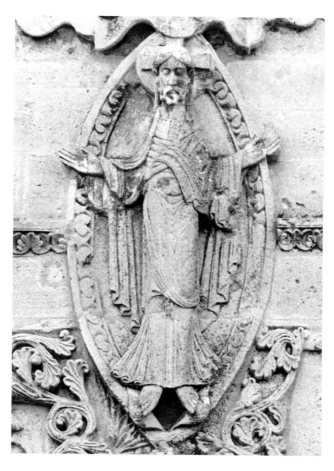

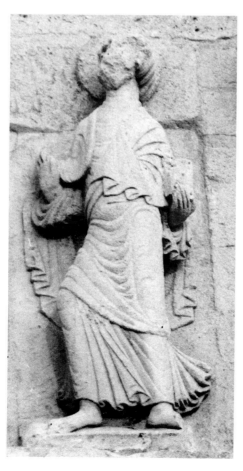

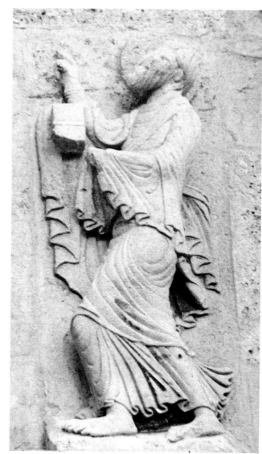

PL 234. Angoulême Cathedral, western façade, zone 3, north side: an Apostle (photo: author)

PL 235. Angoulême Cathedral, western façade, zone 4, south side: an Apostle (photo: author)

PL 236. Angoulême Cathedral, western façade, zone 4, north side: St Peter (photo: author)

PL 237. Angoulême Cathedral, western façade, zone 4, south side: St John the Evangelist (?) (photo: author)

PL 238. Angoulême Cathedral, western façade, zone 5, south side: the Elect (photo: author)

PL 239. Angoulême Cathedral, western façade, zone 4, north side: a hell scene (photo: author)

PL 240. Angoulême Cathedral, western façade, zone 4: another view of the hell scene in PL 239 (photo: author)

PL 241. Angoulême Cathedral, western façade, zone 2, north side: a figure from a hell scene (the head and the adjacent rider are nineteenth-century fakes) (photo: author)

PL 242. Angoulême, Musée de la Cathédrale, a lion from the cathedral (photo: author)

PL 243. Angoulême, Musée de la Cathédrale, another view of the lion in PL 242 (photo: author)

PL 244. Angoulême, Musée de la Société Archéologique et Historique de la Charente, Roman lion (photo: author)

PL 245. Angoulême, Musée de la Société Archéologique et Historique de la Charente, another view of the lion in PL 244 (photo: author)

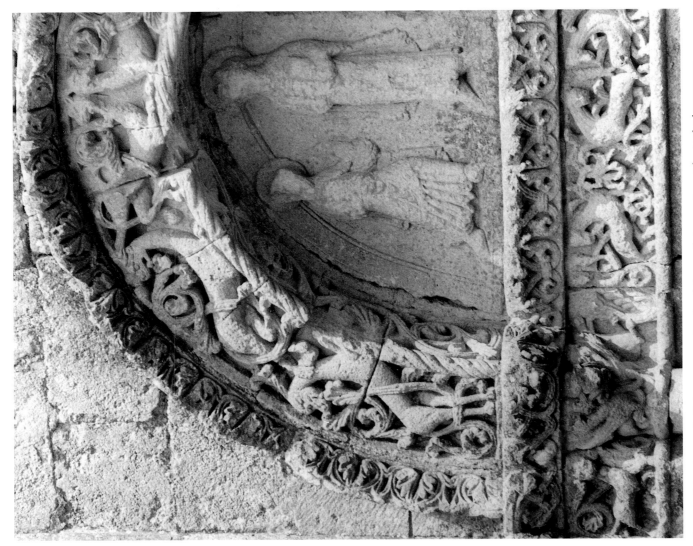

PL 247. Saint-Amant-de-Boixe, western façade of the north transept, a niche in the lower zone (photo: author)

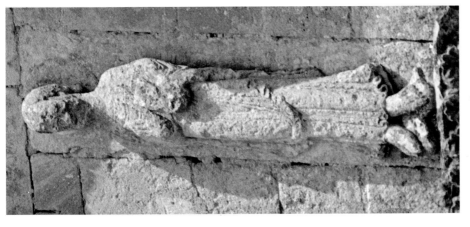

PL 246. Saint-Amant-de-Boixe, western façade of the north transept, a saint in the upper zone (photo: author)

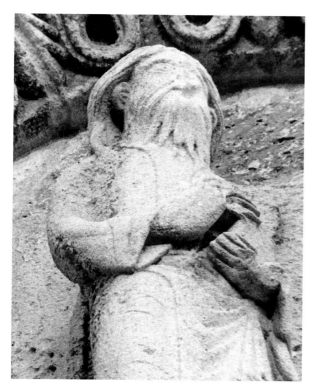

PL 248 (*left*). Angoulême Cathedral, western façade, zone 3, north side, detail of an Apostle (photo: author)

PL 249 (*below*). Parthenay-le-Vieux, Saint-Pierre, western façade, north niche, detail of the rider Constantine (photo: author)

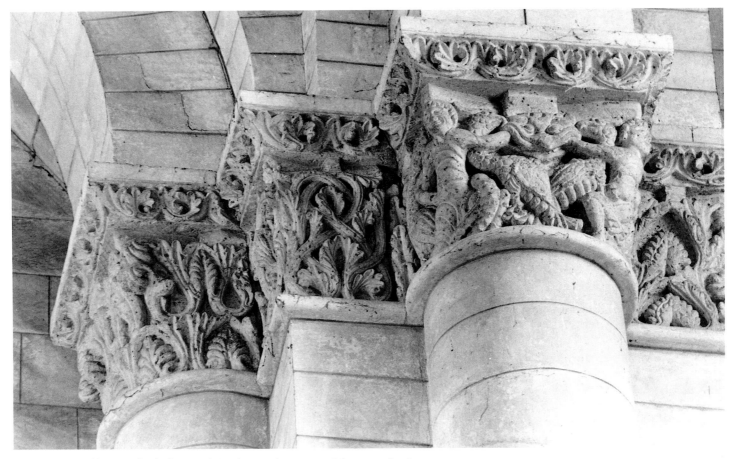

PL 250. Angoulême Cathedral, capitals in the north transept (photo: author)

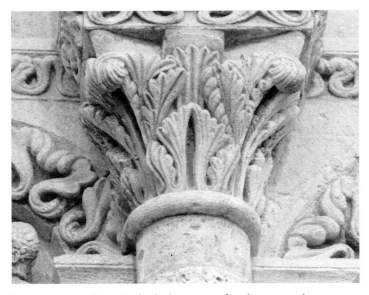

PL 251. Angoulême Cathedral, western façade, a capital in zone 4 (photo: author)

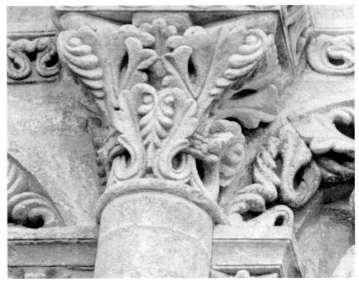

PL 252. Angoulême Cathedral, western façade, a capital in zone 4 (photo: author)

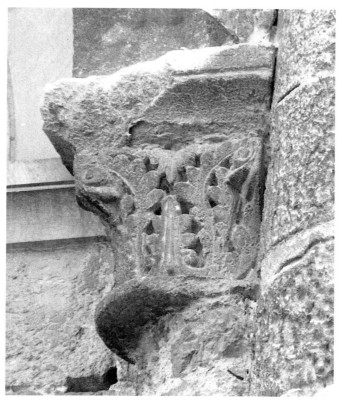

PL 253. Saintes, Abbaye aux Dames, a capital on the exterior of the apse (photo: author)

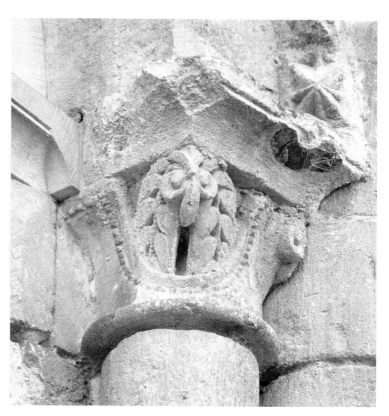

PL 254. Saintes, Abbaye aux Dames, a capital on the exterior of the apse (photo: author)

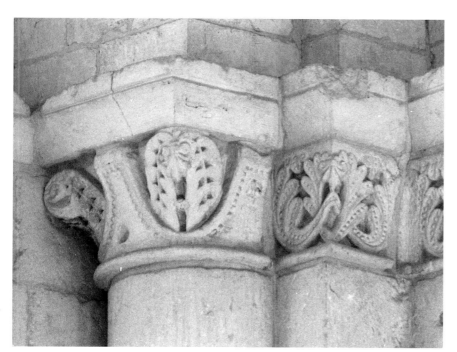

PL 255. Saintes, Abbaye aux Dames, pier in the nave, capitals (photo: author)

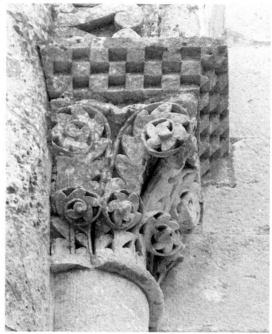

PL 256. Saintes, Abbaye aux Dames, western façade, a capital in the upper zone (photo: author)

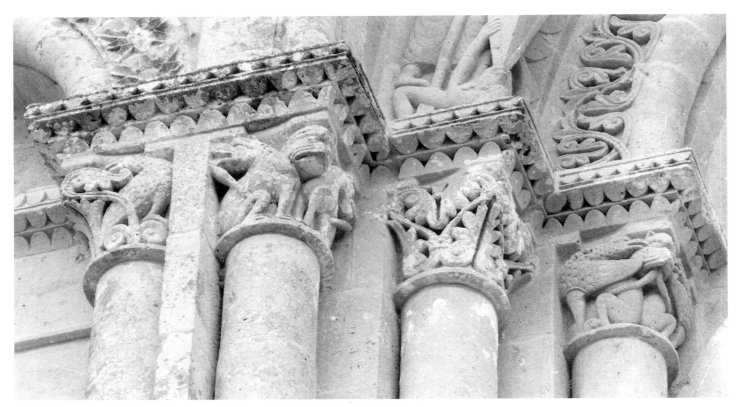

P L 257. Aulnay, Saint-Pierre, south transept façade, capitals in the upper zone (photo: author)

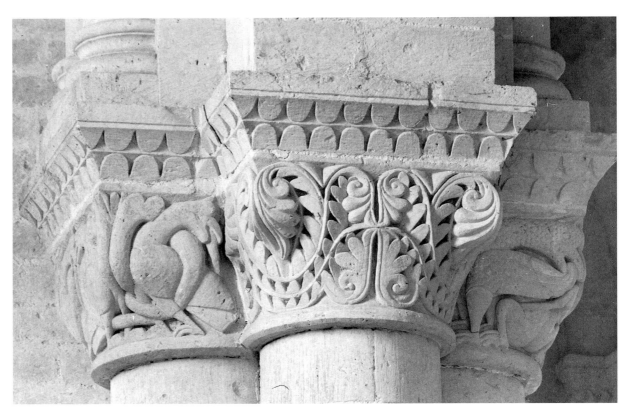

P L 258. Aulnay, Saint-Pierre, nave, capitals in the south arcade (photo: author)

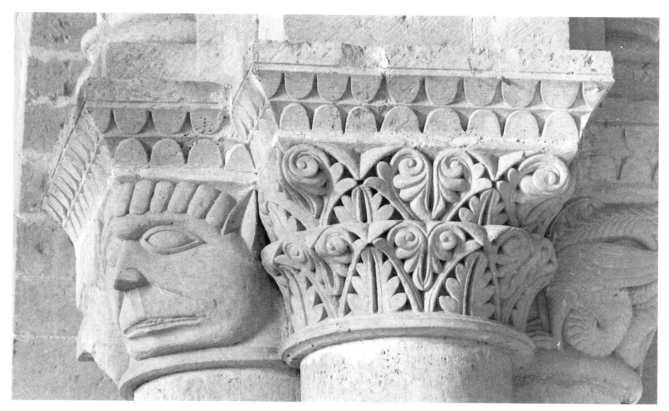

PL 259. Aulnay, Saint-Pierre, nave, capitals in the south arcade (photo: author)

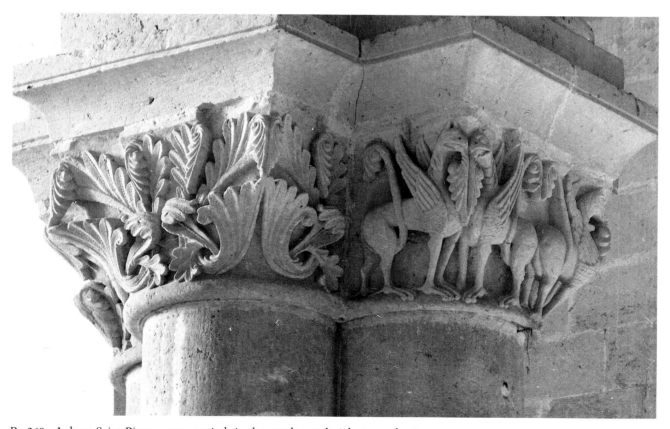

PL 260. Aulnay, Saint-Pierre, nave, capitals in the south arcade (photo: author)

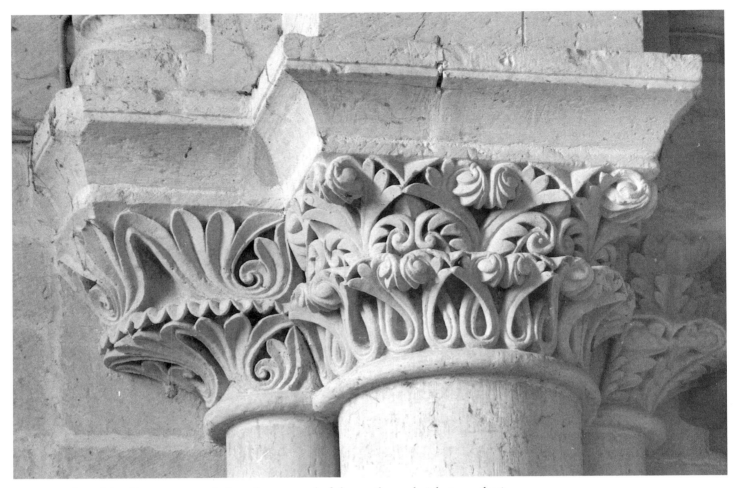

PL 261. Aulnay, Saint-Pierre, nave, capitals at the west end of the south arcade (photo: author)

PL 262. Aulnay, Saint-Pierre, western façade, portal hood (photo: author)

PL 263. Aulnay, Saint-Pierre, western façade, frieze in the south niche (photo: author)

PL 264. Aulnay, Saint-Pierre, western façade, archivolts in the south niche (photo: James Austin)

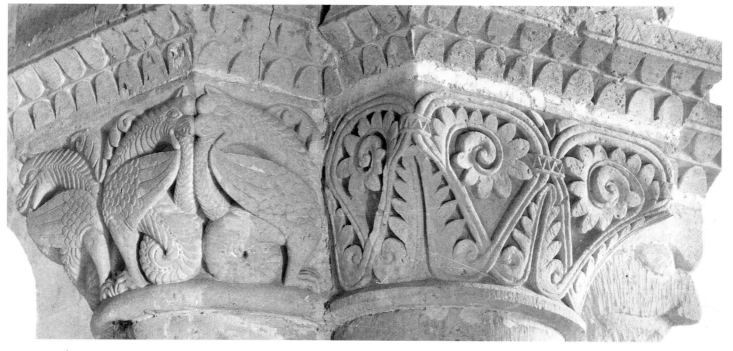

PL 265. Aulnay, Saint-Pierre, nave, capitals in the south arcade (photo: author)

PL 266. Aulnay, Saint-Pierre, nave, capitals in the south arcade (photo: author)

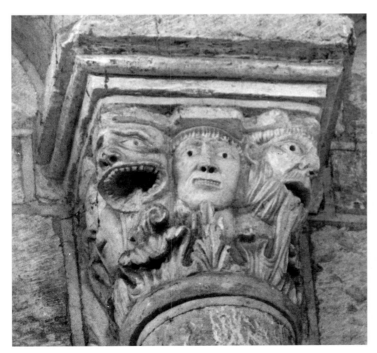

PL 267. Saint-Benoît-sur-Loire, choir, capital in the blind triforium (photo: James Austin)

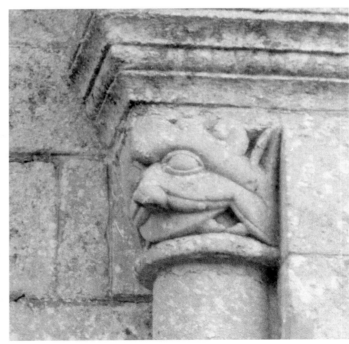

PL 268. Aulnay, Saint-Pierre, north side of the nave, exterior window capital (photo: author)

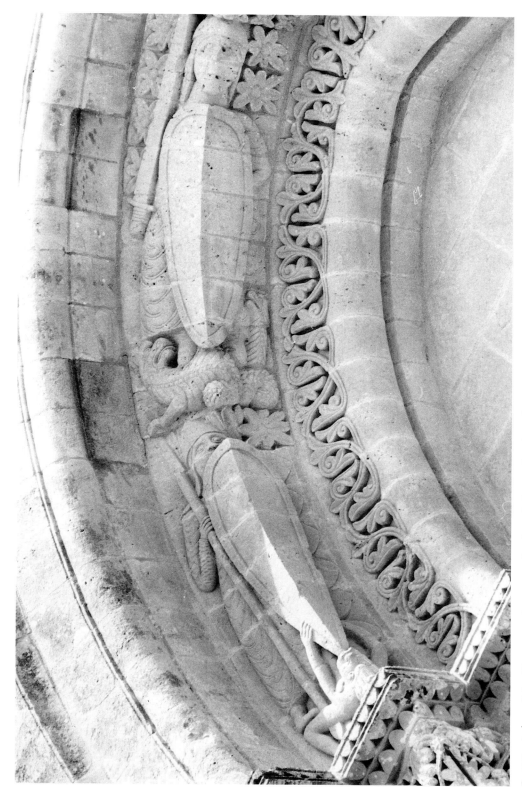

PL 269. Aulnay, Saint-Pierre, south transept façade, window archivolt in the upper zone: Virtues and Vices (photo: author)

PL 270. Saint-Jouin-de-Marnes, chevet, interior view (photo: author, courtesy of the Conway Library, Courtauld Institute of Art)

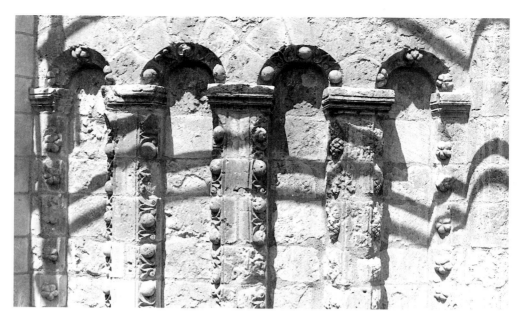

PL 271 (*right*). Saint-Jouin-de-Marnes, chevet, exterior dado arcading of the south chapel (photo: author, courtesy of the Conway Library, Courtauld Institute of Art)

PL 272 (*below, left*). Fontevrault, abbey church, chevet, exterior buttress (photo: author)

PL 273 (*below, centre*). Saint-Jouin-de-Marnes, chevet, detail of exterior dado arcade (photo: author, courtesy of the Conway Library, Courtauld Institute of Art)

PL 274 (*below, right*). Jazeneuil, apse, detail of exterior dado arcade (photo: author, courtesy of the Conway Library, Courtauld Institute of Art)

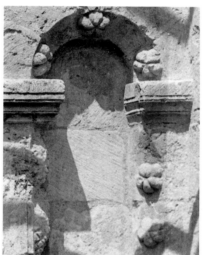
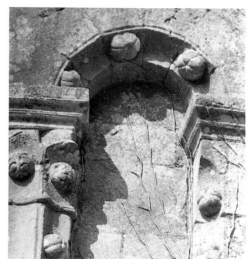

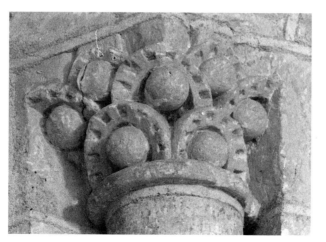
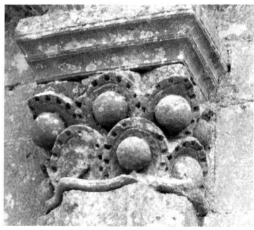

PL 275. Saint-Jouin-de-Marnes, chevet, capital in the central ambulatory chapel (photo: author, courtesy of the Conway Library, Courtauld Institute of Art)

PL 276. Jazeneuil, apse, capital in the exterior dado arcade (photo: author, courtesy of the Conway Library, Courtauld Institute of Art)

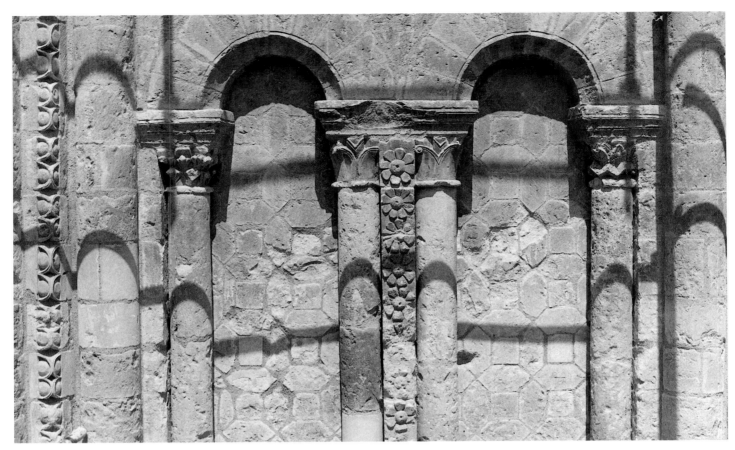

PL 277. Saint-Jouin-de-Marnes, chevet, exterior dado arcading of the ambulatory wall (photo: author, courtesy of the Conway Library, Courtauld Institute of Art)

PL 278. Saint-Jouin-de-Marnes, chevet, capital in the ambulatory (photo: author, courtesy of the Conway Library, Courtauld Institute of Art)

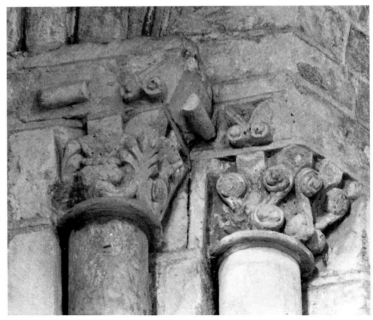

PL 279. Saint-Jouin-de-Marnes, chevet, capitals in the ambulatory (photo: author, courtesy of the Conway Library, Courtauld Institute of Art)

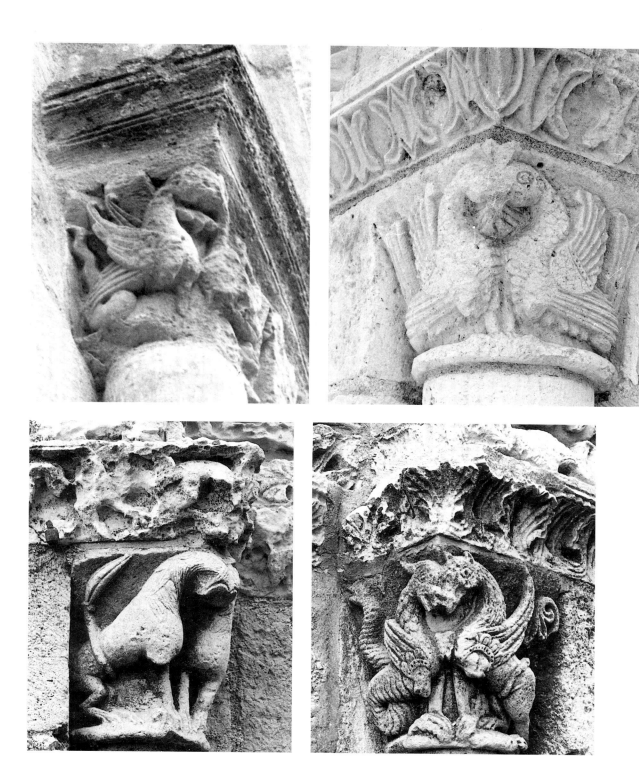

PL 280 (*top, left*). Saint-Jouin-de-Marnes, chevet, exterior of the north chapel, window capital (photo: author, courtesy of the Conway Library, Courtauld Institute of Art)

PL 281 (*top, right*). Bonnes, capital in the west portal (photo: author, courtesy of the Conway Library, Courtauld Institute of Art)

PL 282 (*above, left*). Champagné-Saint-Hilaire, capital in the west portal (photo: author, courtesy of the Conway Library, Courtauld Institute of Art)

PL 283 (*above, right*). Champagné-Saint-Hilaire, capital in the west portal (photo: author, courtesy of the Conway Library, Courtauld Institute of Art)

PL 284. Poitiers, Notre-Dame-la-Grande, western façade (photo: Arch. Phot. Paris/SPADEM)

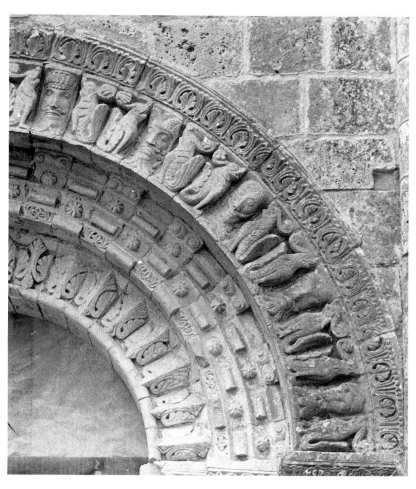

PL 285. Poitiers, Notre-Dame-la-Grande, western façade, archivolts in the north niche (photo: author, courtesy of the Conway Library, Courtauld Institute of Art)

PL 286 (*above, right*). Villesalem, portal on the north side of the nave, archivolts (photo: author, courtesy of the Conway Library, Courtauld Institute of Art)

PL 287 (*left*). Poitiers, Notre-Dame-la-Grande, western façade, portal archivolts (photo: author, courtesy of the Conway Library, Courtauld Institute of Art)

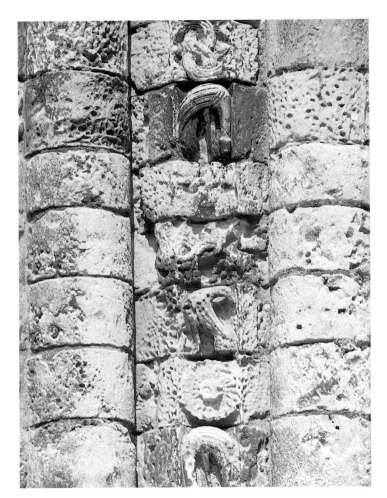

PL 288 (*right*). Poitiers, Notre-Dame-la-Grande, western façade, nook-motifs on the south buttress (photo: author, courtesy of the Conway Library, Courtauld Institute of Art)

PL 289 (*below*). Poitiers, Notre-Dame-la-Grande, western façade, capitals and archivolts in the upper zone (photo: G. Zarnecki, courtesy of the Conway Library, Courtauld Institute of Art)

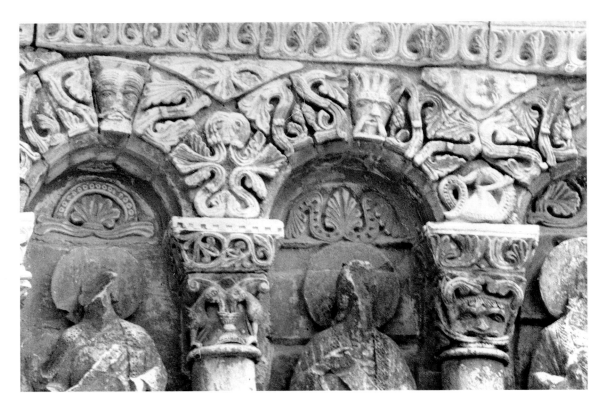

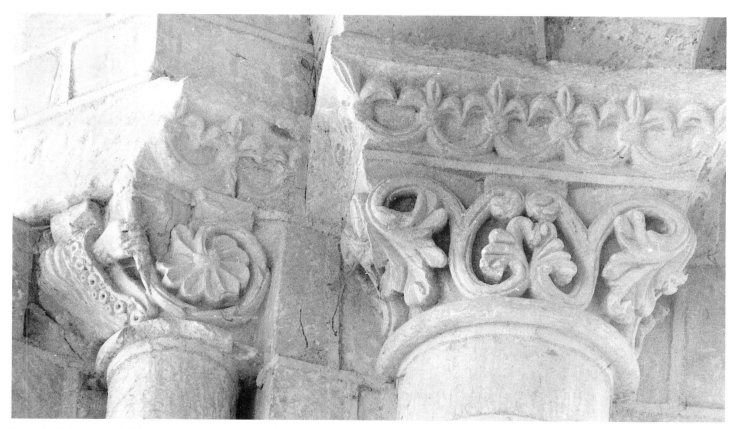

PL 290. Saint-Jouin-de-Marnes, chevet, capitals in the south chapel (photo: author, courtesy of the
Conway Library, Courtauld Institute of Art)

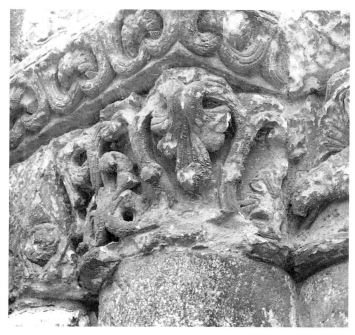

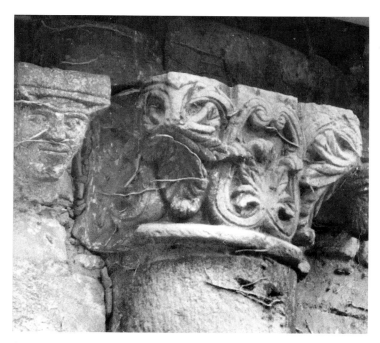

PL 291. Poitiers, Notre-Dame-la-Grande, western façade, capital
in the lower zone (photo: author, courtesy of the Conway
Library, Courtauld Institute of Art)

PL 292. Poitiers, Saint-Germain, apse capital (photo: author)

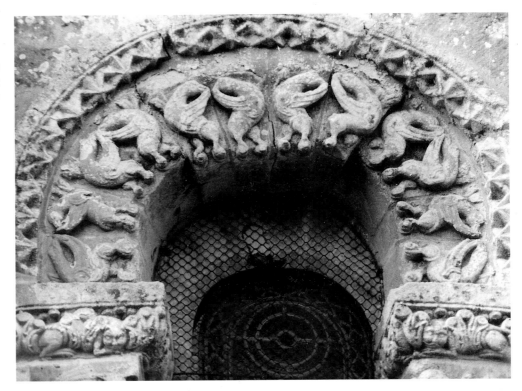

PL 293. Vouvant, north transept
chapel, window archivolt
(photo: author)

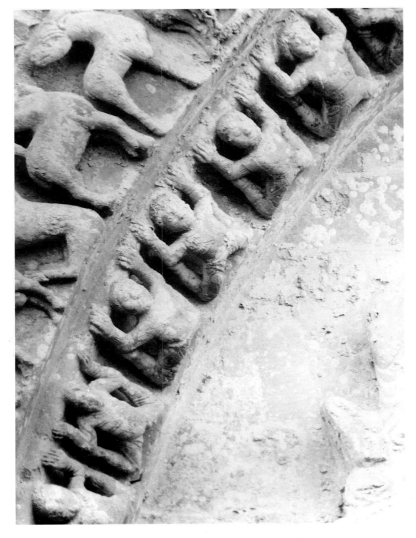

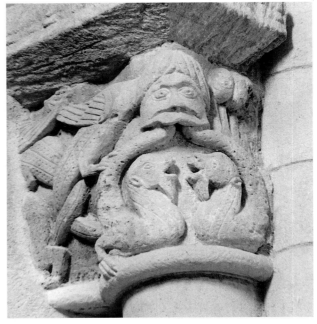

PL 294 (*left*). Vouvant, north transept façade, portal
archivolt (photo: author)

PL 295 (*above*). Marestay (Matha), crossing capital
(photo: author)

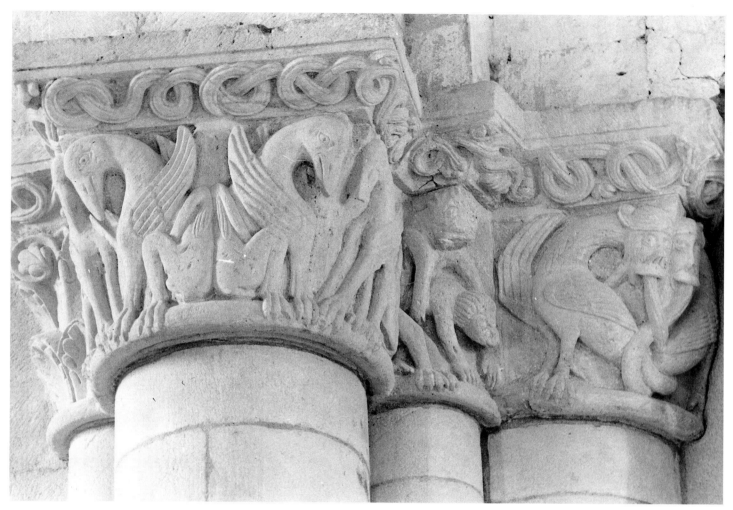

PL 296. Marestay (Matha), crossing capitals (photo: author)

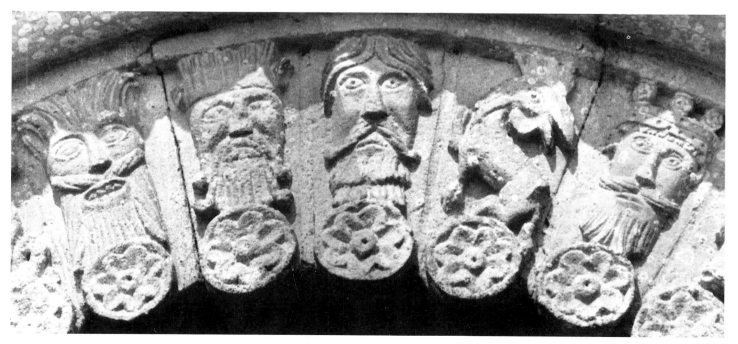

PL 297. Marestay (Matha), apse, archivolt of the central window (photo: author)

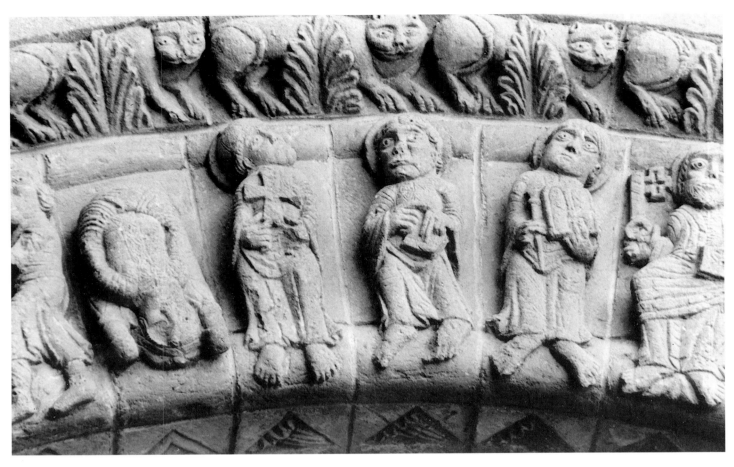

PL 298 (*above*). Foussais, western façade, portal
archivolt (photo: author)

PL 299 (*right*). Foussais, western façade, nook-
motifs in the portal jamb (photo: author)

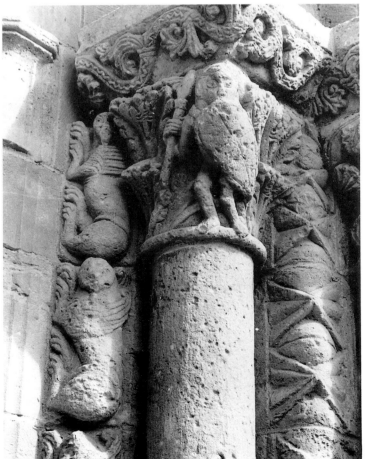

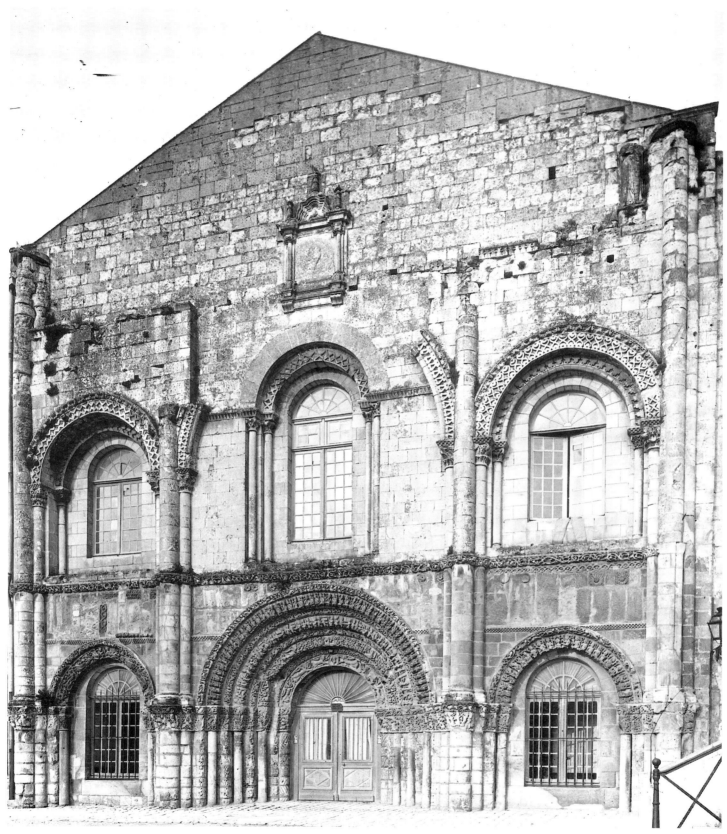

PL 300. Saintes, Abbaye aux Dames, western façade (before the restoration) (photo: Arch. Phot.
Paris/SPADEM)

PL 301. Saintes, Abbaye aux Dames, interior view of the nave, facing west (photo: author)

PL 302. Saintes, Abbaye aux Dames, western façade, spandrel area of the lower zone, south side
(photo: author)

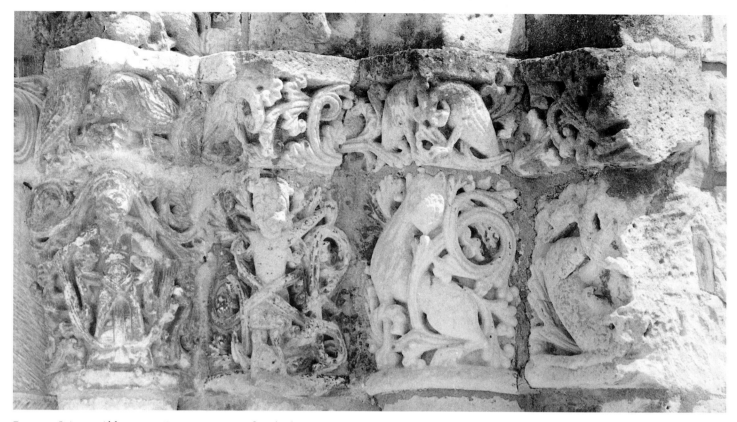

PL 303. Saintes, Abbaye aux Dames, western façade, lower zone, capital-frieze on the south side (photo: author)

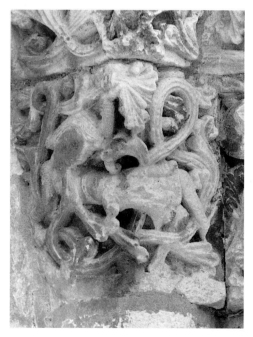

PL 304. Saintes, Abbaye aux Dames, western façade, lower zone, detail of the capital-frieze (photo: author)

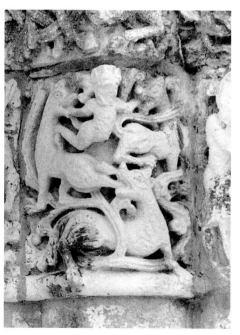

PL 305. Saintes, Abbaye aux Dames, western façade, lower zone, detail of the capital-frieze (photo: author)

PL 306. Saintes, Abbaye aux Dames, western façade, lower zone, detail of the capital-frieze (photo: author)

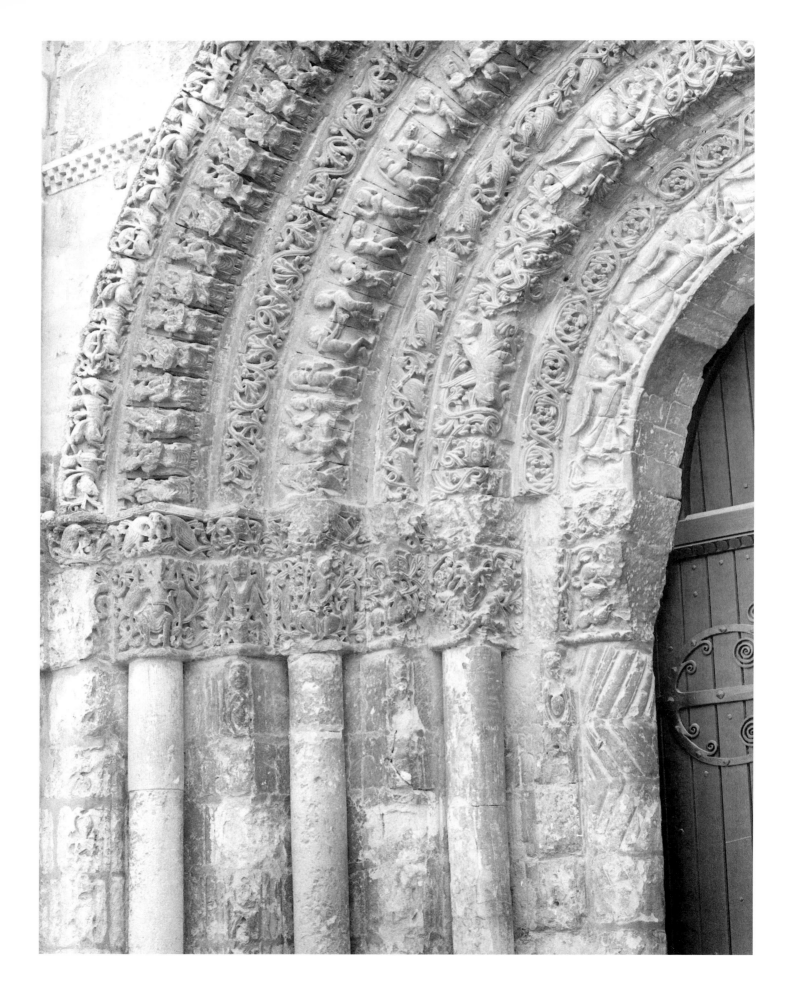

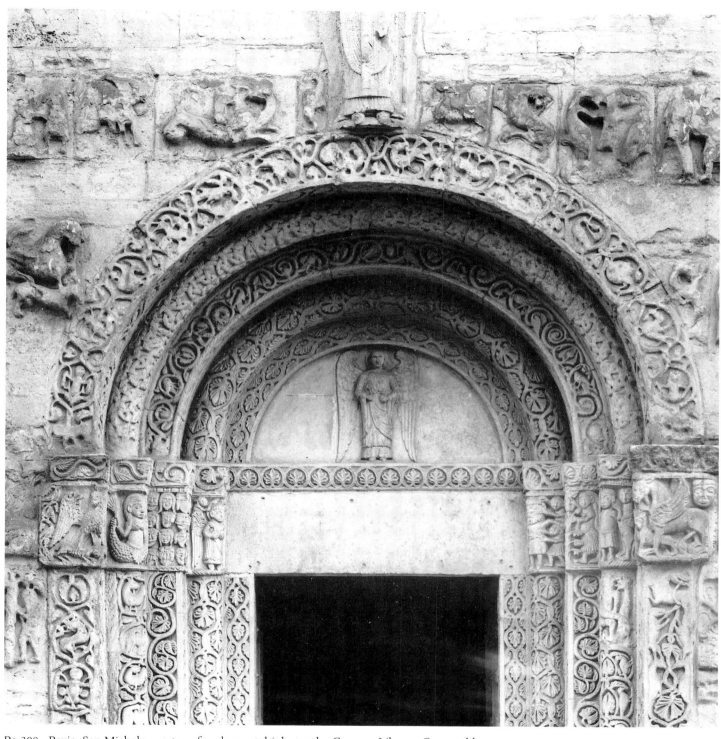

PL 308. Pavia, San Michele, western façade, portal (photo: the Conway Library, Courtauld Institute of Art)

PL 307 (*facing*). Saintes, Abbaye aux Dames, western façade, portal (photo: author)

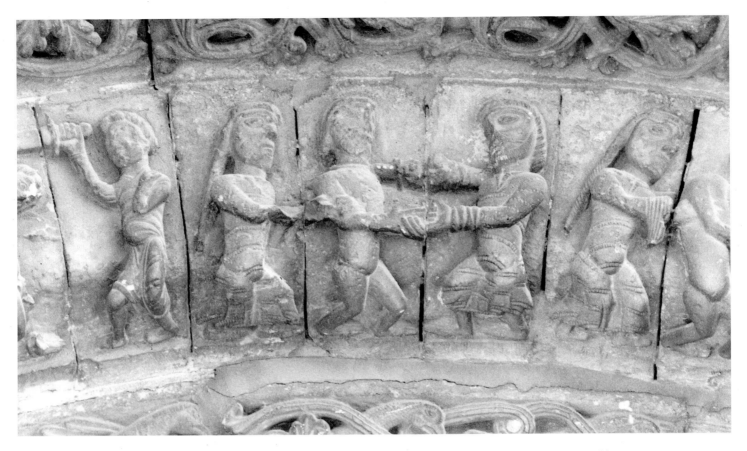

PL 309 (*above*). Saintes, Abbaye aux Dames, western façade, lower zone, voussoirs in the portal (photo: author)

PL 310 (*left*). Saintes, Abbaye aux Dames, western façade, lower zone, voussoirs in the south niche (photo: author)

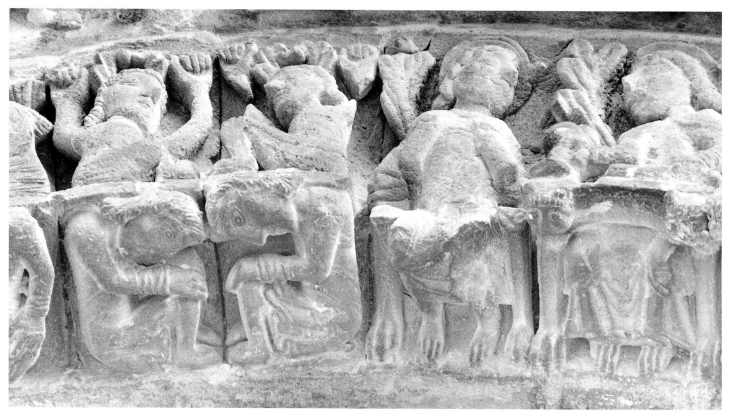

PL 311. Saintes, Abbaye aux Dames, western façade, lower zone, voussoirs in the south niche
(photo: author)

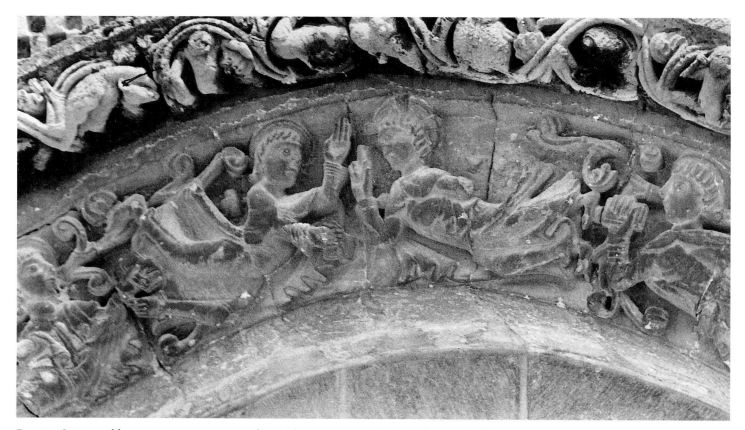

PL 312. Saintes, Abbaye aux Dames, western façade, lower zone, archivolt of the north niche
(photo: author)

PL 313. Saintes, Abbaye aux Dames, western façade, lower zone, archivolt of the north niche (photo: author)

PL 314. Saintes, Abbaye aux Dames, western façade, lower zone, hood of the south niche (photo: author)

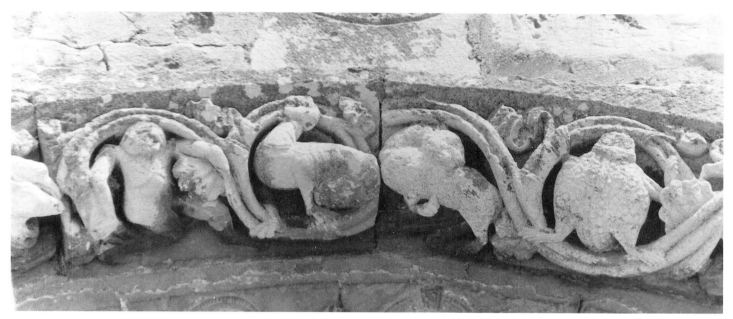

PL 315. Saintes, Abbaye aux Dames, western façade, lower zone, hood of the north niche (photo: author)

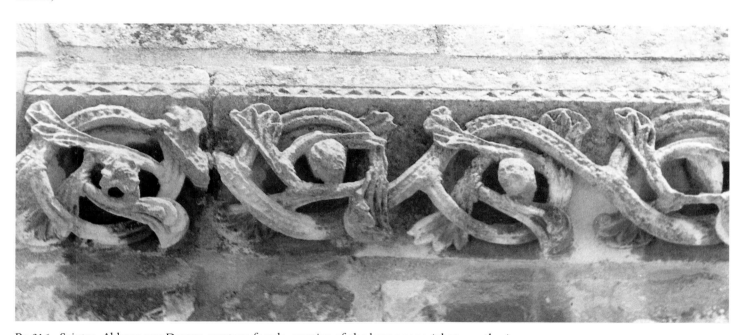

PL 316. Saintes, Abbaye aux Dames, western façade, cornice of the lower zone (photo: author)

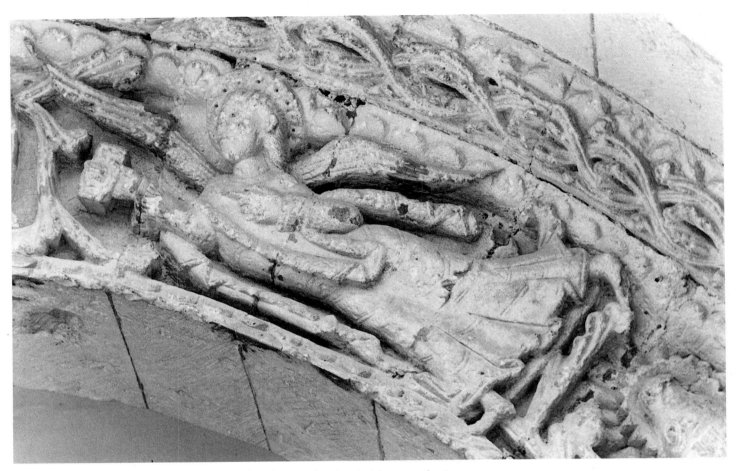

PL 317. Châteauneuf-sur-Charente, western façade, portal archivolt (photo: author)

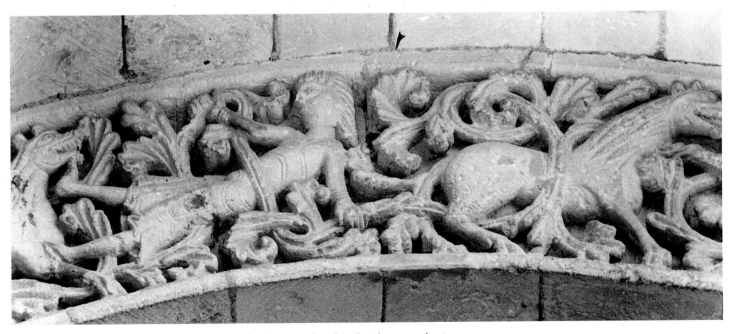

PL 318. Châteauneuf-sur-Charente, western façade, portal archivolt (photo: author)

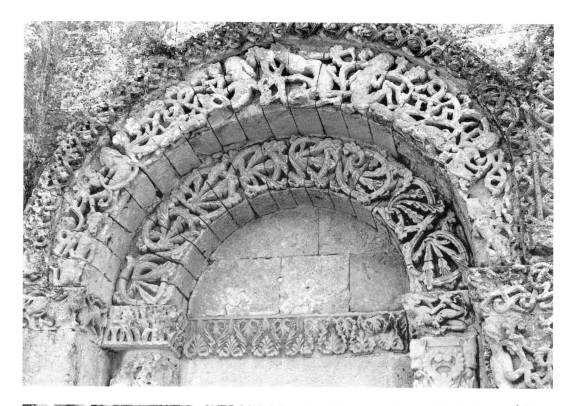

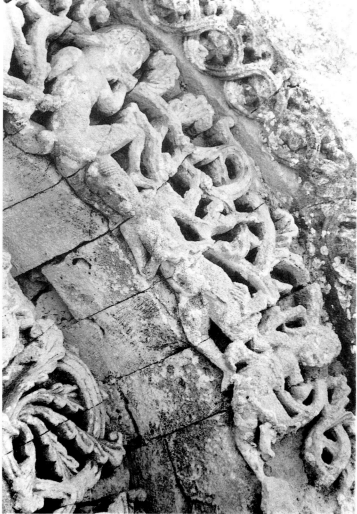

PL 319 (*above*). Corme-Écluse, Notre-Dame, western façade, north niche (photo: author)

PL 320 (*left*). Corme-Écluse, Notre-Dame, western façade, detail of PL 319 (photo: author)

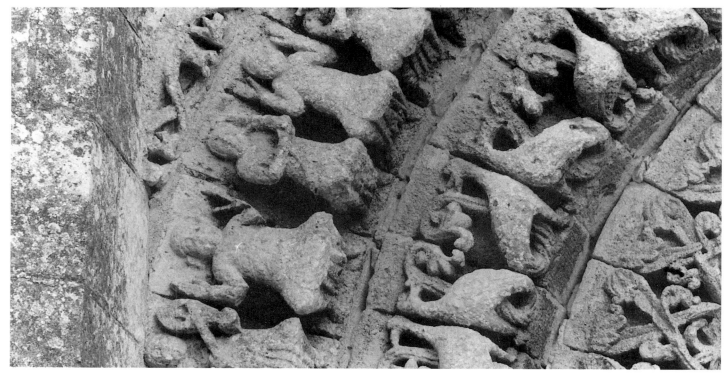

PL 321 (*above*). Saint-Symphorien, western façade, portal archivolts (photo: the Conway Library, Courtauld Institute of Art)

PL 322 (*below*). Maillezais, Saint-Nicolas, western façade, portal archivolt (photo: author)

PL 323 (*right*). Maillezais, Saint-Nicolas, western façade, nook-motifs in the portal jamb (photo: author)

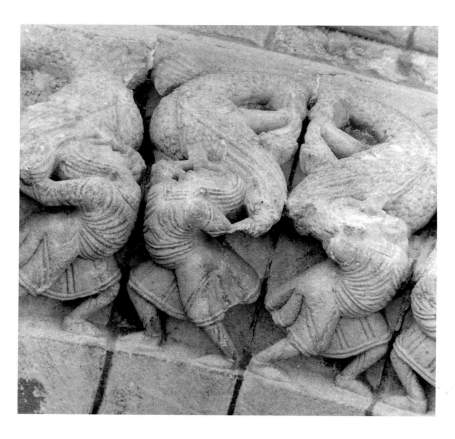

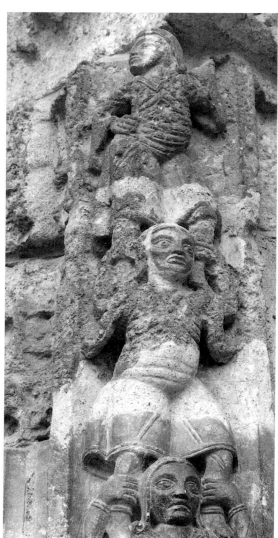

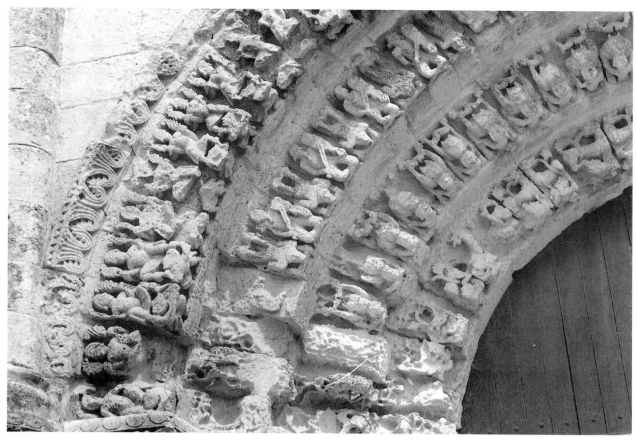

PL 324. Maillé, western façade, portal archivolts (photo: author)

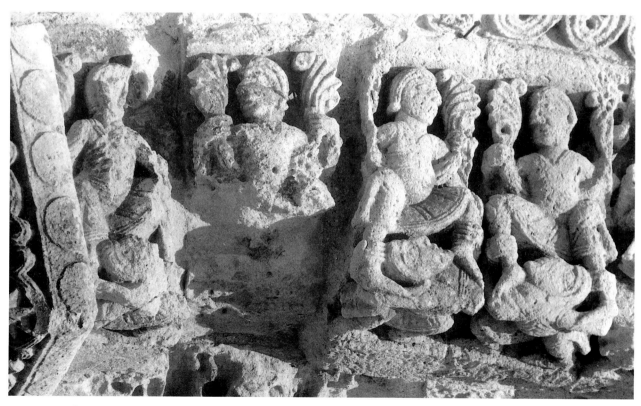

PL 325. Maillé, western façade, voussoirs in the outermost archivolt of the portal (photo: author)

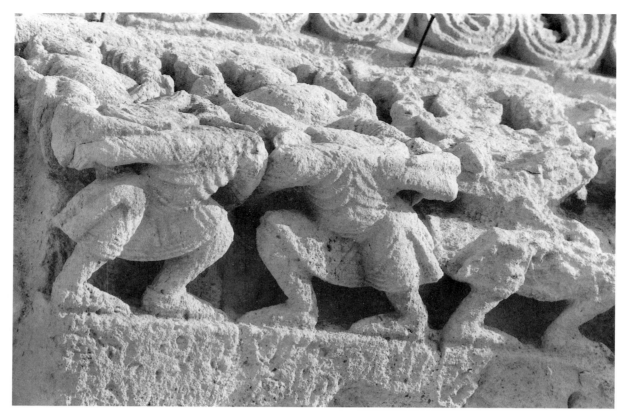

PL 326. Maillé, western façade, soffit of the archivolt in PL 325 (photo: author)

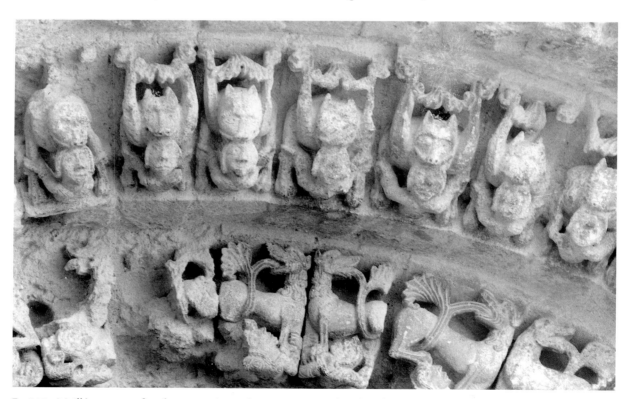

PL 327. Maillé, western façade, voussoirs in the innermost archivolts of the portal (photo: author)

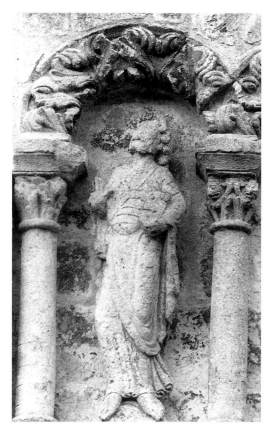

PL 328. Ruffec, western façade, an Apostle in the upper zone (photo: author)

PL 329. Ruffec, western façade, portal archivolt and hood (photo: author)

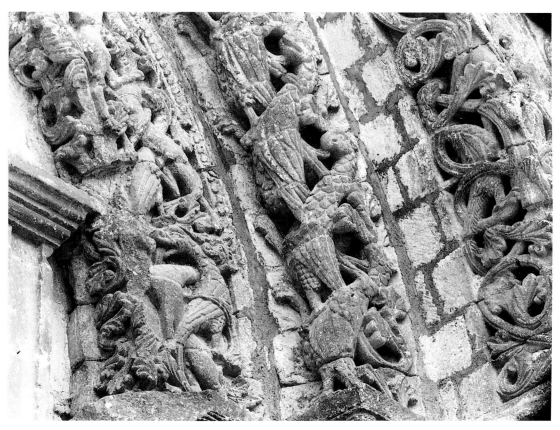

PL 330. Ruffec, western façade, portal archivolt (photo: the Conway Library, Courtauld Institute of Art)

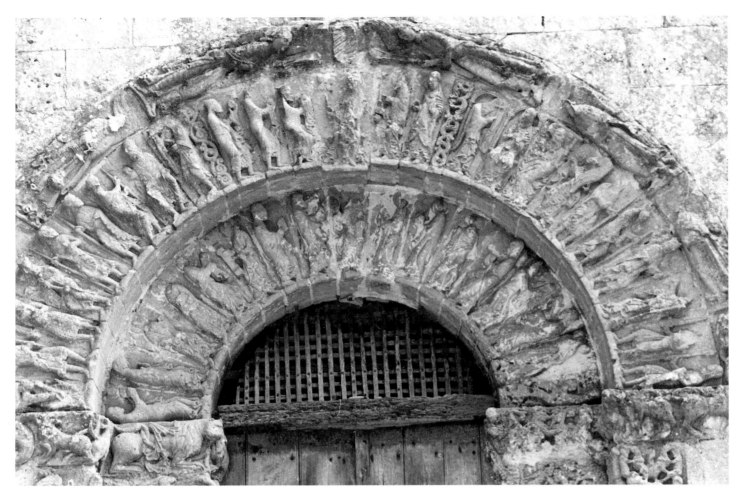

PL 331 (*above*). Nuaillé-sur-Boutonne, Sainte-Marie, western façade, portal archivolts (photo: author)

PL 332 (*right*). Nuaillé-sur-Boutonne, Sainte-Marie, interior capitals (photo: author)

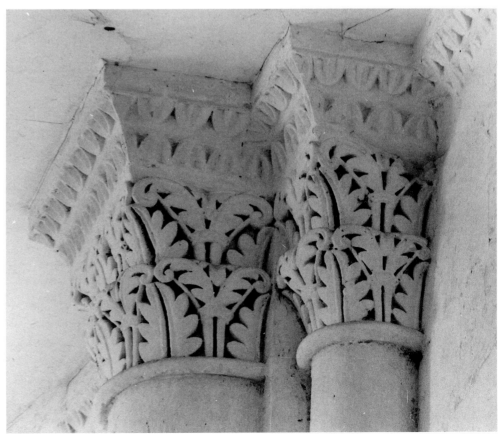

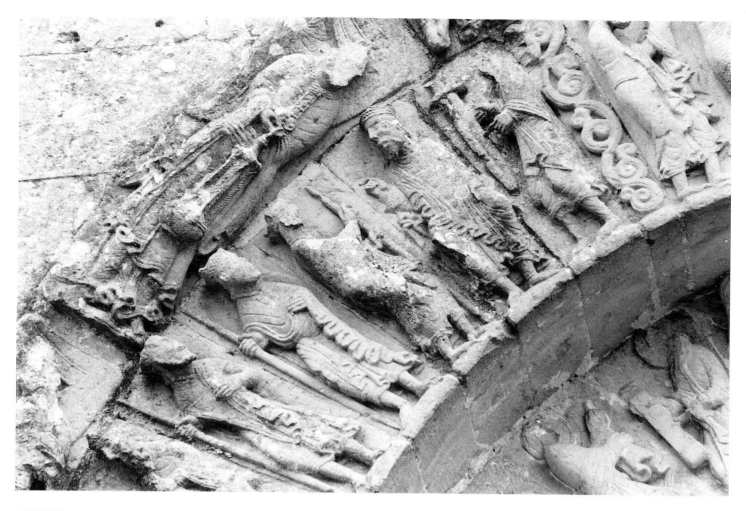

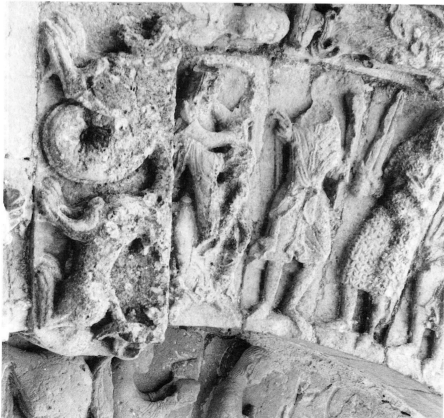

PL 333 (*above*). Nuaillé-sur-Boutonne, Sainte-Marie, western façade, portal, voussoirs in the outer archivolt: the Magi before Herod (photo: author)

PL 334 (*left*). Nuaillé-sur-Boutonne, Sainte-Marie, western façade, portal, voussoirs in the outer archivolt: the Massacre of the Innocents (photo: author)

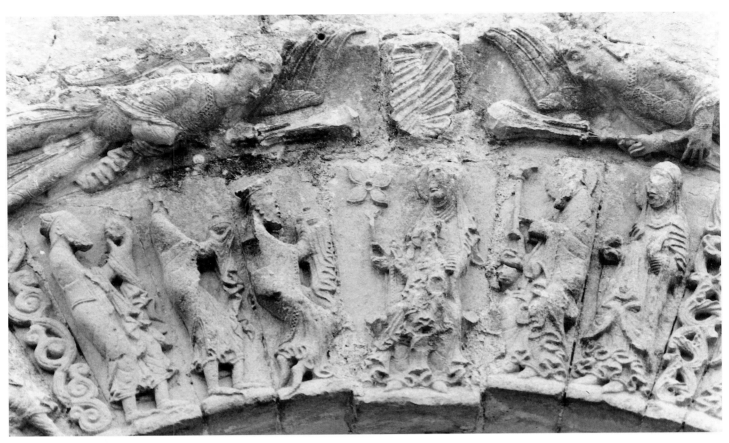

PL 335. Nuaillé-sur-Boutonne, Sainte-Marie, western façade, portal, apex voussoirs of the outer archivolt: the Adoration of the Magi (photo: author)

PL 336. Angers, Saint-Aubin, an arch in the cloister, combined decoration in sculpture and painting: the enthroned Virgin and Child and a Magi Cycle (photo: author)

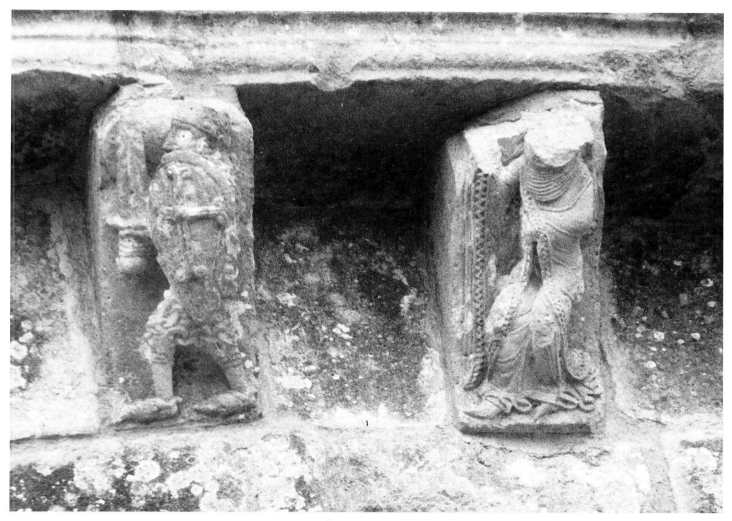

PL 337. Varaize, Saint-Germain, corbels on the apse (photo: author)

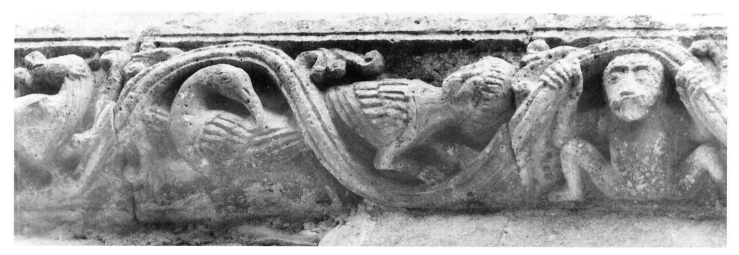

PL 338. Varaize, Saint-Germain, south side of the nave, cornice above the portal (photo: author)

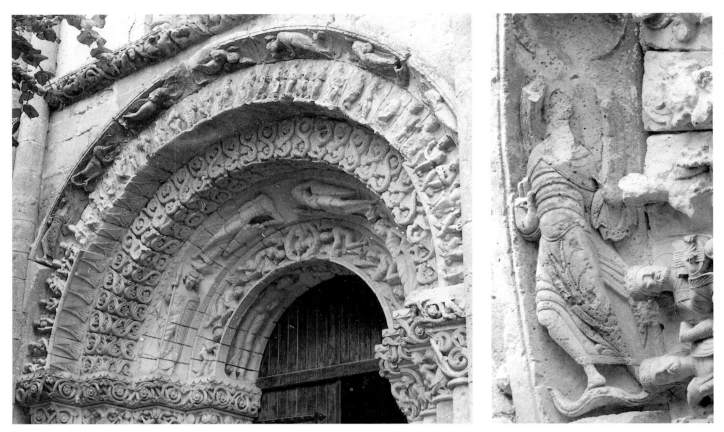

PL 339. Varaize, Saint-Germain, portal on the south side of the nave; and PL 340 (*right*). detail of hood (photo: author)

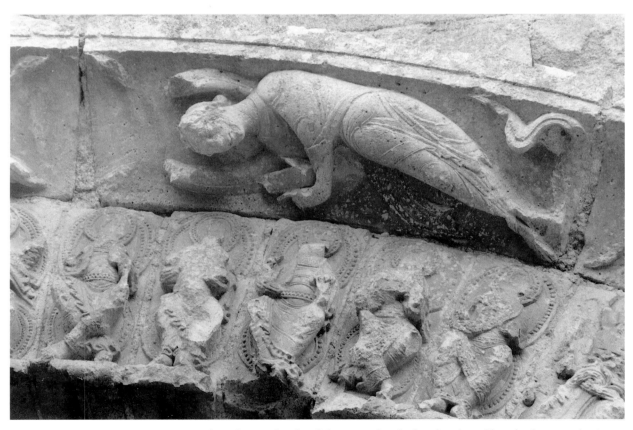

PL 341. Varaize, Saint-Germain, portal on the south side of the nave, detail of archivolt and hood (photo: author)

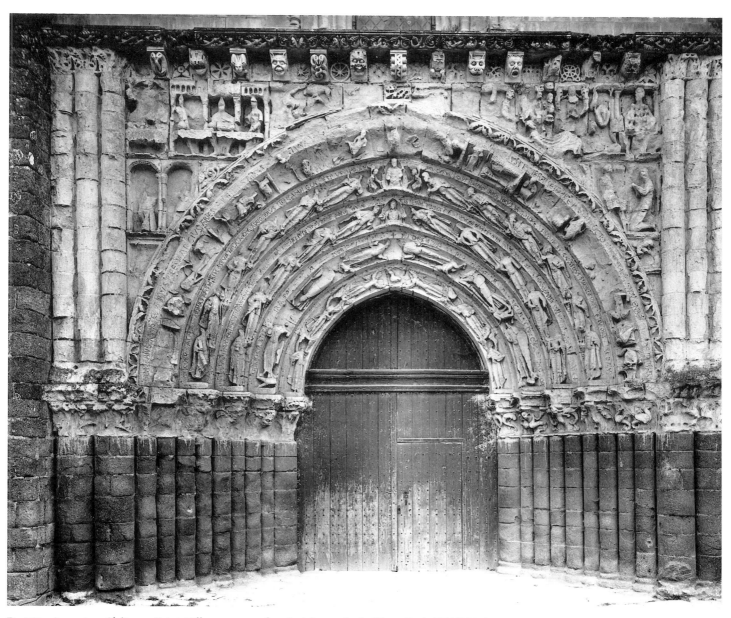

PL 342. Argenton-Château, Saint-Gilles, western façade (photo: Arch. Phot. Paris/SPADEM)

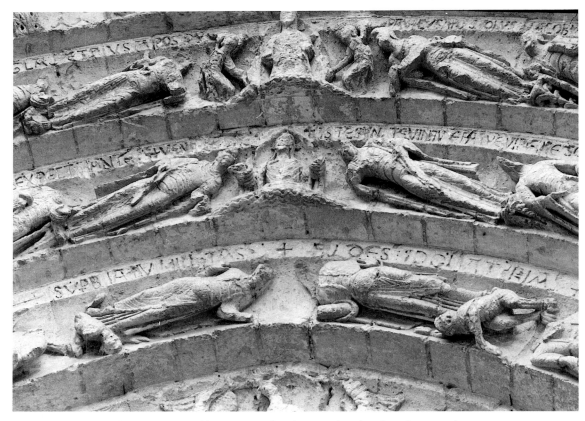

PL 343. Argenton-Château, Saint-Gilles, western façade, portal archivolts (photo: author)

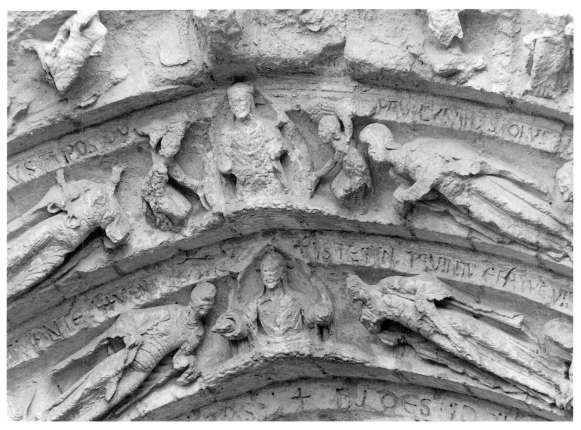

PL 344. Argenton-Château, Saint-Gilles, western façade, portal, archivolts 2 and 3: Apostles witnessing the Ascension, the Wise and Foolish Virgins (photo: author)

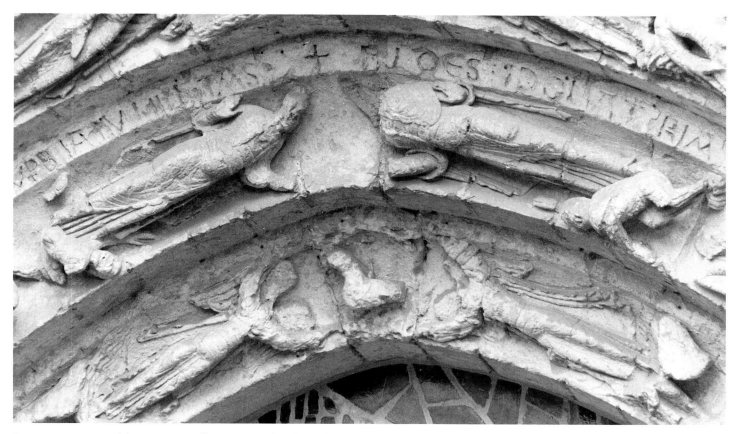

PL 345. Argenton-Château, Saint-Gilles, western façade, archivolts 4 and 5: the Virtues and Vices, the Lamb of God (photo: author)

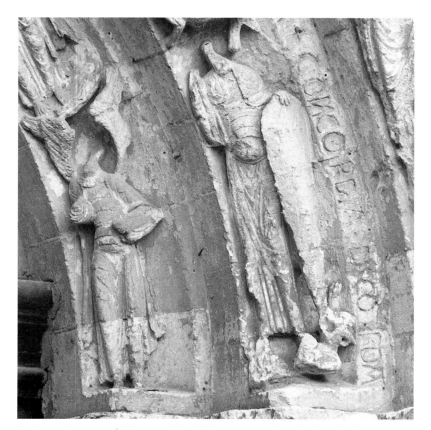

PL 346. Argenton-Château, Saint-Gilles, western façade, detail of portal archivolts: an angel and a Virtue (photo: author)

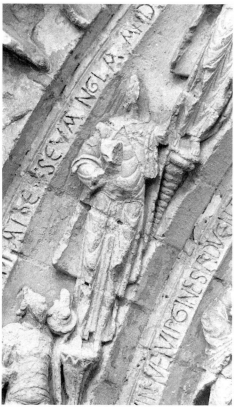

PL 347. Argenton-Château, Saint-Gilles, western façade, detail of portal archivolt: an Apostle (photo: author)

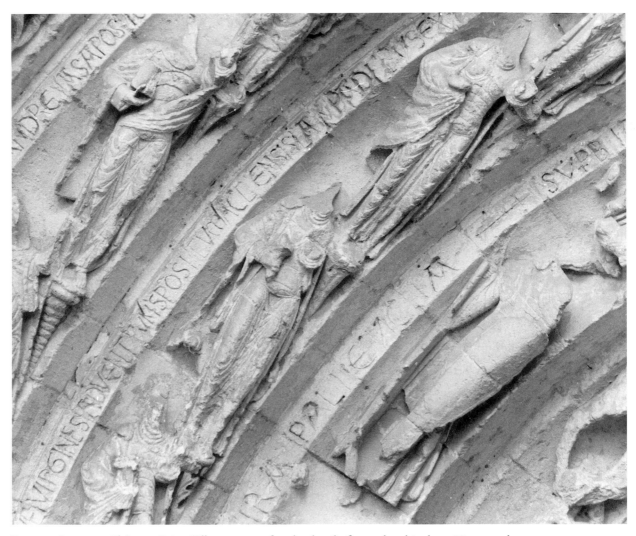

PL 348. Argenton-Château, Saint-Gilles, western façade, detail of portal archivolts: a Virtue and two Wise Virgins (photo: author)

PL 349. Argenton-Château, Saint-Gilles, western façade, portal spandrel, the Lazarus frieze: Heaven and Hell (photo: the Conway Library, Courtauld Institute of Art)

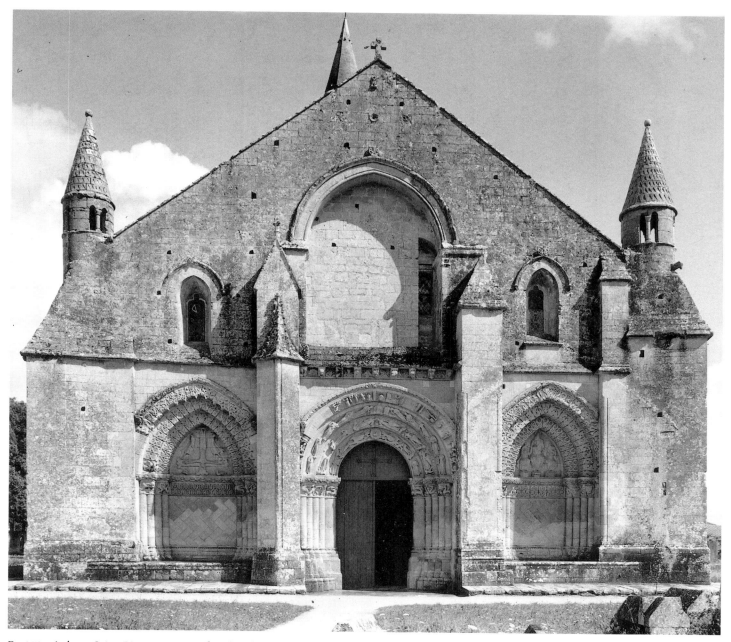

PL 350. Aulnay, Saint-Pierre, western façade (photo: James Austin)

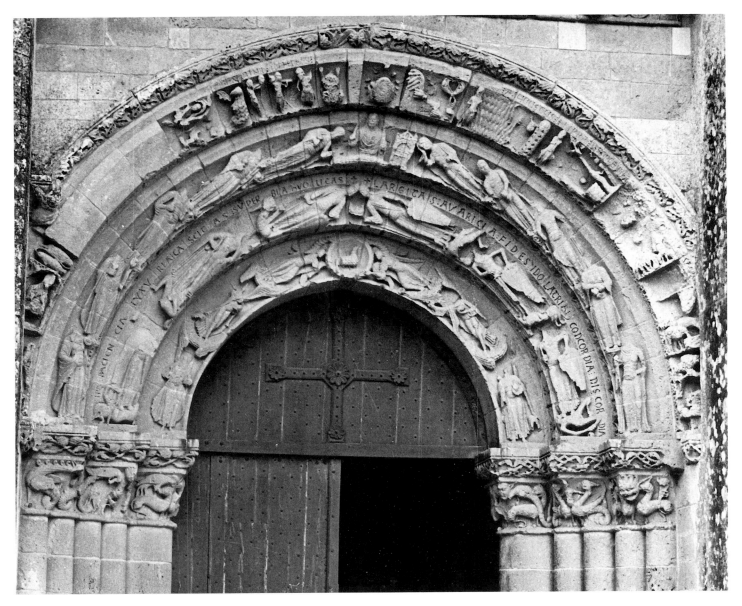

PL 351 (*above*). Aulnay, Saint-Pierre, western façade, portal
archivolts (photo: G. Zarnecki, courtesy of the Conway Library,
Courtauld Institute of Art)

PL 352 (*right*). Anzy-le-Duc, west portal, tympanum and
archivolt: Ascension with the Elders of the Apocalypse (photo:
author)

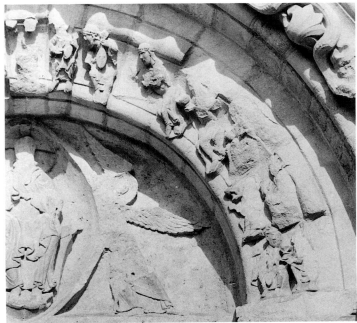

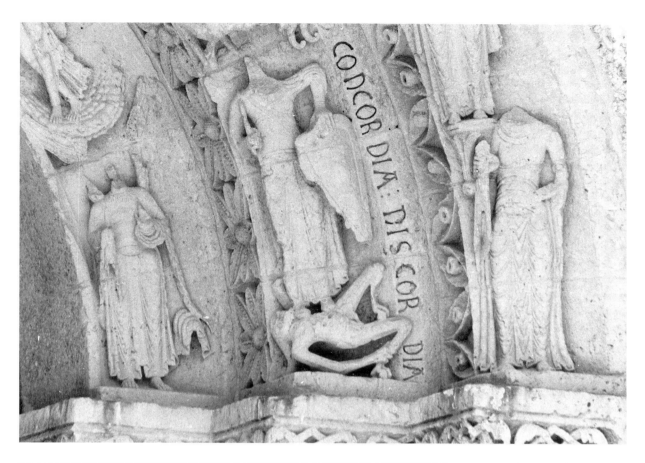

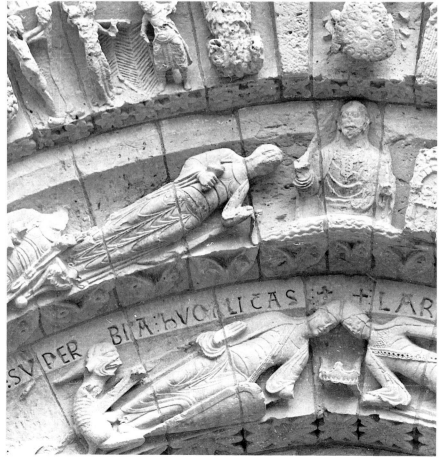

PL 353 (*above*). Aulnay, Saint-Pierre, western façade, detail of portal archivolts: a Foolish Virgin, a Virtue, and an angel (photo: author)

PL 354 (*left*). Aulnay, Saint-Pierre, western façade, detail of portal archivolts: Christ and a Wise Virgin, the Virtues holding a crown (photo: G. Zarnecki, courtesy of the Conway Library, Courtauld Institute of Art)

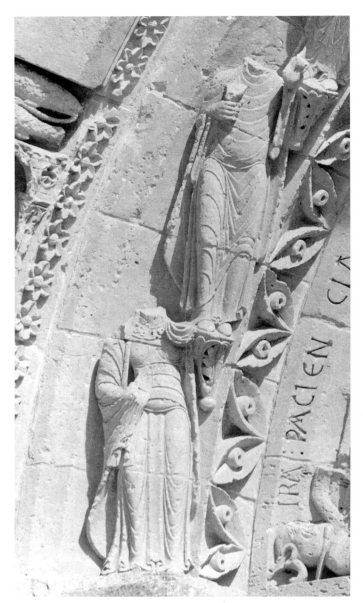

PL 355 (*above*). Aulnay, Saint-Pierre, western façade, detail of portal archivolt: two Wise Virgins (photo: author)

PL 356 (*above, right*). Saint-Michel-en-l'Herm, chapter house arcade, fragment of archivolt (photo: author)

PL 357 (*right*). Thouars, Musée Municipal, slab-relief (photo: author, courtesy of the Conway Library, Courtauld Institute of Art)

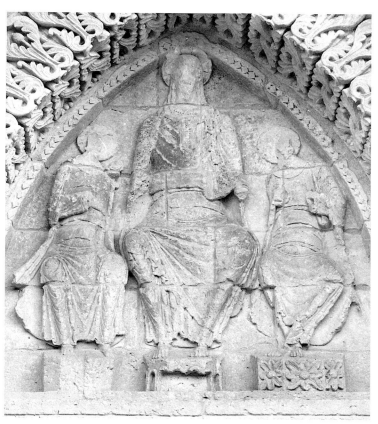

PL 358 (*left*). Aulnay, Saint-Pierre, western façade, relief in the south niche: Christ and two Apostles (photo: James Austin)

PL 359 (*below*). Aulnay, Saint-Pierre, western façade, relief in the north niche: Peter's Crucifixion (photo: James Austin)

PL 360. Fontaines-d'Ozillac, portal archivolts (photo: the Conway Library, Courtauld Institute of Art)

PL 361. Saint-Pompain, western façade, detail of portal archivolt: a Virtue (photo: author)

PL 362 (*right*). Varaize, Saint-Germain, portal on the south side of the nave, detail of archivolt: a Virtue (photo: author)

PL 363 (*far right*). Blasimont, Saint-Maurice, west portal, detail of archivolts: a Virtue (photo: Bildarchiv Foto Marburg)

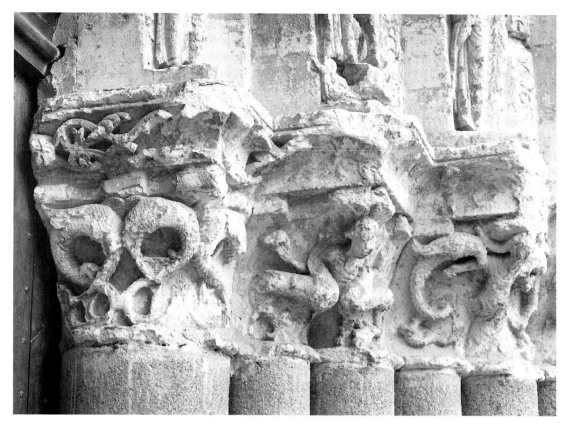

PL 364. Argenton-Château, Saint-Gilles, western façade, capitals in the portal (photo: author)

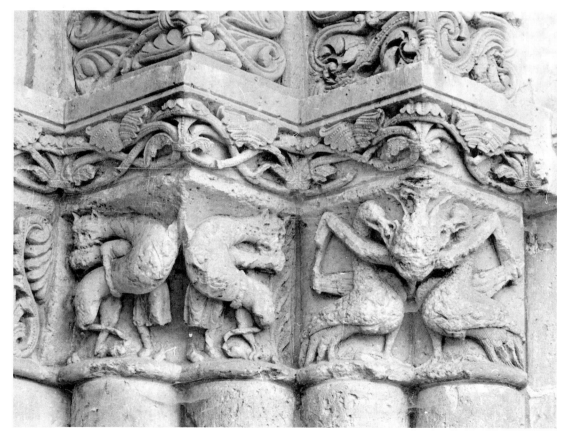

PL 365. Aulnay, Saint-Pierre, western façade, capitals in the north niche (photo: the Conway Library, Courtauld Institute of Art)

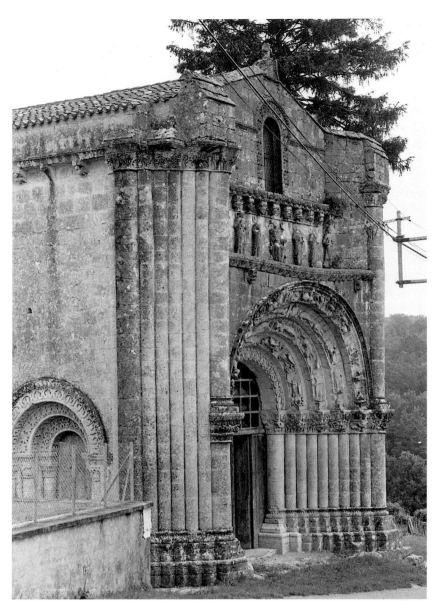

PL 366 (*left*). Fenioux, Notre-Dame, view from north-west (photo: author)

PL 367 (*above*). Fenioux, Notre-Dame, interior capital (photo: author)

PL 368 (*below*). Fenioux, Notre-Dame, portal on the north side of the nave, capitals (photo: the Conway Library, Courtauld Institute of Art)

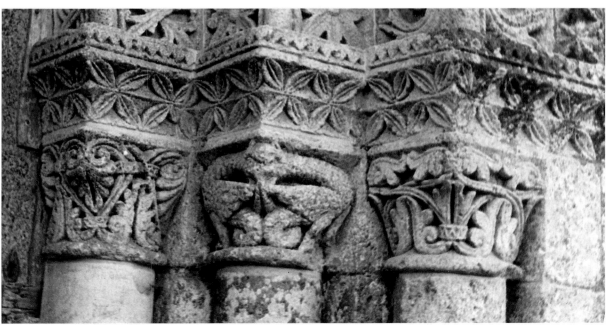

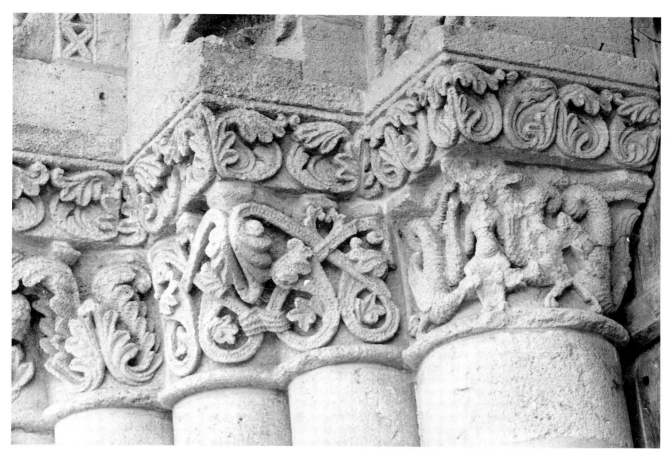

PL 369. Fenioux, Notre-Dame, western façade, portal capitals (photo: author)

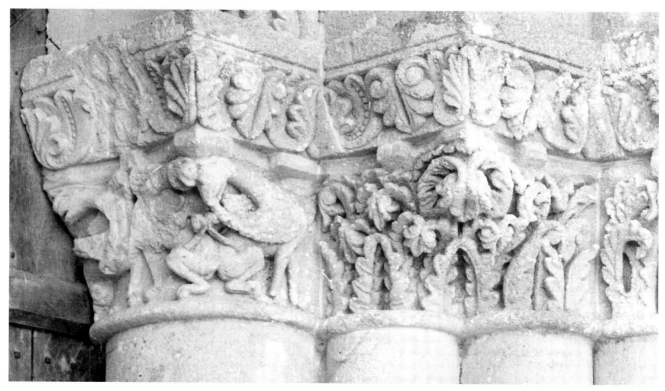

PL 370. Fenioux, Notre-Dame, western façade, portal capitals (photo: author)

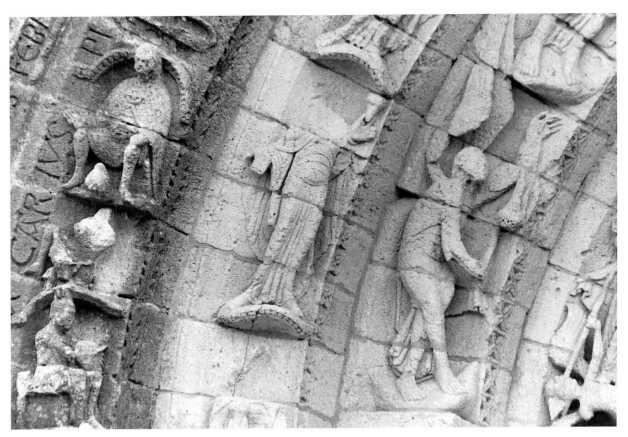

PL 371. Fenioux, Notre-Dame, western façade, detail of portal archivolts: the months of January and February, a Wise Virgin, and an angel (photo: author)

PL 372. Fenioux, Notre-Dame, western façade, detail of portal archivolts: angels with the Lamb of God, Virtues (photo: author)

PL 373 (facing). Pérignac, western façade (photo: author)

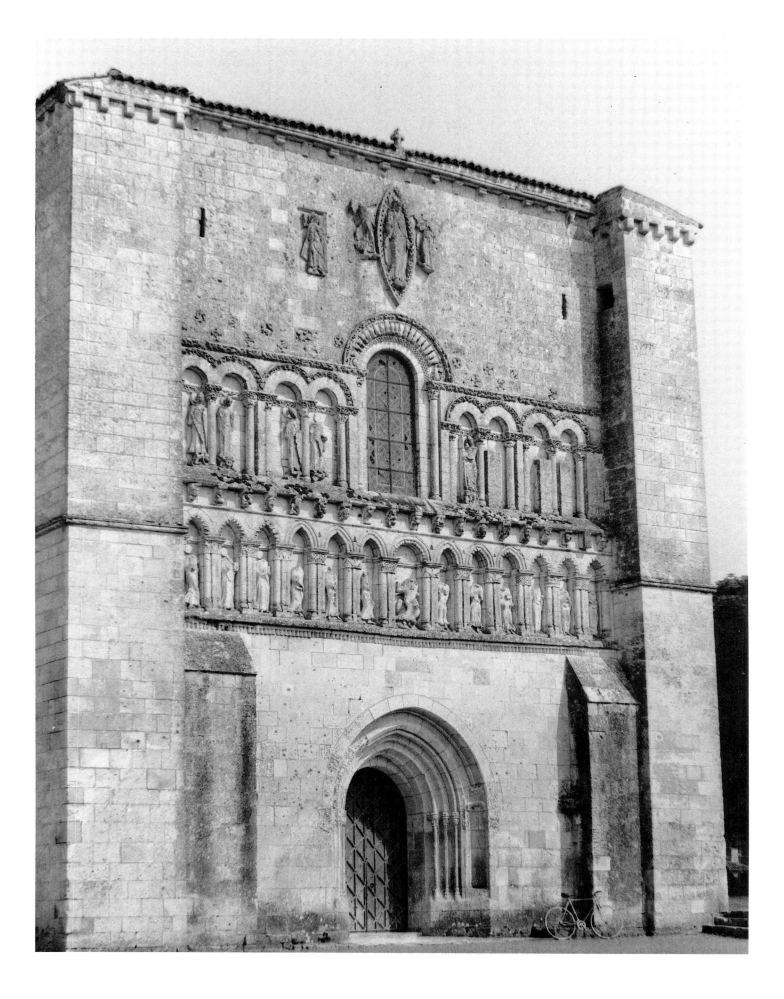

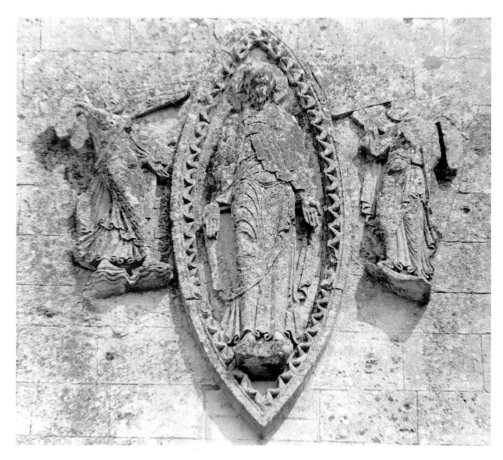

PL 374 (*above*). Pérignac, western façade,
uppermost zone: Christ and two angels (photo:
author)

PL 375 (*right*). Pérignac, western façade, statues
in zone 3: Virtues (photo: author)

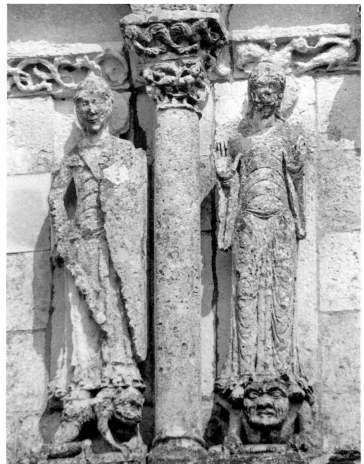

PL 376. Pérignac, western façade, statues in zone 2: Christ and an Apostle (photo: author)

PL 377. Pérignac, western façade, statues in zone 2 (photo: author)

PL 378 (*right*). Châteauneuf-sur-Charente, western façade, statue in the upper zone: the rider Constantine (photo: author)

PL 379 (*below*). Poitiers, Les Trois Piliers, fragment of a rider (photo: author, courtesy of the Conway Library, Courtauld Institute of Art)

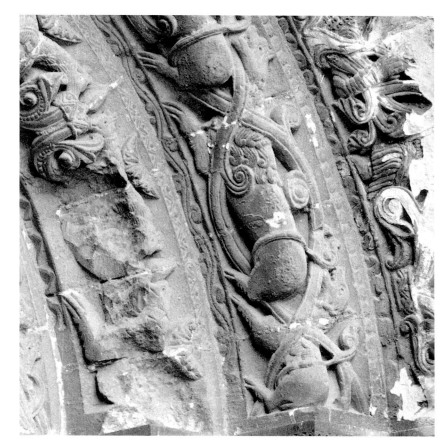

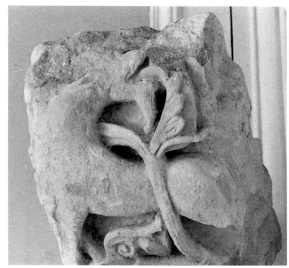

PL 380 (*left*). Beauvais, Saint-Étienne, north portal, detail of archivolts (photo: the Conway Library, Courtauld Institute of Art)

PL 381 (*above*). Chelles, Musée Municipal, voussoir from a destroyed portal of Chelles Abbey

PL 382 (*below*). Châteaudun, La Madeleine, hood of the south portal (photo: the Conway Library, Courtauld Institute of Art)

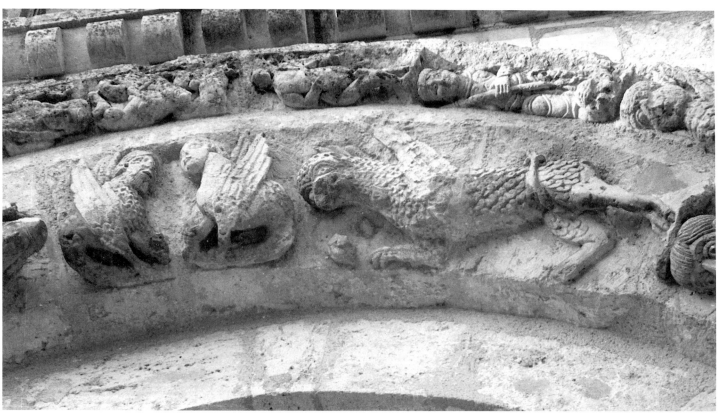

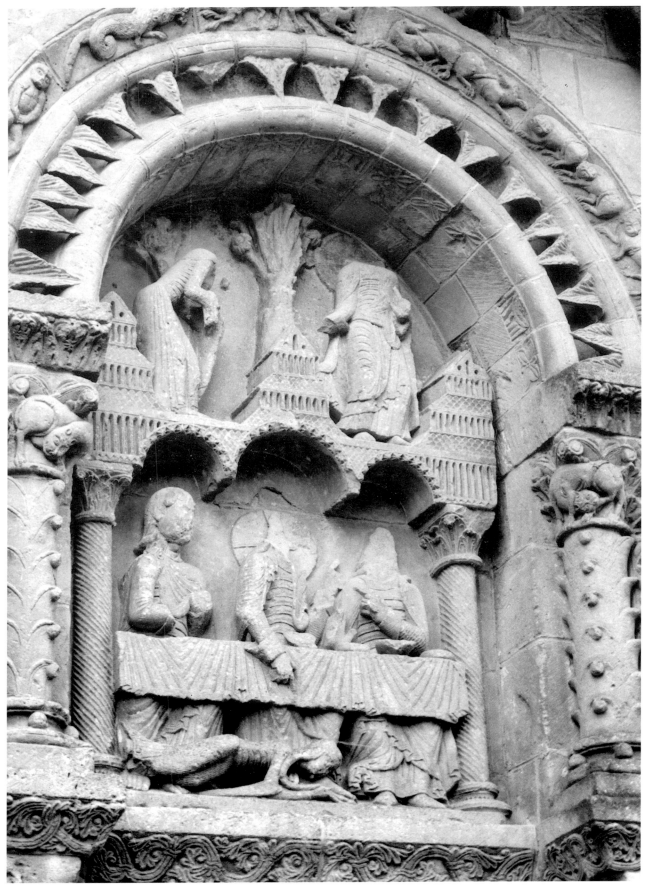

PL 383. Foussais, western façade, relief in the south niche: Christ in the House of Simeon and Christ's Appearance to Mary Magdalene (photo: author)

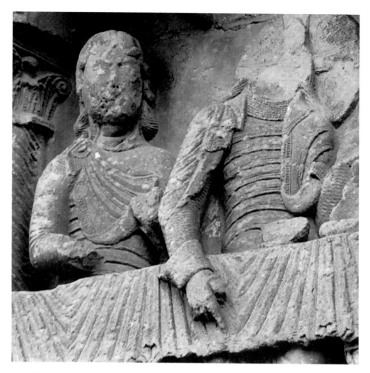

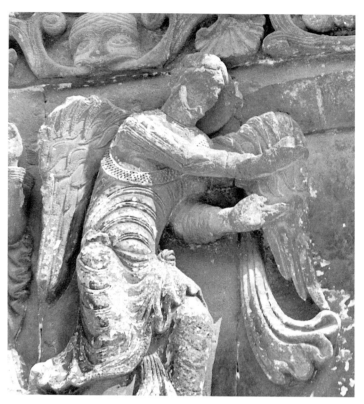

PL 384. Foussais, western façade, detail of the relief in PL 383 (photo: author)

PL 385. Poitiers, Notre-Dame-la-Grande, western façade, detail of frieze: the angel of the Annunciation (photo: author)

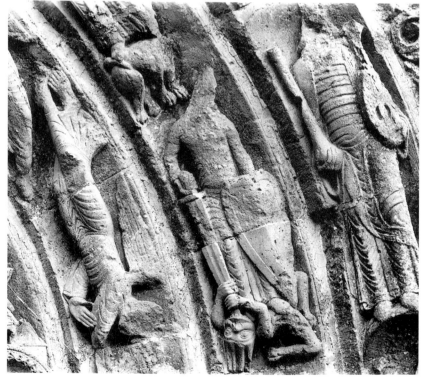

PL 386. Poitiers, Notre-Dame-la-Grande, western façade, detail of frieze: Prophets (photo: author)

PL 387. Parthenay, Notre-Dame-de-la-Couldre, western façade, details of portal archivolt: an Elder of the Apocalypse, a Virtue, and an angel (photo: Bildarchiv Foto Marburg)

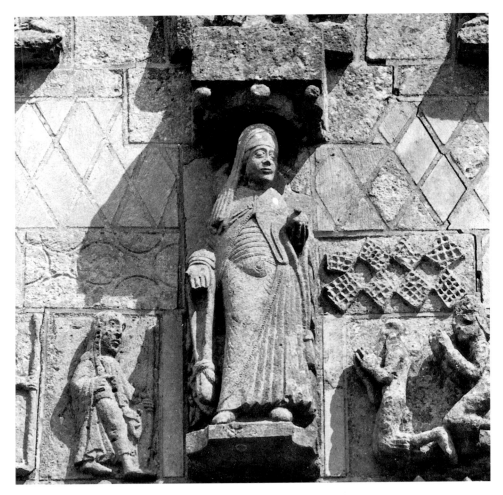

PL 388 (*above*). Saint-Jouin-de-Marnes, western
façade, mid-twelfth-century revision: the Virgin
Mary (?) (photo: James Austin)

PL 389 (*right*). Maillezais, Saint-Nicolas, western
façade, statue in the north niche (photo: author,
courtesy of the Conway Library, Courtauld
Institute of Art)

PL 390 (*far left*). Saint-Jouin-de-Marnes, western façade, mid-twelfth-century revision: Luxuria (photo: James Austin)

PL 391 (*left*). Montmorillon, Octagon of the Maison Dieu: Luxuria (photo: author, courtesy of the Conway Library, Courtauld Institute of Art)

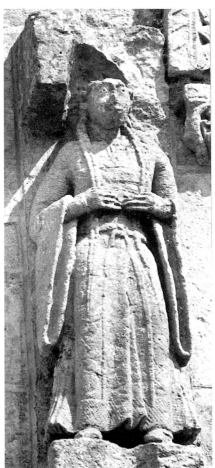

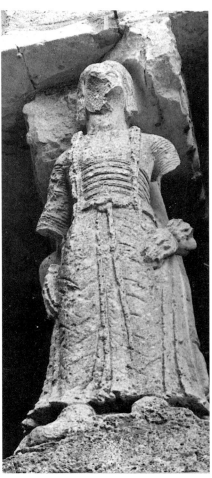

PL 392 (*far left*). Saint-Jouin-de-Marnes, western façade, mid-twelfth-century revision: an 'elegant lady' (photo: author, courtesy of the Conway Library, Courtauld Institute of Art)

PL 393 (*left*). Montmorillon, Octagon of the Maison Dieu: an 'elegant lady' (photo: author, courtesy of the Conway Library, Courtauld Institute of Art)

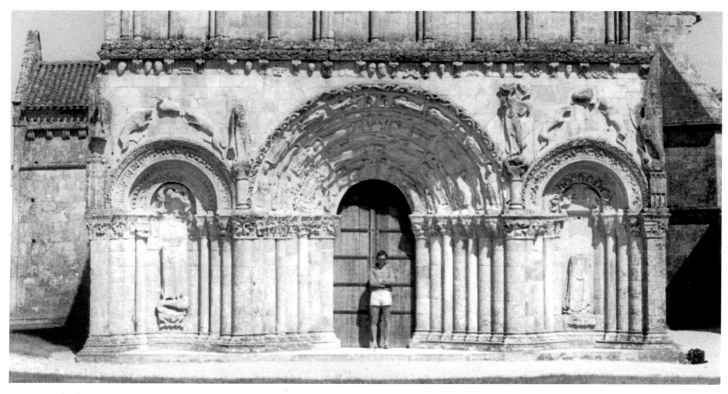

PL 394. Chadenac, Saint-Martin, western façade (photo: author)

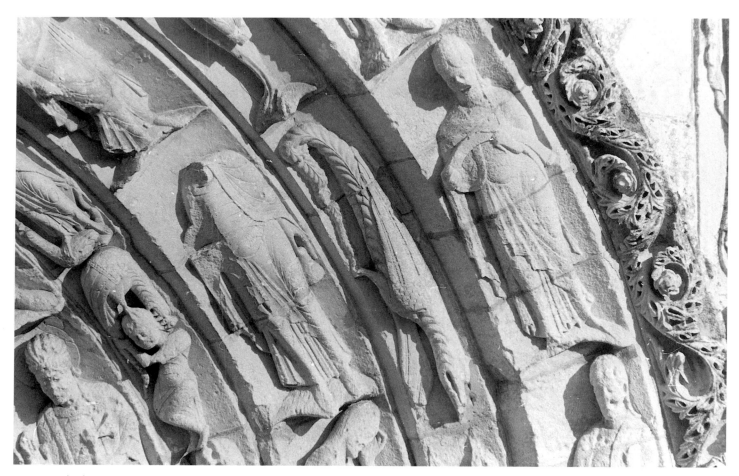

PL 395. Chadenac, Saint-Martin, western façade, detail of the portal archivolts: an Apostle, a Foolish Virgin, and other themes (photo: author)

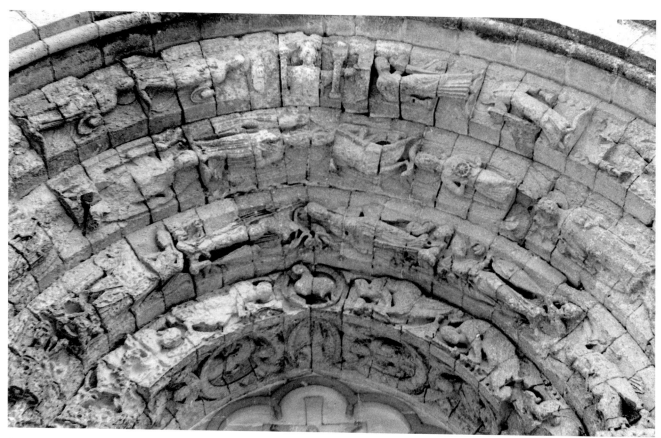

PL 396. Pont-l'Abbé-d'Arnoult, western façade, portal archivolts (photo: author)

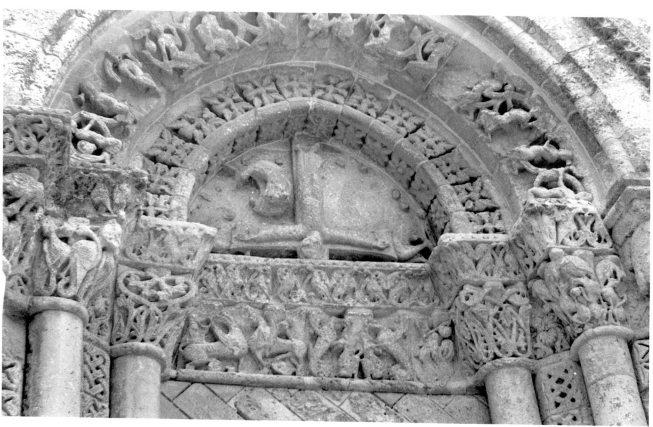

PL 397. Pont-l'Abbé-d'Arnoult, western façade, south niche (photo: author)